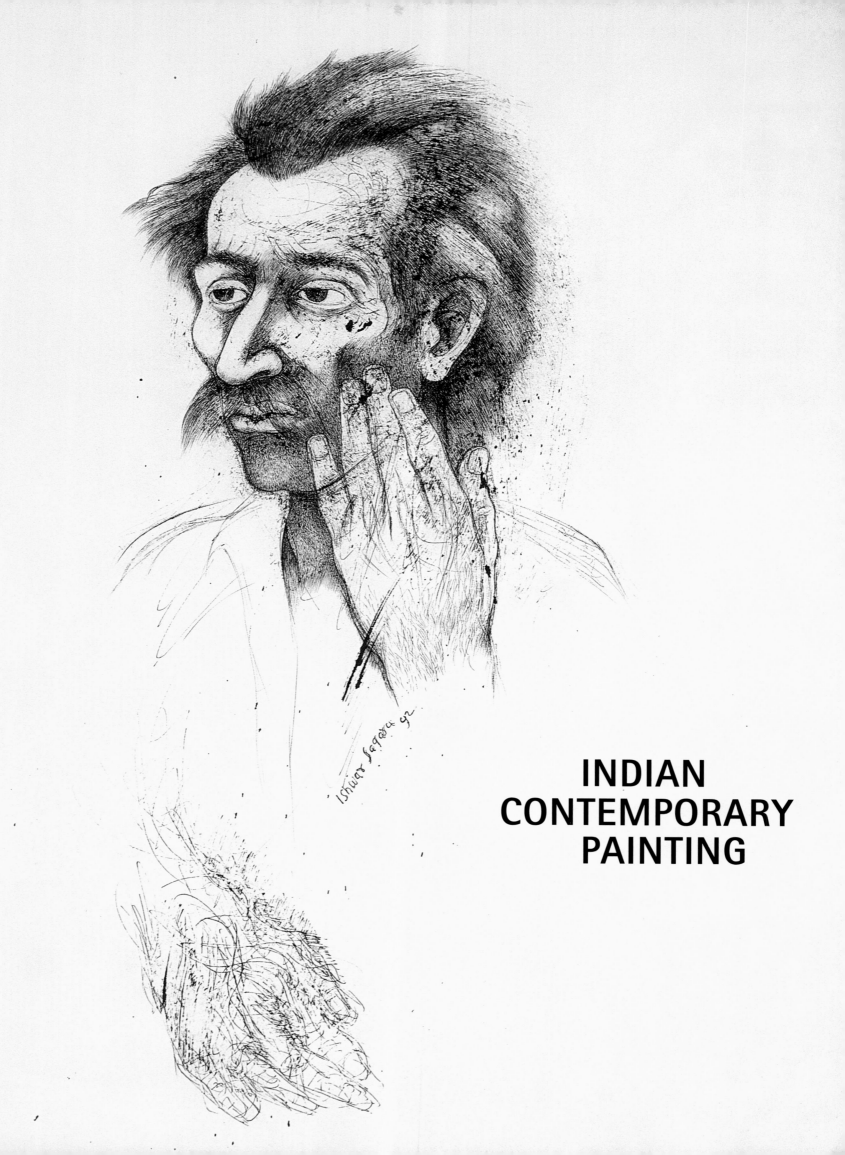

INDIAN CONTEMPORARY PAINTING

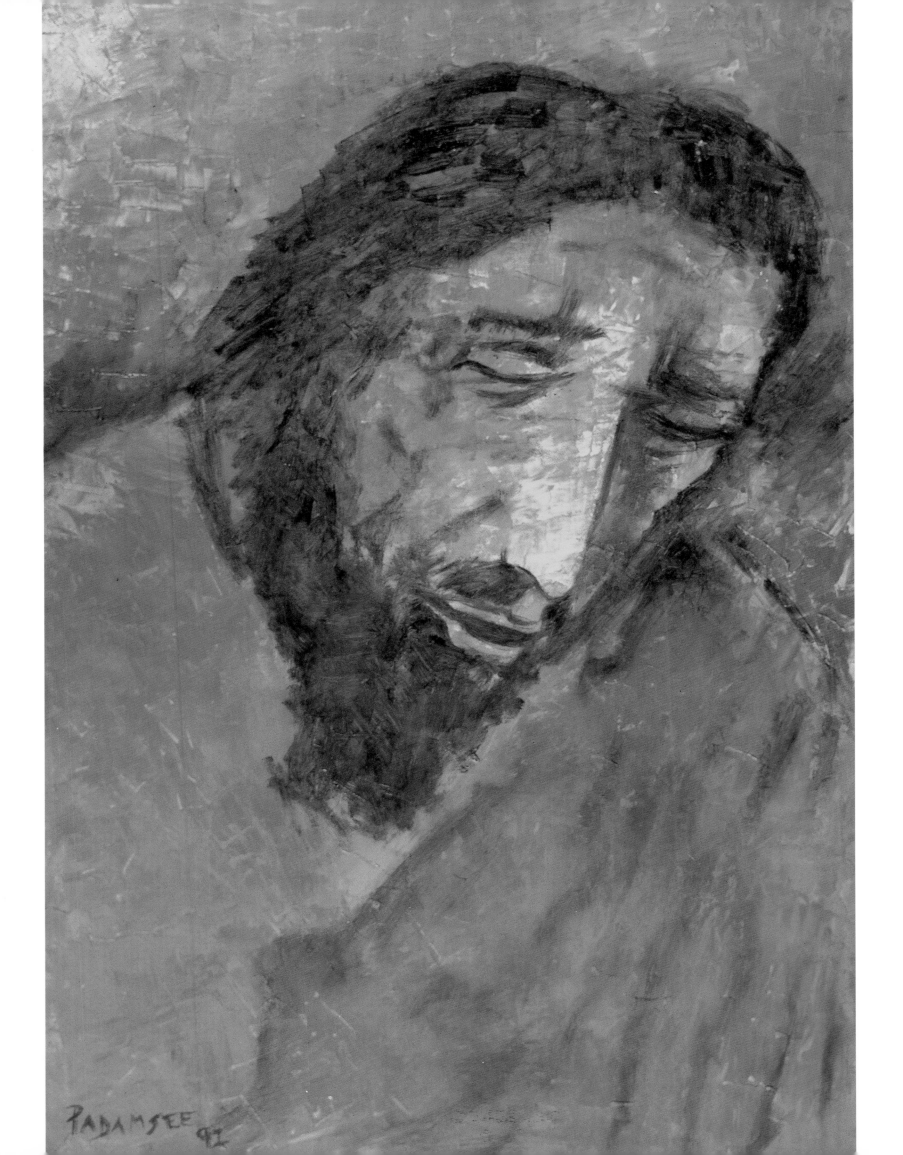

INDIAN CONTEMPORARY PAINTING

Neville Tuli

Harry N. Abrams, Inc., Publishers

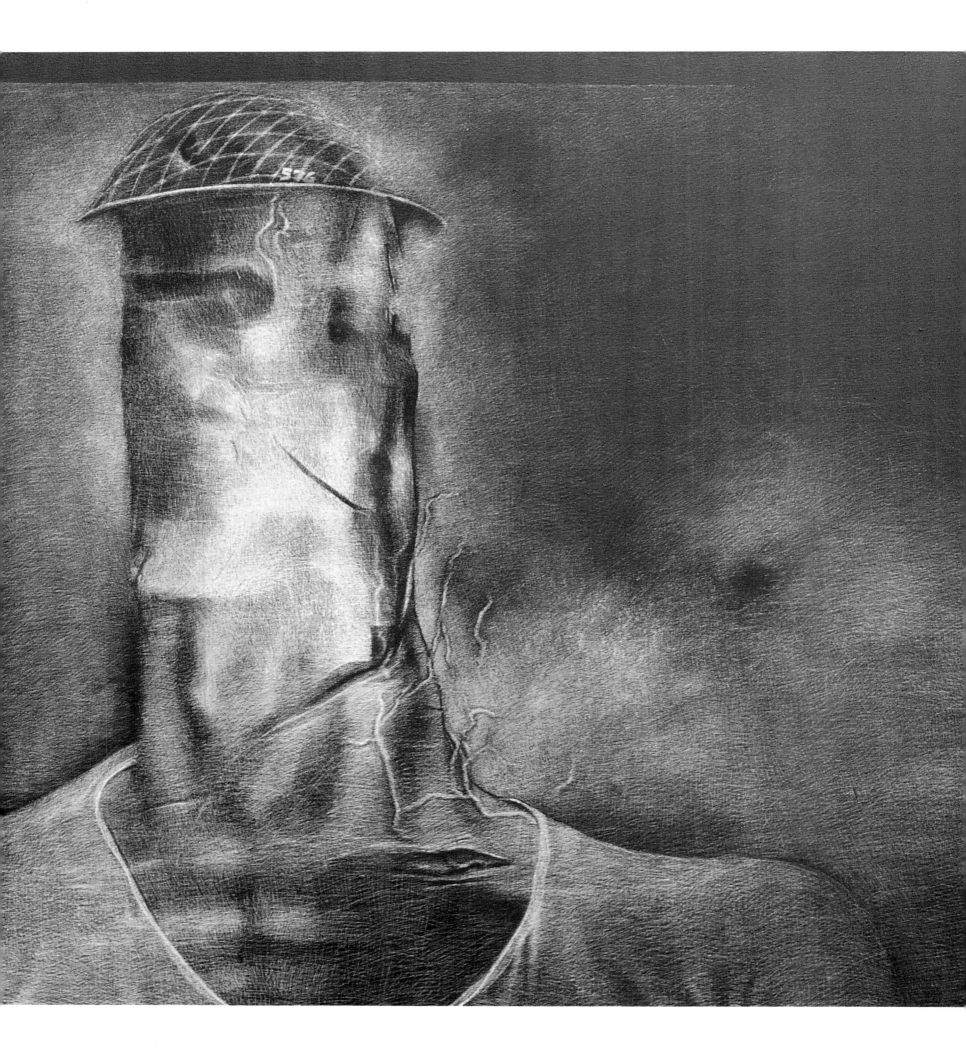

for
mummy & daddy

The Tuli Foundation for Holistic Education & Art

HEART, a registered Charitable Society aims at building an integrated infrastructure for the Indian Contemporary Arts. Its educational programmes, documents and archival materials focus on the holistic roots of knowledge and cover the entire field of Indian Fine Arts, Literature, Philosophy and Cinema.

A first step in this pioneering project is a wide range of publications and films to establish photographic and textual documentation of Contemporary Indian Art. This seminal collection will become the base of a Documentation Centre which will then lead to an educational complex for all Contemporary Indian Arts.

Edited by Shernaz Cama
Designed by Kirti Trivedi
Color Separations by Reproscan, Mumbai

Library of Congress Cataloging-in-Publication Data
Tuli, Neville.
 Indian contemporary painting/Neville Tuli.
 p. cm.
 Includes bibliographical references and index.
 ISBN 0-8109-3472-8 (clothbound)
 1. Painting, Indic. 2. Painting, Modern—20th century—India.
I. Title.
ND1004.T86 1998
759.954'09'04—dc21 97-36828

First published in India in 1997 by
The Tuli Foundation
for Holistic Education & Art (HEART)
in association with
Mapin Publishing Pvt. Ltd.
Chidambaram, Ahmedabad 380013 India

Published in 1998 by Harry N. Abrams, Incorporated, New York

Printed in Singapore

Harry N. Abrams, Inc.
100 Fifth Avenue
New York, N.Y. 10011
www.abramsbooks.com

Page 1:
Ishwar Sagara
Head
Pen & Ink, 1991

Page 2:
Akbar Padamsee
Head
Oil, 1992

Page 4:
Rameshwar Broota
Unknown Soldier
Oil, 1987

Acknowledgements

As always, my mother and father are the unqualified pillars of what I do and may do. Unqualified freedom has been their gift to me, and constant renewal whenever I have failed to be true to that freedom. My sister's love has always reinforced this foundation. During the writing of this book I married, and to my loving wife, Zothanpari, I am grateful for reducing my self-absorption and supporting the difficult task of achieving one's vision.

To my dear friends: Rajit Kapur, Faiz Khan, Sanjeev Khandelwal and Percy Marchant, thank you for sharing with me your space and love, and having faith in my work.

To all the Council Members of **HEART** but especially Rashmi Poddar, Rupika Chawla, Priya Paul and Sanjeev Khandelwal, the backbone of a nascent dream, I gratefully thank you for your faith and affection, time and energy, and for the years of efforts you still have to give.

To Lord Prof. Meghnad Desai for always providing loving encouragement and critical humour. To Niranjan Desai for giving me the chance on my first published essay on Indian Contemporary Art. To Bipin Shah for his unstinting professional help, care and enthusiasm in bringing out this book. To Mallika Sarabhai for her openness, sensitivity and decisive abilities. To Edward Booth-Clibborns and Vernon Futerman for their affection and support in sustaining the project from the earliest day to its end. To Dr. Shernaz Cama for her meticulous and supportive editing and thoughts. To Prof. Kirti Trivedi for his clear and wise sense of design and patient friendship. To the team at Reproscan for their diligent processing work.

From the start of the project the help of Prakash Rao and his dedicated camera has been much appreciated. Without his fine work and friendship the book would have taken much longer.

Similarly, since day one the whole Indian Contemporary Art community warmly opened their arms, sharing their affection, transparencies, and scarce time. My gratitude to the following artists who helped the project in varying degrees: Altaf, Badrinarayan, my dear friend, the late Prabhakar Barwe, Manjit Bawa, R.B.Bhaskaran, Rameshwar Broota, Arpana Caur, Jogen Chowdhury, Amithava Das, Biren De, P.D.Dhumal, Atul Dodiya, C.Douglas, Shyamal Dutta Ray, Satish Gujral, Ganesh Haloi, Somnath Hore, Shamsad and M.F.Husain, Ranbir Kaleka, Sanat Kar, Bhupen Khakhar, Krishen Khanna, Prabhakar Kolte, Achuthan Kudallur, Nalini Malani, Tyeb Mehta, Anjolie Ela Menon, Reddeppa Naidu, Akbar Padamsee, Laxman Pai, Madhvi and Manu Parekh, Sudhir Patwardhan, Gieve Patel, Ganesh Pyne, Mona Rai, A.Ramachandran, Ramkumar, Rekha Rodwittiya, Suhas Roy, Jehangir Sabavala, G.R.Santosh, Paritosh Sen, G.m.Sheikh, Laxman Shreshtha, Arpita and Paramjit Singh, Francis N. Souza, K.G.Subramanyan, Vivan Sundaram, the late J.Swaminathan, Vasundhara Tewari, and S.G.Vasudev.

Most critics and historians provided the same affection and time. Keshav Malik, Ranjit Hoskote, Mala Marwah, and Rakshat Puri, four sensitive poets, demand special thanks. From the gallery owners, all generously shared their time and views, especially Kekoo, Korshed and Shireen Gandhy, Dadibha Pundole, Pheroza Godrej, Prakash & Soumitra Kejriwal, Renu Modi, Geeta Mehra, and Arun Vadehra. My thanks also to Dr. Anjali Sen at the NGMA for her kind co-operation; Dr. Archana Roy at the Birla Academy of Art and Culture (Calcutta), Mr. S.Dayal & Mr. Walia at LTG Gallery, Mrs. Usha Gawde at Cymroza Gallery and Ashok Tawde and Ashley Rodriques at Gallery Chemould.

Late in the project came the affection and encouragement of Ebrahim Alkazi. His idealism and integrity reminding me that I had to go even deeper if one was to inspire and sustain a vast vision.

Apart from these friendships, the love of Kaka mama, Amita mami, Baby aunty, Pashi mama, Mani uncle, Pushpa aunty, Manju & Mona didi, Keetu mama, Suresh uncle, and Manju masi, sustained many a rough moment. My thanks also to Anal Chandaria, Ravi Dayal, Dinesh and Amrita Jhaveri, Duleep and Visaka Ghia, Jehangir Nicholson, Prabjit Singh, the late Anis Farooqi, Anil Metre, Lucie Vellaise, Russell Middleton, David Graham, and Mainee Khan, who all helped in their loving ways to facilitate the project. Further, my thanks to Vikas and Somesh Mehrotra, and the Research Team at VLS, as well as Angira Arya for their invaluable help and support towards this book.

However, despite the co-operation of many people, it was a singular effort. I say this only to stress how difficult it would be for others without the infrastructure created by oneself. One feels the frustration of so many who have struggled in an insecure system for years, through apathy and neglect. It is time we radically change the terms of communication. It is time we transform the infrastructure into an interconnected educationally inspiring system, able to generate finances from within, to encourage without the fear of having to denigrate or marginalise another; to create a system rooted upon intellectual rigour and unstinting documentation with no short cuts.

The passing away of my dear friend Prabhakar Barwe has saddened me. He was a man of humility, integrity and wisdom, besides being one of our foremost artists. His open artistic mind was an inspiration to many, and one will miss the shared dialogues, let alone the imagery. More than a year earlier, another eminent thinker-artist, J.Swaminathan, passed away. My acquaintance with him was less entrenched, yet, one knows the regard and love in which he was held by so many in the art community. The very kind K.K.Hebbar has also passed away in recent weeks.

What saddens me further, is that so many of our eminent artists are in their late sixties or older, having struggled and created for over forty to fifty years, and still no comprehensive documentation exists on their artistic contribution and significance. A radical change in attitude is essential; it is hoped that this book will act as a catalyst in this regard.

Finally, I would like to express my gratitude to all those individuals and organisations who helped **HEART** sustain the pioneering exercise of preselling **The Flamed-mosaic.** To Rashmi Poddar, Priya Paul, Pheroza Godrej, Sanjeev Khandelwal, Vipula Kadri, Niranjan Desai, Rupika Chawla, Rajit Kapur, Renu Modi, Firdaussi Jussawalla & Ritu Singh, Mehli Mistry, Gokul Binani, Bernhard Steinrucke, Niraj Bajaj, Dennis Grubb, Vivek Gupta, Anjana Somany, Nirmal Bhogilal, Prakash Kejriwal, Nasser Munjhee, B.P.Singh, Anjali Sen, Meera Shankar, Kunti Shah, Kawwas Barucha, Pallavi Jha, Aditya Kanoria, Yash Poddar, Shekhar Dutta & Thomas Furtado, Ashish Jalan, Akram Fahmi, Piyush Singhal, Pawan Ruia, Ranjani Dhandekar, Viraf Ghyara & Bill Roberts, Rajiv Nair, Cyrus Guzder, Rajiv Bapna, Debashis Poddar, Ms.Nanda, Madhu Kanoria, Harshpati Singhania, Madhulika Khaitan, Roda Mehta, and Swaraj & Ramjee Dass Tuli, my warmest thank you for your genuine support and goodwill.

Lastly, once again my gratitude to the team of **HEART and Mapin**, without whose faith and love I would be counting brinjals in Bareilly or chasing horses in Hereford.

Foreword

Every book tries to hold more than its structure allows.

Over three years ago when I introduced myself to Indian contemporary art, there was only a mild curiosity in this static-visual idiom, for like most one believed that the written word and the moving image were enough for expression and communication in India.

One did not expect to find a meaningful and unique contemporary art aesthetic. The chances of creating a framework, conceptual and infrastructural, with the fine arts playing a pivotal role, by which all creativity and its aesthetics would clarify itself across the nation and internationally, also seemed unlikely. To discipline economic and religious values through creativity, thereby giving civilisation-building a more complete developmental process seemed and still seems remote. If anything, India is moving further away from her universalist and holistic wisdom towards the practical mediocrity of the local-communal-regional basis of identifying and organising human life.

However, if India is to restructure her long term idealism, the onus of initiating this transformation lies upon the artistic community. The need is to harness the aesthetic force, bringing it to the centre of contemporary culture and education, inspiring self-criticism and joy into the institutional framework whereby science and arts, artistic creativity and education, logic and intuition, begin creating new bridges so that the economic and religious forces are given a deeper discipline.

However, translating such a vision into a collective reality requires grappling with a vast conceptual framework, hand in hand with building interconnected structures, simultaneously on many fronts, while bringing together people who would normally not unite. All such has to be accomplished at a pace which changes attitudes irreversibly, creating a new rhythm, more in tune with the restlessness within, hence more credible in providing a rest ...failure is destined in one's lifetime, but the process if sustained will fundamentally improve daily existence. In its small way **The Flamed—mosaic: Indian Contemporary Painting** has triggered this process within me. It has begun the battle, so to speak.

For we must not forget, that aesthetics is seemingly in a state of war, it lacks respect as a daily living and motivating force. Hence we must become warriors of non-violence through our creativity and its vast value system, inspiring intellectual activity on a scale not seen before, cohesive and diverse, simple yet rigorous, financially independent and uncompromising in integrity. It is all feasible, but we must unite across all borders, rejuvenating the wisdom of compassion and its inevitable fearlessness, and in this process help structure the uncertain with a degree of fluidity which the economic system is failing to fulfil, and help nurture the joy of daily existence which the religious can only fulfil with fear and subservience.

Contents

Abbreviations

Art Galleries & Institutions

AH	Art Heritage, at Triveni Kala Sangam, New Delhi
AIFACS	All India Fine Arts & Crafts Society, New Delhi
BAAC	Birla Academy of Art & Culture, Calcutta
CIMA	Centre for International Modern Art, Calcutta
CCA	Centre for Contemporary Art, New Delhi
CGAC	Government College of Art & Craft, Calcutta
Chitrakoot	Chitrakoot Art Gallery, Calcutta
Cymroza	Cymroza Art Gallery, Bombay
Dhoomimal	Dhoomimal Art Centre, New Delhi
Espace	Gallery Espace, New Delhi
Gallery 7	Gallery 7, Bombay
Gy.CH	Gallery Chemould, Bombay (If ExC. refers to Calcutta branch, it will be specified)
IIAS	Indian Institute of Advance Study, Simla
IIC	India International Centre, New Delhi
ISOA	Indian Society of Oriental Art, Calcutta
JG	Jehangir Art Gallery, Bombay
J.J. School	Sir J.J. School of Art, Bombay
Kala Yatra	Kala Yatra & Sistas, Bangalore
Kunika-CH	Kunika-Chemould Gallery, New Delhi
LKA	Lalit Kala Akademi, New Delhi
MGAC	Government College of Art & Craft, Madras
NCPA	National Centre for Performing Arts, Bombay
NGMA	National Gallery of Modern Art, New Delhi
Pundole	Pundole Art Gallery, Bombay
RB. LKA	Rabindra Bhavan Gallery, Lalit Kala Akademi
Sakshi	Sakshi Art Gallery, Bombay (If ExC. refers to Madras or Bangalore branch, it will be specified)
Shridharani	Shridharani Gallery, at Triveni Kala Sangam, New Delhi
Seagull	Seagull Foundation for the Arts and/or Seagull Publications, Calcutta
T & H	Thames & Hudson, London
Vadehra	Vadehra Art Gallery, New Delhi

Journals/Magazines/Bulletin

AHJ	*Art Heritage Journal*, New Delhi: Art Heritage at Triveni Kala Sangam
Artrends	*Artrends Bulletin*, Madras: Progressive Painters Association.
IWI	*Illustrated Weekly of India*, Bombay
JAI	*Journal of Arts & Ideas*, New Delhi
LKC	*Lalit Kala Contemporary Journal*, New Delhi: LKA
Rupam	*Rupam Journal*, Calcutta: ISOA

Miscellaneous

Acrylic	Acrylic on canvas
Enamel	Enamel on canvas
Gouache	Gouache on paper
Oil	Oil on canvas
Tempera	Tempera on paper
W/c	Watercolour on paper
Apprx	Approximately
ed.	editor
ExC.	Exhibition Catalogue
LKNA	Lalit Kala National Award
Q	Quarterly Journal
Rpt.	Reprinted
SOCA	Society of Contemporary Artists, Calcutta
Trans.	Translated/Translator

All measurements are in centimetres and 'height x base' format.

Introduction

To begin on a personal note. Why should one have written such a book? One did not know the a, b, c of Indian contemporary art in 1993, yet I have devoted the last three years of prime time to an unrelated subject. Why indeed?

There are now many reasons; at the beginning, it was merely an instinctive curiosity. One came across Indian Contemporary Art just by chance in 1993 at one of those misleading auctions. Phases of obsessional buying were followed by periods of reflective unease. From sustaining this ebb and flow originated the urge to research and understand more deeply.

A number of factors had brought my literary work to a crossroads. I was being accused of excessive self–absorption with my own creativity. Spending time to understand the creativity of strangers was one idea that struck me. The trigger came through Indian Contemporary Art.

Being an 'outsider' to the art community there were few preconceptions. I realised, that apart from the love and study of the subject, this book would also serve as a relatively objective example to help clarify my perceptions regarding the significance of aesthetics to daily life.

Some people have always been convinced that aesthetics and its creativity must be at the heart of an education system. The aesthetic cannot be delinked from ideas regarding the nature of uncertainty, freedom or the fearlessness of the mind. As a result, aesthetics and ethics become two aspects of a single stream of consciousness. There is in India a need to visualise, conceptualise and implement simultaneously, to build an infrastructure which will nurture beyond all else this fearlessness of the mind. This book represents a stone in the bridge of various forthcoming projects, such as a series of 30 books on Indian contemporary art and literature.

The shortcomings in the book are many, despite an attempt to make it comprehensive. Not being an artist or art theorist naturally has its drawbacks. Nevertheless one's aesthetic sense has been disciplined to serve a rigorous study. While the objective context of contemporary Indian art is sought to be presented, every work is forced into incomplete selectivity, where many artists who demand greater attention are neglected, and those more popular are included. One hopes that later works will rectify the ongoing imbalance.

This book in its original format had included a deeper study of painting, sculpture, graphics and mural art, but publishing practicalities demanded a rethinking. Hopefully the essence of the Painting Section has remained. Nevertheless, the challenge of maintaining the balance between intellectual rigour and creating a wider audience for the subject, has induced certain compromises. Even though the reading public for such a book is relatively limited today, interest in the subject is developing rapidly. As a result the structure of this book is intended to accommodate the lay reader, hand in hand with the student and scholar.

I have also chosen to present my first meetings with various artists, rather than later dialogues, in the form of abridged conversations. These occurred within a compressed period of a few months during late 1993, when curiosity was raw, energy intense and perceptions non–judgmental.

Yet in the end all text in a book on Art is like an appendix to the illustrations, and one has tried to bring new significant works to view. I hope it brings joy and a fuller understanding of Indian Contemporary Painting to the reader, and begins to make us see the deeper relevance of contemporary art and its aesthetics to daily life.

2

India is unique. At the heart of this uniqueness lies the wisdom of universality. But India today seems unable to build a value-system capable of nurturing her world view and its unique universality.

One reason for this inability lies in the negligible role contemporary culture and education has been expected to play in India's daily life. In the urgency of alleviating poverty the focus is on a narrow and mediocre agenda, dominated by indisciplined economic and religious values. This can only exacerbate the country's dilemmas and increase the inequality.

Political apathy is reinforced by an inability of the cultural and educational infrastructure to clearly express and nurture its values and relevance, in the wider context of providing pride in a national identity.

Indian contemporary art, while evolving its mask and remaining true to a possible universality, has imbibed nearly a century of artistic and non-artistic influences, visual and non-visual, traditional and contemporary, local and universal. The vast diversity of these influences, and the randomness with which each emerges in daily life, has led to an unique style of absorption by most Indian artists.

However, the infrastructure has fallen short of nurturing this contemporary language, despite efforts by a few gifted artists, scholars, bureaucrats, and connoisseurs. They have not been able to clarify the links of artistic creativity with all aspects of life, nor maintained aesthetic integrity on the scale required.

The heart of this integrity lies in the ability of creativity to fuse the popular with the rigorous, the unique with the universal. In doing so it allows each to renew and deepen itself. As long as this holistic integrity is not clear, the chances of aesthetics moulding the values of society will be low.

However, given the growing interest in Indian contemporary art and the potential allocation of resources to the sector, there is a chance of building a cohesive network which can link up with other cultural disciplines, helping to inspire, clarify and sustain a more complete daily value-system for the nation's development.

At present the logic by which the infrastructure has evolved reveals a highly regionalised attitude, unconducive to the spirit of creativity. Local priorities are in conflict, as no holistic vision which critically disciplines the local, holds credibility. We have, paradoxically, regionalism going hand in hand with an economically enforced globalisation, a narrow inwardness with a sluggish internationalism. Globalisation, an economic and technologically inspired movement, is unable to tackle the narrow mental rigidities which build up in the mind when faced with a vast plurality of new ideas and people.

Hand in hand with this plurality, the daily violence and human indignity on every street corner, makes visions of a vast unifying thread nonsense. When such a thread emerges dogmatic notions of God come to stake claims, leading to a partial picture. However

change and continuity constantly seek balance. The wisdom of this balance depends on the ability to institutionalise self-criticism. It is self-criticism which links change with continuity. Human creativity, especially artistic, most deeply recognises the reach of self- criticism and its relevance to our daily change-continuity continuum.

Further, artistic creativity also provides joy with the self-criticism, thereby infusing a confidence in the process, so allowing it to be sustained deeper. It is this joy which allows the artist to play with uncertainty before giving it a structure. Thus art, in its wider sense, has the self-analysing depth to create an alternative system which can counterbalance the motivations and incentives of the economic system.

Once we have this equal platform where, besides economic activity, aesthetics also provides discipline, the potential to temper material and religious excesses will become a living force. Creativity will then underpin the values of daily life. The issue is: how does one create this platform from where aesthetics ensures, and is ensured an inspirational role?

Both East and West have tried throughout time to give creativity this pedestal, but it was always unsustainable. The reasons are many, and before a renewed attempt gains credibility, many attitudes have to be changed. Yet the change is inevitable, if humanity continues upon the journey of knowing itself more deeply. After two World Wars this has been the modern dream, which has not been destroyed, only distracted.

The main reason for this distraction is that instead of the fluidity of aesthetics structuring life, we have the flexibility of economics dominating the day. Economics in needing to precede the perceived luxury of a creative life, has set up an occupation army of unparalleled dictatorship.

Yet economic values maintain a monopoly because of the flexibility they provide in tackling the concrete, transforming intangibles into tangibles. The battle is to regain control, to discipline economics, so that it remains in its proper place, as a tool and a medium of exchange, and not the moulder of human values.

Perhaps easier said than done, but there is the realisation today that the grid upon which economics generates knowledge and wisdom is inadequate. The world is full of strong people involved with professional jobs or economic pursuits, yet as soon as emotional trauma, spiritual awareness or aesthetic integrity are at stake, they collapse, unable to handle such issues.

As a result, self-critical counterforces to the monopoly of economic values are weak. This state of pessimism is ripe for a more sober idealism.

In a way, this realisation has led to many economically less-developed nations searching for new means of development, whereby one can earn the required wealth while maintaining the holistic integrity of the individual. Unfortunately, in most of these nations, faith has been the alternative to temper economic imbalance. As a result civilisation-building has found no deeper alternative to Western models. Yet, the possibilities are present. India stands at the threshold of such a possibility. Whether she grabs the opportunity and inspires others is another story.

The key issue to India's success will be the ability of the cultural and educational sectors to stretch out for radical changes, and inspire the rest of the nation. Few can believe, let alone visualise such a scenario, where aesthetics disciplines and pivotally structures India's developmental process. Yet, if the wisdom of the ordinary Indian can be directed and motivated correctly it will not be impossible to fulfil this task.

3

As with all civilisation-building attempts, it will be India's ability to handle uncertainty which will determine the wisdom of her development. As a result, to continue with what seems anarchic and unsustainable, to allow uncertainty to reveal its own rhythms, becomes a core virtue in building a structure. Those who see reality as it is, are those who have the patience to let things be, to wait and observe, for as long as possible, and then act swiftly, simultaneously on many fronts.

In a way, each aspect of Indian life, from the mundane to the sublime, daily nurtures our patience with anarchy and its seeming contradictions. Yet today our patience is seen as a fatalistic weakness.

One is not romanticising the injustice in any way, only stating the facts, for all contradictions are given a balance in India, like nowhere else. To encapsulate this balance, this ability to find harmony amid anarchy, we all try in acts trivial and profound. The energy which absorbs and balances the outer mess is revealed in many ways. This degree of balance is the uniqueness and overwhelming force of India.

The artist tries to capture the journey of this energy through imagery. The power of what is captured can only be understood if one grasps the potency of the daily rhythm. A thousand new impulses come from the most mundane deed. For example, take the act of participating in Indian traffic, a daily ritual, and yet how it must affect the eye and its hand, our sense of tension with the line, our textural impressions, sense of colour, the depth of our vision.

Daily, we see road space cut into, pedestrians and dogs running across, from any corner, dark or light. Various objects which float upon the road: cars, carts, cows, scooters, bicycles, trucks, rickshaws, stray dogs...all fuse into a rhythm. There is a manner by which seeming chaos is transformed. A strolling cow sits down in the middle of the crowded road, and suddenly she has become a roundabout, ordering the traffic. Of course highways are desired, but such by–lanes need to be transversed with joy.

A family of four, baby in arms balancing on scooter, with the father taking risks which are not even seen as risks, with the mother smiling. Pregnant trucks loaded beyond logic or legality, quietly sneak past highway patrols in the polluted night. Rickshaws pull jeeps, carrying burdens heavier than should ever be. Families pleading to be squeezed into corners where a modern toilet could not be accommodated, while some laze on golfing gardens, as others mesh into the background, until they cannot be distinguished from the dirt and dust they clean.

Marriage tents are erected in the middle of roads, so that traffic diverts, and civil courtesy dissolves, while every urban corner is dotted with idols or toilets, so conditioning our image of godliness, the mundane and omnipresent, common and sublime, trivial and profound. For, to piss and to pray, there is no other way...faith and scepticism, doubt and trust, in a continual lila...if the artist is to create, where is the space which allows humanity to accept the upliftment? How can creativity kindle aesthetic energy amid such numb blankets of noise? Can one be convinced that creativity is indeed at the root of life's rhythm...?

Yet India does provide this possibility. It somehow harnesses anarchy and its hidden harmony. India forces one to treat uncertainty with a greater freedom. This is the universal dilemma it tackles uniquely. This is the image the artists reveal in their imagery.

Allowing uncertainty a pivotal role in the process, helps one visualise new related rhythms. By encapsulating the daily ebb and flow of opposites the artist structures this elusiveness, as if capturing the traces of air left behind by birds in flight...

India reveals a rhythmic unity where outer anarchy mirrors creative logic, encouraging the artist to search out the deeper reality. Representation takes meaning only when one possesses this ability to let uncertainty reveal itself, disciplining the urge for answers, withholding a desire to impose a structure, thus revealing an imagery which taunts, renews, teases and delights simultaneously, fulfilling the joy of the creative moment, and stringing together the delusions of the day.

This aesthetic energy holds within it a continuous sense of wonder. If this energy is nurtured even when unsure of any tangible direction, infinite are the forms and images that emerge.

Rabindranath Tagore probably best grasped this in his all encompassing creativity, beginning to paint from mere doodles. Creativity lies within every individual, if only

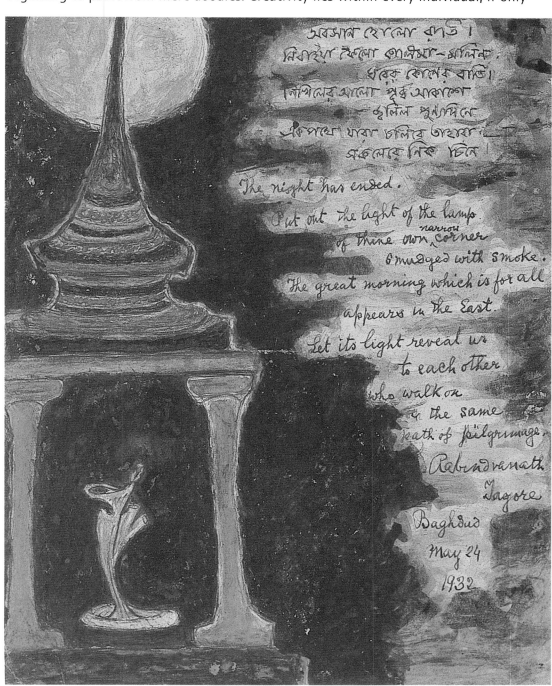

1
Rabindranath Tagore

Composition
24.6x19.8. W/c, pen & ink, c. 1932
Rabindra Bhavan, Visva Bharti University

their inner determination can be nurtured to balance and sustain the hand with a combination of humility and confidence. This point of sustaining a doodle is critical. It can become the trigger for people to realise their inherent creativity, a desire to complete unfinished forms. Soon in the doodle, a line connects, a balance is created here or an emptiness there, some shading follows, a bit of hesitancy, a new line, maybe tangential, new connections link up, making a whole; then to break away, to see it balance, to play with it, to try and give a meaning to it, or to stop looking for meaning, to enjoy being free from wanting meaning, just moving with the flow. A rhythm develops and the creative spirit finds a new outlet. On and on goes the play within, and so, weeks, some months, years, down the line, as the pace is sustained dissolving oneself amid vast energies, yet always alone, evolving a compassion for all things, an interest in all things, ... So creativity may begin, from self-absorption the first seeds of a selfless act are sown.

Soon there is an aesthetic delight, and an ethical awareness, without a tone of judgement. Joy alone is the motivation, to translate the ideal into its material image, to make the elusive moment sustainable, self–renewing, so that they become the pace of the day, the energy which puts new life into the step, new hope in each act.

Later the artistic activity may indeed become the life force itself, indestructible, always capable of inspiring the day. To create then is the very essence of life,... it is this which clarifies freedom, for in the end it is about becoming free within; a freedom which can only come with the fearless ability to absorb everything, and yet remain true to oneself. Even if one piece of the mosaic is missing, there is incompleteness, and so anarchy, which itself is a joy, but that's another tangent...

An Opening Focus

What is unique about Indian Contemporary Painting? The root lies in the process of its artistic creativity, in the ability to absorb seeming contradictions and move towards an aesthetic completeness. It is this underlying motivation which has sustained the individual creative journeys of most of our foremost artists.

It has been a daily process of absorption, devoted not simply to a wishful fusing of colours as if within the spectrum of a flame, or an eclectic bringing together of shattered pieces of a mosaic. It has been fuller, like the created space of a flamed-mosaic, capable of merging the intuitive roots of one with the logical emphasis of the other.

In doing so it dissolves false polarities, and reveals the intuitive-logic of the human psyche, allowing specialised imagery to serve a holistic vision. Freedom no longer wishes to possess faith without continual self-criticism; it is unwilling to rest even if unrest becomes the norm.

Yet, to visually structure such potential anarchy, requires an ability to experience inspiration without placing undue judgement on its material hierarchy. It requires disciplined openness to the living folk-tribal-urban continuum. It requires a sense of detachment from the awe-inspiring classical art forms as equally from the ever present trauma of contemporary life. This allows the limiting medium to serve every obsession, taking human understanding deeper.

This is the place where art has its abiding relevance: in sustaining the individual journey of knowing oneself, inspiring humanity into a deeper visualisation of itself. In doing so, one merges the unique with the universal, absorbing the relative and absolute, so paving the way for a fuller daily aesthetic experience. It is towards building this uniquely-universal foundation that Indian Contemporary Painting brings its vital energy. In a land of a thousand gods, it dares to taunt uncertainties without erecting false gods.

BARWE, Prabhakar

Alphabets of Nature
120x175. Enamel, 1988
Gallery Chemould, Bombay

" Prabhakar Barwe's paintings, reflect certain essential features of poetic form; the brevity of elements, the multiple resonance of their meanings, a certain instantness of something grasped lucidly. These paintings do not reflect the world but rather show one way of seeing reality and at once experiencing it...His space is not merely a receptacle for the forms, but as an independent element in itself. However diverse or disparate the elements, it is one benign space that holds them in graceful balance; none is more or less important than the other. The profound stillness that emanates from this space is a contemplative silence in which the spectator's eye is turned inward..."

Vijay Shankar Sharma, (27.10.1987),
Gy. CH ExC. Dec. 1987

3

BAWA, Manjit

Siva with Snakes
183x137. Oil,1983
Abhishek Poddar, Bangalore

" Certainly the element of the unexpected in your work is quite remarkable. Whereas your theme or subject matter is straightforward enough, its treatment is so unexpected whether it's the stylised distortion in the drawing or the startling yet subtle use of colour. Seems to me that you quite purposely go outside of chromatic sequence, or for that matter the use of complimentaries and most often you seem to get away with a sequence which could jar and hurt the eye. The surfaces of your paintings are impeccable and never intrude on the inner strength of the work."

Krishen Khanna, 'A letter to a fellow Artist' (Manjit Bawa). *LKC* 32 (April 1985)

4

BHATTACHARJEE, Bikash

The Totem
157.5x105. Oil, 1971
LKA

" The supra-natural quality present in Bikash Bhattacharjee's works lures the viewer to amble into a world of almost concrete mystery and tangible unreality. Most of his pictures give a glimpse of a world that lies beyond the canvas which, on its part, ceases to be a quadrangular piece of linen and becomes a door leading to a world unknown-a world of immeasurable depth, haunted by mute, mysterious myrmidons of secretive, sulking souls."

Arany Banerjee, 'Exhibitions' *LKC* 15
(April 1973)

An Opening Focus

BROOTA, Rameshwar

Man No.22
177.8x381. Oil, 1988
Private, New Delhi

" The **Man**, a lonely, tragic solitary
giant, set against the clouds, often
blatantly nude, inspires a strange
feeling of awe...stripped to his
primeval form. In a world of
turmoil, of disarray, of people
living in a constant state of fear,
Broota's **Man** is the vanquisher...
a quiet solitary mythical figure...
much larger than life...
a lonely Christ showing the way. "

Arun Sachdev, from Gallery 7 ExC.
Festival of Indian Contemporary Art–1,
Gallery 7 ExC. London 1989

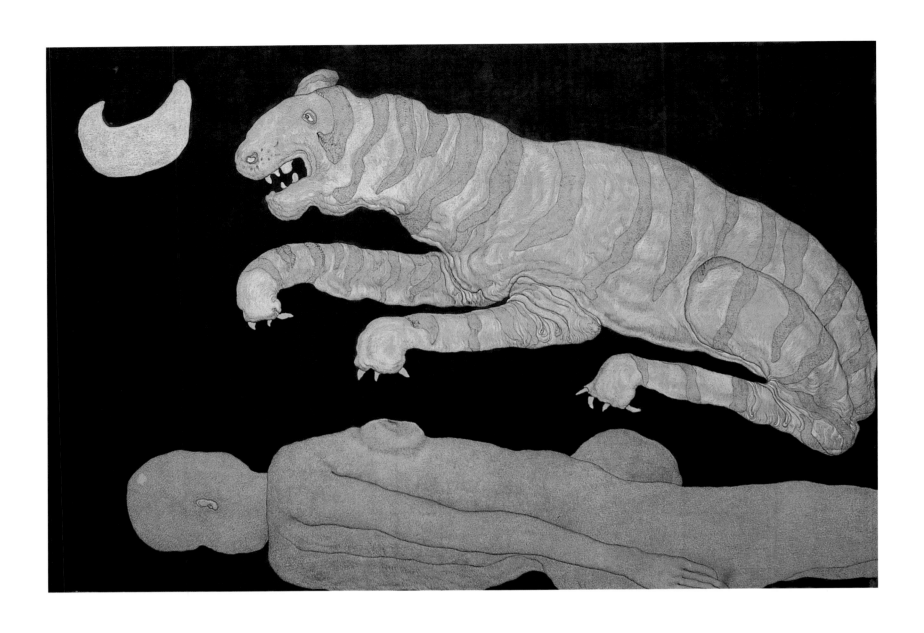

6

CHOWDHURY, Jogen

Tiger in Moonlit Night
152x228. Ink & Pastel on Paper, 1978
NGMA

" He (Jogen) has developed a highly original idiom which allows him to explore a private world of real and imaginary beings, of dreams, fantasies, childhood recollections, as well as the objects and people he sees in his environment. Working in ink and pastel, he builds up his images through a fastidious process of cross–hatching, allowing a mild tint of colour gradually to seep in...In a series of dream–pictures, for instance, he has as it were, tried to plumb the depths of an abundantly fecund unconscious, coming up with images at once fantastic, archetypal and visually poetic. "

Deepak Ananth, An Engagement with Reality. In *India: Myth and Reality- Aspects of Modern Indian Art* ExC. Alkazi, E., D.Elliot & V. Musgrave, eds. Oxford: Museum of Modern Art, 1982.

7

DE, Biren

August '90
122x76.5. Oil, 1990
Private, New Delhi

" To fully appreciate his work, one will have to know the leading thread of the whole and penetrate into the philosophy on which it is based and grows with the line of Indian tradition...A central point which is to be found in each of Biren De's canvases and which constitutes its pivot is the invariable centre immovably fixed and serenely poised of the unmanifested around which other forms of the manifested fold and unfold."

Ajit Mookherjee, *LKC* 32 (April 1985)

8

GAITONDE, V.S.

Untitled
127x101. Oil, 1972
Kali Pundole Family

" Texture is structure. How he
achieves this texture is the secret
of Gaitonde's style... In the
application of the colour itself
there is an order...The colour settles
and congeals into a series of
approximate horizontals throwing
the compositional weight
somewhat lower than centre and
balancing the left and right of the
canvas like the arms of a scale. The
order is almost deliberately
obscured by the distribution of
near−random forms across the
surface. These topographical or
hieroglyphic forms themselves are
made to dissolve into the field like
enamel in an encaustic."

Pria Karunakar, *LKC* 19−20
(Apr−Sep 1975)

9

GOUD, Laxma

Women in Interiors
37.5x24.1 each. Gouache, c. 1986
Private, New York

" I want my audience to see my work as an insider, as some one who understands what I am doing. I want to seduce them with my line. When there is such a seduction, when such an interaction takes place between a viewer and my work, there is a pure sense-laden moment of communication – Total communication! You can't explain it. Maybe you can call it love, peace, affection, all these things are there at that moment. It's a point of pure joy. What is this quality? Can you find it hidden in a line? That is the mystery that only a true artist can bring out."

Laxma Goud, Rpt. in Geeta Doctor's
'A Meeting with Laxma Goud' *Cymroza Annual* (1991–2)

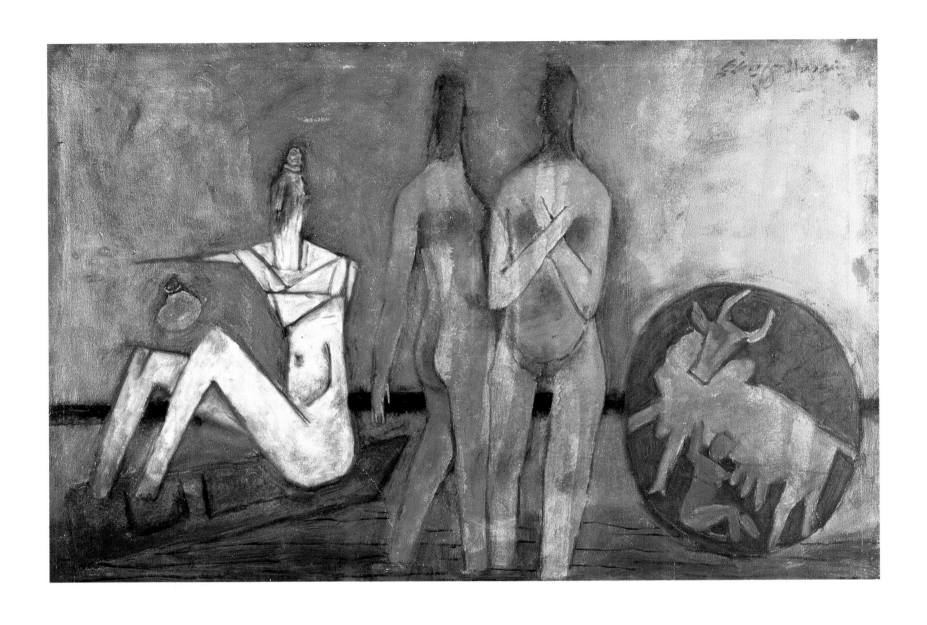

10

HUSAIN, Maqbool Fida

Ganga
114.3x168.3. Oil and Gold paint, 1973
Private, New York

" The modernist painter did not suffer from the anxiety of influence...He was free to choose his roots from among cultures and traditions that were considered alien. What was borrowed was modified. Without any definite break with tradition, modernism in India produced its own tradition...it was made by individuals who had in their work an unmistakable sense of Indian present...Husain's is the most authentic Indian variety of modernism."

K.B. Goel, *CCA Annual* (1990–91)

11

KALEKA, Ranbir

Family – II
91.5x122. Oil, 1993
Kanwaldeep & Devinder Sahney, Mumbai

" The figures are over-valorised in their fluidity and pose, and deny themselves the privilege of subjectivity even as they become suffused as raw, pre-narrative instincts...The erotica, here, is non-definitive, even non-descriptive. One can think of very few, hardly any, examples in our tradition where the erotica aspires towards an elemental sign as it does here."

Madan Gopal Singh, 'Libido & the Elemental Sign'. Rpt. in Art Today ExC. Jan. 12-25 1996

12

KHAKHAR, Bhupen

Yayati
171.5x171.5. Oil, 1987
Private, London

" Modern art has seen to it that there is actually only one criterium for the judging of art, and that is, namely, authenticity...he has self–assuredly processed the things of the world from his own, unique perspective without looking to anything or anybody for sources of influence. He is a completely assured artisan who isn't afraid to think. In Khakhar, intellect and artistry go hand in hand. He has his own style that cannot be compared with anyone or anything else, and in that style he is completely at home...Bhupen Khakhar is authentic."

Jan Hoet, 'Authenticity is the only Criterium' from India Contemporary Art Rpt. in Inventure-Collection, Amsterdam ExC. Nov. 1989

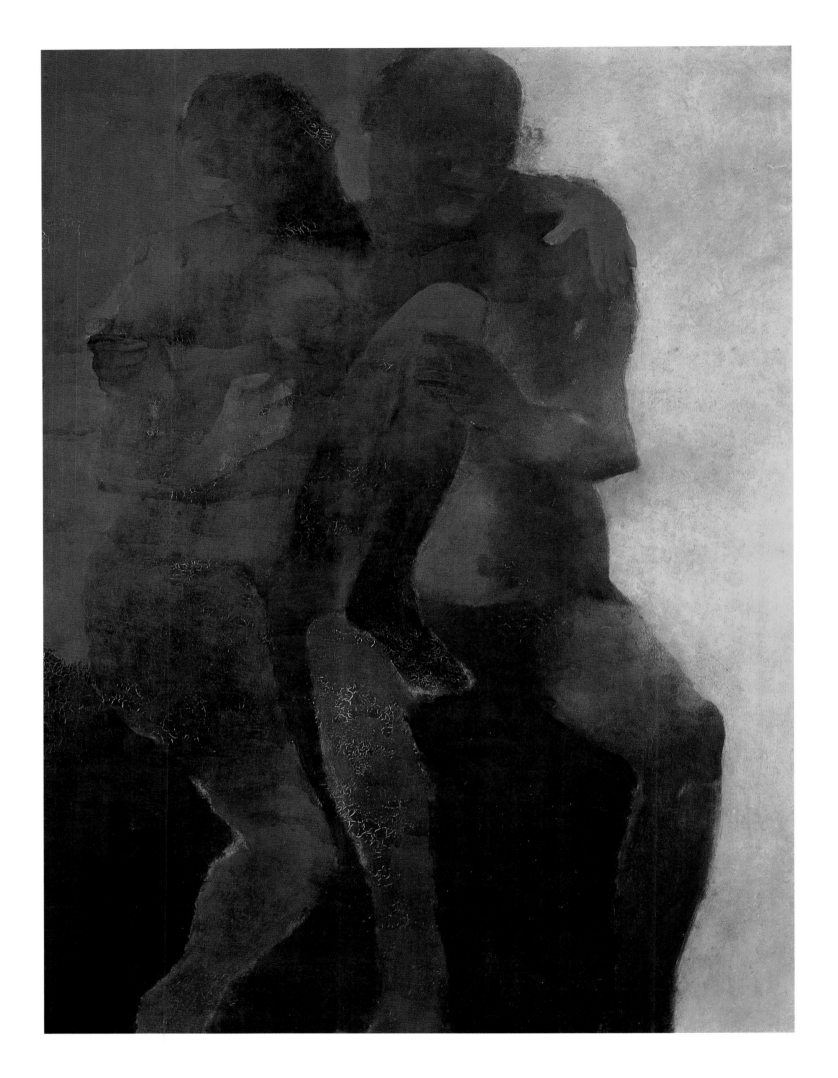

An Opening Focus

13

KHANNA, Krishen

Lovers
165x122, Oil, 1973
Jehangir Nicholson Museum, NCPA

" The feminine subjects in the compositions presented the sensuous possibilities inherent in the figure and in the use of vivid, live colour which could suggest, reveal and conceal. The figure was not quite separable from the configuration of colour and it was built into the schemes of colour...Outstretched almost provocatively with faces obliterated or in deep shadow these women were disturbingly evocative. The spectator was drawn into speculating whether this was sleep or death. The drawing was firm and sure, the colours unfurled brilliantly but in no way naturalistically. Placed as segments to set off the figure, colour was used to enhance the prevailing mood of mystery. Deep browns, reds and blues lent weight to the strikingly sombre structure."

R. Bartolomew, 'Attitudes to the Social Condition: Notes on Ram Kumar, Satish Gujral, Krishen Khanna and A. Ramachandran'. *LKC* 24-25 (Sep 1977-Apr 1978)

MEHTA, Tyeb

Studies of Trussed Bull on Rickshaw
116.8x91.4 each, triptych. Oil, 1985
Ebrahim Alkazi

" I am not concerned with the problem of relationships in painting so much as with the activation and neutralisation of opposing forces...the idea is to define an opposition and control it in terms of space, action, image and colour; to precipitate a crisis, established by the gesture, and hold it in check."

Tyeb Mehta, 'Beyond Narrative Painting: an interview with Yashodhara Dalmia'. *AHJ* 9 (1989–90)

15

PADAMSEE, Akbar

Mirror-Image Series
91.4x243.8 Diptych I. Oil, 1994
Private, Bombay

" Space-cognition and time-cognition depend on a compound duality, inside-outside, expansion-contraction, exhalation-inhalation, the round and the square. We inhale, the trees exhale, we exhale, the trees inhale, a mirrored symbiosis.

Expression must contain its dialectical opposite, the conscious and unconscious on the same psychic plane. I have two eyes, two retinas, but the mind compounds the two images into one...

Colours expand and contract, colours reach out of their skins to invade each other's territories, the blue goes in search of its complementary counterpart yellow or orange. The further away from each other I place them the greater the space and the voyage..."

A. Padamsee, as told to Meher Pestonji;
Mirror-Images Pundole ExC.
21 Nov-9 Dec 1994

PATEL, Gieve

Off-Lamington Road
152.4x259. Oil, 1983-6
Procter & Gamble, Bombay

" The crowd at the foot of the cross in Pietro Lorenzetti's **Crucifixion at Assisi** spoke to my sense of a Bombay backstreet and resulted in my painting **Off-Lamington Road.** Figures, for once, tumbled out of my brush in an apparently spontaneous mayhem of relationships. A culture that had warmed to the luxuriance of its own humanity had liberated me to confront the prolixity of my own time and place. However, there is no cross in my painting, though it is present in the sense of buildings looming over the crowd... "

Gieve Patel, 'Contemporary Indian Painting'. *Daedalus: Journal of the American Academy of Arts & Sciences*, Fall 1989. p 198-9

17

PATEL, Jeram

Black 3
104x74. Pen & Ink, 1973
LKA

" It all begins with a spot that gathers flesh around its centre: this is also the secret of Jeram's drawing technique; initially a dot, around which gradual hatching of pen builds the body of form, to be enwrapped in the knife-edged skins of animals of prehistory. Yet the process of drawing is not additive; it follows the logic of its expanse on the frame, the weight of figures and space in which they are left afloat... There hardly seems any movement in space; the figures stand and lurk; lick the earth scoop their teeth in the empty sky or loom over the horizons. Jeram has been consistently drawing since the early sixties... his dexterity in using space, both formally and existentially fills his drawings with a force that challenges our feet from the ground – and earns him an unequalled place in contemporary art.

G.m. Sheikh, Jeram Patel's Recent Drawings, Shridharani Gallery ExC. Oct 1968

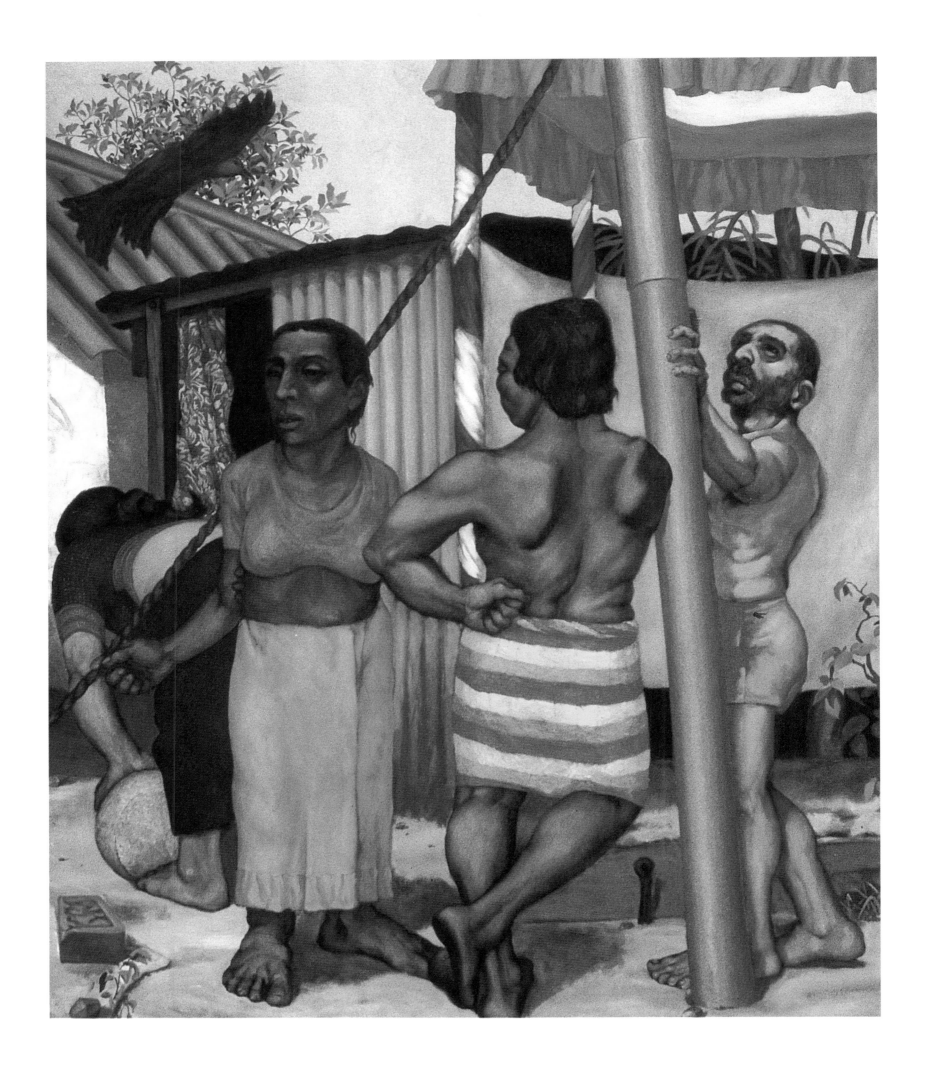

18

PATWARDHAN, Sudhir

Ceremony
127x107. Oil, 1984
Chester & Davida Herwitz, USA

" ...A fuller understanding of
another person's life is dependent
upon my involvement. Involvement
brings with it identification and
projection of impulses. Unchecked,
this projection leads to interference
and distortion of the other's
image...Then again, a fuller
understanding of another's life is
also dependent upon distance. It
depends on the acceptance of the
other's autonomy..But this will lead
to retraction and separateness from
the other...For me, however, there is
the need to keep alive within myself
the vigour of both extremes, and to
objectify each separately when
necessary, and together when
possible. Below the surface, both
impulses are active simultaneously
and pull in opposite directions. In
my work they become embodied in
figures near and far."

Sudhir Patwardhan, Nov. 1985. Rpt. in
George Pompidou Centre– National
Museum of Modern Art, Contemporary
Galleries, Paris ExC. Mar–May 1986

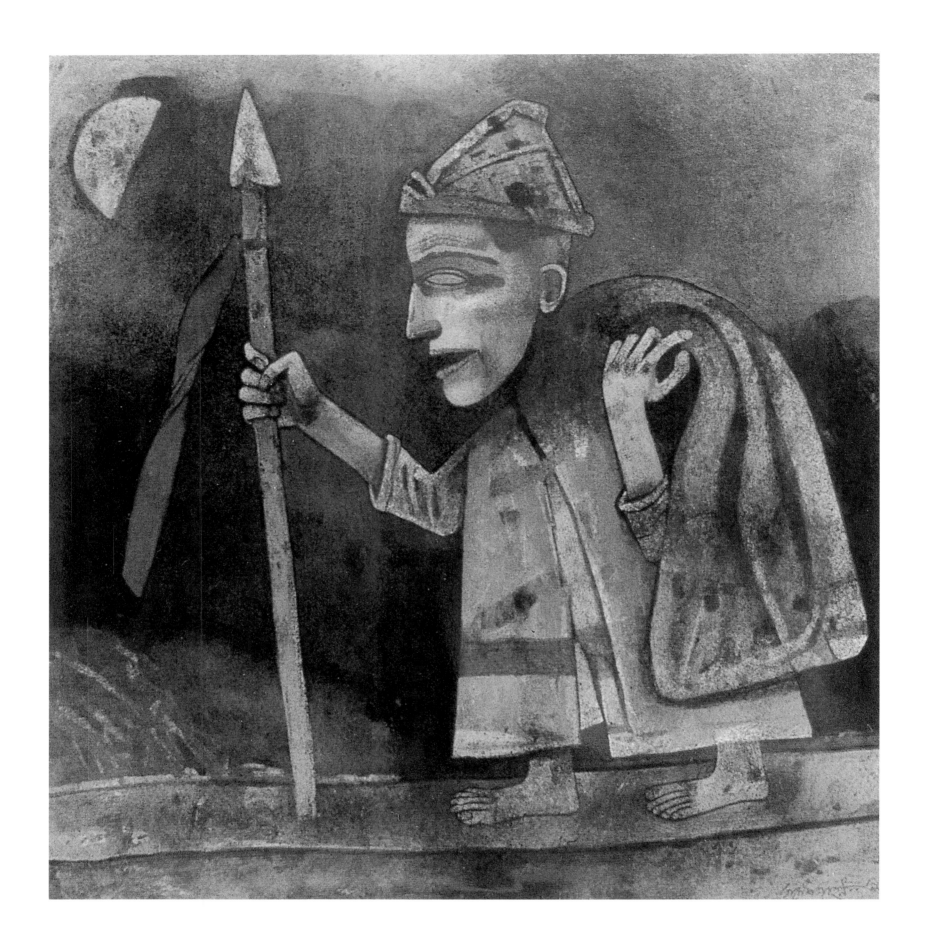

19

PYNE, Ganesh

Ancient Salesman
57.5x57.5. Tempera on canvas, 1993
Private, Calcutta

" Nature is so beautiful, it makes
you feel sad. It also makes you feel
elevated simultaneously. This is not
a contradiction. It's like the crest
and trough of a wave. The same
wave, life and death, birth and
rebirth,..."

Ganesh Pyne, 'Conversation with Arany
Banerjee', *LKC* 15 (April 1973)

RAMACHANDRAN, A.

Lotus Pond (Night)
216x182.9 Diptych. Oil, 1988
Private, New Delhi

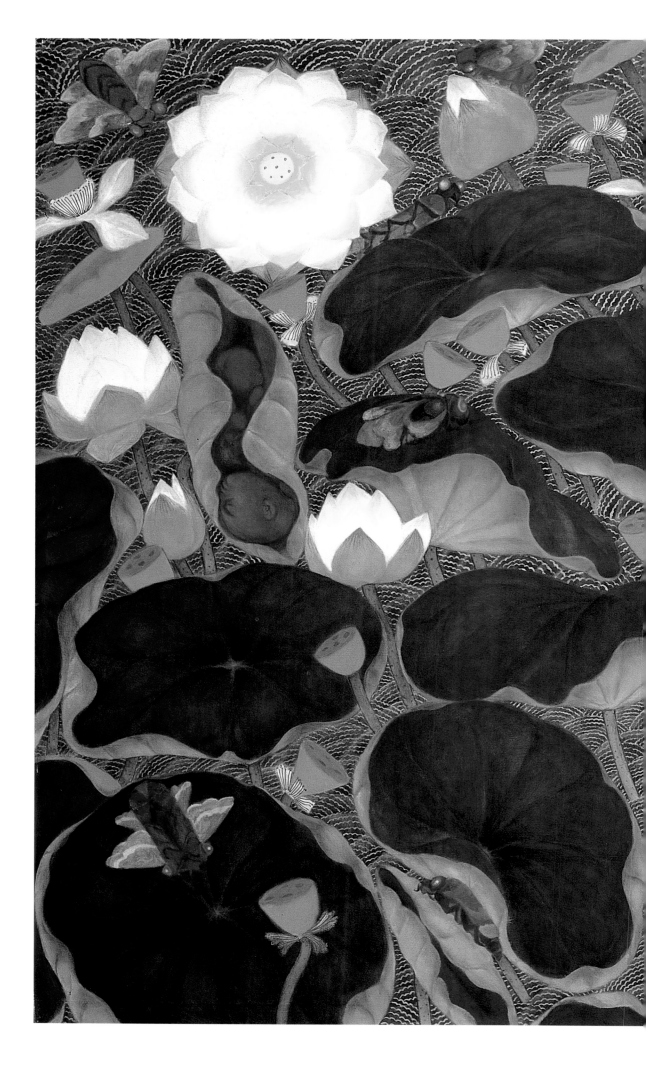

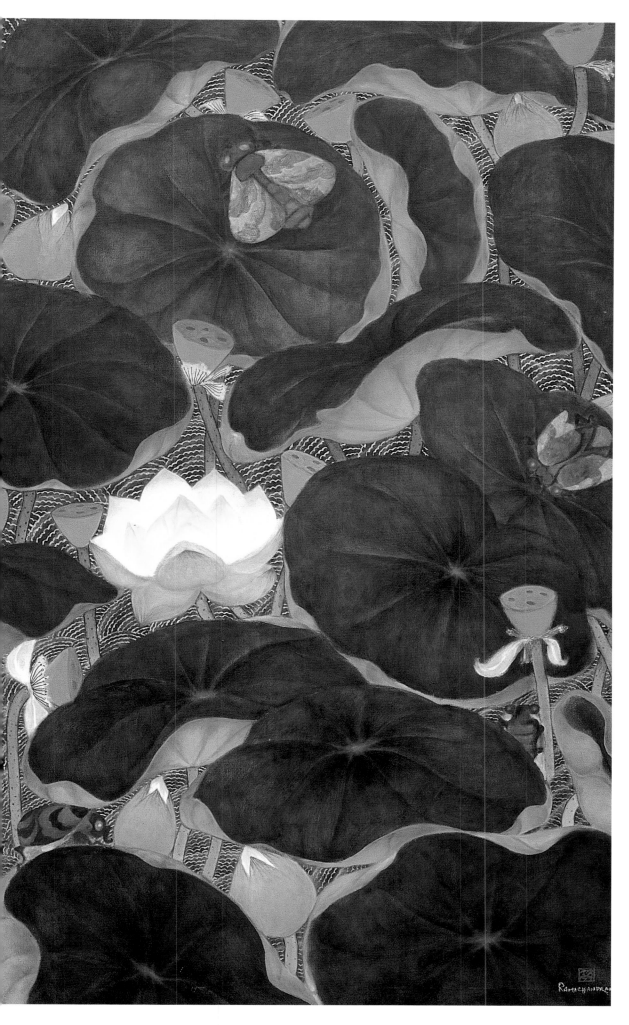

" 'Decorativeness can be brought to realistic imagery corresponding with what you have been carrying in your mind.'... The many lotuses came to his mind when he started work on the motif in 1986. What also nourished him were the endless stretches of lotus ponds in the Kerala of his childhood. As a boy he had leapt into such waters, developing an intimacy with stem, flower, bud, and all creatures afloat therein...It was only natural that Ramachandran would extensively explore the pictorial potential of the lotus pond, visualising it during different times of the day...The mood of **Lotus Pond (Night)** rises from the dark indigo leaves bathed in shyam colour which appears when day is done and sunlight is absent."

Rupika Chawla, *Ramachandran– Art of the Muralist*. Bangalore: Kala Yatra & Sistas Publication, 1994. p 96

21

RAMANUJAM, K.

Untitled
49x56. Pen & Ink, 1972
NGMA

" You know, he is a very interesting example. I used to say this also to Paniker: If you take all his works from the beginning until the end, it is just the same form. In this same form he has refined and refined and refined until finally ended with what you cannot go beyond in that form, given his nature. That is all I say about Ramanujam, fantastic...all his handicaps were his assets."

Reddeppa Naidu, conversation with author, Madras 17 Jly 1993

22

RAMKUMAR

Untitled
144x84 appx. Oil, c.1988
Private, New Delhi

" What seems heroic in the entire enterprise is that Ramkumar never succumbed at any time to the easy temptation of using ready-made symbols to 'represent' his search for what he felt to be true at the time...Spiritual in Ram Kumar's paintings lies not in painting the 'sacred', but in overcoming the dichotomies and displacements of the profane, man-made world. It is precisely in this 'overcoming' that Ram Kumar is able to 'look beyond and within'...His 'abstractions' are not the flights into the 'unknown', but like a shifting beam of light they move, passing through the entire space of the painting, from one segment of reality to another, uncovering the hidden relations, between the sky, the rock, the river. The sacred resides not in the objects depicted, but in the relations discovered."

Nirmal Verma, *Ram Kumar- Retrospective*, NGMA-Vadehra ExC. 20 Nov-12 Dec 1993

23

RAZA, Syed Haider

Paysage
119.4x119.4. Oil, 1983
Private, New York

" Certain fundamental elements
are integrated, interrelated, and
determine the nature of form. Their
understanding is indispensable in
the creative process. Whatever
direction art expression may take,
the language of form imposes its
own innate logic, reveals infinite
variations and mutations. The
human mind can perceive these
mysteries only partially. The
highest perception is of an
intuitive order where all the
human faculties participate,
including intellect which is
ultimately a minor participant in
the total creative process."

S.H. Raza, *Artists Today: East-West Arts
Visual Encounter,* Ezekiel, N &
U. Bickelmann, eds. Bombay: Marg
Publications, 1987

24

SANTOSH, Ghulam R.

Untitled
35.5x27.5. W/c, 1971
Private, Bombay

" My concept is broadly thus:
Sex is elevated to the level of
transcendental experience. I take
the human form in its dual male
and female aspects, in sexual union,
in a state of unalloyed fulfilment,
caught in a trance. I try to capture
this intensity, order and what is
regarded as a yogic discipline."

G.R. Santosh, 'Image and Inspiration-
Studio interview with S.A. Krishnan'.
LKC 12-13 (Apr-Sep 1971)

25

SHEIKH, Gulam. m.

Passing Angel
152.5x76.3. Oil, 1985–7
Chester & Davida Herwitz, USA

" In art, painting came in the company of poetry, overlapping and yet independent of each other. Images came from many times, each flowing into the other. Some came from life lived, others from a feeling of belonging to a world of other times, sometimes from painting, sometimes from literature, and often from nowhere, emerging simultaneously through scribblings, drawings, and writings. The multiplicity and simultaneity of these worlds filled me with a sense of belonging to them all. All attempts to define the experience in singular terms have left me with a feeling of unease and restlessness. Absence of rejected worlds has haunted me throughout."

G.m. Sheikh, 'Among Several Cultures and Times', a presentation at the Smithsonian Institution Symposium 'The Canvas of Culture', 1985. Rpt. in Art Heritage-Shridharani Gallery ExC. New Delhi, 12-24 Feb 1988

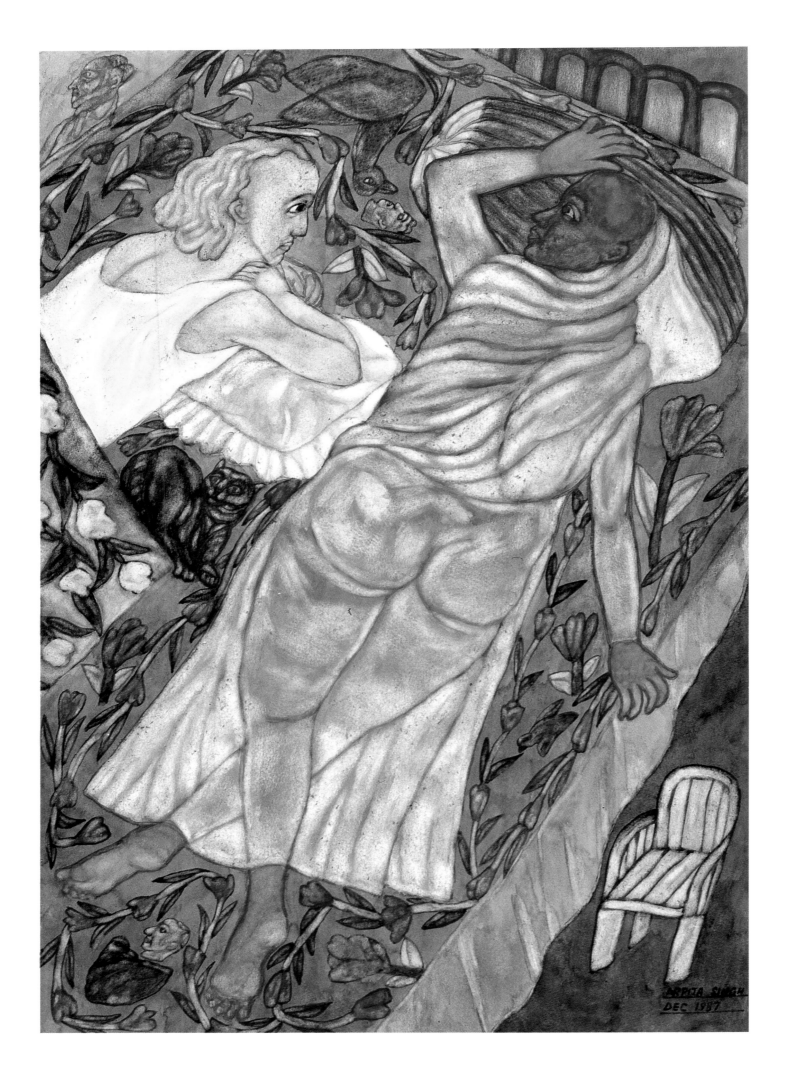

26

SINGH, Arpita

Two Figures Lying on a Bed
41.3x28.6. W/c, 1987
Private, New York

" It is not lyricism alone that works magic into Arpita's water colours. Increasingly, texture is used to create resonance and rhythm... Dots and stripes, checks and flowered patterns begin to assert themselves, to adorn the tablecloth and the contours of cats, to flow all over the figures, and even to populate the ground surface of the canvas... so that all seem interrelated, enmeshed in one destiny... It is of interest that the same kind of palpable form and pattern is found in early Indian art, say at the reliefs of Sanchi, where lotuses, ducks, trees and human figures are inextricably intertwined into one whole– as though they were infused with the same life–force, and made of the same substance...Much of the same feeling is reproduced here, although without deliberate imitation."

Geeti Sen, Woman in Red. In *Image and Imagination: Five Contemporary Artists in India*, Ahmedabad: Mapin Publishing Pvt. Ltd., 1996. p 114-5

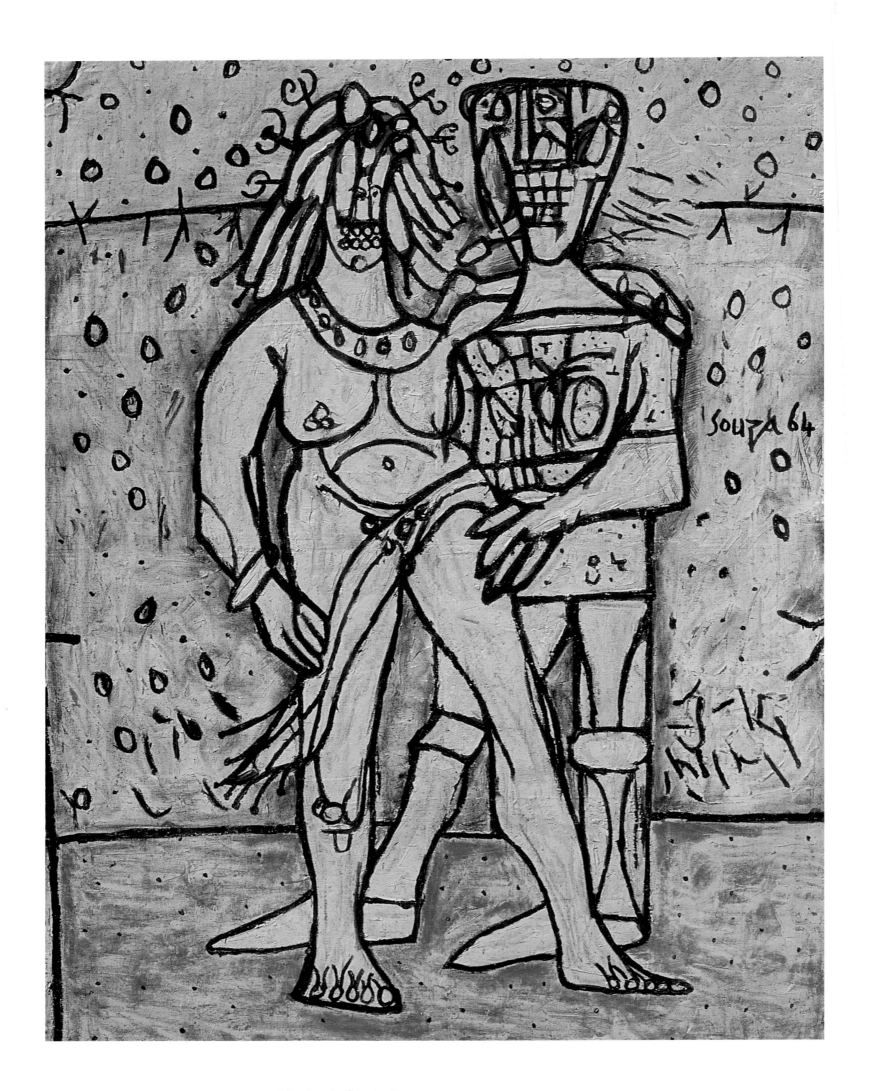

SOUZA, Francis Newton

Couple
172.7x132. Oil, 1964
Private, Bombay

"...a series, over two hundred, of black canvases and a number of rather abstract compositions in strong colour...The black paintings are more impressive...They are like stained–glass windows, the forms outlined in thick lines like leading. As you move before them and different facets catch the light, they vary in tone, texture (like black velvet) and colour (not only blacks and greys, but impressions of purples and indigo)..."

Cyril Barnett, 'Souza/Geoffrey/Rao'.
Studio International, London (May 1966)

SUBRAMANYAN, K.G.

Inayat Khan Series:
Houses with Flying Horses
81x61. Gouache & Oil on perspex, 1988
Ebrahim Alkazi

" In reality the structure of human creativity is complex; it has dissimilar, often warring ingredients; it is both private and public, conformist and innovative, free and subject. But a lot of modernists cannot countenance this messiness, this conciliation of opposites. They would rather counter one with the other. "

K.G. Subramanyan, *The Creative Circuit*,
Calcutta: Seagull Publications, 1993

29

SULTAN ALI, J.

Kondapalli
57x154. Pen & Ink on paper, 1965
LKA

"...complexity of meaning is reflected in a corresponding complexity of technique. From 1963 onwards Sultan Ali has been developing a very elaborate way of representing space: figures are superimposed on figures, colours merge into each other...All images are interdependent, each one is modified in its impact by the others. His pictures could be read as a mass of detail, but essentially Sultan Ali achieves a single impact, a single mood through these technical processes which he has labelled "pictorial unification ".

Ulli Beier, Introduction *J. Sultan Ali*. New Delhi: *LKA*, 1983. n.p.

30

SUNDARAM, Vivan

Arabesque
137x175. Oil, 1989
NGMA

" ...he (Vivan) shows what memory has reorganized into layers of sediment. His paintings appear to me to be a process of excavation...The excavation is not noisy, recall has a quality of silence. Just as paintings are silent...What is blocked from view, what is erased, rubbed, washed over with veils of paint as in **Easel Painting** and in **Arabesque**, becomes a metaphor, both of memory and of excavation simultaneously. Then Vivan ornaments the painted surface and that makes the metaphors and the 'descriptions' thick if I might put it like that. This ornamentation is significant not so much to the story as to the act of painting."

Anuradha Kapur, 'Stage Motifs'.
Shridharani & Gy. CH Joint ExC.
15 Feb–31 Mar 1990

SWAMINATHAN, Jagdish

Text De-Text Series
171.4x171.4, Oil & Wax, 1993
Private, London

" He did not believe in any theory of communication,... He seriously questioned the notion that modernism in India emanated from its encounter with the West. For him there was a much more open-ended and integrated continuum of modernism existing in India. It was from that Indian modernism that Swaminathan drew his zeal for redefining the contemporary to include the so-called folk and tribal with the urban, and to override the hiatus between arts and crafts."

Ashok Vajpayi,' J.Swaminathan: A Furious Purity'. *Art & Asia Pacific Q* 2.1 (Jan 1995)

The Aesthetic Framework

Creative and Critical Unity

Disintegration and Integration

Passionate-detachment

Flamed-mosaic

Distraction and Concentration

Fearlessness

The Absorption of Contradictions

Creative and Critical Unity

Human consciousness demands that it knows itself, to be true to this search is the chief motivation of the mind. The artistic creative process is one evidence of this journey. Through artistic self-awareness, one evolves a relationship with the material world and other living creatures, a specialised knowledge which is slowly transformed into a more complete wisdom.

Creativity is a means of disciplining the limitless freedom of the human mind. It continually tries to encapsulate itself within any given corner. With this discipline comes an acceptance of our limitations, from which evolves our ability to give freedom to others.

Humanity tries to harness this act of giving freedom. With this exchange we also reconcile our insignificance with omnipotence. We realise the incompleteness in giving and receiving, and begin to sense the pre-existence of freedom and its energy.

Eventually we fuse all this knowledge to moments within the the present: traditions within the contemporary, change within permanence, the speculative within the reasoned, the mental within the material.

Resolving these contradictions is the essential step towards a deeper self-awareness for an individual or a nation. However, the act of nurturing this civilisation falters when material flexibility cannot keep rhythm with mental fluidity.

The main reason for this faltering is that material flexibility depends on the specialisation of human labour with its categorising attitudes, while mental fluidity is holistic, non-judgmental. As a result the transformation of an idea into action is always partial. The way we accept this incompleteness is the issue, for the idea loses much of its original integrity in this process of transformation.

One of the main arguments which has caused this loss of integrity has been the lack of objectivity regarding self-knowledge. Academic orthodoxy teaches us that self-awareness is conditioned by the language systems we use and the environment within which we live. Our perceptions are not to be trusted, the path to knowledge through self-awareness is limited. Ultimately, one must only rely on scientific discoveries to clarify truths.

However, the credibility of scientific facts which keep changing is also low. Criticism regarding the distorting nature of scientific processes and their accumulative value has become an orthodoxy.[1]

Therefore, given the oscillation between moments of self-revelation and scientific reaffirmation, history today teaches us that civilisation must be very wary of holism, whatever its self-criticising faculty. Holism and its harmonious utopic vision, is the bias science has come to doubt, and which creativity must defend.

Creativity by its nature is all-encompassing in its vision, but is unable to provide the verification that scientific enquiry requires. Here lies the conflict, and the source of fusion. Creativity takes a leap into an unverified zone, which science initially vilifies. Yet scientists are drawn into pursuing experiments to 'rationally' verify these intuitive insights. As a result the space of consciousness leaps forward, simultaneously with the

[1] eg: " The more they carefully study, say Aristotelian dynamics, phlogistic chemistry, or caloric thermodynamics, the more certain they feel that those once current views of nature were, as a whole, neither less scientific nor more the product of human idiosyncrasy than those current today. If these out-of-date beliefs are to be called myths, then myths can be produced by the same sort of reasons that now lead to scientific knowledge. If, on the other hand, they are to be called science, then science has included bodies of belief quite incompatible with the ones we hold today. Given these alternatives the historian must choose the latter. Out-of-date theories are not in principle unscientific because they have been discarded. The choice, however, makes it difficult to see scientific development as a process of accretion. The same historical research that displays the difficulty in isolating inventions and discoveries gives ground for profound doubts about the cumulative process through which these individual contributions to science were thought to be compounded." (Thomas S. Kuhn, *Structure of Scientific Revolutions*. Chicago Press, 2nd Ed. 1970, p2-3)

[2] " Throughout this book the central underlying theme has been the unbroken wholeness of the totality of existence as an undivided flowing movement without borders... Ultimately, the entire universe (with all its 'particles', including those constituting human beings, their laboratories, observing instruments, etc) has to be understood as a single undivided whole, in which analysis into separately and independently existent parts has no fundamental status.... however, Einstein was not able to obtain a generally coherent and satisfactory formulation of his unified field theory...moreover...the field concept, which is the basic starting point, still retains the essential features of the mechanistic order, for the fundamental entities, the fields, are conceived as existing outside of each other, as separate points of space and time, and are assumed to be connected with each other only through external relationships which indeed are also taken to be local... " (David Bohm, *Wholeness and the Implicate Order.* London & New York: Ark Paperbacks, 1992. p173)

[3] The doubting-joy an eminent Physicist feels in the following passage is a good example to demonstrate the commonality of scientific and philosophical speculation: " 'One day of Brahma elapses when the four yugas Krita, Treta, Dwapar and Kali, are repeated a thousand times. One cycle of four yugas takes up to 12000 divine years. One divine year is equal to 360 million years. (*Vishnu Purana,* Book 1, Ch 3, vv 12-15)'. I am always intrigued by the above quotation...doing the necessary multiplication, we find that the day of Brahma, the Creator of the Universe, is 4.32 billion years, a figure that is of the same order of magnitude as current estimates of the age of the universe based on the latest astronomical observations. How did the ancients arrive at this figure?" (Jayant V. Narlikar, *The Primeval Universe.* Oxford: O.U.P., 1988. p1)

expanding influence of science. Thus the two realms of the human mind act as complements, disciplining each other, enriching the other.

For example, relatively recent research from certain areas of Quantum Physics tell us that a continual unbroken wholeness as the substance of nature, is a most realistic possibility.[2] Most monistic philosophies and their creative speculations have for centuries visualised such a home, but without the science to build the house. In the source of their seeming opposition, we are finding areas of daily fusion and surprise.[3]

Yet this fusion is not well structured in our civilisation-building processes. One of the main reasons for this has been the structural dependency upon specialisation of labour. What should be a catalyst for interconnecting all humanity, has become an obstacle.

Another reason why the artistic and the scientific do not interact well, is that too many intuitive leaps demand credibility. Every instinct yearns for its rational bed-fellow which the grid of scientific relativity cannot allow or provide. As a result the holistic vision is not a daily living force, and disenchantment drives the mind into seeking categorised corners of certainty.

The main problem concerns handling uncertainty. The issue lies in accepting the incompleteness and yet not being overwhelmed by the transition. That this transition may stretch over a lifetime, is the individual dilemma. It then comes down to balancing detachment with passion, involvement with quiet. To be the creator, the spectator and the unconcerned, all in one, simultaneously slipping into each, is the issue. This helps one realise that each is genuine, and yet each is inadequate for the real nature is that which allows this slipping into each, that which allows the fusion of the creator, spectator, and the unconcerned.

That substance which allows the creator-spectator-unconcerned continuum to exist in us, is the reality we are trying to grasp. This is the unexpressed direction civilisation has been trying to structure.

It is like the trace of air left behind by birds ahead. Institutionalising that trace of flight so as to allow continual unrest within rest, is the human journey. Yet answers can be sought without recourse to building a nest or laying foundations. It is like stopping in mid-air, realising the sensation of being suspended, yet convinced that one will not collapse. Thus one pushes the state of suspension, and demands answers in the middle of the sky. Others sensing the audacity of these deluded birds, call them artists. Yet their formless dance must be incorporated into this bedrock of nest building.

It is the characteristics of this continuous flight, which we are trying to grasp, in its entirety. Sooner or later artists and scientists merge, and saints are created. Living saints are scarce when the arts and sciences fail to interact. When they are scarce, notions of god and other such doomed ultimates ease the transition.

Disintegration and Integration

Every saint finds a patron. Modern societies entrust expectations to the economic mechanism; translating our ideal reality into its material image, of transforming mental fluidity into material flexibility.

The problem is that this mechanism also possesses its separate logic. The ability of the economic system to absorb change is unsurpassed. Given this monopoly power it tries to determine the value-system by which we direct coexistence. It is this hidden economic agenda which we have been unable to control. It has conditioned everything. The positive trade-off is that it provides a structure to coexist.

In the West, it was an initial sense of feeling suspended, after the disintegration of the religious world-view, that directed the psyche into specialised identities, through the engine of industrialisation. At that time, neither the arts nor the sciences were in a position to foresee the power of economic logic. They actively participated in giving momentum to the machine. That the faculty of self-criticism would remain in the machine was the faith of human reason. Centuries of tussles with materialism made such a god inevitable.

The trade-off has been acceptable, it provides stability. This is now the nature of material flexibility, though not so within mental fluidity. As a result we have alienation. With the mental and material out of tandem, pseudo-spiritualism and violence become temporary but popular crutches for people. Yet faith in self-criticism, as the only mode of change, remains.

In the West, prevailing bouts of modernism and counter-modernism seem to reaffirm that the self-critical mode is still allowing possibilities of change and increased freedom. The cyclical process now seems to be accepted as the orthodoxy.[4]
Today, the present open–ended post–modern pluralistic relativism, especially in the urban West, is beginning to tire people.[5] As a result there is a latching onto narrower identities, a retreat upon crutches which are local and easy to verify. There is a cry for an unintegrated independence. Globalisation attempts are hence witnessing a simultaneous increase in communal mentalities, implying a greater intolerance towards difference.

Today, differences cannot help but become divisions. People are convinced that each difference has an in-built tension destined to divide. Once this process begins, the division creates a barrier. A barrier instigates an atmosphere of conflict, incomplete coverage leads to a fragment being splintered, and soon what were calm differences co-existing, have become polarities, contradictions, forming two separated worlds, unable to see their unity, desperate to cling onto their partial identities, further feeding the original paranoia of separation. Communication disintegrates and all the technology in the world cannot mend those fences, invisibly erected.

The absorption of differences as nurtured by economic logic, is failing to provide the inner glue. It is not preventing local paranoias from transforming themselves into divisions. The main reason for this, is that the created system structures human coexistence amid a grid of labour specialisation. Yet specialisation, once the essential motor for industrial growth, is today revealing in-built inconsistencies. It has been unable to squeeze out the holistic vision necessary to discipline the specialised knowledge.

The system of economic pragmatism which structures our life, gives each person a function within the network, but without a simultaneous glue which reveals the

[4] Eg: " The apocalyptic mood in which our Modernism and post-Modernism have been viewed has obscured the fact that there have been earlier Modernisms and earlier post-Modernisms. A Modernism is a cultural period characterised by two mutually supportive and mutually validating views about history and self-hood. 1) History seems to have an upward inner directive, a driving force of progress operating within it. In such a situation, innovation and change come to be valued over the stabilising influence of tradition. There is a sense of confidence in history, which seems to be on one's side. 2) Validated by the inner purpose of history, the self inflates. There is an apothesis of will and personal creativity, as the sources of historical change. Self-expression and originality are revered as the expressions of history's inner directive. There is a heroic view of the self as adventurer, innovator, and guiding force of history. A post-Modernism, on the other hand, is a period when the Modernist faith in history has been lost, usually through political developments. The support of history's inner meaning being withdrawn, the self deflates. History now seems to have no shape and the self no anointed mission. There are attempts to re-establish connections with the traditions destroyed by Modernist innovation." (T.McEvilley, *Art & Discontent: Theory at the Millennium*. New York: Documentext, McPherson & Co., 1991. p136)

[5] That tiredness is cynically disguised as maturity is but one indicator of disenchantment.

interconnectedness of all things, ideas, and people. The network becomes a web. As a result the system cannot help but inculcate attitudes which are not geared towards bridging disciplines, let alone communities and nations. The frustration worsens as opportunities open up but a sense of belonging does not emerge. One is forced into a tribal-like conformity, and the potential which technology provides remains but a gadget for economic games.

This sense of division is reinforced through educational processes which need to cut up the macro, so as to study the micro. Micro knowledge is indispensable, but what balances it, and gives it significance? Learning continues until we die, yet formal education is structured during short intervals of life, based on preconceived notions of unfathomable mediocrity. For most it pushes the mind into years of underutilisation and violent boredom. The growth of informal education, interdisciplinary studies, summer exchange courses, and the like, are but minor amendments to an system which requires a radical overhaul, the world over.

Given these inbuilt distortions the attempts at re-integration within the mind are destined to dissatisfy. There is confusion in the diversity, because an in-built disintegration process goes hand in hand with the integrating efforts. Yet this counter-force is not the problem. Civilisation-building cannot be accomplished without categorisation and specialising efforts. These are the micro-weapons which have allowed one to reaffirm a fuller vision. One falls apart without the other. There is no incompatibility, only a lack of understanding regarding their interaction.

In grasping this fuller interaction, one requires a deeper ability to let a state of flux be, of waiting for a moment longer, not bringing any judgments to the so-called confusion. It is about giving freedom to our perception of uncertainty. This means a refocused infrastructural support to nourish this ability to wait, this letting it be, this absorbing without preconceptions, clearing the mind and yet retaining all, of a full openness, maintaining faith in the act of allowing doubt its freedom. It is about faith preceding, yet embracing scepticism.

What allows such contradictions to co-exist? Where is the source of confidence for faith to let its denier run free? Creativity at a certain stage is the most honest way of allowing this balance...

Passionate-detachment

Essentially such a balance requires detachment within the energy of involvement. The idea of inner detachment is misunderstood, by both East and West. One has highlighted the passive and fatalistic, while the other has focused on the cynical and anti-pleasure aspects. This has led to detachment not being able to sustain a viable practicality for itself. The value of detachment cannot be calculated and the fear of its anti-motivational aspect is too risky. This lack of living use is reinforced by institutions unwilling to nurture the idea through an educational and work process. As a result materialism places detachment, as with integrity and love, upon isolated pedestals.

In artistic creativity, detachment is carefully cultivated. Like other human values, detachment represents different facets at different stages of maturity. At lower levels it can lead to indifference or a cool cynicism; inspired as readily as self-absorption. However it is detachment which nurtures discipline so that every indulgence and obsession can be given freedom.

At higher levels, detachment can inculcate a sense of humour and playfulness which absorbs all like a participating- spectator. At even higher levels it inspires a calm sense of duty, rooted in absorbing all through a wisdom which grasps the essence of non-judgmental judgments, of continuous effort which seeks no reward but that of being true to its activity and pleasure. At still higher levels it can inspire action in others though remaining quiet or neutral in itself.

Thus one pivotal dilemma which confronts all individual activity at a certain stage, is that non-activity seems wise. The path towards this wisdom implies attitudes which will not nurture the creative act or any other activity. Thus an artist who truly wishes to know oneself, and the nature of one's creativity, must sooner or later come to terms with this spectre of non-activity. This spectre can emerge at any age, not just in the twilight, or when energy is tired. The issue is how to allow this seed, a significant freedom in the mind, and still continue with a self-renewing creativity. This is the duty of detachment.

In general, the positive force inherent in detachment has not been emphasised in the Western inner journey. For the East, the non-violent and passive aspect of detachment today lacks a credibility, for it is unable to discipline daily violence. Hence the contemplative tranquillity associated with detachment seems a feeble force, unable to convince that it is a virtue whatever be the circumstance and place.

A re-education is required. Our understanding regarding love and compassion, within which the greatest force for detachment exists, must be one area of focus. The knowledge that once one received unqualified love, is enough for most to selflessly devote their lives with lesser demands of reciprocity. To give not because one necessarily wants to give, but that one cannot help but give. It is a compulsion which also influences our own desires and wants. An overwhelming momentum is created which sooner or later calms want. Wants and desires are clearly recognised and yet somehow a smile can control their venting.

Soon togetherness is rarely about the person beside one. Any and every person could be a companion. It is no longer about demanding faithfulness from another, it is about asking them to be faithful to themselves, and in that hope rely on the existence of love and its freedom.

Once daily experience reaffirms this, it feels at times a most non-romantic affair. Yet 'letting it be' requires a passionate discipline. For only the most passionate can sustain such detachment and duty. Duty becomes the act which absorbs all pleasures.[6] Detachment is the wisdom which disciplines duty to realise its pleasure. Creativity is the most complete duty which strives to fulfil this pleasure.

It is a passionate-detachment which creativity most clearly reveals. As a result, it is within the creative journey that specialisation finds its finest holistic discipline. If this understanding can be structured into the educational process the principles of creativity can most fully enrich our value-systems.

[6] I recollect a passage: " ...this duty to eschew the rule of ritualised decorum also demands that one goes beyond the language of duty. One must not be friendly or polite out of duty...Would there thus be a duty not to act according to duty, neither in conformity to duty...nor even out of duty? In what way would such a duty, or such a counter–duty, indebt us? According to what? According to whom? " (J.Derrida, *Passions: An oblique Offering*, In *Derrida: The Critical Reader*. D.Wood, ed. Oxford: Blackwells, 1992. p8) Western thought has always been unable to comprehend the sense of necessity, or humility, or the sense of pleasure within duty. Duty feels too imposed a task, in conflict with notions of individual freedom. Again it seems a justifiable scepticism because such an ideal duty cannot easily exist within the daily material cage, and yet of course the preconception induces and perpetuates the cage.

Flamed-mosaic

The nature of our creative evolution may always be difficult to grasp. Many impose a narrow consistency to attain a coherent whole, while others reveal the anarchy with its limitless randomness, calling it chaos. Whatever the approach, the intuitive and logical have rarely found a sustainable coexistence, where neither tries to dominate each, where both dissolve into something fuller.

Few sustain the search until the limits of logic cajole intuitive freedom into a state where there is no separation. It is to have serenity and intensity moving hand in hand, the obsessive and the calm smiling within the embrace of each. Creativity accomplishes this. Any source, any moment, becomes a trigger for creativity. The 'irreducible plural text'[7] becomes a daily expression. The moment encapsulates past and future without attachment to either, yet respect for both.

It is indeed difficult to reveal this dissolving process with detachment, while having to live within it, to observe into it, and to rise from it. However, this relationship between the intuitive and logical can be clarified in another way...Imagine a mosaic shattered into thousands of pieces falling all over the world. People gather these pieces and are now trying to join them together. Yet no one knows the original image, maybe there was no original image. As a result each is happy to create their own vision, imagining it to be the full picture.

Some even crack up their shattered pieces so as to create a new mosaic, of an image they have now clearly seen. Instinctively they know that this cannot fulfil them, and so the search to integrate with other pieces and their owners continues. And so globalisation, technological advances, new economic unions, move hand in hand with regionalism, a narrow clinging to identity.

Now imagine a flame, which cannot be shattered, where the cohesive holism is clear, as are the aspects of colour within the spectrum, and its degrees of temperature and warmth. The integrity of the flame inspires confidence, while the mosaic within is also recognised. But this too is incomplete, for it relies on an intuition which cannot verify its existence. The flame, in itself, also fails to fully satisfy.

In general, civilisations have oscillated between emphasis on either the logical or the intuitive. Today it seems, that broadly speaking, Eastern civilisation is in awe of this flame, and the West in awe of the mosaic-like surface. Each flirts with the other, but neither have created a space within which their civilisations can fulfil the human compulsion towards the fullest freedom. Both are incomplete, and both are striving to be more complete.

Now imagine a flamed-mosaic, a fuller space so far instinctively felt and partially verified within. There is no infrastructure which can nourish this idea, let alone nurture the values which will sustain a way of life. For what is the flamed-mosaic? What is the space it occupies? What are the essential values it implies? Is it a wavelength of the mind which we can practically sustain?

The difficulty of venturing into spaces, such as the intuitive-logic and passionate-detachment implies a transition through seeming anarchy. It requires the freedom to play with uncertainties without having to impose established certainties. If intuition is allowed to infiltrate critical analysis without discipline, the very role of each can be compromised, leading to the seeming failure of both, and a breakdown of the infrastructure.

7 " The text is an 'irreducible plural'. The Text is not a co-existence of meanings but a passage, an overcrossing; thus it answers not to an interpretation, even a liberal one, but to an explosion, a dissemination...what he (the reader) perceives is multiple, irreducible, coming from disconnected, heterogeneous variety of substances and perspectives: lights, colours, vegetation, heat, air, slender explosions of noises, scant cries of birds, children's voices from over on the other side, passages, gestures, clothes of inhabitants near or far away. All these incidents are half-identifiable, they come from codes which are known but their combination is unique..." (R.Barthes, *Image Music Text.* London, 1977. Trans. by Stephen Heath from '*De l'oeuvre au texte*', Paris, 1971. Rpt. in *Art in Theory 1900-1990: An Anthology of Changing Ideas.* Harrison, C & P. Wood, eds. 942 Oxford: Blackwells, 1993)

One essential strand of the present counter-modern Western journey is focusing on this fusion, by gathering various Eastern philosophies and forms of creativity from the past. Attempts at conceptualising wider questions, mostly come to focus upon the limits of intuition and its logic. It is a most difficult balance, and the need not to overflow into areas which one cannot explain efficiently, requires immense intellectual discipline.[8] Also, one needs to recognise that the preconception regarding the initial separation of intuition and logic, distorts the criticism which later denies the holistic framework. Thus one requires a re-examination of the grid upon which self-knowledge is based. This is not just to say that linguistic constraints and environmental conditioning affect the credibility of self-awareness, but that, these limitations themselves are supposedly binding because of the distorted manner in which they have been formulated.

Of course, the above statement, falls into the trap of being dismissed by the very limitation it is trying to dismiss. Nevertheless, this trap exists only because one assumes a certain scientific thinking regarding the nature of consciousness–matter. If progress in various scientific insights regarding the 'unbroken wholeness' of nature can be verified for a fuller context, then the victims of the trap change.

All attempts at revealing a creative and critical fusion cannot help but pass this gulf, where a leap into uncertainty is required. The leap will sustain new directions if a significant infrastructure simultaneously accompanies the conceptual framework.

This simultaneity requires a thinking process more capable of dissolving certain attitudes of categorisation, while creating the clarity so as to replace the need for categorised structures.

This realignment can occur if we sustain a passionately-detached aspiration towards nurturing our intuitive-logic and inner fearlessness. Through the experience of artistic creativity these values are most clearly nurtured. The specific example of Indian Contemporary Art and its history genuinely reflects the living image of these values, within an environment which allows the history of many centuries to co-exist in daily routine.

Distraction and Concentration

This whole process of dissolving categorised attitudes demands an understanding of the reasons why and how an individual focuses on any issue.

Let us try to understand the relationship between distraction and concentration. No concentration over time is possible without distraction. If distraction is not effective concentration falls apart. As a result concentration must really be part of a distraction-concentration continuum. By making the distraction of today the concentration of tomorrow, one moves towards a fuller sense of proportion, and the wisdom of non-judgmental judgments.

If silence scares, and one needs background music to stay calm, then its background neutrality is most vital and volatile. In this neutrality the distraction serves its role. Concentration may be achieved only by concentrating on the distraction. Distraction-concentrated is a necessary step for a fuller understanding of concentration. That this may later lead to distracted- concentration is but the transitional trade-off. From it will emerge a deeper concentration; thus the idea of inner quiet constantly evolves through concentrating on distraction. Only if absorption not avoidance is the pivot of thinking, can such self-awareness grow.

[8] eg: "The frailty of the genre-distinction between philosophy and literature is evidenced in the practice of deconstruction: in the end, all distinctions are submerged in one comprehensive, all embracing context of texts– Derrida talks in a hypnotizing manner about a 'universal text'...This aestheticizing of language, which is purchased with the twofold denial of the proper senses of normal and poetic discourse, also explains Derrida's insensitivity toward the tension-filled polarity between the poetic-world-disclosive function of language and its prosaic, innerworldly functions... Linguistically mediated processes such as the acquisition of knowledge, the transmission of culture, the formation of personal identity, and socialization and social integration involve mastering problems posed by the world; the independence of learning processes that Derrida cannot acknowledge is due to the independent logics of these problems and the linguistic medium tailored to deal with them. For Derrida, linguistically mediated processes within the world are embedded in a world-constituting context that prejudices everything...Derrida holistically levels the complicated relationships in order to equate philosophy with literature and criticism. He fails to recognise the special status that both philosophy and literary criticism, each in its own way, assume as mediators between expert cultures and the everyday world." (J. Habermas, *The Philosophical Discourse of Modernity*. Trans: F. Lawrence. Cambridge: Polity Press, 1994. pp.190, 205, 207)

Unless the distraction was initially given the freedom to be something fuller, one would not be able to pursue the journey of dissolving it. This example can be applied to the absorption of intuition within logic. This has been the continuous historical process of modernism, but today the balance is towards stagnancy and adamancy. Instinct is weak and considers itself weakened by an awareness of itself. Thus the anarchic discipline which instinct could provide daily life is stifled in the ironic desire to be instinctive and impulsive.

This results from one's concept of focus and singlemindedness. Today this simply breeds a paranoiac defensiveness which has conditioned one's mind in tandem with one's concentrated speciality. Belonging only seems to come from little, familiar corners. The local is comfortable, and complacency is but a step away. It is this lack of synchronicity with the world and one's need for a narrow sense of belonging which is eating away at human fearlessness.

Fearlessness

Fearlessness comes from being part of each corner, having let each idea lived within, having been given the opportunities to give anarchy a freedom. It comes from the ego realising its role, rooted in the humility of its insignificance and the confidence that awareness is indestructible, ever-changing. To demand freedom is an early desire of the ego; to give freedom, is an inner compulsion of the mind.

Fearlessness comes from living a life rooted in absorbing all which comes one's way, and yet moulding this absorption with some unique aura. Aura is the appendix of clarity; in clarity lies fearlessness, a clarity which never closes the eye to the surrounding flux. The intent to be fearless is thus rooted in the belief that fearlessness may never come. Yet that is irrelevant after a certain duration, by then enough discipline has been nurtured to let a vulnerability be itself. A frailty is allowed to be revealed without fear. Such is the nature of fearlessness that fear becomes a permanent tenant, detached into a corner, which one has no need to evict.

Art has always nourished this fusion of contradictions, to emerge with fuller forms, and the openness of mind which encourages fearlessness. It manifests itself via experimentation, or a belief in randomness, or the ability to merge uncertainties without the need to resolve, in its ability to accept inspiration from any corner, from trivial notions or profound ideas, from ugly forms or beautiful images, from vulgar circumstances or serene moments. There is no sense of proportion but the limitlessness within. There is no value which burdens the creative impulse, for each act of creativity becomes a discipline to sustain the day.

A value-system is required, rooted upon the principles of creativity capable of providing a sustainable individual-national-universal identity, where each moment of existence feels vibrant, holding sufficient critical-faith and passionate-detachment to know that it is irrelevant whether or not answers are found. Where every answer seeks a fuller question. Where every resting point begs for new directions of search, and a sense of rest comes in sustaining the restless journey. Where an organic discipline can be nurtured only with fearlessness as companion; to doubt all and yet lose no confidence regarding the will to be true to oneself, and thereby to all surroundings.

That this arrogance will translate into an authentic humility, is just a matter of sustaining the journey. To be given a freedom so that one may give another that same right, only to realise the delusion of giving freedom. Yet in this realisation one eases the demanding. The genuine need is to be brave, to dare, to go beyond every envisaged

moment of certainty, so taunting the very basis of uncertainty. To live amid the randomness which was once feared. To let each unknowing situation reveal itself, to just spectate and in that distance become the most active participant.

It is like the lover who sometimes needs to give distance to loved ones, for they may not be ready to accept love. In that show of trust, one gives the other a chance to act positively. In that retreating step, one moves towards a fuller togetherness, which otherwise would have resulted in a pushing away, a demand of faithfulness which could not have been fulfiled. Few have the courage to tell their partner you be faithful to yourself, first and foremost, and I trust that in that act our love will be sustained.

It is only after such shows of faith that one can take another for granted. For by then it is no longer 'taken for granted'. It has become transformed due to love, which has been nurtured amid this mutual freedom. This is the essence which will mould the future coexistence of people, where the only violence will be the war we wage within. To reach this non-violent violence is the process upon which we must act. To make the non-judgmental judgment, to cry the joyful tear, these are the daily rituals one cannot help but face.

The calm eventually comes from realising that our energy has kept pace with the energy that seemingly occupies this world, and yet our rhythm has not faltered, that human intensity has not been compromised.

This 'giving of freedom', and 'letting uncertainties be' are subtle ideas which require reaffirmation in daily life. The present system does not allow one the space and time to practise such ideals, and so naturally their usefulness is negated, and the philosophy dismissed. Thus it becomes the duty of the artist and philosopher, to also become the teacher, economist, politician, and sage; each aspect disciplining the other, thereby giving a fuller authenticity to each specific role.

It must be stressed that the merger of different disciplines is not simply a result of synthesis. The initial separation is the illusion, which is then paradoxically denied by an attempt at synthesis. This gives the human mind the false accolade of creating a form, when all which actually happens is that the underlying unity is revealed.

The artist-philosopher-teacher-economist-politician-sage is already existing in the human psyche. To reveal the unity is the requirement, rather than teaching that one is creating a union. Thus an educational system which allows an inner organic search, rather than imposing a preconceived interdisciplinary hierarchy is more likely to succeed. However, the critical faculty which structures a framework so that holism can become a living force, requires the transition of interdisciplinarity. Further, the creation of synthesis is easier for the mind to assimilate, especially one focused on the reality of opposition. With this merger, of the artist-philosopher-teacher-economist- politician-sage it is easier for one to translate ideas into action for themselves, rather than solely relying on a system and its hidden agenda. This in turn remoulds the system. With this merger comes the chance of sustaining idealism's integrity.

Within creativity exists the genius to grasp the nature of uncertainty. It alone has the openness of intent to give the unlimited more freedom. In this process it has the ability to be fair. It is in providing this spirit of fairness that lies the ethical dimension of creativity, rooted in the instinct of giving freedom, itself dependent on the will to be self-critical with joy. It is this joyous self-criticism which is the foundation of civilisation building, and it is in creativity, especially artistic, that this wisdom awaits to be continually transformed into daily practicalities and fuller visions.

The Absorption of Contradictions

The absorption of seeming contradictions directed towards a fuller-full ...Indian Contemporary Art offers a living affirmation of this process. As a result a deeper grasp of the unity between life and artistic creativity is possible. However, for many the chances of a vast integrated value-system evolving from the ideas of Indian contemporary creativity seem remote.

For most developing nations urban creativity is seen to be a luxury, a remote by-product of daily life. The gulf between popular culture and intellectual rigour is too wide, and the relevance of creativity lost in this gulf. Gone are the claims that it may generate a value system capable of re-moulding a violent materialist world. Yet the role of creativity and its aesthetic is to structure life, nothing less is true. The main factor which allows creativity to fulfil this role, is the ability of the artist to play with uncertainty a bit longer, without imposing a preconception. The process of transforming questions into answers, intangibles into tangibles, formlessness into form, must include sufficient openness so as to allow each created answer to reveal a fuller question, each created form to reveal a clearer formlessness.

This ability to let uncertainty be, of waiting with it, giving it the freedom to be itself, is the root of creativity. In the act of giving, one gives oneself the space and time to mature, while simultaneously absorbing the intensity of the moment. In this tussle evolves the wisdom which realises that all activity is attracted towards non-activity. Change and permanence, detachment and motivation, energy and quiet, are all visualised afresh, their existence re-examined.

This inevitable pull towards contradiction frightens everyone. For all of us there are days plenty when any corner feels a home, and every human a loved one; while other days tell that no corner is home and all are strangers. These inconsistencies feel confusing and so we demand a clarity, and so impose a simplicity. Suddenly identities are made from little localities and narrow communities, and this uniformity feels comfortable. In this comfort, complacency blooms, and our play with uncertainty begins to compromise. To prevent the human being from making this compromise is the duty of creativity.

This is the task one needs to set oneself. A vast body of creative work needs to be brought together within one's mind, and the underlying principles of each discipline understood and documented by the individual. This will become a holistic living experience which initiates and sustains effort.

One difference between the interdisciplinary and the holistic is the latter's ability to allow uncertainty a clear role in dictating one's knowledge. Inter–disciplinarity is but an effective stepping stone towards holism and its interconnectedness. You cannot simply take five different departments put them into one enclosed space and institution, and say interconnectedness exists. The process is like the rocky water source which encapsulates and then flows into different streams, and when more steady, its streams come to merge into an all encompassing powerful flowing river. Interdisciplinarity is more like the deeper dam which collects and allows the later merger to occur more efficiently. However, the process of integration, common today, has disintegration in–built from the start, given our belief in polarity and its structural indispensability. To cut and categorise, therefore synthesise is the mechanical process. Thus the freedom given to uncertainty is misunderstood. Hence the relationship between an absolute and its self-critical faculty is distorted. Cohesion is rarely possible. Relativism and its plurality become the continual mirage.

To understand how one maintains the self-critical faculty within an absolute cohesion is still being pursued, for this has been at the heart of the modern Western journey and its creation of wealth. The issue is not to replace specialisation but to make it more disciplined, to make it deepen its reach, and realise the holistic vision which it serves. If India is to give new impetus to the relevance of creativity in our daily value systems then the dilemma facing her is how to create material wealth without sacrificing the holistic integrity of the individual. This will predominantly require a radical overhaul of the education system, linking the principles of creativity and its aesthetic with every subject and its daily application. It falls upon the creative community to initiate this process.

It demands that those responsible for building the network, first nurture an artistic integrity which then cultivates financial discipline. This requires a creative-infrastructural merger within the mind. It requires the artist- philosopher to realise his warrior aspect, a warrior of non-violence. The duty is to persuade others that the only genuine war is the war we wage within, expressed through creativity.

However, in India where the resources devoted to contemporary culture and education are relatively scarce and most unequally distributed, patronage to guide the thinking can be easily abused. The transformation of knowledge into dogmatism is inevitable. Eventually dogmatism becomes a means of survival in a system which lacks respect for wisdom. Open and positive criticism is stifled because one feels the system cannot cope with the transitory anarchy. Eventually blaming the system becomes blaming individual personalities, and an insecure defensiveness surfaces everywhere. Soon radical change becomes the only alternative.

Through laying a solid documentational and educational network within the Contemporary Indian Arts, financially independent and self-sustaining, one has a chance of creating the basis by which India can harness her energy and wisdom, tempering the inevitable material excesses and manipulated religious fevers, providing that inner freedom and outer balance which is the dream of all societies.

History of Indian Contemporary Painting

A Pictorial Survey

Pre-1947

What makes a pioneer? To oppose the common perception if it rules against your inner journey and to be true to oneself, yet never forgetting common roots. To sustain the resistance until a new path is cleared; to walk alone, to wait, to stare...To stare, while others barely visualise the image, is also called madness. Every pioneer must be able to taunt that madness, to tease and play with that which opposes, to absorb this opposing force, seducing it into the journey, and in that embrace sow those seeds of fearlessness, which sustain creative compulsion. It is fearlessness rooted in humility and compassion, which can create holistic hope in the tiniest fragmented corner.

VARMA, Raja Ravi **A Girl Holding Hooka in One Hand & Broom in Another**

.

TAGORE, Abanindranath **Journey's End**
MAJUMDAR, Kshitindranath **Ras Lila**

.

TAGORE, Gaganendranath **Princess of the Enchanted Palace**
ROY, Jamini **Last Supper**
TAGORE, Rabindranath **Two Figures**
BOSE, Nandlal **Drummer: from Haripura Posters**

.

SHER-GIL, Amrita **Bride's Toilet**

.

VAIJ, Ramkinkar **Landscape Series**
MUKHERJEE, Benode Behari **Tree Lover**
ROERICH, Nicholas **Himalayan Deity**
BENDRE, N.S. **Fisherwomen**
KEYT, George **Reflections**

VARMA, Raja Ravi

**A Girl Holding Hooka in One Hand
& Broom in Another**
50x32.5. Oil, 1904
NGMA

" His works are known throughout India, have often been reproduced and are still growing in popularity...the untrained public, finding a painter who...produced realistic pictures of familiar subjects, welcomed him with open arms. It has, indeed, been his reward for choosing Indian subjects, that he has thus become a true nationalising influence to a certain degree...He is the landmark of a great opportunity, not wholly missed, but ill availed of. Theatrical conceptions, want of imagination, and lack of Indian feeling in the treatment of sacred and epic subjects, are Ravi Varma's fatal faults."

A.K. Coomaraswamy, 'The Present State of Indian Art' *Modern Review* (Aug. 1907). Rpt. in *Raja Ravi Varma– New Perspectives*. National Museum ExC. 1993

33

TAGORE, Abanindranath

Journey's End
15x21. Tempera & Wash, 1913
NGMA

" Art is not for the justification of the Shilpa Shastra, the Shastra is for the elucidation of Art. The restraints of childhood are to keep us from going astray before we have learnt to walk,...not to keep us cramped and helpless forever within the narrowness of limitations. Even so, the novice in Art submits to the restraint of shastric injunctions, while the master finds himself emancipated from the tyranny of standards,...As no amount of familiarity with the laws of religion can make a man religious, so no man can become an artist by mere servile adherence to his codes of art,...If we approach our sacred art-treatises in the spirit of scholarly criticism, we find them bristling all over with unyielding restrictions,..."

Abanindranath Tagore, *Modern Review*
Trans: Sukumar Ray, from the Bengali. Originally published in *Prabasi*, (1913)

34

MAJUMDAR, Kshitindranath

Ras–Lila
14.3x9.4. W/c, 1926
NGMA

"...In the midst of these Gopis the almighty son of Vasudeva appeared to be superbly beautiful even as a large emerald shines in the midst of other gems of golden hue. With their measured steps, with the movement of their hands, with their smiles, with the graceful and amorous contraction of their eyebrows, with their dancing hips, their heaving breasts, the moving locks of hair covering their forehead, with drops of perspiration trickling down their countenance and with the knots of their hair and garments loosened, these lovers of Krishna began to sing and they appeared beautiful as flashes of lightning illuminating a dark cloud."

Pannalal 'Majumdar's 'Rasa–Lila'' *Rupam 5,* (Jan. 1921)

35

TAGORE, Gaganendranath

Princess of the Enchanted Palace
24x37.5. W/c, 1925
Private, Calcutta

" No stereotyped architectural design is there, nothing to connect it with the familiar forms of masonry work,...there does not seem to be anything in the line of conventional forms except a few touches at different points...yet I believe that a lover of art will find in these formless forms of absolutely no historical or racial context some of the most vitalizing colour- compositions and architectonic expressions...."

Prof. Benoy Kumar Sarkar, 'Tendencies of Indian Art: A Review' *Rupam* 26 (Jan 1927)

36

ROY, Jamini

Last Supper
57.5x194. Tempera on cloth, c.1945
Sadrudin Daya, Bombay

" It is sometimes asked why an orthodox Hindu who has never even read the New Testament should be interested in the subject of Christ. Jamini Roy gives several reasons. In the first place, he wanted to find out if his new technique could be applied with equal effect to a subject remote from his personal life... he wanted to show that the human and the divine could be made one only by abstract, symbolic means... In particular, one can find a close parallel between Jamini Roy's studies of Christ and the anonymous French folk-painters of the 12th century whom Gauguin copied."

John Irwin and Bishnu Dey, *Jamini Roy.* Calcutta: ISOA, 1944. Rpt. Jamini Roy NGMA ExC. 1987. p 13

TAGORE, Rabindranath

Two Figures
25x17.3. W/c and ink on board,1934
NGMA

" I, as an artist, cannot claim any merit
for my courage; for it is the unconscious
courage of the unsophisticated, like that
of one who walks in dream on perilous
path, who is saved only because he is
blind to the risk. The only training which I
had from my young days was the training
in rhythm, the rhythm in thought, the
rhythm in sound... And therefore, when
the scratches in my manuscript cried, like
sinners, for salvation, and assailed my
eyes with the ugliness of their irrelevance,
I often took more time in rescuing them
into a merciful finality of rhythm than in
carrying on what was my obvious task."

R. Tagore, Foreword to Gallerie Pigalle ExC.,
Paris, May 1930. Rpt. in *The Calcutta Municipal
Gazette: Tagore Memorial Special Supplement.*
Calcutta, Sep 1941. Rpt. 1986

BOSE, Nandalal

Drummer: Haripura Posters Series
62.5x55.5. Tempera, 1937
NGMA

"...Each subject (of the **Haripura Posters**) was clearly defined against a contrasting background and finished with a freely flowing calligraphic line... The folk elements if any are transcended. Nandalal paints in his own style, a language that was at once intelligible and clear, that created a new standard or norm... The style is...at once traditional and contemporary, naturalistic and ornamental...Nandalal's lines combine the plasticity of Indian sculpture with the fluency of calligraphy...the designs are not mere patterns, they are a new and delightful reality, bouyant and joyous, containing the prana or life-breath of Indian art."

Jaya Appasamy, *Haripura Posters*
New Delhi: LKA, n.d.

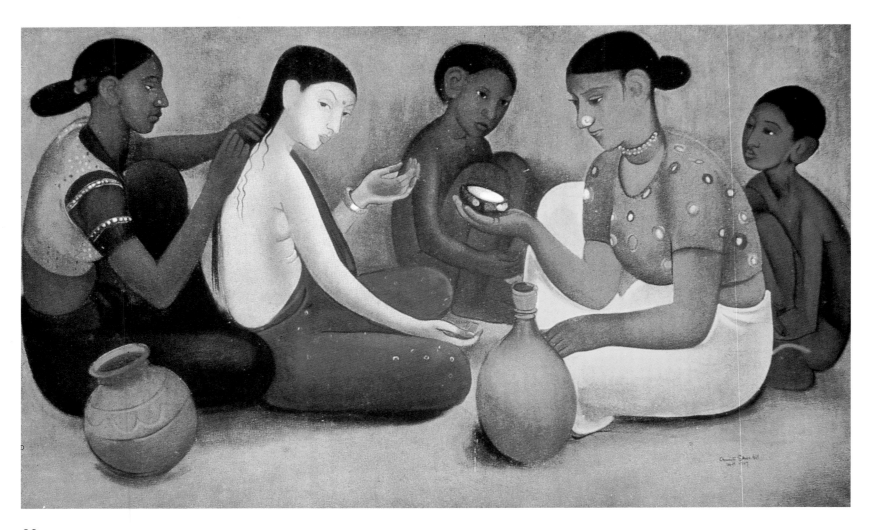

39

SHER–GIL, Amrita

Bride's Toilet
87.5x145. Oil, 1937
NGMA

" Shall I describe the colour scheme? The fat woman's skirt which is an unexpected greenish yellow lights up the whole picture. The little girl in the middle is clothed in a crimson cloth with white circles, her face and body are sort of ivory colour. The woman doing her hair is a rich burnt sienna with reddish oranges in it, her skirt is a warm peacock blue, her blouse acid green with purple sleeves, the pots pink, the whole background and foreground a greyish ochre more or less uniform...The kid in the centre is a deep red brown with occasional green tinges and the child on the extreme right is as though lit up by a flame, as somebody said."

A. Sher-Gil, referring to Bride's Toilet, letter to Karl Khandalavala, dated 15/6/1937

40

VAIJ, Ramkinkar

Landscape Series
18.5x27. W/c, c.1940
Private, Bombay

" ...I can safely say that Ramkinkar's (and Benodbehari's) understanding of the graphic conventions of Cezanne– and its aftermath– was much sounder than that of any other artist of that time. You can see proof of this in Ramkinkar's pen sketches and studies, in the way he structures and uses colour in his watercolour landscapes. His general work-attitude also is similar to Cezanne's – to extract a motif from nature. So all his work arose from a tangible visual experience."

K.G. Subramanyan, 'Remembering Ramkinkar' *AHJ 9* (1989–90)

MUKHERJEE, Benode Behari

Tree Lover
72.5x39.5. Tempera, 1932
NGMA

" In his art the interest in historic and romantic subject matter or even in subject matter at all is swept away by an interest in form and colour, in arrangement of balances and tensions for their own sake. There is no effort to consciously express an idea, for the painting itself is a reflection of the artists idea...Early compositions are from the landscape around Santiniketan, the surge of vegetation and the turgid dark leaves of bushes make a relentless pattern and seem to have a torrid organic life..."

J. Appasamy, *Abanindranath Tagore & the Art of his Times*, New Delhi: LKA, 1968

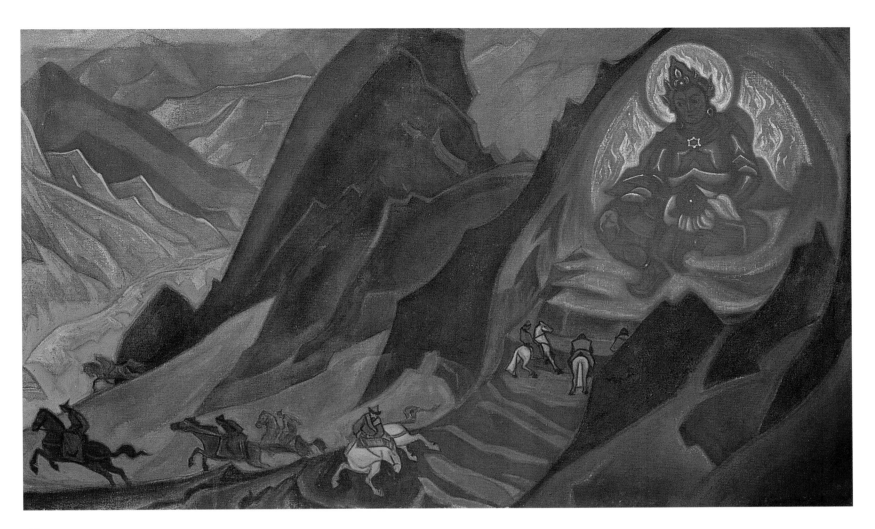

42

ROERICH, Nicholas

Himalayan Deity
91.7x152.5. W/c on canvas, c.1940s
Govt. Museum & Art Gallery, Chandigarh

" (Dr.H.) Goetz remarks that Nicholas Roerich was the first Russian representative of that simplified style developed by Manet, Gauguin, and van Gogh which led to a new spatial and atmospheric probability by means of an intensive line and colour which in its turn evoked responses never possible in Eastern art. N. Roerich made a deep and intimate study of the rocks and mountains of the inner Himalayas, and his Himalayan landscapes reveal unearthly beauty and grandeur. His colours may appear exaggerated to the people who live in the dusty plains, but those who have had an opportunity of travelling in high altitudes know what brilliant colours can be seen there at dawn and sunset..."

M.S. Randhawa, The Art of Nicholas Roerich', *LKC 18,* (Sep 1974)

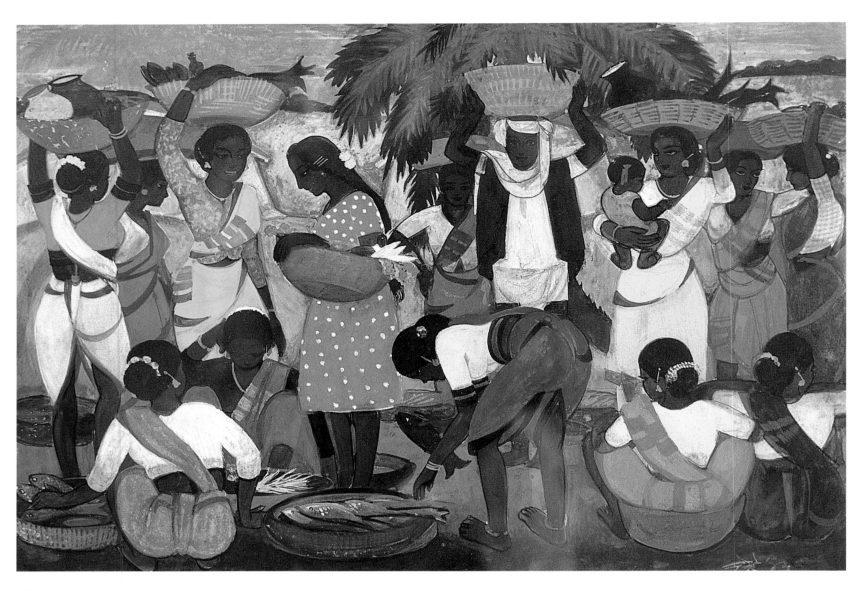

43

BENDRE, N.S.

Fisherwomen
28.5x42. W/c, 1943
Private, London

" Bendre is undoubtedly a versatile artist.
He is descriptive at times,
representational at other times; he may
be naturalistic in one picture, and purely
romantic in another. He is always anxious
to see a new work and how it is executed,
and will borrow or invent a formula to
paint a particular type of subject...I would
like to paint the people of Malabar, the
scenery of the Himalayas, the colour and
costumes of Kathiawar, and the Hindu
architecture of South India..."

Present–Day Painters of India,
G. Venkatachalam & Manu Thacker. eds. Bombay:
Sudhangsha Publication,1950. p 8

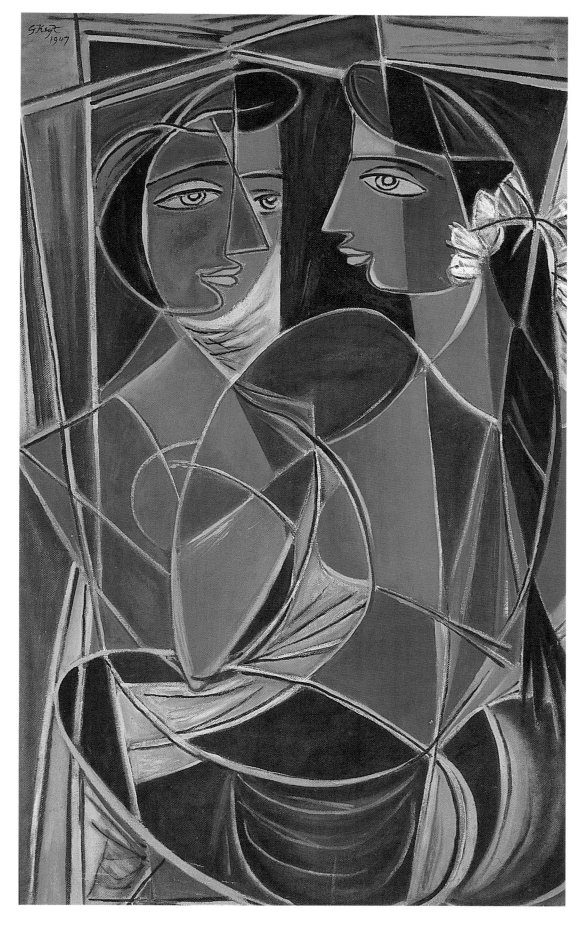

KEYT, George

Reflections
120x72. Oil on board, 1947
Gallery Chemould, Bombay

" Keyt espouses the cause of comparatively rapid execution and complete frankness so that preliminary drawing and changes of plan are sometimes visible in his pictures, as they are in the Sigiriya frescoes, in some Pallava frescoes,...in some of the work of Picasso... Keyt's heads seem to be inspired by the heads of the Ceylon bronzes, or by the stylised heads painted by the artists of the Kandyan craftsmen, a harmony which is, perhaps, only perceptible to those who know or, from the paintings, are capable of imagining, something of the Sinhalese way of life among the innumerable villages of the Island...Keyt has drawn on sources both ancient and modern. To this modernity the Indian background has added the vitality of an important human tradition."

M. Russell, *George Keyt*. Bombay: Marg Publications, Feb 1950

1948–55
Energy, Infrastructure & Freedom

1956–63
A Search Within:
The Consolidation of Western Influences

" Contemporary Indian Painting is primarily expressionistic. And this is in keeping with the best traditions in Indian Art. There is still much that is derivative. The transitional phase, however, has ended. The tentative, experimental and exploratory tendencies are now resolved ...the strong reaction from 1940 to 1950 against the pseudo-classicism of the Bengal School, principally revivalist, has cooled down...In this phase of introspection and of consolidation there are signs that a national idiom is emerging...Drawing is boldly delineated. Brilliant colours, flatly applied or facetted with the palette-knife are juxtaposed daringly. The image is not amorphous but organic. Though economical, the drawing is fluid, stressing the cast of the eyes, the gestures of the hands and of the fingers..."

Richard Bartolomew, Nov. 1957. Rpt. in *Modern Art of Asia*. Tokyo: Toto Shuppan Co. Ltd., 1961

MOOKHERJEA, Sailoz Vision
HEBBAR, Krishna K. Pandits

.

SOUZA, Francis N. Landscape in Red
ARA, K.H. Black Nude Series
HUSAIN, Maqbool Fida Man Series

.

SANYAL, Bhabesh C. In Brooding Mood
KRISHNA, Kanwal Homage to Light Series

.

GUJRAL, Satish Condemned
SABAVALA, Jehangir A. Crucifixion
PADAMSEE, Akbar Still-Life with Tea Pot
DE, Biren Apparition

.

SULTAN ALI, J. Village Life
PANIKER, K.C.S. Garden Series

.

PAI, Laxman Geet Govinda Series
SAMANT, Mohan Untitled

45

MOOKHERJEA, Sailoz

Vision
110x87.5. Oil, 1959
Jehangir Nicholson Museum, NCPA

"... When a whole lot of Indian artists
were discovering the 'significance' of
cubism etc., and blazing new trails by
turning on to Indian-based works dyed in
half-digested Western styles, Sailoz was
painting the Indian landscape in such an
easy, unintellectual, unpretentious
directness that he seemed to have missed
the experimental spirit of the times."

J. Swaminathan, 'Homage to Sailoz',
(28.10.62). Rpt. in *LKC* 40 (Mar 1995)

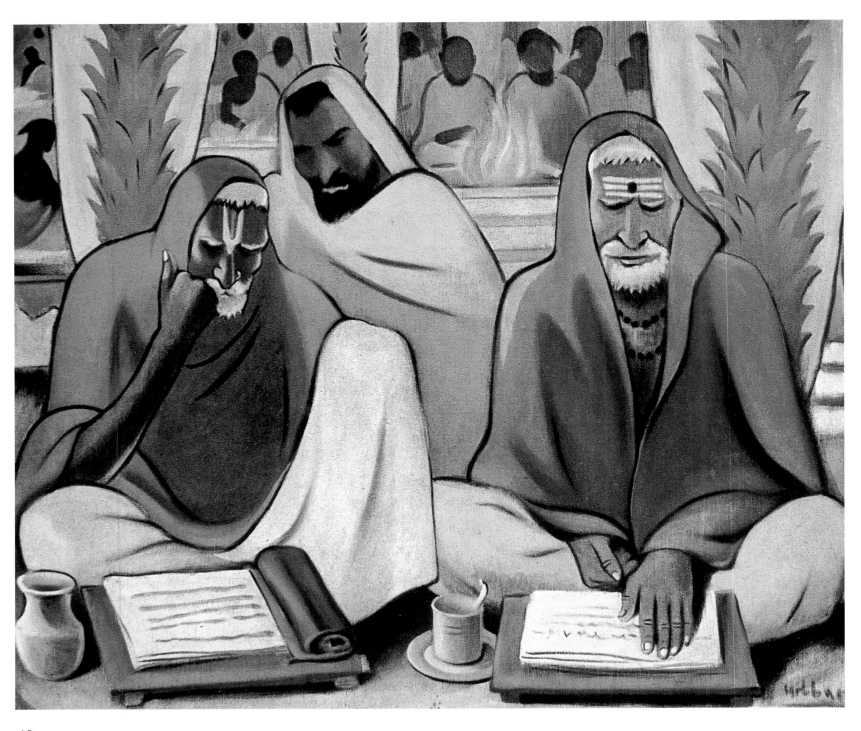

46

HEBBAR, Krishna.K.

Pandits
76.2x89. Oil, 1948
Private, Bombay

" He experiments to evolve a technique of his own, combining eastern and western methods. One such successful experiment is his **Pandits**, in which his impression gained at the Lakshachandi Maha Yagna in Bombay is superbly rendered."

Manu Thacker, Rpt. in G. Venkatachalam's *Hebbar*. Bombay: Nalanda Publications, 1948. n.p.

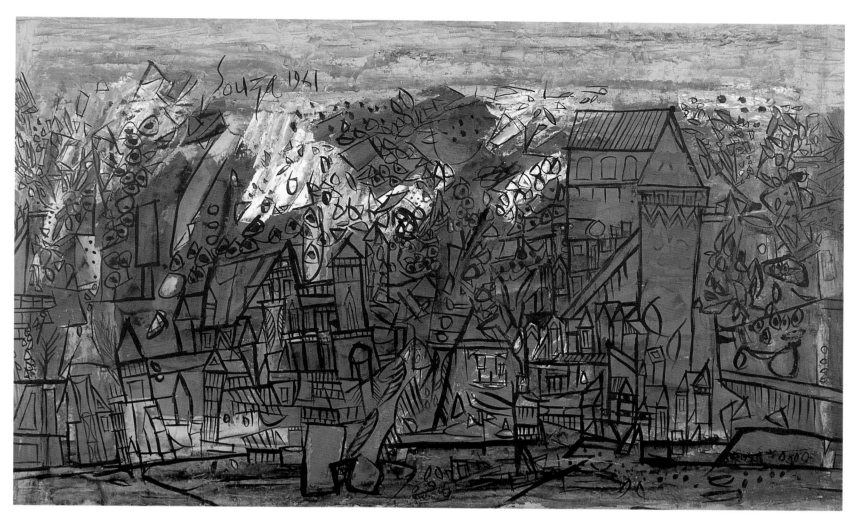

47

SOUZA, Francis N.

Landscape in Red
78.7x132.1. Oil, 1961
Jehangir Nicholson Museum, NCPA

" Souza is a painter of cityscapes and religious themes. While in the latter he is loaded with a troubled presentiment, in the former he is singularly devoid of emotive inhibitions. Unlike the cityscapes of Ram Kumar which ooze a silent melancholy and flare warmly from amidst the gloomy shadows of all-consuming time, Souza's cityscapes are the congealed visions of a mysterious world. Whether standing stolidly in enamelled petrifaction or delineated in thin colours with calligraphic intonations, the cityscapes of Souza are purely plastic entities with no reference to memories or mirrors."

J. Swaminathan, (21.10.62), *Souza's Exhibition.* Rpt. in *LKC* 40 (Mar 1995)

ARA, K.H.

Black Nude Series
81.3x60.1. Oil, 1963
Kali Pundole Family, Bombay

" Ara is the first Indian contemporary
painter to use the female nude
systematically as a subject, keeping
within the limits of naturalism...the still-
life effect is charged with the feeling of
potential movement, which is the
characteristic of the posing female
figure."

Nissim Ezekiel, 'Ara as a Painter of Nudes'.
Design 4.3 (Mar 1960)

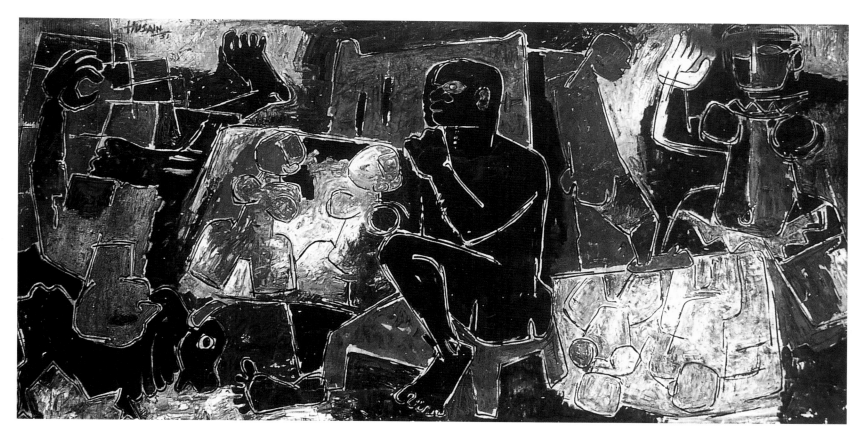

49

HUSAIN, Maqbool Fida

Man Series
122x244. Oil, 1951
Chester & Davida Herwitz, USA

" ...The contradictions and inconsistencies of our civilisation are revealed pictorially by a juxtaposition of masses, colours, and a complex symbolism which is a synthesis of traditional and modern mythology...The amorphous colours and complex masses of Husain's earlier pictures have undergone a rigorous discipline resulting in simplicity...It is a development which springs from a recognition of the materials he uses."

K. Khanna, 'Studies in the Development of Husain.' *Marg* 6.2 (1951)

SANYAL, B.C.

In Brooding Mood
113x82. Oil, 1960
LKA

" Sanyal's forte is colour, and this can well be exemplified by two of his more recent works: **In Brooding Mood** (1960) & **Mother** (1960). The former painting is heavy with a sense of tragic isolation. The pale moon makes a vain attempt to dispel the turgid flood of space. The leaning structures of Jantar Mantar await the unseen call of disintegration. In the midst of the dull fury of nature, the monumental figure of a woman stands creating a new horizon for the spectator. She too has wrapped herself with the turgid colour of the sky...Her lower garment is aglow, with earth red...She seems to symbolise the spirit of woman, who has suffered and sorrowed but still retains the will to live..."

Dinkar Kowshik, *B.C. Sanyal*.
New Delhi: LKA, 1967

51

KRISHNA, Kanwal

Homage to Light Series
53.5x74. Oil, 1962
Private, New Delhi

" Light reveals the secret of darkness...In Art forms, Light creates shadows and not shadows create Light...Light reveals to us; Darkness makes us conscious...We can reach Light only through our shadows; otherwise the source of Light we can never trace. The realisation of our own weakness is the true source of our new energy...Darkness, I feel, is the other side of Light–the unseen one. Homage to Darkness is homage to Light Unseen'...New Art Forms are born and not created...Light relaxes in the lap of Darkness..."

Kanwal Krishna, From My Note-Book 1962-3, New Delhi: Private Brochure, 1963

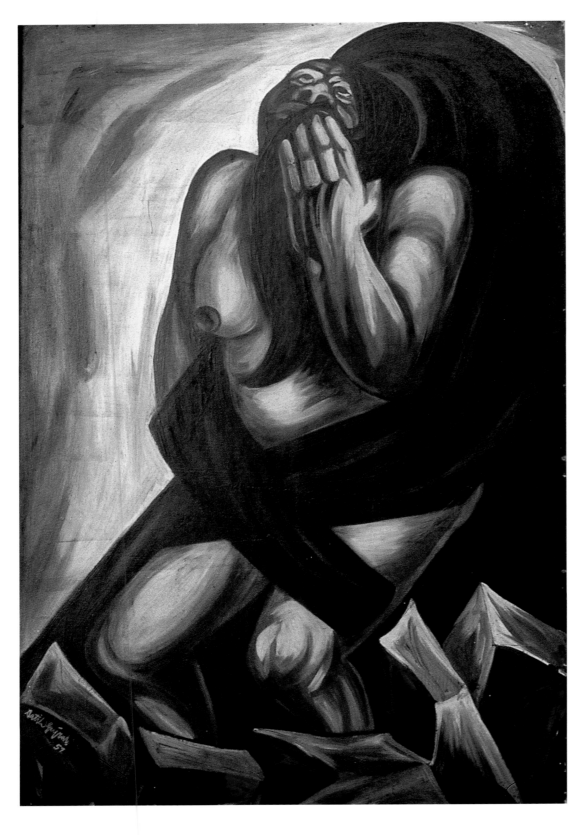

52

GUJRAL, Satish

Condemned
124.5x83.8. Oil on board, 1956
Private

" Gujral has a method of selecting his subjects and a desire to restrain himself in the presentation by avoiding histrionics or sentimentalism. This, in a great measure, keeps him away from the pitfalls of exhibitionism and gives his social awareness the legitimate value that it deserves. All his work has tended towards the larger canvas as against the use of the fashionable little easel spaces by the imitators of the Paris Schools."

S.V. Vasudev, 'Seven Contemporaries', *Marg 6.1* (1952)

53

SABAVALA, Jehangir A.

Crucifixion
81.3x61. Oil on board, 1958
Private, Bombay

" But his greatest strength is linked with his greatest weakness. For while his pictures are always interestingly arranged he tends to overburden his canvas with too many and too large objects. The result is exuberant but over-dramatic...This same exuberance is seen in his use of the colour. There are canvasses on which the entire gamut of colour seems poured out. An instinctive colourist, he manages to turn a defect into a tour de force, but he could strengthen his painting by a more selective and restricted palette."

Chitra, 'Studies in the Development of Sabavala.' *Marg 6.2* (1951)

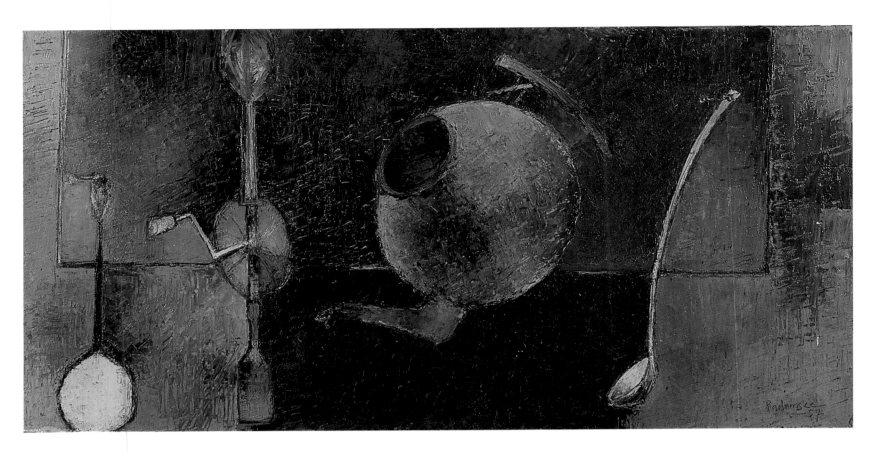

54

PADAMSEE, Akbar

Still Life with Tea Pot
50.8x99.1. Oil, 1957
Jehangir Nicholson Museum NCPA

" Even the kitchen utensils painted in the
same year bear witness to the same sense
of desolation. These are not things with
whose aid a man cooks food to nourish
his body. They look more like strange
instruments with which he tortures his
spirit. And yet there is not even a hint of
the macabre about all this. Everything is
said simply with an almost classical
restraint."

Shamlal. *Padamsee.* Sadanga Series, Mulk
Raj Anand, ed. Bombay: Vakils & Sons, 1965 p 6-7

55

DE, Biren

Apparition
89x114. Oil, 1957
LKA

"His work, on the whole bears eloquent testimony to his talent, vision, integrity and determination. A visit to his unorthodox murals at Delhi University would be rewarding. Fusion of science and humanities is the theme. If one has the patience and no prejudice, and pursues every form, one will forget all about the Cubists and Mechanists of whom these panels are only superficially suggestive. De's figures have sprung from the soil. They are vitally Indian in their colours, costumes, gestures, grace, in everything. And they speak a living language..."

A.S. Raman, 'Some Younger Indian Painters'. *The Studio*, 1956

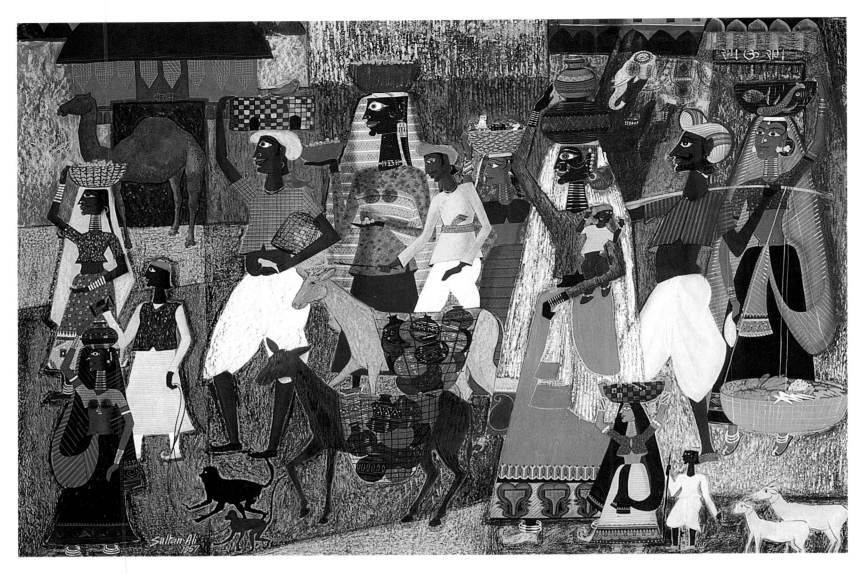

56

SULTAN ALI, J.

Village Life
122.5x182.5. W/c & pastel, 1957
Shoba Bhatia, New Delhi

" The paintings we know from the mid-fifties still have a certain stiffness about them: coloured dawings rather than paintings; with hard outlines and motives that are folkloristic in an obvious way, rather like illustrations. But Sultan Ali took his time...He takes little notice of what is fashionable...'Creative work should grow methodically', he says, 'no jumping about! The mind has to be extremely clear– one phase should give direction to the next. There is no short cut.'"

Ulli Beier, *J. Sultan Ali*. New Delhi: LKA, 1983. n.p.

57

PANIKER, K.C.S.

Garden Series
66x60. Oil, 1958
LKA

" Paniker seems truly to herald a
renaissance, both by the gem-like
brilliance of his colour-technique,
recalling tempera, and by the latest
evolution of his sense of form. In both
respects, his works make an abiding and
deep impression...his colour techniques
are entirely faithful to the spirit of the
Ajanta and Chola frescoes...he is able to
choose a small band of the spectrum, and
create a 'symphony' with one
predominating colour as the keynote, the
textures laid with undimmed luminosity
and precision..."

M. Anantanarayanan, *Artrends 1.1*
(Oct 1961)

तव विरहे वनमाली सखिव सीदति ॥ध्रु०॥
वहति मलयसमीरे मदनमुपनिधाय ।
स्फुरति कुसुमनिकरे विरहि हृदयदलनाय ॥१॥
गीतगोविन्दम् ।

PAI, Laxman

Geet Govinda Series
61x51. Oil, 1954
Private

" Laxman Pai's retrospective exhibition (1948-62) was a rewarding experience ...He has certainly travelled a long way from his early stylised Indian-style and symbolic paintings to his latest style in which there is more of forms created by colours and less of dots and lines. The wide variety of exhibits ranging from oils to engravings, silk paintings to pen-and-wash drawings revealed that he is the most literary and intellectual among our painters, steeped as he is in our myths and legends, from which he derives his inspiration."

Jagmohan, 'Art Chronicle', *LKC 1* (Dec 1963)

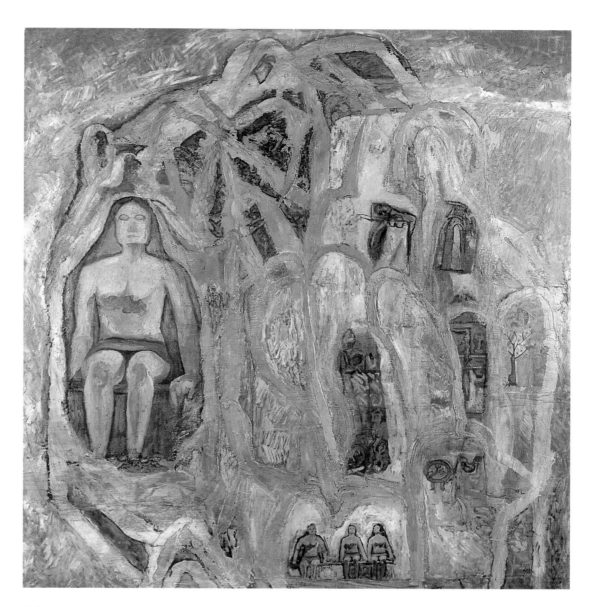

59

SAMANT, Mohan

Untitled
152.4x144.8. Oil & Plaster, 1965
Jehangir Nicholson Museum NCPA

" Most art brut bears a primordial stamp but Samant's is sophisticated; his indecipherable scribbles speak to man deeper than the syntax of known language. To Samant they tell of his own introspection: 'It is as if I have walls around me.' Yet he speaks to the world through their painterly surfaces and centuries echo musically off them.

Time magazine, 6 Mar 1964. Rpt. in Gy. CH ExC., Feb 1966

1964–72
A Material Indianness Clarifies

" There is a very strong notion current in the Indian art world today that to be individualistic in expression one need merely achieve variation in formal arrangement, and that contemporaneity need just be a certain capacity for innovation. Thus we have the traditional image sometimes making its appearance clothed in new-fangled technique and textures, sometimes disappearing altogether in the name of abstraction for a mere arrangement of textures in space...The real struggle of the artist therefore lies in unlearning tradition..."

J. Swaminathan, 'art now in India', Gy. CH–Commonwealth Institute ExC. For the Commonwealth Arts Festival, London 1965

PANIKER, K.C.S. **Words & Symbols Series**
NAIDU, Reddeppa **Deity Series**
RAMANUJAM, K. **Untitled**

·

GUJRAL, Satish **Playmates (1)**
PATEL, Jeram **Jeram 2**
KHAKHAR, Bhupen **Factory Strike**

·

RAMACHANDRAN, A. **Iconography**
MEHTA, Tyeb **Diagonal Series**
PATEL, Gieve **Floral Rostrum for Politician**
KHANNA, Krishen **Game I Series**
BHATTACHARJEE, Bikash **Doll Series**

·

SANTOSH, G.R. **Untitled**
MAZUMDAR, Nirode **Chandani Holding Gurudas' Feathers**

·

SEN, Paritosh **Bade Ghulam Ali Khan**
SINGH, Paramjit **Stone on the Wall**
DAS, Sunil **Untitled**
SWAMINATHAN, J. **Perception Series**

60

PANIKER, K.C.S.

Words & Symbols Series
43x124. Oil on board, 1965
Gallery Chemould, Bombay

" ...My work of the **Words and Symbols** series, started in 1963, using mathematical symbols, Arabic figures and the Roman script, helping me create an atmosphere of new picture making which I seemed very much to need...in the course of time when my symbols changed I found the Malayalam script more congenial ...The scripts are not intended to be read. To make them illegible I introduce strange shapes and characters in between the groups of letters. The symbols and diagrams, the tabular columns etc. have no meaning whatsoever other than their visual aspect and images born out of association of ideas."

K.C.S. Paniker, 'Contemporary Painters and Metaphysical elements in the art of the past', *LKC 12–13* (Apr–Sep 1971)

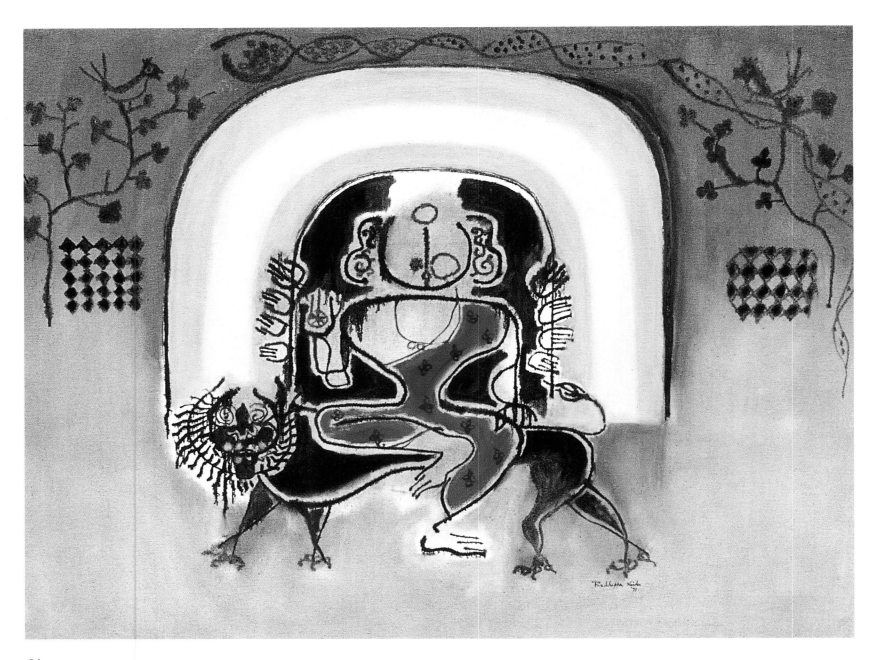

61

NAIDU, Reddeppa

Deity Series
86.3x111.8. Oil, 1971
Masanori Fukuoka, Japan

" In his **Deity Series** of paintings...
Reddappa (sic) Naidu brought to a height
a fine figurative style...The nervous line of
his drawing– light, uneven, done with a
dry brush which became almost
characteristic of this painter, would not
penetrate, cut or divide. Neither would it
take on some profusion of emotion and
strain and fray. It moved quietly, instead
making up extremely fragile states of
stillness and wholeness..."

Josef James, 'Reddappa (sic) Naidu'
LKC 22 (Sep 1976)

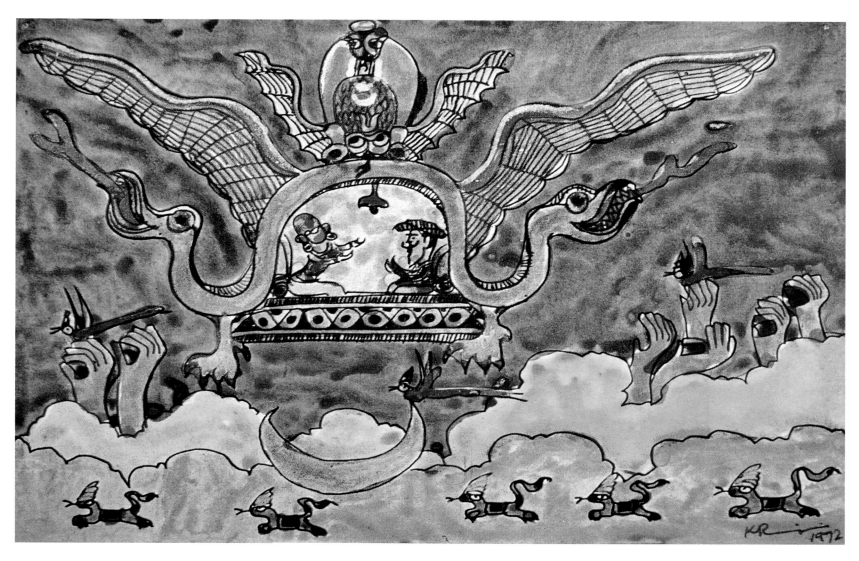

62

RAMANUJAM, K.

Untitled
55x75 (?). W/c, 1972
Chester & Davida Herwitz, USA

" The awareness of a world other than the one he creates in his pictures is a sign of maturity in an artist. He begins to be cautious of his own spontaneity and seeks to verify his intuition. It is the total absence of this element that makes Ramanujam's work distinct. He paints as if his world and the image he has of himself in it are the only things he knows or the only things he can ever know...At a time when artists in the country attempt to make their creations real to themselves and convincing to others in terms of the two worlds of modernity and tradition, there is a danger of losing incidentally the quality of innocent intimacy with oneself which makes genuine his personal legend."

Josef James, *Artrends 5.4 & 6.1* (Jly–Oct 1966)

63

GUJRAL, Satish

Playmates (I)
122x181. Collage on paper, 1967
LKA

" Content, after all, is only a vehicle for putting one's feelings on canvas: once a feeling is formulated, content is dissolved...An artist might be inspired by a social reality but in the act of creation, social reality dissolves into form, an ideal...art is meant not merely to depict a social reality, but to contribute towards a more harmonious and total awareness amongst people. That's how it shapes aesthetic awareness, it increases our capacity to appreciate the obviously and latently beautiful."

Satish Gujral, Why Murals: An Interview with Satish Gujral by Uma Vasudev', *LKC 14* (Apr 1972)

64

PATEL, Jeram

Jeram 2
61x61. Blow torch on wood,1967
LKA

" Jeram Patel is one of the representatives of the present generation of painters, who are torn between supposedly unreasonable demands of saying something through the act of painting and of regarding the act as an end in itself... He seemed to be primarily interested in the exploration of visual potentialities of the materials. Burnt wood, nails, tin, pieces of cloth, paper pieces, etc. on canvas and on board, seemed to fascinate him."

Pranabranjan Ray, *LKC 4* (Apr 1966)

65

KHAKHAR, Bhupen

Factory Strike
91.4x91.4. Oil, 1971
Mala Marwah, New Delhi

" I wanted to do a revolutionary painting under the influence of my talks with a few friends. Their statements were that not only should we be politically conscious but we should strive for the revolution...The middle-class man has a peculiar position in society. He wants to reach the top but there is no room for him or people at the top will not accept him. He cannot belong to workers because he always feels superior to them. He is in a dilemma. That is the reason why he stares at the audience. He is left alone.

My friends criticised this painting in the following way. The workers look inert. They look so unconcerned that it is not possible for them to carry the torch of revolution. Lamely, I had put my argument stating that this is the first day of the strike and they are gathering up momentum. They said that if it is so then at least the leaders should have some energy. My arguments did not convince them. "

Bhupen Khakhar, booklet: 'Truth is Beauty, Beauty is God', Mar 1972

66

RAMACHANDRAN, A.

Iconography
167.6x167.6. Oil, 1969
LKA

" His figures show that he is deeply interested in the body– its form, structure, musculature and surfaces. His work reveals an original interpretation of this theme: for the forms are felt as volumes, as surfaces rippling with convexes and depths; as design rich in colour, strengthened with dark and light tones which together build up the human frame. The limbs in this style are taut and tense,... they are displayed as motifs that contain both form and emotion. The movement is not that of the figures themselves but of the pattern. The eye is led from limb to limb or suddenly confronted with the contrasting squares of planar surface or of holes. The figure is used as a pictorial element to span space or to accumulate into a fleshy mass."

J. Appasamy, *Conversation with Artists,*
LKC 17 Apr 1974

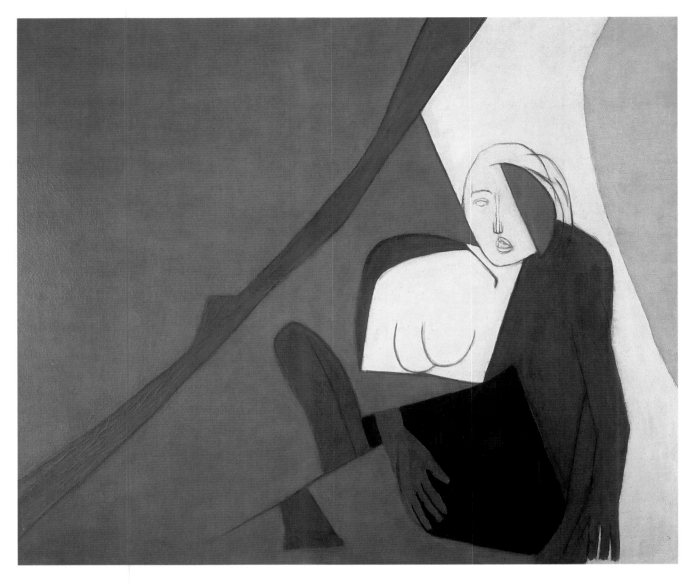

MEHTA, Tyeb

Diagonal Series
152.4x177.8. Oil, 1972
Private, Bombay

" If you express ideas in terms of tone and colour, you are making a suggestion. And suggestion is more powerful than direct message...Tyeb always starts a painting with an image derived from a drawing....In my drawings I create modules. Then mutation takes over....The most striking feature of Tyeb's current phase is the use of the bold diagonal that divides up the canvas, often harshly slicing through human bodies...it is purely a pictorial device, a means of solving the problem of painting in a square. I was looking for larger areas of colour; I was trying to minimise textures. The diagonal simply helped me to break up the picture."

Georgina & Ulli Beier, 'Tyeb Mehta: Artists of the Third World' Series. Port Moresby: Institute of Papua New Guinea Studies, 1977

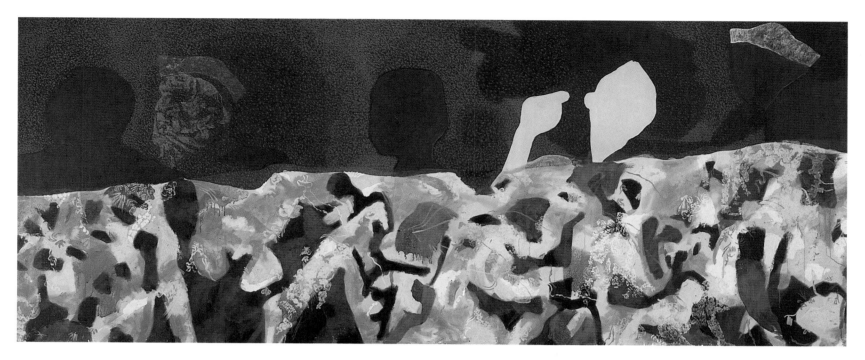

68

PATEL, Gieve

Floral Rostrum for Politician
114.3x281.9. Oil, 1972
Jehangir Nicholson Museum, NCPA

" Since the early 1970s...Gieve Patel has painted details of public life and its physical components with almost altruistic detachment...There is a caustic silence in his paintings– an imperceptible pause...in the narrative he is strongest, assigning a special place to the most banal and occasionally most lurid detail. While preferring a more clear-cut solid structure and heavy massing, applies his brush in a formal-poetic manner– working up the surface to a highly textured visual pitch, allowing it to flow suddenly into an area of flat colour...In **Statesman on a Floral Rostrum** the figures and part of the platform are positioned flatly across the length of the canvas so as to emphasise repeitition and symmetry in the emphatically horizontal arrangement."

Mala Marwah, 'Notes on Four Artists: Bhupen Khakhar, Nalini Malani, Gieve Patel & Vivan Sundaram', *LKC 24–25* (Sep 1977-Apr 1978)

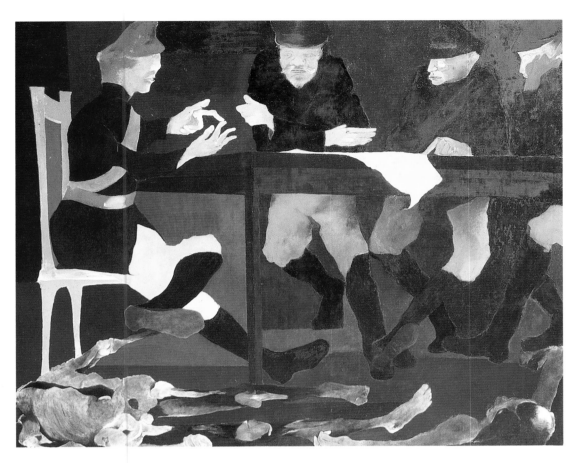

KHANNA, Krishen

Game I Series
172.1x213.4. Oil, 1971
Private, London

" The leaders, their faces blank and
anonymous, a bit like a jury discussing
poverty– while the carcass of a poor man
lies outstretched below the table...So
powerful are these people and really so
inspiring that in my fascination I forget
that the true spirit of painting is abstract
– pardon me for being weak but I can't
seem to prevent them from creeping on
to my canvas and making it impure...
Krishen Khanna's canvases are a
statement of the human predicament. It
matters little whether they relate directly
to the Indian scene...in the final analysis
they are a biting comment on the visible
increase of violence in the world and of
its grim tolerance and acceptance of
death."

Times of India, Bombay, 11 Dec. 1973

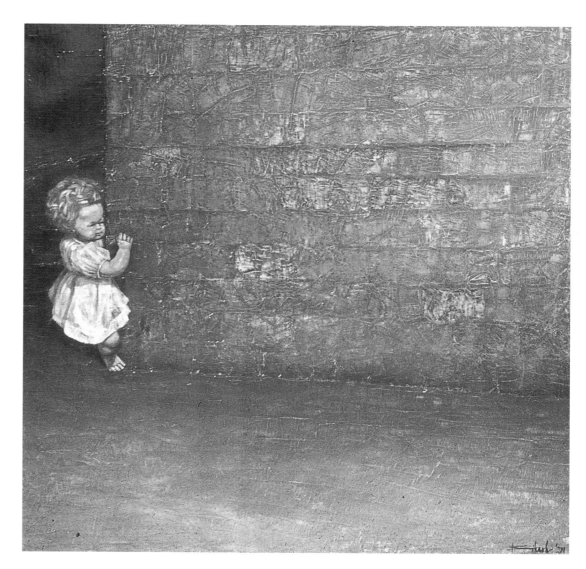

70

BHATTACHARJEE, Bikash

Doll Series
122x122. Oil, 1972
Private, New Delhi

" His subject-matter is always clear and recognisable, painted with a faithfulness to detail and invested with a sense of the dramatic. This last quality is due to a certain arbitrary lighting which heightens his effects...It is apparent that Bikash uses reality only as a point of departure; his real goal is fantasy where the improbable assumes a new reality. For this purpose he puts together people or objects in startling juxtaposition; or isolates fragments which fulfil an unexpected role..."

Jaya Appasamy, 'Two Artists of Distinction: Bikash Bhattacharjee & Sarbari Roy Chowdhury', *AHJ* (1978–9)

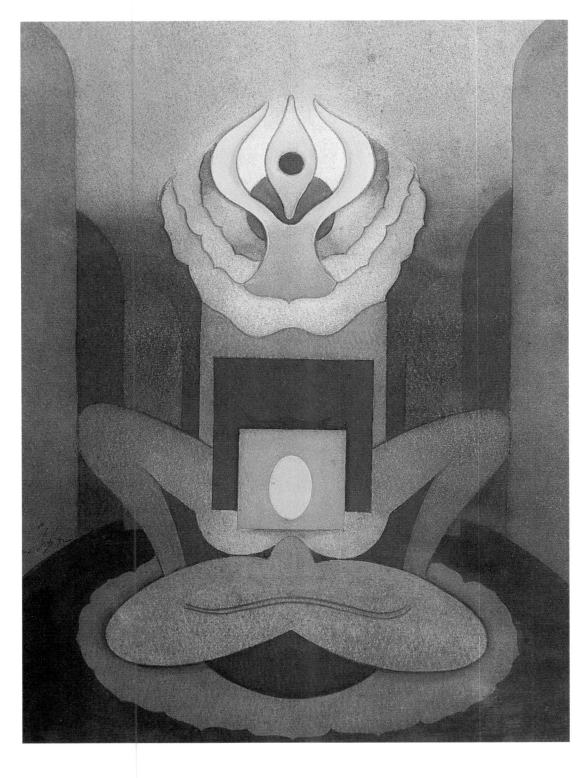

SANTOSH, G.R.

Untitled
37x28. W/c, 1971
Private, New Delhi

" The mind of an artist is conditioned and activated by continuity of thought, thereby rendering the creative expression self-consistent...Indian tradition is based on the universal concept of the ultimate reality manifesting itself in a myriad shapes and forms in time and space. My own self is preoccupied with the same universal concept...My paintings are based on the male-and-female concept of Siva and Sakti and, therefore, construed as Tantra...To me painting is a necessary, normal activity, no more special than any of my other activities."

G.R. Santosh, 1978, '*Tanmum Trayate iti Tantrah*'. Rpt. in Booklet, New Delhi, 1989

72

MAZUMDAR, Nirode

Chandani Holding Gurudas' Feathers
81.3x66. Oil, c.1968
Jehangir Nicholson Museum, NCPA

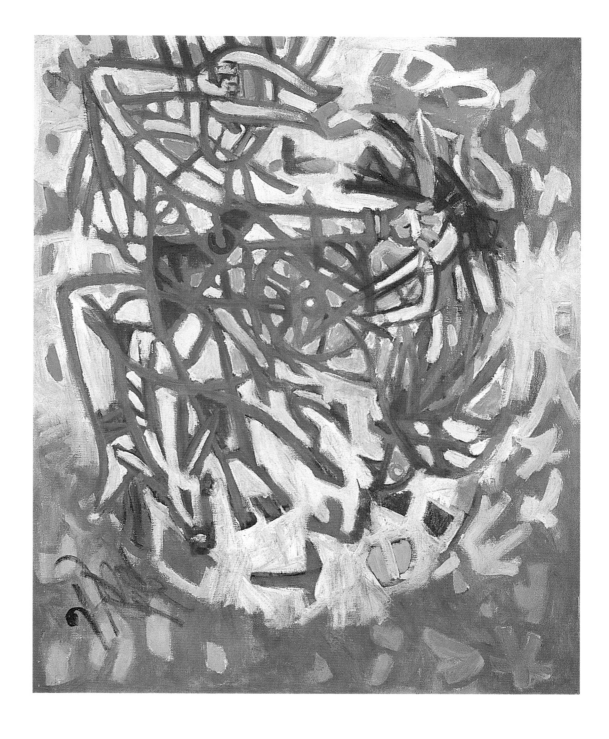

" For the last twenty years I have tried to
find solutions, maintaining as far as
possible the symbolism of colours
according to the *gunas*, time, etc. in my
paintings, conceiving my works by series,
each of the picture in a series being a
temporal image related to the point
marking the centre, from which the whole
picture generates and to which the
figures developing first in the form of a
lotus will ultimately return."

Nirode Mazumdar, 'On Tantra Art'
LKC 12-13 (Apr-Sep 1971)

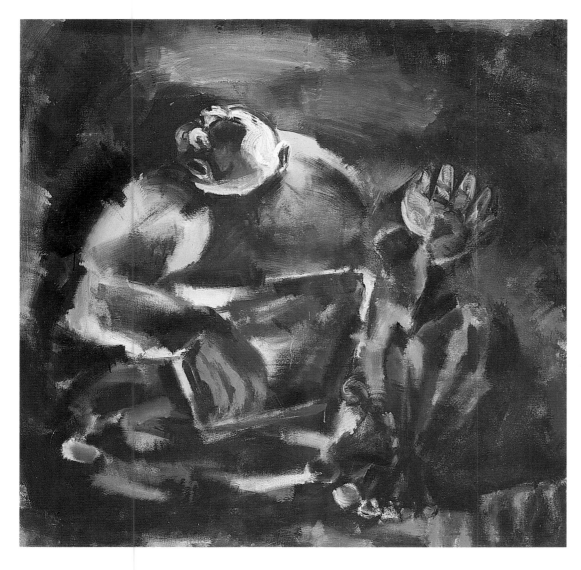

SEN, Paritosh

Bade Ghulam Ali Khan
170.2x170.2. Oil, 1967
LKA

" Visually I want my images to remain in
that twilight zone of ambiguity which is
midway between figuration and non-
figuration. The figure is very much there
but not fully revealed. This occurs through
the brutal simplification of the form. This
in turn endows it with a certain air of
mystery and, as a result, different viewers
imagine different things in it...This air of
mystery comes about through the
spontaneous activity of the paint...as if
the paint is celebrating its freedom."

Paritosh Sen, 'Reflections' *LKC 9*
(Sep 1968)

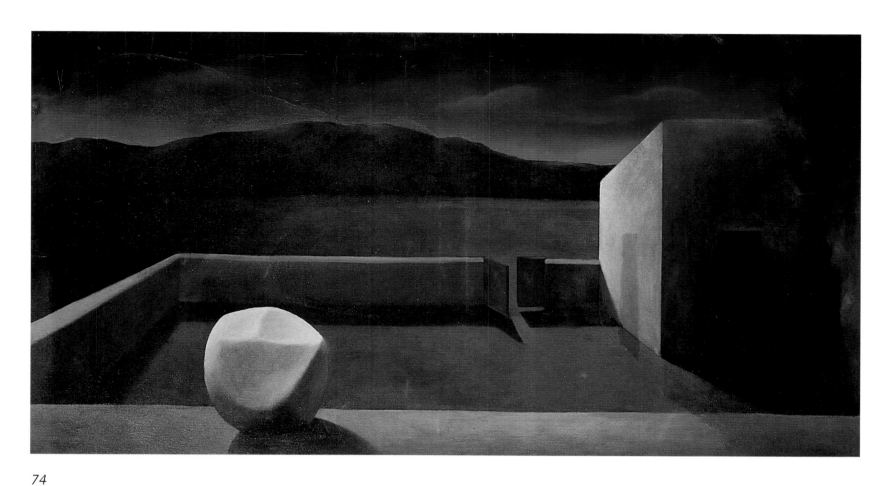

74

SINGH, Paramjit
Stone on the Wall
93x178. Oil, 1970
LKA

" By giving the stone a little flight, a little take-off, the painting gives situation to the feeling, it suggests a new probability like a gate that begins to open for a man, he is free to carry whatever feelings he has with him, to call it what he pleases... Fantasy? To me it is a situation that seems to contradict a known reality (like a stone flying) so as to suggest a different kind of reality altogether, a reality where anything may happen."

Paramjit Singh, conversation with
Pria Karunakar, *LKC 15* (Apr 1973)

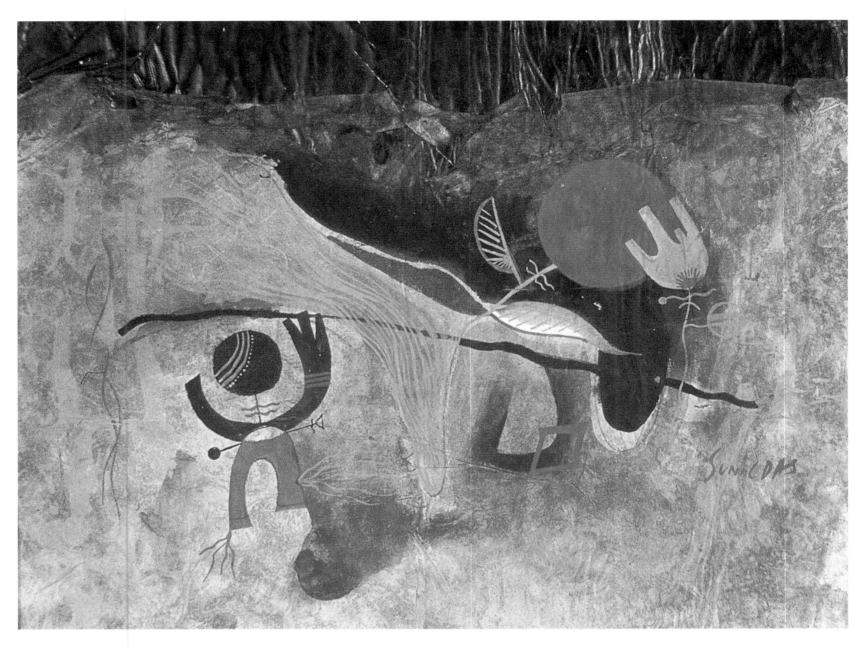

75

DAS, Sunil

Untitled
31x40. W/c & Ink on rice paper, 1966
Private, Bombay

" He tries to construct a plastic image
that appears to the senses without in any
way departing from the plastic equivalent
of its concept. Sunil Das is a symbolist
and as such probably believes that there
is a parallel to the development of a
conscious method of reasoning, a latent
conception of images which give an extra
perceptual meaning to his art. He
succeeds in delivering his message largely
because his craftsmanship is so terribly
good. But then the question arises about
how profound his Tantric statements
are..."

'Symbolic Art of Sunil Das', The Statesman,
Oct 1972

SWAMINATHAN, J.

Perception Series
177.8x127. Oil, 1972
Jehangir Nicholson Museum, NCPA

" Swaminathan moved into a fourth phase in 1968. In these paintings,...he selects images from nature, but dematerialises them by making them metaphorical. He expresses a spiritual sentiment about the unrealised universe, but through the mediating mirror of nature...Swaminathan's paintings have, it seems to me, the one explicit purpose: of offering praise. And since in his chosen metaphysics, ecstatic contemplation of Maya bears the potentiality of drawing the self into the Whole, his pictures in consequence have this peculiar attribute: the projected image appears like a sign in the illumined void; a lure to gain entry into it."

Geeta Kapur, *Contemporary Indian Artists*, New Delhi: Vikas Publishing House, 1978. p 201 & 203

1973–82
Inner and Outer Clarity,
as Postmodernism Reaffirms
the Continuity

" There has been a perceptible change in the Contemporary Indian Art scene since the last decade– a movement towards indigenous sources which include the Indian pictorial tradition and the immediate urban and social environment. The tradition itself ranges from temple sculpture, frescoes and manuscript illustrations to the tribal, folk and popular arts which are practised and lived with. The predominant influence of the Western concepts in terms of various schools and isms' is becoming a matter of the past and can now be seen only in its perspective. The Indian artist is in a position which may not be altogether secure but one from which he can question the relevance of modern Western art to the Indian context, at the same time re-evaluating the Indian heritage in terms of his contemporary experience."

Dhanraj Bhagat & Jyoti Bhatt, Commissioners of the Third Triennale, Feb.1975. Rpt. in LKA Triennale ExC. 1975

CHOWDHURY, Jogen **Life-II**
PYNE, Ganesh **Ganga**
DUTTA RAY, Shyamal **Overthrown**
BHATTACHARJEE, Bikash **Portrait of Das**

.

BHARGAVA, Veena **Pavement Series**
MALANI, Nalini **Women Series**
MENON, Anjolie Ela **Nude with Pears**

.

BROOTA, Rameshwar **Gorilla Series: Havaldhar**

.

BARWE, Prabhakar **Blue Cloud**

.

SABAVALA, Jehangir A. **Of Cliff & Fall–V**
PADAMSEE, Akbar **Metascape Series**

.

KALEKA, Ranbir **Nuptial Bubbles**
SHEIKH, Ghulam m. **Speaking Street**
SUNDARAM, Vivan **Portrait of Father**

.

SUBRAMANYAN, K.G. **Bowl of Fruit & Blind Mother**
Pink Woman, Blue Man

77

CHOWDHURY, Jogen

Life II
154x152. Ink & Pastel, 1976
Private, Calcutta

" Large and baggy bodies of men and women seem to have been distorted by the dark background that delineates their contours. Through literally thousands of cross-hatches Jogen brings out the sagging folds of their tired flesh, the flesh that suggests past experience, excesses and corruption...the most expressive symbol of corruption is a close-up of the fatigued woman, flesh which often seems to hide a process of decomposition just beneath the surface."

Santo Datta, 'Visitations', *AHJ 2* (1982–3)

78

PYNE, Ganesh

Ganga
54x69. Tempera on canvas, 1974
Sadrudin Daya, Bombay

" ...True darkness gives one a feeling of
insecurity bordering on fear but it also
has its own charms, mystery, profundity, a
fairyland atmosphere. Darkness still gives
me the same feelings now as it did when I
was a child. The only difference is that I
try consciously to analyse these feelings
now. Mythology and fables also fascinate
me. Probably for the same reasons. I now
look at things with eyes that are, I think,
more mature but I also have a sneaking
suspicion that when one is confronted
with primeval values, one has little to
gain through maturity..."

Ganesh Pyne, conversation with Arany
Banerjee, *LKC 15* (Apr 1973)

79

DUTTA RAY, Shyamal

Overthrown
49x62. W/c, 1982
LKA

" Shyamal Dutta Ray can rightly claim to be regarded as the most significant and creative watercolourist in India today. He has rejected the Anglo-American tradition of anaemic watercolour. He can, at ease handle weight, depth and volume, and infuse to light and darkness luminosity and mattiness through the use of transparent watercolour. He weaves designs with commonplace objects, light and shade, elevates the commonplace to the status of symbol that bespeaks of a human commitment of a non-ideological kind."

Pranabranjan Ray, 'Shyamal Dutta-Ray Exhibition Review', *LKC 23* (Apr 1977)

BHATTACHARJEE, Bikash

Portrait of Das
106.7x103.6. Oil, 1980
Ebrahim Alkazi

" Portraits serve Bikash specially well in extending his basic conceptual understanding of relation between appearance and reality. He transforms the perceptible appearance by clever juxtaposition of comprising parts and play of colour, tonality, light and shade to visually objectify the hidden reality. Representational photomorphic approach to images, makes the men and women of Bikash's paintings– real individuals of flesh and blood, even when they are not. But these individuals are at once identifiable as representatives of certain social types with definite roles. As soon as the individuals get identified with certain archetypes– the particular attains generality."

Pranabranjan Ray, Bikash Bhattacharjee
Dhoomimal ExC. 23 Oct–4 Nov 1979

81

BHARGAVA, Veena

Pavement Series
148x173. Oil, 1973
Artist

" In the paintings of the middle seventies by Veena Bhargava what seems at first to be a pictorial reportage on pavement dwellers builds up as powerful indictment. The frame truncates visages in most canvases; this is the faceless crowd. In the treatment of the limbs, the flesh seems to be planed off to reveal the emaciated skeletal core, their ends as jagged as the edges of the broken flagstones of the pavement. The colours are mostly muted, though angry streaks erupt here and there. Sometimes a large canvas is a close-up of only hands and the elongated bony fingers compose a macabre ballet by themselves."

Krishna Chaitanya, 'Art and the Predicament of Man', *LKC 24–25* (Sep 1977-Apr 1978)

MALANI, Nalini

Women Series
121.9x121.9. Oil, 1974
Sadrudin Daya, Bombay

"Why have you painted your woman in this ghastly way?"

"This is a painting of a woman who has woken up after making love all night. She is tired, so she looks this way. There are various strata in the human mind and some are absolutely savage. When I paint the grotesque strata, this sort of painting is the result. It is an obsession, there is little one can do about it. Last year I painted the aggressiveness of man over woman. Man is the persecutor, woman the victim."

Nalini Malani, The Current, 2 Feb 1974

83

MENON, Anjolie Ela

Nude with Pears
95x125. Oil, 1981
Private, Bombay

" To the chic, upper urban strata that collects her work avidly, a Menon hardboard conjures visions of a breathtakingly beautiful nude with magnificent breasts– a pensive face, elongated limbs, an ambience of melancholia and the mistakable medieval tinge in palette with an antique patinated finish."

Isana Murti, JG Retrospective ExC. Bombay, 1988

84

BROOTA, Rameshwar

Gorilla Series, Havaldar–II
177.8x127. Oil, 1979
Private, New Delhi

" Broota's recent practice suggests that despite the continuation of the ape in his compositions, the whole tenor of his work has veered away to different pastures...In this work, though it had no 'humour', was expressed the apocalyptic vision of darkness with great suggestive power...But since then, oscillating between formalism and communication, Broota has arrived at a calm and serene style of much greater spaciousness, a greatly distanced view of the human sense...The serenity of some of the work is inherent in the tone of pigment, the sober choice of colour. It does not however appear a departure from social meditation or reflection as much as a maturer consideration of it, with greater detachment. The purely aesthetic element now takes precedence..."

Keshav Malik, 'Thoughts on Six Painters',
LKC 24–25 (Sep 1977–Apr 1978)

85

BARWE, Prabhakar

Blue Cloud
107x122. Enamel, 1976
LKA

" Since Barwe mostly uses the house-painter's brand of synthetic glossy enamels, he relates himself with a pertinence to the loudness and tenor of city existence. However, it must be remembered that Barwe's use of enamel paint has long ago outlived the purpose assigned to it here, simply because the painter's own thematic and stylistic preoccupations have undergone a change...The manner in which he deployed his motifs or symbols, one felt that Barwe was aggressively making somewhat aphoristic statements."

Dnyaneshwar Nadkarni, 'Prabhakar Barwe',
LKC 27 (April 1979)

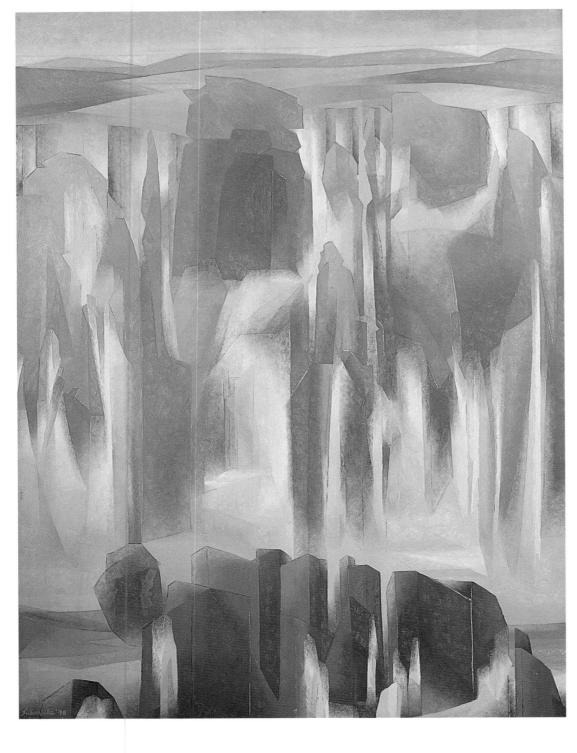

SABAVALA, Jehangir A.

Of Cliff & Fall–V
140x104. Oil, 1978
Private, Bombay

" His imagery is the result of deliberate contemplation and is rarely guided by the subconscious or unconscious levels of the mind– all logically juxtaposed and rendered in subtle middletones. His palette excludes pure colours– whether he depicts the glare of the midday sun beating on parched earth covered with golden grass, the diffused light of evening, the verdure of forests or the rush of surging tides. Meticulously planned, each one of Jehangir's paintings is marked by a sureness of execution, leaving nothing to chance. He successfully creates an illusion of depth with the help of receding planes, textured to suit the content..."

Ram Chatterji, J.A. Sabavala's JG-Gy. CH ExC. Mar 1976

87

PADAMSEE, Akbar

Metascape Series
122x122. Oil, 1975
Sadrudin Daya, Bombay

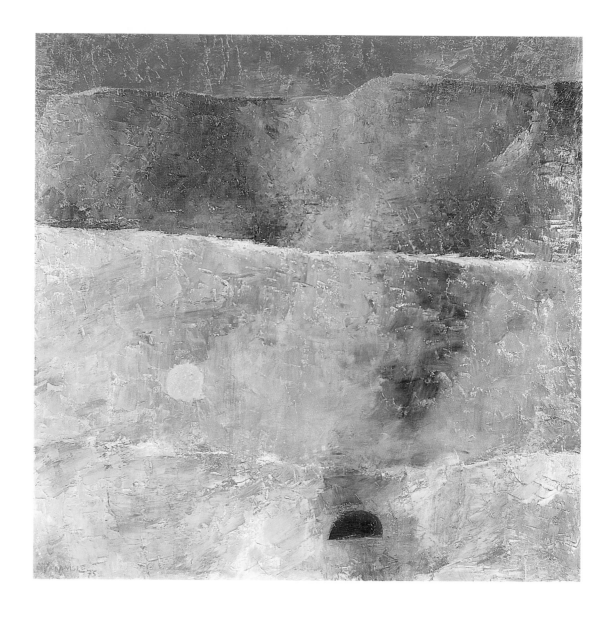

" A sensuous immediacy and eternal
remoteness, these form the dialectical
counterpoints in Akbar's approach to
nature; the fusion and friction, the
interpenetrating energy of the natural
elements in contrast with their
mesmerized visage. It is an intriguing
counterpoint, but there is no attendant
mystery. Akbar's landscapes are not
mysterious. If they sometimes appear so,
it is because contradictory viewpoints
have been synthesized. "

Geeta Kapur, *Six Contemporary Artists*,
New Delhi: Vikas Publishing House, 1978. p106

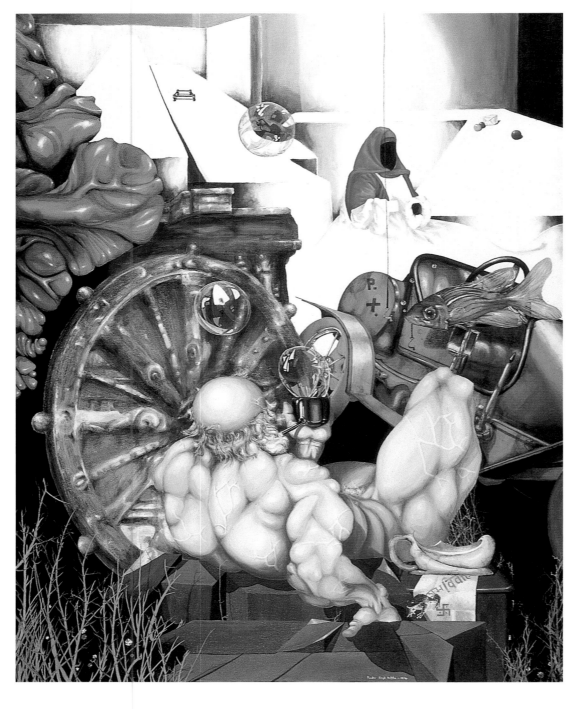

KALEKA, Ranbir

Nuptial Bubbles
144.8x114.3. Oil, 1974
Private, New York

" The earlier paintings of Kaleka dating
from the seventies...reflect a view of the
world that is highly internalised and
appear to place much reliance on the
juxtapositioning of improbabilities...The
family of artifacts and figures featured in
these pictures is curiously weightless and
thus to an extent implies an absence.
Realism is however affirmed through an
exactitude of technique in which every
part of the painting is projected with the
same degree of focused intensity."

Peter de Francia, 'Profiles', Bombay: Gy. CH
Publication, 1985

89

SHEIKH, Ghulam.m.

Speaking Street
122.7x103. Oil, 1981
Roopankar Museum of Fine Arts,
Bharat Bhavan, Bhopal

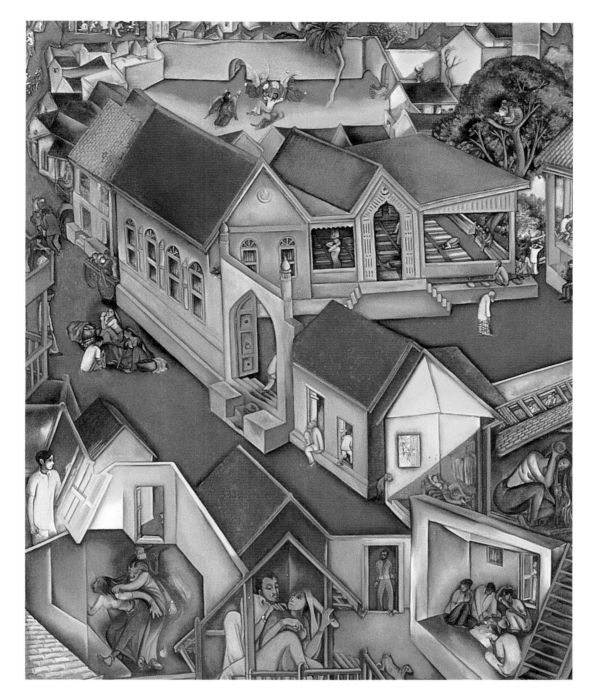

" Living in India means living
simultaneously in several times and
cultures. One often walks into 'medieval'
situations and 'primitive' people. The past
exists as a living entity alongside the
present, each illuminating and sustaining
the other.
As times and cultures converge, the
citadels of purism explode. Traditional
and modern, private and public, the inside
and the outside are being continually
splintered and reunited. The kaleidoscope
flux engages the eye and mobilises the
monad into action... Like the many eyed
and armed archetype of an Indian child
soiled with multiple visions, I draw my
energy from the source."

G.m. Sheikh, Place for People ExC.
Nov-Dec 1981

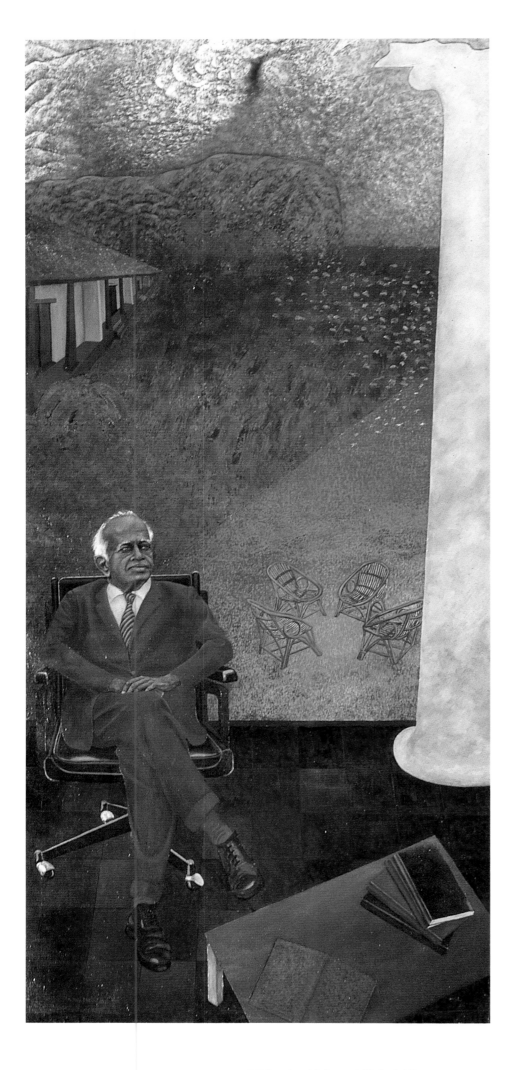

SUNDARAM, Vivan

Portrait of Father
183x84.5. Oil, 1980
NGMA

" Vivan's desire to make a particularised comment quickened his realisation that in order to do so he would have to make the image more simple and direct. The symbol has become larger and more singular, almost idol-like, with something of a menacing visage...Vivan's work is something of a helix, in the complex circularity of presenting what is often bitterly didactic in a manner that is designed to seduce...Yet it is perhaps these very contradictions that contribute to his calibre as a painter. This contrariety is something that will always remain, as Vivan says, 'open-ended' and makes it truly a human dilemma than anything else..."

Mala Marwah, 'Notes on Four Artists: Vivan Sundaram, Nalini Malini, Gieve Patel & Bhupen Khakhar' *LKC 24-25* (Sep 1977-Apr 1978)

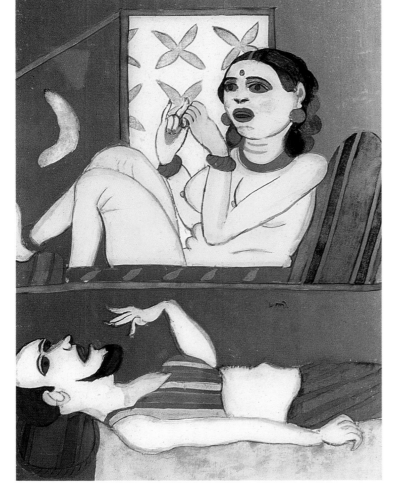

SUBRAMANYAN, K.G.

Bowl of fruit and Blind mother
58.5x43.5. Oil on acrylic sheet, 1980
NGMA

Pink Woman, Blue Man
58.5x43.5. Oil on acrylic sheet, 1980
Private, Santiniketan

" The imagery is thus voluptuous without being naturalistic, ornamental without being flat. Further, the language so devised being contrary and crossed, it allows for transformation of subject and motif...What I believe draws Subramanyan most of all to nineteenth century popular art is precisely this erotic impulse which intertwines moral categories with some innocence and much audacity. Even the moral tales revel in wickedness so that finally the good and bad are thoroughly mixed in a pictorial vocabulary of comic delight. The pictorial vocabulary is devised eclectically. Techniques of delineation affect the style and the style affects the typology."

Geeta Kapur, *K.G. Subramanyan.*
New Delhi: LKA, 1987. p42-3

1983–1996
International Assimilation and
a Uniquely Universal Foundation

" The tendency on behalf of Western
critics is to inspect a contemporary Indian
canvas, to notice that it contains Indian
colors, forms, and symbols but to write
these off as inherently awkward when
conjoined with Western styles...The
underlying perspective is that East is East
and West is West: traditional India is
essentially incompatible with
Westernization...This view holds that,
once art has become modern, the Indian
traditional palette, forms, and symbols are
equally inappropriate...Why there should
be only one path to modernization,
namely that of becoming as much like the
West as possible in as many ways as
possible, is something left
unexplained...Behind all of this skewed
perspective lurks a definition of what is it
to be Indian...The desire to claim for India
a clearly demarcatable essence is then
more than a colonialist ideology; it is also
a desire bred of the fear, that in the
absence of a cultural essence to rely on
there will be no cultural identity at all.
Postmodernism has produced a similar
cultural fear...The idea that either one has
a clearly demarcatable identity or none at
all is an idea running through broad
domains of human thought."

Daniel A. Herwitz, Indian Art from a Contemporary
Perspective. In *Indian Art Today*, New York: Grey
Art Gallery & Festival of India, 1986

DE, Biren **October '91**
GAITONDE, V.S. **Untitled**
RAZA, Syed Haider **Surya**

.

HUSAIN, Maqbool Fida **Karbala: Civilisation Series**
HEBBAR, Krishna K. **Rituals**
PAI, Laxman **Veer Navrasa Series**
RAMACHANDRAN, A. **Hannah & Her Goats**
GOUD, Laxma **Untitled**
BAWA, Manjit **Flute-Player with Cows**

.

SUBRAMANYAN, K.G. **Scene from Ramayana**
SOUZA, Francis N. **Eros Killing Thanatos**
KHANNA, Krishen **Four Bandwallas in Procession**
DOUGLAS, C. **Untitled**
BARWE, Prabhakar **Lamp and the Empty Box**

.

HALOI, Ganesh **Untitled**
PATEL, Gieve **Looking into a Well II**
PAREKH, Manu **Flower of the Ganga**
SINGH, Paramjit **Water Mirror**
RAMKUMAR **Untitled**
SINGH, Arpita **Couple Having Tea**

.

DAS, Amitava **Situation III**
PATWARDHAN, Sudhir **Pokaran**

.

MAZUMDAR, Chittrovanu **Untitled**
RODWITTIYA, Rekha **Sharing Secrets**
TEWARI, Vasundhara **Subterranean**
DODIYA, Atul **Dr. Patel's Clinic-Lamington Road**

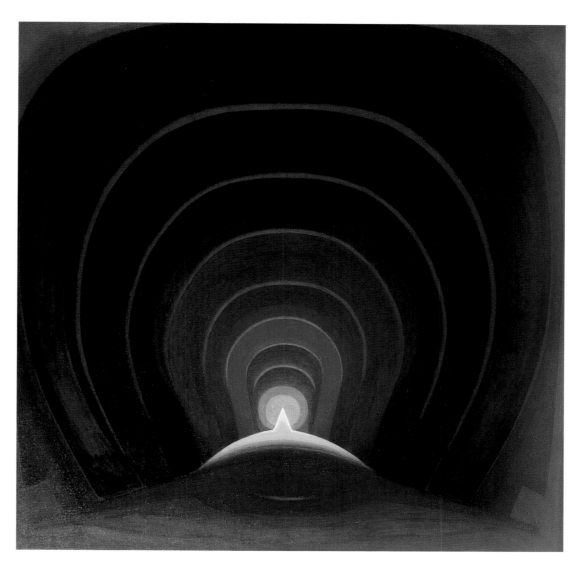

92

DE, Biren

October 1991
96.5x96.5. Oil, 1991
Private, New Delhi

" Between blue and red... Red is outside, it is raw, it is everything, basically due to my contradictory experiences with the tribals, the adivasis, and the sadhus, the ones that have left everything. There is something which is beyond me, beyond all of us, a kind of surrender. Surrender is very important. This does not mean that you become a fatalist. I have been trying to push out, to counteract the rest with the passion, and so red is easy, red vibrates like this, and blue brings you in; I am oscillating between the two. Thus my paintings are for self-integration."

Biren De, conversation with author, Delhi, 9 Sep 1993

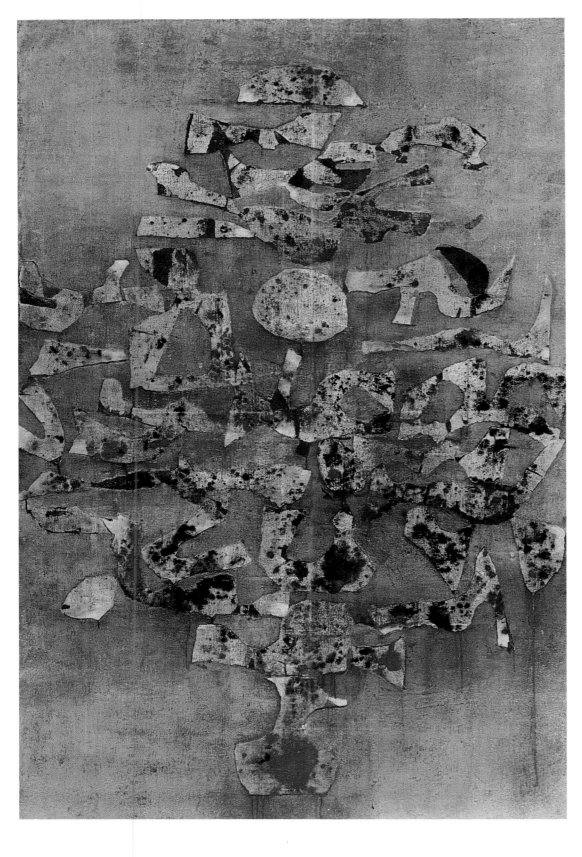

GAITONDE, V.S.

Untitled
153x102. Oil, 1985
NGMA

" My entire outlook changed when I came to know that the Chinese have no epics to boast of– for the simple reason that an epic covers a long period of time and it is basically wrong to say, for instance that any age can be heroic...Any abstract feeling– love, courage, etc.,– can be valid only for a given moment. One is not in love eternally, even if the feeling is there. The ecstasy of the moment cannot be stretched over a long period."

V.S. Gaitonde, conversation with S.V. Vasudev. Rpt. in Dnyaneshwar Nadkarni's *Gaitonde*. New Delhi: LKA, 1983

94

RAZA, Syed Haider

Surya
203x190. Acrylic,1986
Private, Paris

" 'My present work is the result of two parallel enquiries. Firstly, it aimed at pure plastic order, form order. Secondly; it concerns the theme of Nature. Both have converged into a single point and become inseparable; the point, the bindu, symbolises the seed, bearing the potential of all life, in a sense.'...To express this concept, the artist (Raza) resorts to the principles which govern pictorial language: the essential vocabulary of the point, line, diagonal, circle, square and triangle...This concern with pure geometry and its signification can be misconstrued to suggest the approach of a formalist, or a structuralist, or even that of a neo-tantric. Nothing could be more misleading. "

Geeti Sen, Genesis. In *Raza Anthology 1980–90*. Bombay: Gy. CH Publications, 1991

95

HUSAIN, Maqbool Fida

Karbala: Civilisation Series
213.4x335.2. Acrylic, 1990
Artist

" The art produced by this very prolific, very influential, nationally honoured and still active post-Independence generation of artists was in fact, when the chips are down, never properly modernist in the Greenbergian definition, and it was not certainly avant-garde in the historical sense of the term. Indeed one might say that with all its antagonism to the overtly nationalist art of Bengal, this generation too was concerned, in its imaging mode, with a (national) need for self-representation. At times, as with Husain, indigenous iconographies were heralded almost in the form of posters to the world at large even as he extends himself now, through iconographies of comparable civilisations."

Geeta Kapur, 'A Stake in Modernity: Brief History of Contemporary Indian Art'. Rpt. in *Tradition and Change*, Caroline Turner, ed. University of Queensland Press, Australia 1993. p 36

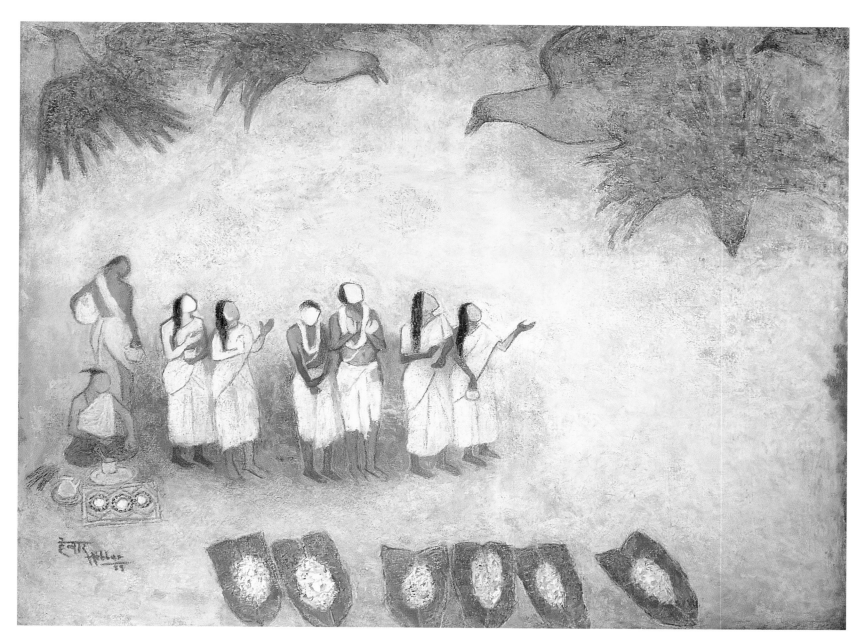

96

HEBBAR, K.K.

Rituals
91.4x121.9. Oil, 1989
Private, Bombay

" **Rituals** depicts the austerity of a group of ancestor-worshippers, and the awe-inspiring atmosphere created around them, with oversized crows to signify the spirits of the dead who are being appeased, sweeping down to accept the offerings."

K.K. Hebbar, conversation with author, Bombay, 12 Aug 1993

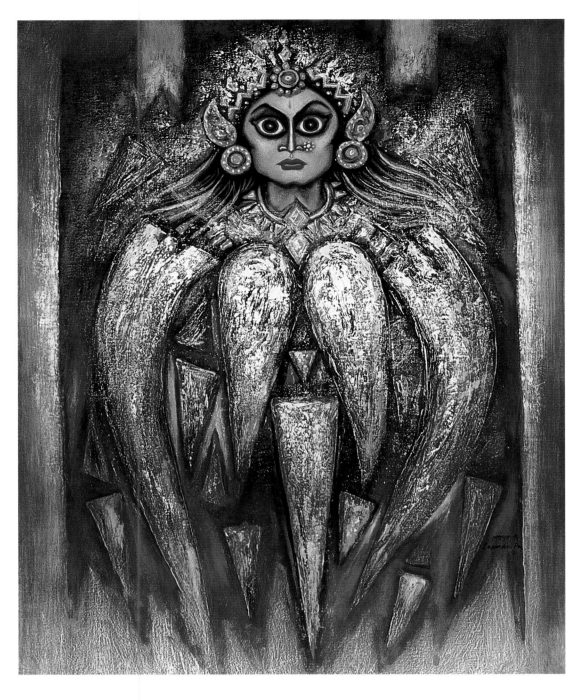

97

PAI, Laxman

Veer Navrasa Series
127x102. Acrylic,1990
Private, New Delhi

" Laxman Pai...has shown restless quest to express his inner visions all along his artistic career of about four decades or more by honing his aesthetic sensibilities only to shift his creative energies from one theme to another and one medium to another...this artist has never been static but always experimenting for bringing innovations into his work...It is difficult to lable his works with so-called 'isms' but one can say with certainty that Laxman Pai after absorbing various influences has daringly stuck to his roots. This is one of his major achievements as there are very few who have been able to resist the temptation of getting enmeshed into the most confusing global art scene today. "

Manohar Kaul, 'Laxman Pai: Restless Quest for Inner Expression'. *Kala Darshan 3.2* (1990)

RAMACHANDRAN, A.

Hannah & Her Goats
203.2x142.2. Oil, 1994
Rupika Chawla, New Delhi

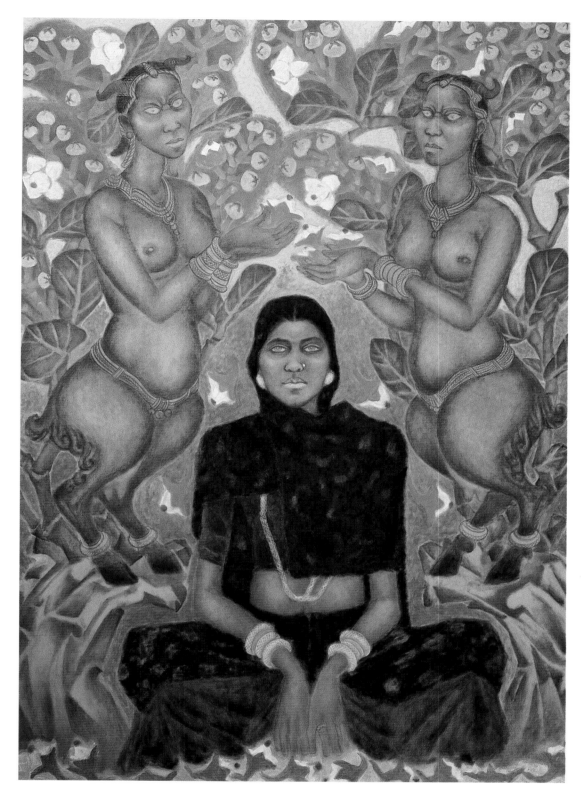

" A two-legged goat is created by Ramachandran in **Hannah and the Goats**. (sic) Hoofs and legs curve gently into thighs and stomach that could belong to both woman and animals, rising up to muscular breasts and shoulders feminine enough but lacking sensuality. The face, too, continues the hybridism with the characteristics of a bad tempered goat and the features of a woman. Mastoid shaped akunda plants, purple tipped, Shiva's favourite flower, burst forth with abandon in the background.

Steeped in realism, Hannah seated at the edge of the canvas appears to be on the point of leaving it. Her calm face, as close to being a realistic portrait as possible, exists in the fantasy of her surroundings."

Rupika Chawla, *Ramachandran-Art of the Muralist*, Bangalore: Kala Yatra & Sistas Publication, 1993. p 116

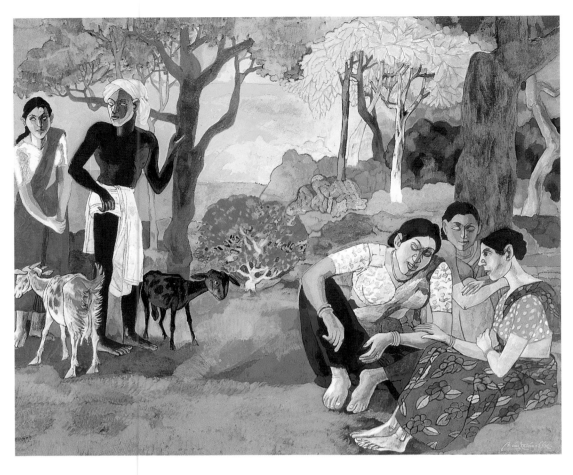

GOUD, Laxma

Untitled
44.5x53.3. W/c & Bodycolour, c.1991
Private, New York

" We come from a culture which spoke openly about the man-woman relationship, about fertility. When it recurs in a contemporary context, why should anyone pull a face? I am continuing that discourse,... I am trying to understand it in aesthetic terms, not for its thrill...Whether the eyes see it or not, there is eroticism in nature itself. Some see it through the senses even when it is not seen by the eyes. And there it becomes an obsession...Overt eroticism may not be before us, but the positive and negative confronting each other is something we find everywhere...It is the organic not the organism that I depict...I want to stress the organic relationship between human and animal.You don't raise a goat– or any domestic animal– to cut it and eat it; you do so for the whole relationship. "

Laxma Goud, conversation with Ratnottama Sengupta. New Delhi: Times of India, Apr 1995

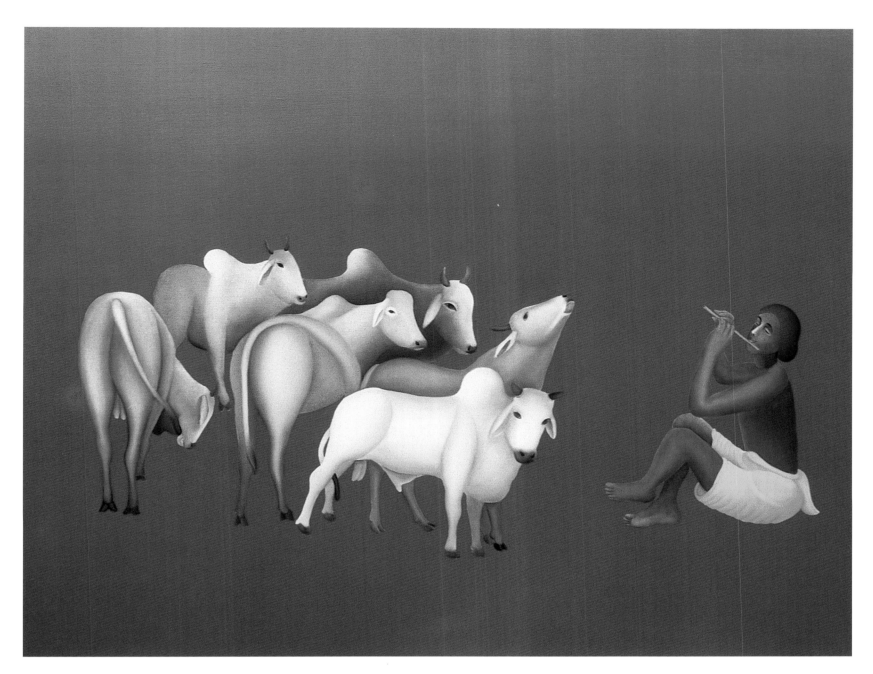

100

BAWA, Manjit

Flute Player & the Cows
119x152. Oil, 1992
Private, New Delhi

" The eye determines all in Manjit Bawa's painting. The image fills the picture frame as sculpture confronts the viewer with its material reality. It energizes the space within which it is seen with a mode of stillness specific to Manjit's form-making manoeuvres. They turn the viewer into a voyeur...Colour acts as a coordinate to the pleasurable sensations which are close to those where a woman is subjected to the male gaze: the voyeurism within the viewer sees himself being seen and seeing."

K.B. Goel, 'Nine Indian Contemporaries'
CCA Annual (1990–91)

SUBRAMANYAN, K.G.

Scene from Ramayana
70x55. Gouache on paper [Varnished] 1991
NGMA

" 'What is it that you are after in your recent paintings?'

'Nothing in particular', I said...

'Many themes repeat in your recent paintings. Even images recur.
The Goddess and the Buffalo, The Mother and Child, The Family Group, The Blind Man and the Black Muse, and The Enchanted Woods, Teeming with man, bird and beast.'

'All that does not prove anything', I said, 'We all have our little obsessions. And they may be continuous. But not enough to become a goal. At least a grand, steady goal. Really speaking, I do not want any more goals and challenges. If the little things I see around excite me and link up into stories of a kind, that is good enough.'"

K.G. Subramanyan, 'Uncoded Myths: conversing with a Japanese friend', *AHJ* 10 (1990-1)

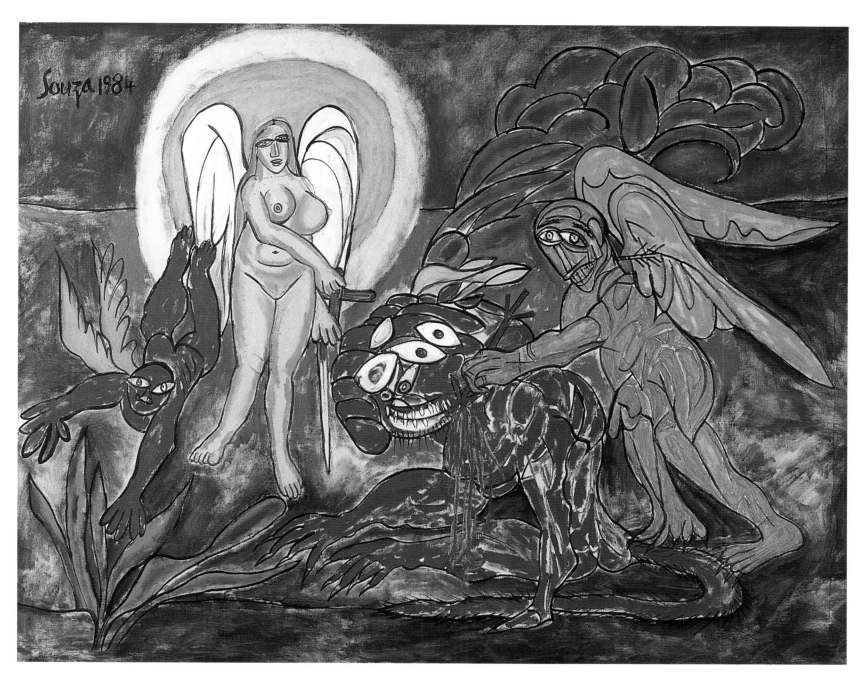

102

SOUZA, Francis N.

Eros killing Thanos
121.9x152.4. Oil,1984
NGMA

" Scenes of tortured martyrdom, medieval in their bleak cruelty but redeemed by no religious faith, figure prominently in Souza's oeuvre. It is as if he seeks to exculpate sinful acts by summoning up visions of the mortifications and despair of the son of God, to the extent of identifying himself with him. He seems to want to persuade God into believing that, sinner though he may be, and prey to all the temptations of the flesh, he shares with Christ his anguish. This duality is the essential content of all Souza's paintings – sexuality rising to a pitch of religious ecstacy."

E. Alkazi, 'Souza's Season in Hell',
AHJ 6 (1986-7)

103

KHANNA, Krishen

Four Bandwallas in Procession
198x103. Oil,1989
NGMA

"What would happen were I to begin with no drawing or compositional props, where figures are not in space but are space themselves, and colours ringing loud and clear in merry juxtaposition without tonal continuities or intermediary greys, and the application of colour pigment were assertive and not tentative? I found a new exuberance in the act of painting. Using the image of the *bandwalla*, I let go, not attempting to rub out or physically eradicate, and gave vent to all the possibilities stimulated by that odd instinct."

Krishen Khanna, 'Beyond the Bandwalla's Cacophony: a non-committal statement by the artist' *AHJ 10* (1990-91)

DOUGLAS, C.

Untitled
99.1x78.7. Mixed Media, 1995
Private, Bombay

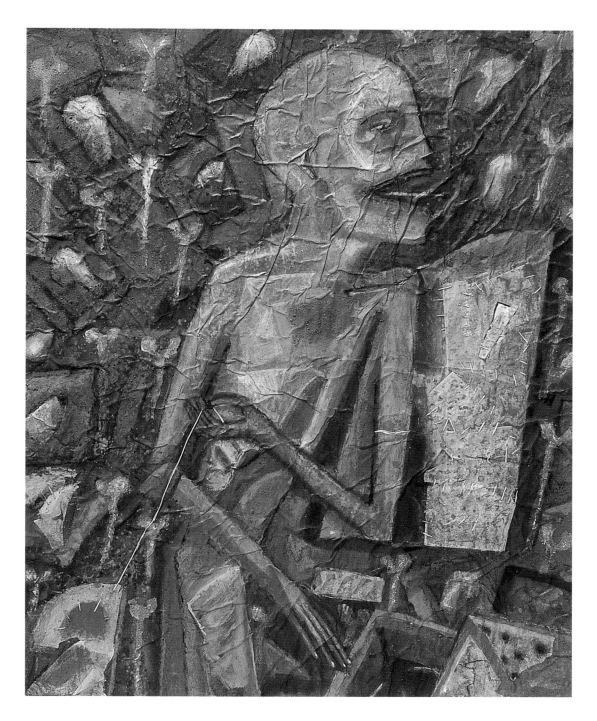

" There is a considerably slow shift from
my earlier work towards a clear stress on
personalisation and an attempt to bring
the self to the centre of the work, to
make it a 'revelation of the soul'... The
wish to give rational order to vision with
essential and fundamental forms as
started clearly in art from Cezanne,
through cubism, constructivisim and
minimalism, seemed quite academic... Yet,
I saw, the 'doubt', when Albers discussed
colour and its dependence on
individuality, submissiveness, and
neutrality. He was eventually saying
colours are only vessels of magic which
hold the absolute but are not absolute
themselves."

C. Douglas, *Nine contemporary Indian
Artists* ExC. E.M. Schoo, ed. Arnhem: Municipal
Museum & Amsterdam: Lotus Gallery.
21 Sep-11 Nov 1991

105

BARWE, Prabhakar

Lamp and the Empty Box
90.2x120.6. Enamel,1990
Private, Bombay

" Every component of a painting, be it form or colour, in a way gets transformed into space... In the process of such transformation, colour or form gets detached from its restricted 'actual-meaning-context'. And, from this alone, the visual result of the painting in totality is born. In my paintings such 'result', I feel, is abstract... For this to happen, initially form gets itself transformed into object, after which the object gets itself settled in the painting-space as an abstract sign. And colour, moving towards colourlessness, that is being devoid of its distinctiveness or individual identity of a colour and becoming as it were, colourless, merges (interfuses) with the colour-atmosphere of the painting in its entirety."

Prabhakar Barwe (translated from Marathi by artist)(30.1.92) Rpt. in Gy. CH ExC. in Gallery Chemould ExC. 25 Feb–14 Mar 1992

106

HALOI, Ganesh

Untitled
25.9x22.9. Gouache, 1995
Private, Bombay

" They are the works of a thoughtful,
matured artist. Meditation has replaced
poetic lyricism and a subtle abstraction
gives his present works, in spite of their
modest dimensions, – an air of
monumentality and power. He has
abandoned the specific visual reality of a
subject and now sets out, instead, to
reveal and express with deep emotion the
pictorial possibilities of the rhythm of
spaces that he realises in the various
oppositions and continuities of forms."

Sushil Mukherjee, JG–ExC. May 1993

PATEL, Gieve

Looking into a Well II
147.3x147.3. Acrylic, 1994
Private, Bombay

" Anyone who happens to peep into a well
is first confronted by the image of his
own face looking up at him from the
surface of the water. However, if he waits
a bit and continues to gaze down into the
depths he soon discovers...cool serenity,
the heavens reflected on the surface of
the water, plant and animal life under the
surface, weeds sprouting from the sides
of the well, mud and chalk lining the
walls, a world indeed."

Gieve Patel, 'Looking into a Well' Gy. CH
ExC. 15 Dec–15 Jan 1996

108

PAREKH, Manu

Flower of the Ganga
122x122. Oil, 1989
Private, Bombay

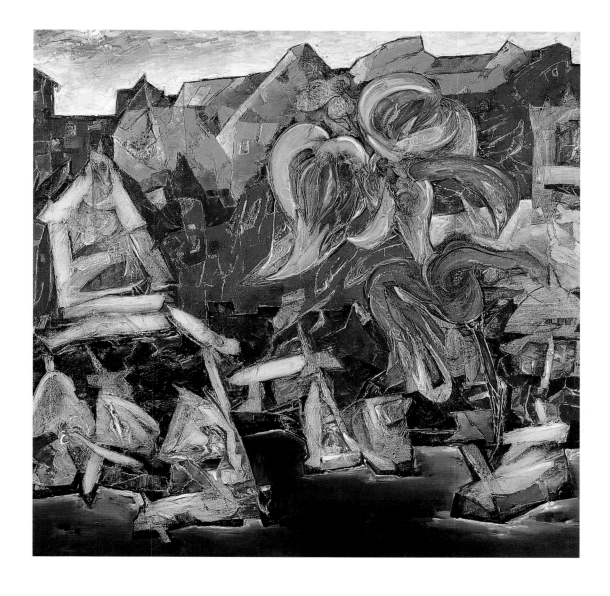

" In Benaras, Manu once again discovered
the primordial source of energy. The river,
with the ghats, the temples, the shrines,
the trident... all mingled,...he transmitted
the cityscape into an organic structure
where without the human image coming
in, the pulsating life drama of human
presence can be felt."

Ananda Das Gupta, Manu Parekh,
Dhoomimal ExC. 23 Feb-4 Mar 1988

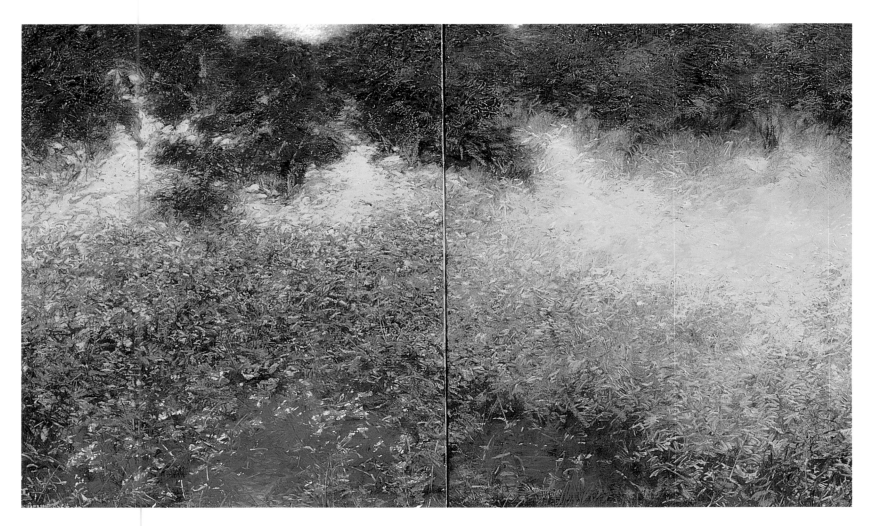

109

SINGH, Paramjit

Water Mirror
91.4x152.4. Diptych, Oil, 1995
Private, New Delhi

" Paramjit Singh's mode of applying
colours and his compositional structure
mesmerize the viewer and give an
impression of alternating visions: of the
represented and of the abstract elements.
That means, on the pictorial plane there is
a point of departure as well as a point of
meeting. Every moment they merge or
overlap. There the familiar becomes
unfamiliar and vice versa. Again the artist
returns. This time, he goes back to the
surreality: the reality of his inner
landscape."

M. Ramachandran, 'Alternating Visions',
Paramjit Singh: Vadehra Gallery ExC. 26 Dec 1995
-16 Jan 1996

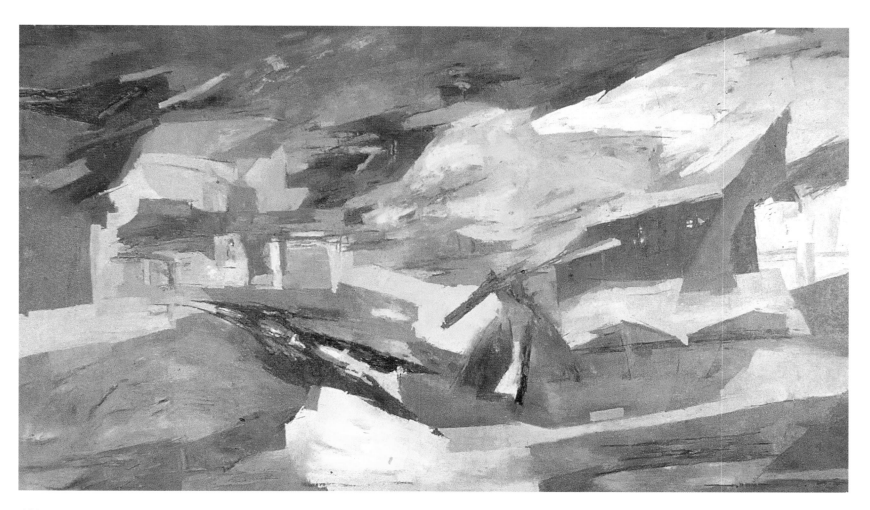

110

RAMKUMAR

Untitled
84x144. Oil, 1987
Kali Pundole Family, Bombay

" Look at a Ram Kumar painting as you would look into yourself when you try and recall your experience of a vacation in the hills, your visit to a lake, or of your being air-borne for the first time...His recent paintings are built of structural parts, wedges, segments, angular drifts of paint which, while they have a directional movement, and suggest a sweeping view, cohere as a fabric of colour...The browns, greys and blues, the occasional green or orange, are areas of positive sensation...The structure reveals itself formally, expressive in many parts but evocative as a whole, a gestalt."

R.L. Bartolomew, 'Landscape as Vision'.
Reprinted in *AHJ 4* (1984–5)

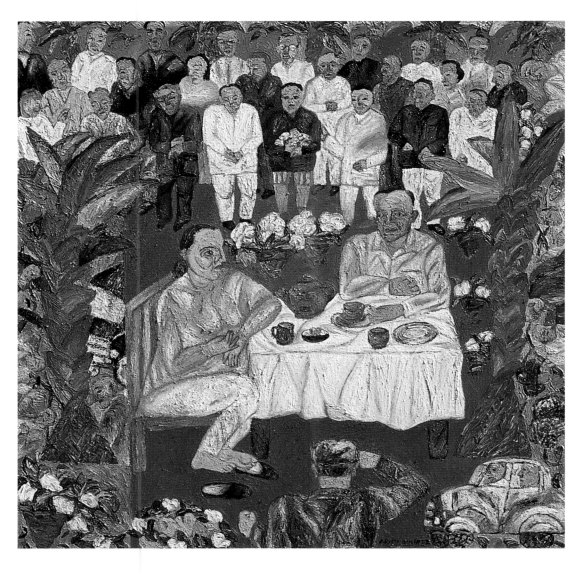

SINGH, Arpita

Couple Having Tea
106.7x106.7. Oil,1992
Times of India Group

" There is in her paintings the substance
of wakeful dream materialising image and
mirage, body and fabric... The making of
beauty obsesses Arpita. For her the
pleasure and ploy of ornamentation is
both celebration and disguise. Along with
Modernist techniques of painting she
foregrounds other devices to celebrate
the surface: the use of decorative motifs,
patterning and what I would like to call
illuminating, inexorably bringing to life,
tending, a surface she fears might dull."

Nilima Sheikh, 'Materialising Dream: Body
& Fabric', Jne 1994. In Arpita Singh. Vadehra
Gallery ExC. 29 Sep-31 Oct 1994

112

DAS, Amithava

Situation III
161x117. Oil, 1988
Private, Bombay

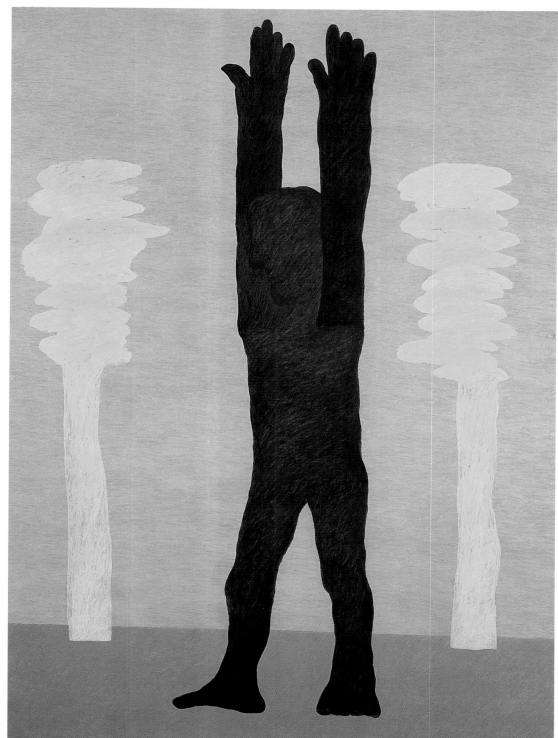

" Amithava's canvasses have only a few forms: man, tree, animal, earth, sky...Wind blows through and light becomes luminous. Layers of colour appear as if postures caught in duration...The duration of this play hangs like a paradox and fogs memory. And yet there is a dislocation: men, animals and trees stand forlorn within this sparse play of wind and light. This play that was pleasure once! There is now a line of sorrow across their face...There is in these canvasses a resolute ability to suffer. Pain absorbed patiently though not helplessly...These canvasses also express his love for nature and all that is beautiful and yet vulnerable in this world...Amithava's art is indeed very close to poetry."

Prayag Shukla, trans from Hindi by Madan Gopal Singh. Rpt. in Dhoomimal ExC. 1988

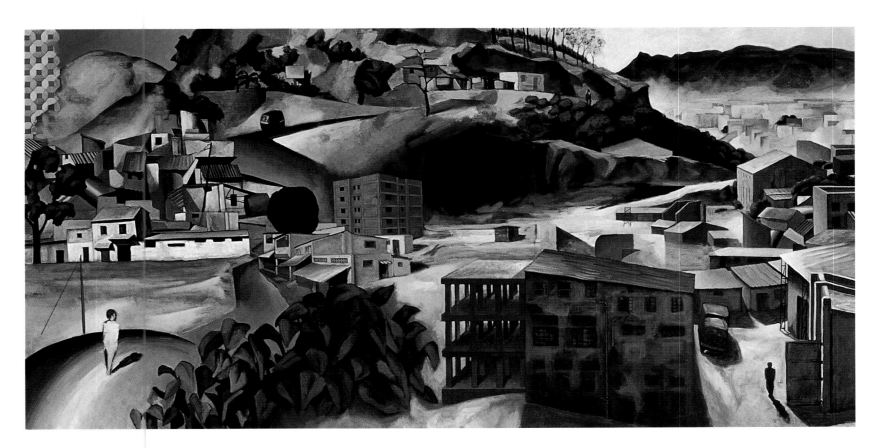

113

PATWARDHAN, Sudhir

Pokaran
121.9x243.8. Oil, 1992
Chester & Davida Herwitz, USA

" Pokaran, ten minutes away from where Patwardhan lives, is a strange place. A twisting U-shaped road maps out, with geographic precision, the stereotypical Indian frontier town... It is a land where what is happening is open for anyone to see: where the contending forces of industrial capitalism... are laid bare, in shantytowns and in the twisting alleyways where floating perspectives of urban architecture have so easily given in to corrugated tin roofing and piles of industrial waste. This is Patwardhan's country, these are his people. He does not record what is happening, he prefers, rather, to make the act of painting here an active participating element in this culturally unformed land. The lost paradise has to be redeemed."

Ashish Rajadhyaksha, 'Sudhir Patwardhan: The Redemption of the Physical' *AHJ 9* (1989-90)

114

MAZUMDAR, Chittrovanu

Untitled
150x131. Acrylic, 1994
Private, Bombay

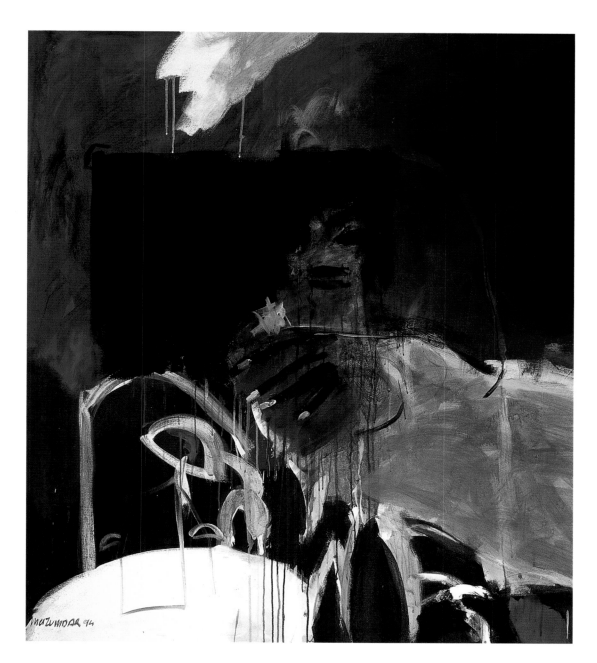

" ...The very concept of the normative is under stress. Heterogeneity is the dominant reality, both visually and experimentally. With displacement and diaspora in points of view, we are forced to affirm the presence of several realities and many, often assymetrical and dysjunctive, 'truths'...So we cope with the active experience of contradiction and paradox, of the disparate in coexistence, with fragmentation. But not chaos. Chaos implies the absence of authority, of control, the breakdown of a system. We realise that the randomness we experience is merely apparent: the system is in place, control has intensified, it is just that the design and structure– like in the famous primitive desert art– is on so vast a scale that we increasingly need the aerial view to perceive its pattern."

Anjum Katyal, Chittrovanu Mazumdar: Recent works. ExC. A Seagull Exhibition. May–Jne 1994

RODWITTIYA, Rekha

Sharing Secrets
182.8x121.9. Acrylic & Oil, 1996
Private, Bombay

" ...the root of all my motivation and strength has come from my feminist beliefs. My life and my art has consistently been guided by these politics...In conceiving this show I decided that the predominant colour would be red. This colour has always evoked and signified sacrifice, passion, desire and protest for me. These works also house emotions that are fragile, tender and vulnerable."

Rekha Rodwittiya, 'One Full Circle' In Shades of Red: Recent Works, Sakshi ExC. 1996

116

TEWARI, Vasundhara

Subterranean
121.9x182.8. Acrylic on paper, 1991
Kanwaldeep & Devinder Sahney, Mumbai

" In Vasundhara's paintings, it is the body
of a young working woman, a body that
has known fatigue and experienced
mental depression, a body that readily
responds to its inner being and to the
world outside. A body not without charms
perhaps, but somnambulistic in
movements, as if gliding through
a dream-crossed world, describing in
ballet-like configuration of movements-
in this context- in involuntary reflexive
gestures of modern expressionist ballet-
a whole gamut of human emotions."

Santo Dutta, 'Dream Reality' Pundole ExC.
Feb 1991

117

DODIYA, Atul

Dr. Patel's Clinic—Lamington Road
175.2x243.8.
Oil, Acrylic & Marble Dust, 1995
Harsh Goenka, Bombay

" Atul Dodiya does not subscribe to the creed of complacency; he retains the courage to change direction in mid-passage. Having grown steadily more dissatisfied with the photorealism, shot through with a wry fondness for kitsch, that defines his accomplished manner, he has now renounced it in favour of a more flexible mode of image-making. Relying on metaphor rather than on reportage, this mode offers him a greater scope of montagistic invention, permits him access to a wider gamut of moods and conditions of representation than was possible earlier..."

Ranjit Hoskote, Atul Dodiya: Oil Paintings, Gy. CH ExC. Feb 1995

History of
Indian
Contemporary
Painting

An Essay

There are many angles from which to study the history of Indian contemporary painting.

The search for 'Indianness' is one focus; the oscillation between a traditional artistic heritage and the changing art norms of Western modernism being its main pendulum. The changes reflecting shifts in patronage as the nation state evolved is another perspective, as are patterns in the teacher-student relationship and related aspects of art education. The movement in urban art consciousness, and its links with folk and tribal ways of life, becomes another angle to be analysed. To all these can be linked the relationship with international postmodern art and economic liberalisation.

The deeper these issues are interconnected, the clearer becomes one's grasp of the unique unifying aesthetics of the Indian contemporary artist. This brief essay will only be able to introduce these issues, providing the foundation for deeper studies.

Pre-1900
First Steps

[1] " Company painting definitely needs a better evaluation and study than it has received so far. The stereotyped notion that its style was wholly dictated by consumers of art who hailed from Europe, or that it was a hybrid production with hopelessly mixed up features has to be abandoned forthwith...It also ushered in an interest in painting the natural and social ambience, the animal world and the world of human beings of all sorts of types and vocations. While it is true that this interest was stimulated by Western demand, let us not forget that the seeds were there in the tradition, though dormant." [Krishna Chaitanya, *A History of Indian Painting: The Modern Period*. N.Delhi: Abhinav Publications, 1994. p111]

[2] Regarding the Kalighat Pats, eg: " There is an exquisite freshness and spontaneity of conception and execution in these brush drawings. They are not drawn with the meticulous perfection which gives such distinction to Mughal portraiture. They have not the studied elegance and striving after effect of the charmingly sensitive later drawings of the Kangra school with which they are contemporary. But there is boldness and vigour in the brushline which may be compared to Chinese Calligraphy. The drawing is made with one long sweep of the brush in which not the faintest suspicion of even a momentary indecision, not the slightest tremor can be detected." [Ajit Ghose, *Rupam* (Oct. 1926). Rpt. in W.G.Archer's *Bazaar paintings of Calcutta*. London, 1953. p5]

During the late 18th to early 19th centuries with the decline of Mughal power, painters who had enjoyed court patronage scattered around the country. Tanjore, Lucknow, Patna, Murshidabad, Nepal and the Punjab Hills, such as the Basholi, Kangra, Chamba, Jammu, Nurpur regions, (which became known as the Pahari Miniature School) became their main areas of activity.

At the same time a few European painters, such as J.Zoffany (1733-1810), Tilly Kettle (1735- 86), T.Daniell (1749-1840), W.Daniell (1769-1837) and others came to settle in India. These were the artists who introduced a romanticised Indian landscape through the medium of easel-oil painting. With the introduction of this academic idiom the art of anonymous Indian Company Painters evolved, uniquely merging Eastern and Western themes and techniques. With the advent of photography, Company Painting drifted closer to assimilating Western traditions of perspective and chiaroscuro amid the diminishing traditional miniaturist norms.[1]

The eventual fragmenting of traditional Indian arts was mainly the result of a cultural imperialist infrastructure entrenching itself, bringing a change in sources of patronage, among other factors, and hence a change in the style of art and attitudes. The conflict between notions of individuality, rooted in the dominance of subjective reason, against attitudes of artistic anonymity, rooted in the dominance of joy and its intuitive faith, become one such transition.

British officials soon dominated the patronage of Indian art. The painters paid homage to their whims for the traditional craft guilds had broken down. As the relationship grew, a kind of traditional forerunner to the modern idiom came to be recognised by the 1830s in the work of the Kalighat *patuas*, artisans.[2] These firstly depicted traditional poetic or religious sentiments and themes, and by the late 19th century were expressing a satirical comment on the upwardly mobile Indian upper middle classes. This work was paralleled by eastern taste and western technique, which the academic colleges would shortly institutionalise.

118
Kalighat Pata
Untitled
53x148. Tempera, c.1860s
Shirin Paul

In 1854 the first Industrial Art Society was set up in Calcutta by Rajendralal Mitra, Justice Pratt, Jatindra Mohan Tagore and others. By 1864 this was converted into the Calcutta Government College of Art (CGCA). With the British Crown taking over the East India territories in 1857 and Queen Victoria becoming Empress of India, the Bombay Government Art College (later renamed the Sir J.J. School of Art) and the Madras Government College of Arts & Crafts (MGCA) were also established.

By 1867 twenty-two Industrial Art Societies and three Government Art Schools in the Presidency cities – Calcutta, Bombay & Madras – had been established. After ongoing

debate between the craft-oriented Central School of Industrial Art at South Kensington and the academic fine art focus of the Royal Academy, an art curriculum evolved. Within this agenda there was little attempt at interlinking architecture, painting, sculpture, with music, drama and dance, as within ancient Indian aesthetics.

The fine art education soon supported a package of oils on canvas and clay modelling, with an emphasis on portraiture, landscapes, and still-life. This was coupled with a shift towards studying 'illusionistic-realism' rather than conceptual forms, especially within human figuration. The use of chiaroscuro instead of flat colour patterns; of tonality rather than line; and perspective instead of decorative compositions, were a few of the other changes.[3]

This academic perspective was not the manner with which the Indian vision had been fashioned. In Indian thought, the perspective of the mind's eye was far more relevant than representation. The spectator could be put anywhere, usually in the middle of the 'canvas'. Thus any Indian painting, fresco or miniature, tended to become part of a larger arrangement, with multiple vision manifesting itself in an open-ended segment.

It was within this context that the art of, a mainly self-taught Raja Ravi Varma (1848-1906) and a few others, came to be recognised.[4] The Patna Company School had to an extent freed Indian art from myth and religion as the main subject-matter, having introduced themes from nature, festivals and the common man's life in a realistic style. Ravi Varma took India back to feudal themes. He was one of the first Indians, to be followed by the likes of Hansaji Raghunath, Pestonjee Bomanji (1851- 1938), M.V.Dhurandhar (1867-1944), and later, M.F.Pithawala (1872-1937), A.X.Trinidade, (1870-1935) Hemendranath Mazumdar (1894-1948), Atul Bose (1898- 1977) and others, to master the oil on canvas technique.

[3] One dominating intention of British Art institutions could be summarised by the following statement from the 'Report of the Director of Public Instructions', 1876-1877: "The object of the institution was to give the native youth of India an idea of men and things in Europe both present and past, not that they might learn to produce feeble imitations of European art, but rather that they might study European methods of imitation and apply them to the representation of natural scenery, architectural monuments, ethical varieties, and national costumes, in their own country."

[4] "...whether one should attribute to Ravi Varma the distinction of giving us the art of easel painting, is in itself debatable. The more legitimate claimants for this honour would be the many 'unknown artists' whose work we associate with what is called Company Art, which flowered in the feudal courts of India in the early 19th century. Their works created the conditions for legitimisation of easel painting." [K.B.Goel, 'Of Figures and mirrors on the wall...', Economic Times, 15 Jne 1993]

119 (Right)
RAGHUNATH, Hansaji
Maharani Jamna Bai
175x130. Oil, 1878
Maharaja Fatesingh Museum Trust, Baroda

120 (Far Right)
Mysore School
Saraswati
100.3x76.2. Mixed Media, c.1850
NGMA

Raja Ravi Varma mixed the decorative attitudes of the Tanjore School of glass painting with his British academic training, arriving at a fusion of Indian themes and the oil on canvas technique. Also, given his background, the influence of the 19th century Parsi Theatre, Malayalam classics, Hindu mythology and Kerala's Kathakali idioms were absorbed within his imagery. However, the authenticity with which Western notions of surface were reflected through his art idiom, as with a few others, seems questionable.

[5] For example, art historian Geeta Kapur, reiterates the Western orthodoxy as pertinent to Ravi Varma: " Oils as paint matter encourages the simulation of substances (flesh, cloth, jewels, gold, masonry, marble) and capture of atmospheric sensations (the glossiness of light, the translucent depth of shadows). Realism flowing from such material possibilities of paint is a way of appropriating the world, saturating the consciousness with it...This realism is a complex and often paradoxical phenomenon and has a run of several hundred years before its culmination in the nineteenth century with Courbet. What appears with an artist like Ravi Varma is not in fact realism. It is an adaption of the more academic versions of European painting in the seventeenth to nineteenth century and the adaptions range all the way from portraits to narrative allegories." [Geeta Kapur, 'Ravi Varma: Representational Dilemmas of a nineteenth century Indian painter' *JAI* 17–18 (Jne 1989): 60–1]

121
VARMA, Raja Ravi
Radha Rukhmini & Krishna
55x34. Oleograph with embroidery, c. late1890s
Private, New Delhi

[6] " Under a new wave of nationalist reinterpretations of Indian art and aesthetics, the very factors that had been central to Ravi Varma's pictorial achievements were turned against him. His real–life impersonations of mythological characters were attacked as 'vulgar' and 'demeaning', his dramatization of classical episodes condemned as crudely 'theatrical', and his entire tenets of academic realism declared antithetical to 'Indian subject matter'. The ascendancy of the new 'national art' of Abanindranath Tagore in *swadeshi* Bengal revolved around the displacement of Ravi Varma as 'kitsch'." [T.Guha–Thakurta, 'Visualising the Nation: The Iconography of a 'National Art' in Modern India' *JAI* 27–28 (Jne 1995): 19]

[7] Asok Mitra, 'The Forces behind the Modern Movement' *LKC* 1 (Jne 1962): 15-9

Nevertheless, his fame, especially as a portraitist, hastened the stress on artistic individuality, so encouraging another facet of modernity. Through his popular oleograph reproductions, he gave the Indian public images with which they were most comfortable. The oleographs reached out to a wider audience, creating a 'calendar' image which has kept its wonderful yet gaudy mass appeal until today, significantly moulding the Indian eye.[5]

Just as Victorian themes were subjects with which the British public would feel at home, Varma's themes were those with which the Indian public would feel comfortable. Despite his intent, soon the values implied by his artistic idiom proved unsuitable for the direction of India's political aspirations. Raja Ravi Varma became the perfect scape-goat for the emerging art movement in Bengal.[6]

Yet the steps taken by Ravi Varma and others should not be underestimated, for the consequences were far-reaching: "Ravi Varma struggled to introduce a great many new elements into Indian painting,...perspective, European drawing, construction and composition and a new medium altogether: oil. He tried to wield the new tools in the Indian context and what he produced was not European painting at all but a new way of seeing. He introduced large bright areas of colours in his portraits and landscapes, adapted oil to the Indian light. It would be a mistake to regard his work as only a cheap or pointless imitation of the European technique."[7] Also, it is unfair to belittle the importance of an appropriately restructured academic training, and the many positive aspects of British education. The inappropriateness lay in the necessity of the times and the nature of the assimilation rather than in the object of assimilation.

1900–21
Roots of Indian Modernism:
The Bengal School

[8] Eg: " If one asked me under which sky the human spirit had most fully developed its most precious gifts and sounded to the most profound depths the grandest problems of life and found for some of them solutions which deserved to attract the admiration even of those who had studied Plato and Kant, I would indicate India... " [Max Mueller. Rpt. in Andre Karpeles 'The Calcutta School of Painting', Trans. from French by Gurudas Sirkar. *Rupam* (Jan–Jne 1923)]

[9] " Twenty four years ago I was sent out to India to instruct Indians in Art, and having instructed them, and myself to the best of my ability, I returned amazed at the insularity of Anglo–Saxon mentality which has taken a century to discover that we have more to learn from India than India has to learn from Europe... There will never be a true renaissance of art in India until the fine arts are restored to their proper place in the national life." [E.B.Havell, *The Studio* 44.184 (15 Jly 1908). Rpt. in *The Basis for Artistic and Industrial Revival in India*. Madras: Theosophist office, 1912]

The seeds from which a movement towards modern Indian painting grew were the existing Western academic art education, which seemed against the grain of the Indian psyche; a reaction against the popularity of artists such as Ravi Varma; the vast cultural Indian heritage which was being denigrated by a Macaulayan cultural policy and forgotten by its own people; a growing wave of Orientalism influencing European art and thought[8], as well as the political climate and its urgent issue of national identity, reflected via the *Swadeshi* Movement (July 1905-8).

The trigger which integrated these issues and created a 'movement' was the coming together of E.B. Havell, with Abanindranath Tagore and A.K. Coomaraswamy among others, so as to resuscitate the neglected Indian cultural heritage.

In July 1896 E.B Havell (1861-1934) was appointed the Principal at CGCA, after H.H.Locke (1837-85). His romanticism, inspired by the artistic vision of the pre-Raphaelite movement and W.Morris' craft emphasos, were instrumental in rediscovering the artistic and educational relevance of the ancient Indian cultural ethos and seeing it in relation to modern art.[9]

However, the strength of the Academic wing can be gauged by the actions of Ranada P.Gupta, who retaliated against Havell's efforts of introducing a curriculum which also recognised Indian traditional arts. Gupta established the Jubilee Art Academy, Calcutta (1905) in a bid to save British academic art from neglect. His later students, such as Hemendranath Mazumdar and Atul Bose among others, would maintain the Western Academic legacy in Calcutta; as was being done in Bombay, at the Sir J.J.School of Art. This parallel focus gave a unique vitality to the possibilities of new artistic directions, creating an atmosphere of creative conflict.

Abanindranath Tagore (1871-1951), the first major artistic figure of Modern Indian Art, evolved a 'national' style and school of painting, The Bengal School, not just using national themes as earlier done by the academic artists. His early works fused Rajput

122
TAGORE, Abanindranath
The Passing of Shah Jahan
Oil on board, 1902
Rabindra Bharati Society, Calcutta

[10] Partha Mitter, *Art & Nationalism in Colonial India 1850–1922*: Occidental Orientations. Cambridge: C.U.P., 1994. p288

[11] Abanindranath Tagore, *Some Notes on Indian Artistic Anatomy*. Calcutta: ISOA, 1914

[12] " The Arabian Nights Series owed their origin, as many of his writings do, to this remarkable gift of his in reconciling contraries, through a surprise of fancy and imagination." [B.B.Mukherjee, 'The Art of Abanindranath Tagore'. Trans. by Nirmalchandra Chattopadhyaya from Bengali, *Visva Bharati* Q (May 1943)]

[13] '*Sadrsya*'(Likeness), 1925, from A Tagore's *Bageswari Lectures*. The meaning of 'likeness' is something more like 'correspondence of formal and representative elements in art' [A.K.Coomaraswamy, *Transformation of Nature in Art*. 1934. Rpt. by Dover Publications, 1956. p10]

[14] *Ibid*, p12-3

[15] Eg: "...there was a time when Europe and Asia could and did actually understand each other very well. Asia has remained herself; but subsequent to the extroversion of the European consciousness and its preoccupation with surfaces, it has become more and more difficult for European minds to think in terms of unity, and therefore more difficult to understand the Asiatic point of view. It is just possible that the mathematical development of modern science, and certain corresponding tendencies in modern European art on the one hand, and the penetration of Asiatic thought and art into the Western environment on the other, may represent the possibility for a renewed rapprochement. The peace and happiness of the world depend on this possibility." [The Theory of Art in Asia, In *Transformation of Nature in Art*, Dover Publications, 1956. p3–4]

[16] First stone of Santiniketan laid on 22 December 1901; formal stone for Visva Bharati laid in 1918; Visva Bharati inaugurated on 23 December 1921

[17] eg: Sri Aurobindo, Sister Nivedita, Kakuzo Okakura, James Cousins, W.Rothenstein, Sir John Woodroffe, Count Keyserling, Stella Kramrisch, Sylvian Levi, Anna Pavlova, Goloubew, Andre Karpeles, amongst others.

and Pahari miniature traditions with his training in European painting, especially pre-Renaissance Florentine influences, and his Western academic ideas of portraiture and watercolour landscapes. Also, works such as: **Last Days of Shah Jahan** (Oil on board, 1902), announced the arrival of a new direction in Indian modern painting where the 'treatment of *bhava*, feeling, becomes the leitmotiv of his work' arousing a 'nostalgic evocation of history'[10].

Abanindranath's art implied a deep respect for the individual creative journey: "...let me also make this little request...in the quest for that realisation which is the fulfilment of all art, that they may not make these aesthetic canons and form-analyses of our treatises,...as representing absolute and inviolable laws, nor deprive their art-endeavours of the sustaining breath of freedom, by confining themselves and their works within the limits of Shastric demonstrations. Till we find the strength to fly we cling to our nest and its confines."[11]

This freedom was well demonstrated in his later works such as the **Arabian Night Series** (W/c, 1930) which fused myth and the contemporary life of Calcutta[12]; his folk inspired **Krishnamangal & Chandimanagala Series** (Tempera, 1938-9), and his playful Kutum Katam Series of experimental toys (1942-51) made from twigs, buttons, wire, metal, drift-wood, stone, and scrap cloth. However at the heart of his aesthetic was the intent to fuse what seemed contradictory: "To turn any obstruction into one who destroys all obstructions is the most skilful way to employ contradictory likeness; it is an attempt to prevent any hindrance to the appreciation of *rasa*, by the clash of incongruous objects."[13]

It was left to A.K.Coomaraswamy (1877–1947) to provide the relevant aesthetic and philosophical framework, so as to link Indian Modern art with its ancient cultural ethos. For example, regarding 'Likeness', *Sadrsya*, he comments: "The aesthetic *sadrsya* does not imply naturalism, verisimilitude, illustration or illusion in any superficial sense...Ideal form and natural shape, although distinct in principle, were not conceived as incommensurable, but rather as coincident in the common unity of symbol...The nature of the assimilation (*tadakarata*) is illustrated by the *sadrsya* of seed and fruit, which is one of reciprocal causality. The *Nyaya-Vaisesika* definition of sadrsya...is literally 'the condition of embracing in itself things of a manifold nature which are distinct from itself', or more briefly the condition of 'identity in difference.' *Sadrsya* is then 'similitude', but rather such as is implied in 'simile' than by 'simulacrum'... *Sadrsya*...has nevertheless been commonly misinterpretated as having to do with two appearances, that of the work of art and that of the model."[14]

His was an aesthetic grasp without parallel, as was later revealed in his pivotal role of trying to clarify the framework for a 'renewed rapprochement' between European and Asiatic aesthetics.[15]

Rabindranath Tagore (1861-1941) also gave his initial support to the Bengal School, though in time his vision demanded a fuller view, and hence a separation from the 'movement'. His educational institute, Visva Bharati at Santiniketan[16] devoted to a National- Pan-Asian-Universal vision would be his chosen vehicle. Winning the Nobel Prize (1913) added to his aura as he became the dominant cultural voice, attracting scholars and artists from the world over[17]. Linked to this Pan-Asian vision was Kakuzo Okakura's (1862–1913) oriental idealism– *nihonga*, motivated by the urge to form a substitute culture to Western civilisation, focusing on the inter relationship between a respect for nature, tradition and one's inner originality. Upon his first visit to India (1902) he was introduced to the Tagores by Sister Nivedita, another devoted 'orientalist'. This rapport was strengthened when Okakura sent artists such as Y. Taikan (1868-1958) and H.Shunso (1874-1911) to work with Abanindranath Tagore and

others. It was through this collaboration that the 'wash' technique was evolved by Abanindranath, which dominated the Bengal artistic idiom.

Thus the Bengal School matured in reaction to these and a few other efforts. That the consolidation of this movement occurred during the Swadeshi Movement, meant that an in-built non-artistic criterion was established within art. This would sooner or later artistically fossilise the movement.

[18] Eg: Educational Society's, such as the Indian Society for Oriental Art [ISOA], 1907; clubs, such as Vichitra at Jorasanko, 1916; and publications, such as *Prabasi*, Modern Review (Estb: 1901), and the later *Kumar* (Estb: 1914) & *Rupam* (1920-30) established by Dr. O.C.Ganguly.

[19] All of whom were students of Abanindranath Tagore

However, for the first time, the movement gave rise to an infrastructure separate from British patronage. Various means of discussing and disseminating artistic ideas were growing to counter colonial structures.[18] The artists of the Bengal School included: Nandalal Bose (1882-1966), K.Venkatappa (1887-1963), Samarendranath Gupta (1887-1964), Asit Kumar Haldar (1890-1964), Kshitindranath Mazumdar (1891-1975), Sarada Ukil (1892-1940), and M.A.R Chughtai (1897-1975).[19]

123 (Right)
BOSE, Nandalal
Jagai–Madhai
22.3x16.7. Pen & Ink, c.1908
Indian Museum, Calcutta

124 (Far Right)
VENKATAPPA, K
Ramayana Series: Ravanna & Jatayu
Tempera & Wash, c.1913
Private, Calcutta

[20] eg: Nandalal Bose became the Head at Kala Bhavan, Santiniketan, in 1923, succeeding Asit Kumar Haldar. The latter became Principal at the Maharaja School of Arts & Crafts, Jaipur (1923-24) and later the first Indian Principal of a Government Art College, at Lucknow (1925-45). Shailendra Dey succeeded A.K.Haldar as Head at the Jaipur School of Art & Craft. Kshitindranath Mazumdar became Principal at ISOA (1913-31) and then the Principal at Allahabad University (1942-64). Sarada Ukil started his Ukil Art College in Delhi. Samendranath Gupta became the Principal at the Mayo Govt. College of Arts & Crafts, Lahore. K.Venkatappa joined the Mysore College in 1917. D.P.Roy Chowdhury became the first Principal at MGCA (1929-57)

The early sources of inspiration for the art of the Bengal School came from the frescoes at Ajanta and Bagh; Persian, Mughal, Rajput and Pahari miniatures and the Silpa Sastra's. East Asian calligraphic techniques, especially works on Chinese scrolls and Japanese woodcuts, were also key sources, which were fused within themes mostly from Indian classical mythology and religion. The preferred medium of these artists was watercolour, ink and tempera, rather than oils, and they generally preferred a small format. The Japanese inspired 'wash' technique was applied to the paintings, giving a mystic sense of space and atmosphere, diluting the impact of colour. No clay modelling was encouraged, because of its connotations of Western academic art education. Soon the Bengal School, in consolidating its rebellion, became closed to other sources of inspiration, and oblivious to contemporary Indian values. The compulsion to create became subordinated to the tutored need of painting certain pictures. It resulted in an illustrative art unable to express the intensity of the times. As K.Chaitanya pointed out, the School's method of selecting inspiration from the past, choosing the courtly and classical miniatures rather than, say, the *Mahabharata*, and other popular texts, was in part responsible for its stagnancy. However, the first significant foundation stone for the growth of modern painting had been laid. Teachers, from the first batch of Abanindranath's students, spread out around the country, giving Indian painting a new cultural consciousness.[20]

[21] When the Swadeshi Movement was beginning and Abanindranath was going to Kalidas for inspiration, the first major retrospective of Cezanne and the first joint Exhibition of 'Le Fauves' was being held at Paris (1905). Great Britain had not even held its first Impressionist Exhibition, which occurred in 1910. Thus Great Britain's lagging behind French *avant–garde* art naturally had its repercussions on the idioms evolving in India.

[22] S. Gujral, from *Satish Gujral.* New Delhi: UBS Publications, 1994

[23] Refer to Satish Gujral's Biography, *ibid*, regarding the influence of Roopkrishna upon Amrita Sher–Gil and other contemporary artists.

In Bombay, the influence of the Bengal School only marginally increased after the appointment of Gladstone Solomon as Principal of J.J.School (1919-36). The Royal Academy agenda still dominated the J.J. perspective, reflected in the art of Pestonji Bomanjee, M.V.Dhurandhar and M.F.Pithawala, among a few others.[21]

In Lahore, traditional interest had revolved around the design of textiles, furniture, and jewellery. The Government Mayo College of Art had orginally (1878), under the leadership of John Lockwood Kipling (father of Rudyard Kipling), tried to mesh some of these traditional master-craftsmen, *mistri*, techniques with an academic training so that the "*mistri* was not just a skilled labourer hired as a mason or a carpenter, but an overall creator and co-ordinator, well versed in all contributing techniques."[22]

Unfortunately this vision became a rigid and lifeless orthodoxy by the 1920s. Thus the area was also open to the influence of the Bengal School as a parallel movement developed especially given the presence of artists such as Samendranath Gupta, M.A.R.Chughtai and Roopkrishna, among others. Roopkrishna was also one of the first Indian artists to have studied and lived in Paris during the 1920s, bringing back many influential ideas regarding European Modernism and its applicability within the Indian milieu.[23]

Thus, by the early 1920s the parallel streams of British Academic orthodoxy and modern art inspired by traditional Indian sources ran simultaneously. Neither were open to sufficient internal self-criticism. Yet these two stepping stones would engender enough reaction to open up new paths, as revealed through the art of a few creative pioneers.

1922-29
The Foundation Diversifies: Individual Pioneers

[24] " When deformities grow unchecked, but are cherished by blind habit, it becomes the duty of the artist to show that they are ugly and vulgar and therefore abnormal." [G.Tagore, *Birup Bajra*, (Strange Thunder bolts), 1917]

[25] " The successive stages of Gaganendra's artistic career was marked by daring originality of conception, and execution of a bewildering variety of themes in different styles and techniques. The broad phases are: i] Brush drawings in Japanese style– some of them with exquisite gold backgrounds ii] Portrait sketches iii] Illustrations for Rabindranath Tagore's Jivansmriti iv] Water-colour sketches of Rural Bengal, Ranchi and Puri v] Himalayan studies vi] **Chaitanya Series** vii] Caricatures of Indian life viii] Semi-cubistic experiments ix] Folk-lore pictures x] Symbolic pictures of death and the other world. A remarkable thing about these phases is that they did not follow in strict chronological order, nor were they mutually exclusive episodes." [Kshitis Roy, *Gaganendranath Tagore. LKA*, 1964. p ix]

125 (Right)
TAGORE, Gaganendranath
Ball Room Dance [The accompanying lithograph
was called **Wrong Combination**]
27.3x19.8. W/c & Ink, 1916
NGMA
126 (Far Right)
TAGORE, Gaganendranath
City in the Night
21.3x15.5. W/c, 1925
Rabindra Bhavan, Visva Bharati University

By the early 1920s pioneers like Gaganendranath Tagore, Jamini Roy and Rabindranath Tagore were pursuing their own creative experiments, giving a new diversity to modern Indian painting.

Gaganendranath Tagore's (1867-1938) refined aesthetic eye and love of pattern, his open attitude towards experimenting with Japanese (1906-10) and modern Western art, from *art nouveaux*, futurism and the cubist framework, to the ideas of German Expressionism; and his three *avant-garde* caricature albums (1917-21)[24] reflecting the social and religious hypocrises of his times, mark him as a pioneer.[25]

[26] The exhibits were mostly woodcuts and engravings by W.Kandinsky, L.Feininger, E.Nolde, P.Klee, Christian Rohlfs, F.Marc and others.

[27] In 1930 he was struck by an attack of palsy. Until his death in 1938 he was unable to create.

[28] De Stijl's notion of the city seems well suited regarding Calcutta's inspirational quality upon Gaganendranath's Art: " The truly modern artist regards the Metropolis as an embodiment of abstract life; it is closer to him than nature is, and gives a greater feeling of beauty. For in the Metropolis, nature has already been straightened out and regulated by the human spirit. The proportions and rhythms of planes and lines in architecture will mean more to the artist than the capriciousnes of nature." [De Stijl. 1, 132]

[29] eg: Helping to establish the ISOA (1907); reviving Bengal crafts by helping to establish the Bengal Home Industries Association

In December 1922 the first major exhibition of the *avant-garde* German Expressionist art by the Bauhaus artists was held outside Germany, at the Samavaya Mansion Hall, in Calcutta.[26] Hereafter the European inspiration was more clearly absorbed within Gaganendranath's unique sense of design and mystic mood. His playful focus on patterns of light falling on objects gave a sense of weightlessness to his work, creating an aura of fantasy, coupled with a brooding mysticism, as if playing with death.[27] This duality was further crystallised through the dark atmosphere inspired by the crumbling Anglo-Indian architecture of Calcutta and the decadence of its Zamindari class.[28]

Further, Gaganendranath's infrastructural efforts cannot be underestimated. These pioneering efforts[29] allowed future artists to revel in a social respectability and artistic freedom, which we now take for granted.

In a way, Gaganendranath's collection of folk art was also helpful in encouraging another, very different individual journey, that of Jamini Roy (1887-1972). He was the first Indian artist to draw sustainable inspiration from the living folk and tribal art forms and traditions, while realising the underlying unity this idiom shared with the modern.

30 " Jamini Roy's experiments were not forced on himself simply by will or intellect. The whole personality was involved, which made this change not a break but a development...In his choice of media, Jamini Roy showed the same desire for simplification. Expensive oils were given up in favour of tempera and the cheap materials of the village craftsmen. His palette was usually limited to only seven colours. Indian red, yellow-ochre, cadmium, green, vermilion, grey, blue and white. The first four were made from local rock-dust, mixed with the glue of tamarind seeds, or occasionally white-of-egg, to give adhesion. Vermilion was made from the mercury powder used by Hindu women in their ritual-worship. Grey was a composition of alluvial mud; blue was made from indigo, and white from common chalk...The linear brushdrawings were done in lampblack. Using for canvas the cheap home-spun cloth of his village, he prepared it as a basis for paint by coating it with a mixture of alluvial soil and cow-dung, followed by whitewash." [John Irwin and Bishnu Dey, *Jamini Roy*. Calcutta: ISOA, 1944]

127
ROY, Jamini
Santhal Dance
36.5x70.5. Tempera, c.1927
NGMA

31 " He (Jamini) has always held in contradistinction to the theorists and practicians of the Bengali School, that a picture is Indian, not because of its subject matter, but because of the technique and the conception...the indigenous use of the clear-cut angular lines by the painter and his clean colours have given it the pity and the tenderness of Bengal more convincingly than the efforts at dim portraiture of the genre life of the province by the followers of the Bengali School." [S.Suhrawardy, *Marg* 2.1 (1949): 75]

32 Eg: "Basically his art derived its strength in his ability to distil the design in the pictorial space to the barest essential." (B.C.Sanyal, *Jamini Roy* LKA, 1992) " Be it in wood or clay he understood the principle of simplification of form, a problem that many artists struggled with for years." (Ajit Chakravati, *ibid*, 1992)

33 'The Patua art of Bengal' (translated from a Bengali article by Debiprasad Chattopadhyaya based on a series of interviews with Sri Jamini Roy and intended to record Sri Roy's views. Rpt. in *Jamini Roy*. NGMA Publication, 1987. p71)

34 " Roy noted that the art of Metropolitan Calcutta, irrespective of whether it was revivalist or in the western academic style, was dependent on not only elitist but affluent patronage and he wanted art to regain the easy availability and inexpensiveness it had in the traditional life of the people...He was wholly in favour of making art, meant for the collectivity and not just for the affluent few." [K.Chaitanya, *A History of Indian Painting: The Modern Period*. New Delhi: Abhinava Publications, 1995. p178]

35 Rabindranath Tagore's letter to Jamini Roy, 1941. Rpt. in *Rabindranath Tagore: On art and aesthetics*. Prithwish Neogy, ed. Calcutta: Orient Longmans, 1961. p107-9.

36 Eg: " Meanwhile the twilight dust of weariness descends with the waning of vitality... Nevertheless, this intoxication with the game of inventing forms persists. It makes me forget my duties and obligations to such an

The urban-rural hybrid Kalighat Pat, with its bold sweeping brushstrokes, best served his purpose. 1921-24 marked the first period of his experimentation, with the Santhal motif being the chosen trigger of departure, away from his Western academic idiom of portraiture and Impressionist landscapes.[30]

His art was also a reaction against the prevailing Bengal School orthodoxy which Roy felt had lost touch with the vitality of the people. For example, Roy's focus on tribal women and lower caste women, in a non-sentimental manner, is in sharp contrast to the upper class damsels and *apsaras* portrayed by the Bengal School.[31] Underlying all these artistic shifts was the philosophical quest of trying to capture the essence of things, and simplicity.[32] As he himself would clarify: " What is it that the *patua*-art wants to express? It is certainly not a meticulous copy of nature; it is as certainly a conveying the essence thereof... A tree painted by the *patua* is unmistakably a tree, but you can hardly call it any actual tree of your concrete experience. In other words, it has everything that is essential for a tree, though nothing belongs to the limitation of any individual tree."[33]

Though coming from diverse backgrounds, Roy's intention of wanting art to reach out to a wider section of the population was similar to Ravi Varma's.[34] Further, Roy's search, at a time of colonial domination, with the need to be contemporary and to find an Indian individuality, has been seen to metaphorically merge with India's march to freedom. His **Christ Series** (early to mid 1940s) best reflects the culmination of this process.

In 1941 Rabindranath wrote to Jamini, saying: " Most people do not or cannot use their eyes well. They go about their own little business – unobservant and listless. The artist has a call and must answer the challenge to compel the unperceptive majority to share in his joy of the visible."[35]

Rabindranath Tagore's (1861–1941) artistic priority to the free creative spirit, nature, and aesthetic imperatives, amid a local-national-Pan Asian-Universal framework, made him stand out as the true artistic visionary. Through his educational centre, Visva Bharati, at Santiniketan, he tried to structure his dream.

In terms of his personal journey, art rejuvenated a tiring spirit, reintroducing the sense of wonder for life which wisdom always seeks.[36] His horoscope had predicted an earlier death; given that he survived 1928, a new sense of freedom probably entered his mind. He began transforming his doodling and play with lines into a serious pursuit: " I am

extent that all else seems useless waste of time. Thus my mind has turned the full cycle and come back to those irresponsible early days when my eyes were hungry for the world of form and I was a mere boy absorbed in his playthings. That is why the other day I spent the idle hours...watching the shadows sweep across the green meadows and blue sky like a gigantic brush..." [R.Tagore, letter to Ramananda Chatterji, (translated by Kshitis Roy) March 1930. Rpt. *ibid.*]

[37] R.Tagore, letter to Rani Mahalanobis. 7 Nov. 1928. Rpt. *ibid.*

[38] Rabindranath Tagore, letter to Rani Chanda, 24 July 1939. Rpt. *ibid.*

hopelessly entangled in the spell that the lines have cast all around me...It is the element of unpredictability in art which seems to fascinate me strongly ... Firstly, there is the hint of a line, then the line becomes form...This creation of form is a source of endless wonder."[37]

In another letter he writes: " ...it is in my nature deliberately to spoil the first attempt and build it anew. The picture has about it a sense of brooding melancholy...I do not know why this should be when I like a good laugh myself and love to make others laugh. Probably I have a touch of sadness – deep down."[38]

128
TAGORE, Rabindranath
A fantastic bird (with poem inscribed in Bengali)
17.8x22.8. W/c & Ink on paper, c.1929
Rabindra Bhavan, Santiniketan,
Visva Bharati University

With Tagore it was discipline teased by wonder, wisdom playing with its child pretender, idealism having grown tired, wanting to become silent, to return to those eternal questions of 'why', and yet content in just playing with 'why', not needing to reveal what lies beyond.

These are the eternal dictates of creativity. In taking them into restless forms lies the movement of creativity. In being true to these impulses lies the integrity of creativity. Without movement and integrity there is no art, in harmony they create rhythm. Tagore understood rhythm.

39 Pablo Neruda, review of Keyt's joint exhibition with W.W.Beling, Jan. 1930. Translated by L. Wendt in 'Times of Ceylon'. Rpt. in M.Russell's *George Keyt.* Bombay: Marg Publication, 1950. p42.

40 " Quite obviously we can now serve no artistic end by returning to a mere imitation of the art forms of Sigiriya, Anuradhapura, & Polonnaruwa, however 'national' the results may be...A strong eastern influence is conspicuous in the work of Mr.Keyt...The spirit of the Sittara work of Ceylon, of the frescoes of our Viharas, has been grasped and absorbed, and made one with the outlook of the age...Various are the influences in his paintings– Sinhalese, Tamil, Indian, Sittara, modern...Through abstract form, decorative form, and representational form the pictures range; but it is the strong, bold sense of rhythm and design that unifies them, and is the key to their understanding."
[W.W.Beling's review of the 1936 Colombo Art Gallery Exhibition, printed in the 'Ceylon Daily News'. Rpt. in *George Keyt. ibid.* p46.]

The different poetic rhythm of the Ceylonese artist, George Keyt (1901-93) was also finding its aesthetic maturity during the late 1920-30s. At his first major exhibition in 1928, he attracted rave reviews, from various personalities, such as Pablo Neruda: "Keyt, I think, is the living nucleus of a great painter...In all his work there is the moderation of maturity, the beautiful stability of achievement– qualities most precious in so young an artist. Magically though he places his colours, and carefully though he distributes his plastic volumes, Keyt's pictures nevertheless produce a dramatic effect, particularly in his paintings of Sinhalese people. These figures take on a strange expressive grandeur, and radiate an aura of intensely profound feeling."[39] As with the evolving Indian artistic modernism of the times, Keyt's journey epitomised the fusion of diverse sources of inspiration, away from the traditional sources which were easily identified with one's national identity. Ancient Indian art and its Hindu mythology, European modernism, especially the idiom of Cubism, and Sinhalese art, were the main pillars supporting his individuality.[40]

129
KEYT, George
Yama & Savitri
147.3x71.2. Oil on paper, 1938
Lionel Wendt Memorial, Sri Lanka

41 Jamshed Bhabha, *Homi Bhabha*, Bombay: Private Publication, 1966. p6

42 Eg: "...the idea of imbuing inanimate forms with dynamism and movement was born of his admiration for late Baroque and Rococo architecture and sculpture. He had been exhilarated by the sweeping lines, curved facades and elliptic domes of the churches of Francesco Borromini, such as San Carlo alle Quatro Fontane and Sanluo della Sapienza, and by the dynamic flamboyant shapes of the draperies of Rococo sculpture..."
[J.Bhabha, *ibid.*]

It was also during the late 1920s that the talents of one of India's scientific geniuses, Homi Bhabha (1909-63), was finding its artistic maturity. His figurative work was now accompanied by his 'abstracts', which revealed a "deep interest in the volume and solidity of forms and shapes and their inter-relationship..."[41]. Yet, in both idioms, the aesthetic ideal of arousing dynamic movement from inanimate objects dominated his artistic slant.[42]

Given the constraints of time, and the need to prioritise, Homi Bhabha's artistic efforts would soon be rechannelled through his pioneering patronage work which would help sustain the creativity of many individual artists during the 1940-50s, especially with the help of resources from the TIFR (The Tata Institute for Fundamental Research, Bombay).

1930-37
Depth and Growth:
Rabindranath Tagore's Santiniketan

[43] W.Gropius, 1923. *Bauhaus 1919–28*. H.Bayer, W.Gropius & Ise Gropius, eds. New York: MOMA, 1938. Reprinted in *Art in Theory: An Anthology of changing Ideas 1900–1990*. Oxford: Blackwells, 1993. p340-1.

[44] T.Guha-Thakurta, "Visualising the Nation: The Iconography of a 'National Art' in Modern Art". *JAI* 27–28 (Jne 1995): 29

[45] The influence of K.Okakura in Nandalal's aesthetic thinking was evident.

[46] Commissioned by Mahatama Gandhi for decorating the pandals at the Indian National Congress Session at Haripura in 1937.

[47] Refer to T.Guha-Thakurta's *The Making of a New Indian Art* (C.U.P., 1992) and Partha Mitter's *Art & Nationalism in Colonial India, 1850–1922*: Occidental Orientations (C.U.P., 1994) for well-documented accounts of Pre-1937 issues, which essentially link this period's artistic changes with the ongoing process of evolving a national identity for India.

[48] " Devi Prasad Roy Chowdhury is known to the art world of India as a painter of decorative pictures, as a portraitist and as a sculptor...He was intrigued by the decorative qualities of painting and was not averse to Chinese & Japanese influences if they aided his purpose...It was pattern, colour, design, and pure visual appeal which he sought to achieve. He had no allusions. He did not attempt the emotional approach and peter out into sickly sentimentality. If his women were decorative they were meant to be so. They were not his theme but a motif in a larger design. They were not intended to be manifestations of a spiritual ideal, but to frankly convey their human charm..." [Decorative Artist by Karl Khandalavala In *Chowdhury & his art*. P.R.Ramachandra Rao, ed. Bombay: New Book Co. 1943. p73]

To understand the ethos at Santiniketan it is helpful to recognise the shared vision of Rabindranath Tagore and W.Gropius, and their respective institutions. Both reached their holistic conclusions as a result of a creative journey, propelled forward by a mind eager to affirm that it can indeed absorb whatever there is: " The guiding principle of the Bauhaus was therefore the idea of creating a new unity through the welding together of many 'arts' and movements: a unity having its basis in Man himself and significant only as a living organism. Human achievement depends on the proper co-ordination of all the creative faculties. It is not enough to school one or another of them separately: they must all be thoroughly trained at the same time. The character and scope of the Bauhaus teaching derive from this realisation."[43]

From the perspective of an evolving national ethos, T.Guha-Thakurta views the Indian art movement in Santiniketan's purpose as being: "...now directly engaged with the natural environment and the physical realities of form (with everyday images of humans, animals, trees or landscapes), even in seeking out the visual ingredients for mythic and classical themes. Riding on this trend, it also now openly appropriated the 'popular' in the reformulation of its 'Indian' and 'modern' idioms. This was to be seen in the thematic involvement with rural life and culture, in the stylistic borrowings from folk art traditions like the *patachitras*, and also in the new institutionalised concern with handicrafts...in the artist's educational agenda. The 'nation' was now located in the living traditions of village India: so emerged the need to transcend colonialism's divisive barriers and realign the 'classical' with the 'folk', the 'artist' with the 'craftsman'."[44]

Within Nandalal Bose (1882-1966), the Bengal School and the Santiniketan ethos were most deeply merged. As Head of Kala Bhavan (Art Dept.) at Santiniketan (1923-51), he and his first batch of students, such as Ramkinkar Vaij, Benode Behari Mukherjee, Ramendranath Chakraborty, and others, pioneered experiments in modern Indian sculpture, fresco, and graphics.

Nandalal Bose believed the creative urge was not to be constrained by any ideology. His artistic progression, from say **Parthasarthi** (tempera, 1912) & **Siva Drinking Worldly Poison** (wash & tempera, 1913) to his **Haripura Posters** (tempera, 1937) to his later ink and brush drawings and the printmaking experiments, revealed a vision which possessed the humility that inspiration can come from any source, while maintaining a confidence in one's creative stubbornness. Creativity would maintain its originality as long as respect for nature and tradition were disciplined by an inner voice to be free.[45] It would be rooted in being open to all and yet sprouting from one corner, like faith without dogma.

His later work, such as **The Haripura Posters** (1937)[46] heralded a new realism in Indian art, having evolved from a universal perspective of life, rooted in myth and spirituality, which progressed by finding a resolution with nature, tribal vitality and the simplicity of rural life.[47]

Another later student of Abanindranath Tagore at the ISOA was D.P.Roy Chowdhury.[48] He was appointed Principal at the MGCA in 1929. His personality attracted many students during the 1930s, who would play a fundamental role in the future of Indian Contemporary Art, such as K.C.S.Paniker, K.Madhav Menon, K.Sreenivasulu, J.Sultan Ali, Gobardhan Ash, Paritosh Sen, Prodosh Dasgupta, Gopal Ghose, among others.

[49] " Between the two extreme poles of romanticism of the Bengal School and the drama of light and shade of the Rembrandt School, Deviprasad tried to find a synthesis, which apparently was impossible...The delicacy inherent in the Mughal and Rajput miniatures...is temperamentally opposed to the basic structural qualities and the leaden colour scheme inherent in the Western School of painting." [Prodosh Dasgupta, BAAC ExC. Dec-Jan.1989]

[50] Later Raval set up 'Chitrashala' in Ahmedabad, where Rasiklal Parekh and Kanu Desai were teachers in the 'Indian' style of painting, similar to the later classes of J.Ahiwasi at the J. J. School of Art during the 1940s

[51] Eg: " The tendency nowadays is towards freedom in ideas and expression...There was a time when deities appealed to and evoked the admiration of the average man. We seem to have out-grown that now. We go to modern life with all its expansions and achievements." [A.K.Haldar, 'Stray thoughts on arts' *Rupam* 18 (Apr 1924) 1996, and once again we are revisiting the deities with awe.]

Given D.P.Roy's experiences he evolved a teaching ethos which attempted to fuse the craft traditions of South India with the idiom of the Bengal School and Western academic training.[49] What resulted was a unique confusion, laying a deep foundation for artists to go out and search for their individual styles, entrenching the discipline of experimentation.

By 1929 the first batch students from the Indore School of Art had also graduated. The teaching here tried to fuse the Western academic training with the tenets of the Bengal inspiration. Teachers such as Y.D.Deolalikar and R.S.Raval[50], represented this period of transition. Students such as N.S.Bendre, Manohar Joshi, Rasiklal Parekh, G.M.Solegaokar, V.A.Mali and others would all contribute to the modern movement, none more so than N.S.Bendre, especially through his art educational efforts.

The efforts of Asit Kumar Haldar, as Head of the Govt. College of Art (1925-45) and Bireshwar Sen (joined in 1929) were responsible for Lucknow receiving a dose of modern Indian painting, basically rooted in the ideas of the Bengal School.[51]

130
HALDAR, Asit Kumar
Jagai Madhai & Nityananda
Fresco, 1929
Govt. College of Arts & Crafts, Lucknow

With the appointment of Charles Gerrard as Principal of J.J.School of Art (1936-46) early modern European art, including Impressionism & Post-Impressionism, were finally introduced into the curriculum of the Government colleges. However, ideas of Cubism were still too *avant-garde* to be included. In Britain, it took the 1945 Victoria & Albert Museum exhibition of Picasso and Matisse for the British establishment to begin to realise the significance of the new modern art. Thus, once again Britain's relatively slow adoption of certain European modernist art practices resulted in India suffering a similar if not greater lag. The process of catching up would take some time, as after Independence the Indian focus would primarily shift to the School of Paris, whilst the *avant-garde* activity was shifting focus towards America and its Abstract Expressionism.

With Amrita Sher-Gil winning the B.A.S. Gold Medal in 1937 for her painting: **A Group of Three Girls**, another vision of Indian realism, was placed before the public, increasing the interaction with the orthodox aspects of European Modernism.

1938–47
A bold palette: Amrita Sher-Gil.
Interaction with
Modern European Art Increases

[52] "... Colour is my domain and I am on terms of easy domination with it. My sense of form on the other hand is only developing now and still has a strong tendency to evade me." A.Sher-Gil, letter, 1st July 1940 Saraya. Reprinted in *Amrita Sher-Gil*. V.Sundaram et al, eds. Bombay: Marg, 1972

[53] " I am an individualist, evolving a new technique, which though not necessarily Indian in the traditional sense of the word, will yet be fundamentally Indian in spirit. With the eternal significance of form and colour I interpret India and, principally, the life of the Indian poor on the plane that transcends the plane of mere sentimental interest." [Amrita Sher-Gil, *The Evolution of My Art*, 1935. Reprinted; *ibid.*]

[54] K.G.Subramanyan had highlighted this point in *Amrita Sher-Gil*, ibid. For example: "She realised 'that Ajanta was not an abstract from a static realism, but the mobile terminology of a sophisticated pictorial language'".

[55] " Another period of transition is approaching. One of a greater reflection. Of more conscious painting more observation and more stylisation in the sense of nature." [Amrita Sher-Gil, letter to Karl Khandalavala, 18/12/1939, Saraya. Reprinted, *ibid.*]

Amrita Sher-Gil (1912-41) created an European Post-Impressionist romanticised imagery. Her vision was highlighted by her emphasis on colour[52], which contrasted with the atmospheric mistiness characterising the Bengal School works. After her initial academic studies, her themes came to focus on mostly rural visions of the village woman, where her helplessness would merge with a vibrant sense of joy from partaking of the smallest tasks.[53]

Her most creative period came a month after her return from visiting the Ajanta frescoes. Thereafter she painted: The Fruit Vendors (Jan. 1937), followed by the Trilogy: The Bride's Toilet (April 1937), Brahmacharis (May 1937) and South Indian Villagers going to Market (Nov. 1937). Hereafter she shifted her attention towards the Mughal, Rajput and Jain miniatures as sources of inspiration rather than Ajanta, whose aesthetic of translating one's simplified 'contemplative essence' into its pictorial form, she found difficult to grasp, as did most artists.[54]

Her later transitional works[55], such as Resting and Two Girls (1939) showed a change towards a more sombre and reflective art. A comparison of Bride's Toilet & Resting starkly reveals the development. Both use the same subject matter and compositional format, and yet the interaction and proximity of the figures reveals a different level of personal comfort and understanding, though in both cases the young onlooking girl reveals her vision and sense of belonging to some extent.

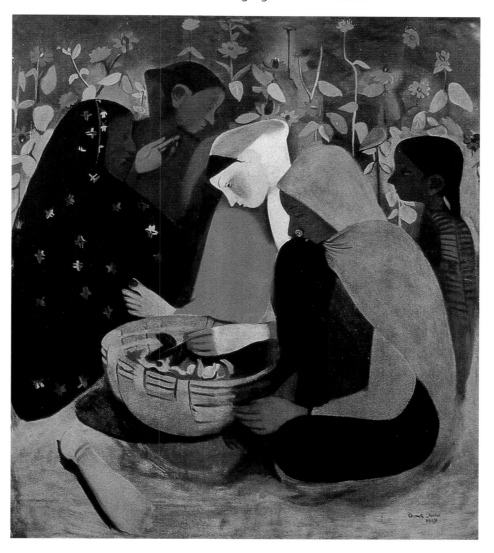

131
SHER-GIL, Amrita
Resting
114.3x99.1. Oil, 1939
NGMA

Rabindranath Tagore passed away in 1941; the same year in December, Amrita Sher-Gil's early death denied the world a chance to see her art mature further.

With the passing of these two pioneers and the commencement of India's indirect participation in World War II the two major art centres, Calcutta–Santiniketan and Bombay, were affected differently. For example, with the Japanese bombing of Chittagong (1941), the inflow of refugees and British soldiers, and the Bengal famine (1942–3), the Bengal intelligentsia received a severe jolt which Bombay was spared. Artists, Zainul Abedin (1914-76) and his students Chittaprosad (1915–78) and Somnath Hore (b.1920), among others, expressed a somewhat sentimental, yet socially responsive expressionism. Yet, their work helped initiate a growing awareness throughout Bengal regarding the social responsibility of artists, and the role they must play.

During Bengal's turmoil, and Gandhi's Quit India call, a group of artists came together to form the 'Calcutta Group' (1943–53). The original members were: Prodosh Dasgupta, Nirode Mazumdar, Paritosh Sen, Gopal Ghose, Raithin Moitra, Abani Sen, Subho Tagore, Prankrishna Pal, & Kamala Dasgupta. Respected Calcutta–based critics such as Bishnu Dey, Sudhindra Dutta, Shahid Suhrawardy strengthened the intellectual base, while interaction with scholars such as John Irwin, Stella Kramrisch, E.M.Foster, W.G.Archer, and others, added to the international dialogue. Their first public exhibition was held in 1944 at the Services Club, Calcutta.

The group was determined to produce an art which took into account contemporary values, something which the orthodox schools were failing to do. A greater interaction was sought with modern European art, along with a deeper role for socio–political comment: " It is better that we consciously discriminatingly choose and integrate foreign influences with our national style and tradition; for otherwise, influences, unconsciously imbibed might distort rather than enrich our art. This is the ideal motivating the 'Calcutta Group'...art should aim at being international and interdependent."[56]

Soon their reputation spread to Bombay. The influential critic, Rudolf von Leyden commented on their work: " ...a sizable *avant-garde* of young artists, quite determined to break with the past, to be modern and to explore with the same experimental processes that have led to some of the modern styles in the west...They (The Calcutta Group) have sought to imbibe a far more vital feeling from contemporary Far Eastern and European art than their elders did. But this is not to suggest they are in any sense imitative, for their love of the people and the old folk culture of Bengal roots them in the long Bengal tradition"[57]

In 1950 the Calcutta Group held a joint show with the later established P.A.G. (Progressive Artists Group) of Bombay, initiating a much needed regional interaction, which till today remains inadequate.

Out of the original members of the Calcutta Group, Nirode Mazumdar (1916–82) was one of the first Indians to receive a French Government scholarship to Paris (1946). His entry into modern art was nurtured by the tutelage of Braque and Brancusi, providing a solid foundation, from which he went on to create a uniquely indigenous art, a combination of tradition and contemporaneity. His later work, focusing on a series of restructured Hindu idols, set amidst a linear randomness and sombre colours, reveals an iconoclastic and cerebral art, in search of an intuitive–logic balance.

In contrast to Mazumdar's cerebral approach, Gopal Ghose's (1915–80) non-narrative use of the line was directed towards expressing nature and her landscape, with no

[56] Prodosh Dasgupta, 'The Calcutta Group: Its Aims & Achievements' *LKC* 31 (Apr 1981)

[57] Rudolf von Leyden, *Marg* 1945 & 1953.

58 " The clean spaces and swift brevity of line recall the eloquent brushwork of classical China and at the same time the fluid linear mobility of a modern like Gaudier-Brzesca, particularly in his lively studies of animals." [G.Venkatachalam, *Present Day Painters of India.* Thacker, Manu & G.Venkatachalam, eds. Bombay: Sudhangshu Publications, 1950. p73.]

59 Eg: " Whoever wrote on modern India art in the forties and fifties had certain ill-researched preconceptions about its genesis and growth– with sharply drawn lines between revivalist and modern tendencies; it was distracting for them to accept that distinctive modern artists came from Santiniketan, which they had already marked out, however erroneously, as a revivalist stronghold..." [K.G.Subramanyan, *The Living Tradition: Perspectives on Modern Indian Art.* Calcutta: Seagull Publications, 1987.]

132
VAIJ, Ramkinkar
Santhal Family
Height: 428. Sand & pebble casted sculpture, 1938
Kala Bhavan, Santiniketan
(Visva Bharati University)

133
VAIJ, Ramkinkar
Threshing
121.5x89. Oil, c.1957
NGMA

60 " Later in his development the cumulative effects of his prolonged studies in Chinese and Japanese painting and the traditional craft forms of India began to be clearly felt. A visit to Japan in 1936 was particularly important in his mature stylistic orientation. An admirer of the Tosa school of painting, Benode Behari was impressed by the bold surface divisions, the unerring placement of abstract areas of intense colour, the refinement of stylised shapes, and the precise economy of lines, all unified in acute confrontation and juxtaposition in the melancholy grandeur of the screens of Tawaraya Sotatsu...In considering George Seurat along with Sotatsu, Benode Behari reveals his affinties with the profoundly ornamental, which for all its analogies, metaphors and lucidities, betrays a deep romanticism at the core." [Pritish Neogy, *Benodebehari Mukherjee.* LKA, 1965]

61 " He chose his subjects from the Birbhum landscapes, from nearby communities, from the mural project itself as a theme, or again from Tagore's dance-drama or even the Nativity of Sri Chaitanya. But so well were they interwoven and integrated that the time and space dimension instantly dissolved. The dancing girl of the Buddhist world and the Santhal damsel, an everyday neighbour, merged together to leave behind the epic ecstasy common to them...The absorbing colour orchestra that these 'Jaipuri' murals with their characteristic forms and patterns poignantly placed fulfils a comparatively pictorial demand rather than the monumentality associated with murals...Benode Behari

priority given to the figure or its traditional iconic role. As with the other members, G.Ghose's involvement with the Calcutta Group proved an essential trigger in his process of absorbing European influences, and revealing his own modernist tendencies.[58]

Outside Santiniketan, the pioneering work of Ramkinkar Vaij (1906–80) and Benode Behari Mukherjee (1904–80) went largely unappreciated.[59] During this time Ramkinkar created **Santhal Family** (1938), a sand-casted open-air sculpture. It seems to be dug out from the bowels of the earth. Built with the logic of a poetic-engineer, its rhythmic eroticism reveals a profound unity with nature.

 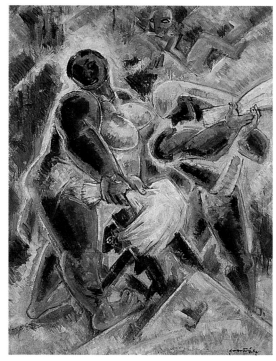

Ramkinkar was also the first artist to experiment with abstract sculptural forms. Apart from his sculptures, his oil on canvas paintings, especially within the cubist framework, reveal a rare experimenting nature, beyond its time, free from dogmas except the compulsion to be true to his creativity.

However, it was with watercolours that Ramkinkar Vaij's sense of rhythm was most evident. The fluidity of this medium was ideal to express the spontaneous vibrancy which he felt amid nature. His sense of harmony with the earth provided the creative discipline to structure this fluidity, transforming erotic energy into its artistic pace.

Benode Behari's work also derived much of its inspiration from the landscape and everyday rural life, but unlike Ramkinkar, his spontaneity was tempered by a cerebral structure and sense of detachment. This was mostly reflected through an eclectic ability to share his vision with international influences and search out the conceptual roots of his creative impulses.[60] For example, when others were occupied with easel or miniature formats, he was experimenting with screen and scroll paintings, helping him grasp the space proportions for mural art.[61]

Using traditional methods his pioneering experiments with the mural medium began in the early 1920s, maturing by the 1940s. For example, his Hindi Bhavan fresco of the Medieval Saints, depicted a river-like swell of human movement, disciplined by a calligraphic approach, thus merging disparate influences through a stark unifying vision, like colours in the sea.[62]

is not merely the father of modern Indian murals, but remains also unsurpassed...." [Kanchan Chakraberti, 'Murals in Santiniketan' LKC 14 (Apr 1972): 11–2]

[62] "The Hindi Bhavan mural established Benodebehari as a major figurative artist, somewhat overriding his earlier achievements as a landscapist. It is his largest and most ambitious work and the most complex narrative painting by a modern Indian artist. It spreads over three walls across which the figures move with a measured rhythm...The rhythmic flux leads us from one figure to the next and herds them into smaller and larger groups. Whilst the groups maintain the continuum, they also form discrete narrative and psychological units marked out by the topographical and spatial shifts that punctuate the progress. The narrative is neither strictly historical, nor based on based on episodic coninuity. It grows out of the figures, their gestures, the way they stand in relation or juxtaposition to one another, and it unfolds in an imaginary space and time" [R.Sivakumar, *Santiniketan Murals*. Calcutta: Seagull Publications, 1995. p54]

After the late 1930s, pre-Partition Lahore was also experiencing a burst of modern art activity encouraged by the presence of personalities such as M.A.R.Chughtai, Mary and Roop Krishna, A.Sher-Gil, B.C.Sanyal, Dhanraj Bhagat, among others. The proximity of the great Russian artist, Nicholas Roerich (1874-1947), and his Urusvati Himalayan Research Institute in the Kulu-Manali Valley, provided another dimension to the exchange.

Nicholas Roerich, who permanently moved to India in 1936, shared the same love and deep respect for nature as R.Vaij and B.B.Mukherjee, but with a scale of vision which encompassed the grand splendour of his explorations amid the Himalayan mountains and deserts. These experiences, trying to reveal the underlying unity between aesthetics and ethics, were fused amid a creative holistic vision similar to Rabindranath Tagore's. However, unlike Rabindranath's introspective subconscious imagery which tried to express a sense of freedom, Roerich expressed this same limitlessness through the imagery of nature's vastness juxtaposed with the solitariness of the human, his insignificance and awe evident.

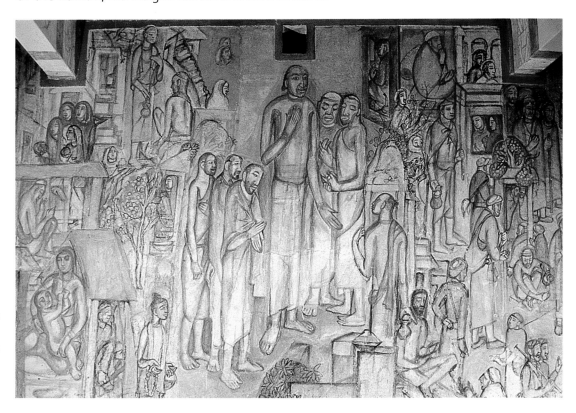

134
MUKHERJEE, Benode Behari
Medieval Saints
from Hindi Bhavan (detail)
(South central portion), Santiniketan
fresco buono, 1947

The young B.C.Sanyal (b.1902) had left the CGCA, joining the Mayo College as a teacher (1929-36). His personality proved a rallying point over the next forty years, during which time his efforts helped generate opportunities for many artists. With the coming of Partition many Lahore-based artists would move to Delhi, and help nurture its art infrastructure, especially through the Delhi Polytechnic of Art and the Delhi Silpi Chakra, providing an alternative to the Sarada Ukil's School of Art and AIFACS.

[63] " The Young Turks wanted to embark on pastures new after shaking off the influence of painters of the earlier generation like M.V.Dhurandhar, S.L.Haldankar, J.A.Lalkaka, M.F.Pithawala, A.X.Trinidade on one side and Abalal Rehman, J.M.Ahiwasi, N.L.Joshi and Ravishankar Raval on the other side. The Young Turks tried to emancipate themselves from the formalism of the Royal Academy and the revivalism of the Ajanta frescoes and Mughal miniatures. They branched out into undigested Impressionism and vague experiments in colour." [Jagmohan, 'The Bombay Art Scene in the Late forties', LKC 28 (Sep 1979):]

It was only after Charles Gerrard, the Principal at the J.J.School of Art (1936-46), incorporated certain developments of European Modern art, such as Fauvism & Post-Impressionism, into the curriculum, that a new sense of expressionist freedom permeated the student body. For example, in 1941 a group show featuring the 'Young Turks': P.T.Reddy, A.A.Majeed, M.T.Bhople, C.Baptista and M.Y.Kulkarni of the J.J.School, created some ripples amid the Bombay art scene.[63] Added to this impetus was also the inspirational role Amrita Sher-Gil's art was beginning to play upon the sense of colour of many up and coming Indian painters, such as B.C.Sanyal, N.S.Bendre, K.K.Hebbar, P.T.Reddy and S.H.Raza.

History: An Essay

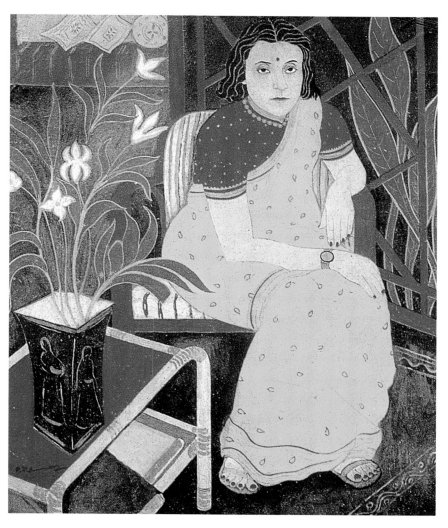

135
REDDY, P.T.
Portrait of Mrs. Krishna Huttee Singh
71x61. Oil, 1942
NGMA

Most of this activity continued amid a dearth of public patronage. Indian connoisseurs such as Homi Bhabha and the novelist-art historian, Mulk Raj Anand (b.1905), were the rare exceptions who merged pioneering patronage with their own creativity. M.R.Anand's artistic contribution range from his editorship of the MARG magazine & Sadanga Series, to the organising of significant exhibitions, such as George Keyt's Bombay show in 1947, to his later Chairmanship of the Lalit Kala Akademi, among other activities.

The significant influence of a few Jewish immigrants who came to settle in Bombay during the late 1930s needs to be highlighted. Kathe and Walter Langhammer (Painter & Art Director, **Times of India**), Rudolf von Leyden (Art critic, **Times of India**), and E.Schlesinger (patron), among others, formed an essential link between the artist, critic and patron. They purchased indigenous art and introduced the young artists to the expressionist art of Europe, such as Kokoschka, Rouault, Modigliani, and Klee.

Soon a new generation of artists would give renewed momentum to Indian modern painting, partly as a result of these infrastructural efforts.

1948–55
Energy, Infrastructure & Freedom

[64] J.Appasamy's term, *Twenty Five years of Indian Art.* LKA, 1973.

136
ARA, K.H.
Bathers
Oil, c.1948
Private, Bombay

[65] G.Venkatachalam, *Hebbar.* Bombay: Nalanda Publications, May 1948.

[66] "...the artist must discover himself an appropriate form of self expression which will be not less different from modern Western than from ancient Indian art. But how can he develop his personality, how can he find his own style form when we try to enforce on him either a foreign style as 'modern' or an archaic one as 'national'? How can we evolve a modern Indian art when our official exhibitions stigmatise any new experiment and any personal expression which deviates from the old traditions, as 'foreign' and relegate the work to the foreign section." [Dr.H.Goetz, 'Whither Indian Art' *Marg*, 1.2 (Jan 1947): 88]

[67] The founder members included: S.Kramrisch, Mulk Raj Anand, Dr.Shahid Suhrawady, Dr.Nihar Ranjan Ray, Barada Ukil, BC Sanyal, Kanwal Krishna, G.Venkatachalam, Kekoo Gandhy, R.S.Raval, Manu Thacker, among others.

[68] Sailoz Mookherjea, "Sailoz Mookherjea: A Memory", by A.S. Raman, *IWI* 1964. Rpt. in *The Critical Vision*, New Delhi: LKA, 1993. p30

[69] Arpita and Paramjit Singh, conversation with author, New Delhi, May 1995

1947 was an arbitrary line for an inner creative journey, despite the profound changes it may have symbolised. As a result both the sense of disruption and continuity prevailed within the work of certain 'artists of transition'[64]. Most exuded a sense of joy in their expressionism, focusing on the lyrical nature of the line and an outburst of warm colours.

Artists such as B.C.Sanyal, Sailoz Mookherjea (1906-60), N.S.Bendre (1910-92), K.K.Hebbar (1911-96), K.H.Ara (1913-85), Shiavax Chavda (1914-92), Gopal Ghose (1915-80), and Vajubhai Bhagat (1915-92), best exemplify the spirit of *joie de vivre* during this transition, focusing on themes such as oneness with nature, rural serenity, and the shared rhythms with music and dance.

However the merger of artistic *ananda* with the contemporary trauma proved difficult for many. Various art commentators of the time, were far from convinced of the 'modernising' process. For example: " Plastic form, which is merely a sensible correlation of line, colour, light and mass to produce the desired effect, is nothing mysterious after all. Primitive art is full of it. Why then this eagerness, this unholy joy on the part of the Modernists to show the worst in man in this manner and under the cloak of art? Why reveal the baser and bestial side of man through art?...I must confess that I do not see anything really great, enduring or inspiring in Modern Art except clever technique and the skill of the artist. There is no beauty, no vision, no humanity, nothing worth while to make it immortal."[65]

However many artists tried to see the middle way, giving the East-West oscillation a renewed swing. However, exploring this East-West merger, once again faced numerous infrastructural constraints, making artistic choices even more difficult.[66]

The AIFACS, B.A.S. and Calcutta Art Society (C.A.S.) network was not facilitating the required patronage and encouragement. The setting up of the All-India Association of Fine Arts[67] on 25th March 1947 heralded the infrastructural thrust and in-fighting which would continue within our country, up until today. This body sought affliations with other existing groups, but the venture failed to provide a viable national alternative. Eventually the Lalit Kala Akademi would become the official body which would try to integrate the national art infrastructure.

Regarding the 'artists of transition' Sailoz Mookherjea's artistic spirit represented certain rural themes with a kind of necessitated faithfulness before 1947. After a few years of Parisian education a spontaneous joy emanated from his free flowing lines and colour play as in works such as **Shehnaiwala**: " I owe my basic inspiration to Matisse's odalisques. I accept whatever new forms of self-expression suit my oriental temperament and tradition. No doubt my simplification of form and vibrancy of colour derive from the Ecole de Paris...but my main influences are the folk art of India and the Basohli miniatures.[68]

Further, Sailoz's influence as a teacher at the Sarada Ukil (during the late 1940s) and the Delhi Polytechnic needs to be highlighted. For example, his ex-students, now respected artists – Arpita & Paramjit Singh, state: " Actually he (Sailoz) made us conscious of Western art, the individual's importance in art, the modern media and the importance of colour and its application in the modern context."[69]

137
MOOKHERJEA, Sailoz
Shehnaiwalas
86.3x132.1. Oil, 1957
NGMA

[70] " Chavda's art had hitherto sacrificed the essence of things to their lively, beautiful surface and had, thus, presented us with that joyful lightness, that harmonious freedom which makes, for example, the art of Matisse or Duffy so enjoyable." [H.Goetz, *Chavda. LKA*, 1960]

[71] Karl Khandalavala, JG ExC. March 1981

K.K.Hebbar's early oil on canvas works such as **Pandits** (1948), following his small-format tempera works, such as **Cattle Mart** (1942) and **Festival Dance** (1945), revealed a powerful sense of colour, which was to dominate his later art along with his lyrical line, trying to invoke, as with the work of S.Chavda, the maximum sense of movement through using the minimum amount of lines. Chavda's early Parisian education and his stage designing apprenticeship with Leon Bakst further refined his visual sense of linear rhythm, rooted in traditional Indian dance and music.[70]

In Vajubhai Bhagat's art one found a rare aesthetic sensibility, rooted in a traditional decorative art language while contemporary in spirit. He was capable of finding inspiration from seemingly mundane activities: " Life does not consist only of great events. Much of its joy can be derived from trivial things we witness day-to-day,...'Flower sellers in Lohar Chawl' or 'Grant Road Station', equally alike, intrigue the artist. Vaju Bhagat is not concerned to propogate profound truths for he is not a painter with a mission,...he delights in things of a simpler order..."[71] He translated routine themes into a miniature two-dimensional world, with a sense of humour and keen observation. The murals of Pandan-Singha, Nana Rajkot, and Sihor (visited in 1943) along with the Jain miniatures at the Baroda Museum further moulded his jeweller's sense of design.

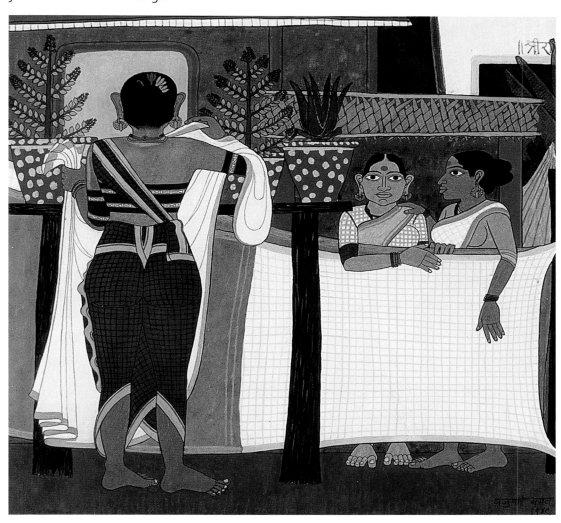

138
BHAGAT, Vajubhai
29.2x30.5. **Fisherwomen**
Tempera, 1949
Bhagat Family, Bombay

However, the urgency necessary to give a greater jolt and momentum to the movement of Indian modern painting came from the Progressive Artists Group (P.A.G.)(1948-56) whose sense of continuity was overwhelmed by their need to disrupt.

P.A.G. Members (1948)

[72] " What drew us together was an idealism by which we wanted to produce a new art...a new art which was entirely Indian plus it was modern. At this time, there were hardly any books available, ...all the books were small black and white copies..." [F.N.Souza, conversation with author. New Delhi, 6 Sep 1993]

[73] " Art has always been an elitist activity. Always, and appreciation by the elite for the elite. It was always been commissioned by the elite and purchased by the elite. Common people don't really enjoy art. When we were in the PAG we arranged exhibitions in dense labour areas like Parel. We did it for the fun of it. Finally, the response was from those with money." [F.N.Souza, interview with S.Balakrishnan, IWI 21 May 1989 Rpt. in CCA Annual (1990-1).]

[74] Eg: He left India in July 1949 after the police raided his studio in search of 'obscene' paitings. In 1954 he exhibited in a group show at the Institute of Contemporary Art, London, besides P.Picasso, Henry Moore and George Sutherland; in 1955 he was part of a group exhibition besides F.Bacon and J.Dubuffet. He won the John Moore Prize from the Guggenheim Foundation in 1957.

F.N.Souza (b.1924), S.H.Raza (b.1922), K.H.Ara (1913-85), M.F.Husain (b.1915), H.A.Gade (b.1917), & S.K.Bakre (b.1920) were the original members. They emphasised a new conceptual freedom in the use of colour, allowing it to express their individual pent-up emotions, desperate to break with the past orthodoxies. The expressionism of Rouault, van Gogh, Klee, Modigliani, in vogue in Paris during the 1940s formed the inspirational basis of this artistic thrust.[72] Though they tried to reach the common man, this was not a deep-seated belief in the thinking of their spokesman.[73]

Souza's confident ability to transform his erotic-religious feelings into a wild-discipline of expressionist drawing and pigment handling, brought him significant international acclaim by the 1950s.[74]

139
SOUZA, Francis Newton
Mystic Repast
Oil on board, 1953
Private, Paris

At the root of Souza's art is an intense evolutionary self-belief which has been able to transform potential aggression and torment into a refined flow of creative rhythmic 'friction'. Though his early work, had focused on the suffocating nature of religious values, and its taboos against sex, it was during the 1960-70s that his sexual fever would be harnessed so that one could arouse erotic tension even from still-lifes or landscapes.

No contemporary Indian painter has managed to discipline and sustain such a passionate obsession through creativity.[75] His early writings, though more deliberate, also revealed this feverish wish to just flow with his artistic impulse: " I'd want my language to ooze out of my mouth naturally, pure like a bubbling spring, a fountain spurting out, its source embedded deep within the crevices of pristine music,...A drunken state is when humility escapes and remorse sets in...But it is really a state of humiliation more than anything else, and at such times, truth comes crawling out like a maggot out of the dead or out of dung... I was a blooming maggot on a dung heap.. That's exactly from where I originated."[76]

K.H.Ara's art, in evident contrast to Souza's angst-burdened work, was rooted in the joy of creativity. However, like Souza, he also focused on a few themes, such as the nude, human figure studies, and still-life compositions. On the surface it seemed an art not capable of progressing through an inner self-criticism, too preoccupied with the simple joys of creating, in awe of being lucky enough to be allowed to create. Yet there was a uncommon discipline, a willingness to learn, to understand the structure of this instinctive weapon he uses. The way he 'systematically studied the female form' marks him down as a pioneer, apart from the infrastructural boosts he gave Indian contemporary art, through his ability of bringing people together.

Like Souza in 1949, Raza would also leave India (1950). Unlike Souza, Raza was never able to give the human figure any role in his art. Even before his abstract work (1955-6), his landscapes and cityscapes work denied the relevance of the figure. The 'tenacious' childhood memories of the darkly silent Madhya Pradesh forests have been an abiding source of inspiration.

On arrival in Paris there was a greater emphasis, towards a hard-edged geometry, where the house acted as the transitional motif. In France, Raza's search towards a form-content unity, nurturing his tussle between a free colour play and the geometric discipline of the line, deepened. By the early 1970s this need to reconcile seeming contradictions would lead Raza into seeking inspiration from the pictorial language of the Neo-Tantric art forms and its philosophy.

Like Raza, Gade allowed his conceptual framework to discipline the intuition. His scientific background led him to express his colour sense through a range of minimalised and simplified forms, (the motif of the house served Gade, as it did Raza) which also reflected his leaning towards certain aspects of child art. Yet in 1948 he was at a loss, like so many others, to understand the nature of his art: " ...the painting was so different, so unrelated to the feelings inspired by the atmosphere, so detached from the image at the back of my mind, from my vision...For the first time I realised a disparity between what I felt and what I saw. It was the beginning of the creative experience."[77] Yet by the late 1950s he was more aware of his artistic direction, and its intuitive-logic dilemma: " I am scientific in my temperament... I think quite a lot about a painting and rationalise for a long time, but when I start painting it is the emotion at work...As a colourist I owe much to emotion. Perhaps, I have described myself as a dual personality. I believe all artists are. What differentiates the work of one from the other is the emphasis of one of these traits."[78]

[75] Laxma Goud's erotic work of the 1960s–70s in the etching medium is the only comparable collection.

[76] F.N.Souza, 'Nirvana of a Maggot'. First published in *Encounter*, London, February 1952. Rpt. in *Words & Lines*, London: Villiers, 1959.

[77] Gade, referring to his 1948 Onkarashwar on-the-spot painting experiences. *Gade*. Sadanga Series, Bombay: Vakil & Sons, Apr 1961. p3.

[78] *Ibid*.

140
RAZA, Syed Haider
Haut de Cagnes
70x74. Gouache, 1951
Private

141
GADE, H.A.
Yellow & Green
45.7x61. Oil, 1955
Private, Bombay

[79] " My paintings, drawings and the recent paper work has been directly influenced by my experiences of traditional Indian dolls, paper toys,...shapes galore. The experience of being with them and the inspiration to create them are inseparable. A painter is a child in his purity of feeling, for only then he creates with authenticity of his being." [M.F.Husain, *Design* 2.3 (Mar 1958)]

[80] " The modernist painter did not suffer from the anxiety of influence...He was free to choose his roots from among cultures and traditions that were considered alien. What was borrowed was modified. Without any definite break with tradition, modernism in India produced its own tradition. And this tradition has as many faces as there were modern movement makers, for it was made by individuals who had in their work an unmistakable sense of Indian present...Husain's is the most authentic Indian variety of modernism." [K.B.Goel, *CCA Annual*, (1990-91)]

[81] " Once a sign board painter, he is completely self-taught and as such he is not cramped by academic formalism and obtuse theories of painting. In his works the elements of traditional expressionism are the most eloquent. Husain is a great draughtsman, a subtle colourist, a conscientious experimenter and a purist in technique. His influence on the younger generation is apparent. " [R.Bartolomew, *Husain*, R.Bartolomew & Shiv S.Kapur, ed. New York: H.Abrahms, 1971]

[82] M.F.Husain, conversation with author, Bombay, 19 Oct 1993

[83] M.F.Husain, 'M.F.Husain–Contemporary Indian Artists 9', by Vinayak Purohit, *Design* 2.3 (Mar 1958)

F.N.Souza's significance is also enhanced given his pivotal role in introducing M.F.Husain to Indian Contemporary Art. In M.F.Husain one finds the epitome of India's intuitive creative energy. He possesses a sense of the Basohli spirit of colour and spontaneous brushstroke, tempered within a calligraphic discipline; an ability to fuse the innocence of folk art forms[79], music, dance, popular cinema, Indian sculpture, through the nomadic energy of a Islamic-sadhu. All such diversity is made to cohere amid his holistic love for life, and its joyful will to create. Further, his refined intuition is aware of its relative conceptual lacking. Chasing these missing pieces has dictated a few artistic phases of relative compromise, especially in recent years. Yet for any artist whose oneness with their work is so clear, chasing what you lack will result in such moments. Only the truly gifted can readily absorb such moments, thus never having to qualify their art, never having to detach their life from the art, creating strength from weakness. As a result Husain has expressed the diversified-unity we call Indianness, bridging divides such as popular and elite, rural and urban, east and west, like no other artist.[80]

In Husain, representing both the common man and the creative artist, the P.A.G. heralded a whole new freedom for Indian art. Social background had seemingly become irrelevant.[81] With his **Zameen** (1955) winning the first LKNA, his reputation was entrenched: " In this painting I brought the village life together. The other thing was that like the Jain miniatures, the sections idea, but giving an organic feel in which you tell a story. This was the first time I used this method. R.von Leyden referred the work to Beckmann's wild beast force, but at that time I did not know about German Expressionism. After that I got a few books on German Expressionism."[82] With one dose of public recognition, his artistic confidence now aspired to connect seemingly everything which inhabits this world: " My endeavour is to relate the bottle and the tree. Or generally, to make a sensible pattern out of objects which are not apparently capable of sustaining meaningful relations between them..."[83]

This absorption process was not based on some intellectual eclecticism so as to feel the novelty of differences, it was rooted in an intuition which had faith in its

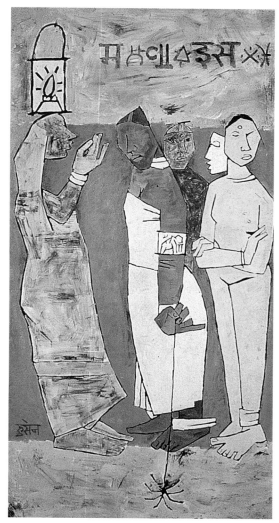

142
HUSAIN, Maqbool F.
Between the Spider and the Lamp
244x122. Oil, 1955
The Artist

84 B.C.Sanyal, conversation with the author, Sep 1993

85 By the early 1980s galleries such as Kumar Gallery, (1955), Kunika-Chemould (1962) Shridharani at Triveni Kala Sangam (1963), Rabindra Bhavan at LKA (1964), Black Partridge (1973) and Art Heritage (1977) had also been established.

interconnectedness with all things, ideas, places. Husain's art manifested this experimental journey of trying to reaffirm the holistic creative force.

With the departure of F.N.Souza, S.H.Raza and S.K.Bakre from the P.A.G, artists V.S.Gaitonde (b.1924), Krishen Khanna (b.1925) and Mohan Samant (b.1926) joined the P.A.G. in 1950 for a short while. Also, by the late 1940s-early 1950s Delhi and Baroda, had begun expanding their infrastructural foundations of art activity.

In post-1947 Delhi, art activity received encouragement through the activities of the Delhi Silpi Chakra and India's first private art gallery, the Dhoomimal Gallery. (Estb. c.1939). The artists B.C.Sanyal, Kanwal Krishna (1910-93), Dhanraj Bhagat (1917-82), K.S.Kulkarni (1918-94), P.N.Mago (b.1925) and others, spearheaded the activities of the Delhi Silpi Chakra: " We decided that we will not seek patronage. You must uphold the dignity of the artist...We would show our work in the park in Connaught Place, each one commenting on the others work and self-criticism, then the consensus would appear,..."84 The group collaborated with a private individual, Ram Chander Jain (Ram Babu), who had an art-accessories shop at Connaught Place. Soon it was transformed into the first private Indian art gallery, Dhoomimal Gallery. Even during 1946, group shows were being informally held at the gallery; with the help of the Silpi Chakra members this became an ongoing and more professional endeavour. Dhoomimal Gallery remained one of the dominant private galleries in Delhi up until the early-1980s.85 With this exhibiting space many young artists, such as Ramkumar, Ambadas, K.G.Subramanyan, Satish Gujral, Bimal Dasgupta, Shanti Dave, and many others, were encouraged and given an initial platform.

Of all the founder artists, Kanwal Krishna had achieved the widest international recognition by the early 1950s. The Italian (1951) and Norwegian (1952) governments had sponsored his artistic travels and studies, and in 1952 he studied under S.W.Hayter for a short while, thus enabling him to become one of foremost printmakers in Independent India. Yet the basis of his technical ability was his fascination with the light which he had experienced during his Himalayan travels, an inspiration akin to N.Roerich's spirit. Also, given the Lahore connection with most of the Delhi Silpi founding members, there was a certain respect for absorbing a craftsmanship within their modern journey, which was lacking in other artists during this time, except those working in South India and a few others such as S.B.Palsikar.

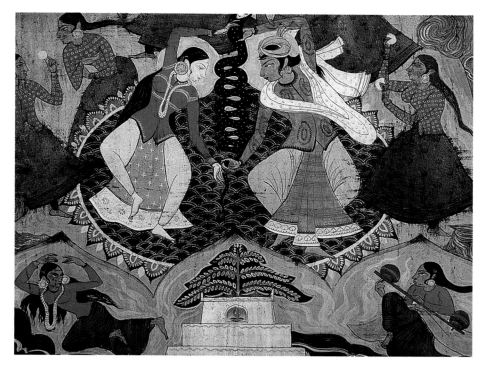

143
PALSIKAR, S.B.
Dancers with Snake
23.5x30. Gouache, c.1953
Private, New Delhi

[86] S.Gujral, *Satish Gujral* from New Delhi: UBS Publications, 1993

[87] "A lot of my works of 1952–55 drawn from ordinary motifs, mother and child, woman at the tap, woman with lamp, or before mirror, fisher folk on Bombay seaside, all pulled in this direction, from a volatile sketch to a stable hieroglyph." [K.G.Subramanyan, BAAC Retrospective ExC. 1983]

[88] He interacted with artists such as V.Pasmore, W.Coldstream, R.Hilton, P.Heron, during his studies here.

[89] Eg: " He delights in ornament, in minute details of jewellery and designs on the garments. On the other hand, both have been moved by the formal strength and simplicity of folk art in their respective regions. The Sukhalis of Rayalaseema may have had the same impact on Sreenivasulu as the Santhals on Jamini Roy. Both have derived sustenance from folk theatre. The *pats*, folk toys, terracottas from Bankura, Birbhum & Midnapur fascinated and effectively determined the very personal style of Jamini Roy, just as the Kondapalli & Tirupati toys, the leather puppets & temple painting moulded the style of Sreenivasulu. Lepakshi played the same role in determining Sreenivasulu's early style as the terracotta tiles of Vishnupur & Danihat sculpture did in the case of Jamini Roy." [S.A.Krishnan, *Sreenivasulu. LKA,*1966]

[90] Also an 'artist of transition', but one whose work during the late 1940s/early 1950s carried a grim social comment rather than a joyful expression of, say, rural or folk life, as expressed by Sreenivasulu.

[91] KCS Paniker, *LKC* 12–13 (Apr–Sep 1971): 11

[92] He became Dean of the Fine Arts Faculty, 1959–66, after the departure of Markhand Bhatt.

[93] Later he would become Dean of the Fine Arts Faculty, Baroda [1968–80] and at Kala Bhavan, Santiniketan [1981–]

[94] " Before the inception of the college at Baroda, the only two methods of art teaching prevalent in art schools were either the European academic and the so-called traditional. Both these approaches were too narrow...The approach adopted at Baroda does not recognise national boundaries in art...It is above all based on the primeval human urge for creativity. It accepts the fact that every human possesses the creative faculty. Provide him the suitable environment and proper equipment so that it can emerge out of him, grow and fructify." [Ratan Parimoo, *Selection of Essays on Modern Indian Art*. New Delhi: Kanak Publications, 1975]

[95] Eg: J.Sabavala (arrived 1945, England–Paris); N.Mazumdar (1946, Paris) F.N.Souza (1949, England–New York); S.H.Raza, Ramkumar, Paritosh Sen (1950, Paris); L.Pai, A.Padamsee (1951, Paris); S.Gujral (1952, Mexico); N.Mohammedi (1954, England); K.G.Subramanyan (1955, England); Sakti Burman (1955, Paris). N.S.Bendre, K.K.Hebbar, K.C.S Paniker, M.F.Husain, & Chintamoni Kar, among others, also briefly travelled out of India for the first time during this period.

For example, as Satish Gujral points out: " In contrast to the flagrant indifference towards craftsmanship that had been the hallmark of the work created by the Revivalists and the emergent group of progressives (P.A.G), Mago's work was gifted with as much technical competence as with contemporary flavour and ingredients. It was a modernity that I considered indigenous...Mago and Jamini Roy exuded not only a freshness, but also the smell of the soil I knew so well."[86]

One of the few artists who has been able to conceptualise and creatively absorb the living roots of the craft traditions within the Indian folk-tribal-urban continuum is K.G.Subramanyan (b.1924). Yet this focus came to maturity only by the early 1970s, after much experimentation and travel. The seeds were probably sown during his childhood in Kerala (1924-43) and during his students days at Santiniketan (1944-50). His early student and teaching experiences in New Delhi (1950-51), Baroda (1951-55; 1961-80)[87], Slade School of Art, London (1955- 56)[88], and Bombay (1957-61, at the Weavers Centre) provided him with an authentic vision which could fairly scan the whole country, encouraging an open national perspective which calmly assimilates international inspirations, merging all such geographical and local factors towards an individual creative journey, which tries to fuse the creative with the educational and infrastructural.

Naturally, many South-based artists shared this respect for craftsmanship and the decorative lyricism of the line. K.Sreenivasulu (1923-94) was the foremost artist who represented the romantic strain of craftsmanship, despite the formal influence of Jamini Roy being pivotal to his work.[89] An artist such as K.C.S.Paniker (1911-77),[90] though respecting the South Indian craft traditions (especially after the late-1950s) initially expressed a social concern through his sombre expressionistic art, with paintings such as **Blessed are the Peacemakers (1951), December & Pavement Dwellers** (1952). Nevertheless, as with most true artists, this phase proved temporary, a reflection of reacting to the times rather than any inner compulsion. Also for Paniker, the inspiration of Western modern art would soon wane, as he began his search for a contemporary Indian pictorial idiom: " To me the Modern art of the West had as early as 1956 ceased to be, a living or vital source of inspiration capable of sustaining me further. I had to begin afresh."[91]

All this creative activity in the main metropolitan centres was only informally building up an art infrastructure.

It was in Baroda that the M.S.University, a modern educational institution devoted to the Arts was established in 1950, under the leadership of Markhand Bhatt, Hansa Mehta, N.S. Bendre (1910-90)[92], and Sankho Chaudhuri (b.1916); K.G.Subramanyan joined them as Reader in 1951.[93] The M.S.University soon became a leading academic institution for the arts in India. It introduced aesthetics, psychology, music and history of world art into its curriculum, while also trying to achieve a greater inter-relationship between the various faculties.[94] Some of the early students who graduated from M.S. University included: G.R.Santosh (b.1929), Shanti Dave (b.1931), Himmat Shah (b.1933), Jyoti Bhatt (b.1934), Ratan Parimoo (b.1936), and G.m.Sheikh (b. 1937). Each of these artists would significantly contribute towards the fuller development of Indian Contemporary Art, either through painting, printmaking, sculpture, photography, art criticism, education, or by a combination of these disciplines.

The opportunity to study and exhibit abroad had increased significantly after Independence. There was a swell of artistic impatience desperate to know about European modern art. Anyone who could muster funds went travelling abroad, many cultivating a sustained education.[95]

The main early lessons which were imbibed from the various Western 'isms' and art techniques were: a greater emphasis upon the material medium, its inherent creative possibilities and the importance of aesthetic autonomy; a need for intellectual discipline so as to strengthen the intuitive and emotional base; and a greater respect for the intellectual role of an artist in society.

By the 1940s Cubism had become a standard academic subject in Paris. Artists such as Paritosh Sen (b.1918), J.Sabavala (b.1922), and Ramkumar (b.1924) were exposed to these tenets directly under the tutelage of Andre Lhote, one of the chief protagonists in transforming cubism into its academic orthodoxy.

Awe and confusion initially marked the response of most Indian artists facing the wealth of Modern European Art hanging in centres like Paris. There had been no comparable experience of seeing actual works on this scale: " When I arrived in Paris I was a little confused. You see, suddenly I was confronted with a world which overwhelmed me because before that I had never experienced such a fantastic exposure to modern art. I gradually began to determine what I thought was good, relevant to my work, concentrating on works of a few artists who I thought represented modernism in most aspects: Picasso, Braque, Matisse, Rouault, Chagall, Kandinsky and Klee. Towards the end of my stay I began to get a glimpse of the American Abstract Expressionism. Yet I have always been interested in the human condition and so abstraction never took root as an idea."[96] For Paritosh, acquaintance with Picasso, Brancusi and the Huxley brothers proved fruitful, helping to harness the intellectual rigour which allows creativity to objectively source from any corner, while maintaining one's inner stubbornness so as to mould such corners into one another.

It took Jehangir Sabavala nearly fifteen years since beginning his Cubist studies (1949) to evolve his own style, which eventually fused a gentle romanticism, a love for nature, and a longing to belong to some peaceful land, within a re-moulded cubist framework, somewhat similar to Feininger's mood. Like with many other young artists, the positive dialogue with Charles Fabri, a respected art critic, proved helpful in clarifying his artistic choices: "He (Fabri) was trying to tell me that either you proceed and work in depth, in say the school of cubism, or if you can't then full stop. Or are there other facets to your personality, if so, discover them, search as best you can, experiment and see if something comes. I took his word seriously, and it took me a long time to see that the paintings were growing softer, that more emotional content was coming through, that my palette was changing."[97]

Ramkumar had the privilege to also study under Fernand Leger. Upon returning to India he began depicting the social injustice of the times, focusing on themes such as the alienation suffered by the urban middle classes, young unemployed graduates and the like. These issues were structured using an expressionist figuration within a loose cubist framework. The influence of Mascaccio and Modigliani was also clear in the earliest figurative studies. Further, his emotional intensity allowed a fairly swift absorption of Cubist techniques, which unlike with J.Sabavala, held no deep curiosity for Ramkumar. With time he would progress into an abstract idiom, using the city of Benaras and the stark Greek landscapes as transitional triggers, linking the figure to his inscapes.

Like Ramkumar, Satish Gujral (b.1925) also received encouragement from the Delhi Silpi Chakra in his early days. Unlike Ramkumar, his artistic journey has been dominated by experiments with different media. Before leaving to study mural painting under D.A.Siquieros in Mexico (1952-54), he held his first solo show in Delhi (1952), a revealing prelude to the powerful figurative work which he produced after returning from Mexico and New York.

[96] Paritosh Sen, conversation with the author, Calcutta 19 Aug 1993

[97] J.A.Sabavala, conversation with the author, 9 Jly 1993

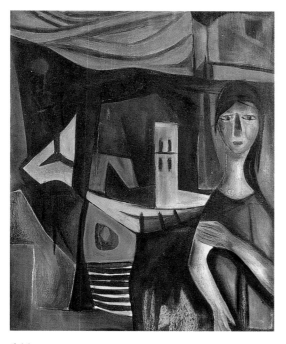

144
RAMKUMAR
Prisoner's Dream
65x52.5. Oil,1950
Jehangir Nicholson Museum, NCPA

History: An Essay

98 " It is wrong to believe that the function of art is to make people happy. Art makes us neither happy nor miserable. Art stirs. It elevates man, even the most tragic art. Art does not offer a gospel. It frees your spirit to enable you to find a truth for yourself. Art speaks to the spirit. If I can create the stir then I am an artist." [S.Gujral, 'Satish Gujral– Contemporary Indian Artists 10' by R.L.Bartolomew, *Design* 2.4 (Apr 1958)]

145
DE, Biren
Jain Monks
76x61. Oil, 1954
Coll: Chester & Davida Herwitz, USA

99 H.L.Prasher, regarding the 4th Annual LKA National Exhibition, New Delhi. Rpt. in *Design* 2.3 (Mar 1958)

100 "We are aware that the rural milieu and the institution of the village has disappeared but we still paint these, so as to preserve them in the memory of our people...Our paintings reflect our love for the land and our desire to act as recorders of the history and culture of our people." [Lalbriaklara, conversation with Zothanpari Hrahsel. Rpt. in 'Mizos Venture into the Mainstream' the *India Magazine*, 13.8 (Jly 1993): 64]

The main force which revealed itself in Gujral's early work was the manner in which the creative material discipline, came to temper the personal anguish, so endowing it with greater potency. Gujral had grasped the artistic potential of 'giving' a burst of energy to others, hence art's communicative and social validity.[98]

Biren De (b.1926), like Souza, Raza, and Ramkumar, has focused his abundant creative energy into one medium, and that to within a growingly focused range of imagery, in contrast to the range of media handled by M.F.Husain and Satish Gujral. Yet both groups of artists represent the finest examples of artistic integrity and creative individuality, one having found their focus by honing into their inner energy, the other by spreading their energy through a visual and material vastness. De's early stark stylised figurative work, such as **Jain Monks & Vaishnavites** (1954), **Bathers** (1955) & **Sisters** (1956) were by 1957 becoming transformed into free shapes, soon taking him into abstraction which would best reflect his creative uniqueness.

With the Government's First Five Year Plan (1951-56) India adopted a Cultural Policy and initiated the building of a national infrastructure for the arts. Unable to merge AIFACS, B.A.S and the C.A.S, the government established the Lalit Kala Akademi (LKA) and the National Gallery of Modern Art (NGMA) at Jaipur House, New Delhi, 1954. The first LKA National Exhibition was held in 1955 and became a major focus point until the mid-1970s. Yet even by the early 1950s voices of discontent were raising pertinent arguments. For example: " The Exhibition this year, as usual was an omnibus show. The Akademi has no clearcut policy and no criteria before it, its object being to encourage all artists, even those indulging in imitative inanities...At least one hundred exhibits come into the category of the immature."[99]

Nevertheless, the institution has stood the test of time, and continues to provide help via the use of facilities at the Garhi Artists Studios, New Delhi, and the various regional centres; its exhibition halls at Rabindra Bhavan; a poor reference library facility; and now and again it publishes various artist monographs and exhibition catalogues. However, their well-edited journal, the *Lalit Kala Contemporary Journal*, has been a unique saving grace. Yet on the whole, the Lalit Kala Akademi is perceived to have become an infrastructural failure. It is imminent that an alternative will have to be created or a radical overhaul implemented.

The unique Jehangir Gallery in Bombay was established in 1952, essentially with the patronage of Sir Cowasji Jehangir and the Parsi community. Its value lay in its democratic system of allowing any artist to book the exhibiting gallery space for a fixed period. Naturally it attracts plenty of mediocre work, but such a trade-off can still be considered acceptable in a system where finding, nurturing and promoting talent is most ineffective.

It would take a long time before other smaller centres (eg: Hyderabad, Calicut, Bangalore, Jaipur) would evolve an art infrastructure, given the lack of an integrated approach. In some regions their rich creative heritage has still received no encouragement, for example the North-Eastern region of India. Creativity is sustained here only because it is at the root of daily life, not because the infrastructure is fulfiling its role. Recent exhibitions of Mizoram and Assam based contemporary artists reveals the artistic potential, hand in hand with their lack of exposure to world art movements.[100]

By the mid-1950s the modern Western abstract idiom had filtered into the contemporary Indian art experience. Yet within a different context abstraction has been long rooted in Indian art traditions.

Sustaining the abstract idiom reflects an inwardness, a belief that the logic which structures this universe and one's mind is not to be predominantly understood by the tangible objects one can construct. Of course painting is locked in by its own materiality. Any glimpse of the intangible can only come by providing a burst of energy, arousing the spectator to share the painter's invitation and maybe the vision.

Abstraction's integrity comes when it has absorbed the outer material images. It is within this absorption of the outer that the abstract finds its relevance. This is the glimpse which the spectator seeks – how a harsh world has been absorbed and transformed by an ideal compulsion. This then is the living force of the abstract focus.

Despite imbibing its visual idiom, the abstraction which evolved in contemporary Indian art did not emanate from a reaction against an entrenched materialist-realist outlook as with modern Western art.[101] The authenticity of Indian contemporary abstraction, comes from a philosophical idealism which no other land has pursued with such committed openness.

The first post-Independence Indian painters to sustain this path were: S.H.Raza (b.1922), V.S.Gaitonde (b.1924), Biren De (b.1926), G.R.Santosh (b.1929), followed later by certain members of the 'Group 1890'[102], such as Ambadas (b.1922), J.Swaminathan (1928-94) and Jeram Patel (b.1930), among others.

S.H.Raza's **Village** in 1956, the year he was awarded the Prix de la Critique,[103] marked the start of his abstraction. The will to encapsulate all within the artistic moment seemed the motivation: " I paint whenever I feel like painting – and the contemplation, conception and execution are more or less simultaneous..."[104]

[101] " ...modern Indian artists, although they accepted the realist aesthetic, never assumed a stolid objective-realist position and, consequently, did not have to struggle hard to break out of its confines. Probably this also accounts for the lack of (or at least, the rarity) of any subsequent preoccupation on their part with problems of non-objective abstraction. They were satisfied to forge visually evocative images; their departure from reality was hardly drastic or complete; and when they used iridescence of colour similar to that of the Impressionists or the interpenetration of planes similar to that of the Cubists, or simplifications or distortions of form, or linearities, or colour constrasts, their purpose and rationale were not comparable to those of their Western counterparts to whom these accrued out of an effort to dethrone the illusionistic objective-realist art concept that had held sway over their minds for over five centuries." [K.G.Subramanyan, *The Creative Circuit*. Calcutta: Seagull Publications, 1993]

[102] 'The Group 1890' was established in Aug 1962, and held its first and only exhibition in October 1963.

[103] The first non-French artist to be presented the award.

[104] S.H.Raza 1965. Rpt. in Gy. CH ExC. Apr 1968.

146
RAZA, S.H.
Untitled
65.5x48.3. Oil & W/c on paper, 1958
Private, New York

[105] Eg: The five elements: earth–water–fire–sky–ether, and their related colours: yellow–white–red–blue–black would conjure various imaginative scenario's for expressing the inspiration of the landscape through the idiom of an inscape.

[106] "It is not that I have nothing to say through my paintings. I may not be making a statement. I don't have to. But what I want to express I strive to say in the minimum of words." [V.S.Gaitonde. Rpt. by D.Nadkarni in *Gaitonde*. LKA, 1983]

[107] V.S.Gaitonde. Reprinted by Foy Nissen in 'V.S.Gaitonde– Contemporary Indian Artists 8' *Design* 2.2 (Feb 1958)

[108] " Something in his (Klee's) use of the line excited me; I gradually came to identify myself in his work. I liked Klee's imagination and fantasy; also Rouault's broad planes and luminous colours." [V.S.Gaitonde; *ibid*]

147
GAITONDE, V.S.
Untitled
37.5x45. W/c, 1952
Jehangir Nicholson Museum, NCPA

[109] Biren De, 'Evolution of my Art', *LKC* 32 (Apr 1985): 34-9

[110] Biren De, conversation with the author, Delhi, 9 Sep 1993

[111] Keshav Malik, Times of India, 26 Feb 1965, regarding Biren De's Feb. 1965 Kumar Gallery Exhibition.

Soon the geometric emphasis of the suspended house motifs during the early 1950s would be transformed into a free expressionist structure, dominated by the movements of colour. Thus once again an oscillation between the logic of linearity and the intuitions of colour play would direct Raza's evolution. The work of the 1960s to the late-1970s would best reflect this tussle, with the joy of colour's intensity dominating the canvas hand in hand with the use of certain artistic implications of neo-tantric symbolism.[105]

V.S.Gaitonde's (b.1924) break with representationalism came in 1957. After experiments with serigraphy and ink-drawings during 1956-7, he was creating fields of single colour, disrupted with a horizontal band in heavy impasto. There was a stark evolving attitude towards renunciation. The later affinity with Zen deepened the contemplative aspect in his art. Philosophy was transformed into pattern through the authenticity of an artistic compulsion, which needed to discipline and reaffirm thought through form.[106] Soon the momentary emphasis within creativity came to dictate Gaitonde' manner in which all sources of inspiration were absorbed with clarity. For example, the Basohli and Jain Miniatures impressed Gaitonde, " ...by the elements of design and colour in them as paintings, not as tradition."[107], as equally as the works of say, Paul Klee.[108]

Biren De's figural disintegration received public acclaim with the painting: **Apparition** (1957). By the early 1960s the ongoing Neo-Tantric awareness merely accelerated the change in an already existing search. A few years later the artist clearly explains this instinctive evolution: " From around the end of 1956 the human figures in my compositions started getting disembodied and turning into free shapes and units; but the shapes continued to be reminiscent of known images...But the most important development in my paintings at this period was the appearance of streaks of light in the distant horizon... So the original characters enacting the drama of my canvases – the man and woman – became heavy black, brooding shapes. And these shapes were placed on a darkbrown foreground denoting earth...out of all these ingredients, at the end of 1959, emerged two major signs (or symbols) one (U-like) representing the Female principle and the other straight and wedge like representing the Male principle. From 1960 onwards my work has sought the unity of these two, by arranging and rearranging them over and over again, and placing them alongside other fundamental shapes – the ancient circle and the square, cylinder and parabola."[109]

A visit to America in 1959-60 on a Fulbright scholarship revealed his artistic dilemma: " The American scene, in general, made a resounding impact on me... Initially what I saw unsettled me very much. When I could, I stood away from all this and started reflecting on everything. The introspection led to a strange feeling...I felt I should reject everything, to start afresh, to reassure myself ...I had to reject both the figurative and the abstract... to be myself, with a sense of calm and tolerance."[110]

Keshav Malik was one of the first critics, along with Richard Bartolomew, who had grasped the unique journey embarked upon by the artist: " Biren's compositions are far more definite than before. They carry conviction. They would perhaps properly be described as abstract, but they are no mere shots in the dark...whether or not their message is explicit, its implicit force does not fail to make its mark. The work has the balance of a pair of scales. The lines are stark, strong and simple. It has the force of geometry. The whole series is a loving recapitulation of the mystery of Being. The symbolic recreation of the solar system. The purity of light in Genesis 1 (1963) is like a prayer. One must not read too much overt meaning into the confrontation of symbols...but sense the silence that was at the beginning of the world, and that which will be there at its end."[111]

His later imagery, effusive with the origins of light and its energy, has few comparisons with any contemporary art. It reaffirms the ancient joy of merging the ascetic way of life with the eroticism of the tribal aspect, through the intellectual heat of the restless romantic. It reveals an inner journey, sustained to the point where pain and joy, movement and stillness, art and life, are fused.

G.R.Santosh was a student of painting, weaving & papier mache (1954-6) with N.S.Bendre when the Baroda Group was established in 1956. To experiment with abstraction was one of the main tenets of the Group's direction.[112]

112 " To me creative art demands transforming raw materials from surroundings observed deliberately or by chance into an integrated whole. The process has meaning and purpose ...all great works of art according to me have abstract considerations at the root of the process, such as establishing aesthetically desirable relationships of parts with the whole" [N.S.Bendre, *Artists Today: East-West Visual Encounter*. Bombay: Marg Publication, 1985 p106]

For G.R.Santosh, whose inclination was towards the landscape, philosophy, poetry, and the man–woman relationship, the early abstraction seemed the ideal idiom. However, despite a delicate play with colours and texture, the involvement seemed insufficient for him. By 1965 he had stopped painting, seeking a resolution to his questions in other disciplines. However, after three years Santosh returned to paint his **White & Red Series** (1968), a transition towards his later appropriation of an ancient philosophical tradition, so placing himself at the vanguard of the movement which sought inspiration from tantric diagrams, rituals and insights.

A similar mystical resolution was sought by Ambadas and J.Swaminathan from their art. The convoluted grid of fluidity which Ambadas created in his large oil on canvas and small–format watercolour on paper works during the 1960s, reminds one of a restless freedom which wishes to discipline itself, though realising its unending swirl. Form emanates through this tussle, as rest is found within perpetual unrest.

Like most, Swaminathan, initially found it difficult to creat new artistic norms and idioms despite being dissatisfied with the prevailing art. As the spokesperson of the 'Group 1890', his rhetoric illustrated his intentions, and its struggling idealism. For example: " The artist does not communicate an experience or an idea. The act of painting is itself experience to him. The viewer has not to look for communication, he has to be in communion with the work of art. It then becomes...a thing of wonder, as when a child first opens its eyes to its surroundings."[113]

113 J.Swaminathan, Kunika–CH ExC. Dec. 1962

Nevertheless, as Swaminathan sustained his vision, the instinctive creative impulses, which he had wished to express, slowly transformed themselves into a compulsion. To recreate the very aura and myth of ritual which the American Abstract Expressionists had set themselves was being done with authenticity by someone like Swaminathan.

Hand in hand with its creativity, the Bombay art infrastructure was witnessing increased activity as professionals and enthusiasts tried to create platforms for promoting Indian contemporary art by the late 1950s. Bal Chabda's 'Gallery 59' (1959-61) represented a passionate but short–lived attempt to provide an exhibition space at the Bhulabhai Desai Institute for artists such as M.F.Husain, V.S.Gaitonde, T.Mehta, A.Padamsee, A.E.Menon, N.Mohammedi, P.Pochkhanwala, and others. It was this kind of special enthusiasm which helped the artists sustain their journey in an environment of public indifference.

MF Husain, A.Padamsee, & Bal Chabda

114 Regarding the nature of the collector, E.Alkazi states: " ...One acquires art works to satisfy an inner need that goes beyond acquisitiveness...They should give him the same sustained joy, stimulation and solace that one discovers in a soul- companion...They should widen one's horizon, stir one's deepest emotions, and, through the values and attitudes enshrined in the work, give one a sense of upliftment and release." ['Notes on Masterworks from Alkazi Collection' AIFACS ExC. 16-30 Nov 1995]

Ebrahim Alkazi, who was running his theatre company at the Bhulabhai Desai Institute during the 1950s-60s, became one of the rare serious gallery owner-cum-connoisseurs of Indian Contemporary Art, grasping the holistic nature of its creativity and the need for accompanying infrastructure building. The idealism and disciplined passion with which he has tried to nurture artistic talent knows no comparison. Together with Mrs.Roshan Alkazi, they would manage the Kunika-Chemould, the Black Partridge & the Art Heritage Galleries with a rare professionalism and integrity.[114]

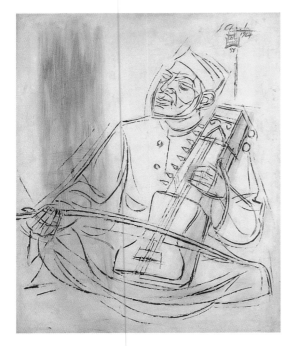

148
CHAVDA, Shiavax
Sarangi Player: Khan Shaheb– Ghulam Sabir Khan
76.2x61. Oil, 1964
Jehangir Nicholson Museum, NCPA

115 G.M.Butcher, Tyeb Mehta: Gallery 1 ExC. London, Jly 1962. Rpt. in *Kunika–CH ExC*. March 1970

Kekoo Gandhy's infrastructural-building efforts also started in those same early years of the mid-1940s. His journey has also been rooted in an integrity devoted to an aesthetic fulfilment and its practical realisation, as it was with Kali Pundole. Their dedicated work in Bombay was implemented through the galleries: Chemould (Estb:1963) and Pundole (1964) respectively.

In 1956 the 'Bombay Group' was formed as the P.A.G. dissolved. Once again K.H.Ara proved instrumental in bringing artists together. K.K.Hebbar, S.Chavda, D.G.Kulkarni, H.A.Gade, B.Satwelkar and Mohan Samant were the other members. The group received valuable patronage from Homi Bhabha and his association with the Tata Institute of Fundamental Research (TIFR), as well as the support of the **Times of India** Group.

The main intent of these artists was to establish some kind of deeper East-West fusion, which would go beyond the East-West difference; a difference which had been highlighted in the early years after Independence. However, as with most groups, they carried no coherent manifesto. The group was simply a collection of individual artists trying to alleviate the alienation, trying to be modern, to be Indian, to be themselves. Each differed only in the degree of discipline the material medium placed on their emotional expression.

It was during this period that two of our foremost artists, Tyeb Mehta (b.1925) and Akbar Padamsee (b.1928) were establishing their unique imagery. In Tyeb Mehta's art we find the subordination of personal anguish to aesthetic maturity and its material discipline, culminating in a few powerful images, over the years such as the trussed-bull, the falling figure, the rickshawala, Mahisasuramardini, and the Goddess Kali.

His stay in London, (1959-64), while working in a morgue and facing various personal tragedies, probably instilled a Baconian mood which cannot help but pervade his art, reflecting the quiet sadness which many artists of his generation shared. Yet he possessed that rare courage which realised that obedience to one's art implies a fearlessness.

Each obstacle was transformed into a source of inspiration. The agony of daily fragmentation was disciplined through the prevailing norms of expressionism, using thick impasto applications with its heightened textural focus. " He (Tyeb) uses oil paint as though born with it. He constructs his image with the intense logic of a de Stael, of a Cezanne. He makes absolutely no gimmicky use of his national origins... Nevertheless, it is Tyeb's profound sense of personal identity, of national origin and of voluntary exile, which gives him an unfailing ability to depict compassion...Tyeb is a painter among painters. His roots draw substance from both East and West; and he is, himself, of neither – or of both."[115]

149
MEHTA, Tyeb
Untitled
122.5x147.5. Oil, 1966
Jehangir Nicholson Musuem, NCPA

[116] A.Padamsee, 1965. Rpt. by Ella Datta in 'The Spirit of Order', *AHJ* 8 (1988-9): 43

Akbar Padamsee's early still-life work of the 1950s also possessed the heaviness of texture, directed by an inch by inch fascination with the process of creativity, to capture the underlying grid which structures the surface: " Order does not belong to the picture-space but to the act. Order cannot be given as one arranges furniture in the room. If the act is not in the spirit of order it cannot impart order..."[116]

Few have been able to reveal the mathematical coldness of a landscape hand in hand with the mysterious oneness humans feel for their earth. The passionate-detachment which allows this feeling for the land, as if a human companion, is the evolving thread of Akbar's artistic wisdom and its materialist philosophy.

150
PADAMSEE, Akbar
Juhu
121.9x610. Plastic Emulsion, 1960
M.F.Husain

[117] Eg: " Because of an entirely different teaching programme, a new type of artist has come into being– one who thinks in terms of the pictorial form and not in a national style. He does not know any geographical or time barriers in art. For him, an Indian scuplture or Brancusi's 'Bird', a primitive African carving or a Greek statue, a Jain miniature or a collage are only different means of expression...(yet) Too much concentration on the surface and on the formal design has resulted in a certain impersonal quality and calculatedness. One misses the Expressionist eruption or the involvement of the subconscious." [R.Parimoo, 1965. Rpt. in *Studies in Modern Indian Art: a collection of essays.* New Delhi: Kanak Publication, 1975]

[118] He became Principal of MGAC in 1957

[119] *Artrends* 1.1 (Oct 1961) An Indian quarterly art bulletin published and edited by P.V.Janakiram (1930–95) for the Progressive Painters' Association, Madras

Both Tyeb and Akbar, along with a host of other artists, such as M.F.Husain, S.G.Vasudev, P.Kolte, acknowledge their debt to S.B.Palsikar (1917-84), an influential teacher of Indian Contemporary Painting. His inspirational force came from uncompromisingly trying to unite life with his artistic thinking, absorbing the sacred with the decorative, the artistic with the philosophical. This same fusion was in clearer evidence in the brilliantly intricate work of J.Sultan Ali (1920-91).

The underlying spiritual purpose of art as emphasised by S.B.Palsikar and J.Sultan Ali was naturally different from that found at Baroda. Here Palsikar's teacher, N.S.Bendre and others, were focusing on the underlying material tenets of modernism.[117] K.G.Subramanyan's second stint at Baroda, witnessed his experiments with the abstract idiom, mostly as a result of the influence from his Slade School experiences. Soon this curiosity waned and he returned to media closer to his local roots, but within an evolving universal vision.

Another teacher who created a unique direction and imagery for himself and his students, was K.C.S.Paniker. His influence on various south-based artists[118] proved pivotal, given the creative freedom he and his colleague, Dhanapal (b.1916), allowed their students.

In February 1964 they established the Cholamandal Artists' Village, near Mahabalipuram. The intent of the Cholamandal project was to create an alternative to the artistic derivativeness from Western norms. This was clearly expressed in the first words written in the *Artrends* bulletin: " Life in India today seems to provoke her artists to begin to think more pertinently of their aesthetic requirements, and to evolve in their own minds a clearer picture of what they are looking for in the art of their time. They fairly accept that what passes for modern Indian art in many quarters here is, at best, an almost sterile Indian version of a European way of art expression. It still lacks vital Indian inspiration, which alone can ultimately fuse the apparent contradictions into an acceptable pattern..."[119]

By the mid-1960s a number of talented artists were working in an atmosphere of urgent inner search, focusing on the use of the line, within an idiom which respected the traditional South Indian craftsmanship, especially its decorative aspect, hand in hand with a conceptual rigour.

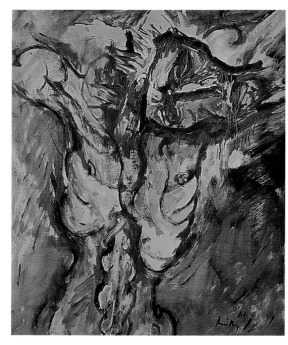
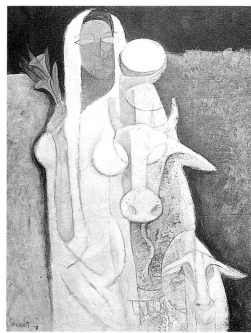

151 (Right)
PANIKER, K.C.S.
Moon on The Cross-A
76x62. Oil,1961
LKA

152 (Far Right)
HORE, Somnath
Companions
117x86. Oil,1960
LKA

[120] He was the Principal of Delhi College, between 1953–60; the Secretary of the LKA between 1960–69

[121] Later renamed Delhi College of Art.

[122] "...it was the sculptural aspect of printmaking that he commenced to develop; not as many other sculptors the repetition of sculptural drawings nor the representation of sculptures realised or to be realised, but rather the plate as a sculpture in itself and its amplification by means of print." [S.W.Hayter, *Krishna Reddy Retrospective, Bronx Museum ExC.*, New York, 1982. p10]

[123] " Water Lilies– so beautiful and radiating– are full of life. I grew up in a village with a pond full of water lilies and lotus flowers. The subject inspired me to develop a whole new way of working the plate and printing in colours. Trying to emphasize the impact of flowers led to the discovery of the contact process. Working the linear structures, penetrating and receding and weaving into flowers was an extraordinary experience." [Krishna Reddy, *Ibid.* p68]

[124] " For me a new form results not merely from the fusion of different formal elements but by the fusion of forces. Unlike man–made architecture, a creative visual form can result from the lines of forces that interpenetrate and recede into space. This whirlpool of interpenetrating forces is what one visually sees as a form, a flower, a star, etc., the form itself completely related with a larger universe. Plastically is it possible to realise this experience? This is my problem at the moment." [Krishna Reddy. Rpt. by V.R. Amberkar, in 'Krishna Reddy' Design 3.1 (Jan. 1959)]

In Delhi, B.C.Sanyal's teaching aspirations, like a few others, focused on trying to increase the interaction between the Fine Arts and Applied Arts Faculties at the Delhi College of Art.[120] One major success was the coming together of Somnath Hore, (Head of the Graphics Dept., 1958-65), Krishna Reddy (b.1925), Jagmohan Chopra, and others to constitute the Graphics Faculty at the Delhi Polytechnic.[121] With both Kanwal and Devyani Krishna joining the Modern School in 1953, Delhi became the leading centre of graphic art experimentation.

Before this, Shantiniketan had played the lead in introducing Printmaking to Indian art education, though most artists were self-taught. Thereafter, the efforts of many Calcutta based artists, especially Arun Bose, proved pivotal for future generations.

Somnath Hore's earliest work was influenced by the need to include a socio-political comment in his art. Later oil works such as **Father & Son** (1958), and **Companions** (1960) reveal the artistic shift which translates passion into compassion while maintaining the material pictorial integrity. However his work in oil had to be sacrificed, to learn printmaking, so as to teach it at the Delhi College of Art.

Visually contrasting with Somnath Hore's untutored work stands the uniquely brilliant graphic art of Krishna Reddy. His early experiences with the sculpture medium very much moulded his intricate graphic images.[122] However, the effect he produced in works such as **Pastorale** (1958), **Water–Lilies** (1959)[123], **Whirlpool** (1962), **Wave** (1963) & **Reflections** (1967) reveal an ability to fuse contradictory forces, amid a mind which cannot help but recognise the unifying 'fuller-full'.[124]

In Calcutta, a new generation were coming into maturity by the early 1960s. They would carry the burdens of a powerful heritage, merging the orthodoxies of the British academic discipline, the Bengal School, Santiniketan and modern Western art. To this they would add the dark inspirational quality unique to Calcutta: an aggressive heaviness to life, full of vibrant contradictions, which no creative mind can escape. Surrealism is a daily ritual. Each artist is tempted to absorb the mayhem, to imbibe a socio-political comment in their art, to be at peace with the anarchy; to believe that it is not anarchy.

Paritosh Sen's (b.1918) art has epitomised Gaganendranath Tagore and Daumier's socially responsive spirit. Unlike most artists Paritosh's art sustained the balance

between socially incisive caricature and fine art. Few can nurture this trade-off. Most are too afraid to risk such a balance, which requires a sense of humour wrapped around a deep-seated compassion, tinged with sadness, yet disciplined through reason and talent: " Visually I want my images to remain in that twilight zone of ambiguity which is midway between figuration and non-figuration. The figure is very much there but not fully revealed. This occurs through the brutal simplification of the form. This in turn endows it with a certain air of mystery and, as a result, different viewers imagine different things in it...This air of mystery comes about through the spontaneous activity of the paint...as if the paint is celebrating its freedom."[125]

[125] Paritosh Sen, 'Reflections' *LKC* 9 (Sept 1968): 33

During this time, most artists were self taught. Even those at College required an informal platform given the poor public, corporate and government patronage.[126] This led to the forming of various guilds, as in other parts of the country. The Society for Contemporary Artists (SOCA), established in 1960, was founded by Nikhil Biswas (1930–66), Bijan Chowdhury (b.1931), Shyamal Dutta Ray (b.1934), Sanat Kar (b.1935), Ganesh Haloi (b.1936) and others. Compared to most informal groups this organisation has stood the test of time well, performing invaluable services in helping to sustain many artistic journeys, especially in its contribution to the graphic arts.

[126] " We wanted to paint, wanted to be modern, to work outside our classes mostly, and the teachers never interfered, they let us be, they understood." [Sanat Kar, conversation with author, Santiniketan, 17 Aug 1993]

An artist such as Nikhil Biswas represented the romantic aggressiveness of the times, which reacted to social conditions with an energetic expressionism, though '...At no stage does he use the line to beguile and seduce.'[127] His **Bull Series** (1960-66), as with Sunil Das' (b.1939) brilliant Spanish inspired **Bull & Matador Series** in charcoal best reflects the mood of the times.

[127] Ella Datta, 'Nikhil Biswas: Clowns and Martyrs' *AHJ* 8 (1988-9): 106

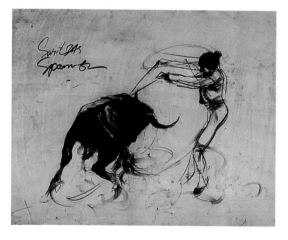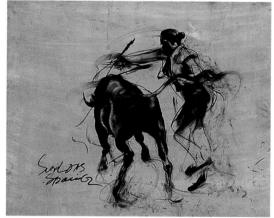

153
DAS, Sunil
Bull & Matador Series
73x86. (each) Charcoal on paper, 1962
Shirin Paul

Thus by the early 1960s the first stage of a national assimilation of modern Western art was nearing completion. Many seeds of reaction against this influence and towards an Indian-cum-modern idiom had been sown. One such seed came with the 'Group 1890' Exhibition in October 1963, New Delhi. With Prime Minister Jawaharlal Nehru's inauguration and Octavia Paz's support, the spokesman J.Swaminathan let loose his tirade for change: " We reject the vulgar naturalism of Raja Ravi Varma and the pastoral idealism of the Bengal School, down through the hybrid mannerisms resulting from the imposition of concepts evolved by successive movements in modern European art on classical, miniature and folk styles, to the flight into abstraction in the name of cosmopolitanism, tortured alternately by memories of a glorious past born out of a sense of futility in the face of a dynamic present and the urge to catch up with the times so as to merit recognition... "[128]

[128] J.Swaminathan, 'Group 1890' Manifesto, 1963

Upcoming artists such as Ambadas, Jyoti Bhatt, Eric Bowen, Raghav Kanneria, Rajesh Mehra, S.G.Nikam, Reddeppa Naidu, Balkrishna Patel, Jeram Patel, Himmat Shah, Ghulam mohammed Sheikh, and J.Swaminathan participated in this event. Many

artists of this group were making the transition towards a deeper understanding of their creative will.

It was also the case that many of those artists who spent a significant period abroad also created what could clearly be seen as 'Indian' contemporary art. Laxman Pai, Mohan Samant (b.1926), and Avinash Chandra (b.1931) were three such artists, among a few others.

Laxman Pai's (b.1926) draughtsmanship reflects the poetic rhythm which his deep love for music, nature and the Indian mythical and philosophical traditions have nourished. That much of his best work was done during his Paris stay (1951–62)[129] reveals the complexity of Indianness[130].

Mohan Samant's international recognition came with the inclusion of his **Sun Chariot** in the 102 Dunn International Exhibition, (USA) Feb. 1963. The Exhibition Catalogue simply stated: " An oriental feeling for design and colour gives a strong personal flavour to his style which in part derives from Tapies." Samant's focus on an abstract expressionism and its textural play proved influential for many Indian artists of the time.

An ardent supporter of Indian Contemporary painting, G.M.Butcher, recognised the 'Indianness' debate, when commenting on Avinash Chandra's art: " It is clear that I am making a plea for a very national kind of art. But I am also making a plea for that aspect of nationalism which welcomes 'foreign' influence in order to achieve more convincingly, its own individual identity... (for the Indian painter's mind) the 'play' of the pattern comes first; there is never any attempt to exclude an image for the sake of 'pure' pictorial values."[131]

Soon, with a growing appreciation of Pop Art and its norms, especially after Rauschenberg's Venice Biennale Award (May 1964), these influences spread

[129] Eg:1952–3 **Symphonie de la vie** (oil); 1953 **Sun and Shadow** (oil); 1954–5 **Geet Govinda Series** (oil) 1957–8 **Ramanaya** and **Gandhi Series** (w/c); 1959–61 **Life of Buddha Series** (12) (coloured etchings) 1961 **Four Signs** (etching) (LKNA)

[130] Or a sense of any nationality

154
PAI, Laxman
Four Signs
27x35.5. Etching,1959

[131] Avinash Chandra, Molton Gallery, London, ExC. Sep 1960

155
CHANDRA, Avinash
Trees
87.5x103. Oil, 1955
NGMA

throughout the Indian artistic scene. Simultaneously, the Neo-Tantric awareness efforts of Ajit Mookerjee, came to influence the arts. Also the ideas regarding the folk-tribal-urban continuum in fine arts, began to reach a wider audience, especially during the 1970s. Here the efforts of J.Swaminathan and K.G.Subramanyan were especially influential.

Thus by the mid-1960s the tide of change was entrenched. A reaction against the partially justified tag of Indian modern art being derivative had set in, and the realisation that an Indian identity must be re-created, capable of absorbing the modern 'isms' and emerging with something fresh, became the motivating principle of the 1960s. As a group, the Cholamandal School would best reflect this reaction, while Husain would dominate individual attention.

156
AMBADAS
Hot Wind Blows Inside Me
132x133. Oil, 1966
LKA

158
DAVE, Shanti
Untitled
62.5x87.5. Oil & Wax, 1962
Jehangir Nicholson Museum, NCPA

157
DASGUPTA, Bimal
Reminiscence
112x82. Oil, 1964
LKA

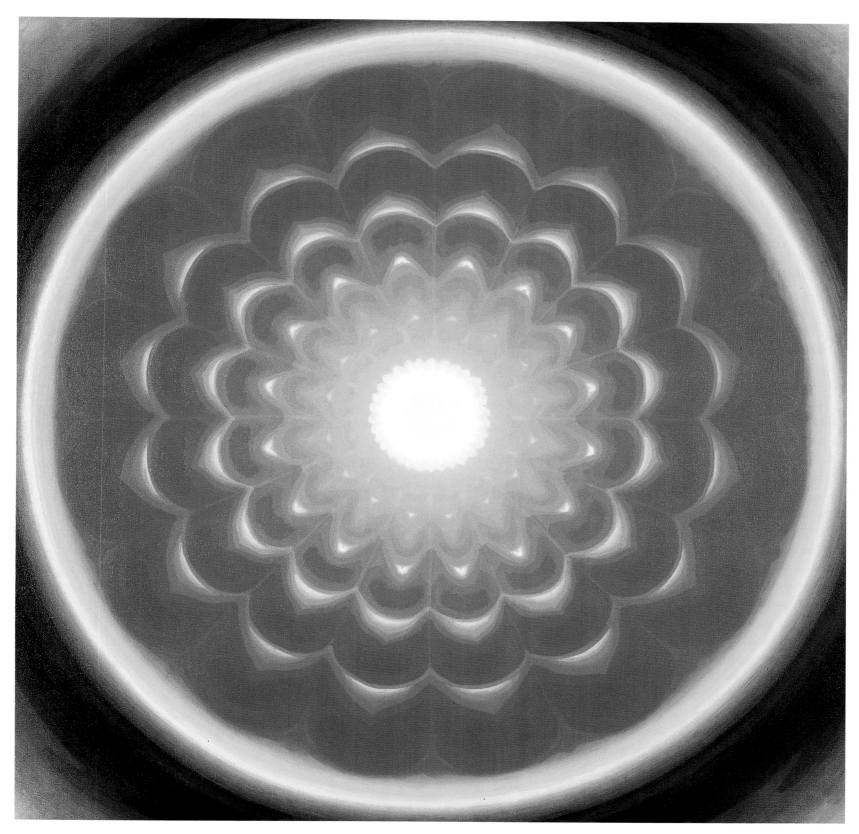

159
DE, Biren
You, July 1970
132x132. Oil, 1970
Chester & Davida Herwitz, USA

160
GAITONDE, V.S.
Untitled
175x125. Oil, 1969
Sadrudin Daya, Bombay

161
KOLTE, Prabhakar
Space X-Rayed
120x150. Oil,1973
LKA

163
PALSIKAR, S.B.
Colour and Sound V
125x100. Oil, 1972
Private, Bombay

162
MOHAMMEDI, Nasreen
Untitled
91.3x61.3. Oil, c.1965
Geeta Khandelwal, Bombay

223 | An Abstract Focus

164
PATEL, Jeram
Untitled
55x75. Pen & Ink, 1971
Private, Bombay

165
RAMKUMAR
Untitled
100x80. Oil, 1969
Sunita Khandelwal, Bombay

166
RAZA, S.H.
Grey Landscape
147.5x147.5. Oil, 1968
Jehangir Nicholson Museum, NCPA

167
REDDY, Krishna
Water-Lilies
33x46. Engraving & Etching, 1961

168
REDDY, Krishna
Whirlpool
37.5x49.5. Intaglio on Paper, 1962

169
SANTOSH, G.R.
White & Red No.1
127x127. Oil, 1968
Gallery Chemould, Bombay

170
SHRESHTHA, Laxman
Untitled
150x150. Oil, c.1975
Jehangir Nicholson Museum, NCPA

171
SWAMINATHAN, Jagdish
Colour of Geometry Series
58x91. Oil, 1968
Private, Bombay

1964-72
An Indian Identity Clarifies

By the late 1960s K.C.S Paniker, S.Dhanapal, J.Sultan Ali, L.Munuswamy (b.1927), P.V.Janakiram, A.Santhanaraj (b.1932) and Reddeppa Naidu, Anthony Doss (b.1933), K.Haridasan (b.1937), K.M.Adimoolam (b.1938), A.Alphonso and Viswanandhan (b.1940), K.Ramanujam (1941-73), S.G.Vasudev (b.1941), R.Bhaskaran (b.1942), Arnawaz Vasudev (1948-88), and a few others, had come together at Cholamandal.

Their experiments were carried out amid the decorative craft traditions of South India and the influence of Jamini Roy. For example, with an artist like Reddeppa Naidu, the influence of Indian traditions of textile design and the delicate play of the line served a pivotal role in determining his aesthetic: " ...textiles is one of the greatest mediums to know, the greatest of our people's expression. The techniques and great forms which are still alive, repeated and repeated. To draw like that is the Indian way to make a form, as with our temple architecture and wood-carvings...Suppose you take a parrot,...the concept of the bird is not taken in just a realistic form, or photographic...When I work in the contemporary idiom of a parrot, I will omit the details and stick to the barest simplicity,... this knowledge is essential to have a continuous growth. It is applicable to everything around me, in life, not just the parrot."[132]

[132] Reddeppa Naidu, conversation with the author, Madras, 17 Jly, 1993

Reddeppa's teacher, Paniker, had evolved his expressionist journey from the early socially sensitive works through his more imaginative **Garden** (late 1950s) and **Christ** (early 1960s) series, culminating with the famous **Words & Symbols Series** (1964-late-1970s).

The **Words & Symbols Series** represented an abrupt break from the earlier work.[133] The notions of mass, time and space were re-examined, using the 'time' implications of an horoscope, while 'mass' was redefined as the intensity of line arrangements and script. The use of colour, playing a subordinated role, tried to satisfy the demands of space. The importance given to the geometric as a means of creating the decorative centre, was partially inspired by Tantric symbolism.

[133] " **Words & Symbols**...when placed in time with his earlier works, seems to subordinate all the phases to a bigger design, that is a three-decade long denouement of a tragic sense of life. After this surging fugue of pigments, came the sudden hush of impersonal linear geometry, reducing all the warm human elements to cold deterministic patterns of horoscopes...**Words & Symbols** only suggest what Paniker left unsaid about the insignificance of individual existence." [Santo Datta, 'Three Retrospective Exhibitions', *LKC* 27 (Apr 1979): 15-6]

From among Paniker's students, L.Munuswamy succeeded him as Principal of MGAC. Munuswamy spent his adult life since Independence at the MGAC and Cholamandal, first as a student (1948-53), then as a student-teacher (1958-): "...I could not turn away from the new introspective spirit of KCS Paniker...he never underestimated the need for personal accomplishment and identity, linked with native genius...and his frequent discussions and analytical studies of problems facing contemporary artists paved the way for the questioning by the younger generation of artists of the authority of the Establishment and the ultimate breakaway from the so-far existing decadent British and Oriental styles."[134]

[134] L. Munuswamy. Rpt. by Anjali Sircar in *L.Munuswamy* LKA,1985

[135] It is interesting to see the similarity with, for example, Helene Smith's work, eg: **Martian Landscape** (1896); reprinted by Ken Johnson in 'Significant Others' *Art in America* (Jne 1993). There is definitely a psychological link which reveals itself in certain visual forms. Helene Smith sincerely believed she was going to the planet Mars; Ramanujam only went to see Tamil & Hindi films.

Among the other students of Paniker, the art of K.Ramanujam was the most original and obsessive. His talent was moulded by pain, sexual frustration, and his sense of alienation especially due to his being a midget.[135] His genius lay in being able to subordinate the suffering through his aesthetic discipline, creating line-dominated visions with limited technique and materials. The realm of fantasy, particularly inspired by popular Hindi & Tamil films, became his chosen idiom, reflecting the escapism necessary within the Indian day. The loneliness of his life finally became too much, resulting in his suicide at the age of 32. A hundred and one such talents roam the streets of India everyday, with chalk in hand, and no teacher to hone their instincts.

136 " **Nandi** allows me the enormous possibility of a good, solid pictorial form, and its several associations with life, myth, legend. I was particularly struck by its virility, energy and its remarkable, nonchalant stance and movement." [J.Sultan Ali, 'Conversation with S.A.Krishnan', *LKC* 29 (Apr 1980)]

J.Sultan Ali joined Cholamandal only in 1969. His art exemplified the decorative aspect, imbibed through a philosophical temperament, using the folk and tribal art forms [eg: *Nandi*, bull, *Narasimha*, lion, *Naga,* snake][136] as pivotal sources of inspiration, especially to manifest his concerns regarding the nature of energy. His experiences with teaching children art at the Rishi Valley School (1951-4), J.Krishnamurti's ideas of a philosphical human-nature unity, and his interaction with the tribal Lambadis at Madanapalli, left a deep creative impression upon Sultan Ali, motivating his search for a modern Indian pictorial idiom. The earlier intricate pen and ink works, as best reflected in **Kondapalli** (1965) were later transformed into a similar complexity of symbolism in the watercolour medium with a superimposition of figures and a gradual dilution of colour's relevance.

172
SULTAN ALI, J.
Untitled
75x100. Pen & Ink, 1975
Private, Bombay

173
VASUDEV, S.G.
Maithuna Series
115x232. Oil, 1972
NGMA

The change in the art of S.G.Vasudev, who had been at the J.J.School before coming to the MGAC (1964-8), revealed the main aspects of the Cholamandal aesthetic. The early influence of F.N.Souza's expressionism had soon dissolved, though Palsikar's philsophic attitude would remain: " By 1969 I had completely got rid of impastos and my forms were very free at the time. With the brush itself I would create texture. Then I did a series of paintings called **Fantasy**. I brought in mountains, the sea, trees, animals, stars....this gave me more freedom, away from the impasto technique...leading me into the **Maithuna** Series (1970-) where it was not just the act of love between man and woman, but a vast concept of love between all forms – between the planets and the earth, between the mountain and the sea, the trees and the birds, reptiles, and animals."[137]

All this creative activity at Cholamandal and parts of South India was continuing without much public awareness or recognition. R.B. Bhaskaran, having emerged from such public apathy, clarifies this experience: " What happened was that there was no buying, selling when the new movement started. The public totally denied it...So at a time when the public was not in support of this modern art movement in the South, where the press was not in favour of contemporary art, the galleries had not started in Madras, the artists had only confidence in themselves, that they had to do it, which resulted in success only after twenty-five years, now...Success in the sense of artists

137 S.G.Vasudev, conversation with the author, Madras 16 Jly 1993

138 R.B. Bhaskaran, conversation with the author, Madras 17 Jly 1993

being recognised as important intellectuals, part of society. They are wanted now because their works are known; this is the transition."[138] The dedicated efforts since the 1960s, of Josef James, an art theorist, to bring this work to the wider national attention deserves special mention.

Thus by the mid-1960s the manner and reasons for interacting with modern Western art was the pivotal debating issue. To discover an 'Indianness' within the modern art idiom continued to dominate the aspiration of most artists.

Ironically, one trigger in bringing about this gradual shift, came from the exhibition of 'Two Decades of American Art' (1967-8), curated by Clement Greenberg, at the Rabindra Bhavan, New Delhi. Reddeppa Naidu tells of the significance to the Indian artists of this exhibition: "It was a big eye opener for Indian contemporary artists. The reason is: until then they were looking to Paris, now to see how the Americans had freed themselves from their French influence, and could be of themselves in their abstraction... it revealed that the free mind is the biggest asset, that you can do a painting out of nothing, you can do a painting out of everything, to use tomato can soup labels,...it was a new experience."[139]

139 Reddeppa Naidu, conversation with the author, Madras, 17 Jly 1993

This access to international art was then institutionalised with the First Triennale (1968) organised by the Lalit Kala Akademi. A recurring event, though later marred by the politicising of the institution, it proved to be a turning point in the interaction between Indian artists and the rest of the world.

In a way the Greenbergian version of Modernism, at its peak of popularity by the late 1960s, was now ripe for initiating its counter-modernism. One early consequence of this was the encouragement given to Pop Art and its norms. The renewed focus on the Printmaking media was another offshoot, bringing affordable art to many. Artists such as Kanwal Krishna, Somnath Hore, Krishna Reddy, Jyoti Bhatt and Laxma Goud (b.1940) emerged to create some of the most aesthetically refined art works of our contemporary history.

174
BHATT, Jyoti
Self-Portrait
50x33. Etching, 1970

140 " (At Baroda) I began to understand: if I wanted to become a real artist I had to create something not interchangeable, something reflecting my inner self, my very personal experiences and imagination." [Laxma Goud interview with Dr.H.Winterberg, *LKC* 15 (Apr 1973)]

The drawings and etchings of Laxma Goud, which evolved from the late-1960s, focused on the erotic idiom structured around the human-animal-vegetation continuum. After studying Mural painting and drawing under K.G.Subramanyan at M.S.University,[140] and a stage of working on papier mache masks and batiks, Goud returned to his rural village roots, to reveal an obsessive mind capable of grasping the roots of a sexual drive and its links with natural forms. The chaotic theme was masterly disciplined through the demands of the zinc and copper etchings media, bringing to the fore his refined draughtsmanship, which, till today, remains at the core of his art. His themes merged the rural and urban, the human and animal, the male and female, the beastly and benign, like few before him.

175
GOUD, Laxma
Untitled
49.5x30.5. Etching & Aquatint, 1972

141 " A polyptych does in the small what mural does in the big. It brings together into a larger design various frames of intimate detail and action and these are not necessarily congruent. It has some analogy with our vision of the world. In the small windows of the world people laugh, weep, love and live, die but together they are part of the whole placid scheme, an architecture of permanence and continuity. A big landscape bristles with patches of quiet and ferment, concupisence and violence, a butterfly flutters innocently on a flower but a snake swallows a frog in the undergrowth, on the soft face of a rose a spider gnaws a fly; but altogether it glistens like a chequered carpet in the sun."
[K.G.Subramanyan, BAAC Retrospective ExC. Dec 1983]

142 Ibid.

176 (Right)
SUBRAMANYAN, K.G.
Hunter & Trophy Series
62x59. Terracotta Relief, 1970
Private

177 (Far Right)
BADRINARAYAN
Family
102x71. Oil, 1965
LKA

143 " I think it is important to get art into the environment. To strew art around in the environment seems to be the only way of rescuing it from the crowded catacombs of culture that our museums are fast becoming...If art has to be alive, it has to be alive in use. If art has to be seen well it has to be seen through time, not in brief weekend exposures...Again, working with the environment is the best chance we have for a continuity in tradition as of environmental relevance. It does not appear to me that such relevance is genetically predetermined as some believe in comfort...It depends on the culture complex and the physical environment...This needs thinking together and working together." [K.G.Subramanyan, 'Thoughts on Murals', LKC 14 (Sep 1972): 18-9]

Laxma's teacher, K.G.Subramanyan, was slowly becoming the most influential artist-teacher in Indian Contemporary Art. His small format work with terracotta tiles, which began in 1969, reflected the fusion of his earlier mural work with his peephole like format for the polyptchs,[141] while exploring the underlying playful eroticism of the terracotta material: " I do terracotta reliefs because clay has a quality that comes close to human flesh; when handled in a certain way, it folds, fissures, warps, tends like flesh does."[142]

 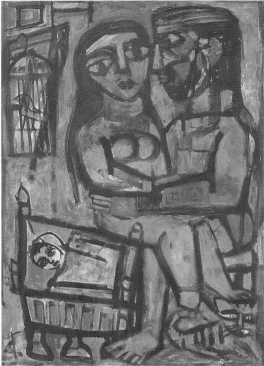

The integrative approach of the fine and applied arts, as with Subramanyan[143], was also expressed through two other very different creative journeys, that of Badrinarayan (b.1926) and Satish Gujral. Badrinarayan's quiet attitude, rooted in the timeless joy of creativity, spread itself among various activities from painting, mural, ceramic tiles and mosaic work, book illustration, teaching, and script-writing. With time his early Rouault-like expressionist oil work would be compassinately rechannelled into the watercolour and ink medium, focusing on a few deeply rooted themes.

Satish Gujral's repertoire from drawings to architecture, reveals an affinity with the material few have matched. From each he has dug out rhythmic forms peculiar to that medium, displaying a rare tactile response, which his deafness heightened. His collage work (1965-72), the pen and ink drawings (1967-8), and the metal assemblage work of this period, expressed the aggressive mood of the machine age, mixed with Neo-Tantric and Pop Art inspiration, fused within an original vision inclined towards mural art and its wider architectural context.

One of the first Indian artists to absorb the daily gaudiness of popular art into the mood of fine art was Bhupen Khakhar (b.1934). His work after the oleograph-inspired enamel medium and oil works such as **People at Dharamsala** (1967) and **Residency Bungalow** (1969) soon came to focus on the daily ritual of middle-class professions in the **Trade Series** (1971-mid 1970s), through the narrative eye of a sympathetic voyeur. It reveals his care for detail, which his aesthetic refinement utilises to create a non-judgmental aura despite its incisive social comment.

Further, Bhupen's relatively weak draughtmanship dictated the manner in which his early figure was placed within the frame, hence the sensation of emotional

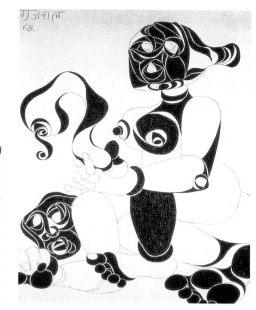

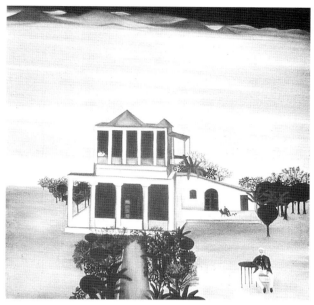

178 (Right)
GUJRAL, Satish
Untitled
117x88. Charcoal drawing, 1968
Private

179 (Far right)
KHAKHAR, Bhupen
Residency Bungalow
120x120. Oil, 1969
Private

detachment, derived through the awkward use of space. Another reason for the figure not asserting itself at this stage, was probably that Bhupen wanted to express the relationship between men, but did not possess the relevant confidence or receive the needed support at this stage. The ability to transform potential vulnerability into strength lay at the heart of Bhupen's evolving artistic compassion.

[144] Though the fashion of Pop Art gave its usage a significant boost

The use of enamel paint during the early 1960s was imposed on many due to economic necessity, but few continued its use.[144] However, no artist has sustained the journey (into the 1990s) with this medium, apart from Prabhakar Barwe (1936-95). In doing so he has been able to express moments of weightlessness from density, and a sense of suspended contemplative quiet, from an essentially loud and gaudy medium. The artistic achievement is all the more worthy given the intensity and frustration with which it began in the early 1960s: " I thought painting was like war with the canvas, only later I realised it was not so, that one has to surrender, to start speaking, so that there is a dialogue. This I only understood later."[145]

[145] P.Barwe, conversation with the author, Bombay, 12 Jly 1993

180
BARWE, Prabhakar
Untitled
Enamel, c.1973
Private

[146] "That is the way I felt. Everywhere I looked I saw an image of man that disgusted me. There were fat men at weddings, parties, piling onto foodladen trays, images of overpampering of the flesh, of overconsumption, of corruption in high places, everywhere." [R.Broota, 'Conversation with Keshav Malik', *LKC* 24-25 (Sep-Apr 1977-8)]

The use of social satire which Bhupen Khakhar hinted towards was explicitly expressed in the early art of A.Ramachandran (b.1935) and Rameshwar Broota (b.1941). Both revealed a fascination with the human body, and its power to absorb pain, while emerging triumphant. R.Broota's comment was directed towards the greed and complacency of the times,[146] but always with the dignity of a quietness which realised that whatever occurs on the outside, it is subordinate to an inner absorbing will. It was the constant nurturing of this inner stubbornness which allowed Broota to evolve his unique organic imagery, as manifested in his later **Gorilla and Man Series** and the semi-abstract work during the 1990s. His dedicated teaching efforts since 1967, as the Head of the Triveni Kala Sangam Art Department reflects the same inner promise to himself.

181
BROOTA, Rameshwar
Ape Series: That Unending Story
148.6x203.8. Oil, 1971
Private, New York

[147] R. Chawla, *Ramachandran– Art of the Muralist*, Bangalore: Kala Yatra & Sistas Publication, 1994. p49

[148] *Ibid* p49

[149] " The moment I use the diagonal, the square splits, it gets a momentum, it gets activated. Otherwise the square is a very static form...it has become a means of dislocating the image in any area of the canvas." [Tyeb Mehta, 'Tyeb Mehta: Beyond Narrative Painting - An Interview with Yashodhara Dalmia' *AHJ* 9 (1989-90): 77]

[150] " When I came back from New York, I had seen alot of minimal painting,...I realised that if I had to use colour as an element I had to give up using certain things, like give up a very definite planar structure. Because when you start structuring in planes, what you do is your brush runs in a certain way, according to the plane, creating its own texture, its own surface. I wanted to create large areas of colours..." [Tyeb Mehta, conversation with the author, Bombay, 17 Sep 1993]

A.Ramachandran's rise to public attention came after his first exhibition at the Kumar Gallery (1966), where he achieved recognition for the raw expressionist power of his twisted human forms. Calcutta and its 'dead souls' provided an obvious source of inspiration, as also the art of the Mexican muralists, especially Orozco's work. With paintings such as **Iconography** (1969), **Ceiling** (1970) and the later **Kali Puja** (1973) Ramachandran began to shift the influences on his work towards Indian art, especially the 'flat frontality of Indian iconography'.[147] As Rupika Chawla further elaborates: "**Iconography** was...an attempt to focus on an area he had not concentrated on before: Indian iconography ...while the mural format had helped him with space and structure, other aspects of traditional Indian murals – namely the treatment of form, colour, perspective, embellishment – and the philosophical content, had yet to develop. Indian mythology made its first appearance in the Creator, Preserver, Destroyer concept of **Iconography**."[148]

Tyeb Mehta's images of the falling figure were activated by the use of the pictorial diagonal in 1969.[149] The expressionist impasto use of pigment which had won him the First Triennale Award (1968) was now given up, as with most artists. In its place evolved a non-textural colour application method which seemed independent from the drawing.[150] With this discipline, personal anguish was subordinated to the dictates of materiality; expression of excess became credible because of the restraint. This creates the opportunity for the audience to enter the image, giving them a freedom to search

for the suggested motives. This suggestion is the abiding quality of Tyeb's haunting imagery.

[151] Eg " There seems to be a growing distrust of idealism and its unfulfilled promises. The 'real' of today as it is posited by this new art has nothing to do with metaphor, or symbolism, or any kind of metaphysics...but instead offers itself for whatever its uniqueness is worth– in the form of the simple, irreducible, irrefutable object." (Edward Goosens, Introduction to 'Art of the Real' ExC. *MOMA*, 1968–9. Rpt. by Pria Karunakar in 'Tyeb Mehta: Abstraction & Image', *LKC* 17 (April 1974): 31

[152] " In Gieve Patel's paintings current political personalities have featured irrespective of adherence to any specific political ideology. Again his is a case of using the human image but here the much familiar costume like the Gandhi cap or the *khaddar kurta* has turned into symbols of inconsequence, just as the inauguration ceremony with political celebrities grouped around a table only points out to the triviality of such stately occasions. But the technical significance of his paintings is in the use he made of the newspaper photograph. Pictorial use of the photograph has also been taken up by Krishen Khanna as well as Vivan Sundaram in their 'political' paintings." [R.Parimoo, 'New Trends in Figurative Painting' (1975). Rpt. in *SIMA*, New Delhi: Kanak Publications, 1975. p103]

[153] eg: "The Difference in the Morgue" (1966)

"In the large dissection hall
Is the nobility, the classical feeling,
the possibility of diversion,
the pause in learning– looking out
At mango trees as they change
From the dark winter green
To the summer leaves.
The sun touches the mango bark.
In the dissection hall the head
Is shaved, the outline clear,
Cranium, grand dome, contained
In my glove hand
Death is seasoned.

The morgue is different.
As I lean into the cold
The recent dead

On the whole, artists were unable to create their own archetypal symbol so as to reflect the pain of daily existence, such as Tyeb's 'falling figure' and 'trussed bull' or Somnath Hore's **Wounds** Series. They took recourse to twisting the realism here and there, reacting to the times, deriving their imagery from specific outer events, which were on reflection tempered by their inner vision.[151]

A young Gieve Patel (b.1940), already a poet, playwright and doctor by the 1970s, best epitomised the attitude of trying to grasp the pain of the common people by not sentimentalising their anguish. To express the daily corruption, thereby steeling one's romantic ideals, was the role Gieve allocated his art. He was also one of first post-Independence artists to use the photo-like realistic imagery of the existing political scenario upon which to base his early artistic creativity.[152] This approach seemed most likely to succeed with Gieve, who possessed a rare intuitively-logical balance, which while refusing to obey purified categories, still pursues clear structures.

Given Gieve's ability to merge various disciplines within his creative vision, it is most interesting to study the manner in which each becomes a source of inspiration for the other. For example, one could see from his early poetry the seeds of his future imagery.[153]

Krishen Khanna (b.1925), who had given up his banking career to become a full–time artist during the late 1950s, possessed a materialist philosophy, which was capable of absorbing change with a rare flexibility. This in-built ability, rooted in his affinity with material logic, allowed him to renew his artistic imagery when others stagnated. Yet his earlier socially responsive works, (eg: **Game** Series, 1970-3) did not possess the material obsessiveness of later years, as he himself recognised: " In the early work I use to leave a lot of blank canvas, I did not fill in everything on the canvas, only the figure or what I was doing would be the activated space..."[154]

The expression of social comment through art, naturally found very different forms in Bombay and Calcutta. It is sad that very few Bombay based artists really appreciated the unique difference of the Calcutta inspiration, and the patience required to channelise this sentiment. To inspire one towards the surrealistic is the norm for Calcutta. It is the ability to discipline this dark destiny which dictates the imagery of most artists.[155] The art of Bikash Bhattacharjee (b.1940) the small format watercolour and tempera works of Shyamal Dutta Ray (b.1934) & Ganesh Pyne (b.1937) respectively, best epitomised this dark mood.

Cut into sight
Sharp, fresh images;
The mouth not dried
Into attitude, Surprise is clear."

It seems that the painted crushed heads and the diseased faces of the 1980s were waiting to be expressed as early as the 1960s, when he came across such distortions as a doctor.

[154] K.Khanna, conversation with the author, New Delhi, 3 Aug 1993

[155] eg: " ...later I even realised that there is a typical Calcuttan painting, like that dark brown colour in Ganesh Pyne's work, or Shyamal Dutta Ray's colour...also Calcutta provides more sources of content and images than any other place...There is not a searching for outside sources. Calcutta overwhelms, allowing you to go in." [Manu Parekh, conversation with the author, New Delhi 3 Oct 1993]

[156] Eg: the broken bowl as the symbol of starvation, the monkey as the entertainer on a leash, the dog as an outcast, the chair as the unstable & corrupt seat of power.

[157] " I have always thought that I had some duty, not only picture making, and so I had to do something to combine,...newspaper comments would make me react, inspired me. It is very simple, but there is no anger. My work is more a prayer rather than a protest." [S.Datta Ray, conversation with the author, Calcutta, 19 Aug 1993]

The early work of a young Bikash Bhattacharjee (b.1940) grew upon the tidal wave of Calcutta-inspired surrealism, culminating with his **Doll Series** of the early 1970s. With a growing focus upon detail and the realistic aspect of draughtmanship, he began to discipline the free flight of imagination, which now relied on slight twists and subtle discontinuities.

S.Dutta Ray's control over the watercolour medium, reinforced by his academic training, resulted in images which transformed common placed motifs into personal symbols.[156] The masterly manner in which he placed responsibility upon the decorative aspect so as to reveal human pain, reflects a gentle romanticism, which observes and accepts, relying on art to sustain this faithfulness to life.[157]

183
DUTTA RAY, Shyamal
Chair
55x44. W/c, 1971
NGMA

The authenticity of Ganesh Pyne's (b.1937) dark moods were such, that they absorbed the inspiration of any specificity, revealing only the mythical magic of his original vision. Since his first exhibition at the BAAC (1967-8), he has used his refined draughtmanship to give form to his unconscious or other worldly imagination, mostly rooted in childhood memories.[158] Ganesh Pyne's early influences, such as Rembrandt, Abanindranath & Rabindranath Tagore, Paul Klee, Atul Bose, Jamini Roy, were all absorbed to suit his unique introspective temperament, reinforcing rather than remoulding his vision. This is the thin difference which eventually determines the degree of artistic originality.

[158] " Myth is a very regulating factor in my work, and the source of my myth were basically my grandmother's stories with their certain mystic elements,..." [G.Pyne, from conversation with Arany Banerjee, LKC 15 (Apr 1973):]

[159] G.Pyne, conversation with the author, Calcutta, Aug 1993

Ganesh Pyne was in awe of "...the haunting atmosphere he (Rabindranath) used to create and his tremendous power to ignore the technical riddles of his work."[159] This appreciation of Rabindranath Tagore as a major contemporary painter only began to snowball during the late 1960s, after years of relative misunderstanding. Another artist to take up this reappraisal was J.Swaminathan: " Tagore's revolt against tradition in art was an isolated phenomenon and even to this day the significance of his break –

184
PYNE, Ganesh
Mother & Child
55x66. Tempera, 1971
NGMA

[160] J.Swaminathan, 'art now in India' ExC. for the Commonwealth Arts Festival, London, 1965.

[161] Eg: " All Creations, according to Tantra, is preceded by a focal tension called Bindu. This is the centre of every creation based on a fundamental dualism... Every conjunction of opposites produces a rupture of plane and ends in the rediscovery of the primordial spontaneity. The conjunction of opposites further represents a transcending of the phenomenal world, abolishing all experience and duality...Only the one without a second is ever existing and will ever exist." [Ajit Mookherjee, *Art of Tantra*. Kumar Gallery Publication, 1967]

through is not fully appreciated...the 'modern' approach of enlightened nationalism has been to advocate the necessity of striking a balance between 'tradition' and what is considered as the contemporary Western contribution. It is this seemingly reasonable and suggestive argument which finds easy currency with the well-wishers of Indian art abroad, that has been the most damaging influence in the country's aesthetic thought..."[160]

The balance and dilemma between the traditional and modern, the philosophical and artistic, absorbed another new player, when awareness regarding Tantric art forms, received renewed momentum after the mid-1960s, mainly due to the scholarly efforts of Ajit Mookherjee. This interest culminated with the first international exhibition on Tantric Art at the Hayward Gallery in London (1971). Though this phase is somewhat snubbed today, its influence has been significant and the lessons to be learnt are relevant. It provided contemporary art a chance to create an original and abstract idiom upon which to construct an artistic Indianness.[161]

The historical timing was as important as the contents absorbed, until many realised the vast task they had unwittingly taken up. Nevertheless, the few who sustained the journey created a powerful body of work, rich in design, glowing from an inner sense of geometry and iconographic order. As are the quirks of history, the first artist to be seen as a 'tantric' inspired artist was Biren De. This misleading label, resulted because his aesthetic evolution, since the late 1940s, shared many characteristics with Tantric philosophy, such as pursuing an understanding of the male-female unity and the nature of human energy. After his 1965 Exhibition at Kumar Gallery, where works such as **Genesis 1 & 2** (1963–5) were displayed, the movement of Neo-Tantric inspired modern art escalated throughout the country.

By the early 1970s the struggle of the ancient and modern was being clearly revealed in Biren De's dilemma. Ironically, one recalls, Krauss' statements regarding Stella's

185
DE, Biren
Genesis '64
76x152.5. Oil, 1964
NGMA

[162] " The flatness that modernist criticism reveres may have expunged spatial perspective, but it has substituted a temporal one– i.e. history. It is this history that the modernist critic contemplates looking into the vortex of, say, Stella's concentric stripes: a perspective view that opens backward into the receding vista of past doors and rooms…" [R.Krauss, 'A View of Modernism', Artforum, NY, Sep 1972. Rpt. in *AT 1900– 90*, Harrison & Wood, eds. Oxford: Blackwells, 1993. p 956.]

[163] S.Palsikar, 'Thoughts on Tantra' *LKC* 12–13 (Apr–Sep 1971)

[164] " I feel the main problem lies in that, as a whole, the only thing valid at present seems to be the sensible intuition; whereas tradition is based on intellectual intuition, by which one can come to a point of total expression in art form. This was my own problem and I envisaged my work accordingly. First of all, I wanted to acquire the technique so as to have the means of extension necessary to express my own self." [Nirode Mazumdar's conversation with A.S.Raman, 1980. Rpt. in *The Critical Vision*. LKA, 1993]

[165] eg: P.Barwe, Badrinarayan, R.B.Bhaskaran, Jyoti Bhatt, Sunil Das, Bimal Dasgupta, Satish Gujral, Devyani Krishna, Laxman Pai, S.H.Raza, P.T.Reddy, Piraji Sagara, Sunil Madhav Sen, J.Sultan Ali, J.Swaminathan, and others.

concentric circles[162], when viewing Biren De's vortex like images, though they are far removed from the materiality of pattern and the historical justifications of modernism. Instead it reveals the instinctively honed realisation about human existence. It aptly reflects the different roots with which western and eastern idealism have flourished within their material bottlenecks.

An artist who has uncompromisingly sustained the Neo-Tantric idiom has been G.R.Santosh. His search for answers was also best served by Tantra and its art forms, given the above mentioned foci, which needed to be realised in mind and body, with the iconographic absorbed within the geometric. The gradual process during which Santosh dissolved the specific features of the human anatomy, especially during the act of union, reflect a focusing of the mind on essence and its iconicity. His artistic difficulty would emerge during the late 1980s in trying to reveal the renewable aspect of essence through a limiting artistic idiom. Naturally artists of the earlier generation such as S.B.Palsikar, Nirode Mazumdar, and K.C.S.Paniker, who had already satisfied their Western art curiosities, found a greater sense of oneness with this idiom, especially given their philosophical attitude towards art and its abstraction.

As an influential teacher in the academic discipline of portraiture, Palsikar had finally found the ideal philosophy to ground his lifelong artistic quest: "'It is not the world that matters but how you are attached to it.' This is the real core of our investigation through Tantra, the possibilities of new approaches to give concrete meaning to the abstract expression in the contemporary art movement in the country in particular and to find out to what extent we can contribute to the world art movement in general."[163]

Nirode Mazumdar, whose grounding of European modernism was second to none, also came to focus on the possibilities of new artistic directions through a deeper interaction with an ancient ritualised philosophy. This mix helped Nirode towards understanding the open-ended structure of creativity, while being rooted in a tradition. The iconic is to be preserved and dismantled, simultaneously, as revealed in his works, such as **Chandani holding Gurudas Feathers'** (c.1966).[164]

Many other artists also experimented with neo-tantric symbolism as a source of inspiration[165]. For most it was just a passing phase. The only other artists who have sustained this idiom with dedication have been K.Haridasan, Om Prakash Sharma, Viswanadhan, Sohan Qadri and Prafulla Mohanti, among a few others. The easy borrowing led to a placing of tantric symbols into an arena unable to nourish a logic of contextualising, which each symbol requires to assume relevance.

[166] The six artistst studied in the book were: F.N.Souza, M.F.Husain, A.Padamsee, B.Khakhar, Ramkumar & J.Swaminathan.

[167] G.Kapur *Contemporary Indian Painters*. New Delhi: Vikas Publishing House, 1976. p199

[168] Ibid

[169] T & H, 1971 & 1973

[170] Eg: " Husain in the early sixties seemed to be such a dominant painter on the scene that it appeared that no significant painting of non–Husainesque kind could be possible...The sad monumentality of Rabindranath Tagore's pictorial image of Indian women can be linked with those of Amrita Sher–Gil and Husain suggesting a current of which he was the initiator– the dark tanned face, partially veiled in deep shadows, cow–eyed, melancholic glances, not looking straight into the onlooker but from the corner of the eye, apprehensive and withdrawn." [A.S.Raman. Rpt. *The Critical Vision*. LKA, 1993)

[171] Awarded the Golden Bear Award, at the Berlin Film Festival, 1968

J.Swaminathan's transition from an abstract expressionist idiom with an affinity to primitive symbolism, towards a greater use of folk and tribal motifs, faced such an obstacle, which Geeta Kapur, in her pioneering book – 'Contemporary Indian Artists'[166], had expressed well: " ...To rob a symbol of its hallowed place and register it on the blank canvas... is to a large extent futile. It is with a specific purpose and belief that a votive tablet with a relief of a snake image is placed at the roots of a pipal tree...the numen in every icon needs its own special locale and ambience to manifest itself....What then is the purpose which Swaminathan hoped to accommodate with his symbolic paintings?"[167] To 'knock off the demarcation between the traditional and the modern, dissolving historical categories in the spontaneous and stubborn act of creation'[168] seemed to be one purpose of his creativity. By late 1968, Swaminathan had moved into his luminous, Kangra and Rajput miniatures inspired **Mountain Trees and Birds** Series.

Thus by 1971, the international awareness regarding Tantra was at its peak. Following Ajit Mookherjee's work, P.Rawson's 'Tantra'[169] was published, further increasing the awareness regarding Tantra, which since the pioneering efforts of Sir John Woodroffe had steadily gained greater awareness among various orientalists.

Away from this source of inspiration in Bombay, the popularity of M.F.Husain and K.H.Ara continued unabated during the 1960s. Husain devoted his rare energy towards helping to bring contemporary art to the common person, unlike any other artist.[170] From his debut short film 'Through the Eyes of a painter'[171] to his Performance art show of 'Six Days of Making' at the Shridharini Gallery, New Delhi, (27 Dec to 1 Jan.

186
HUSAIN, Maqbool F.
Mahabharata Series: Bhim
121.9x91.4. Oil, 1971
Private, New York

1968), he spared no efforts. Unfortunately, given the poor public interest and understanding, his pioneering efforts were sometimes dismissed as gimmicks, mostly by a few envious artists. His Retrospective, 1945-69, at the Gallery Chemould, revealed his vast range of imagery and the rare spontaneous energy of his creativity.

At the Sao-Paulo Biennale (1971), his **Mahabharata Series** (1970-1) was presented the accolade of exhibiting in the shared space besides Picasso. Soon with the support of noted collectors such as Ebrahim Alkazi, Chester Herwitz, Kekoo Gandhy and Kali Pundole, Husain's profusive output would attract greater documentational attention.

Amid all this creative activity, the infrastructure remained piecemeal and inadequate. A.S.Raman best describes the situation: " The Indian artist has achieved economic security, but at the expense of something priceless: aesthetic integrity. The Indian collector buys paintings not because he loves them, but because he has money. Also, he assumes that art acquisitions will enhance his social respectability. Thus a painting becomes not a source of pleasure but a mere status symbol. Who are the patrons the Indian artist can rely on for constant sales? Members of the diplomatic corps who are too polite to be critical of the objets d`art they acquire, partly out of curiosity and partly for propriety's sake: tourists on the souvenir-hunting spree, art-dealers with the obvious and justifiable objective of reselling and manufacturers of greeting-cards. Large-scale institutional buying tends to be progressively on the increase. But still there is no genuine art consciousness in India. No healthy art movement is possible where there is no climate of creativity, criticism and connoisseurship."[172]

[172] A.S.Raman, 1971. Rpt. in *The Critical Vision* LKA, 1993

The comments seem as pertinent for today as for the 1970s. Yet with the critique of modernism gaining momentum in the West, the domino changes would filter into the Indian contemporary art community, opening out new directions, and reaffirming old ones, mostly by revealing the unity between ancient and contemporary creativity, the marginalised and the orthodox.

[173] " I consider man to be part of the total cosmos which is organic, infused with energies which emerge before us in the experience of phenomena...man has the power of feeling, thus able to have a sensuous apprehension of the cosmos...through the dialectics of experiences, awarenesses and visions, man not only seeks information and knowledge of outside things, but recreates them as the wisdom of the heart, and can become a whole man, nearly a god, by accumulating insights and achieve grace, poise and some harmony in disharmony...man's creative energy thus transforms materials into a near total or total structure, coherent form or organised forces,...Within the humanist framework the awareness of tragic experience and disharmony is as capable of providing inspiration as the sense of harmony...every work of art can provide man the ability to live at the highest intensity of awareness..." [Mulk Raj Anand, *25 Years of Indian Modern Art. LKA*, 1972]

[174] " The scientific and techno–industrial outlook of the existing situation has emphasised the cerebral trait of human character almost to the exclusion of all other aspects of his personality. He distrusts his basic emotions and sentiments. Spirituality is generally an anathema, except as a means of escape for some. He is hardly conscious of his emotional problems. His sensitivity to his immediate environment is truncated by a suspicion of everything that does not conform to his personal reasoning. This generally is the backdrop of our current creative movement." [Ram Chatterji, J.A.Sabavala's JG-Gy. CH ExC. Mar 1976]

[175] Prof.R.Parimoo, *SIMA*, New Delhi: Kanak Publication, 1975.

[176] J.Beuys, from 'Not Just A Few Are called But Everyone', 1972, in *Art in Theory 1900–90*, Harrison & Wood, eds. Oxford: Blackwells, 1993. p 890-2.

[177] Leo Steinberg, from a lecture at MOMA, NY 1968; published in *Other Criteria*, London/NY, 1972. Rpt. in *Art in Theory 1900–90*, Harrison, C. & P.Wood, eds. Oxford: Blackwells, 1993. p 952-3.

The early 1970s reflected the slow maturing of the transition period, away from stressing the idealistic attitude[173], towards a greater emphasis upon the material objectivity of daily routine.[174] The aesthetic implications of this world-wide counter-modernism would take time to clarify. Yet the Indian psyche would be well-prepared to reaffirm the realisations regarding contradictions and paradox which post-modernism would revive.

An artist-critic-teacher such as Ratan Parimoo was able to grasp this holistic understanding, though still rooted in a dualistic philosphical outlook: " It [the Indian psyche] unites the spiritual and the sensual, the beautiful and the grotesque, the simple and the complex, the chaste and the ornate. It is full of contrasts, always pairing opposites. It is as if it were based on the duality of life itself, the evil and the holy. The devil and the *devata* co-exist together...The myths appealed so much to the artists that in their delineation they could effortlessly combine the animal head with the human body, they could make the figure multi-armed or multi-headed, make them dance or make war, without any incongruity."[175]

Yet this ability to absorb contradictions was still unable to structure itself through sustainable educational institutions of quality which could nourish the understanding that aesthetics plays a pivotal role in every aspect of life, and that without this living knowledge of creativity, human life will always remain alienated from itself and its material organisations

In the progressing Western counter-modernism, an artist-teacher such as Joseph Beuys, was one of the rare voices who recognised the essential bond between art and daily life. For example, regarding his 'Aesthetic Education' he states: " I don't believe that an art school, which should stress new artistic concepts, should lay emphasis on fixed places to work in the school...My concept of organisation is an artistic one insofar as it must come to fruition according to the laws of organisms and in organic form...For this, man needs the Aesthetic Education. The isolated concept of art education must be done away with, and the artistic element must be embodied in every subject,... I am pleading for a gradual realisation that there is no other way except that people should be artistically educated. This artistic education alone provides a sound base for an efficient society...One of the greatest of these restrictive mechanisms is the present–day school, because it does not develop people but channels them."[176]

Another influential perspective was provided by the aesthetic of Rauschenberg's mixed–media work after which Leo Steinberg introduced the concept of the 'post-Modernist' painting, and opened up new directions for artistic progression: "Rauchensberg's picture plane is for the consciousness immersed in the brains of the city...The all-purpose picture plane underlying this post-Modernist painting has made the course of art once again non-linear and unpredictable. What I have called the flatbed is more than a surface distinction if it is understood as a change within painting that changed the relationship between artist and image, image and viewer...It is part of a shake-up which contaminates all purified categories. The deepening inroads of art into non-art continue to alienate the connoisseur as art defects and departs into strange territories leaving the old stand-by criteria to rule an eroding plane."[177]

Thus, by the 1970s a renewed urban sense of social awareness began to inspire the international artistic vision. In India, many Calcutta-based artists continued to reflect

187
HORE, Somnath
Untitled
26.5x37. Pen & Ink drawings, 1977
Ebrahim Alkazi

[178] " There are certain things in us which we cannot overcome,...a sense of obsession with form, the dimension of form, its heaviness, this is always with me, even if I make a single line, my line gets that kind of tension." [J.Chowdhury, conversation with the author, Santiniketan 18 Aug 1993]

an artistic sense of social responsibility, for Bengal once again bore the brunt of extreme violence with the Bangladesh War (1971-2) and Naxalite movements.

Somnath Hore's social responsiveness steadily matured, through the discipline of his graphic art and drawings, and culminated in his K.Malevich inspired white on white mould print on pulp **Wounds Series** during the 1970s. The ability to surrender the human figure from his imagery, even for a short period, was a rare feat, which very few Bengal-based artists could accomplish. Somnath's later broken, textured and burnt wax-strips sculpture cast in bronze reveal a masterful handling of material; a playfulness amid pain, which only the most stoic wisdom can provide.

It was in an artist from a later generation, Jogen Chowdhury (b.1939), that the moral corruption of the times found its finest artistic imagery. His obsession with the in-built tension of the line, gave rise to a focus on the intricacies of texture and its refined decorative possibilities.[178] He evolved images in the ink and pastel medium, which have come closest to dissolving the notions of ugliness and beauty, vulgarity and sublimity, making one realise the aesthetic potential of persuading one to stare at a gruesome reality, and yet remain in awe of its visual delight. His earlier, **Reminiscences of Dreams Series** (c.1967-1973) and **Ganpati Series** (1973-74), gave way to even more exquisitely disciplined works such as **Man on the Sofa** (1976), **Life I & II** (1976-77) and **Tiger in Moonlit Night** (1978).

The dark recesses of Ganesh Pyne's (b.1937) imagery and refined draughtsmanship overwhelmed whatever crossed his path. An aura of brooding sadness always underlies

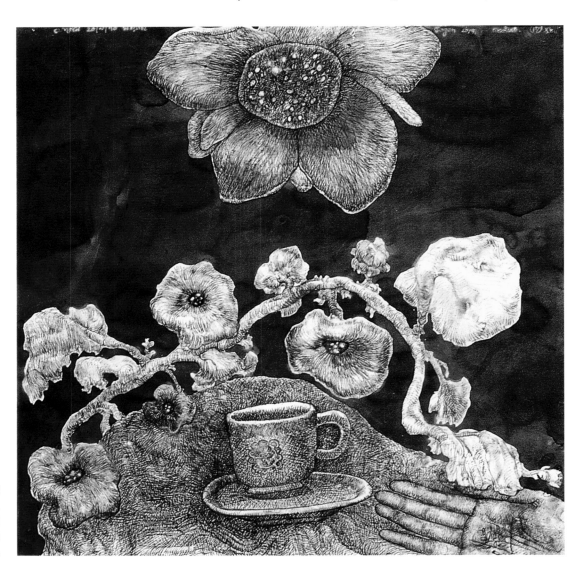

188
CHOWDHURY, J.
Reminiscences of Dream Series XVII
55.2x55.2. Ink & Pastel,1970
NGMA

179 Eg: " As a boy, I remember a very private play I use to play when everyone was asleep. I use to build a boat, a paper boat, very visually, with all details on sails. Now one fine noon I used to burn it, alone, just to see the beauty of the total thing burning." [G.Pyne, conversation with the author, Calcutta, 19 Aug 1993]

180 " The same style in the painting **Homage to Angurbala** tells a whole story. This is possible because the model is not posed with natural neutrality but steered to catch a specific expression in the process of appearing. An aged and forgotten singer and erstwhile film star was felicitated at a function and asked to sing once more. The return to glory was both pitiable and touching. The artist with unsparing frankness showed the decay of her body, the heavy, sagging skin, the stooping shoulders, the face all puffed up and wrinkled and her hair unmanageable. The remnants of splendour– the glittering bangles, the earrings and the deep lipstick may be bizarre as is the enormous garland which follows the contours of her massive arm. Despite this, the artist's sharp eyes discover a moving, sincere human being, and even through the costume and the make-up." [Marta Jakimowicz–Karle, *Bikash Bhattacharjee*. Bangalore: Kala Yatra & Sistas, Publications, 1991. p10]

181 " Presently I am more involved with figurative subjects. I incorporate the play between blacks and whites through line and aquatint, often scraping the dark areas to get the tonal variation and an effect of smooth chiaroscuro. At times I mix photographic images with drawn areas, in an effort to juxtapose the subjective interpenetration with a backdrop of hard objective reality– to contrast the indifferent background from quietly pulsating human forms. Most of my works are reflections of the environment and people around– the reality existent in their minds, which is more real and meaningful for me than mere physical reality." [Anupam Sud, *Indian Printmaking Today*, Bombay: JG Publication, 1985. p38]

182 Nalini Malani, regarding her **Women Series**. Excerpts, from "A conversation between Yashodhara Dalmia and Nalini Malani" *AHJ* 1 (1979-80): 41

his work, served by a tranquil-obsession with death.[179] That many of the memories, dreams and fairytales came from his grandmother's narration, within their sheltered ancestral home, meant there was an in-built force towards fusing the joyous with the mythic, the nostalgic with the eternal, the protected and its intruder. Once this contradictory cohesion was sustained no outer trauma could usurp this source of inspiration.

By the mid-1970s Bikash Bhattacharjee's earlier phase had been tempered by a greater respect for realism, especially given his teaching commitments at the CGAC (1973-82). The humorous and the grotesque were the two poles which were trying to find a balance within him, reflecting the need to keep hope alive amid the pessimism of everyday life. This balance was expressed by his unique fusion of imaginative freedom with his love for detail and precision.

The theme of women and the injustice done against them became his focus by the late-1970s. In many of his works, such as **Homage to Angurbala** he expresses the tense balance in revealing one's vulnerabilities while maintaining one's dignity, the still point within our sadness.[180]

Apart from these thematic shifts in the male gaze, the ongoing post-modern reassessment of the role of women and neglected 'others', chiefly manifested itself in the emergence of many more Indian women artists, entering the stage with a greater self-confidence. The process of demarginalisation was gaining momentum as they sought to establish their aesthetic niche. Nevertheless, so slyly implicit and in-built are the attitudes of chauvinism into a 'normal' Indian way of life, that the absolute waste of female artistic energy and talent is unfathomable. Though the artistic community may not see the man-woman difference as a division, the infrastructure that facilitates the opportunities has no such sense of equality.

However, artists such as the brilliant Ira Roy (b.1935), Arpita Singh (b.1937), Veena Bhargava (b.1938), Kishori Kaul (b.1939), Madhvi Parekh (b.1942), Suruchi Chand (b.1944), Arnawaz Vasudev (1948-88), Navjot (b.1949) and others, held their first solo or group shows during 1971-3. The gifted printmaker Anupam Sud (b.1944) held three solo shows between 1969-71 exhibiting her maturing talents, as best expressed in her later **Dialogue Series**, where the art of human communication and togetherness is expressed through the mood of a mature silent acceptance.[181]

Another young artist, Nalini Malani (b.1946) began work on her introspective **Women Series** during the early 1970s. Regarding the work she summarises: " I was obsessed about achieving the 'correct' look of the person, the tilt of the head and the splay of the body. The woman was large and ominous. She was almost pinned down against her will, struggling to push herself upward and outward. The skin was stripped revealing a network of blood vessel and vein– the mouth emanating a soundless scream. The edges of the canvas amputated the limbs above the elbow and knee. One felt voyeuristic about these women – yet they left one with guilt and horror..."[182] Thereafter, during the 1980s she focused upon the wider role of the woman, especially in a joint family urban context.

Devyani Krishna's introspection did not demand the use of socially relevant comments or the figurative idiom, as with most of the aforementioned artists. Her printmaking journey reflected a rare feminine attempt to fuse the ancient symbolism of various religions with the contemporary demand of self-awareness and its scientific inclination.

[183] Eg: " The ecclesiastical severity of her pensive figures becomes more celebratory with a shift in palette– the sombre hues, the madders and browns embellished by strong whites. The unique coloration that is to inform her later works begins to evolve... Instead of choosing the 'School of Paris' as a point of departure, Anjolie drew sustenance from anonymous Romanesque paintings, and from Botticelli, Busch and Giselbertus. The resultant still, stiff quality of her work...becomes a conscious stylistic choice, softened in the late 1960s by the artist's own experiences of motherhood." [Isana Murti, *Anjolie Ela Menon*. New Delhi: Ravi Dayal Publications, 1995. p26]

Another artist whose introspection also found expression through a geometrically disciplined abstract idiom was Nasreen Mohammedi (1937-90). Unlike Devyani and Nasreen, Anjolie Ela Menon and Gogi Saroj Pal (b.1940) could never discard the human figure. Anjolie's early interaction with fresco painting and Byzantine iconic art, helped structure her emotional progression. Her experiences as a woman, coming to terms with her freedom and the later obligations of marriage and motherhood, gave rise to gently sombre images during the 1970s, away from the expressionistic fervour of earlier years.[183] Also, like Amrita Sher-Gil, Anjolie Ela Menon was able to focus on the female nude with an ability of creating a languid and timeless mood, unlike other women artists of her time. Gogi Saroj Pal's early figurative work focused upon the sad and alienated aspect within each of us. However, by the 1980s this pain would have been absorbed and her imagery reflected the emergence of a more compassionate and assured identity, at ease with one's vulnerabilities and strengths. Her later work drew upon traditional myths, for contemporary relevance, focusing upon the harmony between animals and humans, as was also the case with the instinctive art of Madhvi Parekh. The village and folk roots, of Madhvi Parekh's vision provided her the ability to harness, the naive and fantastical into an evolving language where the relationship between gods, humans and animals is clearly revealed, becoming dissolved into a continuous lila, playful yet aware of the lurking violence just beyond.

As a result of these efforts, no longer would the created archetypal images of human fragmentation, violence, corruption and stoic resilience be dominated by men. Nevertheless, this shift would be a gradual process, reflecting the wider struggle of the women's movement towards attaining its due respect within India's woven fabric.

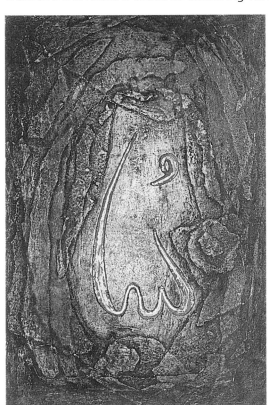
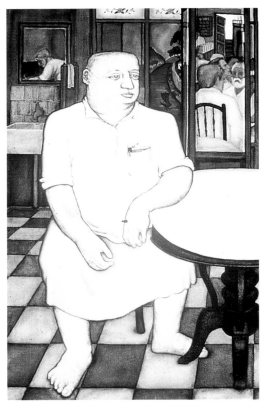

189 (Right)
DEVYANI, Krishna
Allah Series
42x27. Etching, 1974

190 (Far Right)
PATWARDHAN, Sudhir
Irani Restaurant
142x89. Oil, 1977
Masanori Fukuoka, Japan

During the 1970s a range of post-Independence second generation artists such as A.Ramachandran (b.1935), G.m.Sheikh (b.1937), Gieve Patel (b.1940), Rameshwar Broota (b.1941), Vivan Sundaram (b.1943), S.Patwardhan (b.1949), among others, best expressed another perspective of urban pain and protest in cities such as Bombay and New Delhi.

It was the balance between expressing one's anguish while not sentimentalising the issues, not exploiting another's pain to give a crutch to one's sense of helplessness or

guilt, which dominated the aesthetic dilemmas of many artists during this time. As a result many artists attempted to impose a clearer cerebral detachment upon their expressionism. It was indeed a sense of guilt at being an artist amid such national poverty and inequality, which heightened this process of steeling oneself.

The artistic choices of a young artist-doctor such as Sudhir Patwardhan (b.1949) clearly reflected this genuine struggle. As the artist himself states: " Painting the human figure is a commitment and a responsibility. I would not be able to justify being a painter without being a painter of people...I would have liked to be a revolutionary, or one who works directly for the improvement of society. I became an artist instead. And the guilt of this choice has not left me."[184] The additional weight of a Marxist-inspired ideology compounded the psychological pressure, where his desire to feel the pain of the working class, seemed obsessional.

[184] S. Patwardhan, conversation with the author, 8 Jly 1993

A more detached perception, regarding the pain of the people, though no less compassionate, was seen in the maturing art of Gieve Patel. Like Sudhir, Gieve worked as a doctor for the working classes. This obvious contribution to society was probably their way of defending a sense of artistic helplessness. Nevertheless, by the early 1970s the clearcut attitude not to sentimentalise the plight of the downtrodden had been accomplished. For Gieve this had been achieved by a shift of subject matter, away from the politicians and their corruption, towards revealing the stoic inner strength of the common man, as in paintings such as **Figure in Landscape** (1976), **Two Men with Handcart** (1979) and **Early Morning Local** (1982).

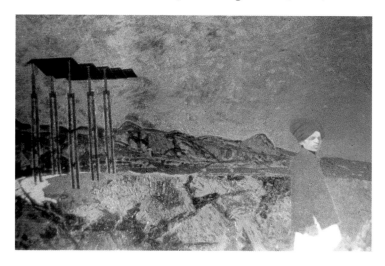

191
PATEL, Gieve
Figure in Landscape
121.9x274.3. Oil, 1976
NGMA

Even with a relatively senior artist, such as Krishen Khanna, this issue of 'guilt' took time to mature, as he himself clarifies: " I have been asked why I choose sad, tragic and even morbid subjects. Maybe it is because of the inequity we see and therefore, a sense of guilt. I cannot really believe in *karma*. I know also that by exercising these images I am not being socially effective. I have even thought that painting such pictures could be an indulgence, worse still that I could be acting as a parasite, making all that should be changed into something acceptable. I think every artist becomes his own tormentor."[185] The transformation from works such as the early **Truck Series** (first series in 1974) to the later **The Marriage Bandwallas Series** (late 1980s–1990s) best revealed his evolving artistic confidence, in its ability to fuse sadness and joy, colour and sobriety, material flexibility and emotional fluidity.

[185] K.Khanna, "Looking beyond his Canvas" (based on interview with Chanda Singh), *the India Magazine* 4.10 (Sep 1984)

[186] " Memories of this air, this land of my childhood, entwining me like dry, crabbed shrubs. Mynas screeching on the platform,...and before I open my eyes, the train, and its rushing tongue carrying me like an insect towards my childhood...Huts silent in the villages; torn, frayed, the pregnant earth ravished with wild currents; awakening an old feeling of desolation,..." [a Gujarati short story 'Returning Home' written by G.m.Sheikh, 1975. Rpt. in *Aspect: India Issue*, U. Beier, ed. 1982]

Even though G.m.Sheikh's (b.1937) **Indian Man Series** (1974) and **Speechless City** (1975) expressed a more direct social comment, such as protesting against the Emergency, the main thread of Ghulam's work was a revival of his childhood memories, merging with his literary work, to find a place of belonging.[186] Eventually he remoulded the honeycomb-like compartments of the Mughal miniatures such as the **Razm Nama**

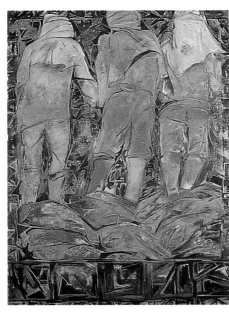

[187] Examples of other such attempts were: *Artrends* established in 1961 by P.V.Janakiram; *Contra* established in 1966 by J.Swaminathan but was a very short-lived effort; *Art Today* was established by Jogen Chowdhury & Shuvaprassana in 1981. *Vrishchik*, established in Mar 1970.

[188] Just before the 2nd International Triennale on 20th Decemeber 1970, a petition of 150 artists, organised by the magazine *Vrishchik* and personalities such as G.m.Sheikh, J.Swaminathan, Geeta Kapur, and Vivan Sundaram, demanded a restructuring of the Lalit Kala Akademi and its patronage activities, especially regarding its 'mishandling' of the Triennale. This tension would be an ongoing process, despite attempts to bridge the differences. The cracks would grow daily, reflecting the collapse of a national institution and the increasing public condemnation of its internal inefficiencies. On a deeper level it revealed the national failure to conceptualise and structure creativity in our overall development as a group of people and nation.

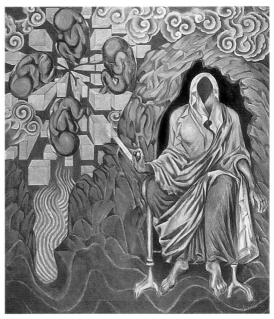

and Khusrau's **Khamseh** to express the simultaneity and multi-faceted nature of everyday existence with a mature vision of artistic openness, and plurality, as well as the hope for some root of cohesion.

Like only a few other artists, G.m.Sheikh tried to redress the poor critical-literary base which supported Indian Modern Art, with an art magazine/bulletin called *Vrishchik*, which he published and edited along with Bhupen Khakhar.[187] During the early 1970s the magazine would also provide the leading platform for protest against the Lalit Kala Akademi and its handling of the International Triennale among other activities.[188] Yet on the whole, few artists met the infrastructural challenges. It was not seen to be their duty. Gradually the inadequate infrastructure deepened their sense of alienation and introspection. Most retreated into small self-sufficient artistic worlds, coming to terms with the eternal questions of existence, its pain, its absorption, one's sense of release and calm.

This ability to harness personal anguish through one's creative discipline was best epitomised in the art of Tyeb Mehta. With the merger of his falling figures and the pictorial diagonal, Tyeb Mehta had established an archetypal imagery of fragmentation. The authentic intensity of his figural collapsing-balance reveals living on the edge. Creativity and its integrity alone sustain sanity amid this swirling whirlpool.

A.Ramachandran's early focus on the human body also strove for that same suspended anonymity as Tyeb had accomplished. However, in contrast to Tyeb there was an abundant human energy waiting to vent itself, retwisting the helpless destiny of his figures. Soon these figures were transformed through transitional works such as **The Nuclear Ragini: The Dancers Series** (1975), inspired by classical miniature and Rajasthani folk-art idioms, and triggered by the 1975 Indian nuclear testing at Pokharan (in Rajasthan), and his faceless female forms as in the **Nayika Series** (1979). These periods of suppressed sensuousness were later exorcised in his monumental erotic-mythic **Yayati Series** (1984-6). This work had clearly imbibed the language and traditions of Indian classical art, especially the mural art of Kerala, revelling in its decorative use of line and colour, imparting joy through absorbing sorrow. His later **Urvashi & Pururavas Series** would also reflect the ongoing pursuit of a contemporary language rooted in moulding traditional norms and forms.

Rameshwar Broota's experiments with space, as reflected in works such as **The Spectator** (1977) and **Shabash Bete** (1978), implied the temporary suppression of the human body. This period also served as a link from Broota's earlier allegorical

195
BROOTA, R.
Runners
203.2x203.2. Oil,1982
Private, New Delhi

Chimpanzee & Gorilla Series to his powerful **Man series** of the 1980s. Here the human figure would emerge as a 'Colossus-like warrior', fighting with quiet dignity the violence which surrounds but cannot engulf. Its isolation would be its inner strength as well as its flaw, reflecting the struggle of aesthetics in trying to dictate daily material life.

The social satire of Broota's earlier art was something an artist such as Bhupen Khakhar also shared. Bhupen's work during the 1970s came to focus on his **Trade Series** and themes which dealt with the common mundane realities of middle class life. Work such as **Janata Watch Repairer** (1972), **Deluxe Tailor** (1974) and **Man eating Jellabi** (1976) reflect a unique visual image. The Pop Art norms of merging the popular and elite, the loud and the refined, is one driving motivation during this period. He realised that the gulf between vulgarity and beauty can be superficial, so much so that positions can be easily reversed, once compassion overwhelms the tired sense of hierarchy. The detached–empathy with which one eyes and sustains this (supposed) vulgarity is the strength which sustains Bhupen's creativity. That the difference was never really significant in the first place adds authenticity to Bhupen's art. For example, though a statement such as: " It was only in his late thirties that Khakhar arrived at a hybrid idiom, in which Rousseau, Hockney, Sienese pedellas, the oleographs of the Bazaar, the temple maps of Nathdwara and awkward observations of 'Company' painters, are all somehow fused together. And with this idiom a new world opened, which no painter had ever dealt with before; the vast expanses of half-Westernised modern, urban India...",[189] clearly recognises many of the tangible ingredients of Bhupen's art, the process of fusing the ingredients is not clearly understood. The reason being that the initial belief in polarities may not have existed with Bhupen Khakhar,

[189] Timothy Hyman, A Critical Difference ExC. [An Aberystwyth Arts Centre & The Showroom, London, collaboration], 1993. p3

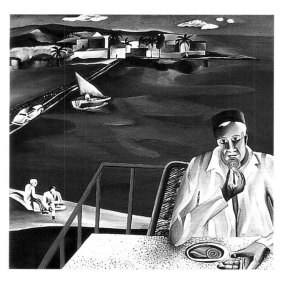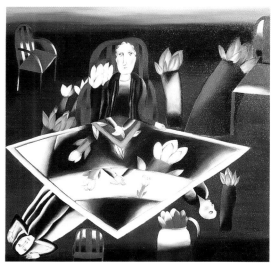

196 (Right)
KHAKHAR, Bhupen
Man Eating Jellabi
111.5x111.5. Oil, 1976
Private, London

197 (Far Right)
SINGH, Arpita
Figures & Flowers Series
121.9x121.9. Oil,1972
Private, New Delhi

and so any consequent deconstruction becomes secondary. It is not so much about creating a synthesis, but about revealing an already existing unity.

This philosophical subtlety was differently recognised by Prabhakar Barwe, who had also begun his artistic journey with enamel on canvas, but unlike Bhupen he sustained the sole use of this medium. At the same time, Prabhakar was gradually progressing towards an understanding of one's inner space, in works such as **Mystic Wheel** (1973) and **Blue Cloud** (1976), just as Bhupen Khakhar was progressing towards a sense of being honest with oneself. That Barwe focused on the revelational aspect of honesty, and Khakhar on the confessional aspect, merely reflects the personal circumstances and the nature with which Western art and thinking had been imbibed.

Arpita's **Figures & Flowers Series** (early 1970s) using oil as if expressing the gaudiness of enamel, revealed a fine inner playfulness through which she transformed everyday feelings and incidents, while arousing a joy of colour and movement. Her wisdom was not rooted in a contemplative maturity as with Barwe's enamel work, but based upon the genuineness which familiarity breeds. Through this authenticity, she gradually evolved an artistic vision, reflecting a shy spirit of human optimism, aware of continuity, and its open-endedness: " Well, it is difficult to say, but I believe that, afterall I am not the first or last human being, I am part of a chain. The exact stock from which I come, I cannot say. The only thing that I am expressing, whose dream, whose wish, I don't know. Maybe they have concentrated in me, perhaps. Thus if I say that this is the reason why I have made the flowers or placed the figures, I don't know, I really don't know, because that part of memory, all I remember is the form, not the cause, that I have forgotten."[190]

By the mid-1970s Arpita had drifted into experimentation with black-and-white abstract forms, but was unable to sustain the idiom and its stark temperament. In contrast, Nasreen Mohammedi's temperament and aesthetic was by now finely tuned towards the potential austerity of an abstract idiom devoid of colour. Having been fascinated by the infinitude of pebbles and sand on the beach, through a Zen-like lightness, and having absorbed the intricacies of the mediating design of the cobweb, it seemed inevitable that the idiom of Op-Art would be appropriated to reflect her own inner turmoil, which was searching for some clear cut order by the late 1970s.

Perusing the personal notes in the recently published book: **Nasreen in Retrospect** (1995), one can gauge the manner of her artistic evolution during this period:

" Vision of rain...breathtaking tonal values.
From one central idea...expand.[191]...

[190] Arpita Singh, conversation with the author, 9 Sep 1993

[191] Nasreen Mohammedi's diary, 7th Aug 1973. Rpt. in *Nasreen in Retrospect* Altaf Mohammedi, ed. Bombay: Asrhaf Mohammedi Trust, 1995

198
MOHAMMEDI, Nasreen
Untitled
50.8x71.1. Pen & Ink Drawing, c.1978
Private

[192] 11th January 1974; *ibid*

[193] 1st February 1974; *ibid*

[194] 10th May 1974; *ibid*

Study the basic elements.[192]...

The maximum out of the minimum. Think.[193]...

Rain.
Detached ease.
Unity through function. Function through unity.[194]...

Nothing dies, much lingers on, co-existing, transformed and recycled. This reflects the ethos of daily life, as much as the nature of the idioms within contemporary art. This is also one reason why many artists were seen as stagnating, conjuring up variations of a habitualised idiom, the same signatures in different colours or textures. The situation was no different in India.

The Neo-Tantric and Pop Art norms, coupled with an inherent rural romanticism, would soon give way to a deeper appreciation of one's social responsibility, especially after the Emergency imposed by Indira Gandhi in 1975. At the same time, the introspection would reveal a deeper need to grasp India's folk–tribal–urban continuum as well as renew one's relationship with nature, as reflected in the art of J. Swaminathan. With his **Colour Geometry of Space Series** (late 1960s) the influence of the Neo-Tantric idiom and other mythic and abstract symbolisms, were remoulding his experiments. As Geeta Kapur points out: " This abstract phase was notable mostly because the painterly techniques evolved at this time were utilized later. The palette was lightened to iridescent hues like pink, mauve, pale green, and lemon yellow, and the painting was conceived entirely in terms of colour. There was no tonal contrast and also neither thickness nor depth; the geometric shapes were arranged very simply and in a flat pattern on the picture surface. This more or less formal exercise yielded images that were to configurate later in more...significant ways."[195]

[195] Geeta Kapur, *Indian Contemporary Artists*. New Delhi: Vikas Publishing House, 1976. p201.

The **Mountain Trees and Birds Series** (late 1960s-mid 1980s) which followed this transition revealed the sense of awe which humans feel with nature. There was a simplicity of form which finally allowed his inner vision to radiate through, free of the cluttered symbolism which the earlier cleverness manifested.

[196] J.Sabavala, *AHJ* 1 (1979-80): 13

[197] " I find myself concerned and entralled with nature. The sun, the moon, the stars– "heavenly alchemy"– it is in the region of the beyond that I find myself free to dream and build a world of mystery and beauty...I love mist and rain, sunshine through great banks of cloud...I seek to haunt by the use of the broken tone– a moss green rather than a pure green, russet and brown and gold, rather than a primary red or yellow. I now try to paint 'man' as a wraith–like form, and not as the solid, carnal creature that he really is." [J.Sabavala, 1966. Reprinted by Priya Devi in *Jehangir Sabavala*. LKA, 1984]

Many artists also returned to nature as a source of inspiration so as to resuscitate their aesthetic sense. A classical respect for nature always underlay Jehangir Sabavala's artistic vision. Within the confines of his remoulded Cubist idiom, his works of the **Of Cloud and Air** Series (1977) and **Of Cliff and Fall** Series (1978) best epitomise this cohesion of one's inner vision and the adopted painterly techniques. The transformation took time, as Jehangir himself recognises: " Over the past several years vivid colour and an extroverted expression of the senses have disappeared from my canvases. I have been seduced instead by a palette of broken tones... by a visible search for a more distilled essence."[196]

However, the cystallisation of water which these works reveal, seem to have eternally captured the momentary joy of a ever flowing nature, and the human awe of such unattainable essence through a disciplined eye.[197]

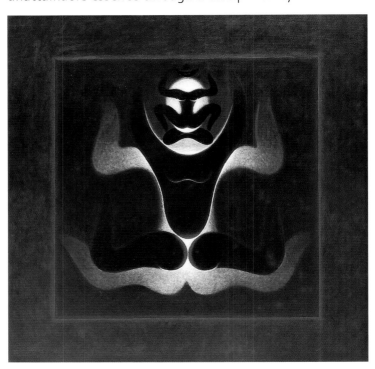

199
SANTOSH, G.R.
Untitled
Oil, 1982
LKA

[198] "'Conflict' is the essential means of all art forms. A dyad: union-separation, the horizontal and the vertical, two planes contraposed and we have a beginning... Tension can create a void and can fill a void.
The positing of opposites, their permutations, combinations will lead to consequences beyond our power, beyond our control.
Programming implies two movements: intensive and extensive. Intensive - towards the centre; extensive - away from the centre.
The intensive phase towards ultimate invisibility. From a point to a point on this axis, art is possible; and life vaccilates." [Akbar Padamsee, Opening, Paragraph from *SYZYGY Jawaharlal Nehru Fellowship Project, 1969-70.*]

The nature-human link had also been the dominating early inspiration in the art of S.H.Raza and G.R.Santosh. Their deepening metaphysical emphasis had by now appropriated various structural and symbolic techniques from Neo-Tantric art forms. For Raza, the device of the Bindu was apt in facilitating his contrast of shapes, as well as providing a pictorial focus.

Akbar Padamsee has also possessed an intimate affinity with the landscape, especially its elemental grid structure. (eg: his **Metascape** Series, 1970-85; this series was based on his Nehru Fellowship Project: SYZYGY [1969-71])[198] At the same time he possessed a philosophical attitude, clearly recognising the compulsion to absorb contradictions, and its mystical promises. Yet his art never incorporated such symbolism, thereby maintaining a rare artistic integrity, reflected by the starkness of imagery.

[199] G.M.Sheikh, *Laxma Goud*. Andhra Pradesh LKA, 1979

An oneness with nature was also seen with a different focus in Laxma Goud's work, reflecting the folk-tribal-urban continuum, through an emphasis on the male-female-animal-nature unity and its eroticism, as G.m.Sheikh's clearly recognised: " He discovered the raw sexuality of the village, against the cagey urban middle classes. He wished to 'emancipate' them, and restore the eroticism of the temples and sculptures...The rift between the urban claustrophobia and the rural primitivism has caused some of the creation to occur. The pure unpolluted sex appeals more than the complex psychological relationship between sexes in the urban middle classes."[199] His

200 Eg: " I have been to villages where folk art in its desolation throbbed with an intense poignancy. I felt strongly the pulse of creativity that ran like a rich mineral seam through their art..There is some kind of faith, an organic energy that sustains all people...It is individual faith, a faith in other people. This kind of faith kept me anchored to my mode of expression for over two decades. Even when the modes in vogue were otherwise I could not go adrift." [Manu Parekh, *SOCA Album 1960–1991*, Calcutta, 1992]

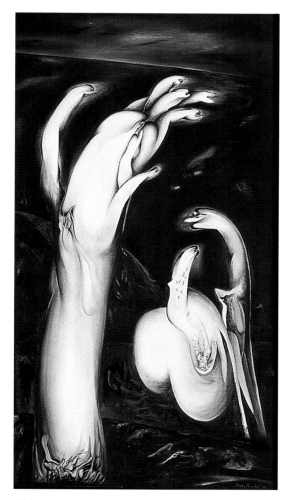

200
PAREKH, Manu
Tree & Bird in Landscape
Oil,1979
Private, New Delhi

201 Dr.B.N.Goswamy, Sohan Qadri –Gy. CH (Edition Klingmann) ExC. Apr–May 1977

Forest Series (1976) on copper plates and his numerous drawings manifest this increasingly disciplined vision, but with the ideological freedom which a daily obsession provides.

It is also interesting to compare Goud's refined work with the art of contemporaries, such as Manu Parekh (b.1939) and Laxman Shreshtha (b.1939), as all three began to unearth the seeds of their erotic and sensuous intent from rural sources. Manu Parekh's early introspection eventually sought inspiration from outer points of conflict. Cities such as Benaras and Calcutta provided ample sources of contradictory forces, thereby energizing his inner psyche into feeling a unity with such brooding anarchy.[200]

A similar erotic vein, with the aura of the landscape underlying the mood, was reflected in the abstract art of Laxman Shreshtha. By the 1970s his raw romantic energy found its focus in trying to grasp the male-female and human-nature dualities. A more subtle play with colours evolved, which abandoned the brut impasto technique, and moved towards a gentle exploration of texture, akin to his own mellowing process, which juxtaposed the firm line against soft colours; simulating mountainous terrains besides deep valleys, streams besides cliffs, tender love besides frustration, rural energy besides urban stifling.

Thus with many artists during this period, such as Anjolie Ela Menon, J.A.Sabavala, J.Swaminathan, L.Shreshtha, one finds the trend towards a use of light tones, revealing the radiance of colour, away from the heavy and dark textures of earlier expressionist influences. A comment by B.Goswamy on Sohan Qadri's abstract work aptly reveals this shift: " ...A third concern of Mr.Qadri is with textures. This is of relatively recent origin, for his work in India before he went away to Europe showed little preoccupation with them...In his resinous forms there is no opaqueness, no feeling of dead weight; he consciously works on the other hand to keep his canvases light, air–borne as it were so that he applies layer after translucent layer of paint, achieving tactile satisfaction, without imparting a hard, caked look, to his paintings."[201]

By the 1970s the internal self-criticism of modernism was extending its coverage to all branches of thought. Major changes in attitudes were filtering across the world. India was no exception, despite not seriously entering the postmodern race.

In a way this lack of participation was sad, though understandable. Yet, just about every postmodern idea has been heading towards a merger with our ancient intuitive wisdom. A greater involvement would have meant a deeper understanding of our own past, with a greater credibility for the holistic way of life. It would also have meant a more healthy relationship with the West, recognising the shared journey rather than only recalling colonial struggles. The economic liberalisation processes would have met with a more conducive foundation rather than what is occurring in the 1990s. At the same time, it may have been possible to have tempered the excesses of both the religious and material value-systems more effectively. As a result, the task of clarifying that aesthetic wisdom which is at the heart of a civilisation building process will now probably take a longer time.

Regarding counter-modernism many events acted as triggers for the renewed self-criticism by Western society. The Vietnam War and its aftermath, the Civil Rights movements, a growing activation of the working class and the women's movement, the flower-children and their half-baked sense of freedom, along with a growing Maoist attitude within the student bodies and the industrial trade unions, meant, among other consequences, that the dominance of the international *avant-garde* shifted away from America towards Europe.

202 Eg: " The critique of subject–centred reason is thus a prologue to the critique of a bankcrupt culture...To the necessity that characterises reason in the Cartesian–Kantian view, the radical critics typically oppose the contingency and conventionality of the rules, criteria, and products of what counts as rational speech and action at any time and place; to its universality, they oppose an irreducible plurality of incommensurable lifeworlds,...the irredemiably 'local' character of all truth, argument, and validity; to the a *priori*, the empirical; to certainty, fallibility; to unity, heterogeneity; to homogeneity, the fragmentary; to self–evident givenness ('presence'), universal mediation by differential systems of signs (Saussure); to the unconditioned, a rejection of ultimate foundations in any form...Interwoven with this critique of reason is the critique of the sovereign rational subject– atomistic and autonomous, disengaged and disembodied, potentially and ideally self–transparent." [Thomas McCarthy, Introduction, in *The Philosophical Discourse of Modernity* by J.Habermas, Cambridge: Polity Press, 1994. ppviii–ix]

203 Eg: " The single human figure is a swell thing to draw...I'm talking about skill and imagination that can be seen to be done. It is, to my way of thinking and in my own experience, the most difficiult thing to do really well in the whole art...It is there that the artist truly 'shows his hand' for me. It is then that I can share in the virtue of failed ambition and the downright revelation of skill..." [R.B.Kitaj, **The Human Clay ExC**. for the Arts Council of Great Britain, 1976. Rpt. in Robert Creeley's Introduction for R.B.Kitaj's Marlborough Fine Art (London) ExC. Apr–Jne 1977]

204 R.Broota, conversation with Keshav Malik. Rpt. in 'Thoughts on Six Painters' LKC 24–25 (Sep 1977- Apr 1978)

The literary-philosophical ideas re-examined covered every branch of thinking, with aesthetics and its relevance being at the core of the re-appraisal. Also, at the heart of the self-criticism, was a reaction against the idealism of a subject-centred reason, and that western context which nourished such a potential absolute.[202] Critical revisions by various French philosophers with a Marxist and psychoanalytical emphasis, dominated this counter-modernism, which would gradually adopt the garb of a post-modernism. Previously neglected and marginalised aspects, such as the participation of ethnic groups, the role of women, the treatment of Third World nations, along with a reaction against the hegemony of bourgeois logic, were finding new practical reinterpretations. For example viewing historical narratives from a post-colonial feminist-Marxist perspective became fashionable.

Other ideas came to focus on the relationship between the artist and spectator, and the influence of the exhibiting space, the medium of painting and its commodifiable potential. Further, traditional societies were re-evaluated, no longer seen in opposition to Modernism, praised for their ability to dissolve various differences such as that between 'high' and 'popular' art norms. Soon a pluralistic vision of a relativist reality was the grid upon which knowledge and society was structured.

One of the visual implications of this counter-modernism was a renewed Western interest in the figurative idiom, with a stress on expressing one's humanity with a greater objectivity. For example, the views of an artist such as R.B.Kitaj[203], found a fertile corner in Baroda with a small group of artists keen to build new bridges with the ongoing European modern historical narrative. The Indian artists found a reaffirmation of their own ongoing figurative pursuits. There was a renewed sense of confidence and a deeper international dialogue.

The aesthetic integrity and commitment to the human figure, of an artist-teacher such as Rameshwar Broota, could be seen to epitomise the aesthetic freedom an artist must give oneself, if a clear focus upon one's inner compulsions is to be attained. As he himself states: "I don't understand dogma in art, the theme I happen to pursue does not make the art important. No generations are possible here. To force art into this or that mould would be death to art. It is education that needs change, not art. The habits of viewing art must change...In one sense an aritst has spiritual self-sufficiency; he needs no preconceived ideas; an artist is, after all, a search for possibilities. He cannot therefore be bound down, no matter how noble ideal considerations. Neither 'Indianness' nor social content must be enforced or enjoined. Visual qualities, as we know, are all that are important; what one expresses is a matter of chance; certainly one requires emotional maturity but since art is a child of freedom of spirit, we must not set out to make orthodox or partisan value judgements..."[204]

Despite this recognition of freedom and change rooted in some creative stubbornness, the artistic journeys of many senior artists seemed to be reaching a saturation point by the early 1980s. They had sustained their styles for a number of years, expressing varying forms within the same idiom. Yet the sense of unity between their technique and life was also evident, and so the possibility of change was always imminent. They created the benchmark standards which inspired the younger generation of artists to potentially seek different directions.

For example by the late 1970s, M.F.Husain clearly epitomised the energy of Indian Contemporary Art. He bridged the varying sensibilities which transversed the common and elite like no other. If the masses had any knowledge of Indian Contemporary Art it was due to his efforts. However, for some he was now indulging in gimmicks, where his technique had become a constraint, capable of only illustrating different facets and events of life with an all too familiar signature. This was true to an extent, but like any

all-encompassing creativity, it represented but one aspect, which became clear with a deeper documentation of his artistic range.

The dedicated study and documentation of Husain's profuse output by Geeta Kapur (eg. 1967 & 1978) R.L.Bartolomew & Shiv S. Kapur (eg. 1971) and Ebrahim Alkazi (1978) highlighted his uniqueness. For example, a broad categorisation of Husain's work (mid 1940s-78) as made by E.Alkazi reveals the vast artistic range:

1.	The urban scene	eg: **Man Series** 1950
2.	Rootedness	eg: **Indian Village** 1955
3.	The Interior Landscape	eg: **The Voice** 1959
4.	Innocence and Experience	eg: **Blue Night** 1959, **Fatima** 1960, **Black Moon** 1960, **Nartaki** 1964, **Devdasi** 1965
5.	Alienation	eg: **Pamosh** 1953, **Passage of Time** 1954, **Second Act** 1958, **Empty River Bed** 1961, **Quivering Brown Bodies** 1966
6.	The Visual Metaphor	eg: **Varanasi Series** 1973 (seriagraph)
7.	Links with tradition	eg: **Village Life** 1955, **Autobiography** 1965
8.	The Dignity of Man	eg: **Ahmedabad Drawings** 1976
9.	The Metaphysical	eg: **Passage Through Human Space Series**, 1975, **Series of Dimen-sion** 45 watercolours – Gandhiji, Astronaut, Shakti, Black Cloud,...
10.	Epic and Myth	eg: **The Mahabharata Series** 1971-2, eg: Vyasa Ganesh, Draupadi, Ganga, Visvamitra
11.	Human Suffering	eg: **The Cyclonic Silence** 1977

However, in 1979, M.F.Husain created his famous **Mother Teresa Series**, which fused all the emotional fervour of a child yearning for his mother with poetic idealism,[205] hand in hand with the stray material triggers off memories which creates an art work.

The dialogue with international post-modern art was nevertheless best reflected in the work of the post-independence second generation artists. One such group came together in the seminal 'Place for People' Exhibition (Nov.-Dec.1981) at the Jehangir Gallery, Bombay & Rabindra Bhavan, New Delhi. Their work highlighted the shift in emphasis towards a greater urban art consciousness, with its willingness to comment on social-political issues, contextualising the figurative idiom.[206]

Bhupen Khakhar (b.1934), Gulam m. Sheikh (b.1937), Jogen Chowdhury (b.1939), Vivan Sundaram (b.1941), Nalini Malani (b.1946), and Sudhir Patwardhan (b.1949) were the participating artists, each consolidating their reputation. The added positioning of respected art critic Geeta Kapur, reinforced the base of the exhibition, providing an essentially post-colonial feminist-Marxist perspective on historical narratives in the Indian context.[207]

The basic mood and intent of the exhibition was well summarised by a participating artist Jogen Chowdhury: " It is most essential that our painters represent the unique reality, nature, life and psyche of our own experience. When an artist truly involved is able to represent such reality in a meaningful way in his work, he is also systematically able to solve the problem of style and language by creating a new one... We can create an art that perhaps no other group of people in the world can, because of our unique situation. This also includes the situation where the whole society is distorted, caught in the midst of social disbalances and haphazard efforts of development...I strongly feel, that already a breakthrough is in the process and it will, in the coming decades, cohere into an original and significant activity. These artists are open-minded and observant of art movements taking place outside India, and know that it is necessary to

[205] "Send me a snowclad sheet of sky bearing no scar.
How shall I paint in white words
the encircling contours of your boundless norms when I begin to paint
hold the sky in your hands as the stretch of my canvas is unknown to me." (M.F.Husain). Rpt. in *Aspect*: India Issue. U. Beier, ed. 1982.

[206] "Basically all of us were interested in relocating the human figure, not just in existential terms, that man is man, and out of context, but in a context....(also) in bringing back the figure one put certain constraints upon oneself. The intention was that one did not want to distort the figure in the modernist way, which had become part of convention." [Vivan Sundaram, conversation with the author, 2 Sep 1993]

[207] " Since the 1970s the specific physiognomy of Indian figures is slowly uncovered, and some artists adopt that ancient activity of story-telling which bridges the commonplace and the fabulous worlds. However, in strictly urban situations, where the artist is born outside tradition, experience presents itself like a puzzle; you fit together the parts according to willed purpose. Narration becomes allegorical. Used self-consciously and with the historical construct, it can trace the trajectories of individual and collective motivation. This is the premise of recent figuration in India." [Geeta Kapur, Royal Academy of Art ExC. London, 1982]

208 Jogen Chowdhury, Place for People ExC. Sep 1981

be aware of them...a tulip can bloom in Europe while a lotus opens its petals in India. Technical elements of a painting may be in some instances accepted internationally, but I see no reason to be part of the international trends."[208]

Bhupen Khakhar's evolving narrative was represented by works such as **Celebration of Guru Jayanti** (1980) and **You can't please all** (1981). Soon, as his confidence and exposure grew, his art would express deeper concerns regarding his homosexuality with greater artistic freedom, as in later works such as **Two Men in Benaras** (1983) and **Yayati** (1987). With this venting of suppression, a new playfulness and abandon entered his creativity, manifesting the transformation of struggle into joy.

209 " I wanted a picture, that is not a static image within a frame, but one that could be read visually through movement. In fact, in **City for Sale**, the intention was to make the viewer move with the picture– thus he adds his own movement to the space movements of the picture...I may begin with one detail and it flows into another, either opening into a new space or closing down on it or juxtaposing with it, with sharp divisions, and slowly a complex structure begins to evolve." [G.m.Sheikh, interview with Gieve Patel, Rpt. in Georges Pompidou Centre Paris., ExC. Nov–Sep 1985.]

G.m.Sheikh's work imbibed influences from all over the world, yet unlike with lesser artists, the eclecticism possessed an inner cohesion reflecting his open attitude to life. The desire to say 'everything, all at once' gave his work during the 1980s, a sense of swirling movement, intense colour use, and a division of space as in the spirit of Mughal and Pahari miniatures, reflected in works such as **About Waiting & Wandering** (April, 1981), the **The Speaking Street** (May 1981) **Revolving Routes** (September, 1981) and the later **City for Sale** (Oil, 1981-4).[209]

His art had recognised the thin balance of living with differences, hoping they shall not become divisions or violent barriers, and yet aware of the imminent disintegration. As a result the sense of a cohesive multiplicity falls apart. The unifying threads of the diversity seem to slip away, and this tug of war creates the tension which motivates his work. These ideas would receive a jolt during the 1990s, especially with the demolition of the Babri Masjid in December 1992, temporarily dissolving his colourful simultaneity into a brooding darkness.

Given Vivan Sundaram's intellect and aesthetic eye, his family and educational background, it seemed inevitable that he would be at the forefront of trying to initiate some form of sustainable dialogue with the Western modern-postmodern journey, while bringing his own heritage to this interaction. His earlier drawings on **The Heights of Macchu Picchu** (1972) and **The Indian Emergency 1975–77** revealed his academic discipline and socially responsive attitude, within a certain materialist-Marxist paradigm, while also reflecting his romantic streak. This struggle between the realist and idealist, the politician and philosopher, would dominate his future artistic progression.

201
SUNDARAM, Vivan
Fire Next Time
Oil, 1975
Private, Bombay

His open experimental approach, would take time to find its own rhythm, away from earlier works such as **Guddo** and **Portrait of a Father** (1980), towards paintings such as **Quintal of Grass, Two boys sitting on the outer wall** & **Ten foot Beam** (all in 1985), where his refined sense of colour and its sombre romanticism are clearly evident. There is no dialogue within his interrelationships; the dialogue is with the world outside of the artist who sees himself, his silence, his need to partake and the need to be detached. It is a complicated vision of balancing contradictory forces which few artist nurture with rigour, emotional and conceptual.

210 Nalini Malani, in Engagement with Reality an essay by D.Ananth, 1982. Rpt. in *India Myth and Reality-Aspects of Modern Indian Art*. E.Alkazi, V. Musgrave and D.Elliot, eds. Oxford: Museum of Modern Art, 1982

Nalini Malani's impressionable introspection focused on the experiences of a young woman trying to etch out her own space and sense of identity in an urban, joint family context, as part of the worldwide process of demarginalising one's 'otherness'. As Nalini Malani herself summarises: " I began by painting the extreme close-up of the woman, where even the pores of skin are gaping holes. Then I moved her to a mid-shot where she was contained in a room, the surroundings of which she was dimly aware. Now I am using the wide-angle lens. The environment that encloses her is not only the suggestion of a bed, a chair or a room. It includes other people each supporting the other, held together by the stretch and pull of relationships, embodying a history of its own."[210]

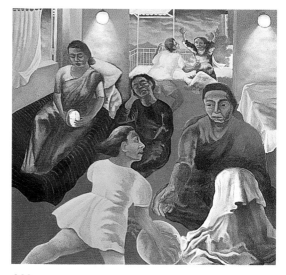

202
MALANI, Nalini
His Life Series
121.9x152.4. Oil, 1980
Private

[211] Gieve Patel, Sunday Observer, Bombay 30 Dec 1984. Rpt. in George Pompidou Centre Paris. ExC. Mar–May 1986

Her mix of revealing a sense of suffocation and support was expressed through the gesture and figural placement. Exhibited works such as **Unmarried daughter** (1980) and **Concerning a friend** (1981) from **His Life Series** best reflected her expressionism, wishing to find its inner detachment, and hence a clearer sense of identity.

Sudhir Patwardhan's ability to unify the figurative-urban landscape idiom also came from the tense romantic-realist mix he held amid a refined aesthetic intellect, continually nurtured by a genuine compassion. The maturity of his intuitive-logic was seen to be clarifying itself, now sure of its participating-detachment, yet falling short of playfulness in mood. The precise artistic balance of details represented his cerebral hold, and his need to be objective and fair.

Works such as **Ceremony & Town** (1984) and **Nullah** (1985) were more successful attempts at the same preoccupations concerning the dignity and pain of the working class, and the possibility of encapsulating ground realities with a degree of compassionate objectivity, as clearly pointed out by Gieve Patel: " In his painting **Town**, Sudhir Patwardhan uses the well-known device of seeing the town from several different visual angles, and incorporating all of them into one unified image...However, and here is the difference. Patwardhan takes great care to avoid any uneasy sense of compression, or of optical distortion. We are led to believe that the condensed and relaxed scene presented on the canvas is what we would normally see outside it, in any one single moment...The aim of such a painting is not to give a false impression of our small-town life. It is not to evade an honest facing up to its poverty or destitution. Rather, the artist holds this destitution within himself, and gives out instead a view that has corrected some of life's disappointments."[211]

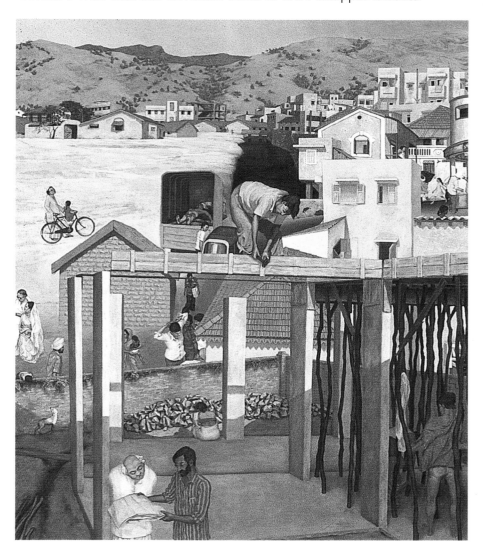

203
PATWARDHAN, Sudhir
Town
183x152. Oil, 1984
Chester & Davida Herwitz, USA

212 Jogen Chowdhury's diary entry 1980. Rpt. in Drawings 1959–94, Seagull- Vadehra ExC. 1994

Jogen Chowdhury's highly instinctive aesthetic discipline had by now matured his intricate play with linear textures into a technique which could transform notions of ugliness, decay, corruption, and shallowness, into an erotic design of line and its inner tension. As Jogen clarifies: " A certain tension is most essential in art work which is the result of the total effect of composition, colour and rhythm or sensitive lines...I do not agree that it is only 'speed' which creates such tension (Ramkinker's view), but it is 'stillness' which can create even greater tension in a work of art...Aesthetic tension in an art work is very different from an 'expression of speed'. Speed is not necessarily important for a painting, or an art form, but tension is important."212

The very notions of beauty were twisted wide open amid his unique vision. The inner sense of distortion which he has continued to evolve in his figures, revealed an erotic unfulfilment, merging the vulgar and refined, the sensuous and dead, the shy and obsessive, the universal and Indian.

However, it was in the artistic and conceptual maturity of K.G.Subramanyan, that one found unique images clearly reflecting artistic thought–processes which were capable of grasping the underlying unity of creative works, across places and through time. His work seemingly arose from absorbing the materialist dominated philosophy of urban social consciousness, the mystic inclinations of the abstract idiom, and the erotic playfulness of traditional arts such as the Kalighat *patuas*. As a result, a language trying to encapsulate the folk-tribal-urban continuum has come closest to realisation in his art.

213 His collection of essays in books such as *Moving Focus* (1978), *Living Traditions* (1987) and *The Creative Circuit* (1992), reveals the fuller vision his art cannot help but absorb.

214 K.G.Subramanyan, BAAC Retrospective ExC. 1983

After dispensing with the use of the oil-easel medium by the mid-1970s, he began work with various indigenous media, such as glass paintings. From his 1979 **Girl with Cat** glass paintings and various paintings on acrylic sheet one can clearly see the demands of his intuitive-logic asserting itself. His ability to clearly conceptualise such instincts was another reason for marking him out from other contemporaries213. For example, regarding his glass works: " In images mixing up uncouthness, swarthiness, disproportion, even brazenness of gesture with a brisk, high-keyed, distanced statement; something between a pin-up and an icon. The glass painting technique which is half-way between the deliberate and the spontaneous lends itself to this."214

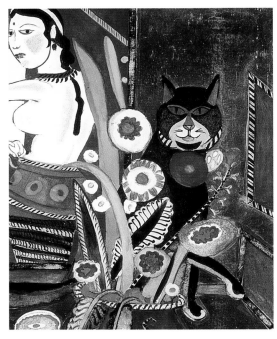

204
SUBRAMANYAM, K.G.
Girl & Cat Series
39x31. Glass Paintings, 1979
Private, Baroda

This will to create a spontaneous-icon, as reflected in all his works, especially the **Inayat Khan** Series reveals the belief that sees no gulf between encapsulating all tradition within the contemporary moment, as freedom finds rest in any corner, being sensuous yet tired, erotic yet indifferent.

With major retrospectives of his work being held at Bharat Bhavan (Inaugural Exhibition, 1982), Birla Academy of Art & Culture (1983) and Art Heritage (1984), along with other awards, his contribution was increasingly moulding the orthodoxies within Indian Contemporary Art and its wider links with folk and tribal arts.

However, it was with the establishment of Bharat Bhavan at Bhopal (1982), a brainchild of J.Swaminathan created with government support, especially through the efforts of B.V.Karnath and Ashok Vajpayi, that the conceptual ideas of a folk-tribal-urban continuum and discontinuity found an infrastructural image and sustained encouragement.

215 "My aim as a painter is...to integrate the representational, the metaphysical, the suggestive and symbolic in two-dimensional images, in order to achieve inner satisfaction...There was no need to understand art, one should spontaneously enjoy it. Art has a right to choose from wherever..." [K.K.Hebbar, *Voyage in Images*. Bombay: JG Publication, 1991.]

Parallel to the work of artists engaged in a systematic dialogue with international postmodern art and thought, there existed many who had already established deep rooted sources of inspiration, where the postmodern issues were of lesser relevance to their artistic journey. The timeless effusion of '*ananda*', joy, dominated their mood and intent. Senior artists such as K.K.Hebbar,215 M.F.Husain, J.Sultan Ali, Laxman Pai and

205
SULTAN ALI, J.
Bhumi Mata
36x43. W/c, 1981
Private, W. Germany

[216] Rupika Chawla, *Surface & Depth*, New Delhi: Viking Publications, 1995. p65-7.

the later work of A.Ramachandran, best epitomised this attitude, as well as relatively younger artists such as Laxma Goud & Manjit Bawa (b.1941).

With time Bawa would mould a unique pictorial world, from a base of a few shapes and obsessions. The fluid metamorphosis between living creatures, was evident in the profound simplicity his art epitomised. This sense of form was reinforced with a refined sense of colour, inspired by miniatures, especially Basohli, and moulded into his own unique style: " Bawa redefines mythology,...blending the established with the unconventional...Mythology is also the excuse to use a subjective palette, since a new iconography gives him the freedom to do whatever he likes with colour...Bawa relates to colour the way he might do to humans. Wanting to know the steadfastness of a colour is like testing the inner stability of a person. It takes time to understand a certain hue in the way a person's barriers are difficult to penetrate. Using and mixing colours, juxtaposing them is analogous with human interactions and relationships."[216]

206
BAWA, Manjit
Untitled
201.3x151.8. Oil, 1983
Private, New York

[217] However, after nearly a decade of artistic inactivity, Gaitonde has temporarily returned to painting in 1995.

One cannot ignore the interpretation of artistic stagnancy which repeated variations imply. Also, one cannot dismiss the idea that after a certain mental maturity, artistic creativity has served its role. If the individual is to remain true to knowing oneself, then an alternative is some gradual detachment, with diversion of energies into other areas, leading to complete inactivity in uncompromising cases, as it was with V.S.Gaitonde.[217]

Gaitonde's explorations regarding the luminosities and densities of colour, could best be clarified if one tries to imagine the formation of puddles of water on a marble floor, hand in hand with their consequent drying process. Random shapes emerge, only to disappear and re-emerge. These uncertainties are played with, each moment demanding a stillness. Soon one feels that randomness has been given sufficient freedom, and is about to return the compliment, revealing herself through some recognisable form.

Yet nothing emerges. At this point the temptation to create a form is immense. To let the formlessness be requires an uncompromising discipline. Yet in this act of letting it be, appears the imagery. It is a most honest-deceit, whose only concern is to air the space within, to allow one joy in openness, and the act of giving space, so realising the futility of occupying space. That is the contradictory hold creativity arouses when motivation and the demand for inactivity tease each other, playing habitual hide and seek, as water evaporates and air moistens. These were what Gaitonde may have experienced in his moments of play with colour and its material infinities.

207
GAITONDE, V.S.
Untitled
148x108. Oil, c.1980
Private, New Delhi

One could also attribute some of these sensations to the abstract work of two younger artist: Parabhakar Kolte (b.1946) and Achuthan Kudallur (b.1949), though in their case, the lightness of colour seemed absent. As a student of S.B.Palsikar, and a most dedicated teacher himself, it was in Nature that P.Kolte sought his essential inspiration, evolving an inner detachment which would eventually enable his art and life to seek daily coincidence, free from the mundane routine of a urban context and its vulgar obligations. Such freedom could only be attained by absorbing vulgarity into the realm of colour. This obligation represents the heaviness which a free spirited Gaitonde had turned away from, and which Kolte was forced to gradually melt down.

[218] Achuthan Kudallur, conversation with the author, Madras.

"To witness, not to act is the first role of the artist"[218]. This view of Achuthan Kudallur was in sharp contrast to Kolte's view of Nature creating first, and looking later. This difference of emphasis reflects the opposite directions in which both artists reach their abstract balance. A.Kudallur's need to verify contrasts with P.Kolte's inability to discard faith, and yet both strive for the other. A.Kudallur's Black and White drawings of the early 1980s reflects, the struggle of re-adopting colour in its joyous form, combining playfulness with a morose introspection, evolving a search within a limiting environment, which cannot help but unearth lightened dark alleys.

Thus by the 1980s a whole spectrum of values and idioms were seemingly dictating Indian Contemporary Painting. Most Indian, let alone international commentators were not fully aware of this multiplicity, its history or aesthetic. Those who tried an overview, interpreted the immense visual differences through used ideas inappropriately borrowed from another context, or cliched notions of romantic idealism and its essence. Of course a sense of cohesion was sensed by many, but the ability to dig into the organic roots was not encouraged. After all, Western ideas were now fashioned by the relativity of pluralism, its multi-faceted mosaic demanded no organic core. Notions of a potential absolute, whatever its self-critical openness, were unable to be conceptualised.

A few Western commentators with an experienced eye and keen understanding came closest to revealing the universal nature of creative absorption, though their post-modern relativism could not help but rear its influence. For example: " Like the proverbial wise bamboo always bending, always growing, Indian art has been able to absorb foreign influence and to embellish, enhance and tailor it to fit the size of the subcontinent. In short, Indian art is at its source, uniquely heterogenous, and eminently adaptable..."[219]

[219] T.W.Sokolowski, In *Contemporary Indian Art from the Chester and Davida Herwitz Collection.* New York: Grey Art Gallery and Study Center, 1985

What is that which allows Indian art to be so adaptable? This was something most failed to correctly understand. Without grasping the tone and process of being adaptable, adaptability can be seen as a weakness. For example, this is the fundamental dilemma facing Hinduism today, hence its vulnerability to being manipulated by political logic, distorting its holistic wisdom to serve some narrow and manageable image. Similarly, if the local emphasis of the pluralistic relativism comes to dictate, then honest unity is broken, and one sees categorised identities, leading to inevitable separation and violence. This is evident the world over. The issue is to provide the fuller value-system. Creativity and its aesthetics is the source of this value-system. It must also become the source of the simultaneous infrastructural transformation.

208
BAWA, Manjit
Krishna with Dancing Cows II
148x170. Oil, 1982
Private, New Delhi

209
BENDRE, N.S.
Untitled
180x90. Oil, 1987
Usha Mirchandani, Fine Art Resource, Bombay

210
BHASKARAN,R.B.
Life Cycle Series
122.5x97.5. Acrylic, 1991
Sadrudin Daya, Bombay

211
BHATTACHARJEE, Bikash
Two Sisters No. 2
122x122. Oil, 1982
Private, New York

212
BROOTA, Rameshwar
Vanishing Figure
177.8x228.6. Oil, 1991
Chester & Davida Herwitz, USA

213
CHOWDHURY, Jogen
Man & Woman
64.8x97.2. Pen, black ink & w/c, heightened with
bodycolour on paper, 1987
Private, New York

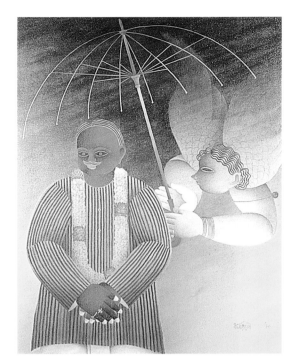

215
DASGUPTA, Dharamnarayan
Untitled
71x55. Gouache, c.1989
Private, Calcutta

214
DAS, Sunil
Untitled
150x150. Oil, 1992
Private, Calcutta

216
DODIYA, Atul
The Room
120x180. Oil, 1989
Private, Bombay

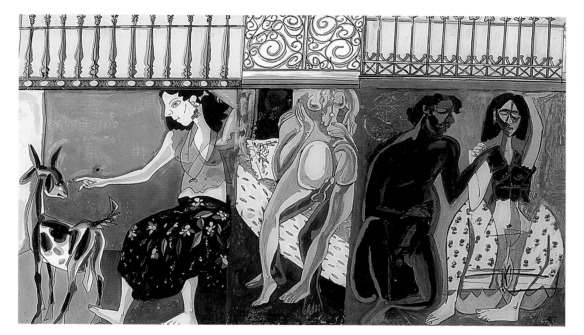

217
GOUD, Laxma
Untitled
40x60. Glass Painting, 1991
Private, New Delhi

218
HUSAIN, Shamsad
Untitled
102x81. W/c, 1982
Kali Pundole Family

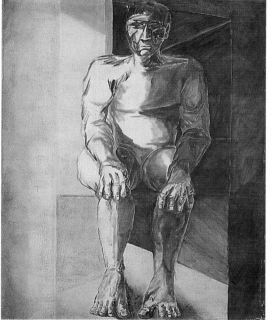

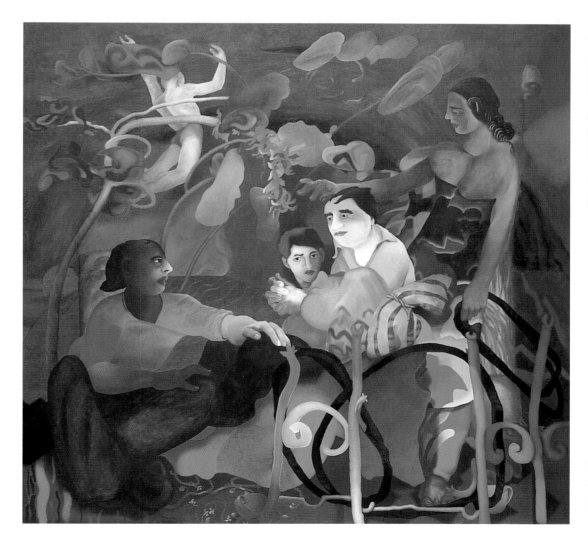

219
KALEKA, Ranbir
Family-1
244x259. Oil, 1984
Chester & Davida Herwitz, USA

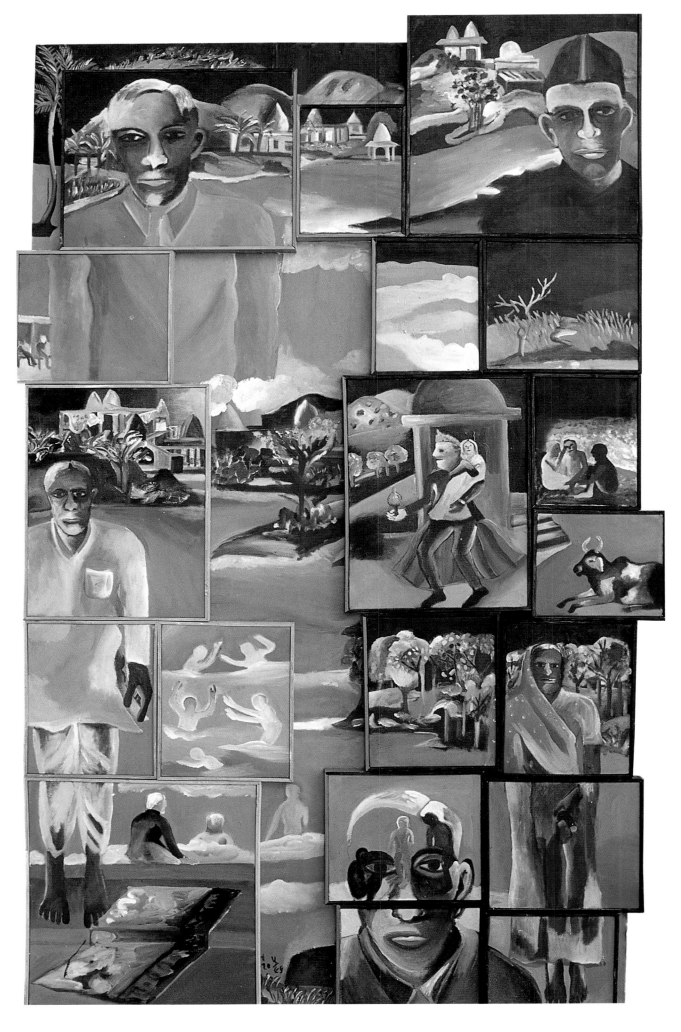

220
KHAKHAR, Bhupen
Night
213x137.
Oil on canvas
& canvas on board, 1996
The Artist

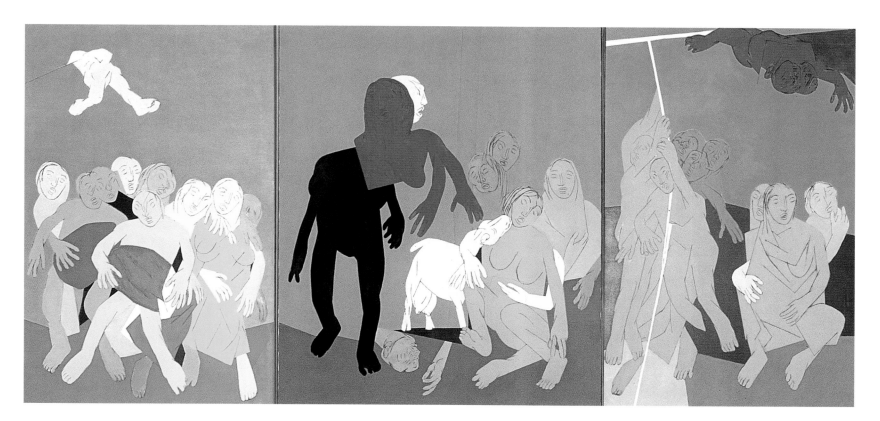

221
MEHTA, Tyeb
Santiniketan (Triptych)
209x444. Oil, 1986
NGMA

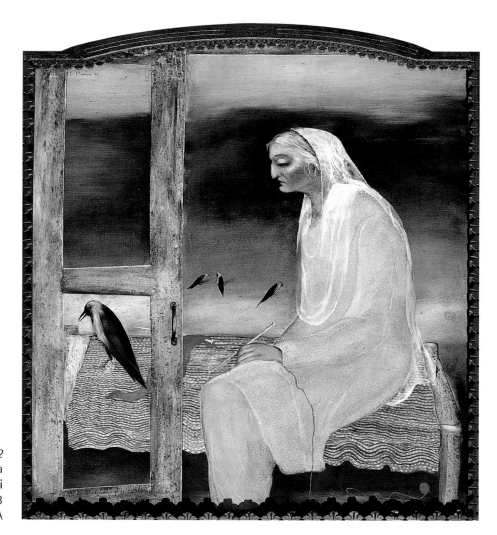

222
MENON, Anjolie Ela
Mataji
137x121. Oil on Board, 1983
NGMA

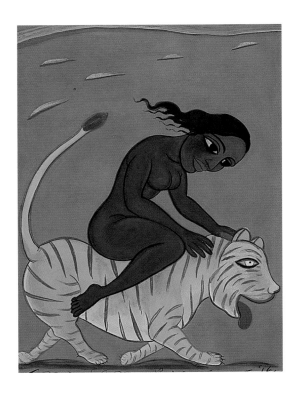

223
PAL, Gogi Saroj
Yogini Shakti
76x55. Gouache on paper, 1996
Private, London

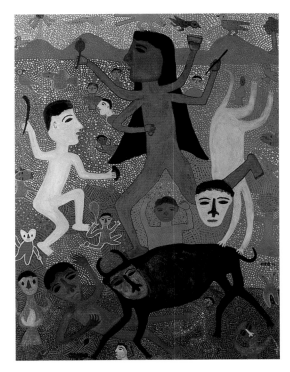

224
PAREKH, Madhvi
Blue Goddess
122x97.5. Oil, 1992
Private, Bombay

225
PATWARDHAN, Sudhir
Pokaran I
100x100. Oil, 1989
Private

226
PYNE, Ganesh
Night of the Merchant
50x55. Tempera, 1985
Private, Calcutta

227
ROY, Suhas
Radha Series
86x73. Oil, 1992
Private, Bombay

228
SEN, Paritosh
Boy Chopping Chicken in Market
100x100. Acrylic, 1983
TISCO

229
SUBRAMANYAN, K.G.
Fairy Tales from Purvapalli Series
85x59.5. Oil & W/c on acrylic sheet, 1986
NGMA

230
VASUDEV, S.G.
He & She Series
110x122. Oil, 1993
Private, Bombay

1983-96
International Assimilation and
Uniquely Universal Foundation

220 Eg: " We realised that it cannot be the question of seeking or desiring alternatives to post-modernity – an escape set up for us by the dominant discourse– but to liberate modernity from its imperial masters, to constantly interrogate and confront modernity, which remains trapped in its Eurocentricity. *Third World Perspectives* gives us a new radical framework within which to conduct the interrogation...The dominant discourse is still obsessed with the idea of the 'Other' and how to tame and assimilate it within its Eurocentric perspectives." [Rasheed Araeen, Interview with Hou Hanru, *Art & Asia Pacific* 2.1 (Jan 1995): 105]

221 "The concept of the Festival of India was simply to depict India in a holistic manner through exhibitions and performances planned around central concepts which portrayed India- its Indianness and the creative attitudes embodied in its artistic and cultural mainfestations...the endeavour was to present *through Indian eyes*, the living essence of Indian culture..." [Niranjan Desai. 'Festival of India: A Cultural Construction Board' *Indian Horizons* 44.3 (1995): 200]

222 "The function of a Gallery, as we see it, is not the periodic arrangement of pictures on walls with a view to their widest sale. It is to discern from amongst the confusing welter of current forms those shapes of thought which go beyond providing an insight into our poisoned times, by sustaining, through the precious miracle of creativity, man's hope for the future." [E. Alkazi. *AHJ*1(1981-2)]

As counter-modernism gained respect Indian Contemporary Art attracted some international attention. That India was a Third World developing nation, an ex-colony, the philosophical melting-pot for a wealth of minorities and their diversity, a land rich in its traditional cultural heritage – classical, folk and tribal, added up to a vast arena needing to be re-examined, especially given the reaction against the prevailing Euro-centricity.[220]

As it is, Indian Contemporary Art was passing through a kind of revival during the 1980s. A diverse historical foundation was seen to be swelling up. There were a greater number of full-time practising artists than ever before, participating within a wider field from which they drew creative inspiration. Major international exhibitions and various Festivals of India were being held to promote the holistic and diverse nature of Indian creativity.[221]

By the 1990s, new collectors, both Indian and international, individual and corporate, were emerging. Many were willing to buy the art of unrecognised artists, though most of the nouveau-riche money was filtering into established signatures. The emergence of international art auctions after the late 1980s also added to the financial appreciation, though NRIs (Non-Resident Indians) were the main buyers, rather than International Art Institutions.

A growing trend of gallery-visiting by the urban upper middle-class was also being witnessed. This in turn led to a greater degree of professional management in the running of galleries, the structuring of exhibitions, the publishing of comprehensive exhibition catalogues and an attention to the conservation of paintings.[222] At the same time the mixed blessings of art entrepreneur-dealers slowly evolved to increase the efficiency of the secondary art market.

However, the progress on all such fronts, government-sponsored or private, was inadequate, given the potential of the activity and the pivotal role it must play within a nation's development. This internal failure naturally led to the international re-examination fizzling out into a superficial interaction, rather than a continual dialogue. International interest still approached Indian Contemporary Art with too many misconceptions, especially as no alternative was effectively presented.

Even among the artists, only pockets of activity maintained a rigorous awareness of international art activities, hand in hand with evolving their own individual vision, rooted in local inspiration and idealism.

Further, few credible private efforts were being made on the educational, documentational and publications front. Connoisseurs and critics, capable of creating a supportive infrastructure, were rare exceptions. As a result the community's collective inwardness was still prone to intellectual indiscipline and a lack of healthy self-criticism. There were few public platforms for rigorous discussions and an efficient dissemination of information. No well-distributed magazines, journals or any serious interrelationships with other media existed. The newspaper spaces allocated to criticism were governed by too many constraints to possess aesthetic integrity.

In such a situation, when public interest increases, the financial aspect is given an overwhelming dominance, so that the 'commodification' of art begins to directly eat away at the remaining aesthetic integrity. This is because the bargaining platform,

providing mutual respect does not exist. The viability of such a platform within the economic system becomes the issue. Added to this, the credibility of the price appreciation is also doubted, as few are able to clarify and justify the criteria for the appreciation. One example of this lack of credibility has been reflected in the distorting role played by certain auctions on Indian Contemporary Art.

An auction is one of the most efficient means of selling and buying. However, its credibility rests on the conceptual and historical authenticity of the commodity it auctions. Without a solid documentational base on the historical significance of each artist, and their international relevance, an auction is forced to play an educational role it is ill-equipped to handle. Price instability, as a result of relatively inexperienced and ill-informed buying leads to infighting and little confidence within the community. especially as most auctions, have so far failed to collate a significant body of work with historical credence.

These transitory problems arise when a rigorous aesthetic and historical basis of the subject is unknown and so open to manipulation by partial views. Without this discipline, all feel justified to defend their partisan case, and promotion usually occurs at the cost of denigrating someone else's art. This breeds a self-perpetuating insecurity, for one is convinced that the system is not being fair. Mediocre artists who have the support of ill-informed patronage, because they can play the game dominate, while the quiet introspective loners, creating significant work, are marginalised.

This problem is more dangerous than ever, especially in a system where the critical counter-forces are weak, and open to dogma. Ironically, the sad issue becomes, that defending intellectual rigour and its freedom becomes a dogma, adding to the defensiveness of attitude.

Many of these insights were highlighted during a project organised by the Max Mueller Bhavan and Marg in 1985, which tried to nurture an interaction between Indian and other international artists. In the accompanying book (**Artists Today**, Marg Publications 1987) regarding this camp-workshop-symposium, the organiser, Anne de Wachter, commented: " I agree with Dr.Lechner who said, 'I do not believe in dichotomies but I believe in alternative answers.' I think that the classification into 'Eastern' and 'Western' could only be justified for the explanation of certain regional singularities,...So I do not understand the polarisation into opposing factions during most discussions. I had hoped for an interesting forum on topics that are equally valid for all artists, yet whenever a discussion started the Eastern artists showed an exaggerated sense of solidarity with their colleagues,...the chance to create an atmosphere of cross-cultural understanding and cross-cultural solidarity was missed..."[223] The lack of understanding lies on both sides.

One of the more serious consequences of an inadequately rigorous exchange between international and Indian artistic thought, has been the manner with which a conceptual integrity is being reached. To conceptually clarify and discipline one's obsessions is something we are always struggling towards. However, the half-baked rigour with which many Indian artists have attempted this merger raises an insecurity which is still raw, capable of causing much misunderstanding when discussed. Many are still content to pompously say: 'if you conceptualise, the impulse disappears' or 'the painting speaks for itself, I don't have to say anything'.

Others, keen to build bridges with the discipline of conceptual clarity, have so far provided only remoulded Western models or half-baked traditional linkages. Designated rather than achieved art is the order of the day, especially within the installation medium. The lack of public platforms and the inadequate dissemination of information,

[223] Participating Indian artists: S.H.Raza, B.Bhattacharjee, F.N.Souza, P.Pochkhanawala, Balan Nambiar, G.R.Santosh, Jeram Patel, Manjit Bawa, Prafulla Mohanti, Tyeb Mehta, G.m.Sheikh, N.S.Bendre, Sunil Das, Tapan Das, Bhupen Khakhar.
Participating Western artists: Ernst Fuchs, Mark Prent, Peter Nagel, Wolfgang Laib, Peter Kinley, Claude Lagoutte, Robert Marx, Dieter Jung, Henry Leo, Schoebel

unable to nurture a daily interaction between artists, critics, gallery owners, scholars, and the wider public, exacerbates the problem.

However, a genuine conceptual rigour reinforcing one's artistic processes and forms has been clearly evident in the work of many of our foremost artists, across the spectrum of ages and styles. K.G.Subramanyan, A.Ramachandran, A.Padamsee, Krishen Khanna, G.m.Sheikh, P.Barwe, Gieve Patel, V.Sundaram S. Patwardhan and the younger C.Douglas (b.1951) and Ranbir Kaleka (b.1953), among others, all reflect a restless conceptual rigour which deepens their creative processes.

231
SHEIKH, Ghulam m.
Passages
130x182. (Diptych) Charcoal & Conte, 1994
Private, Bombay

224 " By the 1970s sculpture had sufficiently mutated to absorb a variety of materials that underscored a rejection of aesthetic values and of the ability of this medium to absorb the dynamics of space and site in interpretating a work of art. Installation also gained currency as a form of protest- one that can be constructed and deconstructed at will, whereby the artist can cock a snook at the vagaries of the art market by existing outside it...Against the horizons of uncertainties, the installation, with its relative lack of definition, ambivalent political status, freewheeling frameless identity and its defiance of nomenclature is the ideal art form. By being no one thing, it is any and everything." [Gayatri Sinha. Installation Art LKC 41 (Sep 1995): 28]

225 " I had to find a new language which would maintain my position as a modernist (or an avant-gardist) within the framework of historical developments, and at the same time which would allow me to express my lived experiences." [Rasheed Araeen, Interview with Hou Hanru, *Art & Asia Pacific* Q 2.1 (Jan 1995): 105]

Vivan Sundaram's ability to discipline the instinctive, thereby giving it greater force, is evident in his ability to maintain the experimental with the orthodox. The lessons from Picasso's regimentation are not lost upon him. By the 1990s his work had come to focus on installation art, thereby staying true to the accompanying international modernist historicism, and one's local inspiration.[224] Few artists have been able to maintain this balanced absorption, which reveals an underlying universal continuum, wishing to find itself in any and every corner.[225]

The dominance of a materialist vision and its language, implied that the growing urban social-responsiveness, focused upon reactions to outside forces, especially the violent and newsworthy. This need to react, and then the desire to control this reaction, only revealed the dilemma of the conditioning; a conditioning aware of its suffocating entrapment and compromises.

However, the brilliance of an artist such as Ranbir Kaleka, has progressed with the overwhelming motivation of knowing oneself, and the limits by which one can allow uncertainty a freedom before imposing a structure. A result is his ability to create an unexplainable unity from a sea of chaotic imagery. The erotic thread in his recent work paradoxically maintains the discipline amid the swirl of intense colouration and fantasy. Works such as **Family-11** (Oil, 1993) and **Scroll with a sculpture** (Oil, 1995) best manifest this inner cohesion which cannot help but doubt itself, taunt itself, glorify itself, and renew itself, simultaneously.

232 (Right)
SUNDARAM, Vivan
Approaching 100,000 Sorties
335.3x152.4. Hand stitched paper & Engine oil in
zinc tray, 1991
Private

233 (Far Right)
KALEKA, Ranbir
Scroll with Sculpture
305x152.5. Oil, 1995
Private, New Delhi

234
DOUGLAS, C.
Untitled
98.5x70. Mixed Media, 1993
Private, Bombay

The mixed media paintings of C.Douglas during the 1990s aptly reflect a tormented inner mind which balances the rigour of formality and its grammar with the desperate need to say something authentically individual and anarchic. Within this idiom he is beginning to evolve an imagery of self-expression, whose dark originality holds a great future, oscillating between the need to suppress colour and reveal its expressionism, to obey the dictates of materiality while unleashing the anarchy of inner obsessions, as if balancing between the aesthetic of Vivan Sundaram and Ranbir Kaleka.

Reflecting a different stage of artistic maturity lies the uniquely mature art of Prabhakar Barwe. In contrast to Sundaram's ability to tackle the issues of urban claustrophobia and violence through the amenable medium of installations, came Barwe's ability to reveal the limitlessness and calm of inner space through the constraining medium of enamel on canvas. In stark contrast to Kaleka's intense ability to make colour colourful, came Barwe's ability to reveal the colour of colourlessness. In contrast to Douglas' feverish introspection came Barwe's calm inwardness which could absorb the ego and express its confident humility though a detached, yet very personal, symbolism.[226]

Another artist, possessing quiet uncompromising integrity similar in spirit to Barwe is Ganesh Haloi (b.1936). Ganesh's focus on the landscape as his dominant source of inspiration, serves as a fine example to counter the urban consciousness which has lost touch with the healing powers of nature. That his art has focused on the small format adds to the awe, given the vast terrains which inspire his vision.

226 Eg. "Barwe has long been preoccupied with the nature of time: in his bewitched terrain, paradox is the dominant truth. Movement and decay seem minimal, yet creep up on the viewer. The apple is not an apple, but a porcelain ghost of itself; its shadow is a wet patch of fungus. Apparition and residue coexist, their arrival and departure calibrate a timetable of riddles. The dark patch on the wall registers a pendulum clock that was once pegged there; the rest of the wall has faded. A hanger hooked in the same place emphasises loss, the passage of years. In Barwe's chronicles each image is an absence, "footprint of an animal in the forest." [Ranjit Hoskote, 'The secret heart of the Clock', Times of India, 10 Dec 1995]

235
BARWE, Prabhakar
The Clock
122x152.4. Enamel, 1991
Masanori Fukuoka, Japan

227 Ganesh Haloi, conversation with the author, Calcutta, 16 Aug 1993

236
SABAVALA, J.A.
Black Dune
152.4x101.6. Oil, 1989
Private, New Delhi

The ability to motivate one's creativity and the journey of self–knowledge, in the spirit of anonymity, away from the material 'rat-race', yet within it, is intrinsic to Ganesh's art: " ... why do I paint? See, in this universe, what I think, there are various sorts of movement. Where there is movement there is sound, vibration, and a visual appearance which makes us wonder. These are things which come when we are not preoccupied with material thoughts... If you are not preoccupied you will receive this vibration, and you will respond. Dancing, music all started with this response. This vibration so makes you become part of that movement."[227]

To extract this joy from nature comes from not feeling outside nature, where the stark isolated terrains and flooded riverbeds reflect nothing less than your dignified sense of isolation. The childhood nostalgia for the Brahmaputra basin which lingers in Ganesh's creative vision reveals the wisdom which knows that childhood can always remain, whatever the day, and from this youthful spring comes many strands of disciplined joy. Not losing hold of this calm obsession, has been the thread of Ganesh's originality and his tradition, as with diverse artists such as J.Sabavala, Ramkumar, S.H.Raza, G.m.Shiekh, Gieve Patel, Manu Parekh, Paramjit Singh, Amithava Das, and a few others.

The quiet integrity which absorbs in silence the outer trauma, while disciplined by a love and respect for nature, is best reflected in Ramkumar's inscapes. In contrast to Ramkumar's style of expressing the awe and pain, lies the work of Arpita Singh (b.1937). Her ability to extricate a sense of joy and playfulness while responding to everyday violence comes from her instinct which can transform any experienced activity and event, however mundane, into a source of inspiration. As with Ramkumar, it is a vision which is unwilling to cut or categorise life, daring to take-on the whole swirl of living, in its entirety, having an aesthetic confidence that creativity can absorb all. There is the compassionate will to sustain the rational and irrational, as manifested in the distinction between profound and trivial, and hence a fluid relationship between doubt and trust.

Thus, given the harsh & incomplete systems which we have created in our world, it is the ability to transform sadness into compassion, thereby disciplining one's compulsion towards silence, which underlines the aesthetic integrity of the artist. As a result the need to communicate is somehow served, while simultaneously revealing the force of suggestion and detachment. It is thus universal transformation process which will sooner or late absorbs the local while letting it be itself; it is this force which will link narrow identities to vast visions, so disciplining relativity beyond its fragmenting duty.

237
SUD, Anupam
Dialogue-1
47.5x64. Etching & Xerox, 1984

238
CAUR, Arpana
Where Have All The Flowers Gone
182.8x365.8. Oil, 1995
Hiroshima Museum, Japan

From the younger generation, artists such as Arpana Caur (b.1954), Vasundhra Tewari (b.1955), Chittrovanu Mazumdar (b.1956), Rekha Rodwittiya (b.1958), and Atul Dodiya (b.1959) best reflect the immense talent throughout the country.

With an artist such as Atul Dodiya the quiet integrity and aesthetic compassion, finds clear continuity with three earlier generations of artists, as best represented by: Tyeb Mehta and Akbar Padamsee, Bhupen Khakhar, and Sudhir Patwardhan. His brilliant draughtsmanship allows a structure which genuinely reflects his emotional discipline, and as a result of this inner–outer synchronicity his art is capable of arousing an

atmosphere of dignified sad quietness in its most appealing form, as seen in earlier works such as **Lodging in Somenath** and **The Room** (1989) and the recent **Crucifixion** (1994) and **Dr.Patel's Clinic–Lamington Road** (1995).

Atul's academic discipline has fused influences from his preoccupation with walls, floors, windows, objects of furniture, their texture and the like; his urban life in suburban Ghatkopar with its related middle-class conflicts. All these have been filtered over the years with greater conceptual clarity, so that today he has emerged with his own individual imagery and an openness of attitude which will be able to constantly renew and deepen itself whatever the circumstances.

Vasundhara Tewari's archetypal studies of the female form and her search for a place and significance in the wider context, is in stark contrast to Atul's local contextualisation and Rekha Rodwittiya's direct feminist positioning of the female form. Their imagery reveals the two pivots of rest around which the artist creates, the inner and the outer. Both are always in transition, finding the balance, seeing each from the other's viewpoint. In the end it is the tussle which makes the scales tilt, thereby providing a different weightage and emphasis, hence defining the need to delve deeper into one's inner stubbornness or usurp from one's outer surroundings. Though a mutually recursive relationship, emphases differ, and therein lies the direction.

This is the idealistic-real dilemma each artist confronts, as reflected in the abstract-figurative, the intuitive-logic, and various other such false polarities, which lack of a fuller language makes us accept as valid today, only to deny its truth tomorrow.

Conclusion

Thus one can see that the present state of Indian contemporary painting, even from a brief appraisal is complex. However, the plurality finds its cohesion in the underlying nature of the creative process, uniquely Indian in its power to absorb, and clearly universal in its need to absorb. Further, the sense of an outer-inner rhythmic unity between daily life and the anarchic potential of creativity, is clear amid the heavy Indian air.

Also, most artists have come to realise that Indianness is not something that needs deliberate pursuit in art. One's art cannot help but be Indian, if the artist is true to the inner aesthetic journey to know oneself and one's compulsion to create, while living in India, or even with regular visits. Openness does not lead to confusion, if discipline has its roots in intuition, daily clarified with a conceptual ability to self-criticise and deepen one's exposure.

At present, the infrastructure required to nurture such a task demands a scale of effort and urgency towards which few are willing to commit. It requires an integrated conceptual clarity, simultaneously translating itself into institutional building, by the same creative visualisers, rather than a leasing out of ideas to bureaucratic minds, who cannot help but cut and categorise.

However, the discipline of cutting and categorising needs to be replaced by the discipline of a holistic framework which inculcates the attitudes of self-criticism more rigorously and openly. This is the dilemma all architects of a cultural infrastructure face the world over, along with the need for internal financial self-renewal while nurturing one's aesthetic integrity. To live and clarify the force of aesthetic wisdom in an age of material complacency and religious closed-endness. This is the duty.

Conversations
with Artists

A Note

The following conversation extracts represent my very first meetings with the artists. Over a compressed period of four months, July–October 1993 one met over sixty artists across the country, though remembering to record only fifty-four of the conversations. From this pool, eight were mistakenly erased.

The length of the conversations ranged between 4500–5500 words on average. Only abridged versions have been presented in this book. The idea of the book, let alone the presentation of conversations was not so clear at that stage, it was simply a learning process, and to once again travel across the country, unlearning certain notions and reimbibing through other eyes.

Now looking back, after many subsequent conversations and three years of work, I can only smile at the intense energy of it all, a genuine raw enthusiasm which all the wisdom in the world cannot revive.

Badrinarayan

NT: ...The mythology of India has influenced your expression– the elderly man, the monk, the young lady, child in mother's arms...

BN: The monk can be me in some form. The idea of motherhood is the flowering of life, bursting forth flowers, like creativity.

NT: Is the man–woman relationship more spiritual rather than down to earth?

BN: It could be husband and wife, but it does go beyond that. The wife is not there for the sake of being a wife, but for her *atma* which is dear to her. The whole format of arts, especially in India, is very interested in the female form, and all her other forms from the *Yakshi, devi*, so on...

NT: Has your interest in the female form lessened over the years?

BN: No, I think it has been the same, an interest in all forms, also in the male form, which is always more benign, with a little bit more of age and experience. My arranged marriage has also influenced things.

NT: How was your work different before the marriage?

BN: After marriage, of course there were many experiences, not necessarily pleasant or happy, but to grow to continuously learn from any given situation has been my way..

NT: Akbar Padamsee told me some days ago, that his teacher asked him why he had begun to learn Sanskrit so late in life. He replied: "To get ready for my next life."

BN: A better answer was given by Socrates, the evening before he was going to drink hemlock. In a solitary cell, with just one window opening into the street, Socrates heard somebody playing a tune on the violin. Up he gets and says, "Hey you, come here, teach me that tune, its so lovely." The musician replied, "You are going to drink hemlock tomorrow, why do you want to learn now?" Socrates answer was "I'll learn one more thing before I die, teach me." This constant learning, this wish to constantly learn; it is no more like that.

NT: We mentioned this before, the lack of wishing to learn...

BN: Even with age it does not always come.

NT: Because old age is very much part of your work, could you explain what it is to age gracefully?

BN: All the elders I have seen around me, except those I have read about, the saints and the mystics, the people who have actually confronted me have been people of great vanity. All I hear from old people when I go to say hello, is complaints: *Morning mein meri bhahu ne doodh mein bournvita kam dhala hai, what does she think of herself?* (My daughter-in-law did not put enough Bournvita in my milk this morning.) At seventy this is the kind of things they talk. There has always been a desire to meet old people with great dignity, so that I would naturally put my head down,...but I never found such people. As a result in my world of paintings. I have brought my own saint, he is the counterpoint of the actuality; he has little to do with modern people.

NT: Why has life come to this?

BN: The main thing is that they have become vain. With vanity and greed one associates oneself only with oneself, and does not ask questions, seeks no spiritual enrichment, does not find significance from every little happening around you.

Once I was going to school, to teach. Small children, about 1st standard, with a stray kitten, were asking for 10/20 paise. They wanted to give milk to the little kitten. They had already collected their own money, and needed a bit more. I ran up to the principal, I said, "I want to see you sir." He said he was very busy, I said, "Just half a minute." "I have been witness to a very spiritual act. Children are giving their pocket money to feed a stray cat, sir, I think this is something we should speak about." He said, "Okay, okay," and forgot about it. There was no response, no sensitivity,...

NT: Perhaps this is because there is no respect for gentleness.

BN: It's all gone, in everything I see...I cannot understand how we have come to this. Simple questions have always troubled us, our pain, grief, death, work. You may not get answers, but the asking will be something, so much wisdom lies untouched, wasting away.

NT: You told me before, that what has been in Western art, was in our art, but we never had the ability, discipline to harness, and logically work out, conceptualise in art,...tell me a bit more.

241
King & The Monk
56x71. Oil,1960
Kali Pundole Family

BN: At least until the 14th and 15th centuries the arts, in icon making or illustrating manuscripts, Western and Eastern art had been virtual cousins. Once perspective, chiaroscuro and other aspects...and since the British took over, with the East India Company, the influence of the West has been misleading. Their good points have not come down, in a way the most inartistic period of influence, the Victorian, has had most influence, and a lot of things have been forgotten. Let us take the European tradition and its use of myth. Their inspiration has come from Biblical mythology, Michelangelo, Rembrandt. It is capable of several layers of meaning, so many allegories painted. I don't see much difference in meaning, beacause this desire to know man, to break the mystery is common to both East and West. The mystics, the alchemists, the monks, share the same traditions, especially in painting. To sit down and paint was the monks' job. I think this was best described by Cezanne in a letter to his son. He says: "Why is painting so difficult? Is it because it is a priestly art?" It is a very priestly art, and it has a very priestly function, so unless the dedication and technique is there, nothing will come.

NT: This kind of harmonious giving and taking has not been in us, our absorption of the Western influences has been from the surfaces, and so most are dissatisfied and blame the very act of taking rather than the method of taking. Most of your influences have been indigenous.

BN: Yes, because I thought we have travelled a little differently from them,...

NT: What was the main difference?

BN: The main difference has been that they have come down from a theory which was interested in making a replica of nature, they worked to that end, and then new ideas came, like Impressionism, because of the influence of optics, seeing the light. With India the questions were: "Why do you want to copy the world? Is this world real? What is it? Is man real? Is his face, body real?...".

NT: I notice a lack of space in your life, it must be influencing your work.

BN: Yes, that is why I paint so many houses,...(laughing) and also because I believe when Jesus Christ was asked, he said, 'in my Father's mansion there are many houses'. I took this to heart. That is why this miracle...

NT: The landlord giving you this space free, without rent, so that you can paint.

BN: Yes, he gives me the keys and says go work. Where does this happen in our world? Of course he may ask me tomorrow to leave, but then I will say I was grateful for these two years. These are practical problems, it is not easy. The reasons why I could not get space is simply economics, I was not making money, neither by writing nor painting. It is only in the last few years that I have been selling. I began with very puritanical views.

NT: In what way?

BN: In those days I felt a work of art should not be sold for more than Rs. 100. I would sleep on the floor, sell works for ten rupees. Incidently I am married to a niece of a painter, Hebber, and he once said: "You have put a hatchet on your leg, ten rupees. You will one day rue this thing, you will never come up in life." I said, "I can't change," People must be able to buy your paintings. These things have changed a bit, in fact there are no regrets, but at times to have a few material things so that I don't have to run, or go through the rain wet, to buy books and then have to give them away, things like that, ...but then you say, let this also go...acceptance, and the fact that you were given the opportunity to work, I think for that one should put down head and thank God and be grateful. So many of my paintings are like prayers. Painting is not only a self–expression, it is a *sadhana*, it is a religious exercise... With a blank paper you are thinking 'how did this come up?' This constant sense of wonderment, I am always wondering, every little thing is great, everything has really been great.

NT: ... like those little pigs running

BN: Yes, pigs with little curly tails, running across, so lovely, but nobody likes these things. They say look at you, act your age, behaving like a child in decent society, is this how you behave, what will your children think your... daughters are going to college and you talk like this, and...so a dream is cut; but this is what it is, it is true, like feeding the stray kitten, all these things are true.

So therefore I am not very keen to sell, or get money, but earning one's bread is a sacred job, that I would like to do. Experiences make you grow a little more sensitive, a little more humble, for if anyone sees the art of the world, East, West, I think every painter has to be humble, there is no other real feeling.

(9 July 1993, Bombay)

Prabhakar Barwe

NT: The dotted line idea in used repeatedly in your work, is there any significance?

PB: Yes, generally I want a line which is geometric. At one point I felt the line was becoming too rigid, though I wanted the preciseness of geometry, I wanted it softer in tone. The simplest method became to draw a dotted line so that you incorporate space and form, space–form; seeing and not seeing, abstract and concrete, tangible and intangible, so that the line becomes flexible. Otherwise, it becomes hard, very hard.

242
Chest Series: The Trunk with a Rainbow
30x47.5. W/c & Ink, 1993
Private, Bombay

243
Chest Series: The Red Box
30x47.5. W/c & Ink, 1993
Private, Bombay

NT: What have been your main reasons for choosing between watercolours and oil?

PB: Watercolour is spontaneity, you can try out various things, dealing with a smaller space. When you go into the larger space there are some inhibitions, therefore

responsibility. Watercolours are more intimate, personal and experimental, but the sustenance of your experiment is in oil.

NT: We were talking of meaning, and how it appears in art

PB: I feel we are always seeking meaning. In literature words have meanings, so the word–meaning relationship is very fixed,...but the form–meaning relationship is not so close. So when painters draw a thing, it does not make the statement as the word makes, this is one difficulty painters feel in their work. In totality there is a meaning, a direction, an intent...Opposites exist and co–exist, and therefore "normal" usage cannot be presupposed.

Every artist has an ego, because he feels the power to create, and so he requires a point where he can surrender. If he can surrender to the canvas, to his work, it is fine; to surrender and concentrate together is very important. It gives rest, which is in my work, also in yoga, where I get physical and mental calm.

NT: You mentioned Paul Klee earlier.

PB: Yes, I saw a big collection, say 80 to 100, in Washington, a good size, and I felt, "Why is every Indian painter interested or at least partial to Paul Klee?"...I saw Klee was interested in miniature and tantric subjects. The rest of the world was dealing with cubism and three-dimensional things, but Klee was dealing in two–dimension.

Now this two–dimensional world is of the Indian miniatures. They did not know or want perspective, but they knew what was the lyric of the line. These aspects are also in philosophies and poetry, and exactly that element was working in Klee's work. His work is a kind of affinity, a bridge.

NT: Let's move on to the significance of the man–woman relationship and the role of sex in your work.

PB: In the late 1950s, early1960s, I thought if there is no sex, there is no purpose to live; the obsession was there to that extent. Sex is also a kind of violence to me, so the work that I produced at that time was very violent work, compared to the existing norms of that period. I was not established, had just passed out of J.J. School and come to Benaras for a job, as a textile designer. I had one relationship, so the mind was anchored in Bombay,...

NT: She was in Bombay.

PB: Yes, so that separation was a form of violence.

NT: Was it necessitated?

PB: Yes. I was thrown into a kind of isolation, and that did help me when I look back, a great deal. At that time however it was a terrible thing, the loneliness and the violent desire. I was also totally dissatisfied with the art that existed in those days. There was a search to get our own language in art. This introduction to *tantra*, the diagram and the word, in that sense, served as a springboard to understand what art is, and I started doing collage,...the basic thing was to seek freedom of application, colour, sticking things together, and of course it did have to do with collages being done in the West, say Andy Warhol, and that whole period, but there are personal reasons too as I explained.

I used cigarette packet silver foil, matches, bits of broken glass,... putting them on mount, small scale, then switched to hardboard, started hammering to glory,...all very violent activity. I thought painting was like war with the canvas. Only later did I realise that one has to surrender, to start speaking, so that there is a dialogue... All through, the very activity of painting was like giving vent to sexual energy, the imagery I made, was like making funnels into breasts,...A World Erotic exhibition in Stockholm or somewhere showed the work, although I was not even fully aware my work had a dominant erotic aspect. This was the tantric phase, you could say.

NT: You must have had a wish to understand woman, your union with her, and so on...

PB: I did feel the realisation, or call it purpose, because in Benaras, in the air there is philosophy. You see dead bodies being carried to the ghats all the time, so you are constantly reminded of death, and I was also all alone, so sex meant existence, it meant survival, and that art was part of my struggle– sex and art fuse together; I cannot separate and whether I understood women or not, I do not know. I don't think I understood women or anything, but I understood the need of that opposite force, which *tantra* also stressed...Some people of course were saying that I was going mad.

NT: Was all this being conveyed on to the canvas?

PB: I suppose so, I was smashing the existing images,...that is why it was a kind of war, and sex is something like that to me, so the art was violent at that time.

NT: Violence in sex has so many angles, in what sense did you portray it?

PB: In the sense of breaking things,...

NT: Didn't it unite?

PB: In a way, all destruction leads to a construction, but not initially. Painting then was stereotyped, dull and monotonous... we thought we had to rebel to create a new language. It was just a coincidence that I was finding myself at the same time, not deliberate.

NT: I am still unclear about your specific sex–violence relationship...

PB: A relationship with woman, to be in love, is like to walk in fire. As soon as there is love there is possessiveness, as soon as this, then you want it all the time, by itself, and then suspicion, doubts, unfaithfulness, betrayals, and therefore violence. You want to have it right now or never, you don't want to postpone it till tomorrow,...so there is an immediacy, urgency. To possess is the main outcome of love.

NT: Even now?

PB: No, at that time, to me love was to possess, the need for sex. For love was sex to me, a need which I felt terribly frustrated about, because in India this is not easy.

NT: Yes, it's a miracle our people keep such control.

PB: Yes, and in those days it was worse, and specially in Benaras, all these things together formed a kind of chemical form into the painting; the sex was there, the love was there, the separation was there, isolation was there and the great desire to search for a new horizon in my own art.... I came back to Bombay, and until 1970 worked in

various ways, realising that I was not a tantric, not a ritualist, and so in that sense I knew nothing,...

NT: And by that time many had adopted the idea,...

PB: Yes, Palsikar, Biren De, Santosh, so many, but I was getting free of *tantra*, *svatantra*, I no longer needed that tradition.

In 1970 I got married in a very regular, arranged sort of marriage. I wanted that way only, because I thought if I am involved so much in my art, then marriage is a must, as sex was important, and if she herself is a painter then family life will not be there, so I thought a girl from the village. My wife comes from the village.

NT: No feeling of compromise?

PB: No, not at all. I was very happy, she loses nothing, I lose nothing, we both gain in this kind of living,...

NT: I say this because in the West people do not understand this, they don't realise the circumstances of the country, so many chances are not available, and only frustration piles up, for both, at the same time. They imagine such life is incompatible with modern thinking.

PB: Yes, and otherwise what would happen is that all the time you would feel insecure from that side also, no family life, and for a person like me, I would have gone astray completely. I would not have become a painter at all. For me it was necessary that the ship be anchored. That is my temperament. Only then can I work, and so from 1970 onwards I started to become quiet.

NT: So simple and funny.

PB: Then came my daughter, which changes things. Up to 1980 I was working in the textile job, but then left it and became a fully–fledged painter. By then I was known; the only thing was that I was not sure whether I could live on a painter's earnings.

NT: After the 1980s what was the major change?

PB: Well, during the 1970s I had a studio near my office in Nana Chowk, a small independent room, everybody had come there once at least, because it was such a ghostly place. The building could have fallen any time. An American friend of mine living in Paris had come and said this is such a wonderful place, I too will have a studio here, let us buy the building, such a romantic place he thought. It was a God-forsaken place, black mice, cats,...but whatever I did there seemed to work. Yet the spiders were continuously working whether I was or not,...and then about 1978 I came here, working here, in my bedroom, am quite happy about it, though I sometimes feel it should have been a larger space, with better light. But the advantage is that I am constantly with my paintings. That constant contact with the canvas is important. Once somebody wanted to interview me, and asked about my studio, when I said I work in my bedroom they did not want to interview me!!! (laughing)

NT: But in the **Chest/Box Series**, the suffocation you are feeling in this box-like room, and the asthma,...seems expressed.

PB: In Bombay any room will be like that.

NT: So the 1980s?

PB: 1980s onwards were lots of changes. First of all in 1985 I went to Paris, for only 4/5 days, but it was a very significant time for me. I found right from the airport to sugar cubes even the drainpipes, everything had an artistic touch, an aesthetic consideration, even the way trees were planted, so my being there was really rewarded. Of course there were the museums and galleries, and I also went to Yugoslavia and Turkey. That was the first exposure to the outside world. Then in 1988, the second exposure, to America. I was now a bit more mature, now capable of receiving things, and had decided to take as much as the world of art offers; I insisted on visiting more museums than visiting artists.

NT: So after Paris and back in India, how was your work affected?

PB: The first part was rather negative,...I thought that I and Indian painting were useless. That was the first impact. Then the second impact, when I started asking "Why do I feel this way?" A feeling of the uselessness, our traditions being snapped off, being like a *trisanku*.

NT: Suspended?

PB: Yes, suspended in air, neither here nor there, that kind of feeling. A realisation there should be a finding of roots, of our identity; this was not only in me, it was in the air....The efforts I made were that, firstly imagery must be related to the environment, a sort of nativism. Later I realised that this does not communicate also. Most people found it too obscure,...and from 1980 to 1990 I became much more peaceful, questioning more the values of colours, co- relations, and the ideas between concrete and abstract, this became the predominant occupation.

NT: How did you solve that sense of feeling useless after Paris?

PB: By becoming aware of the situation that the Indian painters were in. There was, no tradition to lean back upon, It was a one way bridge with the West, leaving them unable to fight back, with no authentic answers. It was finding a content- form relationship, consciously the content must be Indian, but in a modern form.
You see, most of the norms that one finds in Indian painting are not Indian; schools of painting maybe Indian but not norms. They have come from the West, that is certain. Now within the framework of those norms, a painter is working with his own imagery, experiences, but through the norm of Francis Bacon.

To me, the understanding of this norm is a surface understanding, even if we take Picasso, as a very solid example, Picasso's drawings of women. When I went to Paris I understood that this is how women are dressed, how they are. It is not a distortion, but the way they are. That's the way their society is. Before that most of us did not understand how his art was related to his way of living. When we see without living life that way, we interpret it as a norm, and call it a distortion of the human figure. In other words Western art and its relation with the actual life that the artist lived remained unknown to us.

NT: How can one borrow honestly without living there?

PB: That is a better way I feel, but one should be aware of all these things. He should not be taken by its norms.

NT: To see in context requires so much, at least there should be a calm acceptance of an equality.

PB: Actually what should happen is that after knowing the entire perspective of world art, if I have enough confidence in myself, originating from this soil, my content must find its own form, this is the ideal situation. This form may resemble others but I don't care for that, thats okay, for its relativity will be very clear,... and to some extent it has happened here.

NT: What is the underlying thread of your work, the motivating drive, for there has been much growth.

PB: I will read you something, very relevant to this: born 1936. Diploma in Fine Arts 1959. First few years study of illusion, that is visual aspects of *tantra*; later years simplification of imagery up to 1970.

1970 to 1980 involvement with visual space in painting with a kind of archaeological imagery; a process of simplification again from 1980 to 1985, object–space relationship. Questioning of colourlessness from 1985 to 1990; search for new relationship between concrete and abstract. 1990 onwards working in same areas. This gives a kind of gist, ...

But the basic problem is human existence, our relationships. In painting or art, simultaneously two things are at work. Firstly the pure aesthetic, and the second is the content which comes from life. This means when I want to convey my content, it will work only if I find the right visual form.

NT: You like growing plants it seems.

PB: When things grow, it means you have put the seeds, sprinkled water, and you allow them to grow. To observe them, to be associated with that creativity process is a great experience, because that can bring thoughts in your mind, silently things are moving all the time. Silently so many things happening in nature; to be part of that is a great thing...

(12 July 1993, Bombay)

Jogen Chowdhury

NT: ...I wish to know how the man–woman relationship is reflected in your work

JC: The man-woman relationship is very dominating; it affects me very much. Both are engrossed and connected so much, and this human drama of everyday life attracts me, so I am very keen to bring all this out.

NT: Drama through gesture...

244
Ganapati Series
155x110. Ink & Pastel, 1973
Roopankar Museum of Fine Arts, Bharat Bhavan,
Bhopal

JC: It is very balanced in a pictorial way. We use all the qualities necessary for a painting, and at the same time I use dramatic situations, which attract me... The idea of heaviness, the weighted figure, the brooding body, the folds in the skin and the cloth, the idea of opposite poles attracting, the lyrical balanced with the obsessive.

NT: Coming to the flabby flesh, there are many interpretations; from Calcutta's decay, to moral corruption of the people.

JC: Actually, my background is relevant. We came from East Bengal, and when we arrived, Calcutta was quite disturbed with political movements. I am talking about the 1950s–60s. There were many difficult days for our family. This has a definite influence on my work,... like the Ganesha period. The Bengali business class worshipping the icon, and their corruption, how they degenerated just like the flesh. The magnetic forces acting down on the base, the earth, gives the structure to my work, thats why a bed is usually there...and you see darkness. Darkness has many meanings in my work.

When I started painting there was no light in the house, so for a couple of years, I painted with a helican light. Only after 1962 or so we got light. All through my college days, I used a lot of black, a reaction to that. Then also the gloominess of the situation. The social situation was another reason, and then my personal mind could have probably added to all this.

NT: Any darkness regarding the communication with woman?

JC: You see, the work carries all the background of my mind, the social situation, the family situation; so whatever I painted, contained that sense of depression, whether a woman's face or man, or flowers, which were totally grey, a still life with a dead butterfly. It was not that I was consciously trying to do such, it was that I could do nothing else. Since I was unable to become happily engaged in some other thing, I was very critical of society, satires, and....so all this came out of the situation. Then in Delhi, I was the Curator at Rashtrapati Bhavan, with the politicians, and the bad things that were happening.

NT: The relationship with the outside world; I feel is always a struggle with you, there is no harmony.

JC: The outside world, like the inner mind, all comes together. There is always beauty in the work. Whatever the outer form, a lyrical quality is there, but the ugliness is gradually getting eliminated...

NT: Why do you say that?

JC: Well, if you have an inner depression, you come out of it. There was a time when I felt that I could not paint with colour, it was not that I wanted to do so, but I could recognise that feeling in me, and it was not hurting my work. But coming to Santiniketan I felt more liberated than staying in a job. There was a change; this has affected my work.

NT: Your social concern is clear, yet it is clearer that your motivation is always from within. Your imagery, is very deeply entrenched. You must know about this inner compulsion, where it is moving, its source, where is it progressing.

JC: You know, there are certain things in us which we cannot overcome. That can be a positive thing; it can also be a negative thing sometimes. Each personality is related

to certain things, which go along with him. Like our Bengali poets, a certain attitude is always there, and I also have certain things with me for which I am important and for which I can be criticised.

NT: What are these things?

JC: A sense of obsession with form, the dimension of form, its heaviness. This is always with me; even if I make a single line, my line gets that type of tension. If I make a pastel line, it has other meanings, but it gets all the characterisation of my nature, so I have seen it is repeatedly coming to my work.

NT: Can you fight this heaviness? Do you wish to?

JC: No, I don't think I can, that is the quality of my work. I cannot be like.....you know like Subramanyan's work, he has a playfulness with brush strokes, with a lot of gaps. If I want to break that I will totally break my personality, and I don't think that should be the right way.

To paint something which you cannot explain, gives me a jerk. Like in poetry, you can't explain, some sort of fantasy is there, lyrical things which cannot be understood...I have a certain way of looking at things which is focused, and I don't like looking at something else. Sometimes, the blackness is to help the focusing, to see only what I want, but that includes opposite feelings.

I make appearance with the quality of non–appearance. Image and non– image, from the Upanishads, and Tagore also, form and the formlessness. I bring that sense of infinity, a definite thing with the sense of the infinite, this is what I try to make in the work. There was an image of the Buddha, very graceful but with a sense of inner power, eyes half closed. This affected me from the very beginning, this grace with inner power is what I have tried to get. I should have told you this from the start, this was really important for me. That inner power must be in my work.

NT: The very nature of creative work is this absorption of form, formlessness, appearance, non–appearance. These are made part of us, not deliberately, but in the very process of creating. We all are progressing on this level, bringing a unity, stillness yet movement.

JC: Right, this is very important in us. In poetry, in music, we find the same thing, it is actually a format, I feel that I am also opening it, I don't know if it is there.

NT: Tell me regarding your interaction with Western art.

JC: Why should we go to the West now for our work? Our culture is very different; look at these installations being done in the West. Why do we need to take from them, our streets are full of installations everywhere. In America with their clean and regular shapes in life and the cities, you can take irregular forms of this kind and make something. But here the situation is already so irregular that such shapes have no opposing force, the meaning is lostYoungsters go there and so quickly assimilate those ideas, for what? We are such important people ourselves, what's the need?.

NT: Lets come to the themes, the things that change in your work.

JC: I tell you what is interesting. Earlier it was naturalistic, now what I find interesting is the sense of decoration in my work, a realistic approach with decorative

elements, each figure having its separate movement, interrelated in a specific way. This I wanted to bring into my work. Sometimes consciously, this has created a new element in my work. In the new work, there is that dramatic situation, a bit decorative, a lot of new colours coming, subtle movements and poses, which I have had from the beginning, but now more refined.

NT: What are you trying to express with these subtle gestures, poses?

JC: Subtleness is very important in art work, I think. To enjoy things more deeply. The first glance attracts you, then as soon as you go deeper, closer and then you search again.

NT: Will you lose the heaviness?

JC: I will not lose it unless I get a substitute.

NT: Do you have full faith in your talent?

JC: I don't know; whatever I try to do is with confidence. We are limited, but we have imagination, and so move on accordingly. I still can do something interesting, some new things. We are making new traditions with our own past and the West. The time of copying, aping is over, we cannot repeat.

NT: Like Subramanyan's living tradition idea? What can lay the foundations?

JC: Actually our sincere and genuine creativity, when we are honest these things are started. We need a lot of understanding, a sense of history, in our country and outside we must understand. What is growth? The role of artistic heritage, must be clear to an artist. No contemporary artist can do a significant work without understanding this situation.

NT: Also encouragement from the infrastructure....let's come to art education and the major problems facing it today.....

JC: One is that we are still using an old British system. Santiniketan is a bit different, also Baroda, but we have not looked to our own people, our own nature, our traditions. This doesn't mean just Indian things. Paintings, dance, literature, theatre, cinema, without understanding this we cannot make significant progress. Another problem is that there are not enough good teachers.

NT: What makes a good teacher?

JC: A good teacher is one who understands the problem properly, who can communicate with the students...but every institution has very few good teachers. The institutions are not set up in the proper way. The teaching is for the purpose of a certificate and so the whole structure is not towards a creative spirit. If you become more intimate, more homely and open then a better chance exists to teach in a proper way, then it is more possible.

(18 August 1993, Santiniketan)

4

Biren De

"My paintings, I believe, are organic examples of the total me; of what I am and what I would like to be: a continuous striving and therefore, a struggle, to put the shattered pieces together and make a composite whole. My guideline is oscillation between two points: between the peace of graveyard and the peace of the centre of the sun. Either way there is no END, no finality.

It's a journey towards a possible efflorescence– through finding, feeling, knowing and being the diamond core of energy all around us: a simultaneous implosion-explosion of perception. It's touch and come touch and come all the way: a process of hard resistance and slow but sure acceptance;– a process that hopefully, will lessen the gap between the two points with the passage of time, until it is time for total surrender to and merger with "IT" (light? energy? God? a state of compassionate consciousness? –I don't know how one should describe it). This, to me, seems to be the challenge. Isn't it the same for everyone?" (Biren De, 1972)

BD: ...I have now come to a point where I take a long time to complete a painting, and I don't hash out by the dozen; it is just the other way round from, say, some other painters. I want to depersonalise the person. Do you understand?

NT: There are numerous misconceptions in most people regarding your art and its tantric links.

BD: The fact is that I had nothing to do with Ajit Mookerjee. He was a good catalyst. We had not bothered whether he was a great scholar or not, but he brought out something which had fascinated, starting from Paul Klee down to everybody. When I had my show in 1965, I came across him, and he thought I was his guinea pig, but I am not a *tantric* artist.

I never even thought of *tantra* or anything, it was a logical development of mine. I was interested in having man and universe together; that was my journey, it started when I was twenty–three. The mural for Delhi University in 1949, covered space, inner space, and now it has come to this; they are connecting my work to religion; I am, if not an absolute atheist, an agnostic.

NT: Your Lalit Kala booklet was written by Ajit Mookherjee.

BD: Yes, just before he died. He was a good friend, I liked him, I stood by him, but I had not one single book on *tantra*, and I never cared for it. I don't talk about those things, but I know about energy.

Tantra is expansion of your consciousness. All three faculties exist simultaneously: objective realism, fantasy and a urge to transcend. These remain in all human beings, at all times in different degrees. It depends on what you bring out for your everyday living. The energy that you see in my work is not because of some God, *guru*, I hate these things.

NT: How does your painting evolve now?

BD: I do not sit down and think. It is the whole body with energy. All my perception and faculties are absolutely tuned to that point. The painting must be itself. In me there is so much of energy wanting to go out. I want to go into my still point, that

within all of us, that makes me go and makes me come back. It is absolute geometry; my whole approach is geometric.

At the seminar on Time all these people, astro–physicists, scholars are all trying to understand the Black Hole and things like that, and I as an artist, talking on the theme of time, am trying to express the same thing. I have come to a timelessness; the artist can go to that point, but if the artist is worth his salt he has to come back. He does not forget that he is an artist. So he only goes to the periphery, he sees it, but he has to come back.

When one goes into the Black Hole, that is probably what our great thinkers have called *samadhi*, there is nothing after that, and I am bringing it exactly to that point. That does not mean that I am someone who has seen that and is coming back. It is only intuition which has brought me there, nothing more.

NT: Your use of blue fascinates me.

245
Genesis
121.5x182.5. Oil,1978
NGMA

BD: I like blue the most, but I also have blazing reds, I oscillate between the two.

NT: Why?

BD: I am a total failure in all else in life, and it's all connected, it's all autobiographical.

NT: The oscillation of blue and red?

BD: Between blue and red, yes. At one point I want to absolutely go like this (stretching out his arms vigorously in expansion) and at other points I want to hold on to my home wherever it is, here,… (pointing to some corner inside his heart)…Red is outside, it is raw, it is everything, basically due to my contradictory experiences with the tribals, the *adivasis*, and the *sadhus*, the ones that have left everything. There is something which is beyond me, beyond all of us, a kind of surrender. Surrender is very important. This does not mean that you become a fatalist. I have been trying to push out,…to counteract the rest with the passion, and so red is easy, red vibrates like this, and blue brings you in; I am oscillating between the two. Thus my paintings are for self–integration.

NT: What is the difference in your state of being, when you are about to do something in blue or red?

BD: It is difficult to put into clear terms. It is not that I am angry with something or, that I put myself into a kind of bondage. I would break away, do something, invariably come back to that one point, which is right in the middle, in all the red, blue, whatever I do, the central point, that is what I am trying to hold on to, if I don't have it I will be finished, my psyche will go, everything will go,…

NT: There must be so much pain in your life…

BD: Absolutely,… you have touched on a very important point: pain. It is a trite thing to say, I know, everyone has said the same, but the common denominator in this world is pain.

NT: So when did pain become the driving force of your energy? When did it start having this force?

BD: I think right from the beginning.

NT: What about your stay in Calcutta?

BD: Yes, from Calcutta I use to go to the Santhals. I would go to their settlements; I would see their drum beating, it was so important, their muscular body and their taking the woman like this, that was tremendous. Then I would go to Ramakrishna Mission; Vivekananda was not there at the time, I would just look detachedly, just to see what they were doing, I was fascinated, I was intrigued by these people. These two opposites I would ruminate on in Delhi, and paint portraits.

NT: The ascetic and the noble savage.

BD: Absolutely.

(9 September 1993, Delhi)

5

Satish Gujral

SG: What is painting, and what I think is behind the ideas and ideologies of the painter? Artists in our age have been catering to patronage, there is no exception. After Partition it happened that the patronage in India fell into the hands of the Hindus, mostly Marwaris. At first there was no patronage, the only buyers were the diplomats, or Europeans settled in Bombay. The patrons here wanted to have paintings which looked like what was being done in the West, and so that was what the Progressives painted. Then the Embassies started to buy a little in Delhi, but not that which had any Indian philosophy; they wanted something which was fashionable in their own country, and so Modernism begins.

NT: Not so simple. Anyway, tell me about your evolution as an artist.

SG: It is the echoes of the past that come to you slowly. The more I grow the more childhood myth is coming back to me. My background had been in such education that I, from the very beginning firmly believed in the local philosophy of art. My education was not in the way that is fashionable in India. I was trained like a master craftsman in the old tradition: a carpenter, a blacksmith, a printer, a painter, architect, so that I would become an *ustad*. This training was envisaged by the father of Rudyard Kipling, a director in the Mayo School of Art and a product of the Arts and Crafts Movement in Europe.

(We take a tour of his house for a while, seeing pieces ranging over his career)

SG: I have always been more interested in drawing, to let the hand flow. I believe that art is like a signature, not in its content, but the way you write,... and so as I grew the more anti-content I became, because I believe that the artists do not think, they feel. Idea does not come to them in ideas, it comes to them in form, and form is space and how it is drawn, and in this drawing is recognised what is happening within. So in this drawing, its flow, its intensity, is the secret of what is happening within the artist ...I have no style, and I have no image. I do not sit up to paint according to the image people have of me. I follow the mood, without thinking. Throughout my life I have been breaking away from one mood for another mood, to be true to myself. Long ago, I stopped listening to the world, I started listening to myself.

(We drift on to his work in wood, which started around 1977.)

SG: The wood itself has now gone through three different phases, the most recent are those standing sculptures, with those deities, Ganesha like works earlier. The technique – slowly developed, and also its forms, content, and its statement.

(We drift on to his latest series of paintings.)

SG: My mind had been going more towards the composition of miniature paintings, more than ever before.

In them I saw a very simple, innocent feeling where man and nature become one. If you study Indian miniatures, especially Pahari paintings, you see how a tree, or a bird, an animal, or woman figure, are mingled together. It is a total harmony of man and nature. So as I reach this final phase in my life I seem to be ultimately coming in the end to it in my work, where ultimately I shall mix with it, dissolve in it...

SG: My art is a surprise for me always. One night before I do not know, tomorrow it is happening. Something new begins which I had not anticipated. This is why I always said: the mind is the worse enemy of creativity. It curbs you because it wants to tell you what is right, what is wrong, according to what you know of the world outside you. Then you become deliberate, opportunistic. But when you leave creativity to yourself, you do not care,... that is my practical life also, I do not care, and I speak.

SG: ...Basically artists do not change, but their viewpoint and their treatment of the subject does change according to the variance in their inner emotional set up. In these drawings (1967–68 series) there is the same mythological play as in the new series you see, but what changes is the treatment of colour, which is more refined, along with the composition, also my use of the animals and the woman.

NT: What has been the constant thread in you, amid so much change?

SG: I will repeat a line from John Keats, in a children's story– book. It says, " ...and he stood in his shoes, and he wondered, and he wondered,..."

All my life I have tried that, standing in my shoes, just wondering what I see. It is not like my very first period in which there is the direct reference to the atmosphere that I was watching around me, of Partition. However afterwards I always let myself loose, just to play...but to break away, was difficult. When you have built a reputation on a style, it is not easy to drop it. I then asked myself, what I would have been if not a painter? With just this gift, God gave me so much, so my first duty was to this gift, I could not betray it for any consideration, and this is the creed I have followed all my life.

NT: This first break, after the Partition period, why was it so difficult?

SG: I was very well known on the national scene, so naturally I also had this weakness, that I was afraid to leave it. And secondly there was artistically nothing definite before me, all I thought was that one period had outlived itself, and to continue would only be a repetition. It took time, but once I took the plunge, then every time later it was no difficulty, even though it caused me to lose in the worldly sense, because as soon as people started to become familiar with the works of one period and their commercial value started to come up, I would stop it. Up to 1986 it was an accusation, rather than admiration, against me, that I changed...
Since most people did not know about the period before, nor had any idea of my evolution, they thought that I was doing something different every five, ten years which did not resemble my signature. Only in 1986 after my **Retrospective**, I got some credit for all these changes. Also in India the idea is that a painter is a painter, there is no appreciation when you do something in another medium.

I can sell my paintings, of course very easily, but in all other media, even now I cannot sell so easily. People do not think that that is art, they think that painting is only art. Whenever I move from one medium to another, I bring the discoveries of the previous medium to the new. The medium itself then has its own creative powers. I have returned to painting again and again but never repeated, always something afresh. I have never worked on a canvas which was ready made; I have prepared my own canvas, and also my own paints. This acrylic in the markets was invented by Mexican laboratory technicians, who were assigned to the Mexican Masters to invent for them a material which would help them for doing murals. I worked in Mexico with Sequieros and Rivera, who introduced me to their technique. Here I learnt how to make acrylic, about twenty years before they ever came to the market as a commercial product. Those paintings of 1952 are in acrylic.

In this (referring to his recent 1993 canvas) I prepare the canvas with a thick texture, to resemble the mud wall. This provides me with a colour play, by laying the fresh tones upon each other, to make different types possible...so this is the canvas.

I had started to use such technique in canvas almost by the end of the, fifties. Look at the serpentine forms in the wood. There are differences, because there is inner development. And with me it has been a coming together of building, painting, materials, how each has mixed up to make nature. So when I came to this present period, I noticed that when I am drawing a tree, I do not feel any difference whether drawing a tree, or a woman, all looked alike to me. So the overlapping. I think it is like a culmination of my past work and life. The difference between the different forms is disappearing and nature is becoming one to me.

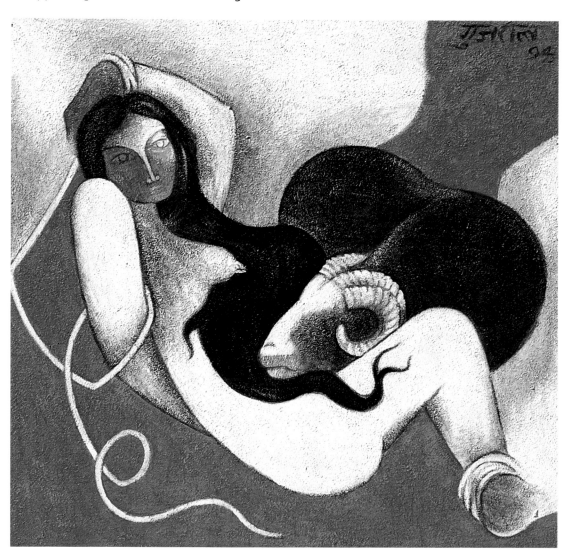

246
Composition
157.5x157.5. Acrylic on Textured Surface, 1994
Private, New Delhi

NT: What about the way you have made the inherent qualities of the material guide your creative direction.

SG: The more refined your sensibility gets the more interested you get in the treatment of the medium itself. I had always been against the content. The material itself is the statement. My interest in this has kept growing. The way I am now treating colour and line has never been so intense.

NT: Any reason?

SG: Maybe the last hurrah!

NT: Is the fear of death in you very strong?

SG: I am not afraid of physical death. I am afraid of creative death, because without this it is just a body without a soul. There is no use to live on, no purpose.

NT: What is the motivation which keeps you creating?

SG: Well, the mind should be turbulent but the spirit should be at peace. Out of this conflict comes art. The peace of the spirit has always been there. It is what has led me, but without the turbulence I would not have been able to search. Peace without turbulence is death. Both are needed for the search. To discover a new relationship, a new harmony, which gives new meaning to the universe around me.

NT: What kind of relationships? What kind of harmony?

SG: It is like travel. You see things which you have not seen before. Similarly the artist looks around, there are objects in which he finds new meanings, relationships. This search is not satisfied with a single meal, it needs constant feeding. When I see repetition in an artist I feel he has forgotten to feed himself.

NT: Tell me a bit about the way you have absorbed influences.

SG: The point is to discover those relationships, influences and try to embody them. It is like a certain fabric which is suitable for slacks but not for a shirt. So I think this relationship is more suited to stone, than wood.

I remember Van Gogh writing to Theo: "I want to paint red, I want to paint red,…with all the passion in my heart." He does not say what, he just wants to paint red. I just want to create a relationship, and so I will find matter, material to create the image. I saw a burning wood, the ash coming down, the cinders, something sublime. Suddenly I had the desire to recreate it.

(5 September 1993, New Delhi)

[Satish Gujral's wife, Kiran, kindly translated what few words I spoke, for Satish to lip read.]

6

Ganesh Haloi

NT: Nature, especially the landscape, seems your deepest source of inspiration?

GH: Yes; a very strong sense of oneness. You merge so much with the landscape, that you lose your own identity; there is no sense of alienation, it is being one with the landscape. Being born on the banks of the Brahmaputra, I cannot escape the landscape. The landscapes are part of me; so what if I do not paint figures? My feelings, affection are here. The mountains, the people playing folk songs on the banks, I do not think it is something separate from me. I am not apart from the landscape.

I am always going alone into the wilderness. The distance, the separation, gives the need to reunite. As with man and woman. The pain in the separation of man and woman, and so the desire to be united again, leads to the pleasure of creation.

247
Untitled
55.9x71.1. Gouache, 1992
Private, Calcutta

NT: Is this why you paint? Or is this what sustains?

GH: Why do I paint? What are the things which make me draw? Why take the trouble to paint? We never used to sell paintings, we were depriving our family, to buy colours, buy canvases, take so much labour, the trouble of taking them to exhibitions....so this is the question I suppose, why do I paint? In this universe, there are all sorts of movements. Where there is movement there is sound, vibration, and a visual appearance which makes us wonder. These are things which come when we are not preoccupied with material thoughts. When they used to live in the primitive age, life was very hard, but they were not preoccupied. If you are not preoccupied you will receive this vibration, and you will respond. Dancing, music, all such started with this response. This vibration makes you become part of that movement.

NT: Then what happens ?

GH: Then you realise that everything is created by a supreme power, and the realisation comes by being isolated there. You become part of that, a kind of spiritual realisation.

NT: Coming back to pain, and its role in your work.

GH: All source of creativity is a pain of some kind. There was one it has been divided into two, so it needs to be united again, to be one. So this source of pain gives us a feeling. It is transforming all we see, it creates a departure. The pain, may not be there tomorrow, but still there is a continuity, life has this continuity. I was a baby in my mother's arms, I have become old now, will become older. Past, present, future, there is a link, but also a transformation, a gradual transformation. You cannot separate. This change is what is painful, what inspires us to paint.

NT: There is no eroticism in your work. Have you thought why?

GH: Intention is the only thing that counts. Life is being, it only depends on intention. By seeing a painting I can make out the intention; whether from within or not. There are many erotic figures, gestures in our art, but you see when they are part of life, it is not erotic. What is intentionally done, a part of life, how can it be erotic? There must be another reason behind it, a sincere reason.

NT: Eroticism can be that very reason. Anyway, how have you tried to understand yourself via your paintings?

GH: It is a path to realising the supreme power; it is a path. Maybe one day I will stop painting if I find this higher stage of realisation. It is a sort of battle, and a kind of feeling comes within me which I try to arrange with the help of forms, colours and space.

NT: Do you see any coming together of your work's evolvement and your own understanding of yourself?

GH: One cannot say, it is a process.

NT: Are you understanding the process?

GH: I cannot say.

NT: What is then motivating you? What are you trying to still express?

GH: I want to see things in a different way. The same thing in a different way. Take a tree. The tree reacts according to my mood differently.

NT: Not simply to express your emotions.

GH: I mean it is a mental condition, a source of pleasure to see a particular thing in a certain different way.

NT: Always based in nature?

GH: Yes, based in nature, but you cannot separate from the human figure.

NT: So not nature, nor the human figure, but a unity of the two, and something you still search for?

GH: Yes, you cannot separate me from this canvas, can you?

NT: So the roots of your work, its most simple essence, is man and nature's unity and separation, and reuniting...

GH: Yes, certainly. The painting being an existence in itself.

NT: You have not much desire to travel to the West or elsewhere?

GH: Today it is much easier to go outside India, after Independence this trend began. What I have seen, is that when artists returned they copied the West. Nowadays they are struggling to become Indian, but there is no question of Indianness in my eyes. I do not like this. Any means is an inspiration, if it makes you paint.

NT: We will be and are Indian in spite of ourselves. That is what we will soon realise. Tell me about Ramkinkar.

GH: I regard Ramkinkar as the true painter. Throughout his life he never cared for money; all his paintings were stolen. Also, with Gaitonde, there is no repetition in his paintings.

NT: What is the main problem in art education today?

GH: The first point is that you cannot make an artist. I can teach them technical things. Out of twenty, one or two may become artists, the rest go to advertisements or commercial art fields, and so they should be taught accordingly. They should be taught drawing predominantly. This is not done, they are all trying to make artists, but it is not so...When your leg is steady you can dance, skate and do all sorts of things. So also you should be steady with the fundamental things, drawings and perspective rules, then they will find their own way. If I ask: What is the basic characteristic of oil painting? Who really knows? The idea of illumination. The behaviour of linseed oil, from liquid state to solid state. It changes, its reflective index, its condition, it becomes more transparent, and so the colour behind the upper layer will be much more interfered with by the underneath colour. Today a very bright yellow, tomorrow dirty.

NT: So what do you tell the youngsters?

GH: They should see nature, nature is the source of everything. They should study nature, construction, branches...just as technology is part of life in the West, so reflected in their work, so it should be with nature here.
But the sincerity is not there. At least the West is sincere to technology, honest. But soon they will be dying for nature. Technology is not a strong foundation.

(16 August 1993, Calcutta)

Krishna K. Hebbar

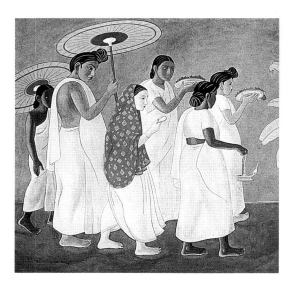

248
To Maidenhood
Tempera, 1947
Private, Bombay

NT: Should we start with your early work, from the mid–1940s.

KH: The idea of mental perspective, not aerial perspective, was in my work, at that time. The Rajputs with their gods–goddesses; Mughals with their courtly work, the idea of big and small, foreground and background, all that.

I wanted to change my academic style of work after 1944, away from these miniature techniques. I felt that I was not doing anything different from others. In 1946 I went on a tour of South India– Kerala. This was a big influence. I was very interested in painting their dark bodies and in those days women were not wearing any coloured saris, only white. Their bodies reminded me of Gauguin's Tahitians; I had seen much of his work and admired it. There were green fields everywhere. I also saw Sher–Gil in 1937 at the Taj, but only after going to Kerala did I get inspired by her work. After coming from Kerala, I did **To Maidenhood**.

This was enacted for me in Kerala by my host, an Ex–Diwan of Cochin. This idea of the girl coming of age was a ritual. If I would not have gone to Kerala I would not have done things I have done after 1946. (eg: **Sunny South, Pandits**)

NT: Tell me about the inspiration you drew from Amrita Sher–Gil's work.

KH: I liked her immensely.

NT: Why?

KH: In the first place, I had not seen work like that in India. Everything was sentimental, with no use of colour. Now there was brightness of colour and simplicity of form. The whole thing was something new. She was like a meteor in Indian art.

NT: Then or even now?

KH: Even today, I do not call it great,… but there was something special in her. Regarding imitating her, I could have done it from 1937 onwards. But such a thing was no idea at all.

NT: What was the main thing about the Bengal School which you did not like?

KH: One thing, it was to too sentimental. All the same things in woman, eyes, hands. It had served its role, and I had made the determination to follow my own path.

NT: So works like **Mahim Darga**?

KH: Yes, **Mahim Darga** (1955) is more an idealistic painting; it is neither realistic nor an experiment. Idealistic, in the sense of simplified. I was staying there, in front of it for about 12–13 years, in that locality. It was too jumbled when I was there. The colour was also idealistic, because it is a devotional place I wanted to create that feeling of peace, unlike in this painting **Cock–fighting**, 1959, where everyone is fighting, they are all gamblers.

NT: You are against gambling?

KH: I have never gambled.

NT: It is not too late, I will rescue you.

KH: (smiling) In 1958 I went to Indonesia, and even though I saw these fights in my country, in South Karnataka, here these creatures, birds, would go on fighting till the last breath. There when the intestines come out, there are experts there who put it back inside, stitch it with thread, on the spot, and with fire burn it to heal. And these sharp things they tie on, if it even touches a human, it is so bad. I never even thought of painting this, until my trip to Indonesia.

When I saw the gambling there, it was so much more organised. There was a huge construction, an umpire, with bell and all the people around, gambling, their faces horrible, so when I came back I painted this picture of **Cock-fighting**.

NT: Any main reason for painting **Mahim Darga**?

KH: No, no reason. I was attracted by the whole situation; hundreds of people going there, and they were getting free food.

NT: They still do. You have always been interested in music, dance, rhythm.

KH: Yes. In 1957 in Delhi, a whole lot of folk artists had come. It was much more genuine in those days, the atmosphere. I was very much interested in them. I made lots of sketches. I would go to their tents in the morning, just to be with them, know them, and I myself have studied dancing, but at the age of thirty learning something is not easy.

(When looking at the Bali sketches) ...this is not composed. I was seeing the performance and there was no light, only a torch. So unless you are accustomed to music you cannot draw such things.

NT: Accustomed, in what way exactly?

KH: You see, when you hear the song and music, your whole body reacts to it, so the hands move. It was not composed afterwards, it was done directly on the leaf. These are not drawings, only sketches. Then later I search for only rhythmical parts, and make a drawing. I will tell you how this **Music Series** started. In 1970–71 Yehudi Menuhin came. He had a show here, and also in Delhi. It was the first time I had heard him, and was very impressed. His sister was playing on the piano. When the whole function was over a Parsi lady took a bouquet of flowers and placed it there, without any words, and he also just came, bowed, and went away. What I saw was all colours, all colours, even when he was playing I was so thrilled, everything in colour. Next day I came and painted **Homage to Western music**, also **Homage to Eastern music**. I made sure the purchaser bought both, to keep them together.

NT: There has never been any kind of eroticism in your work.

KH: No. Whenever an artist has fallen in love with a woman in his painting, he has never gone beyond that physical level in his painting. I do not remember the exact wordings, but I wrote this in my diary once. I like beautiful women also, to look at, to enjoy, not for painting. Painting has nothing to do with beauty, physical beauty has nothing to do with painting. Painting must have beauty with its own form, its own colour.

NT: Can't we find a compromise?

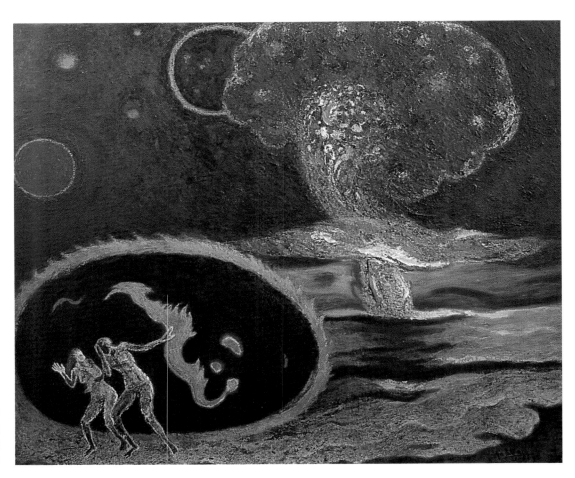

249
Holocaust
102x122. Oil, 1983-6
Masanori Fukuoka, Japan

KH: It can be, of course, but anyway it is like a man walking with a walking stick. The walking stick can balance him; the other thing is to show his dignity, and power. What I want to say is that art should have its own beauty.

NT: Where does this beauty come from in your case?

KH: From within.

NT: Which the love of a woman moulds.

KH: Yes, it inspires you, but is never out of control.

(12 August 1993, Bombay.)

8

Somnath Hore

NT: After the early poster-designing work, during the 1940s, you moved on to printmaking. It must have been difficult; not many knew about the techniques at that time.

SH: I also had to learn it myself. My immediate senior was Kanwal Krishna and his wife Devyani Krishna. To get the right materials was a big problem. I am talking about 1958–59.

Before this I was at the Government College of Art, Calcutta. Here I started etching but had to make everything from text-books of the time. Etching ground and other things were not available in the market, so I had to make them.

I had to give up painting in order to learn the whole technique of print making, because I was in charge of the department, (at Delhi Polytechnic, 1958–65), I was the teacher. I used to go to the exhibitions which were shown here, say Dutch or French prints, English, American. I did not want to lag behind, but technically it was not possible to keep up. They were developing all sorts of modern machines.

NT: So you learnt printmaking so as to teach, or for yourself, or both?

SH: At first it was for teaching, as I was more interested in painting. I was trying to combine both, but then afterwards I could not do it, as I would have to go to college at nine in the morning and return home at nine at night. Yet I had become terribly inquistive about etching, and so I collected all the formulae and materials from wherever, and was able to make the etching grounds. There were no imported materials.

NT: The teaching job was necessary to earn your living?

SH: Yes, at that time there was no question of sale or anything. It was a very weak market, even Husain had to run from place to place to sell his works. We all had to depend on some sort of job.

NT: What were the main early issues concerning your work?

SH: The famine of 1943 had a big impact on my psyche. Then the refugees from Partition. So many people coming to Calcutta. I myself am from Chittagong. I was in Calcutta, before the Partition, since 1940, so in a way I am not a refugee, but they were my people, and so those things affected me. And at that time, whatever I did, were more sentimental rather than artistic creations. I have never hesitated in admitting this.

But then gradually I felt that this should not be my attitude to creativity. Art deals with form. When painting I had to think in terms of colour, space, some sort of spontaneity, so as to create some kind of aesthetic pursuit. Everything should be done with abandon. It must come almost automatically from inside. At the same time I must also give sincere effort...Now suppose I am doing this woman. (pointing to a sculpture of Draupadi) I am not thinking about its particular anatomical features, or how the expression will be, how the clothes will be. I am not thinking of these things. I am just handling material. It is done with sheets of wax. This medium is not really bronze, it is transformed into bronze by casting.

250
Mother & Child
Wax-strips cast in bronze,1985
Private, Calcutta

I am all the time involved in one concern. What I call **Wounds**. Social wounds you may call it. Whether it is famine, or refugees, or the riots, or whatever it is. For this concept I don't have to think, it is there inside me. I only have to think in terms of the material. I will tell you about the idea of **Wounds**, how it started. I remember seeing the metal plate in nitric acid, and the bubbles of anger, making wounds on the metal. I thought this was a most appropriate means to express my own ideas, by this etching process.

NT: This kind of focus, the ability to mould all life to this inner point, whether it is dominated by pain or joy is like living inspite of oneself. Yet nothing is closed, is it? We find joy in everything, in every little thing. There must be so many other things which inspire you?

SH: Yes, there are so many things: small children running around, a calf drawing milk from mother cow, a boy playing with a wheel, a cart going past, a bird singing. These things sometimes come like a wonder,...this magnolia tree, this was the first time there were blossoms on it. This was a wonder for everyone, we had waited for about seven, eight years for it to bloom. So from the very simple to the very complex, things are happening all the time. This wonder has always been, but still I find it easier to do wounds. Yet I get such a thrill when I see the bright colours of Husain, rather than a beautiful thing which I must appreciate through my mind. I have used more sombre colours. I could not use bright colours, it just did not come to me. My wife uses a lot of bright colours, it is natural for her.

NT: Tell me a bit about Ramkinkar, what kind of man did you find him to be?

SH: We knew him since the late 1950s. He did inspiring work and was, so terribly energetic. He had something very special, a dramatic personality. There are so many stories. I have seen some things you won't believe. One day, he was not well, so my wife and I took some food for him.

He use to take food from the *thali*. That day I saw five-six kittens, two puppies or so, taking food from the same *thali* with him, altogether, and he was saying, take it, take it, and himself taking calmly. Can you think of such a thing? No fear of infection, no sense of impurity. So very at home with all this earth.

He use to live in utmost penury even when a professor...there was a saying that he did not drink water, but he never got drunk. He was always very well behaved with me. He never cared for his clothes, or of what others said of him. Always within himself, a remarkable man.

(17 August 1993, Santiniketan)

Maqbool F. Husain

NT: We were speaking about Souza. He had asked you to join the P.A.G. and then came the Rashtrapati Bhavan Exhibition, in 1948.

MFH: Yes. Souza said we must see this exhibition. No other member came, just the two of us. I just wanted to listen at that time. During that journey Souza told me so many things about art. He had a wonderful mental grasp of art. I was just learning about these ideas. So, much credit should go to him.

Both Souza and I were penniless at that time. During that exhibition the kind of running commentary Souza gave was so impressive. My mind was raw in these matters at that time. The colours of the Basohli, those Gupta period sculptures. I was bemused. How do I absorb everything? Then seeing Souza's work, those heavy lines, Rouault's influence, but he would Indiannise it. His focus was still those Byzantine, Christian images, referring to Goa. After this exhibition I sat down and thought about things, did many sketches. I realised that there is nothing original in this life, it is all about how you select and make it part of yourself. That is the eye. So I had to find my own way of selecting from Indian art.

At that time, it was a learning process for all of us. I needed a certain period from Indian Civilisation, for I wanted to evolve a language right from the beginning. Our own colours, our own forms, and sense of space. We did not have the technical advancement. So without telling anybody I came out with five paintings. In these paintings for the annual B.A.S. I used the colours of the Basohli miniatures, the figures of the Gupta Period. Also the innocence of folk art has from the start attracted me most deeply. All the festivals, the earthen toys. Bringing these strands together was my art, at that time. Also my background with cinema hoardings helped me very much with these very strong and raw Basholi colours.

You see, when I came to Bombay I could not read English, but we had a very scholarly family background in Urdu, literature, and poetry. Poetry has infact been a very important influence in my work. As, for example my, **Poetry to be Seen Series**, done in Czechoslovakia.

NT: So after these early days, your first trip to Europe was in 1953, then in 1955, the first National Exhibition, and when **Zameen** wins, a turning point?

MFH: Yes. In this painting I brought village life together. The other was that like the Jain miniatures, the idea of sections, giving an organic feel in which you tell a story. This was the first time I used this method. R. von Leyden referred the work to Beckmann's wild beast force, but at that time I did not know about German Expressionism. After that I got a few books on German Expressionism. Later I painted the **The Voice** (1959).

NT: Between **Zameen** and **The Voice**?

MFH: Basically all the theories, the 'isms' from Paris, London, New York. This was adding a sense of starkness to the work, mixing with those folk–Basohli– Gupta influences. Actually I was a captive, I could not escape. My inside was trying to break free from these Western influences, but at the same time, the circle around me was such, I was almost a captive.

251
Zameen (detail)
 91.5x548. Oil, 1955
NGMA

NT: So in 1971 probably came the release to break free?

MFH: Yes, after that I did not listen to anyone. Also, I had made 'Through the Eyes of a Painter' (1967) a short film, in this UNESCO and Indira Gandhi project where they wanted non–film–makers to do some films. I did not know anything . The Film Division people said you should know something about editing and so on. I refused. The technicians were laughing at me. They thought it was a joke. This was no way to make a film, they said. I wanted to break the norms of film–making, that kind of attitude was in me. I selected Rajasthan first of all. Chittor, Bundi and Jaisalmer. Basically I had a three-line script. Everyone was very upset that there was no script. I said I will just go on the spot, just think and we will make it. Further I said, no colour, we must use black and white.

NT: Why black and white, at that time?

MFH: Because basically Rajasthan and colour, is the attitude everyone has. I wanted to go against it. Lyrical images of Bundi, the strong wall of Chittor, and the infinite space of Jaisalmer. In the morning I would get up early, decide the location, and then shoot.

NT: But you must have had an idea in your mind?

MFH: Yes, basically it was about what we call "found objects". Collecting objects. This I learnt from Rossellini. He had come to Mysore. I went with his crew. So basically I started collecting images and the rest would be done in the editing room. The idea of the umbrella, lantern, shoe, these objects were used like still– life. I did not want any kind of narrative or story, no kind of meaning. Just pure images.

NT: Trying to achieve what your paintings were fighting to do, but not able?

MFH: Yes, I was tired of the narrative in film. I wanted just images, just movement and sound. I remember that floating umbrella scene, that needed 3 to 4 takes.

NT: This fascination with the umbrella has been in so many of us.

MFH: Yes, I did a whole series on the Umbrella, **Portrait of the Umbrella**, about the late 1970s/early 1980s. Basically it is the placing of objects, as a shape.

NT: Also the lantern has been with you a long time.

MFH: Yes, since my grandfather's time. He was a tinsmith, he used to make these lamps.

NT: How about the spider, what was the source of inspiration there?

MFH: That was from a childhood story about the Prophet and he was hiding in some cave because enemies were after him. When the enemies entered they saw all these webs of a spider and so left imagining he was not there,...

NT: Amazing, how many stories, from so many different cultures share the same themes, so similar.

Let's jump a bit. In 1979 your **Mother Teresa Series** begins; was this an important series for you?

MFH: Most important.

NT: For emotional reasons only, or technically also?

MFH: In the way it was conceived, for it went back about 15 years when I was working on the church with Charles Correa, with the stained glass effect, and the later work that I did, dedicated to Cimabue. All those drawings, then going to churches, cathedrals in the small towns, and seeing the relationship of draperies with Byzantine art, and learning to express concepts via draperies, robes, very much stuck in me, the folds fascinated me, and so when I thought of expressing Mother Teresa, and how to do it, these ideas came to my mind.

NT: Okay, so after 1979 what happened?

252
Mother Teresa Series
115x91. Acrylic, 1982
Private, Bombay

MFH: Then in 1980 I met a good patron, a Canadian Jew. He allowed me to travel worldwide, Paris, London,...all my wanderlust was fulfilled. All the work I did I just gave to him, 50–60 paintings. He was a very generous man also. He wanted to promote my work in America, but I wrote him a letter that this was not the right time to do so, that I was all right in India.

NT: Then this 1982 exhibition at the Royal Academy?

MFH: That was only due to Chester Herwitz. The whole collection was his own, he made it all possible.

We met in 1971 when I exhibited the **Mahabharata** Series at Sao Paulo. Then I brought those paintings to Paris, where Pierre Cardin exhibited them. Chester bought the entire collection.

After much difficulty and diplomatic work, cultural pacts, this series was shown in Moscow, at the international museum, and televised, the first contemporary Indian art works shown in the Soviet Union, in 1974.

Later I did many more in the **Mahabharata** Series, just in black and white, with the main theme being the split,...

NT: This fascination with black and white, a reaction from colour, the need to alternate. Any special reason?

MFH: Part of everything. I had once gone to Houston and seen the chapel in which Mark Rothko had worked. Philip Johnson had designed the building, both of them worked on it together, wonderful, just in black and the rays of light. It gave a real spiritual feel to the chapel.

NT: So the place of worship, whatever kind, has always attracted you...

MFH: Yes, all the Renaissance works, all the cathedrals, all our temples, Mahabalipuram, Konarak and Elephanta, these three are the greatest. Even Ellora is fine work, not so much Ajanta.

NT: Okay, so during the 1980s what was happening?

MFH: The **Mother Teresa** Series was continuing with variations, new directions, deeper and deeper, something new everytime.

NT: Since 1979?

MFH: Yes, There have been many pieces. The latest one...(he brings out the latest, nearly completed)...where Mother Teresa is being united with Yashoda and Krishna. So the idea is now becoming focused on the Mother.

NT: The mother theme must be very deep-rooted in you, given your own loss at an early age.

MFH: Yes.

NT: This series (Images of the Raj) reveals your humour and of course the perfecting of your technique, but the quickness has also become a complaint.

MFH: Well you see after thirty or forty years of work if you have to sit and struggle over your technique then whats the point? It is ridiculous. Musicians have,...like Toscanini had each and every note up here (pointing to head) for two hours, how does that happen? It is the same.

(19 October 1993, Bombay)

10

Sanat Kar

SK: ...People forget, that is why we quarrel, that is why we fight, knowing full well for how many few days we are here, few years.

NT: Do you believe that there is one continuing spirit that has been throughout.

SK: At one time I use to tell my students, that I cannot understand why it is, but I thought about it, I still think about it. I am here, others somewhere else, say Germany, but this beat in the same. What is it? Even a child, somebody born here, there, the timing is the same,...Yes, a continuity is there,...

NT: Does not that balance your sadness, that knowledge that it has been always, throughout in all spirits,...

SK: Perhaps. Without knowing it. Perhaps.

(Referring to his collected works, mostly intaglios). Since 1981 I started temperas and since then I have been creating intaglios, temperas, lithos, everything.

NT: Is there any concrete interaction between the media for your work?

SK: Yes, the content for all is relatively the same, but it is only because of the nature of the medium that changes exists.

NT: Tell me, how did this card-board intaglio idea came about?

253
Untitled
Wood Intaglio, 1984

SK: When I started intaglio in the, sixties I did not know anything about it; I wanted books on it but could not get them. I went to some people, they did not help. By chance I started experimenting. Instead of using etching ground, which they used in Europe, I never used that ground, because I did not know. I came to know that printing ink resists acid. So I started using printing ink on the plate, and worked with that, using a stick or something for the drawing, and then gradually creating different textures. I did quite a number of small plates. Then suddenly, I don't know, Dr. S. Rao, the Director of Max Mueller Bhavan in Delhi, I never met him, I don't know him, wrote that he wanted to exhibit some of my works, and then Charles Fabri discovered me.

Then in 1961-2, I showed some other works. I never had any formal training in intaglios, I wanted to do bigger ones so I went to the market to get an acid bath, people were not using bigger plates in those days. I bought an enamel tray, poured acid and started work, and suddenly I found in the middle of the tray, the price was still written on it, it was in some red pencil still there in spite of acid, and so I started using pencil only, discarding printing ink. Then I came to know that even a simple pencil can stand nitric acid because it is made of graphite. Like that I started lots of intaglios. I wanted to replace zinc and copper plate with wood. The first ones were a success. Then I wanted to make it cheaper, as money was scarce, so I started with plywood, but could not do so at first, then I discovered tools so as to cut, draw, get the finest kind of lines on plywood, and how to get rid of the ply-lines. I kept on and named it wood-intaglio, and so a new edition to print-making. Then I wanted to use Sunmica, because metal plates are so costly, and in our country very few do the engravings because it is the hardest and purest of all media. When you use colours, textures, tones, then you are kind of camouflaging. To use only lines, that is very difficult, and is the purest of all art. I wanted to try but the plates are so costly, even nowadays they are very costly, and so

I was thinking of some thing by which to get the same effect but cheaper, so I found this Sunmica, you know, the table-tops, and then discovered tools for it. Even in Delhi, Sankhoda, (Sankho Chaudhuri) was surprised, and said how can you? So I demonstrated.

NT: Tell me how the **Ikebana Series** came about?

SK: I told you about leaving this world. I was thinking that after leaving this world should I be wanting to come back. I must come back because I love my home, and all these things I used. I started dreaming, when I come back I see these things, and it came from that, and it came amidst an arrangement with flowers, so I consider that the painting is a kind of arrangement of different elements, and the idea came from this.

NT: But the motifs in the work have been in you for many years.

SK: Always. You see I smoke, I like it, also I try to give up but I can't, that is why you find its presence.

NT: The head in the vase?

SK: Yes, sometimes I felt like it, depicting ladies instead of arranging the flowers. Anyway, first I make a drawing, like it, it feels complete in itself, even the head in the basket. The present human life is nothing today, everyday so many deaths, it is nothing, nobody cares, what is it? So futile, and always somebody comes from the top, flying in, and the room merges with the sky. That is why the moon comes in, merges, wanting to show outside and inside together, you understand?

254
Ikebana Series
60x52.5. Tempera, 1989
Private, Calcutta

NT: Yes. Were you inspired by any works of Chagall?

SK: No, I like Chagall very much, it is a fact. Of course there is affinity, but he never painted like this, though in Germany they marked me as the Indian Chagall, which I did not like.

NT: There is no need to explain.

SK: I also think that dreams are an essential part of social narrative. You see I am cut-off from society in one way, it is not that I am unsocial or not connected to society. But social narratives do not mean that only you show,...it is also about dreams. Every human being dreams. I am just merging the two. Painting cannot be a sort of reportage, we must use some symbols,...

NT: Symbols which must evolve from within

SK: Yes, they have.

NT: Tell me bit more about this blue, turquoise, light blue colour, so beautiful, like pastel softness.

SK: I use powder colour. The colour is more than a hundred years old. When I wanted to paint in tempera I went to Calcutta. I did not want the colours they were producing now, so they told me to go to their warehouse and find out. So I went there and found those old London Blondell colours, I took them all, I still have so much stock. These are very permanent colours. I use Fevicol to dilute, instead of just water, that is the binding, it protects from insects also; and the board I use, the back-side I cover it with Fevicol, it gives it a weather-proof coat. My whole attitude to tempera is oil-based, the colours I use, the way I work, it comes from my oil techniques, which I started in 1951, up until 1974 you could say, so my background is in oil. The whole attitude, the way I use the brush, I dab it, like that, it is as if I am fighting.

NT: Regarding your **Dry Leaves Series**...

SK: In winter here, in Santiniketan, going to my department I use to see dry leaves lying. Suddenly I started to see those leaves as faces, I started seeing different human figures in them. I did about 20 to 24 paintings.

NT: So even here the figure did not leave you, right from the start the figure has stayed with you, dominated, why?

SK: As I told you in the beginning, I love this world, the world means human beings, I love everybody, all human beings. I understand their suffering, joys, a simple humanistic approach.

NT: And the main problems which face art education today?

NT: One thing is that we do not have enough space. Most students are very poor, they don't have enough to spend on canvases, colours, and then, a good student after passing out, he does not get enough support for carrying out his work.

(17 August 1993, Santiniketan)

Bhupen Khakhar

BK: ...Pink, blues and greens are my favourite.

NT: Why?

BK: I see these colours all around. In the shops, even small *bidi* shops, in the pink lights used at night.

Also I used enamel, between 1964–68, when working on oleographs, which were very bright. Oil seeps into the paper, destroying it. Also oil did not have the brightness of enamel, acrylic colours too were not there at the time. After enamel I thought I must use oil colour, because no one was using watercolour in Baroda at that time; the whole expressionistic tendency was over, which enamel had served, but now I wanted other qualities in my paintings.

NT: Such as?

BK: Humour, working with a space, then depicting people, which I had not done till then. So concentration on people was the key.

NT: This was the **Residency Bungalow** and **Parsi Family** phase?

BK: Yes.

NT: Then the next turning point about 1970 with the **Trade series**?

BK: By this time, my use of colour was changing, I was using more contemporary themes, and the figure was getting a bit bigger. You see it was my inability to draw well which determined the size of the figures previously, and the sense of space.

NT: What was the main motivation to depict this way of life?

BK: I think the main motivation was that I was quite fascinated by the life of these people, and their day-to-day work... Regarding the **Tailor** painting in the **Trade series**, I was looking at him work at night, and was quite struck by the pink lights they used; I could visualise the whole picture, the cutting of cloth fascinated me.

NT: Artists dislike talking about an underlying philosophy in their art, but conciously or not, it is there. What about your philosophy?

BK: I don't think I can give direct answer to the underlying philosophies of my art, because, very indirectly at first, I wanted to put forward the case of minorities, the gay people, homosexuals. This may be one of the reasons why I am prompted to art, but more than that it is certain kind of confession; things which you like you wish to depict. When one paints, what exactly makes one very happy? Sometimes it is the face, which has come off very well.

NT: In **The Bathers** is that happiness found?

BK: Yes, yes,...

NT: How?

BK: It is the whole idea of seeing someone taking a bath, witnessing that,...

NT: With or without their knowledge?

BK: Without their knowledge

NT: That is the interesting part

BK: Yes,...the human mind works on so many levels. Sometimes I am quite intrigued by a relationship one may have. Suppose it is not known, she is married to someone and the man is also married, they have other relationships and then both die, what happens to the one which is left? For me this is a mystery, no one knows about the relationship, and what happens to the love, and what if only one dies? Perhaps I like someone, enjoy looking at them but they are totally innocent, the man or woman I may like are really not aware, this one-sided relationship fascinates me too.

NT: Lets come to your **Bathers** again, a theme done over the centuries, what were your specific reasons?

BK: I think there were multiple reasons at that time. Thinking back, the whole *Krishna–Lila* idea, where the women are bathing and Krishna is watching; I had seen many oleographs of that, so that may have been one of the reasons. The second thing was that I had gone to Hrishikesh, and here I watched people taking baths. I could see a kind of religious happiness which they were having, though I could not share that kind of happiness, I could yet feel that there was this thing in their mind, so they did not care if you watched. The whole experience of going to Hrishikesh and doing drawings, I was looking forward to it, and this series came.

NT: Religion, spirituality and sexuality seems the natural mix for you, given the conflict for most of our people in this thinking...

BK: Yes, I do a lot of drawings where religious people collect. It is not that I believe so much in religion, it is partially so, but I get quite a fascination. Actually you are the one who has really pointed this out to me consciously,...for recently I had gone to Agra and done many such drawings. Here I have depicted a naked sadhu right in the middle, and then the river Yamuna, and a homosexual.

NT: I think you may need a few bodyguards hereafter. Let's come to the arrangement of your figures, for you are narrating stories, from the early **Residency Bungalow** phase where your shyness in drawing gave rise to the space ideas, and then the **Trade Series**, where there is greater confidence in drawing,... how has it changed?

BK: In the beginning the narrative was not so much in my mind. The change came when I got interested in storytelling, and that became evident when I did two paintings based on a Gujarati proverb of the blind man looking into the mirror and his relationship with a woman whose virtues he cannot know in 1978. There was another proverb about how **You can't please all** (1981)... So this storytelling, and the influence of miniatures, Bruegel, all came together,...from here I slowly started depicting gay relationships.

NT: In which picture did you come out explicitly and felt satisfied in your expression of homosexuality?

BK: **Two men in Benaras** (1983)

255
You Can't Please All
167.5x167.5. Oil, 1981
Private, London

256
Fishermen in Goa
175x172. Oil, 1985
Gallery Chemould

NT: Benaras, as always. Are watercolours now more prominent?

BK: Yes, but before that I had gone to Goa, in 1984, where I had done **Fishermen in Goa** (1985). That also has its connotations.

NT: What made you come out in the open? It was obviously very gradual, what was the main trigger?

BK: I think, one thing was my trip to England in 1979, when I met a few artists like Howard Hodgkins, Timothy Hyman, and stayed at Howard's place. From that time onwards, I started discussing this relationship with others, sharing, and knowing that I have friends who are sympathetic. When I came back to India in 1980, I felt more confident that I could share, and also Howard was by that time staying with a boy.

NT: So 1979–80 gave you the mental strength, and then in 1983 **Two Men in Banaras**, and in 1985 **Fishermen in Goa**. So many years even then for coming to terms with it, and **Yayati** was the sort of break in 1987, and since then, you have come to terms with it more calmly, it is no longer a burning issue.

BK: Now it comes like a natural thing. In some paintings it is there, in some it is not, so it comes and goes, and is almost a natural thing even in my mind.

NT: Let's drift elsewhere a bit. You see, the essence for any creativity is the open mind which allows all contradictions to come in, to be absorbed, keep balance, live with it, go beyond our limits at times, feel confused even, but to always keep faith. Moving on, knowing that something fuller is becoming,...do you see this in your creative process?

BK: Yes, I see this, but it is difficult to talk about work I am going to do next, because it feels as if the whole energy goes if I talk before, but I do feel that kind of contrast.

NT: Anything specific? You know like oscillating between two polarities, and in that oscillation you have created some work of art.

BK: There was a painting **Death in the Family** at the V & A, and then I wanted to do **Marriage in the Family**. I tried to do many drawings of this marriage in the family, but somehow could not do so, and ended up doing this **Guru Jayanti Celebration**. That kind of oscillation I have always had; you start with a certain subject, then feel that you are not really equipped, for a painting.

NT: What did you want to do in **Marriage in a Family**?

BK: I wanted to do a portrait of two people sitting on the dais, and all the Indian marriage ceremonies, but somehow these two people looked too small or too big,...

NT: Well obviously, because for a person like you, who is not married, has no wish to marry, the hesitancy must have been there,...you may have been trying to convince yourself obout marriage.

(5 September 1993, New Delhi)

12

Krishen Khanna

NT: What are the fundamental changes between your early work and present paintings?

KK: In the early work I use to leave a lot of blank canvas, I did not fill in everything, only the figure or what I was doing would be the activated space. I am self–taught, and learning all the time, so when dealing with the figure, one is focused on just that. Everything else is peripheral, filling in the rest is not very pertinent to what you have to say. This is the very opposite to what I am doing now, because I think every inch of the canvas does matter. Previously I was using the canvas like a page, like a scribble, a notation, and so there was a certain informality about those pictures, a certain spontaniety, it was not picture–making as such.

NT: But far more emotional.

KK: Yes, it was very emotional, very direct. Also I have always believed that a picture, whatever the methodology, is capable of change, now more than ever. One should use a method in which changes can be incorporated without having to hack out certain areas. Your methodology should be capable of absorption, of any ideas that might happen along the way.

NT: A very fluid structure, capable of resolving opposites,...

KK: Yes, this very fluid structure is in my mind. Also keeping the whole thing open-ended, even until the end.

NT: So what is the motivation?

KK: The motivation is,...it is not a three act play. You are not beginning with a premise, then its development and then an end. You are beginning to discover, maybe that the prime motivation is an idea or a figure. Then as you work on that, you find there is a lot more to it, and then comes the active process of painting itself.

NT: So how did the focus come? After all, this kind of openness begins to gel only after many strands are brought together.

KK: Well it happened I suppose. Otherwise one could go on repeating the same painting, even if the subject–matter is changed, for then it is a question of executing a plan, like an architect might. He has a ground plan for something, he knows what to do with it, the materials to use. Painting is not like that. The greater thrill is dealing with the unknown element. One must tempt the unknown.

NT: But this unknown itself is changing each day.

KK: That's right, once you see it, you react to what you have done. So it's not only that you are reacting to what was the initial theme, you are reacting as well to the actual minute-to-minute business of putting down the paint. Speaking for myself, I know that one picture leads into another, but it also happens that something can be a throwback. An element that you used once, can come out suddenly and alter the matrix of the picture.

NT: So then the issue of subject-matter must be difficult, for you have not abandoned the figure, neither are you working in an abstract idiom.

KK: This is something which is troubling me, its my problem right now. It is so easy to put a thing there, and call it subject-matter, but the paint has its own imperatives. The way it is handled, can create its own interest, rather than the interest which flows from the story or subject-matter angle...It is very difficult to find this imperative of the painting. I mean a mathematical, geometrical painter knows, but a free-flowing kind of painter, the way I am, cannot.

NT: And the figure must stay with you.

KK: Yes, I don't want to get rid of the figure. What happens sometimes, and goes on happening, is that I bury the figure. In the sense that it does not reveal itself with such immediacy. The painting will insist on being looked at as a totality, rather than the descriptive element of the figure alone. For me these are the two polarities I am working with, my points of tension.

257
Zazama: Canon Series
178x128. Oil, 1993
Private, Bombay

NT: Polarities in what sense?

KK: The figure has its own compulsions, its own constructions, everything. Then as soon as it enters the realm of painting, the realm of painting has its own logic and its own constraints, expansion, everything.

NT: So what dictates the balance?

KK: The balance is the resolution of this thing, it depends which way you want to tilt it. You can be satisfied with just painting the figure, like I used to,...but that means dodging an issue. You are then giving only scant attention to the logic of painting itself, to the imperatives of painting.

NT: So, it is a very materialist attitude to painting. That painting is about handling material, matter is fine, but where are all the uncertainties of attitude which your fluid structure demands?

KK: I am dealing with imponderables. I don't know what is going to happen with say burying a picture. How am I going to do it? How am I going to create this balance between what is and should be? It should barely be there, but I think matter too is very important, just as we are flesh and blood, we cannot be other than flesh and blood...It is a prime right of a painting to be a painting. I think it is a very difficult combination to achieve. Frankly, I find it very difficult. Also I think you are assuming that there is a great beyond.

NT: I cannot help but assume.

KK: Yes, but it is a sort of presupposition.

NT: Not really, this 'beyond' is something which is within us; it is the motivation we seek to grasp, deeply within us.

KK: Deeply within us, yes, we know, because everytime you paint a picture you don't think it's the end of the road. Because it is not the end of the road, there is something beyond. What is it that wants you to do the next painting? And what is it that makes Gaitonde stop? I think it is very strange, even taking a simple thing like the cannon. What is it that drives me to make about twenty drawings of the thing? And even when I go home I am thinking about getting its resolution immediately on to paper.
I use pencils, crayons, colour, whatever, as fast as I can, for I want to grip it. I want to grip that moment when the idea comes. This is how it should be. This is what is lacking, what is missing, what I am after. After all a painting is just a stage, I don't think you can say it is a finish.

(3 August 1993, New Delhi)

Prabhakar Kolte

PK: I passed out of J.J. in 1968. I did not know then what to express, but right from childhood I knew that I loved painting. I enjoyed the process, something emerging from nothing, that something is taking shape on the surface.

NT: And today all is abstract.

PK: Yes, today the process of painting has been enjoyed more than the ultimate goal. Behind each painting lies six-seven paintings, hidden. I go on painting until satisfied. I do not think in terms of words, I start thinking in terms of colour and form. The subject is the process itself. I have realised that nature is so vast and infinite, and outside I cannot reach this nature, but at least inside me I have access.

NT: What answers have you come across?

PK: I asked do I paint to represent something? The answer was 'No'. Do I paint to express my ideas and emotions? 'No'. Do I paint to be an artist in the contemporary world? 'No'. I am an artist because I am painting. I don't have to say something to become an artist, I just have to continue my work. Do I paint to represent my times, my country, traditions, cultures, etc.? 'No'. Of course all these questions were relevant, but the answer was 'No'.

Today, painting is a matter of seeing, and seeing alone. Nature does not imitate, it is self-sufficient, complete, and in that completion one finds that nature does not have to depend on anything. If I have to consider myself a part of nature, as Paul Klee says, for Klee has influenced me thought-wise, then why should I paint something; it should be a painting of painting itself. With this outlook I try to expand the possibilities of seeing, so I don't see objects as they are, but as colour forms.

NT: Is it that simple?

PK: It is simple. (Referring to a white ashtray nearby) This thing now transfers to my canvas, not the thing, but the sensation of white. I do not detach colour from the object, everything is part of colour, there is no object.

NT: Yet what we are searching for has no colour, no form.

PK: That is an ultimate stage, not at this stage...

NT: Are you pursuing that in some way?

PK: When I see an object I try to detach it from its identity and not the colour. Colour is my sensation. You see, nature has basic elements which never change,...with those elements I form something which I myself would enjoy seeing, and that which will definitely take me a little ahead in my aim of seeing.

NT: We are seeking that calm in a way, yet even here we ask 'Why?' Why are we seeking calm?

PK: I would see it the other way; "Who am I?" I am not questioning it, I do not want it, it is nature who wants it. That is the requirement of the questioner, nature; it needs it, it needs to be completed. We realise these subtle gaps in between lines, but this

question, why do we need it? I may give you answers in ten paragraphs and still the answer will not be there, it will be in those gaps, between the lines...

NT: Rationalising; and so your use of the dotted line...

PK: Maybe, maybe that is its significance, but I don't use it directly like that, not as a symbol or anything.

NT: It is embedded in you.

PK: Yes.

(We have come to talk about his painting: **Space X–Rayed**.)

PK: This was awarded a Gold Medal by the Bombay Arts Society. There is a story here, which I would like to tell. The original painting was hanging in my small house, and every time I would enter the house, I would see and feel: Oh, this won a gold medal, you know, that kind of feeling. Palsikar, must have observed this, though I had not mentioned it, but he spotted the tone. One day he asked me: Can you stop painting? I said, why, sir? He said, if I give you this option, what is more important painting or life? I said, naturally life, sir, but at the same time how can I separate painting from life. But that is not the total he said, you have to eat, meet people, drink, get married, raise your children, so all the time you are not engrossed in painting. I know that I said but if I don't eat I die, If I don't paint I also die. So he asked me, what are you trying to paint? Whatever you are trying to do, it was done before, fifty years before in other places, it is not new, are you able to give something new? I said for that I need a vast experience. Reading history books is not enough, I must see practically, in the West and here, what is happening in contemporary work. Then he said, you may not get the opportunity to see this, but still you must get an opportunity to decide what is good and what is new. So sir, teach me that, I said. Then he told me something very nice. We all have an inner voice but we do not follow that; if we remain truthful to that we will be able to give something new. I found it very difficult to follow; the false voice would always come, my courage was taken out of me, but slowly I am coming back to my own spirit. Then he said, now you have got a Gold Medal, later maybe a national award. You may achieve some international award, what next? One state to another, then when you reach where you want, what next? You start climbing down, so instead of climbing up, why don't you stay where you are.

In that discussion, he suddenly said: can you destroy that Gold Medal painting? I said no, it is not possible. He told me how he had melted his medal and made a chain for his daughter. He had a habit of stopping abruptly in conversation. These thoughts stayed with me: why did he ask me to destroy my paintings, to stop painting, am I not painting properly?

Yet I did not really change. Later I began to think that if I am not to be what I am, I must take certain bold steps, must try to follow the inner voice, and then in that period one day the thought came into my mind that I should destroy that canvas. So I began painting over the work. I was in two minds throughout the new painting, there was a new experience through colour, for I was caught in between. This **Space X Rayed** is so called because I was more involved with the problems of space, how to create space. The space that I want to create is just not dimension, it is very subtle experience of mind, that was space for me...Anyway after the early 1970s new experiences day by day helped me to forget the past. I must tell you about my concept in those days. I wanted to create a subtle space, layers after layers, in and out, and I don't mean physical dimension but a space...

NT: But this has already been done.

PK: Yes, but unfortunately we never studied history of art.

Afterwards I, studied it, on my own. Only when teachers like Palsikar would tell us would we think about the history. I would say, if it is done, its perfectly all right, but for me it is new, and I am not doing it for somebody else, I am not doing it to prove that I am doing something new; it is new for me. So far as history is concerned they will not take cognition of this, I don't care for that, I only care for my experiences. For me this is new, modern, present; I am pursuing it, my attitude is to have a new experience to others. I am anxious to create, but not bothered whether it is new or old, I have faith in my inner voice.

After the 1973 painting I was taken on the faculty of J. J. I realised that being just a painter is not enough, but every painter cannot teach. I sincerely realised that I needed to read, study if wanted to guide students, and along with my students I started learning the history of art. I attended my colleagues lectures, and translated some of the history into Marathi for the Marathi students. That brought me across the philosophy of Paul Klee.

Beside Palsikar I would regard Paul Klee as my teacher, thought wise, and I suppose even painting-wise, because I said if I am to understand him, I must at least try to paint the way he painted; it was really interesting. As he says: "Think of forming and not forms." This statement is like a *mantra* to me. I came across a good piece by Moholy-Nagy on Klee; he says that Klee takes day-to-day things but in no order, a different order. Thus importance is given to order, to order space with elements. Slowly I started doing that, a lot of paintings in those six-seven years under his influence, and so once and for all the idea of copying vanished from my mind. To follow nature and not imitate nature; this does not mean following what is outside, but following within, and that has improved my attitude towards painting. Since then I treat painting as a ritual. Why do I say ritual? Because when I sit as a painter, I have to sacrifice many things. Your own identity has to be sacrificed, I have been following this for the past twenty years. I am just an element of the painting, and as an element I try to move, it is an experience; it is like entering a space with these pictorial elements of line, colour.... I don't give social or political comment, nothing, no narrative, they are just what they are, they show, it is a *darshan*, every space is a *darshan*, a *darshan* of oneself to oneself.

Up until 1979-80 I painted like this, but 1981 onwards I could see a change, because of that basic *mantra*: think of forming. Added to this was the realisation that nature had basic elements, like with painting: line, tone, colour...some physical elements like pigment, and spiritual elements like space, light. The sun if I paint will not give light, but the idea of light will help me to paint the sun in pictorial space.

Today much is about forgetting what I have done before, being in the present, forgetting the future, and just concentrating on the present situation of mind. It is becoming a mind in terms of colour and form, it is becoming myself. It is a process, for me the process is the entire objective.

NT: Why have you really come to this?

PK: Because I don't have to achieve anything. Who am I to achieve?

NT: What is motivating your process then?

PK: Process is part of man, a part of life; I don't put it on a high pedestal; it is a true friend within yourself.

NT: Are you at peace with this?

PK: Of course, very much. I think I am most content, no complaints. I am very happy. Of course I would like to share my happiness, teach, if they wish to share, if not, fine, I do not lose anything.

(16 September 1993, Bombay)

Achuthan Kudallur

AK: Paint something non-representational, and the finished product starts resembling something in nature, so I painted over and over, I didn't like any of them. Sometimes it is accidental, but the tragedy is that it always resembles something in nature; you can't help it.

NT: Why does it matter if it resembles nature?

AK: You see, it limits the strength of colour, here my idea is to bring colour into prominence.

NT: This wish to express colour, has it evolved from within you, or are you superimposing it?

AK: It has evolved. Why, with so much area and intensity do I go on marking shapes; it is a continuous evolution, seen in nature and craft specific items. Sometimes when I go by bus along that road, I see this water-lorry, bright yellow, and suddenly it is not the lorry, a beautiful yellow, but then you can't paint it.

NT: So, your initial motivation for this work, was to deny all sense of representative influences on your mind, whether figure, sense of colour, nature, whatever and create your own language in your mind.

AK: Yes, but the changes, different colours are now dropping away, now I am not thinking of yellow at all, and these geometrical shapes. I think I am moving away from these, now until I get a new imagery. Colour has its limitations. Now this board painting is in vermilion, just started, then I applied some blue, then other colours. Now with yellow you don't have such range. There are just yellow ochres, a few others, that is a physical limitation I must confront. So until I get some powerful imagery to hold yellow, and evoke, I will not touch yellow. For the last ten years I have not been repeating. All these browns come into a very different group altogether, there is more of the drawing element in them. That kind of red I may not do it again, it was very happy then... When I say I am going to drop the yellow, I mean the feedback is lost for me. I do not go against my instinct.

NT: This feedback is just from the painterly aspects?

AK: Constant feeding from life, that is one important thing, people, political struggle, love,...but nobody asks about these things. Also, many cannot sublimate these feelings, like monks,...

NT: This may be an inevitable evolution.

AK: But it can also lead to escapism. You have to be passionately involved...my mind has become softer over the years. At 20, 25 I could have been a very cruel man, very insensitive, but I became sensitive. I grew up in an atmosphere with Gandhian values, the writing of Ramakrishna, Vivekananda. Yet there are always hundreds of loopholes in our Hindu philosophy to escape, and say that nothing matters; in fact every moment matters. One can easily have a stone-like face, but in our hearts we are boiling. That is why India is so weak, we are not even honest in our passion, even in love, there is a lot of sexual dishonesty.

259
Untitled
44x38. Pen & Ink, 1981
Private, Bombay

NT: Coming to your personal evolution, and the pursuit of love, your relationship with women. Is there any concrete way you can say that it has affected your work?

AK: Not concrete, but,... I was thinking why at a particular time I was doing so much of red, the maximum number of tubes is cadmium, and now why am I getting away from red. Now why a particular blue, when I saw turquoise blue I would pick it up, it used to attract me. There is no explanation why a person likes that blue and red, and not that.

NT: More than knowing why we have accepted a colour, it is clearer why we have rejected other colours, and so narrows slowly...

AK: People simplify, some say use blue for meditation, red is a violent colour, but it is such a regal colour if used properly, so many reds, in contrast with yellow, black, such powerful colours. Now political parties are using them. The way the temples used it, say in Kerala, there it is not violent.

NT: Let's look at the role of solitude, loneliness in your work's progress.

AK: I don't feel lonely, I enjoy solitude, I get a lot of time to read and daydream. I can think of a lot of things daydreaming.

NT: Daydreaming that translates into work later?

AK: No, I just enjoy it. Thinking of the people I met, the scene, the laughing and so on. This I enjoy. But sometimes in your solitude because of a lack of circulation your physicality suffers, and that can impair. But my constant worry is time passing by. Sometimes at midnight I get up and ask how old I am, thirties or forties, and I wish it was a printing mistake. All these catalogues, it is nothing to do with old age, it is just that time past has gone, there no consolation, and I don't believe in reincarnation.

NT: What about this continuous link every artist must feel, that what has been in me has been in others before me, will follow after me, in spirit there is a continuous link.

AK: This link does not console me. Even if I have another birth, it's like having a friend living in the next room, in separate compartments. After twenty years we meet, and he says he has been living next door, it does not console me.

NT: I am not trying to use it as a consolation. It is a very calm acceptance of things.

AK: No, you see it is not my death that bothers me; it is that the world will continue after me, it is a kind of jealousy. Some music will be playing, youngsters, that continuous process, and I am not there to witness it. It is bordering on envy.

NT: This time escaping you, how is it affecting your work?

AK: It makes me very unhappy, that restlessness will always be in my work, I cannot go into a tranquil phase. That's what I mean, I am not a very good person at heart.

NT: Restlessness has little to do with good or bad.

AK: At first I was not so committed to painting, my loyalty was to literature, science. But when you see the whole lot of things disturbing you, painting was the thing I would do instinctively. Music I could have, more sublime, always...Not illustrating musical notations or anything, But the parameters are the same,...

260
Untitled
83x92. Oil, 1989
Private, New Delhi

NT: Parameters in what sense?

AK: For example say from Indian or Carnatic music, how you start repeating, and then extending the first notes in time, then you try to contain the time by musical notes and then play upon the fluctuations in time. How long you can hold the note, how sharp it can be and then an acceptance when you leave a note, a silence and then a gap with another gap. I feel in abstraction that parallelism is there, in the making of the orchestra, the conductor the musical intuition, perfecting the individual elements, to get the total sound structure. We were talking before, about losing faith... We have a clear example in the case of Van Gogh. So many people have handled colour, and the man did not have any guarantees in life, buyer or dealer, but he took nature into his hands and distorted it in his way and you know, there was a time I was not able to appreciate van Gogh..... The whole halo around things and the whole sky becomes widened with brush stroke, everything touched by his agony, restlessness. When there is a great work it must be of a great person but not always the reverse....

(17 July 1993, Madras)

15

Nalini Malani

NM: When I joined art school I had no notion of what it actually was to be an artist. It was only much later when I was working that drawing gave me the ability to talk about myself, as I would be writing in a diary, and that is how I really started my work. I would do 10 to 15 little watercolours in a day.

NT: So right at the beginning watercolours, and now once again returning to them.

NM: Yes, this whole business of picturising my emotional state, fantasies, it was always figurative, never abstract, very concrete. It had to be because of being so close to my emotions.

NT: And you immediately knew you could express your emotions through paint?

NM: This self-destructive seed many artists possess, its not visible in you.

NT: For me the relationship between me and the canvas, my materials, is calm, in harmony, there is no destructive streak.

Let's discuss this art as language idea. Your earlier comments about being envious about the language at a writer's disposal, and that their cauldron is being continually added to, new words, new phrases, meanings.

NM: I want such for an artist too, its very much a Dadaist attitude here, and that is why I use everybody possible visual device, which is outside the orbit of art, whether it is insets, rubber stamps, whether it is floating bubbles,...soon I will start using neon signs. All this language has to be available,... actually as I am drawing I am evoking certain periods, such as the wood-cuts of the Bengal artists. You see when wood-cut engraving came to India, first to Bengal with the idea to illustrate books, labels for objects kind of thing. That was the only means, and commercial artists were given this technology, and so artists picked it up and used black and white stencils, and with a brush did a wash. Sometimes they missed, it was a kind of trial and error experiment. Soon as the means of production and the patronage had changed, no more were the Maharajas buying the work, and the Kalighat artisans were also in a bad way, due to this mass production, and so the technology which was meant for magazines, printing purposes, and so on, was used by the artist,...and so the same thing now. That is one of the reasons I did those books (**The Degas Suite** and **Dreaming and Defilings**)

NT: But obviously the intention of then and now is so different.

NM: Yes, ours is very conscious, just now we may look at xerox as a very cheap reproduction, but soon artists will get use to it.

Women are doing wonderful work. Arpita Singh, Anupam, I respect immensely. Madhavi Parekh is using a whole new language, saying something very contemporary, thought-wise she is not primitive,...we have had many shows together. Also Nilima Sheikh, Meera Mukherjee, Latika Katt, Pushpamala, Sheela Gowda. Also Nasreen Mohammedi who died recently.

NT: Still much more encouragement is needed, so do you think schools specifically devoted to women and their art are needed?

NM: No, no need.

NT: No special emphasis needed?

NM: No, it will just distract, even marginalise, no purpose is served, we are on as firm a footing, as any male artist.

NT: Coming to the main problems facing the contemporary Indian art movement, the lack of infrastructure.

NM: Let's start at the art school level. Like J. J. it is just dying. In the faculty there is no passion, and so no motivation. They are not doing anything. They are just there because it is a government job. I feel that the whole structure and the way students are inculcated is inappropriate. At 15/16 you are just too young to know. You do not need such an institution. Basically it should be a whole group of studios in which students who have already completed an undergraduate degree are allowed and have a kind of world outlook. We need a sort of centre, and to work with the students, I don't want to call them teachers, a kind of floating population of other artists, and not only visual artists, but musicians, dancers, all sorts of cultural interests, that would be needed.

NT: Indian education by the government at every level, in every subject, in every city, town is rotting away, ...what else?

NM: Well lots is happening, we are ticking along with a force, but less and less people are talking to each other.

NT: Why do you think that is so?

NM: I don't know, but I guess there was a whole period in which art was much more visible. Auctions, lots of people buying, and when economics comes in lots of problems set in, and the whole business what it is to be an artist? What is your role? These pre-occupy.

NT: But this money will increase the compromise,...

NM: Yes, but this is true always, but still many can say that they are keepers of their soul, to be an artist is not a matter of producing a product.

NT: Nevertheless the lack of an infrastructure and the poor progress in promoting contemporary Indian art has forced many artists into promoting their own work, dissipating so much energy, even someone like Husain, with seemingly limitless energy.

NM: Husain is a performer, he is not anymore just a visual artist. He is a star. It is very interesting phenomenon, and the fact that he has put the idea of the Indian painter on the street. Ask anyone, what is modern art? Husain, they will say Husain, which is very important. Yet people are still not walking into the wretched galleries, even Pundole, which is at street level, most accessible, people are not walking in, it is a big problem.

NT: It will change, but tell me, this idea about the man on the street walking in, and through him the growth of the art movement, at this stage, how important do you feel it is? The private galleries will not oblige here, will they?

NM: No, but it is important. If you have a show at Jehangir Art Gallery, it's a different ball game all together. People come, ask stupid questions, and if you can keep on

261
Habits of Thinking
152.4x121.9. W/c & Enamel on Glass, 1993
Private, Bombay

answering them, it is a good feeling. I don't have the energy all the time, but Vivan is very good, he answers all the questions. Anyway, the fact is that there is no place like Jehangir; anybody can just walk in, whatever the reason, nothing like it. From the school across the street, the lawyers, these people who will never have any idea of what art is about, they can just walk into Jehangir, even if just to use the toilet, or Samovar,..

NT: If you go to Samovar you will have to go to the toilet,... anyway, so more places like Jehangir?

NM: More places like that, and more cafes to sit down and talk.

(July 1993, Bombay)

Tyeb Mehta

NT: We were talking about your intuitive approach to uniting colour and emotion, and your small repetoire of images from the trussed-bull, to the falling figure, rickshawala, Kali,...

TM: Yes, but the difficulty is that I don't work by making it a convention, by knowing how to make a sign, as in miniature painting. Certain miniature schools have a certain way of drawing an image; once they arrive at the convention they go on repeating it...The moment my work becomes convention, I destroy it. The point is that I try as far as possible not to draw in the same manner or use the same colours, it may happen once a while, but not in the main.

NT: The process itself gives rise to most of the difference, but is there any significance in the difference?

TM: Yes, because it is not telling on the painting. It is part of the painting always, only as a whole.

NT: Early on, was there a stage of focusing on the figure rather than the whole?

TM: Maybe, but the proportions of the colour, the way the line bifurcates that part of the colour from this part, all these are very important to me,...

NT: Must your painting hold only on formal terms.

TM: Only on formal terms.

NT: Why have you mainly focused on a single figure?

TM: I find the minute the second image comes into the picture it becomes a narrative, because then one must relate each other on psychic terms, and many other terms,...I have done it in a few paintings here and there, but by and large I am not

262 (Right)
Rickshawala
Oil, 1962
H. Chaganlal Collection

263 (Far right)
Rickshawala
152.4x121.9. Oil, 1984
Private, New Delhi

interested in that area of function... I did it in **Sequence**, and **Always Now**, an old painting, with about four figures and a bull-head I think, also a triptych at Santiniketan, then I did one painting after the Pakistan War in 1965, when Ramkumar, Krishen Khanna, Husain, and I all went to the front, because there was a lot of destruction, and when I came to Delhi I painted. But this, I don't see how it would solve my purpose of coming to terms with painting better. Yet I do have an idea of a large painting with quite a few figures.

NT: Even in your film "Koodal" I remember the scene of crowds of people gathering on the roadside moment by moment, and yet the focus was on the individual lost in that crowd,...So perhaps you have found your focus, and are just delving deeper and deeper...

TM: It is better to do a small thing, rather than be over-ambitious, and do things one cannot handle, dabbling in areas which I don't understand.

NT: Of your own understanding of yourself as a result of the years of painting, is there any clear evolvement which you can attach to painting?

TM: Well my mind is a little more clearer than when I began.

NT: As a result of painting?

TM: Of course. I would never have understood painting the way I do now.

NT: What about understanding yourself from painting, rather than the other way around?

TM: Myself,...it is just because I paint, that I solve this problem.

NT: Has it given any deep seated calm, balance in your understanding of the world?

TM: I won't say that, because it would be very pretentious to say that. I try to be as good a human being as I possibly can.

NT: But when your work and you are in such a unity, doesn't one work as the balance.

TM: Yes the unity does ultimately work, but I don't want to analyse it, that is not important for me to understand. You see, when you verbalise everything,...

NT: Yes, this hesitancy is in many artists.

TM: The tyranny of words, you say something and so many connotations take place....

NT: From the trussed bull and rickshawala images, the next major change was the use of the diagonal, after coming back from America.

TM: Yes, this was an important pictorial element; it gave me the courage to discard all the elements that I was using earlier, so that I started putting emphasis on areas of colour.

NT: In which sense?

TM: Let me explain to you. When I came back from New York, I had seen a lot of minimal painting, a lot of work, and I realised that if I had to use colour as an element I had to give up using certain things, give up a very definite planar structure. When you

start structuring in planes, what you do is your brush runs in a certain way, according to the plane, creating its own texture, its own surface, and I wanted to create large areas of colours. When I started painting this time I did so with the intention of not repeating earlier work.

So when I had decided on the area of colour, a red, but I did not know how to do it, it came out all wrong, so I worked on the same canvas for I think about two three weeks, trying to figure out, and I was so disappointed with myself. Then simply just one evening, without thinking, I just decided let's put a diagonal, and see what happens, so I put a diagonal and immediately saw that a fragmentation of the image took place, and the moment the image was fragmented, it created its own movement, when the movement was created a definition took place, and as soon as a definition took place I knew I could put colour. Of course it was difficult because I was not painting the way I am painting now.

NT: So the diagonal gave you the movement?

TM: It was not that the movement was absent earlier, and even now without the diagonal there is movement. I am talking about a certain kind of movement, where a definition is needed to eliminate certain elements to create another kind of movement.

NT: Lets come to the art scene in the 1950s.

TM: In 1954, there was no museum, no exposure to see and read; there was nothing to encourage the artist, and so we had to take decisions, which I would not have taken normally. When I painted my first trussed–bull, and then moved on to another kind of painting. Maybe the way I painted my first trussed–bull, I could have carried on for a longer period of time, but the confidence to carry on, and the support that was needed from the immediate surroundings, it was not there.

NT: Even today the alienation of the artist is so immense, and not just between artist themselves, but between gallery and artist, collector and artist, critic and artist, government and artist...

TM: Yes, very strong

NT: Anyway, by say the 1980s, your work,...

TM: By this time (1980s) I was really confident that I could organise such a composition; without the diagonal I could not have reached this far, from my earlier paintings. The diagonal helped me to define the canvas in a certain way.

NT: How about the way you seem to sculpt the line?

TM: I do not want to use line in a very expressive manner. My lines are just enough to delineate the image. If I could do away with the line totally I would do so, but since I am a figurative painter it is not possible.

NT: So you try to represent the maximum with a minimum number of lines,...

TM: Definitely.

(17 September 1993, Bombay)

Anjolie Ela Menon

AM: Has something emerged in the world which nobody has ever seen before? We could talk about Nek Chand. He may not appeal to my sense of aesthetics or whatever, but he has done something totally differnt. I could not even get the NGMA to give him a corner of the garden. Thats the level of understading. If you have not seen Nek Chand you must go and see this mad, crazy garden in Chandigarh.

NT: So how will this complacency change?

AM: We need more Nek Chand's, those who have the impulse and energy to do things as maverick as he has done.

NT: You say you have created a personal idiom, so tell me what underlies this idiom, whats its source?

AM: Source is me.

NT: Whats given rise to this me?

AM: I don't know. It is something which wells up inside one.

NT: Well what have you expressed in the nude, your nude series, which no other nude has portrayed?

AM: Well its not just about the nudes, but a body of work. It is the way I have put paint to canvas. Its got to do with technique. Many say that it is a technique that I have learnt from the frescoes, but it is absolutely opposite of the fresco technique. In frescoe you have to apply the paint once and there is no going back, no rubbing out. When people say that my work reminds them of frescoes, they mean it reminds them of old frescoes which have acquired their own patina. So that is a form of ignorance. I paint on a hard surface, with a series of translucent colours, washes, which are often rubbed off completely, to dry the next day, I never mix colour on the palette. This was achieved a kind of a glaze.

NT: And so?

AM: Well in a sense this technique is the anti-thesis of many modern and post-modern techniques which apply paint thickly, and in that sense it is going back to Renaissance techniques of applying thin washes and glazes.

NT: How did this process come out?

AM: It just evolved over a period of time. Before going to Paris I did paint in that impasto fashion, but then....sometimes I think I am known for my paritcular palette.

NT: In what way ?

AM: Well, the content is contemporary and personal, but the technique is almost Renaissance.

A writer had written that people were 'seduced' by the Renaissance look of my work. And once bought and hung, then many details are understood. I have been described

once as a neo-romantic necrophiliac. There is a great deal of death in the works, the stillness, which I have experienced.

NT: In what sense ?

AM: Clinically I have been dead.

NT: When did this happen ?

AM: About 20-25 years ago.

NT: How?

AM: When my son was born. So I have had that post-death experience.

NT: Do you remember anything of that period ?

AM: Yes, they gave me shocks. Actually I thought that it was all personal to me so I forgot all about it. Then about 10 years later, I read in the Reader's Digest, a series of reports by other people who had experienced clinical death. They were absolutely identical to mine.

NT: So tell me about it; it is quite a major experience. It must have influenced your art, no ?

AM: You see this huge pipe with rings in it, like a tunnel and it just goes on, and then at the end of it there is a very effulgent light and you are being sucked into it. There is a great sense of euphoria.

NT: This is very much what Biren De has visualised through his own journey, especially regarding sex; its higher spiritual dimension.

AM: It is beyond sex, it is just beyond sex. Then this child cried. I have no recollection of the surgical experiences to revive me. There was this experience, which was just for a minute or maybe less. But it felt much longer, so the sense of time goes, as we know it.

NT: You are sure this all has not been added on later, that it's all in your own mind ?

AM: No, not at all. I was sitting in the dentist's waiting room when I read this. It was identical. At least 10 people had been interviewed. This tunnel, and the effulgent light, and that sense of timelessness. No linear progression of say earth, sky, clouds, heaven, just this tunnel and its light.

NT: And all these are ladies who have given birth ?

AM: No, various people who died in accidents and returned.

NT: All this in the Reader's Digest.

AM: It was an excerpt of a book.

NT: How has this filtered into your work ?

AM: I don't think it has, at least not that I know. Anyway, the next experience was of

being on the ceiling of the same thing and seeing all these surgeons in green gowns. Then the child crying. The explanation is that the cry pulls you back, because your desire is definitely to go on into that tunnel. Very, very strong.

NT: And you don't know how this has filtered in your work ?

AM: No, not really.

NT: So then, what has determined the evolution of your art? Any particular triggers, events.

AM: Yes, many, but I do not paint from events like Husain.

NT: No, I mean personal events.

264
MID DAY
121.9x91.4. Oil, 1987
Private, Mumbai

AM: Yes, but that is to be seen, not talked about. You must see more of my work.

NT: I have, I am. Slowly, slowly... Tell me about the empty chairs in your work. Any significance?

AM: Empty chairs, empty rooms because we are always moving, leaving part of me behind. This is my 28th house to which I have moved into since marriage. Thus one needs a very strong bastion so as to compensate for these external issues.

NT: So what can you tell me about this bastion ?

AM: Well, because it is a stronghold I can only allow glimpses of it.

In fulfilling the compulsion to paint one is practising an extreme selfishness. Of course, people say art is needed for every civilisation to flourish and all that, that it speaks of freedom of expression and all that. But in my terms and given the context of where India is today, and given the needs, then I think painting is one of the most self-indulgent things one could be doing.

NT: But others believe that an inner understanding, to know oneself , be true to that is the basis on which any further duty can be accomplished. Creativity provides that basis.

AM: But that is only for me.

NT: But that is the case always. No art in contemporary times, any place is just for the welfare of the civilisation, because the value-systems are not dictated by aesthetics. The linkages have not been understood well enough.

Anyway, if that is your priority you must change.

AM: Well, I am having very serious doubts about painting.

NT: Many artists do. One of the most sincere artists is Sudhir Patwardhan. He started off with a clear Marxist platform, then slowly realising that it is incompatible with his art, also as a doctor working with the common man everyday, sincerely wishing to help them, so facing this conflict clearly as with Gieve. However, both realise that to be true to one's creative vision is the way to strengthen and clarify one's views and duties on all these other issues. In a way if they were not doctors, may be to justify being an artist would be more difficult –they feed each other.

AM: I never aspired to be a great painter or to gain any success, to get known. If it happens, it will be a continual surprise. Today it is not that important.

NT: So like Gaitonde you must stop.

Reddeppa Naidu

NT: We were talking about Western influences.

RN: I do not think the Indian artist is free from these, even today. The reason is that he looks for a pat, Western recognition.

NT: I understand but this idea of east west, don't you think the sincere artist accepts both calmly.

RN: To absorb that way is not that easy. You see, being here with a different environment, when your love is elsewhere, your mind will work towards it all the time.

NT: But today, to take influences from any corner of the world, make it your own, is much more natural.

RN: Influences are inevitable and they are healthy, but not imitation. The linkage between influence and imitation leads to stagnation, and also politics....imitating our past is as bad as imitating the West. Anyway, this imitation of the West started ceasing in the 1960s. One reason is, in 1962, the two decades of American Art Exhibition was shown, it was a big eye opener for Indian contemporary artists: until then they were looking to Paris, now to see how the Americans had freed themselves from their French influence, and could be of themselves in their abstraction, and when Clement Greenberg and others came and talked to us, we participated in seminars, it revealed that the free mind is the biggest asset, that you can do a painting out of nothing, you can do a painting out of everything, to use tomato can soup labels,...it was a new experience.

NT: This is all very manipulated work, hyped-up.

RN: Yes, but it made its own impact at the time. All these gimmicks come and go, even minimalist art,... what happens is an awareness to the mind, that you can be of yourself.

NT: Was this missing in contemporary Indian art before?

RN: We were all the time conscious of Paris. They were looking at a tree as Cezanne would have seen the tree, but not being able to see themselves.

NT: Under Paniker the understanding of the line was paramount; didn't this sort of buffer you from Western imitations. The influence of Jamini Roy was also very strong.

RN: We were all struggling to find our ownself at the time. We were helping each other.

NT: There must have been some guidelines to direct.

RN: No, it was not like that. You see each one is trying to competently work and help the other, so there were bound to be influences, but,...

NT: What about the influence of using script in your work from him?

RN: That is a different thing. The script which is related to the subject and readable is one thing, but in Paniker's work script is just for the sake of script.

NT: What is the intention of script in your work?

RN: When I drew Vyas-Mahabharata, it is like a weft on the work, like on the fabric, interwoven, so the script related to the subject. The subject is not mine, but when I put it into pictorial form, then it is mine, and so I relate, and it creates a sort of curiosity with the viewer. Also this idea existed in our traditional manuscripts and painting.

NT: And Paniker's **Words and Symbols Series**, what was the intention there?

RN: Script was for decorativeness, symbolic, it was not related to any language or anything.

NT: Let's move away, to after leaving Madras in 1962, then where?

RN: I joined Weavers Service Centre in 1963, until 1980.

NT: A long time, so a constant thread, and so this use of fabric, dyes, the influence of textiles,...

RN: Not only that, you see, I had the biggest opportunity to know about our traditions; otherwise like many contemporary artists I too would have lost so much.

NT: How did it influence your work?

RN: Oh, because textiles is one of the greatest mediums to know, the greatest of our people's expression. The techniques and forms which are still alive, and repeated. To draw like that is the Indian way to make a form. It has a wonderful relationship, with our textile-design form, temple architecture and our wood-carvings.

NT: What aspect of the relationship in particular?

RN: Take a parrot, how it is depicted in a wood-carving, how it is depicted in a sari-border, how it has been sculpted on a temple wall, it gives you an awareness of the traditions if studied....say, the concept of the bird is not taken in just a realistic form, or photographic. When it comes to a textile it adds to the technical limitations, the creativity...When I do work in a contemporary idiom of a parrot, I will omit the details and stick to the barest simplicity. This knowledge seems essential to me to have a continuous growth, and this is applicable to everything around me.

In the same way, when I was doing the **Mahabharata** series, I had to free my mind from Vyasa. I had to think that I am creating the Mahabharata, I am responsible for the livingness of the series.

NT: So since 1960s mythology has been your subject-matter?

RN: Yes. It came to me in school, when a classmate, a Muslim told me about Tirupati Balaji, saying that it is worshipped by lakhs and lakhs of people, isn't it a worthy topic for you, he told me. He is now a Telugu poet. So I painted the abstract face of Balaji. Then I saw a Durga on the temple wall, so, my next painting. This is an idea I discussed with Paniker, that there is a great possibility to draw inspiration from our iconography. Actually, the most difficult situation in the 1960s was that we were so loaded with the Western influence, we did not see with our eyes, we could not think with our minds.

NT: I know that mythology is a very essential source of your work, but what about the influence of a woman in your work.

RN: There is woman in mythology.

NT: Coming to the Personal man–woman relationship. How has it influenced your work?

RN: I was doing my early work about day-to-day life, of people, their struggle. Since I had from childhood my parents' influence, of this philosophical bent, that had a bearing on my mind, and so a process of thinking started in me. What was the very existence of these people? What is there beyond this?...also, before that I was looking for art forms without Western influence; is there any art form in this country which does not have a bearing of the West? Then I found the deities in the villages... so after that Balaji I started the **Deities Series**. Then I went to the **Church Series** for sometimes.

NT: Spires, the whole gothic structure must have suited your style,...Coming back to the woman, personal relationship. You are married. So how has your marriage affected your work?

265
Ramayana Series
89x114. Oil, 1990
Private, New Delhi

RN: At that time the situation, the art atmosphere was different here. Even at that time I was never absorbed in the flesh. I was never much interested in its existence. The challenge of meeting life, never pushed me into that kind of thing.

NT: So I am a bit clearer about your motivations and your oneness with the subject-matter, but once more just clarify the underlying thread to your work.

RN: It is a joy, the joy of painting. You see, whatever is done, whether the **Musicians** series, the **Deities**, **Mahabharata**, or **Ramayana** series the joy and how it comes. If a person is to be joyful, how does it come? It won't come to him unless he is elevated, and free from all cliches. You see, that point I reach in the act of painting.

NT: And the Madras School, its influence on you?

RN: I used to say that technique is secondary for me, because when I first get my expression in the line, I instill the joy there. The secondary thing is the application of colour,...that is why all the sixties work was with thin colours, not impasto. But during art school days, small works were all with impasto, palette knife. And now, thirty years later I do it with greater awareness; it adds a new dimension to what I am doing with the palette knife. You see, this world is so much nearer now with the West, Japan, and all, perhaps that kind of influence is in me, which wants a spontaneity, which is a world wide experience. This spontaneity is possible even with all thirty–five years of working.

NT: Do you draw before the painting?

RN: No, it works in the mind. Each canvas is a fresh challenge, a fresh experience. It is not a formula.

NT: What you would tell a youngster about absorbing this world but still being true to the inner direction.

RN: The youngster should be honest when putting a challenge to himself. What is it that he can do with himself, not bothering what is happening around him. Also when

he does something good, there must be a teacher to spot it out and tell. This relationship can be very good.

NT: Poverty and lack of good teachers are everywhere.

RN: Yes. Poverty is a common thing for everyone who comes from this kind of life. That is why many talents are diverted.

NT: What is your solution? Something like Cholamandal?

RN: No, no. I don't think so, because it has its own limitations, and for a limited period is fine, but the whole situation in the art field is better. If there is talent it will be spotted.

NT: Who guided you as a youngster?

RN: I was doing those impressionistic works, small works. When Paniker saw them, he was excited,...

NT: In the late 1950s?

RN: 1956–57. He said this is your artistic personality, from the beginning, and he asked me to show him my work everyday, whenever I did a new work. He never used to say it is not good. He use to say, if he differed with it, very gently, that this was not as good as the other work. I had full faith in him. So if he said it was good, that made me believe it was good. It gave me tonnes of energy, that was my relationship with Paniker.

NT: Were there any major turning points?

RN: Turning points,...A contemporary draughtsmanship exhibition in 1961, only drawings, just line no colour, Madras artists in Bombay. Here the artist showed itself. I was doing palette knife and changed to ink and pen drawings, so if I could show creativity here it would be good test.

NT: What did you gain from that period?

RN: You see, that is actually the line. The line comes into prominence. When you can draw, when you know this, you can paint. That is what the Madras school is. If you don't know how to draw, painting becomes difficult. Of course this is one way, there could be others, but this is the biggest asset, if you analyse our traditions or of the Paris school, it is all drawing. Another important thing is that there should be continuity in the formative period of the artist, an undisturbed travel, which will then continue until the end. Many of our artists suffer due to this break.

NT: Tell me about Ramanujam. His work fascinates me.

RN: He is a very interesting example. I use to say this also to Paniker: If you take all his works from the beginning until the end, it is just the same form. In this same form he has refined and refined until finally he ended with what you cannot go beyond in that form. That is all I can say about Ramanujam, fantastic.

(17 July 1993, Madras)

Akbar Padamsee

NT: Some of the criticism of your work is that the intellectual ideas are fine but they are not reflected in the painting.

AP: I do not want it to come out on the canvas. I am not a seducer. I am notthis snake charmer. I want only two or three people interested in my work. I don't want the masses. I am just doing my own work. I don't even think this language of art is meant for communication.

NT: What is its main intention?

AP: It is an enquiry, a way of thinking. A way of relating myself to myself. To integrate myself.

And also to understand a colour. The way I build my ink drawings, the charcoal, the whole matrix, structure of lines, from this the form emerges. When the form emerges it takes two seconds, and it is on this which everyone dwells, "Ah! look at this".

NT: You want them to see the matrix, the process.

AP: That is the point.

NT: But tell me, why should the matrix be more significant than the final form for the outsider?

AP: It's better if you understand the language, don't you think?

NT: Yes, but few have the wish to understand the language for itself.

AP: Well if you don't, what are you looking for?

NT: Let's come to **Couple in Orange** (1987).

AP: That was the time I met Bhanu (his wife), so personal reasons are important. I may not have painted it otherwise. I did a drawing in the Indo–French camp (1985) which had pushed this idea further. There is a limit, say between orange and blue; though there is no line, the change of colour enduces a limit. I want to destroy the limit. Between the question and the answer, the ideal thing is that the question and answer should merge. The question should contain the answer and vice versa. Sankara, when he is commenting on the Gita, or on any other text, puts forward the argument and immediately gives the counter argument, so creating duality within him. He is both 'Yes' and 'No', the opposites. This is very important, because normally you react, you push it out.

NT: What are the contradictions you absorb in your work?

AP: Not using the line, the changes of colour. I have still not done it in painting. I want to be able to do it. That limit between the residual space and the main space.

NT: So all is along the frontier, the suppressed line.

AP: If I abolish it the form will disappear...

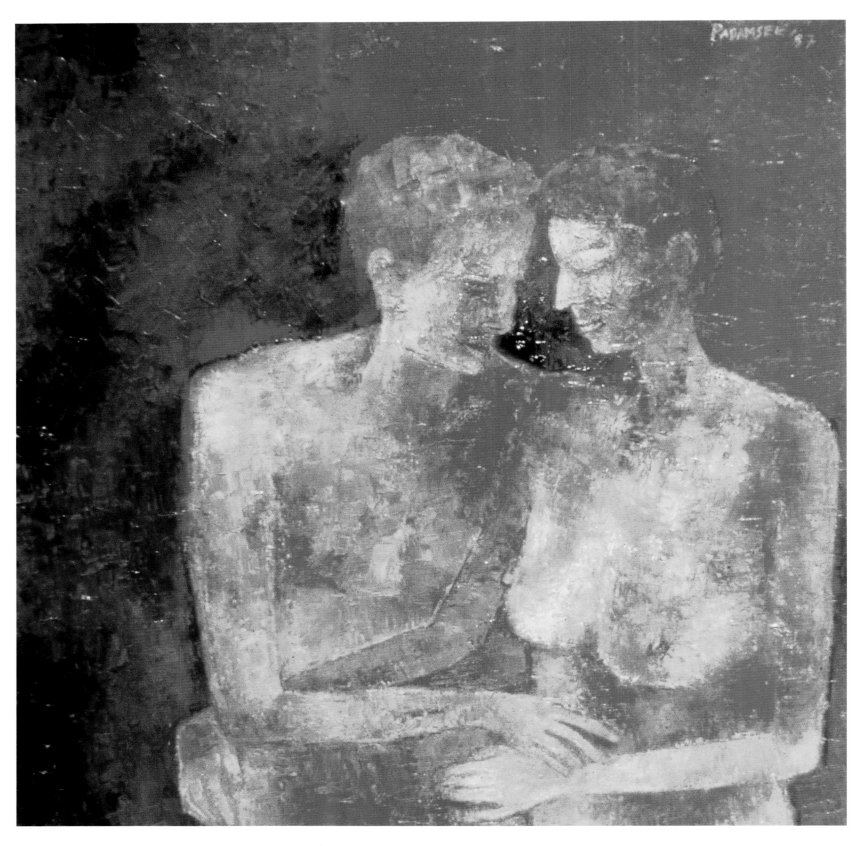

266
Couple
132x132. Oil,1987
Private, Bombay

Let me read you something: "You are you, as I am. The way you are, I am not. ...I and you, neither I and you exist in that space, to that space where I am not, you are not, to that space I belong, where we are not."

NT: You mentioned your sense of destiny, tell me a bit more.

AP: I am pre-destined to do this work. I have a feeling that most people have lost their direction because of a certain loss of memory. When we are born, we are born with certain powers, and either due to parental upbringing or whatever reason we

forget why we are born and what we have to do. So we do the wrong things or other people's jobs.

NT: Do you wish to help others remember what they have forgotten?

AP: No.

NT: How about your relationship with women? Your understanding of her and hence yourself. How has it affected your work?

AP: It has affected me in my life but as far as my work is concerned I am not sure. Naturally what affects me will affect my work, but I cannot say that firmly. I would get certain intuitions when deeply in love. I feel one gets a new state of power, ecstasy, which normally would not be there. You know the secretions in the body start to change, which are not normally so. The body is like a laboratory and things are changing as we experiment. ...Like the musician who is playing for hours. He is a transformed person after the performance.

NT: This kind of ecstasy was in you?

AP: Yes, completely transformed me. People when in love, write poems, why is that? This intuition gives them the insight. But if you do not build with your own discipline, then this positive power is wasted.

I tell you something. When I was going to France. My professor at J. J. was Palsikar, and he told me, "You have not travelled through India so why are you going to France, why don't you go to the South of India?" I saw the Bronzes and was tremendously affected. I think my mind is full of works of art, and so this idea of women affecting my work does not really hold.

NT: All these sculptures have affected your art more than all your personal relationships with women?

AP: Yes, absolutely. I think anyone who does not feel like this will be an inferior artist. You see, first I am a spectator. I first see. When I am doing my own work, I am very observant of what is happening, a spectator of my own work and so if I am not a good judge, I will not be a good craftsman/artist. You see very many people who say, "I need someone to see my work." I say I am the first and most important spectator and critic. It is only because of this I can say things about other peoples work. The critic in me is the most important part of the artist. In the process of working one makes mistakes, but sometimes these mistakes are pathfinders say, in the work of Picasso, some of his inspirations have come from errors...Something that you disagree with can be the beginning of your creation.

NT: I agree. If this sense of detachment is the motivation it must have its foundation in a loneliness, not loneliness in any weak way.

AP: I would say 'alone-ness', not loneliness.

NT: So have you been alone most of your life?

AP: I have spent long periods of 'alone-ness'. You know I would suffer in company. That does not mean I do not enjoy friends, but after a point I like being alone.

NT: Has that inspired you in any way?

AP: No, it has been purging. No one was around to speak to, so then I say let me talk to somebody, let me be with somebody. Even recently, when in France. I was giving lectures in the university, I did not know anybody then, the students had gone on holiday. For a week I met nobody and I got lonely and miserable. The first one or two days it was wonderful, working, drawing then on the third day, I started going out, films, long walks, trying to contact people but not finding any human being. You know I usually get up at 3.00 a.m. in the morning, since many years. Maybe I was born at 3.00 a.m. I don't sleep till about 5.00, and I don't want to sleep, because everybody is sleeping and so I just sit in the balcony, look at the sea, feel the breeze.

NT: So is that a period of creation, this 3.00 to 5.00?

AP: Yes, I always cherish that time. I am not thinking consciously of anything in particular, or maybe just quiet and then back to sleep, that is wonderful, completely with yourself, no loneliness. I would hate it if someone disturbed me....but on the other hand if I am alone for more than three days, I have to call somebody, like Tyeb or somebody to come, have a drink, talk, just sit together.

NT: I understand. So then let's come to the relationship you have with the outside world. Have you handled your financial affairs so that working is not a problem?

AP: Yes, but there is something mysterious in this also. Whenever I need money, I get it, so I become superstitious to the point of thinking that I need not worry about it.

NT: So basically the outside world is just a means of generating thought for you.

AP: But, supposing somebody can't think well, then I feel very disturbed.

NT: Would you stop communicating or would you try?

AP: No, I would just stop. Like the other day, a painter came and started saying: "People are saying we are a hundred years behind the times. What should I do? What advice would you give me?" I didn't want to think about this; it did not concern me so I said, "Forget about it." I don't want anybody to ask me a false question so as to give a false answer, so I said, "Forget it, don't worry yourself."

(1 August 1993, Bombay)

Manu Parekh

267
He
148x167. Oil, 1972
NGMA

268
Untitled I
73.7x99. Mixed Media, Rice Paper on Canvas
Board, 1994
Private, New Delhi

MP: Since 1965 I was an active member of the Society of Contemporary Artists (SCA), Calcutta. Ganesh Pyne, Ganesh Haloi, Bikash, we were all beginners.

There is a lot of connection with Calcutta, even now in my work. For when I went there, I was 23/24, whatever I learnt, started there. Of course, given I was from Bombay, my work was different from the Calcutta scene, so I was an outsider in a way, but becoming an insider,...

NT: What has kept you painting all these years, what has been the underlying motivation to your work?

MP: I think it is a kind of restless energy, the urge to express something, but I do not know what kind of thing, just to express.

Maybe it is also a kind of sexuality, an activity which channelises, I think, from childhood only, because I am not an intellectual in that way,...

NT: So what kind of work did you start with?

MP: Well, up to Bombay it was the American influence, action painting and all that, but as soon as I came to Calcutta so much changed.

You see I was totally restless in Bombay; I could not relate there, a very commercial city. In Calcutta, totally at home, especially the broken walls, doors, the decay kind of element, the kind of darkness,...

NT: That suited your temperament?

MP: Yes. Later I even realised that there is a typical Calcuttan painting, that dark brown colour in Ganesh Pyne, or Shyamal Dutta Ray's colour. I was involved in their basic psyche, but being from Bombay, and coming from an abstract background at J. J., not being figurative at that time. Bombay is very much influenced by the most fashionable trends, even then, and the attitude of questioning was not there, as in Bengal. Also Calcutta provides more sources of content, image than any other place, more possibilities,...

NT: This idea of outside or inside dominating the inspiration, did it start with the outside?

MP: In a way, and when that was found then I came to more inner feelings, imagery. There must not be a searching for outside sources, no? Calcutta overwhelms, allowing you to go in. So most of the work was inner landscapes, from 1965 onwards to about 1980, because there was a kind of organic work.

NT: What do you mean by organic?

MP: The kind of indirect representation of the body, the erotic element, done very suggestively.

NT: But not really a vent for your sexual energy, was it?

MP: No, this so-called sexual energy is not really the case. I basically believe in a growth, a life, like so many human beings, the variety of human activity, and expressions, the kind I tried to bring in my **Head** series. The life which you can see in Calcutta, that can be a good source. If you want to express, then you need a total new language, or from the art that has been, to evolve, and so in that way these organic forms. Maybe there is a Gorky-like image, but not consciously. Consciously is only the organic force, the sexual feeling, there was no narrative background in me. So that was this period, but the undercurrent thought is the belief in human resources, human energy, human relationships.

NT: Tell me about some of the artists whose work you respect?

MP: Firstly Ganesh Pyne, Bhupen's early work and Madhvi. All of them have sustained that magic element, the idea of surprise, and on one level a heroic element, for Ganesh to work magic in such a small format, when big canvas is so fashionable, and Bhupen, untrained and yet to take his work to such high levels, and also Madhvi, untrained, I taught her a little, so all three I respect.

In a way people find it strange that I do not like work similar to mine. You see I like Baroda school work, Bhupen's and so on, even though very different from mine, but they do not have the guts or open-ness to like work which is different from theirs. Because they have that group kind of mentality, which is a very big limitation.
So this idea of wanting to see your work in others, or make others paint what you wish them to paint, is a major problem, it stifles growth. Now take, Madhvi's work, she had no formal training. I taught her in the beginning, but she has no traces of my work or thought, there is no relationship in our work, because I taught her. I did not enter her mind. I entered just to understand her, not to influence her in any way, or even my daughter's work,...

NT: So this open-ness of mind,...

MP: For growth it is essential, but,... also there is the tradition in India of the father teaching the son, telling him to do this, but in art this is not possible, desirable. Yet it happens, the senior painters try to dominate, and this limits the choice, a fundamental weakness, the fact of picking up anything and starting new work, that does not happen here. The moment you start something new it is beaten down. The Indian cinema is the best example. Even in art, there are people who take up some leadership and most do not fulfil any purpose, because they are painting the same old things from the students or followers. It becomes a power-game, and the scene remains limited.
So this idea of getting a stamp from a certain place, now it is much less, as the markets are opening up, but before even the gallery would not take your work until recommended, it was very closed. Even I suffered early on, for I would not agree with certain ways of painting, thinking. In a way that is why I supported Madhvi.

The problem is very deep rooted. Suppose a boy wants to come from the village and become an artist, because he draws in childhood, what is open to him? He has to join an art college. Fine. Now as soon as he joins art college he faces an English speaking culture; what is Matisse, Picasso, and all that. So what happens is that he forgets the area he comes from, the very areas that Matisse and Picasso bowed their heads to,...funny, no? That luckily did not happen to Madhvi.

(3 October 1993, New Delhi)

Gieve Patel

NT: Can you tell me how you try to get rid of sentimentality in your work.

GP: This is such a stroke to-stroke-process, it is very difficult to articulate it. It permeates every kind of breath that you take while you are working on a painting. I am not sentimental. That does not mean I am not emotional, I am very emotional. Sentimentality brings in an element of a lie into a relationship. Similarly in my paintings. I go by Joyce's definition: "Sentimentality is the wish to enjoy an emotion without paying for it".

NT: In what way have you paid for it?

GP: The payment is internal. In my mind it's very very clear where something begins to become sentimental and where it is not. The whole movement of romanticism is not sentimental; it is fully emotional, wonderful... Sentimentality is like rotting ripe fruit...

NT: In your **Off Lamington Road**, what were your intentions?

GP: Again, many intentions. Just after my Italy trip, I sort of felt liberated, I saw the crowd at the foot of the cross in the work of painter after painter, and it struck me that I had my own crowd to work on. The figures just started falling out of my brush, literally. I was just enjoying that multiplicity. It was not sentimental.

NT: Again, this emotional–sentimental difference, it is a key thing for many artists in India, because the suffering of our people is a major topic.

GP: Can I sort of talk of two very great influences as a painter, which are very close to what we are talking about now? For me influences have rarely been for technique or structure, more by the artists' world view. For me there are two polarities: one is represented by someone like Pietro della Francesca and the other by Goya. Both poles

269
Drowned Woman
76.2x45.7. Oil, 1984
Private, Bombay

apart and equally important, and I see no contradiction in the way I receive both of them and how they influence my work. Francesca is capable of showing a man being stabbed at the root of his neck, with the blood squirting out, such a violent act, and yet it is frozen in timelessness...I am very strongly affected by that image, and by the way the violence has been brutally subsumed into the loftiness of his universal vision. This terrible death can be portrayed next to the face of a soldier with absolute nobility and life, as if frozen together.

And then Goya. In one of his etchings he shows two soldiers pulling a man's two legs apart and a third one chopping him through the centre; it is an immediate, palpable depiction of violence, and it is not sentimental, very powerful. Now for me my challenge is to reconcile these two worlds. I can get vibes from both, and hope to create an image, there is no problem bringing them together, it's just that the vision is from startlingly different angles.

NT: One very important part of your work is that when doing **Off Lamington Road** you were also doing figures on their own, like the **Leper**, the **Drowned Woman**...

GP: I don't know if it is reading after the event, but I had this feeling of space, each individual head could have a canvas to themselves, also this idea that man must be both part of the crowd and by himself, so the balance again...(laughing)

NT: After **Off Lamington Road** you did **Fishermen** and the idea of the sea. The sea entered for the first time in **Gateway**; how come it took so long to depict the sea?

270
Gateway
137.1x 274.3. Oil, 1982
Chester & Davida Herwitz

GP: Very often when I take so long to come to something it is perhaps that I feel artistically and technically incapable of handling it. I know when I was doing **Gateway**, I used to go again and again and look at the sea and just could not understand how to handle water...the colour, the surface and all. It is such an electric thing. It is there and it isn't, even for the eye. Constant motion, no colour of its own, it takes colour from all around. And then, if you see the whole history of how water has been portrayed by the Chinese, in their waterfalls, the Impressionists,... It was a daunting area to enter. In **Gateway** it was a very formal narrow band, and I was happy enough to work on it in that way for that painting, but later I wanted the more turbulent, freer, like Tibetan clouds kind of feel...

NT: Coming back to the railway station period, and then a stage of doing a couple of human figures in the environment of urban decay. I remember a light pink use in them...any reason?

GP: Yes, very simple; pink is a difficult colour to work with, to control, and I just set myself the problem. Its associations are kinds of flowers, and candy and things like that, and on the other hand flesh, so I said, can I use the colour and divest it of these associations, and use it as a major inner cityscape and see what happens?

NT: How did you set yourself this question?

GP: I had been working with fields of colour earlier, the railway platforms were all dull numbers, and later when I started working on these urban paintings, there would be green fields and orange fields, still all things which seemed that one could handle, but pink was a real excess, so it was really a lot of fun. Another sort of element of balance also exists,...there are two human figures in that painting, and behind it is a peeling wall, but in this wall I began to see a map or chart, itself an image of order and direction. I was not merely interested in showing urban decay, but the contrary too. This kind of thing operates very often with me, at a certain point at which an opposite takes over.

NT: Why did **Gateway** come in the early 1980's? Did something change in your lifestyle?

GP: I think Sudhir Patwardhan once mentioned, and you also noticed, that a straight line and angularities begin to disappear, and things became more fluid. I can't explain why it happened.

NT: How about interaction with poetry?

GP: Generally I notice that themes which appear with my poems, very early on, sometimes come into my paintings earlier. With water it was so; I would have liked to work with it earlier, with trees also, but I felt I couldn't do it, but here it is a question of a theme taking its own time to come in.

NT: Coming to **Paschim Railway,** and your use of animals, though a goat or two were present in **Off Lamington Road** was this also something that has always been in your work...

GP: Yes, as I said I grew up partly in the city, partly in the country, on my grandfather's estate, partly grew up there, very strongly affected by the landscape, animals, trees, and these are things which I have wanted to bring to my paintings. Its just again the feeling of incapacity which has held me back. So at some point you suddenly begin to feel liberated, and so things can be handled, and I cannot pinpoint why such is so at certain moments in life.

NT: In **Paschim Railway** the whole use of space was different from before...

GP: Yes, I think I do not have any sense of interiors, maybe it is a flaw, or like what I said before, the bounding, the need for space around figures...

In **The early morning local** and **Paschim Railway**, this interiority is very very ambivalently suggested, it is just possible that if the title were not given, then you would not be able to tell that this is an interior.

NT: This is something with which there is tension, a struggle in you?

GP: Yes,...

NT: So this translates to your ideas of space, and things which are narrow, a kind of

corner, because this is clear in so much of your work, the way you treat your figures, the distance between them and the landscape, your difficulty of treating the sea, unbounded, always moving,.... Have you thought about this sort of being the underlying thread to your work?

GP: I have sensed this, you put it quite accurately, I have sensed this struggle, but I have not addressed it directly in any way.

Perhaps if I tackle themes with more interiors, maybe the struggle will come to a head in a certain way.

NT: The tree is a very relevant thing here. Protecting yet open, in the corner yet part of the whole landscape... even in this latest work, the **The Water Tank at Nargol: Boy Bathing Buffalos** (1993), a huge tree covers half the canvas, in **Near the Bus Stop**, action is under the tree...

GP: Trees are tremendously important to me, I think they are very mysterious beings, and that is one of the reasons I am daunted painting them, because structurally they seem so simple, just a trunk and a crown of leaves, like children are horribly taught at school, a line and a circle at the top. I am now beginning to feel a liberation within myself, feeling that I will be able to paint a tree, all kinds....

NT: This latest work of buffaloes being washed and this huge tree trunk covering half the canvas, tell me a bit about it...

GP: I think behind this painting is a Matisse I saw in Chicago (1992). Its called **Bathers near the River**. What struck me about the painting was the individual space taken up by the motifs, a standing figure, the leaves near the river, chunks of space and I remember saying that I wanted to do a painting where a larger chunk of space is taken up by one object... As a painter I think I am more confident of the number of things I can handle and that certainly brings a lot of happiness, but maybe the time has come around again to try to paint a larger number of figures, like the street, or in a railway carriage, in one single canvas, jam packed with human beings.

NT: This jampacked idea; is it trying to overcome an earlier incapacity?

GP: No, not really, I think my mind moves in this kind of opposite, one to another, shuttles back and forth....My bias is definitely towards spaciousness, the single figure, but from time to time the desire to do the opposite comes in....

NT: For most artists the need for solitude, and also a loneliness affects their work very much, and your need to escape from the city, how has this affected your work?

GP: For me, being alone has been a very major thing, right from adolescence, since about the age of 16 or so, to go off, walk alone through the city, for hours, or just take a train and go to my village in Gujarat and spend time by myself.....

NT: But always knowing there was somewhere to come back....

GP: Yes, that's very important, because I have noticed that when I did not know someone, then that kind of loneliness is difficult to take, but it is different if you know there is someone hospitable to come back to. The other experience which has been very important to me, has been that of darkness. There is this beach at Nargol, my village in Gujarat. After sunset it gets completely dark, pitch dark, except for the stars and the moonlight, and totally deserted, absolutely. Sometime around the 60's I started putting

myself to the discipline of exposing myself to this darkness, and saying that I am going to walk on this beach without any light, and I found exhilaration, frightening, but I soon overcame the fear.

NT: Has it been since childhood, this fear of the dark?

GP: It may have been, because I remember a test one of my uncle's put me through in my childhood, saying that he would give me four annas if I walked around the house, in the village, without a lamp, in the dark and came back to the front door. I did it for the four annas. Maybe my uncle was trying to wean me out of that fear.

NT: To have a fear in the dark and the wish to paint, there must be some very clear relationship.

GP: Actually this might be related, that I tend not to have paintings on the walls of my house. Several have remarked on this. I tried a few times, but found that I could not take it. It's like being a composer and then sticking your musical notes on the wall, I think it would be hard to take.

NT: But don't you already have so many distractions, a doctor, a poet, playwright, father, husband, surely enough to allow paintings on the wall for that reason.

GP: I don't know why, but it is a very strong thing. I love looking at paintings, in museums, books, but not otherwise. Maybe this fascination with darkness has something to do with wanting to have clear walls. You know, that darkness is also a kind of cleaning of your vision.

NT: So coming to an underlying thread for your work, what are the things you still wish to express, are still chasing?

GP: I think one of the underlying themes is figure and landscape, city or rural area, and the other thing is how to depict certain themes of human violence and misery, as eloquently as possible, in a contemporary language, without sentimentality of course. So there are a certain kind of themes that I am moving towards, a torn corpse; I also want a large painting of a mutilated corpse, being mourned over by a woman in a landscape. I think it is one of the great themes of art.

NT: Pieta has sort of run its course, don't you think?

GP: So I must be careful not to have too much of a Pieta sense to it, because one would be bringing in a Christian thing which would be an intrusion. Subtle balancing acts. Another kind of theme is a certain kind of misery, cum grandeur. There is a scavenger woman at Bombay Central station; I have many patients from them, the porters, the cleaners, there is a woman, Meera, one of my patients, I was in the carriage and she smiled, with a broom in her hand, amid this pile of shit. The face was beautiful. I said that one day I will do this painting, but must work myself up to the stature to handle it.

(21 July 1993, Bombay)

Sudhir Patwardhan

NT: Let's start with your relationship with woman, or human relationships in general.

SP: More than the man–woman relationship, it is my relations with other people which has affected my work, and my work has moved as these relations have changed, parallel changes…To begin with I had a great need to identify with people outside of my own class. This was, in a sense, growing out of one's class, and commiting oneself to an ideology, Marxism. This phase was to do with the working class figure. I was using the figure, essentially as an autobiographical drawing of my own body. When I say I was using an autobiographical drawing of my own body, it is in the sense that I was imagining tensions in my body, and how these tensions would tear my limbs apart.

NT: Tension in what sense?

SP: The tensions which I was consciously identifying as belonging to the life of the poor people in Bombay, which I was encountering for the first time. In the trains, in everyday living, working in hospitals, you know.
There was both, a getting away from the protected middle class life in Pune, and out here, alone, feeling and reading existentialist things, and at the same time identifying with Marxism, and trying to look at life around you, trying to make sense, and make a kind of violent statement of the life around you.

NT: You were studying medicine at the same time?

SP: I had finished studying medicine, working as a radiologist. Now after this kind of phase, there was a backlash, with a growing sense of guilt. Guilt in the sense that here I was, after 2–3 years of doing this kind of painting, I was not a worker, I was just using my emotion. I was essentially using my frustrations to feed a certain kind of distorted drawing of the body, which I was projecting as the condition of the working class. Now this sense of guilt caught up.

NT: But it was also empathy.

SP: Yes, later when I got over the guilt, I did understand that there was empathy, and that it was not a totally negative emotion. However at that time there was a strong sense of moving back, as if I had no right to be a spokesman for these people. If I had any feeling for them, then I only had the right to allow them to speak for themselves. It is here that the idea of space comes in,…it made me retract, move back from people, and so a different space came in, a whole figure which had its own space around it grew, and also more than one figure could be put in that space. Before it was essentially the artist and the model, as autobiographical, there could be only one, now there could be two figures relating to each other within the space, and the artist could essentially be an onlooker, and that created new possibilities.

NT: **The Train** (1980) would be apt for this period.

SP: Thats true, this was the phase where the retraction from people was not just negative, but had attained the question of giving them an autonomous existence and building up a certain relationship within that space, between different people in that space.

NT: Using these pillars as splitting perspective. Then more cluttered in 1981, the whole idea of so many people, intruding into each others space, like The Accident on May Day.

SP: Actually that was an attempt to somehow reanimate the figure: space with my own feelings. There was a sense that a coldness was coming into my work, as I was moving back.

NT: Moving back, as a spectator?

SP: Yes, a detached spectator. Now there was a sense of losing the emotional involvement that was in the work, so I tried to work against that in paintings like **May Day**, which I think was not very successful.

NT: Why?

SP: Because the attempt was purely in terms of animating the brushwork. Nothing different had happened to the space.

The Ceremony was more successful, where the kind of precise drawing was maintained and yet the figures were much more emotionally taut and tense. Also the projections of, say, the bending bare bodied man, the sense of touching metal, rope, cloth, these came across well.

NT: This sense of moving back and closer to the figure in real life, so determining the pictorial space. And in **Town**?

SP: This is the first time of perspective, questions of how miniatures have handled landscapes. These issues started interesting me, and I started using different view-points.

NT: So **Town** was a turning point painting?

SP: Yes, very important. The kind of healthy but not intense interest in people, and the kind of good one may represent in this way, when one is not knotted up inside with tensions.

NT: So after the **Town** & **Nullah** period, your whole perspective went more towards landscape, in a way. After **Street Corner** (1986) I suppose.

SP: Here again an attempt to get close to the life of the people, and like in **Train, City**, or **Town** & **Nullah** a kind of distance to state the condition of people, the sociological, the class, the family background, you can imagine the life of the individuals, and also a closeness, but for some reason the painting (**Street Corner**) left me very unhappy. With most of my paintings there was a sense of release after completion, a relief that one has loosened something, this one ended up in tying me in more knots.

NT: I noticed a going into the room deeper and deeper, like going into a maze, one step further then lost, but the whole idea is so difficult. To give perspective and space in such congestion, such a cluttered subject–matter, suffocating. And the idea of perspective which your landscapes later possessed; it is clear here, that you are just one step short of the jump.

With **Memory Double–Page** (1989) the jump was complete, but for that you had to leave the subject–matter of people. For me, **Street Corner** is a balanced work, most complex

271
Nullah
180x112. Oil, 1985
Gurucharan Das, New Delhi

355 | Sudhir Patwardhan

and so simple, the need to bring an open-ness to the suffocation. A stranger like me can see it, but obviously you, so absorbed in the work did not see that this painting was the essential step to your landscapes. Even look at the tinge of green in the traffic lights, a sign of hope, it could so easily have been red. So, then **Memory Double—Page**.

SP: Yes, I was struggling with the idea of panoramic landscape. A kind of geographic map of the area which will retain its, in a sense, perceptual beauty. A map which is true to its perceived sensations. I mean, a map is like a conceptual framework, it tells you the roads, charts out, it has signs for buildings, everything else. I wanted a map which did not have signs but had the sensuous,...the way I had perceived a tree, a house,...so I was struck by this place where I had stayed when I was 10–12 years old.

NT: You also mentioned about the bifurcating roads and whether a figure is standing at either end, that it is at the same point from the viewer.

SP: Yes, if one takes a Western perspective, then the top is always so much away from you than the bottom, or even in the way the Mughals structured. Now there can be more ways of organising a painting. All the abstractionists have stressed the blankness of the canvas, which is fine, but for me who wants to represent the outside world, this idea is significant, that is: that I can decide how close any part of the canvas is.

NT: Why the desire to do this? Not just the need for perspective, is it?

SP: Well one reason is pattern, the difference between a painting like this and any painting conceived in the Western tradition; I mean Renaissance to Impressionist tradition, which is conceived of as a window with a vanishing point. Cezanne sees his painting essentially as this, therefore the edges of the painting become extremely important for the composition of the painting, because that determines the structure of what is given inside. Opposed to this, you take anything which rolls out, any sari design, *chataai* bamboo mat. You take one part of it and you know it extends on all sides in the same way. This work continues on all sides as a pattern would, as with **Pokaran** (1992), so no given point is unique as you move about.

NT: So coming to these works in front of us, your latest, this **Artist with Bicycle** (1993), and the **Flood Series**, there is a change in the clarity of the line and the manner of drawing. Why?

SP: The first thing is the importance given to the figure again. In a way the actual events (floods) threw the subject—matter back at me and I had to paint these people. Now this question about pattern and movement beyond the edges of the painting. I wanted to reintroduce this in the figure drawing. Till now I have had figures playing crucial roles in terms of edges of the painting, that is, the way they are placed. Now I want them to sort of move across the painting but at the same time this 'in and out' movement of the figures, will balance this cross flow, so that it is not decorative. Here Ajanta's influence is very clear, probably for the first time I am beginning to handle what I feel regarding Ajanta.

NT: So again the oscillation towards the figure, this seems to be your driving force, within the painting itself and in deciding what to paint as well. Coming to terms or not with the figure are the two extremes, and finding balance is the motivation, yes?

SP: I suppose the two extremes do drive me on, and the balance is what you clutch, to just remain alive or whatever. So driving forces are the extremes. It would be truer to say that than to say that the driving force is the need for balance. The two extreme

forces are falling away and some spiritual force is moving us on, but at the moment I do not feel this, what drives me on are the two extremes.

NT: Maybe because you are closer at this point to the two extremes than the rest?

SP: Maybe.

NT: Okay, lets change a bit...Are you going there (Ajanta) again?

SP: Yes, I went there eight years ago

NT: It seems most Indian artists go there the first time, do not know how to react, or are not fully inspired, yet still return, ten or so years later, and then some link comes, some belief on how to use it as inspiration.

SP: Yes, not only that, there has not been a tradition built up to handle that influence. No great contemporary artist has been able to handle it.

NT: The Neo-Bengal school has not done enough to inspire today?

SP: No, maybe in a very indirect way. Benode Behari in his Hindi Bhavan mural, I think that is a great painting.

NT: One final question about the obstacles facing the modern art movement,...

SP: Frankly I don't know what role an artist is going to play, say twenty years from now. I cannot even imagine what his position will be today. Twenty years ago I had a role to play.

NT: In what way?

SP: When I was committed ideologically. So that I could see that artists had a role and thus see a future for art. Today I really do not know what. The idea of art education and a democratisation of education and a general raising of the awareness of sensibility and so on are empty kind of things for me. I find I cannot grasp anything, they do not fire me in any way.

NT: I understand, but actually I thought it would be clearer now, with the progress in material values, the denying of all which is gentle, frail and tender in us, with a new harshness and cold attitude, and balance being desperately rocked, and what tempered and kept all calm in the past is also under attack. Religion has lost credibility, whatever philosophical solace it gave is being distorted more and more. Culture alone can keep respect for the gentle and delicate alive. The conflict is so much clearer, there is no need for an ideology, it's the most natural feeling for the spirit. An artist like any other creative person is the very protector of this tenderness. His/her role is so very much clearer.

SP: Yes, yes, I did not really see it in those terms.

(8 July 1993, Bombay)

Ganesh Pyne

272
Before the Fountain
55x60. Tempera, 1991
Goodricke Group, Calcutta

NT: You were telling me of the personal motifs collected, such as fire, falling trees, blue boats, the fountain...

GP: This particular concept of the fountain found in **Before the Fountain** 1991, came from a film by Fellini, "La Dolce Vita". Suddenly when I was watching the film it struck, that possibly a fountain could be a life-cycle symbol, because the source of water is the same; the water gushes out again and again it comes back to the source. So I took it as a very significant symbol of the life-cycle. Many times in my paintings I have also used the symbol of falling fruit, where the seed of the fruit is seen through an x-ray. Again the cycle from seed to tree and again fruition...

NT: Why is this recycling, reincarnation idea so important in your work?

GP: Again back to my childhood. My ancestral home like a shrine with my grandmother telling me her fairy tales. Creating new images in my mind. And also dreaming every night, or not sleeping, lying awake while others slept, feeling odd things, that sense of the twilight area.

NT: Even in those early ink drawings like **Lamp**, and then **Fisherman** (tempera, 1972) the death, rebirth idea, the twilight kind of darkness, a feel for myth was there.

GP: Yes, myth. Myth is a very regulating factor in my work, and the source of my myths were basically my grandmother's stories with their certain mystic elements, and being brought up in a religious atmosphere.

NT: Religious in what sense?

GP: The Hindu rituals were observed with keenness, so that was the atmosphere which was the base of my creative mind.

NT: All this was the imagination, where did the discipline to make it into form come from?

GP: In my college days all the forms I used to see around were creations of folk artists, the deities in the temples. I can remember one painting in particular, that was a fantastic one, which brought no certain meaning to me. It was a big blue face, fierce look, and its mouth was agape, it was a vision from Arjun's point of view; it gave a terrible look. Through the mouth, a ring of fire, and from another side a battalion of soldiers, riders, again going back into the mouth. It just fascinated me. Afterwards I came to know, but the sense of wonder was still there. So this kind of strangeness was the start of the paintings, you could say.

NT: And then?

GP: Then it developed through stories, reading literature, poetry, seeing films,...

NT: Let's come back to this solitariness of childhood.

GP: Yes, and it is still there. But of course with time I have had to encounter the world outside me, so I had to build another personality...

NT: Was it difficult for you?

GP: Difficult in the beginning but gradually I had to create two compartments, and there I understood the laws of the outside world. When a different mind encounters me, I know how to be logical to explain my ideas and understand his or hers ideas.

NT: You cannot be this inner self in the outer world?

GP: No. I try in my work.

NT: This desire to sort of hide, is it something with which you are at peace?

GP: I find it difficult to answer. There is very little scope for logical exchange, you know, so that any understanding comes. You see, it is something built up over a number of years. It is not alienation, but to logically explain is difficult.

NT: I fully realise, but by now any outsider realises that there is a very important part of you where logic cannot be imposed, that you are in spite of yourself in this realm. There are always some triggers in life which make us realise why we took a certain path.

GP: As a boy I remember a very private play I used to play when everyone was asleep. I used to build a paper boat very visually, with all the details on the sails. In the noon I used to burn it. Alone. Just to see the beauty of the total thing burning. I don't know why, I was 12/13, no other boy besides myself did it.

NT: So your world of fantasy has given you the strength to fight the outside world rather than withdraw.

GP: Yes, accept it as it is and there is a constant struggle to live with things we do not like.

NT: What are these major things you cannot accept?

GP: Essentially the evil force, a destructive force in the human being. I feel it very much. Violence in nature, violence here has a beauty. Death has a beauty, death has a haunting element within it. Violence sometimes I discover in my paintings.....

NT: Other influences on your work...

GP: A film on paintings by Rembrandt proved to be another bombardment as a student. His drawings fascinated me in particular. To my utter surprise Rembrandt was an appreciator of Mughal paintings. He used to import Mughal paintings from India, and he copied a series, called the **Surat drawings** by him. He even tried to correct some. He also loved oriental dresses very much. There is a kind of gloom in his paintings, which fascinated me. I didn't realise this at first, only later, did I know this particularly strange darkness, light flickering...

NT: After Rembrandt, what came out of you?

GP: Abanindranath's and Rembrandt's style were merged. I was still using watercolours, though oil as a student was necessary. I preferred water colours because they were very thin, very transparent. When I wanted some kind of thickness, density, I started using tempera. To get the particular effects I had to experiment a lot.

NT: In the late 1950s, what was the progress?

273
Untitled
22.2x17.1. Pen, Ink & Wash, c.1960-5
Private, New York

GP: Let me tell you what the critics said of my paintings after 1958. They said that the paintings were taken from fairy tales. This was not true. Because these sorts of imageries were not known to these people; they thought it had no connection with reality. That these were just wishful feelings, a kind of escapism, taking refuge into fantastic worlds; that was their impression. They called me a neo–medievalist. Now they agree that I interpret reality, with different terms. These terms may appear like imaginative, random fantasy. I am a painter, something like a magician; he just creates illusions. The magician is also a character which occurs in my paintings repeatedly.

NT: So the idea of after death, fantasy, myth, have these been the main themes of your work?

GP: It has been repeated, that is true. And that the masters have influenced me is also important....One day in 1953–4 I found a painting by Abanindranath Tagore in a book for children, it was a colour reproduction, and I didn't know why, but I was really fascinated with the work. It was from his **Arabian Nights Series**. That was the first painting I had seen painted by an individual painter, not the folk artists work, the anonymous work. My first encounter with the individual mind of an artist. It was as if in the twilight, with the mystery of colours...Since then I started painting, in that particular style, using water colours, though in a very naive way then got into the Government Art college. I was naive, but I had a tremendous will to paint.

And even though parts of reality were inevitable, parts were not liked by me. As a child I was very lonely; apparently I was a very normal boy, but gradually, I don't know why, I started to build a separate kind of world within myself, almost a parallel one. It was something which probably started like a play. I can remember when everybody was asleep at night, I tried my best not to sleep, so that I could keep my eyes wide open, and keep my mind running. That magic slate, that magic feel was there, always there, still it is there. I do not care whether I am portraying the present situation in our life or not.

NT: This is unlikely to change, is it?

GP: I don't want to change, because that is the only place to rest, that is the only place I can believe, that reality is beyond reach. What is happening just now I do not think I will be able to understand its significance; it is very slippery for me... Intellectual aptitude. I think I exercise only then when I arrange a shape according to pictorial norms. As an artist thinks in terms of lines and colours, I think this kind of arrangement gives a sort of intellectual excercise.

(19 August 1993, Calcutta)

A. Ramachandran

NT: The creation of a personal myth seems to be a continuous thread of your work, how has it changed over the years, say with Yayati?

AR: **Yayati** was the starting point to some extent. Both stylistically and conceptually it was a turning away from the previous work. **Yayati** was a recreation of a myth. It was from the Mahabharata originally, but what I did was to look at it from an autobiographical point also, it is a part of me. It fascinated me because no other literature has such a powerful depiction of old age. How old age deprives man of splendour of freshness, the disintegration of your body and its functions. **Yayati** was painted with the blacksmith gypsies on the roadside of Rajasthan as the background. The women are very sensous, earthy, and at the same time they reminded me of the classical, the Ajanta. It was a huge painting, sixty feet long, three sections– *Ushas*, *Madhya*, *Shyam*, and then a group of sculptures, called **Night**, like an installation. Thirty nude images with a half bull/man image, which was placed on an etched mandala. I was trying to recreate a strange temple, childhood memories, even the sculptures were illuminated with oil lamps, in that light,...thus like making a temple for a man, like **Yayati**, who was totally involved in sensuousness, his good point being the discovery of sensuality, through a painful experience...

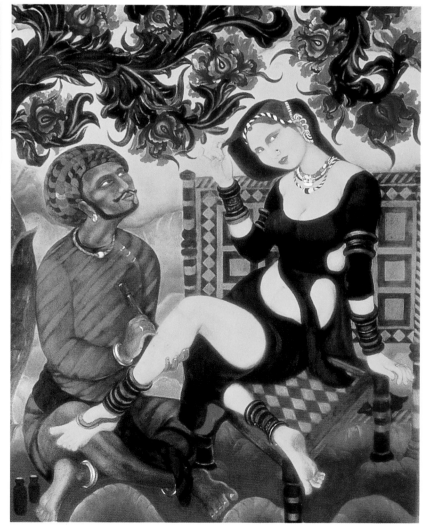

274,275
Yayati Series: Madhyhna (detail)
243.8x616. Oil, 1984-6
E. Alkazi

NT: Have you seen Bhupen Khakhar's **Yayati**?

AR: No, when was it done?

NT: 1986–87. It was a very personal interpretation, focusing on homosexuality. A different interpretation of an ancient myth.

AR: After **Yayati** was the **Urvashi** & **Pururavas** work; my last exhibition. This dealt with an entirely different theme. I am Urvashi and Pururavas together, and I am in search of Urvashi, my tradition which is lost to me, taken away from me. As he wanders around nature, he attributes to them the qualities of Urvashi. Perhaps the artist is doing the same thing, attributing qualities to nature or to woman, or anybody, which are not there. Thus you are creating, giving a distinct personality which is really not there. So that was the main idea and all the images were put with the lotus–pond as the backdrop, like a historical backdrop. Picasso's Minotaur imagery is also interwoven, in a sense.

The work which I am doing now revolves around tree worship, and the tree spirits which I am trying to recreate in a different way. Basically the trees in my village are the inspiration, such as *Palaash* (Flame-of-the-forest),and the myths which are woven around the tree in village life, so that they come to personify the myth. So the same way I am looking at the trees and hence their function. Actually the impression which inspired me was once coming out of a Jain temple in Ranakpur, and seeing monkeys taking a nap in the *Kachner* trees and their tails coming out of the trees like the stamens in the flowers; that rhythmic kind of thing attracted me.

NT: Let's come to your 1966 works, which started your public recognition.

AR: Coming to Delhi meant I was carrying many images of Calcutta and I started with those images. And then the women who worked as *jamadarni's* (road–sweepers) behind Jamia Milia University (where he was teaching), the prostitutes in G.B.Road, women working in Haryana and Rajasthan, they became a kind of material for my work, for I am a painter who can only sketch from life, always needing a reference point.

NT: Let's talk a bit more about these late 1960s work.

AR: I have forgotten most things about that time, but basically in those days I was trying to evolve an imagery from the work of those Mexican muralists. My intention was to use imagery to sort of knock you out. I eliminated the head to create some kind of anonymity for even stylising the head leaves a character. The vocabulary, syntax, I was using was Western and so to incorporate traditional Indian values was being hampered. Eventually I discarded that language and began to relearn my own language. Like now it is purely linear structure and the range of colours I use, the imagery, these are deliberately picked up from Kerala murals, one by one, trying to make it my system. It takes time, study and research, looking very carefully, travelling, our miniature traditions, wall paintings, book illustrations, composite images, the inherent principles of combining two images, and so on.

Some people call me a decorative painter, but I am not decorative by choice. Decorativeness is inherent in the principles of our art, say the *gopurams*, South Indian music, even literary styles, everything is decorative...I am not painting political things or women in jeans. Those things are not contemporary. It has nothing to do with subject matter it is the mind's attitude.

NT: I want to ask you about Ramkinkar, who was your teacher at Santiniketan.

AR: You see, Ramkinkar started abstraction in the 1940s when nobody in India thought about such things.

NT: How did he come to this?

AR: I think that during Rabindranath Tagore's time many eminent people used to visit Santiniketan, he must have come into contact with works of Kandinsky or Henry Moore to some extent, but his hero was Rodin. He was a highly romantic fellow. Epstein and Picasso were also in the background to his work, but his uniqueness was that he was a home-made modernist.

NT: Home–made?

AR: Modernism which came right from his own environment. Very few Indian modernists are such. Most went abroad, saw things, learnt and so on. Most have picked up from reproductions in books. So to some extent it is a shallow modernism.

NT: Was there any other alternative way of doing it, given the circumstances?

AR: No, that's what I am saying. But with Ramkinkar his perception, his way of seeing was the basis of his modernism, in every small thing. Once a Santhal woman was taking a cow for a walk. We were sitting and looking; you should have seen his excitement and then he painted the **Cow and Calf**; its in the NGMA. He transforms it completely, through his unique perception, sheer power to transform, yet retaining the vitality... Technically all the brilliance may be there in the copies but never that direct intuition. In Ramkinkar and Benode Behari that quality was there. If Ramkinker was born in Europe he would have been one of those great masters, a genius, which he is, no doubt.

NT: Genius in what way for you?

AR: Whatever he touched, turned to gold, whether it was sculpture, watercolours, stage designing, you could see the sheer power of originality. You cannot analyse that factor. He treated watercolours like a Chinese painter, say five six strokes for a portrait and yet it looks European. He had that virtuousity to transform visual images like no other. Kiran Sinha is another very significant painter, and his work will be known after he is no more. Anyway, he is also from Santiniketan, painted monumental works, the Santhals and their life. Very much like the Mexican painters, but very original.

(8 September 1993, Delhi)

Ramkumar

NT: There is a very organic feel to your evolvement, from the figurative work of the early 1950s to the Sanjauli/ Benaras landscapes to the later inscapes. What were the main intentions behind that early figurative period?

RK: I think, perhaps every artist starts with the figurative, because when we go to an art school, there is a model there, and we have to do drawings, learning anatomy and all that, and so perhaps a very natural thing, along with landscape, at least for me. The reason I made these sort of paintings, was that I was a bit inspired by the left politics at that time, there was an inclination towards the tragic side of life.....It started here, becoming more mature in Paris. And even if I had not been inspired by politics, perhaps I would have made the same kind of paintings, because that is a part of my nature....some sort of sadness, misery or whatever it is. Also in my short stories, it is always towards people who have suffered...

NT: This compassion, empathy was very clear, also the sense of strangulation felt by the city folk...

RK: I was an urban sort of product, I don't come from a village and so I don't know anything about village life. I spend most of the time in Delhi, and so naturally show the tragic side of urban life, young middle class boys, problems of financial insecurity, unemployment, victims of the joint family as seen in **Sad Town**.

RK: The landscape has become a part of the figures in the foreground, and they are well assimilated, and that is why I was happy; I was a bit sure of this painting. In that

276
Ruins Series
83.8x96.5. Oil, 1964
Private

it had expressed my wishes and had become more mature as far as the organisation of figures was concerned. Figures and landscape are not cut-off from each, but part of the whole scene, and perhaps the landscapes and houses express what the figures wanted to express themselves... a peculiar sort of desolation in the town, and the faces and the dark kind of sky...

In Paris my teacher taught me that to draw the figure, a straight line and then the curve was the key. Later the change in my work came. My stopover in Greece after the Venice Biennale, where I saw a Japanese painter, Hokada, whose works inspired me a lot. There were about six canvases, abstract, but the element of landscape was there, and then I went to Greece, and in the month of October, it was just grey and white, and black, inspiring. The first contact with Varanasi was very awe inspiring. The humanity was tremendous, a vastness. Old women with heads shaved, pilgrims,... We were sketching, but then I thought that the humanity was such an important part in Varanasi, so it is better to eliminate it, because I would never be able to do justice to it. And so I took out the people, and this went on for about ten years, till about the 1970s.

NT: What were you doing in these years in Benares?

RK: I visited Varanasi about half a dozen times in these years, sketching, to revive and refresh my memories, and of course they change from time to time. At the beginning they were just images of *ghats*, straightforward, but later they became more complicated and organisational. After all I was maturing as a painter also, and so memories of Benares receded. I was trying to go forward, and simplify...

NT: So more pictorial qualities were taking precedence?

RK: Yes always, as with the figures in say, from **Workers** to **Sad Town**, as you got more sure, the pictorial qualities dominated, and so now the figures were going into the background.

NT: Okay, so until the 1970s how had your own understanding of yourself, your sense of loneliness, solitude, how had this and your work come together?

RK: There is a close relationship between your own ideas and sense of belonging or priorities with your art. This idea of being alone is in all artists, though I was not a very social person. I thought, let me confine myself to a small area, even in painting. That is why I did not try many other mediums, such as sculpture or printmaking. Nor did I try many colours, to include, say, greens or reds. I did not try. I said let me have a small world of my own, and improve it as much as I am capable of.

NT: What were the main things you wanted to express?

RK: I think it is trying to take you a little above this daily existence, all the problems of daily life, trying to make it more spiritualised by a sense of colour and forms. I was also becoming a little more akin to nature also, though nature had played an important part, especially the mountains, as I was born and brought up in Simla. Perhaps memories too. Perhaps now I was coming more into the outward nature that you see. We would go to the mountains many times. Once we went to Ranikhet, a very quiet place, and once Husain and Bal Chhabda turned up in the month of October, and Husain told me one thing, "How can you paint in such a silence? Perhaps one can write poetry, but one cannot paint here." I still remembered this remark, because he liked sound, activity to produce.

NT: A very different personality. Anyway, there must also be a lot of sadness in you?

277
Benaras Series
127x178. Acrylic, 1993
Private, New Delhi

RK: It is not really so, you realise that the problems of life are not that acute, and that with the passage of time all is accepted, understood.

NT: Now we are in the 1980s and landscapes with solitariness and beyond.

RK: And more emphasis on the pictorial side of composition, more complicated,... it is difficult to say, but you always try to arrange things in a slightly different way. Though my idea is to take something and pursue it in half-a-dozen canvases till I feel I have done enough, cannot go further, and so come to a new organisation of forms.

NT: When were the feelings of new happenings in you?

RK: Difficult to say. I took to some ruins for the past two years. Humayun's tomb is behind here, and the mystery attracted me. I wanted to find out the mystery behind this architecture of Humayun's Tomb, which is like a work of art. I believe there must be something beyond this which an artist can convey; perhaps in his painting, though he is not an architect. The mystery of the black and white lines and the arches, creates a particular kind of mystery, which I have tried to understand. You know changes are very difficult to define; they can be very subtle.

(1 September 1993, New Delhi)

Jehangir Sabavala

NT: You were talking of straight and curved horizons, could you tell me when you used each and what was the reason for the choice?

JS: Sometimes I felt that a straight horizon was essential for my structure, at other times I found the cutting too hard. Actually if you stretch your mind a bit when seeing the horizon you see that it is curved, but when you have lots of triangular and conical shapes you have to soften them, like the human figure is softened, more so the female form, the breasts, etc., softens the structure. I cannot just go to a blank canvas, just attack it and bring something off, because it is not the way I work or think; I proceed step by step and much of it through thought. It is not enough to have a good structure. There are the emotional and spiritual qualities whether they come into the painting or not. This is one thing which I have tried to express from inside and let it come out...of course much depends on your composition, your thought process, mood,....

NT: Have you ever doubted that faith?

JS: If I go back to the 50s and 60s, I didn't know that I had it. Fabri told me where to go from here, and then I just broke away, to make myself softer,...

NT: Break away in what way?

JS: Away from all the disciplines, the schooling one had, and all the 'isms', the Cubism, the Impressionism, the abstraction, this school of thought in which one had grown up. He was trying to tell me that either you proceed and work in depth, in let us say the school of Cubism, and if you can't then full stop. Or are there other facets to your personality? Discover them, search as best you can, experiment and see if something emerges. It took me a long time to see that the paintings are growing softer, that a more emotional content is coming through; my palette is changing.

NT: This idea of the artist being a loner, is not so clearcut, always...

JS: It is a very lonely profession, because you are isolated. Hours and hours go in the studio, locked in with your work, and various processes of thought, and these take you to a lot of things which are not directly related to the painting, so the back of your mind is working whilst your hand is painting.....and I think all of that affects...Only a few hours count, because it is here that you are creative if at all. Otherwise like anything else it is a profession, and that is what you have to avoid so much. That's why I don't show much, for it takes a painter 3 to 3.5 years to say what he wants to say. Also what is very important to me is graph, the continuity of graph, of one's evolvement. It is not easy to do for 3.5 years or so, going from painting to another, maintaining your level. I try not to sell in between shows, because I like seeing it around me to see my own graph, how has it gone? Will it make a good showing? Holding the graph is essential.

NT: Let's come on to one of the constants, like your relationship with your wife, man and woman in general and how it has affected your evolvenent?

JS: In my case it has been constant, a very great help. There are temperaments who need change; in women, men or drink, drugs, they need it, I absolutely do not. If what comes out in the work is good I am all for it, for me there is not censure of a creative talent. I want to reach something that gives me serenity, and a graph that holds even. I

would like to be like a round pebble, not rough, like stones in the Ganges which have been washed and washed and washed by centuries of action over the stone, until you find a most beautifully shaped ovoid, totally smooth.

NT: Does the notion of time running out, death, affect your work?

JS: Yes, its like a spur, to evolve in the time span that you have, if possible.

NT: Evolve on the same path, but what about any major shake-up?

JS: Yes, but within the way you proceed there must be that jerk, like the Benediction painting provided. These are necessary to be revitalized and keep the spark. But evolution, it is used with intrepidation, one likes to think so, otherwise all becomes pointless, why carry on painting if the plateau has come.

NT: Have you felt like plateauing?

JS: Not yet, but I am conscious of it.

NT: And that in a way is a motivation also.

JS: Yes, a motivation not to plateau, that is quite true, but if one is reaching it I think one should stop, I am not sure whether I will or have the guts. I think you must know that now I am not giving anything creative, that I am just riding the wave.

NT: Coming to solitude, loneliness and its role in your work, how has it influenced your growth?

JS: I am very much a loner; I like being a loner, on the whole. The socializing crowds me, and I think: what do you get out of it? Unless you are giving me something, why am I wasting my time? This business of solitude has been there always.

NT: More than with other artists it seems that your relationship with the outside world is harmonious, despite your need to be alone. The conflict and struggle with it does not seem to be there.

JS: No, there was quite a lot, willy nilly, not of one's doing always, especially with personalities, I very often found myself the centre of storm from other people...storms created around me; it is ironic that when believing the opposite I should have been in conflict with so many people. It's not been easy. But now one feels this sense of completeness, the rounded pebble, but so difficult, but this need to be as complete as possible, is something we all want....No painting itself is ever complete. I think it is absolute fallacy for any painter to say it is a complete painting, rubbish. What you can say is that I have finished this painting I cannot do any more, but no completion, for it is always full of faults. Also the idea of the story. Why am I painting in serial form? It is like turning over pages of the book. I want to turn over to the next, it is not finished in one sitting, so say I take 6 weeks roughly for a painting, as an average, then it's over and so many things which I wanted to say are not included, so I repeat the story and go to No.2 of the series. This does not happen in every painting, but in this last show, they were 5 to 6 **Lakes** and others. Now the question of evolution, that something in the painting is different, better or not, is important. For example, I was telling the story of lakes, simple. I wanted the feel of a body of water trapped between valleys or hills or in a plane to give that feeling of that isolated pond which lies like a jewel in the heart of the hills or the plains and plateaus. I did my **No.1** and **No.2** both were lyrical paintings. The palette was highly coloured. Then I fell onto a sketch, constantly drew

sketches of the same things, I found a very asymmetrical design, like a stone, which inspired **No. 3**. I put the three together, two lyric subjects, and this very asymmetrical work in a totally different palette. My **No.4** was a total juxtapositioning, high mountains, and drama and different palette agin. The idea for myself was to show the painter's range. Is he capable of moving from soft lyricism to high drama within the same?

NT: So always a deepening, since the 1970s?

JS: Yes, very much, a further looking in, further searching, searching of the lakes, searching of its backdrop, its colours and so of myself.

NT: In a way we oscillate between two points in your case the two palettes, the more sombre and the highly coloured, more vivid and in finding the balance, both attract.

JS: This is very much so in my work. This is so when I put them all together, showing the viewer how things have evolved, four different stages merge. A painter must not be monotonous, but with the same image how much can I force my imagination. Is the imagination there? Is it vital? Alive? Or is it stagnant and boring? You can only see that when the four are done and are put up. I have to judge myself first and if I think it is looking a bit stagnant then I take it off as a failure. If you are honest and have struggled I think it shows and it holds and it is not done for anyone's effect, who sees, after all for four and a half years. No body saw these paintings except myself and my wife, a very good judge, and hard critic. This is extremely good, it slashes you the whole time, therefore you can improve, otherwise why carry on.

NT: You mentioned before your inability to understand the people working on the street.

JS: It's not to understand them, its to depict them.

NT: Most of our artists, say in Bombay, Gieve Patel, Sudhir Patwardan, Nalini Malani, take their inspiration from these people. Conflict and difference are the inspiration.

JS: You see many of them are interested in social contemplating. If that is your subject fine. This was not mine...Oh by the way, the word I was looking for was archetypal.

NT: The man in **Benediction** was archetypal?

JS: He represents man at a level which isn't the everyday man. More an admiration of the Greek, classic man. Those features appeal to me, I find them easy. Good eyes, nose. The ordinary man in the street, like all of us is full of defects. I am not criticising any painter who is trying to depict; you have to be very genuine and powerful to bring it off, Do I feel the pain, or the noise or whatever it is? I feel nothing.

NT: Our relationship with the West....

JS: I am not one to be fashionable, to jump onto the bandwagon.

NT: This imitation from the West without understanding their evolution, without adjusting it to our progress, its in all areas, education, dress sense, in so many fields, blind imitation.

JS: I tell you why. Basically all the experimentation does happen there not here.

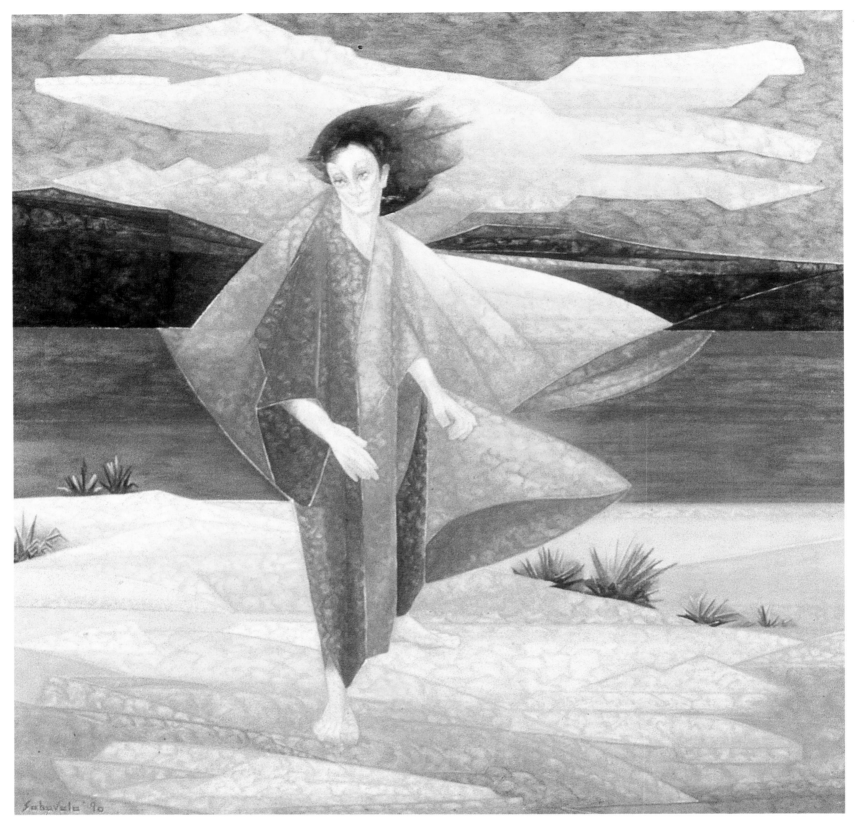

278
The Stranger – I
115x115. Oil, 1990
Private, Madras

NT:	Not so simple. It is also the attitude by which they absorb. This East–West divide is nonsense, you absorb influences from whichever corner they come from, make it your own and move on.

JS:	Of course you paint primarily for yourself, not for an audience, no question about that, you do the best possible. Once your painting is done, I have repeated this many times, many painters say they don't care; it is not the selling, it is the viewing, whether the spectator has a negative or positive reaction, I explain why, this is the link between the painter and his public, the interplay between audience and show, that is no

exhibition... I used to keep these remark books in the corner, people want to say things. A rich dialogue.

NT: It seems that how the world perceives your work after you are gone is heavy on your mind, hence the documentation, the concern with time running out, death and so on.....

JS: It weighs on the mind, but, you see, as a young person, one worked very hard. There was no documentation, now there is; books, articles, much written by myself, in a way pioneering work, because in the 50's there was nothing, no gallery, one had to request people to come, all that is gone, and so in a short span, India has matured. Look at the way the paintings are priced.

NT: Coming to the underlying motivation, the spiritual thread to your work....

JS: I don't like being revealed openly, I won't hide, but it is difficult to show myself. So with time you realise that you have got to engage, you have got to show yourself, through one's work. During the 1970s and 80s the paintings were beautiful, a whole series of pilgrim paintings, a good ten years, like man as the wraith figure, shroud, covered, not exposed, they were paintings unquestioningly of a journey, I did not set off for a journey. The figures were travelling towards the horizon, with backs towards the viewer, most often. I began to realise, how strange, for ten years this thread of these pilgrim journeys to somewhere....To me the pilgrims were very distinctly halfway to heaven, one of the titles, titles chosen from great poems. Another title was **Wanderers in the mist**, mid 70s or so, and I painted it here, three figures appeared out of the landscape, I did not want to consciously do this; the landscape was very sombre, very dark and good, you didn't see land, you begin to question, and the three figures were all white, distinctly they had faces, they were not wraiths, not thin but solid, they were real, unreal. I thought, what is this that I am depicting, I didn't know myself. It was the unconscious which came out, a little eerie, but not unfriendly, it was as if someone was reaching out to help you across......I was more mysterious with this palette.

NT: This new work,.....

JS: The key for it, are the tones I have used, now I am just searching for colour, form. Later on when the groundwork is firm, I can be free, so I break down the groundwork, I effuse it, soften it, yet keep some of the structure, in that is the whole interplay of exciting sensuality. There is a change in the palette, to more mysterious tones, that makes you wonder is it is a grey or a blue, or a combination?

NT: Lets shift, towards the Indian contemporary artists whose works you respect.

JS: The colour sense is very sophisticated. I think we have a higher talent in graphics. Laxma Goud's early works, the erotic works of the early 1970s, wonderful, very special, but he stopped that. Also some of Ganesh Pyne, small format, with tempera. Also Sanat Kar, had something original, but not everybody's cup of tea. There are several Bikash's **Man on the Swing**, but now, I don't know. That continuity of the graph, the movement as a whole is vital and alive, but there is no smooth progress....

(9 July 1993, Bombay)

Ghulam R. Santosh

NT: What were the triggers which got you involved in *tantra* and its expression in your art?

GRS: There were several, but two important triggers were, one, that we were labelled as if we were copying the West in the mid 1960s or so. Imitators. In 1964 I went to Amarnath, just like a tourist, also as a writer, I was looking for another novel. The themes are very important factors for my work. I wanted to symbolise an encounter between a girl of the Hindu faith and a boy of no particular faith as *Shiva* and *Sakti*. I started reading here and there about Eastern philosophy, Shaivism, about *Shiva–Sakti*, but mostly I wrote poems, and suddenly I came to realise that I had to look back to the traditions to understand my dilemmas. Now they were two options for me: the visual images of the past or thought processes and values. With the thought processes, *tantra* came up, and so to move forward I began looking back...

NT: At that time did you think about how the Neo–Bengal School also looked back?

GRS: That was there. The Bengal School was an example of those who went to the visual tradition. That is why I resolved to go to the philosophic traditions, the values of Indian painting. So this was a turning point. The next question was the image, what image to use. Everything had been done, what is there for me. The highest geometry is there, narration is there (not like that of Europe), so what is there to do, and there was a gap in my painting, of two years, only thinking, 1964–66; I could not paint. Another problem was my impasto. This was like a load on my head.

NT: How?

GRS: Because I was fed–up with this texture; it was determining my painting.

NT: Why did you come to it in the first place?

GRS: That was initially how I was handling the oils, and another thing was that colours were not available at that time. They discovered in Baroda this media used by the Egyptians to paint the coffins, by mixing wax and resin, and other things, and so to save colours, and get the same intensity of colour, we mixed this with a little bit of colour, and the impasto became more dominant, though in my later paintings the more mystic element was entering. Finally it was the *tantra* which gave me the image. Particularly the *tantra* of the left–hand practice, the *Pancha-Makara*: *madya*, *mamsa*, *matsya*, *mudra* and *maithuna*. These five aims are there, and it was *maithuna* which gave me the image.

NT: So Ajit Mookerjee's book...

GRS: That came later, that gave only the name *tantra* to the critics and the public awareness. The thinking had begun before, he was there at the same time, but nothing to do with my work at all. I had done two paintings, male and female *maithuna* themes, and so to make the pure image became the question. I took away the head, feet, hands, because the face usually determines the attitude of a figure, so I removed it. In the earlier watercolours you would find the nude image with the mountain like shapes, but still a figuration, an anatomical figure, which later became stylised. That was the beginning. Then came the symmetry. I had to check symmetry for many years.

279
Untitled
178x127. Oil, 1985
NGMA

NT: Why this need for symmetry, was it the process of being initiated in tantric rituals?

GRS: Yes, it came. When you go into this thought process, it resulted in me finally being initiated. First poetry, then painting, then this feeling in me to be initiated into a mystic order, meditation, so as to know the truth, which has been behind all our arts. This came to me automatically. Thinking was there, but there was an inner call. I had to find many things. For instance the border in my painting, then the colour experimentation. The circle format and using variations of black was the simplest way to focus initially. Then borders came in, taking from miniature paintings and their definite borders, also a part of the painting. So came my border to confine my space. Then my meditation, which led me to Kashmir and a renewed focus on geometry in the mid 70's or so. Here my earlier training in Cubism came in handy.

NT: What is the motivation to produce this work of tantric inspiration now?

GRS: I am not tired. Tantric philosophy is a very old concept. Geometry was about space beyond. The relationship between sound and image, *mantra* and *yantra*, pure sound and pure geometry. This is *Tantra*.

NT: Regarding your understanding towards women, love....

GRS: The tantric meditation, yoga is directed towards the female within yourself, realising the *shakti* aspect, her reproductive powers from which she made the cosmos.

NT: What are you trying to express in your work?

GRS: The concept is the same, the image different in each work. The colourless through colour, the formless through form. That we are the same people, human beings. Different in light, costume, still the same.

(9 November 1993, New Delhi)

Bhabesh C. Sanyal

BCS: After about 18 years in Lahore, being uprooted, I came to Delhi looking for some sympathetic person. I wrote an article called "Looking for a Studio" about the situation in which I was not alone; there were a number of artists, students, associates I should say. Satish Gujral, Amarnath Sehgal, Dhanraj Bhagat, Mago, Harkrishen.They were all working in my studio after I left the Government service at Mayo School, over some disagreement. I started my own work in a studio, giving some kind of informal tuition in art without any rigidity.

NT: Why Delhi?

BCS: It was the nearest place more or less like Lahore. I am a Bengali born in Assam, my son-in-law is from Kerala, and so a most integrated Indian (laughingly). Also there was this AIFACS in Delhi which I joined in 1947. But very soon I found that these art societies were mostly concerned about society, a kind of social ladder. The artist was used as a tool. We wanted the so-called society to be for the artist, artists should plan programmes to spread the cult of art in a large way, taking art to the common people....So I got out of there, along with students and associates, and so we said let's do things on our own, but let's keep a few things in view. One that we will not seek patronage. You must uphold the dignity of the artist. When you chose to be an artist you must have known what you were taking on, not to whine and cry. So there was Dhanraj, Mago, Kanwal Krishna, KS Kulkarni, Dinker Kowshik, Ramkumar, Harkrishen Lall. Actually Ramkumar began his career with us. We accepted only those who had a progressive attitude towards work. We would show our work in the park in Connaught Place, each one commenting on the others work and self- criticism, then the consensus would appear. That was one way we could question ourselves, and improve our works of art, left, right or middle, no question.

NT: Then Dhoomimal 'the first' ever gallery in India joined...

BCS: What happened was we used to put up exhibitions, but not inviting any government official, minister, ...I said the day we see the Education Minister coming on his own, then we have achieved something. We would invite literary persons, poets, dancers, musicians as chief guests. I wanted to estabilsh the relationship between the various branches of culture.

We must not isolate ourselves from the driving forces, the sparks can come from people expressing themselves in a different manner, maybe a poet, actor, dancer,... we did it for about ten-twelve years, very active.Then our priorities were getting clearer. First to paint. Then to resettle ourselves, which was no small job; we had no home, no studio, and on top of it to go around and sell our work. Now Dhoomimal used to sell art materials. This fellow said I will give you a little place here in my shop. So we collected some of our works and put up a show and had a formal inauguration: Silpi Chakra Gallery at Dhoomimal.

This is the genesis of the gallery system in India. I had a small period of service, as a teacher at the Delhi Polytechnic. Then after seven years (1953–60) they said you are "superannuated". I thought super, it sounds wonderful, what does it mean? They said it means you are retired!

NT: Okay, lets go back to Calcutta, the start...

280
Three Girls
191x143. Oil, 1941
LKA

BCS: Yes, let me give a brief talk about how I got into the art school, because it is one of the most interesting periods of the nation's life, my life. I am talking of 1920, the first time I came to my home province, Bengal from Assam, to take admission in the Srerampur College, 13 miles from Calcutta. I had a fascination with art, and so I joined the Government School of Art, where there was a certain Mr. Percy Brown, the principal. He was a fairly enlightened person, a good watercolourist, teacher in a way, but he was more engaged in doing his own books and publications.

NT: Our history has sort of ignored him because he was in Havell's shadow from our point of view.

BCS: Havell was one man who realised that there was an attempt to downgrade India as a barbaric country so that the imperialists could go on ruling us....Okay, so let me tell you about my dilemma in 1923 when I joined the Art School, and left in 1929 straight for Lahore.

This dilemma was not just my own, all of us were facing it, in the sense that this Bengal school was growing in stature. They were a few talented people and had great propogandists like Coomaraswamy, who really believed in it.

And they did not confine themselves to India, but were oriental, art from China, Japan, Iran; so the canvas was growing larger and larger, which was a great stimulus, and I would have much discussion with this girl Amrita Sher Gil. She had one screw loose in her head because she did not understand the significance of the movement. Every art movement has a crest and then declines; it is the way of history. As the Oriental art movement was growing, there were a hundred of imposters who thought why not make capital of this.

NT: Imposters in what sense?

BCS: In the sense that they did not believe what was happening, but were clever enough to imitate.

Village and rural life is just wonderful to watch, and understand. I think they retain a lot of our cultural values. They don't talk about it, they just live it; in songs, in their rituals, handicraft work, pottery; it is a daily manifestation of their life integrated with nature, which you do not find in city life. The colour is wonderful, they are always well clad, never shabby clothes.

(1 September 1993, New Delhi)

Paritosh Sen

NT: Some of your work has been termed as caricature. This naturally has affected the way people see your work. Can you sort of differentiate the two for me, how do you see them?

PS: Both are integral to my work. As it is life is full of tears and laughter, joys and sorrows, both are one, like two parallel streams in my work. The caricature and the serious, there is no contradiction. I have always had them in my work, it is my nature...two sides of the same coin. Love and hatred, for love takes the form of hatred in so many stages, but just as a temporary feeling. Also, as you must know, the tradition of caricature in Bengal has been since Gaganendranath Tagore's time. It is firmly rooted.

In the painting like that: **A man in deep thought** (hanging on the wall) I was dead serious. I want to make it very clear. It was a disturbing work about the Gulf War, the senseless killing everywhere, and the oil spills later, and the damage to our world, the animals, so many things. Everyone now knows, but still,...In the **Man for all Seasons Series** the images created were mostly caricatures of political characters, and my intentions then were very different from, say, after the communal riots, or the Gulf War. If you ask, then the main difference between the caricature and the serious work is not in the formal structure or the colour use, it is in the representation of the image. The way I want to represent the figure, and in this there is no scope for cariacture.

NT: Fine. So the figure, which has always stayed dominates in your work, the way each lends itself,...you know, I remember seeing your **Bade Ghulam Ali** work,...

PS: Yes, Bade Ghulam Ali Khan, he had the physical build of a man that lends itself very well for painting. Especially in contrast to the rigid geometry of his instrument, and so this almost liquid, sturdy figure, and the solid treatment of the musical instrument attracted me very much, apart from the respect I had for his work.

NT: Let's go back to the start of your artistic career.

PS: I started painting in the manner of the Bengal School when I reached Madras under DP Roy Chowdhury in 1936. He also encouraged me in this manner, but soon I was disillusioned with the Bengal School. I was more interested in the work of Nandalal Bose, Benode Behari, Ramkinker, who were trying to break away from the Bengal School's work. I had tremendous respect for Nandalal Bose, even Abanindranath Tagore told me to go to Bose. Yet they were looking backwards. Most of the work was illustrative and there was tremendous pressure to do work which was Indian. Also, given there was no time to think over this deeply, therefore the immediate image of India was found in Buddha, Krishna, Ramayana, Mahabharata and so on. The first break against all this started in Santiniketan, long before Amrita Sher–Gil.

Anyway, later I came to Indore, Daly College, as a teacher in 1940. I had always been a great admirer of Van Gogh. I read whatever literature I could get about him, and the British Principal there had good colour reproductions. Anyway, it was only much later when I saw an exhibition of four hundred of his works together, at his centenary in Holland did it make such a deep impression. Only then I wanted to paint a portrait of Van Gogh in the act of painting the sunflowers, and then another with Van Gogh as my model, sitting before me, after cutting off his ear, with anguish in his eyes.

281
Homage to Van Gogh – I
152x140. Acrylic, 1990
Private, Bombay

NT: So after Madras you returned to Calcutta, and the 'Calcutta Group' came together.

PS: Yes, I came back to Calcutta by 1942. The Santhal life in Santiniketan fascinated me at this time, even earlier. This rather than the mythological and historical themes of the Bengal School was my interest. I realised they are as important as *Siva* and *Parvati*. As a result came the break towards painting more and more from real life. Then the turning point came with the famine, and so much anguish, man–made. This was one of the catalyst reasons for the 'Calcutta Group' forming at a historical moment, when Indian involvement in World War II began, as Japan entered Burma. Also Gandhi's Quit India call came at this time. The conjunction of these three important events made all creative people sit up and think what to do in a revolutionary situation such as this. The language of the Bengal School was not adequate to meet the needs of the time.

My concern became: what kind of language must I evolve in trying to represent this crisis. This was the challenge for me, and others, and the Calcutta Group was formed, with Prodosh Dasgupta, Raithin Moitra, and others,... but I was still groping, not knowing exactly what to do. That is why my works of that period show no particular direction, except that I became aware that form and its structure is the end all and be all of everything.

I began to understand Picasso and Braque and the importance of form in art. I went through the history of art, realising that only during the Renaissance and two centuries later was art really naturalistic. The rest of the time it has been the inner world of the artist which has been expressed. And so the simple idea of reacting to the outside world through the inner eye became me, but metaphysical art was not my cup of tea.

NT: Very few contemporary painters have been able to achieve a profound sense of the spiritual in our art, maybe Gaitonde.

PS: No one in India has really evolved a spiritualism in art. Maybe Ganesh Pyne and Gaitonde, yes, that would be true. I do not understand Nasreen's work, but maybe that is my own inadequacy.

NT: So then you left for Europe.

PS: In 1949, after Independence, I went to Paris. Suddenly I was confronted with a world which overwhelmed me because before that I had never experienced such a fantastic exposure to modern art and for a time this totally confused me. I gradually began to determine what I thought was good, relevant to my work. The rest I discovered as I tried to understand what modern art was all about, concentrating on works of a few artists who I thought represented modernism in most aspects: Picasso, Braque, Matisse, Rouault, Chagall, Kandinsky and Klee. Towards the end of my stay I began to get a glimpse of the American Abstract Expressionism. Yet I have always been interested in the human condition and so abstraction never took root as an idea. Near 1969–70 I was close to experimenting through a few nonfigurative works, but easily discovered it was not my cup of tea.

In Indian art the only place you find some non–figuration, not as a deliberate artistic search, but as a consequence of a spiritual search, is in the tantric symbolism between the 17th and 19th centuries, the only aspect of some nonfiguration.

NT: Then you left Paris.

PS: Yes, I came back in 1954. I had realised that Paris did not have anything more to offer me, and that I can never take root in Paris. The language, the customs, the food, habits, too different. Also I was getting stagnant in my work, repetition was creeping in. So I came back home, renewing contact with my people, with the new vision I had acquired.

Roaming the by–lanes of Calcutta, I found tremendous vigour amongst the people, putting great hope in me. For example, the rickshawala's after a whole day of hard labour, sitting with drums and singing until midnight, tremendous hope in the people. My **Pavement Series** came from that period of return, and I found my work to be taking on new forms and dimensions.

After that there has been no major influence as such, just trying to evolve a language of my own,...I wanted to paint in a certain way which would help me express my ideas as forcefully as I wanted. Also I always wanted movement; movement is indeed a most important element in my work. The forces around me are so dynamic, that it can brook no static representation.

(19 August 1993, Calcutta)

Gulam m. Sheikh

GMS: I made two very direct autobiographical paintings, **About waiting and wandering** and **Revolving Routes**. Then along with these, two more paintings **Speaking Street** and its companion piece **City for Sale** (1981–84). Now this work deals with life around Baroda, the city which I came to live in later, after Kathiawar (late 1970s.)

NT: The tree has never left your work, though it is more dominating in your early work. So let's go back, to the start, the early inspiration.

GMS: It started when I was in school, but I had no training, so I came to Baroda in 1955, and got exposed to the art of the world, seeing works of my peers and other reproductions. The series of paintings that I did then were an immediate response to the life that I had lived in Kathiawar. Before that I had done a series on the *taanga* (horse–carriage), partly a take–off from Husain, because he had painted horses, but then aligning it with houses, trees and environment, in a land which I had stored in my memory, and was slowly rediscovering. Thus many paintings were on these themes, during those early years of 1959 to 1963.

Then came an abrupt break when I came to England. I wanted to see the art of the world in original forms, particularly Western art and also to meet artists. I had my tutors who were sympathetic but it was difficult for them to understand the needs of an artist who comes from a distant culture, because there are stereotypes of an Indian artist.

They would say that they must be very colourful skies. Yet it is not colourful skies which makes one think of colourful things, they are many factors. Anyway, it was a very useful experience, discovering their art, and rediscovering something of what I had dreamt about...

NT: In what way?

GMS: Something like a small town space, where you have everything within the reach of hand, where you can personally grapple with reality, you can touch things. It is not a large sort of panorama where things get diffused, but something which is highly personalised, intimate and you estabilsh a relation with a house, with the street. You know your trees, your skies, in that sense. And also there is no difference in what you call real and what is not real. This divide which has been taught, given to us, that there is something called realm of fantasy, realm of dream, realm of reality, et cetera,...I have never understood these things, because they have always been....You cannot extricate one from the other, it is simultaneous, the process is continuous, in that way times collide, spaces collide,...

NT: So in a way the forms that take place in your work very much reflect this intermingling, engulfing,...

GMS: ...But I was not able to formulate these things then. So I was very much drawn towards the early Italian works, especially the Siennese work, very intimate, very personal, something which they had felt and painted, something they could identify, touch, whether the wall or skies, whatever. Then I admired Magritte, Picasso, Beckman, many, but I had to make my own artistry, I had to choose.

NT: Just one curiosity, about Turner's work, did it evoke any response in you?

GMS: No, it did not do anything to me. Turner is too interested in the atmosphere, I am interested in the experience of something which is tactile and which has substance. It is not on the light which falls on the object, I am interested in the object itself. The resonance which the wall emits, their colour, their luminous nature, the physicality... and the colour could be green, resonating from within. This is how I see it in India.

NT: Going back to choosing your own artistry...

GMS: Yes, I use to go to the V & A a lot, the Indian section, to look at the miniatures. These works drew me in, into the whole realm of Indian traditional works, especially those from Kotah,...and since then my interests have multiplied manifold regarding the Indian traditions, something I have not understood fully, only responded to it in my school days,...

NT: So what kind of understanding did it take?

GMS: I came to know that there are many things in the miniatures whose essences continue to live with us, they did not die. An accumulation; there are many memories which are not in the form of one particular accurate object. You felt empathy with a lot of paintings, and it still continues in our life. Now in what way does it continue, that was the enquiry that I began to make when I returned to India at the end of 1966. I went to Kathiawar from Baroda, and found that all my folks were there as I had left them, they accepted me as I was, so I also began to; though I had been abroad, from a small town, middle class family,...they did not ask any questions. I found this passage in time very interesting, that time could accommodate both of us, my family and me, together, and I could enter their lives and they could enter mine, and we could even stop when we wanted to. So this made me think about various things.
Also there was a period of gestation, two or three years, where I was travelling through Central India, around Jhansi, and I remember seeing things which appeared strange, miraculous; unexpected trees on a hill, and you cannot help but ask, what is this, where has it come from? It is wonderful, yet part of our daily life, it is wonder, and every individual knows it,...and so I painted things which are all about trees sprouting from nowhere, or between the hills, and also I discovered that it is something to do with physical experience, sexuality, that one saw things as extensions of oneself, as if it was all growing out of your own body, the world can thus be grasped, embraced by extending the arms, something like that, that kind of experience is within our reach. Of course it is difficult to articulate, but there is something about this world which is so physical, so beautiful, in all its complexities...Beautiful in the sense of what physicality can offer, can produce, and so sexuality. Secondly there were so many terrains, psychological, space terrains, terrains which you do not even know, so many senses which are not even named, nothing extrasensory, but these are all part of us. The history which has entered you, biologically, perhaps genetically, or something which allows you to respond to that which is bygone without being nostalgic, but because it is there. Now this is what I tried to articulate in later years, at a later stage, about ten twenty years after that time. This is the living in different times, but simultaneously, which I had mentioned earlier. Also living in different spaces simultaneously, we can; multiplicity is part of our experience, there is no singularity, because there is no one single vision of life, or the world,...

NT: What about our cohesion?

GMS: The thing is that it may happen at many levels. I don't think the idea of a mono–culture has any significance in India. What happens is that everything exists here simultaneously, there is a coexistence, they may overlap, they may separate, they may continue, so a Kaleidoscope, through which you move constantly,...

NT: There is a sense of unity, isn't there?

GMS: I am finding these words difficult now, because there is a singularity involved in that thing, so I would say that the two constantly co-exist in my mind.

NT: You mentioned before about the body coming out of the land, or the land from the body, like one integrated whole in which we have different manifestations,...

282
Meghdoot
118x169. Oil, 1988
NGMA

GMS: I am unable to articulate this, if it is this. What I feel at the moment is that I am many cells. That there are many more cells, and I constantly see the overlap between you and I. I constantly see the overlap between myself and others, my past and me, my family and me, my friends and me. Also in art, I cannot say here is something in itself, it always refers to something, there is a back and forth, and so a continuity,... It is not linear, it is multi–directional. The only motif I can think, is that of the banyan tree, and I don't know whether it is singular or multiple.

NT: I understand. Also the situation in our country, say the communal problems, and so many other things which can disturb the cohesion, and so coming to terms with one unifying principle can appear aggressive and misguided,...this must be affecting your thinking?

GMS: Well, these are the problems which have occurred later. I was speaking of an earlier stage. I can come to that,... What I found was that there is no need to harmonise things, no need to unify, we can coexist with our differences,..the point is coming together. There may be overlaps of different kinds in which intertwining can take place, so that there would be integration, there would be separation, there would be many processes by which you can describe this process. It is not polemic.

(7 September 1993, New Delhi)

Laxman Shreshtha

NT: You came to Bombay in 1959 to study at J.J. and Sunita (his wife) has been a constant thread all this while.

LS: Everyday we are together, from that time.

NT: This myth of artists needing to be free, reckless....

LS: That's true, we have all that.

NT: Yes, but also the stability of her constant thread.

LS: I think if we are put it to the test that we do not want the responsibility, we want the freedom, we don't want everyone to crowd in, how far would you go? If you get children and life gets crowded for you, would you leave that and move out? When the time comes I don't know, otherwise we all want freedom, and the people close to us all understand that, respect it, otherwise it is very difficult to live.

NT: So the wish for change, the recklessness has been in you?

LS: It depended on the woman I think, if it was not for Sunita,..I am also very reckless, wild, I am wild.

NT: How did she control it?

LS: I learnt a lot of things about life and painting from her. Almost everything. I changed as a human being. There was so much hurry in me. I did not understand the nuances, I did not have time. Riding a bus was excitement for me, everything I did was as if for the first time. Every time I ate, joy in everything, and so my mind was not focused on the nuances,... so when I met Sunita, there were a lot of problems, because I would not understand, because I was so strong in my own ways. Simple things like I would laugh loud and disturb others, but I would not understand, so this also created problems apart from the deeper questions I had. When I saw her, I thought my God, this is a completely different world. She was never in a hurry, never upset, I have never seen her upset, very intelligent, generous, all the love she gives. Tremendous. Through her I started seeing the depths in Indian culture, I calmed down.

NT: She is your anchor.

LS: At that time I did not realize, I lived my own life, but I was a very happy man, very very happy. Peace did not come, but now I can say I am peaceful man also.

NT: What was the early happy work?

LS: Mostly impastos, very abstract, colours like Van Gogh, lots of yellow, thick colours, very colourful, but I also think there was something within. Many Western artists have done this kind of work but it was a pleasant design, an arrangement of colours and forms, this was not with me. It was more innocent and honest in me.

NT: This was the late 1960s or so.

LS: Yes,...then I went to the United States.

NT: Lets just come back to the idea of finding love. Coming to terms with our own need of love brings a calm, it has to be satisfied, one way or the other, so now do you feel you have found your love?

LS: I don't think I was aware that I wanted some kind of love. When I met Sunita, I never thought of love; I just got attracted to her, and in fact I did not talk to her. Instead I talked to all the other girls in class. She was a very beautiful girl and I used to sketch her, I have many sketch books. The girls would go to her and say that there is a boy who sketches you all the time, and one day she came to me, and started talking to me, and from that day on we have never parted. We are together all the time. So I had no idea that I needed her love, I was too innocent.

I was very lonely in Bombay. I come from a very closed family in Nepal, children running around, everyone laughing and playing, enough to eat, lovely in a way, then suddenly I run away from home. They did not believe that I seriously wanted to become a painter, so I ran away. They have not accepted me, till today. It was loneliness. These problems were pushing me towards something very beautiful. One side of me did not want to live, and the other side this love, giving everything of her to me, so I was, as they say, at the abyss, I was at that, completely lost I would have been, but I came out, during that period I learnt so much. I read all the philosophies, German, French, that did not give any answers, but I realised that I am not the only one who has gone through this, that others have lived through this, so I would feel very good reading the books, it would sustain me, but it made me more and more restless, and then I was open to the Upanisads when, I told you, I reached the abyss. The Hindu scriptures were suddenly open to me, and it suddenly changed my life, actually it was Sunita. I could understand her slowly, her gestures, her way of showing love, it wasn't the way I showed my love. Then my painting completely changed, about 1971–72 from the buoyant phase, where I was not so much concerned with the forms, I was open to Indian miniatures, classical music, Indian scriptures, all open to me because of Sunita. I used to show my love all the time; now I could just sit, and feel great, that such a thing existed and the whole thing happened at the same time, so my painting became more introspective, more meditative.

NT: Do you think this was a natural evolvement in you? You see, the joy and zest for life, the wildness of your life, it was natural not to worry so much about your way of talking, dress, everything was more sensuous, earthy, in touch with nature, more pure and then suddenly you are thrown into a city, and besides a woman whom you have not understood but who feels gentleness and tenderness towards your pain, and you are absorbing new ideas, like Indian scriptures, mostly Upanishads, the Gita. Every thinking Indian comes to it; it may not give the answers but it closes off so many irrelevant doors, and then the introspection comes, changing your life's attitude, so do you believe this is genuine, very much of your spirit, or do you have a conflict that you have lost something essential...

LS: No conflict,

NT: No conflict ?

LS: No conflict, but you said, is it a natural evolvement? What do you mean by natural? Suppose I had not met Sunita, I still would have been wild in Nepal, maybe I would have had five wives...

NT: You see, one part of me says that maybe that would have been , that your environment moulds you, but I know that there are certain triggers, and if you were open to those triggers in Bombay you would have been open to them in Nepal...

LS: Yes, you are right....

NT: Maybe the monastery rather than casino in Nepal kind of idea,...

LS: Yes, it could have happened anywhere, true, in that sense I would say it is natural, because I would not fit from where I came either.

NT: Let's come now to the 1970s when your style changed, a new introspection. how did this come in your use of colour and the form of your work?

LS: The impasto went, it did not have the subtlety. I studied Indian miniatures and my relationships with people was seeing all the little subtleties. What interests me right now is intrigue. There are various intrigues in my painting and they are interwoven, they have their own life, potential.

NT: What do you call an intrigue?

LS: Which is obviously not depending on logic.

NT: Something you can't explain?

LS: I can, you see, intrigue is very much connected with mystery...

NT: Mystery of nature?

LS: No, you see, you put colours and movement of forms in your canvases. Let's say I am an abstract painter, it is limiting, but let's say, and you cannot pinpoint why I have done it, even a form of mountains that I use, it is for people to identify and move with it, and suddenly to realize there is no mountain, that intrigue. But what is it, he goes further, and what happens to him is what happens to his life when something deeper happens,...

NT: So you are saying that each intrigue is a new realization, it suddenly happens and you don't know where this realization will take you, and then comes another realization and another direction?

LS: Yes, genuine, and this kind of work is not done by a painter who knows. I would have no interest to paint if would do something I already know. When I have a blank canvas I am very nervous, I don't know how to tackle it, I work like someone who does not know how to paint.

NT: I understand.

LS: The painting takes place at that moment. That is life, that is also maintaining a mystery, thats why I don't like talking about my paintings too much,...

NT: So when you are working you are trying to understand your role in life, yourself,...

LS: No, no, not so clearly, it sounds bad,.. I am just trying to understand. It could be the world, my friends,... Just to understand.

NT: You very much like being quiet.

LS: Yes, many times I sit down, alone, and I think of, ...say a sound, just a sound, or colour, it is very beautiful, your life is involved in that,... I go to the canvas when I am

in such a state, quiet, in that frame of mind, and it does not take long, that is why I live a disciplined life; it does not take long to empty myself of all thoughts.

NT: You told me that when you start a canvas, the 'first filling' is like posing a question,...

LS: When I do, it is not like posing a question. Say something happens, something I read, someone I met, saw, does something to my mind, and a few things gather, and I make it like a project for my next canvas, so more or less I know the kind of structure I want, not completely, but I know, so I know it is a question because I have to answer it, I need to make a complete painting.

NT: Then before the question, how do these threads come together, what are the triggers in your life which would be implicitly chosen or you choose to make up the question, what would be these things?

LS: I want to say more by saying less and less. Being silent has much more meaning. Many people do not like to hear this. I was asked about creativity recently, and I told them that in the beginning you feel you are in control and you are making changes, but as you get more and more involved, and soon as you go deeper there comes a point when the painting dictates to you, and it starts happening on its own, you do not think you are controlling it. A man did not like it, he thought it too spiritual.

NT: Let's come to solitude, loneliness and its role in you work, how has it affected your work?

LS: I don't think any human being would like to be alone to begin with; but he would rather be alone than with people he does not like.

NT: So when you are with your work, there is calm and questions; is there something which you sincerely understand about life which you do not otherwise.

LS: Yes, painting has taught me many things about life. I will make a note, about these things which I have never spoken. But, I will tell you, when I make the first filling, it is part of the project; my purpose is to put it on the wall and answer the questions...First of all there is a desire at heart which makes me restless, burns me, to want to know, for that I would go anywhere. This raw anger, irritation becomes the hard line in the first filling, and questions, and the soft colours the tender part.

NT: These two have always been there?

LS: Always, constant. I told you that there are two sides to me: one is Sunita, and the other my tremendous problems, but not any more, so what happens now; my paintings are not tortured or tormented, there was a time when they were. What I have seen in life, the most beautiful things, I want to put on canvas. There is struggle, anger, but if I feel very irritated then harmony is broken, and if you remain in that state then some kind of order is lost, and I love order, so balance has to be kept.

NT: Do you find any of your paintings ugly?

LS: Yes, many... it is very uncertain what will happen, you never know,...

NT: So given the final form is yours, your judgement, do you know what determines this judgement of yours? This standard.

283
Untitled
152.4x142.2. Oil, 1989
Private, Mumbai

LS: Yes. I do not know if I know or not, but I do not go by logic, intellect in this; my decisions would be harsh, it won't be something living in that moment. What was needed I did, that had its logic and intelligence, now it is only intuition.

NT: What makes a work ugly for you?

LS: Ugly means it did not work.. There are some works which I like less after a time. That's all.

(1 August 1993, Bombay)

Arpita Singh

NT: A figure sitting on the chair, with a lot of swirling movement around it. I remember this image from your work.

AS: Yes, that is the easiest thing which I can do; most natural I suppose.

NT: Why has this stuck? This steady single person, maybe you, and the bustling random movement all around, looking on, detached...

AS: I like to paint, draw the most familiar, what I see everyday, know it, live it, otherwise I cannot draw. This thing of people sitting, perhaps my life is like that. I cannot say why I like to do these things, perhaps I am just made like this...perhaps painting is a way of understanding these things, like when you are a child and are practicing handwriting, that is your way of understanding the alphabets and letters; it is almost like that.

(We begin to look through her latest W/c–acrylic small format series for the forthcoming exhibition at Schoo Gallery, Amsterdam.)

NT: In this picture there seems to be greater interrelationship between the figures involved.

AS: Even here, I think I have put them together, for I do think they are related. Actually, I believe everything is related. There are many ways of seeing these pictures, and interpreting them. I can only say how I started them, put things together. I would

284
Andhretta Lily
78.7x60.3. Oil, 1988
Private, New York

begin with perhaps a chair, or a woman or man sitting, and the things would come by themselves, no extra effort...I don't see them as people, they are forms to me. Because they are human forms they must have some familiar things like eyes, nose, and so on. Sometimes when I begin I don't even know if it is going to be a man or a woman. Everything usually appears in the process... that these works appear as pastel works to you, is to do with the process. One watercolour work takes me about 15 days to complete, because I apply and remove, apply and remove... the texture comes.

NT: So is the process itself the main motivation to continue?

AS: Well during the process I always get something which makes me move further. It can be a new form, a new texture, maybe a little bit of new colour, which leads me into another picture, usually.

NT: So basically these flowers, tables, things which you live with in your home, are you trying to position yourself more clearly through your paintings?

AS: You see, these paintings are me. Whatever I am, I am trying to show as truly as possible to others. I am someone who would automatically believe in something, and at the same time I would doubt also. This perhaps I have analysed, and hence the process I have evolved reflects this. I make a form and then remove it. This kind of duality is in myself.

NT: Uniting this duality is the essence of creating. Yesterday, I was with Swaminathan, his latest **Text de–text Series**, in principle the same idea of erasing meaning, and reapplying, and the focus on looking rather than reading, a common modern trait. Do you see the similiarity, whatever the difference in intention?

AS: Not really. I don't think so. These paintings reflect the way I am emotionally and spiritually, and accordingly I try to create a language, a process. It could have been chairs, people, or anything, that is not very important. To me the texture, the application are very important. Perhaps I use chairs, figures, flowers because these forms very easily suit my expression.

NT: Is this focus very suited to your nature?

AS: Yes, because I have always tried to create these things. I have not purposefully made a texture; it is what I like the most. It is in everything. This woven texture on the sofa, so many things.

NT: Here the figure has three arms, three legs, are you trying to breakdown the iconic ideas which we have?

AS: Rather I am trying to understand the icons. I have always had this feeling that our old gods and deities have some reality behind them. Like Durga with ten arms. At one point a person must have seen a crowd, and he did not understand what there was, and he only saw a woman in front of the crowd, and so a woman with ten arms may be etched in him, even though they are arms of the crowd.

NT: Even in the places where you are trying to express violence, there is gentleness, this dominates your work. Lets come to your early work. In 1972 your first solo show, **The Figures and Flowers Series**, then a abstract, b/w period, how did the transition come?

AS: Well, in the early phase, at some point I stopped and realised that I was thinking too much in the way I was working, that they were not coming very naturally to me. So

I stopped painting and made drawings, just working with basic elements like dots and lines, and so they became abstract naturally, and then say after 8 or 9 years I had a great desire to put colours, and that was when this **Flags** painting came about.

NT: All those pent up colours flowing out.

AS: Yes, I put lines, and patches of colour, and had a great desire to recognise them, not just as patches of colour, and so I called it '**Flags**'

NT: So basically there are three periods, very different, yet interlinked, leading into the next. Can you sort of tell me what has been your underlying inspiration as a painter? Is that possible?

AS: Well, it is difficult to say, but I believe that, after all I am not the first or last human being, I am part of a chain. The exact stock from which I come, I cannot say. The only thing that I am expressing, whose dream, whose wish, I don't know. Maybe they have concentrated in me...

NT: In a way then, it is aspects of Chagall's spirit that you share, many must have mentioned that...

AS: Yes. I have taken so much from Chagall. He is a favourite painter of mine, and I think the common theme is the folk memory behind the work. Folk-memories mean, the stock from which I come. Those memories I cannot translate in any other language except through colours and forms, the memories I have inherited. I cannot locate them or explain them, I can only make them.

NT: Daily life, this house is actually the focus.

AS: Yes. the house means the point where I live. It is very important for me. Also here means India, the light, the colours that the light shows me. If you go to the West, the light is different...I don't see these colours.
(Paramjit joins us for a bit)

NT: What are your impressions of Arpita's work?

P: As I have been watching and living with her work, the quality which I like is the very natural and innovative way she works...There is a flow, a continous reaction and change...a very self-generating process of checking and flowing.

NT: In your early **Figures and Flowers** there is a loud use of colour, calendar tones, almost a Pop Art feel. What brought you to that colour sense?

AS: Well, it seems irrelevant now, but I found a small package of tea in my kitchen, with silver, yellow and red; Red Label and it appealed to me. Why it appealed I do not know. Perhaps I wanted to use those colours as they represented popular art forms of the times, (eg: folk, handicrafts, pottery) and perhaps as a child there was a print of a miniature, in complete red with which I was fascinated. The glossiness of that red was due to the printing effect.

NT: So how did the colours for this new series come about?

AS: *Kyon ki dil kiya* (because the heart desired)

(9 September 1993, New Delhi)

F.N. Souza

NT: Lets start with what was so important about the Progressives (P.A.G.) in your eyes?

FNS: What happened in Bombay, is that we gathered together six artists, the nucleus of it comprised Ara, Raza, and myself. Ara brought in Bakre, Raza brought in Gade, and I brought in Husain. What drew us together was an idealism by which we wanted to produce a new art, which was entirely Indian plus modern. This incidentally coincided with the Independence of India, we did not plan it that way...The reason why the P.A.G. is an important phenomenon in our history of modern art is because we had a definite view, none of the others had this view. We knew what art was and where we were going,..

NT: What about the Calcutta Group, which was set up in 1943?

FNS: Among them was Raithin Moitra, Paritosh Sen, Prodosh DasGupta, and a few others.. it was only later that we came to know what they were doing, and they were not doing anything revolutionary, not at all,...

Their manifesto or their ideology was not revolutionary..You see the British had destroyed our culture, ..., and the organism which controls the environment controls the culture, so the British had controlled culture,..

NT: At the time the Bengal School served a very important role,...

FNS: Not as far as I am concerned. I wrote an article,...where I call Tagore (I assumed he meant Abanindranath, but he meant Rabindranath) a Vedantist who was propped up by Emerson,...nobody has done this before, seen the Bengaliwalas in their proper perspective,...(all are laughing)

NT: That's hardly fair.

FNS: I am not in favour of seeing all the sides and putting them all together, for then you hardly get a form; you will have a thousand different facets which you won't know where one begins and the other ends,...

NT: Let's start at the begining of you work..

FNS: The start of my painting was at art school, J .J. after I was expelled from Xavier's...It has grown. Although I have claimed, in *Words and Lines*, a short autobiography... that I had painted murals on the walls of my mother's womb, implying that I was always an artist, really speaking I was not even an infant prodigy, or never grew on my own, only when I went to art school, and in 1945 I was expelled...I had participated in the Quit India movement. At Xavier's the Jesuit father expelled me. In class there was some disturbance, whispers when I came in, and they said that somebody had drawn dirty pictures in the toilet, must be Francis Newton,...

NT: Was it you?

FNS: No, not at all. I went to see what dirty pictures, I even found the drawing bad, and corrected it.

I was sixteen.

NT: There was a lot of violence in your early work, the way sex and religion was intermingled, and the portrayal of your woman, was this solely due to your background?

FNS: No, this is not accurate at all... thinking that I was rocking the boat, which is not so. No artist goes knocking down things, he is interested in only one thing, and that is aesthetics, the science of beauty. And my whole life has been the quest for beauty...

(Souza is looking through a small pamphlet of his writing he wants included)
"The eye of beauty: many artists have painted portraits, still-lifes, landscapes, compositions, but my work is different, because my concept of the universe's nature is different. Nature is structured from the microcosm to the macrocosm, atoms to galaxies, the structure of nature is a hierarchy, ... nature is structured in a hierarchy of nuances, from ugliness to beauty, beauty is the final nuance of nature. I am searching for that beauty. Beauty is not in the eye of the beholder, but in the cultivated eye."

NT: But there is a link between sex and religion throughout your work, isn't there?

FNS: Well, so it is in Michelangelo's work, with every subsequent work which wanted to destroy the Last Judgement.

I do not find religion interesting at all, and sex of course, without sex man would not exist. Now in ancient Indian art, take a look at Khajuraho or any South Indian temple; sex is in the temple, a place of worship, it is explictly represented,...

This morality which thinks that sex is dirty, does not appear before the Islamic invasion of India...look at some Indian miniatures in which the children are watching their parent's intercourse. That sex is dirty is a Judeo-Christian-Islamic concept...sin.

NT: Yes, so were you trying to destroy that kind of notion?

FNS: In my earlier days I was in the Communist Party...we never defined God, but he was certainly dismissed...total dalliance, this joy, this play, and this sex among the gods is an entirely Indian development,...

NT: Yes, but there was no play in your work, that joyful kind of play was not there,...

FNS: Because I was tied down to this Portuguese-Christianity, Christ, Good Friday and bleeding, and crown of thorns, and flogging and what not,..

When I was growing up, I used to feel very guilty while masturbating...and everytime I had to go and confess to the priest...and of course the priest would get very interested,...

In fact some of my paintings of the 1940s were of pedarasts on Mohammed Ali Road, and,...at one time the police came and wanted to raid my studio,...
So, one fine day, or night, whatever, I suddenly felt no guilt of thinking about sex, or relieving myself,...

My thought-process developed to a point where I discovered that sin was the product of free-will, and free-will did not exist because the laws of nature are ubiquitous everywhere... but changing my view and not experiencing guilt anymore is a much later thing,...

NT: Could you give some years?

FNS: Yes, upto 1949 I was in India. By 1945–46 I had joined the Communist Party. Actually the early meetings of the P.A.G. took place at the offices of the Party...I was in the Communist Party but the other members were completely oblivious to Karl Marx or Engels, whatever, but they did not mind. We just enjoyed the fun and we were all painters basically. I was in J. J. from 1940,...

NT: Your guilt ending?

FNS: That was in London, in the early 1950s?

NT: How did it transform your work?

FNS: Well, no thought as such actually showed then, explicitly...

NT: Let's go on, after you left India, the P.A.G. reorganised?

FNS: Yes, Krishen Khanna became the secretary.

NT: Anything essential about your art of that time that has to be understood?

FNS: The function of art at that time was that art had no function at all, none. Only some folk art was going on. Fine art was not like folk art. Fine art has so many more nuances, and the more nuances then more quality, the greater the work,...

NT: That's debatable

FNS: It's not debatable..

(We drift on to the idea of loneliness)

FNS: Frankly I don't understand what loneliness means; I am never lonely even if in a plain room, and I have got my imagination, which is astounding...I don't identify with the lonely, sick ...I am interested in gigantics,...

NT: Why this indifference towards the gentle, frail?

FNS: They have fallen by the wayside. I take my strides. I am interested in gigantic thoughts, and power and force, energy.

NT: Has this always been so?

FNS: Yes, I suppose it must have been latent. Time, gestation and vocabulary allows me now to say these things, I can define perfectly the concept.

NT: Is this anger?

FNS: No, it is not anger at all, it is a realisation.

NT: Is it your childhood experiences?

FNS: No, I had an easy going kind of childhood, even though I lost my father, my mother took care of me very well.

NT: You called your father a beetle, or something

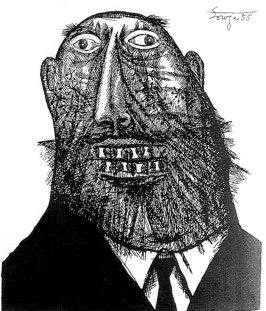

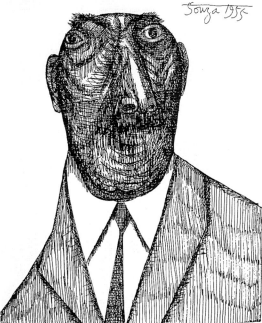

285
Six Gentlemen of Our Times
Pen & Ink, 1955
Private, London

FNS: Yes, in *Words and Lines*

NT: Shows a great amount of tension and resentment.

FNS: Sure, sure, because life is tough

NT: Were they any periods where you did not work on your art?

FNS: No, and I never took any job; I've been at it continuously. Not even in the 1950s...My hands started shaking after I became an alcholic, then I stopped the drinking rather than stop the painting...if my art had failed me I would have drunk myself to death, and said hell with it, but my art did not fail me.

I looked myself in the mirror and asked do I want to be a great drunkard or a great artist? I stopped drinking in 1960–6, the time I was back in London, after my Italian scholarship.

NT: So during those years after leaving India in 1949 to about 1960, what was happening?

FNS: Well, 1955 I made a name in London. Stephen Spender published my "Nirvana of a Maggot", and I had an exhibition in Gallery 1, and subsequently became one of the top five British artists to represent them internationally...

NT: Were you satisfied with your work?

FNS: I am not working for satisfaction, I work under compulsion. I am compelled to paint.

NT: So was there a new compulsion or were you drying out?

FNS: I am aware of the process of evolution, so what I draw today will not be the same tomorrow, it is bound to change, alter, it is bound to. I don't consciously say I am going to change.

NT: Okay, again back to the man–woman relationship because it is so pivotal in your work, and the role of sex, whether conflict or peaceful union,...

FNS: The nature of sex itself, this piston activity, it is very vigorous, one might even call it violent, and the very construction of the female vagina, that it is so tender and delicate, and yet it can take such a lot of friction is one of the miracles of nature, unbelievable,...

NT: How did this filter down into your art?

FNS: Well friction is what creates...like a, pearl created by a grain of sand in an oyster by friction. Violence is the degenerate part of friction which goes into madness, out of control. Friction of a very rhythmic kind, vibrations, that is what art is; colours are vibrant on the retina of the eye, very complex...I was amazed to know that colour is not on the paint; it is light which shows the colour, light contains all. The three primary colours in light are red, blue and green, whereas primary colours in paint pigment are red, yellow and blue...

NT: Were the 1960s a turning point for you in any way?

FNS: In the 1960s I began putting multiple features on a face, multiple eyes, and several fingers on hand. I think this happened with the threat of nuclear war, and the waste matter which was going into the sewers and producing strange looking animals, with anatomical distortions, followed by those children, 1962 or so,... But if you look at the faces only of my work, you will find, that from a pattern like face, outline, they have become more and more realistic and characteristic. It is no longer a drawing with colour filled in, it is something real.

NT: In terms of the distortions, was Bacon's work influencing you?

FNS: I knew Bacon actually; we use to meet quite often in Soho, where we would gather together. We shared common influences in so far as what we would read in the papers, I suppose. I don't know how he worked, but I was influenced by my own background, not by him at all....It is skill actually which has materialised into the development of my work.

I am not saying that skill is art. They are not necessarily together, the manipulation of the technique is skill. You see my art has been a continuous thing, no major jumps, and the subject is also similar. No other subjects apart from still–life, nude, landscape and composition.

....Like a sausage–machine, you chop everything, all your experiences and stuff it in the grinder, and out comes your art, that is what art is.

...the artist does not need society, society wants to deal with the artist. The greater the artist the more individual he is; there is no art which is not original, it has to be original to be worth commenting upon.

(6 September 1993, New Delhi)

Vivan Sundaram

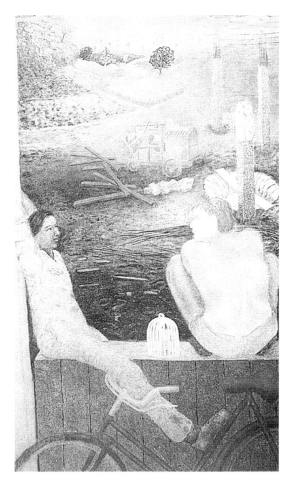

286
**Two Boys Sitting on Outer Wall –
Kalidas & Pandu**
Oil, 1985
Private, New Delhi

287
Allegorical Landscape
89x123. Charcoal on paper, 1989
Private, Calcutta

VS: ... I began using unorthodox media, and then I started the process of breaking out of the easel format, such as by stitching sheets of paper together, which allows one into a space outside the frame, allowing me a greater flexibility.

The paintings that I have worked on, almost self–consciously, obey fairly orthodox principles of picture making, and maybe that was something I needed as a way of an anchor for other works, more free, small, experimental.

I have positioned my works on paper and oil paintings as kind of alternatives. Almost every show has been followed with works on paper, and here I changed the medium everytime, from charcoal to pencil to pastel, to water–colour, engine oil. Each different in their look, and themes which evolve due to the medium itself opening new possibilities. Hence this idea of working on counterpoints and opposites.

NT: How do you feel about the use of oils, a non–traditional medium in India?

VS: We approach the medium in fairly orthodox terms, it is because we have a belief that it carries our statements with conviction. After Ravi Varma's work in oil, there was a gap of about thirty years because of the Bengal School, after which artists took up oil painting once again, privileging it with possibilities to make statements, round about the 1930s, and so the history of images through oil painting is only about sixty years, compared to hundreds of years in the West. This medium is new in India, but it has been the most privileged visual arts medium in the West for the past five hundred years. Sculpture has always been very minor compared to oil painting in the West. So this aspect of the buyers is new in India; it is exciting to explore, hence the belief that oil painting can carry our emotions, images, ideas. We are discovering ourselves and this modern world via this medium.

The implication is usually given that modernism is only to do with the entire break, rupture, or even rejection of whole lots of values, but this is not so, the aspect of the spiritual, religious is in enormous abundance in modern art. The sense of continuity is very real, the river keeps flowing.

NT: But the way in which modernism was accepted, the way it was adopted after Independence, has not inspired the kind of constant change or experimenting attitude...

VS: Modernism till the mid 1960s had developed certain kinds of concerns and preoccupations with language which seemed to do with the way that it was received by Indian artists in a very formal manner.

NT: Formal, in what way?

VS: By formal, I mean when you break out to make new forms, configurations. Then as decade after decade they are there in existence, they get their own orthodoxies; modernism becomes academic. Many of the artists went to Paris, Akbar Padamsee, Tyeb Mehta, by that time in Paris in the 1950s, most of the practice there was conservative, its radical aspect had shifted to New York. That aspect of modernism which came with a radical thrust to begin with, by the mid–1960s had already consolidated itself into a considerable orthodoxy, roots had been laid in India for a decade and a half, and had become the norm as it were, and so the new generation comes,...

NT: How much of modernism's own orthodoxies, and continuities have you chosen?

VS: No. I have not made the concern with the spiritual, metaphysical or religious; it is not a pre-occupation,...

NT: Is that due to your Marxist kind of background?

VS: Even before that. One only became that in the late 1960s. Even as a student I was interested in things in the world, and a kind of irony, a kind of anarchist subversion. So that is my spirit. It is not designated as the spiritual but as the temperament, and through the configurations this temperament makes you discover the world yourself; this questioning is intellectual on one level, and ideological. The temperament of the spirit in me, makes and unsettles, and opens out possibilities of new meaning. In a sense, the interesting aspect of recall, is an element of surprise, shock,... recalling certain things and then the viewers get unsettled, asking is that my work, it doesn't look like my work, and soon they are making connections, links.

Like my recent **Riverscape** drawings which Timothy Hyman said reminded him of my drawings twenty years ago, based on Pablo Neruda's poem.

NT: Regarding your faith in breaking, of making new, is there something you are progressing towards, or is it just for the sake of being radical? Is the mind really sensing more freedom?

VS: Yes, it definitely is giving a freedom to the mind, and the freedom comes only when you are able to sustain your beliefs in this project. I went away to England, and in fact I changed sort of track. In England I became more sort of conservative. Bhupen and I started changes in Baroda, in terms of both the look and the sensibility of how an artist perceives the world. The way they bring into the frame, into the look of the art of that country, that time. This allowed one to bring in the popular, the kitsch, which in terms of aesthetics was considered different. The media we started to use was housepaint, oleographs, the street look, *paan* shop,...and in a few years everyone was doing it, we had brought in a new look, a new vocabulary into Indian art, ...And also an interest in subversion, of opening out areas where the so-called elite notions of art won't venture into, after all one of the functions of the artist is to enter areas other people do not.

NT: During your stay in England, late 1960's to 1970, you mentioned becoming more conservative, in what way?

VS: I was using enamel paints, pure colours, and then while in England the painting developed an interest in a much more refined use of colour. Colour in terms of a whole range of tonalities. When I started foregrounding the human figure as with **The Portrait of the Father** 1980, the colours started becoming more muted, impressionistic even.

NT: What role did your teachers play?

VS: He influenced me, in the aspect, of an attitude towards art, rather than in the actual look of it. That art it is about art language and not of art making. The way you play, and the sense of irony which is very strongly dominant in his work, that interests me, but not stylistically.

NT: Seeing these pictures I notice a kind of interest in this inside-outside notion, with the windows, and the sense of creating a cosy little world, a sense of security,...

VS: But I want slippages to enter too. Like the gun (as in **The Sher Gil Family** 1983–84) that triggers off a kind of displacement, dislocation, a sense of internal collapse, or an intrusion from something from outside.

NT: There seems to be no communication between the figures.

VS: No, I am much more interested in a kind of iconicity, that the aspect of the narrative is not so much between one person and another, but the person and the *mise en scene*, the whole structure, the objects, the placement, it is between that, rather than between the people.

Basically all of us were interested in relocating the human figure, not just in existential terms, that man is man, and out of context, but in a context...

NT: At the same time there was a stiffness in the figure...

VS: Yes, because in bringing back the figure one put certain constraints upon oneself. The intention was that one did not want to distort the figure in the modernist way, which had become part of convention.

NT: Any other reason?

VS: Basically it was the idealogical bind one put oneself into, and it also got related to a kind of discussion and dialogue that was taking place between us in Baroda, and Timothy Hyman, and Kitaj. Part of the argument, Kitaj was developing, questioned many of the dislocations, distortions in his own work, and his desire to bring back the figure with a greater sense of unity, fullness, without it being dismembered. Going back to before this break started, and so working in pastels, referring to the Post–Impressionists, and Degas in particular.

(2 September 1993, New Delhi)

J. Swaminathan

NT: You have said that you do not wish meaning to be read into the 'text' of the painting, and that you have intention of communicating through your work.

JS: No communication, absolutely not. It is meant for only those who can be in communion with the work. Hopefully I have something, which may become a common way of looking or a common capacity for response. After all I am a human being and therefore other human beings are potentially capable of the same kind of response, if not today then tomorrow. So I will wait for tomorrow for the response to come, rather than risk an immediate explanation of a phenomenon which refuses to submit itself to such an explanation.

NT: So there must be complete faith in your sincerity, for you to continue for so long on this path.

JS: More than faith, it is a compulsion.

NT: What gives this compulsion credence in your own eyes?

JS: I don't know. I suppose the fact that it is there. I am concerned with the fact that there is a compulsive urge to paint, and to paint in this particular manner, and so I am rendering that function.

NT: This compulsion is not something sudden; it must have grown over time, deepened, so as to make you realise a focus as of now?

JS: I do not believe in growth or development, because though there is growth and development, each movement is unique in itself. In one sense it is like...a discontinuity which is asserting itself at every point of evolvement.

NT: So discontinuity is the source of your compulsion?

JS: No, discontinuity is the result, the aspect in which the compulsion appears.

NT: Now we are beginning to play with words. Let's understand your ideas about continuity. Maybe then we can clarify a bit.

JS: The elements of continuity are elements which knows no change, otherwise how can they be continuity?

NT: Not necessarily, it will depend on the time span of the continuity, the specific context, spirit or material, by absorbing contradictions we have change and continuity,...

JS: Change and continuity are contradictory. That is the problem.

NT: But that is the very nature of creativity, to absorb these opposites and create a fuller whole.

JS: Yes, but what art deals with, perhaps, is not the continuity but the moment of discontinuity, the aspect of discontinuity. So in that sense there is no growth. It is only when you start putting things in perspective you start discovering the contours of the movement. So if you do away with the perspective, what are you left with?

NT: So you are taking the past and future, and focusing on this suspended moment. Yet even as an artist the creative moment is tempered by the continuum in which the moment is placed.

JS: That is not my concern, that should be a concern for a historian or philosopher or anthropologist. As a painter it is not my concern. You see I keep writing on art, once in a while, which is my philosophical aspect. Also, a work of art is not bereft of any philosophical content. It subsumes that content. The trouble is that once the work comes into being it subsumes so many things, and then what happens is something else. You see, as a thinking human being there are so many ideas which come into my work. What I am saying is that ultimately what emerges is not a depiction or translation or a representation of the turmoils existing in my mind; it is something more, or something less.

NT: Given this focus, let's come onto the creative process itself. What are the crucial principles which move you forward?

JS: The critical part of the creative process for me is to drop all consciously arrived at images, so that whatever else is left, then comes out.

NT: So basically it is like, say, when we are doodling, when most careless, or most distracted,...

JS: Yes, most definitely, certainly, these are nothing else but doodles, of course, a hundred percent.

NT: But at the same time the deliberateness is holding it together

JS: Yes, that is the training of the artist, because the artist, by the very nature of his work trains himself to be so, unconscious. Of course not all artists.

NT: Okay, so what allows this unconsciousness to be most free in your art?

JS: That I cannot say. As a kid I was interested in nothing else but painting, and after matriculation I joined the pre-medical college. Then I ran away from home and college. I found I could draw a cockroach better that I could dissect it. Then I was wandering about, got involved in political activities and then by the 1950s got fed up with the whole damn thing and came back to painting as an adult. How was it that I came out with these kinds of things? These were not a deliberate choice, you follow? I was very suspicious of art schools as well. I studied at Delhi College of Art, for about six months and got fed up. Then I went to Fine Art academy at Warsaw, but left that also. So you see, there must be reasons why I came to such an imagery, but I cannot say what. You see, I am not one of those – it is not nationalism which is urging me to paint in this manner, it is not modernism.

NT: Also no sense of creating a symbolism, or any relation to *tantra* or the like?

JS: No. You see in the early 1960s I happened to write certain articles which other people picked up upon, on the plastic–visual possibilities of tantric art. So the neo-tantric of art took me seriously.

NT: In what respect?

JS: They took the philosophy of *tantra* seriously whereas I was only talking about the visual–plastic elements, as to how they could also be relevant just as what was

288
Mountain Bird & Tree Series
106x122. Oil, c. 1976
NGMA

happening, and had happened in the modern art movement in the West. In my career I have been picking up elements from the Pahari miniatures which are as contemporary as anything else which is 'contemporary'.

NT: So basically it was another source of inspiration, another trigger. But tell me, why are we more responsive to certain triggers than others?

JS: That depends on your genetic make-up.

NT: Is it genetic make-up?

JS: I think mostly.

NT: Is it not a different kind of necessity. I am very wary of this choice and necessity line. I have little idea where one ends and the other begins.

JS: Neither do I. I don't know. We all are children of chance. But you see, once we are born into a certain culture then we tend to accept certain things, reject certain things, depending on your being.

NT: Okay, coming back to this new work. I can see strands of your past very clearly. With the perspective the continuity is there, but tell me, in your mind how are the works linked?

JS: Well, let me put it this way. Two poles cannot exist without being in relationship.

NT: Which two poles?

JS: Culture and nature. Both are sufficient unto themselves and yet they cannot exist without being in relationship. That is the way I see the link between my work in different phases. It is not a dialectical relationship, it is not a continuity,...I don't really know how to express it.

(4 October 1993, New Delhi)

Appendix

Biographical Information

AMBADAS
ARA, K.H.

BADRINARAYAN
BARWE, Prabhakar
BAWA, Manjit
BENDRE, N.S.
BHAGAT, Vajubhai
BHARGAVA, Veena
BHASKARAN, R.B.
BHATT, Jyoti
BHATTACHARJEE, Bikash
BOSE, Nandalal
BROOTA, Rameshwar

CAUR, Arpana
CHANDRA, Avinash
CHAVDA, Shiavix
CHOWDHURY, Jogen

DAS, Amithava
DAS, Sunil
DASGUPTA, Bimal
DASGUPTA, Dharamnarayan
DAVE, Shanti
DE, Biren
DODIYA, Atul
DOUGLAS, C.
DUTTA RAY, Shyamal

GADE, H.A.
GAITONDE, V.S.
GOUD, K. Laxma
GUJRAL, Satish

HALDAR, Asit Kumar
HALOI, Ganesh
HEBBAR, Krishna K.
HORE, Somnath
HUSAIN, Maqbool Fida
HUSAIN, Shamshad

KALEKA, Ranbir Singh
KAR, Sanat
KEYT, George
KHAKHAR, Bhupen
KHANNA, Krishen
KOLTE, Prabhakar M.
KRISHNA, Devyani
KRISHNA, Kanwal
KUDALLUR, Achuthan

MALANI, Nalini
MAJUMDAR, Kshitindranath
MAZUMDAR, Chittrovanu
MAZUMDAR, Nirode
MEHTA, Tyeb
MENON, Anjolie Ela
MOHAMMEDI, Nasreen

MOOKHERJEA, Sailoz
MUKHERJEE, B.B.

NAIDU, Reddeppa M.

PADAMSEE, Akbar
PAI, Laxman
PAL, Gogi Saroj
PALSIKAR, S.B.
PANIKER, K.C.S.
PAREKH, Madhvi
PAREKH, Manu
PATEL, Gieve
PATEL, Jeram
PATWARDHAN, Sudhir
PYNE, Ganesh

RAMACHANDRAN, A.
RAMKUMAR
RAMANUJAM, K.
RAZA, Syed Haider
REDDY, Krishna
REDDY, P.T.
RODWITTIYA, Rekha
ROERICH, Nicholas
ROY, Jamini
ROY, Suhas

SABAVALA, Jehangir A.
SAMANT, Mohan
SANTOSH, G.R.
SANYAL, Bhabesh C.
SEN, Paritosh
SHEIKH, Gulam m.
SHER—GIL, Amrita
SHRESHTHA, Laxman
SINGH, Arpita
SINGH, Paramjit
SOUZA, Francis Newton
SUBRAMANYAN, K.G.
SUD, Anupam
SULTAN ALI, J.
SUNDARAM, Vivan
SWAMINATHAN, Jagdish

TAGORE, Abanindranath
TAGORE, Gaganendranath
TAGORE, Rabindranath
TEWARI, Vasundhara

VAIJ, Ramkinkar
VAIKUNTUM, T.
VARMA, Raja Ravi
VASUDEV, S.G.
VENKATAPPA, K.

* Solo Exhibition

Ex Exhibition

FS First Solo

AMBADAS

Birth
1922. Akola, Maharashtra.

Education
1947–52 Diploma (Painting), J.J. School.

Selected Exhibitions
1960	'12 Young Painters', New Delhi.
1962	Triveni Kala Sangam, New Delhi **(FS)**.*
1963	'Inaugural Ex. Group 1890', New Delhi.
1965	Tokyo Biennale, Japan.
1965–70	Kunika–CH.*
1966	National Ex., RB.LKA. (LKNA: **Hot Wind Blows Inside Me**).
	'Art Now in India' Newcastle, England & Ghent, Belgium.
1967	Sao Paulo Biennale, Brazil.
	'Twenty Five Years of Art in Bombay', Gy.CH.
1968–9	Gy.CH.*
1970	Konarak Gallery, New Delhi.
	'Art Today II', Asoka Gallery, Calcutta & Shridharani.
1971	Gallery Negar, Tehran.
1972	Gallery Coray, Zurich.
1973–5	Surya Gallerie, Freinsheim, W.Germany.*
1974	Henning Larsens Gallery, Copenhagen.*
1975	Kunstforbunder Gallery, Oslo.*
1976	Menton Biennale, France.
1977–9	Gallery Alana, Oslo.*
1988	Takaoka Municipal Museum of Art & Meguro Museum of Art, Tokyo. Festival of India, Japan.
1991	AH.*
1993	Gallery L.M.N., Oslo.*
1994	Vadehra.*

Illustrated Works
1966	Hot Wind Blows Inside Me	156

ARA, K.H.

Birth
1913. Bolarum, near Hyderabad, Andhra Pradesh.
Death
1985. Bombay, Maharasthra.

Education
Self – taught.

Selected Exhibitions
1942	Bombay. (Also 1950, '54).*
1948	Inaugural Ex.: PAG, Bombay Art Society's Salon, Bombay.
1949–55	Group Ex.s with PAG, Bombay, Ahmedbad, & Baroda.
1950	Calcutta Group–PAG Joint Ex., Calcutta.
1956–63	Group Ex.s with 'Bombay Group'.
1960	Bombay*
1963	**Black Nude Series**: Bombay.*
	Inaugural Ex.: Pundole Art Gallery.

Illustrated Works
c.1948	Bathers	136
1963	Black Nude Series	48

BADRINARAYAN

Birth
22 Jly 1929. Secunderabad, Andhra Pradesh.

Education
Self–taught.

Selected Exhibitions
1955	'Indian Art Ex.', Romania, Czechoslavakia, Hungary and Bulgaria.
1957	I Asian Artists Ex., Tokyo, Japan.
1961	2nd Paris Biennale, France.
1963	Vitrum Studio, Geneva.
	Taj Art Gallery, Bombay. (Also 1964).*
1964	'International Graphic Arts', Prague, Czechoslovakia.
1965	National Ex., RB.LKA. (LKNA: **The Family**).
1966	'Art Now in India' Newcastle, England & Ghent, Belgium.
1966–7	5th International Biennale of Prints, Tokyo, Japan.
1968	I, II International Triennale, RB.LKA. (1971)
	'Man and his World', Indian Pavilion, Montreal, Canada.
1976	Surya Gallerie, Freinsheim, W. Germany.*
1980	'Four Indian Artists', Surya Gallerie, Freinsheim, W. Germany.
1982	'Indian Art Today', Darmstadt, W.Germany.
1985	'Collectors Choice', Gy.CH.
1985–6	University of North Dakota, USA.*
1987	Festival of India, Moscow, USSR.
1988	'Art for CRY', Bombay, New Delhi, Calcutta & Bangalore.
1989	B.A.S.Centenary Ex., Bombay.
1990	Pundole.*
1991	Sakshi Gallery, Madras and Bangalore.*
1992	'Journeys Within Landscape', JG. (Organised by Sakshi).
1993	'Watercolours', Pundole.*

Illustrated Works
1960	King and the Monk	241
1965	The Family	177

BARWE, Prabhakar

Birth
16 Mar 1936. Nagaon, Maharashtra.
Death
6 Dec 1995. Mumbai, Maharasthra.

Education
1954–9 Diploma (Fine Arts), J.J. School.

Selected Exhibitions
1959–76	National Annual Ex.s, RB.LKA.
1961	JG.*
1963	Book Bay Gallery, Wisconsin, USA.*
1967	Taj Art Gallery, Bombay. (Also 1968).*
1969	Fifth International Young Artists, Tokyo, Japan.
	'Man and his World', Indian Pavillion, Montreal, Canada.
	'Art of India & Iran', USA.
1970	Pundole.*
	'Indian Painters', Gallery Coray, Zurich, Switzerland.
1971	Gallery Chanakya, New Delhi. (Also 1978).*
	II, III, IV & V International Triennale, RB.LKA. (1975, '78 & '82).
1972	Inaugural Ex.: Gallerie Surya, Freinsheim, W.Germany.
1973	Gy.CH (Also 1983 & '87).*

1975	Inaugural Ex.: Grey Art Gallery, New York University, USA.
1976	Menton Biennale, France.
	National Ex., RB.LKA. (LKNA: **Blue Cloud**).
1977	'Pictorial Space', RB.LKA. (Curated by G.Kapur).
1978	'New Contemporaries', Bombay.
1981	'Indian Painting Today' JG.
1982	Inaugural Ex.: Bharat Bhavan, Bhopal.
	'Modern Indian Painting' Hirschorn Museum & Sculpture Garden, Washington D.C., USA.
	Contemporary Art Gallery, Ahmedabad.*
1984	Gallery 7, Bombay.
1985	I Asian–European Art Biennale, Titograd, Yugoslavia; Ankara & Istanbul, Turkey.
1987	'Indian Drawing Today', JG.
1988	'Seventeen Indian Painters: Celebrating Gallery Chemould's 25 Years at the Jehangir', JG.
1989	IX Biennale, Valpariso, Chile.
1991	'State of the Art', An Ex. of Electronically–aided canvases, JG.
1992	'Journeys Within Landscape', JG. (Organised by Sakshi).
1993	Gy.CH.*
	'Reflections & Images', Vadehra & JG. (Organised by Vadehra).
	Asprey's HelpAge Auction, JG.
1995	'Watercolours: A Broader Spectrum– II', Gy.CH. (Group Show with C.Douglas, G.Haloi, P.Kolte, M.Rai, V.Sundaram).

Illustrated Works

c.1973	Untitled	180
1976	Blue Cloud	85
1988	Alphabets of Nature	2
1990	Lamp and the Empty Box	105
1991	The Clock	235
1993	Chest Series: The Trunk with a Rainbow	242
	Chest Series: The Red Box	243

BAWA, Manjit

Birth
30 Jly 1941. Dhuri, Punjab.

Education
1958–63	Delhi School of Art, New Delhi.
1964	London School of Printing, Warden, Essex, UK.
1967–71	Worked as Seriagrapher, London.

Selected Exhibitions
1963	Annual Ex., Delhi Shilpi Chakra, New Delhi.
1969	Craven Terrace, London **(FS)**.*
1977	'Pictorial Space', RB.LKA (Curated by G.Kapur).
	'Two Painters (M.Bawa & Amithava Das)', Black Partridge Gallery, New Delhi.
1979	Dhoomimal.*
1980	National Ex., RB.LKA. (LKNA: **Purple Panther**).
1982	Asian Art Ex., Fukuoka Art Museum, Japan.
	'Modern Indian Paintings', Hirschorn Museum & Sculpture Garden, Washington D.C., USA.
	'Contemporary Indian Art', Festival of India, Royal Academy of Art, London.
	Inaugural Ex.: Bharat Bhavan, Bhopal.
1984	Cymroza.*
1985	I Asian–European Art Biennale, Titograd, Yugoslavia; Ankara & Istanbul, Turkey.
	II Havana Biennale, Cuba.

1988	Takaoka Municipal Museum of Art & Meguro Museum of Art, Tokyo, Festival of India, Japan.
1989	'The Times of India Auction of TIMELESS ART', Sotheby's Auction, Bombay. 26 March 1989.
1991	'Images the Poet and the Painter, CCA.*
	Sakshi Art Gallery, Madras.*
	'State of the Art', An Ex. of Electronically–aided canvases, JG.
1992	Cymroza.*
	'The Subjective Eye', Sakshi. (Curated by Abhishek Poddar).
	'Indian, European and Oriental Paintings and Works of Art', Sotheby's Auction, New Delhi. 8–9 October 1992.
1993	CCA.*
	Bharat Bhavan, Bhopal.*
	'Wounds', CIMA & NGMA.
	'Trends and Images', CIMA.
	'Reflections & Images', Vadehra & JG.
	(Organised by Vadehra).
1995	Espace.*
	'Contemporary Indian Paintings: from the Chester & Davida Herwitz Collection' Part I, Sotheby's Auction, New York. 12 Jne1995.
	'Indian Contemporary Paintings', Christie's Auction, London. 16 Oct 1995.
	'Contemporary Indian Paintings: from the Chester & Davida Herwitz Collection' Part II, Sotheby's Auction, New York. 3 Apr 1996.
	'Modern and Contemporary Indian Paintings: OneHundred Years', Sotheby's Auction, London. 8 Oct 1996.

Illustrated Works

1982	Krishna with Dancing Cows II	208
1983	Untitled	206
1983	Siva with Snakes	3
1991	Flute Player with Cows	100

BENDRE, N.S.

Birth
21 Aug 1910. Indore, Indore State. (now part of Madhya Pradesh).
Death
1992.

Education
1929–34	Diploma (Painting), State School of Art, Indore. (Student of Y.D.Deolalikar).
1929–33	B.A., Holkar College (Agra University).
1947–8	Study Tour of USA, sponsored by Federation of American Artists (Philadelphia).
1948	Graphic art at the Art Students' League, New York. (Student of Armen Landeck).

Teaching Experience
1939–41	Evening Classes, Dadar, Bombay.
1950–9	Reader, Fine Arts Faculty, M.S. University, Baroda.
1959–66	Dean of Fine Arts Faculty, M.S. University, Baroda.

Selected Exhibitions
1934–43	B.A.S. Annual Ex..
1945	Art Society of India Annual Ex..
	Prince of Wales Museum, Bombay.*
1948	Windmere Gallery, USA (Travelling Ex.).*
1949	Bombay Art Society Salon, Rampart Row, Bombay.

1955	National Ex., RB.LKA. (LKNA: **Thorn**)
1960	Ex. of his abstract works, Baroda (Also in 1962).*
1966	Gujarat State LKA.
1968	I International Triennale, RB.LKA.
1974	Retrospective, JG.*
1985	'East–West Visual Encounter', Max Mueller Bhavan, Bombay.
1987	'Indian Drawing Today', JG.
1992	Individuals Cultural Centre, Jammu.*
1989	'The Times of India Auction of TIMELESS ART', Sotheby's Auction, Bombay. 26 March 1989.
1995	'Indian Contemporary Paintings', Christie's Auction, London. 16 Oct 1995.
1996	'Modern and Contemporary Indian Paintings: OneHundred Years', Sotheby's Auction, London. 8 Oct 1996.

Illustrated Works
| 1943 | Fisherwomen | 43 |
| 1987 | Untitled | 209 |

BHAGAT, Vajubhai

Birth
| 19 Dec 1915. | Lathi, Saurashtra, Gujarat. |

Death
| 12 Jan 1992. | Bombay, Maharasthra. |

Education
| 1938–42 | Diploma (Painting), J.J. School. |
| 1943 | Post–Diploma: Mural Decoration, J.J. School. |

Teaching Experience
| 1946–7 | Evening Classes, J.J. School. |

Selected Exhibitions
| 1945 | 'Indian Art' Burlington House Art Gallery, London. |
| 1981 | JG.* |

Illustrated Works
| 1949 | Fisherwomen | 138 |

BHARGAVA, Veena

Birth
| 1938. | Simla, Himachal Pradesh. |

Education
	Medical College, Calcutta.
1960	Art Students League, New York.
1957– 62	Diploma (Fine Arts), CGAC.

Selected Exhibitions
1972	JG.**(FS)**.*
1976	BAAC, Calcutta.*
1977	Black Partridge Gallery, Gallery Chemould, New Delhi and Bombay.* 'International Festival of Paintings, Cagnes–sur–Mer, France.
1978	IV International Triennale, RB.LKA.
1982	AH.* 'Seven Contemporary Painters of W. Bengal, BAAC.
1986	'Indian Women Artists', NGMA. National Ex., RB.LKA. (LKNA: **The Chrowringhee Crossing**).

1988	BAAC.*
	'Seventeen Indian Painters celebrating Gallery Chemould's 25 years at the Jehangir, JG & Gy.CH.
1989	'The Times of India Auction of TIMELESS ART', Sotheby's Auction, Bombay. 26 March 1989.
1993	'Wounds', CIMA & NGMA.
1994	Gallerie 88, Calcutta.* AH.*
1995	JG.*

Illustrated Works
| 1973 | Pavement Series | 81 |

BHASKARAN, R.B.

Birth
| 1942. | Madras. |

Education
1962–6	Advanced Painting, MGAC.
1964	Fresco Techniques at Bhanasthali Vidyapeeth College, Rajasthan. IAPA, UNESCO Scholarship for Intaglio Printmaking, Lithography & Ceramics at Ein Hod. Israel.
1976–7	Post–Graduate Studies in Printmaking, Portsmouth Polytechnic, England on a British Council Scholarship.
1979–81	Government of India, Cultural Scholarship.

Selected Exhibitions
1968	Ex.s in Madras, Bombay, Tel Aviv, Israel and Jerusalem.*
1971	Ex. at Suva, Fiji Islands.*
1972	'25 Years of Indian Art', RB.LKA.
1975	III International Triennale, RB.LKA.
1982	'Two Person Show', AH. (with K.M. Adimoolam).
1983	National Ex., RB.LKA. (LKNA: **Marriage Photo II**).
1986	Ex.s in Bangalore & Bombay.*
1989	Paul Lingren Memorial Ex., USIS, Madras.
1992	Ex.s in Bombay & New Delhi.* BAAC Jubilee Show, Calcutta.
1995	Cymroza.*

Illustrated Works
| 1991 | Life–Cycle Series | 210 |

BHATT, Jyoti

Birth
| 12 Mar 1934. | Bhavnagar, Gujarat. |

Education
1950–6	Diploma & Post–Diploma (Painting & Graphics), Faculty of Fine Arts, M.S. University, Baroda.
1957–9	Government of India, Cultural Scholarship.
1961–2	Italian Government Scholarship to study painting and etching at Academia de Bello Arti, Naples.
1964–6	Fulbright and J.D.R. IIIrd Fund Fellowship to study printmaking at Pratt Institute, USA.

Teaching Experience
| | Faculty of Fine Arts, M.S.University, Baroda. |

Selected Exhibitions

1956–62	National Ex. of Art, RB.LKA.
1957–8	'Baroda Group' in Bombay.
1959–61	International Biennale for Young Artists, Paris, France.
1963	Inaugural Ex., 'Group 1890', New Delhi.
	National Ex., RB.LKA. (LKNA: **Dark Landscape**).
1963–71	Solo shows of Prints and Paintings in Bombay, Ahmedabad and New Delhi.*
1964–6	3 Ex.s of Prints and Paintings in USA.*
1969	All–India Graphic Art Ex., New Delhi.
1972	Third International Graphics Art Biennale, Florence.
1978	Germany.*
1982–3	'Six Indian Photographers', Museum of Modern Art, Oxford, UK.
1984–94	Photographic Ex.s, New Delhi, Bombay, Calcutta, Bhopal, Baroda.*
1991	'National Exposition of Contemporary Art', NGMA.

Illustrated Works

1970	Self–Portrait	174

BHATTACHARJEE, Bikash

Birth
21 Jne 1940. Calcutta, West Bengal.

Education
1958–63	Diploma (Painting), Indian College of Art and Draughtsman ship, Calcutta.

Teaching Experience
1968–72	Lecturer (Fine Arts Dept.), Indian College of Arts and Draughtsmanship, Calcutta.
1973–82	Lecturer, CGAC.

Selected Exhibitions
1962	Academy of Fine Arts, Calcutta.
1965	Artistry House, Calcutta **(FS)**.*
	Tata Iron and Steel Company, Jamshedpur.*
1968	I, II, III and IV International Triennale, RB.LKA. (1971,'75, '78).
1969	IV Paris Biennale, France.
1970	SOCA, JG.
	Group Travelling Ex.: Yugoslavia, Romania, Czechoslovakia & Hungary. (Also in 1972).
1971	National Ex., RB.LKA. (LKNA: **The Totem**).
	Doll Series, BAAC. & Kunika–CH*
1972	National Ex., RB.LKA. (LKNA: **Man on the Swing**).
	'Twenty–five years of Indian Art', RB.LKA.
1973	USIS, Calcutta.
1974	Gy.CH. (Also 1976, '82).*
1977	'Pictorial Space', RB.LKA. (Curated by G.Kapur).
	Dhoomimal.*
1978	IV Biennale, Paris.
1981	'Indian Painting Today', JG.
	'Four Contemporaries of West Bengal', Calcutta & Bombay.
1982	'Contemporary Indian Art', Festival of India, Royal Academy of Art, London.
	'India: Myth and Reality– Aspects of Modern Indian Art', Museum of Modern Art, Oxford.
	'Modern Indian Painting', Hirschorn Museum & Sculpture Garden, Washington D.C.
	Calcutta Art Gallery, Calcutta.*
	'Seven Contemporary Artists of West Bengal', BAAC.

	'Contemporary Indian Art', W.Germany.
1984	Retrospective, JG*
1985	'East–West Visual Encounter', Max–Mueller Bhavan, Bombay.
1985–6	Festival of India, USA. Includes: 'Contemporary IndianArt', Grey Art Gallery & Study Center, New York University. 'Contemporary Art of India: The Herwitz Collection', Worcester Art Museum, Worcester, Massachusetts.
1986	**She**, Chitrakoot & Taj Art Gallery, Bombay.*
	'Visions', Calcutta.
1987	Festival of India, Geneva, Switzerland & Moscow, USSR.
	'Indian Drawing Today', JG.
	'Environs', BAAC & JG.*
	Taj Art Gallery, Bombay. (Also 1992).*
1989	**Durga**, BAAC.*
	'Sabari', Gallerie 88, Calcutta.*
	'The Times of India Auction of TIMELESS ART', Sotheby's Auction, Bombay. 26 March 1989.
1990	**The Boy**, Gallerie 88, Calcutta.*
1991	'Homage', Victoria Memorial, Calcutta.*
	Kala Yatra. *
	'National Exposition of Contemporary Art', NGMA.
1992	'Journeys Within Landscape', JG. (Organised by Sakshi).
1993	'Wounds', CIMA & NGMA.
	Gallerie 88, Calcutta.*
	Oberoi Hotel, New Delhi.
	Inaugural Ex.: 'Trends & Images', CIMA.
1994	'Recent Works', JG* (Organised by CIMA).
1995	'Contemporary Indian Paintings: from the Chester & Davida Herwitz Collection' Part I, Sotheby's Auction, New York. 12 Jne 1995.
1996	'Contemporary Indian Paintings: from the Chester & Davida Herwitz Collection' Part II, Sotheby's Auction, New York. 3 Apr 1996.
	'Modern and Contemporary Indian Paintings: One Hundred Years', Sotheby's Auction, London. 8 Oct 1996.

Illustrated Works

1971	Totem	4
1971	Doll Series	70
1979	Homage to Angurbala	Back Cover
1980	Portrait of Das	80
1982	Two Sisters No. 2	211

BOSE, Nandalal

Birth
3 Dec 1882. Kharagpur, Bihar.
Death
16 Apr 1966. Calcutta.

Education
1903–5	Commercial Class, Presidency College, Calcutta
1905–10	CGAC, Student of Abanindranath Tagore.

Teaching Experience
1910–4	Part–time teaching at Jurasanko, Nivedita Girls' School
1916–7	Part–time Art Classes at Vichitra Club
1918–21	ISOA, Calcutta, and temporary work at Kala Bhavan, Santiniketan.
1922–51	Adhyaksha, Principal of Kala Bhavan, Vaisva–Bharati University, Santiniketan.

Selected Exhibitions

1908	Inaugural Ex.: ISOA, Calcutta. (Also 1910, '12)
1909	ISOA Ex., Simla.
1911	ISOA's United Provinces Ex., Allahabad.
	Festival of Empire, Crystal Palace, England. (Organised by ISOA for George V's Coronation).
1914	22nd Ex. of Societe des peintres orientalistes francais, Grand Palais, Paris. Travelling to Belgium and Holland and Imperial Institute, England.
1915-6	ISOA Ex., Calcutta & Young Men's Indian Association, Madras
1924	Travelling Ex., USA. (Organised by American Federation of Art & ISOA).
1928	Athenee Gallery, Geneva, Switzerland. (Organised by James Cousins).
1935	Lucknow Session of the Indian National Congress.*
1937	Haripura Posters to decorate the Haripura Session of the Indian National Congress.*
1954	Retrospective Ex., Calcutta.*
1983	'Centenary Ex.', NGMA.
1991	'National Exposition of Contemporary Art', NGMA.
1995	'Man and Nature: Reflections of Six Artists', NGMA (Curated by Keshav Malik).
1996	'Modern and Contemporary Indian Paintings: One Hundred Years', Sotheby's Auction, London. 8 Oct 1996.

Illustrated Works

c.1908	Jagai Madhai	123
1937	Drummer : Haripura Posters Series	38

BROOTA, Rameshwar

Birth
21 Feb 1941.

Education

1960-4	Delhi College of Art.

Teaching Experience

1965-7	Teacher at Delhi College, Jamia Millia & Sarada Ukil for short intervals.
1967 –	Head of Art Dept., Triveni Kala Sangam, New Delhi.

Selected Exhibitions

1973-4	'Contemporary Indian Art', Poland, Yugoslavia, Bulgaria & Belgium.
1975	III, IV & V International Triennale, RB.LKA (1978 & '82).
1976	International Art Fair, Cagnes–sur–Mer, France.
1980	National Ex., RB.LKA. (LKNA: **Man–II**).
1981	National Ex., RB.LKA. (LKNA: **Winners Posthumous**).
1982	'India: Myth and Reality– Aspects of Modern Indian Art', Museum of Modern Art, Oxford, England. 'Modern Indian Paintings', Hirschorn Museum & Sculpture Garden, Washington D.C. 'Contemporary Indian Paintings', Darmstadt and other cities, W.Germany. Calcutta.*
1984	Gallery 7, Bombay.* Tokyo Biennale, Japan. National Ex., RB.LKA. (LKNA: **Man–17**).
1986	II Havana Biennale, Cuba. I Baghdad Biennale, Iraq.

Selected Exhibitions (continued)

1987	Festival of India, Geneva, Switzerland.
1988	Takaoka Municipal Museum of Art & Meguro Museum of Art, Tokyo, Festival of India, Japan. Smith's of Convent Garden, London (Organised by Arun Sachdev & Gallery 7, Bombay).
1990	Gallery 7, Bombay.
1995	Inaugural Ex.: 'River of Art', Art Today, New Delhi. 'Contemporary Indian Paintings: from the Chester & Davida Herwitz Collection' Part I, Sotheby's Auction, New York. 12Jne 1995. 'Indian Contemporary Paintings', Christie's Auction, London. 16 Oct 1995.
1996	'Modern and Contemporary Indian Paintings: One Hundred Years', Sotheby's Auction, London. 8 Oct 1996.

Illustrated Works

1971	Ape Series: That Unending Story	181
1979	Gorilla Series: Havaldhar	84
1982	Runners	195
1987	Unknown Soldier	Dedication
1988	Man. No. 22 (Triptych)	5
1991	Vanishing Figure	212

CAUR, Arpana

Birth
4 Sep 1954. New Delhi.

Education

	M.A. (Literature), Delhi University.
1991	Study Tour of China.

Teaching Experience

1977-9	Deshbandhu College, New Delhi.

Selected Exhibitions

1975	Shridharani.*
1979	RB.LKA (Also 1993).* Gallery 38, London.*
1980	JG (Also 1982 & '84)*
1981	City Hall Gallery, Ottawa, Canada.*
1982	Chapter Gallery, Cardiff, Wales, U.K.* October Gallery, London (Also 1987).*
1984	Ethnographic Museum, Stockholm, Sweden.* National Museum of Denmark, Copenhagen.* Fukuoka Art Museum, Tokyo. (Also 1985). (Organised by NGMA). First Indo–Greek Cultural Festival, New Delhi & Athens.
1985	AH (Also 1988).* Cymroza (Also 1989 & '94).*
1986	II Havana Biennale, Cuba. I Baghdad Biennale, Iraq. 'Indian Women Artists', NGMA. Dacca Biennale, Bangladesh. VI International Triennale, RB.LKA.
1987	'Indian Women Artists' Festival of India, Moscow, USSR. Academy of Fine Arts, Calcutta.* Algiers Biennale, Algeria.
1992	'Journeys Within Landscape', JG. (Organised by Sakshi).
1994	Asian Art Ex., Hiroshima Museum, Japan. Saytama Museum & Glenbarra Museum Ex.s, Japan.

| 1994–5 | 'Imagined City' at Museum of Modern Art in Brasilia, Sao Paulo & Rio de Janerio. |
| 1996 | 'Modern and Contemporary Indian Paintings: One Hundred Years', Sotheby's Auction, London. 8 Oct 1996. |

Illustrated Works
| 1995 | Where have all the Flowers Gone | 238 |

CHANDRA, Avinash

Birth
1931. Simla, Himachal Pradesh.
Death
1991. London.

Education
| 1947–52 | Diploma (Painting), Delhi Polytechnic. |
| 1965 | Rockefeller JDR III Fund Fellowship. |

Teaching Experience
| 1953–6 | Delhi Polytechnic. |

Selected Exhibitions
1951	Srinagar (FS).*
1953	New Delhi (Also 1954).*
1955	National Ex., RB.LKA. (LKNA: Trees)
1957	Imperial Institute, London.*
1958	National Gallery and Museum of Ireland.*
	Architectural Association, London.*
1959	Queen's University, Belfast, N.Ireland.*
1960	Bear Lane Gallery, Oxford, UK.*
	Molton Gallery, London.*
1963	Hamilton Galleries, London.*
1964	Documenta, Kassel, W.Germany.
1996	'Modern and Contemporary Indian Paintings: One Hundred Years', Sotheby's Auction, London. 8 Oct 1996.

Illustrated Works
| 1955 | Trees | 135 |

CHAVDA, Shiavix

Birth
1914. Navsari, Gujarat.
Death
1992. Bombay, Maharasthra.

Education
1930–5	Diploma (Fine Arts), J.J. School.
1935–8	Diploma (Fine Arts), Slade School, London. (Student of Prof. Randolf Schwabe).
1936–9	Part Time Student, St. Martin's School of Art, London.
1937	Academie de la Grande Chaumiere, Paris.
1955	Student with Mr. Helmut Ruhemann, Ex–Chief Restorer of National Gallery, London.

Selected Exhibitions
1945	Bombay (FS).*
	Indian Art, Burlington House Art Gallery, London.
1946	UNESCO International Ex., Paris.

1949	Ahmedabad.
1951	Djakarta, Indonesia.*
	Salon de Mai, Paris.
1952	Singapore.*
1955	London.*
1956	Paris.*
	Zurich, Switzerland.*
1956–63	Ex.s with 'Bombay Group'.
1960	Contemporary Art from India– Folkwang Museum, Essen.
1987	'Indian Drawing Today', JG.
1992	'Indian, European and Oriental Paintings and Works of Art', Sotheby's Auction, New Delhi. 8–9 Oct 1992.
1993	Retrospective, JG.*

Illustrated Works
| 1964 | Sarangi Player | 148 |
| | (Khan Shaheb–Ghulam Sabir Khan) | |

CHOWDHURY, Jogen

Birth
16 Feb 1939. Faridpur, Bengal.

Education
| 1955–60 | CGAC. |
| 1965–7 | French Government Scholarship to Ecole Nationale, Superieure des Beaux–Arts, Paris. Atelier 17 of S.W. Hayter, Paris. |

Teaching Experience
| 1987–92 | Reader, Kala Bhavan, Visva Bharati, Santiniketan. |
| 1993– | Professor, Visva Bharati University. |

Selected Exhibitions
1963	Academy of Fine Arts, Calcutta.*
1967	Gallerie du Haut Pave, Paris.*
1970	Sarala Art Centre, Madras.*
1971	II, III, IV International Triennale, RB.LKA (1975 & 78).
1973	AIFACS, New Delhi.*
1976	Tourist Centre, Embassy of India, Paris.*
1977	Gallery Chanakya, New Delhi.*
	'Pictorial Space', RB.LKA. (Curated by G.Kapur).
1979	Sao Paulo Biennale, Brazil.
1980	Modern Asian Art, Fukuoka Art Museum, Japan.
1981	BAAC.*
	Dhoomimal.*
	'Place for People', RB.LKA & JG.
1982	'Indian Painters', Worspede, Hanover, Braunscheweig, Beirut.
	'India: Myth and Reality– Aspects of Modern Indian Art', Museum of Modern Art, Oxford, England.
	'Contemporary Indian Art', Festival of India, Royal Academy of Art, London.
	'Modern Indian Paintings', Hirschorn Museum & Sculpture Garden, Washington D.C.
1985–6	'Artistes Indien en France', Festival of India, Paris.
1985–6	Festival of India, USA. Includes: 'Contemporary IndianArt', Grey Art Gallery & Study Center, New York University.
	'Contemporary Art of India: The Herwitz Collection', Worcester Art Museum, Worcester, Massachusetts.
1986	'Visions', Calcutta.
1986–7	II Havana Biennale, Cuba.
	I Baghdad Biennale, Iraq.

Bangladesh Biennale, Dacca.
'Contemporary Indian Painters', Panama, Mexico & Brazil.
'Contemporary Indian Painters', Frankfurt Book Fair, W.Germany.

1987 Festival of India, USSR & Switzerland.
1988 Takaoka Municipal Museum of Art & Meguro Museum of Art, Tokyo, Festival of India, Japan.
Olympiad of Art, Seoul, South Korea.
1990 Kala Yatra.*
1992 Nandan Gallery, Kala Bhavan, Santiniketan.
Inaugural Ex.: Husain ki Sarai, Faridabad, U.P. (Organised by Vadehra).
'The Subjective Eye', Sakshi (Curated by Abhishek Poddar).
1993 'Wounds', CIMA & NGMA.
'Trends and Images', CIMA.
Little Gallery, Calcutta.*
1994 Retrospective of Drawings, Seagull Foundation of Art,Calcutta. (Travelling show to Vadehra & Sakshi Galleries).*
'Contemporary Miniatures', CIMA.
'Drawing' 94', Organised by Gallery Espace at AIFACS.
1995 'Fantasy', CIMA.*
Le Monde de l'Art, Paris.
Gallery Raku, Kyoto, Japan.
'Watercolours: A Broader Spectrum–I', Gy.CH. (Group Show includes: A.Ambalal, J.Chowdhury, J.Chakravarty, Madhvi Parekh & A.Singh).
'Contemporary Indian Paintings: from the Chester & Davida Herwitz Collection' Part I, Sotheby's Auction, New York. 12 Jne 1995.
'Indian Contemporary Paintings', Christie's Auction, London. 16 Oct 1995.
1996 Ex. of Oils, CIMA.*
'Contemporary Indian Paintings: from the Chester & Davida Herwitz Collection' Part II, Sotheby's Auction, New York. 3 Apr 1996.
'Modern and Contemporary Indian Paintings: One Hundred Years', Sotheby's Auction, London. 8 Oct 1996.

Illustrated Works

1972	Reminiscences of Dream XVII Series	188
c.1974	Ganpati Series	244
1976	Life – II	77
1978	Tiger in the Moonlit Night	6
c.1987	Man & Woman	213
1993	Head	Back Cover

DAS, Amithava

Birth
27 May 1947. Delhi.

Education
1965–72 College of Art, Delhi.

Teaching Experience
1974–5 Lecturer at the Art Institute, Jamia Millia, New Delhi.
1975–7 Visiting Lecturer, College of Art & Women's Polytechnic, New Delhi.
1989 Fellowship from Federal Republic of Germany for Advanced Exposure to Design and Ex.s.

Selected Exhibitions
1969 'Art Today I', Kunika–CH.
1970 'Art Today II', Ashoka Gallery, Calcutta & Shridharani.

1971 'Art Today III: Graphics & Drawings', Asoka Gallery.
1974–5 'New Group' RB.LKA & JG. (Also 1979)
1976 'Twenty Artists', Shridharani Gallery.
National Ex., RB.LKA. (LKNA: Red Cloud A).
1977 'Two Painters', Black Partridge Gallery, New Delhi.
'Pictorial Space' RB.LKA. (Curated by Geeta Kapur).
1978 'Works on Paper', Dhoomimal.*
1979 'All India Ex. of Graphics' Government Museum & Art Gallery, Chandigarh.
1987 Bharat Bhavan Biennale, Bhopal.
1989 'Contemporary Indian Painting', Darmstadt, Germany.
'Artists Alert', New Delhi.
1990 Sakshi Gallery, Madras.*
1991 AH.*
'Three Contemporary Artists', Bremen, Germany.
1992 'Pioneers to the New Generation', Arts Acre, W. Bengal.
1993 Indische Gegenwartskunst, Mainz, Germany and Stettin, Poland.
'India Songs – Multiple Streams in Contemporary IndianArt', Art Gallery of New South Wales, Sydney.
1994 'Drawing '94', AIFACS (Curated by Prayag Shukla & organised by Espace).
1995 'Works on Paper from 1972–94', Sakshi. (Travelling to Eicher Gallery, New Delhi).*
'View from the Edge', JG (Curated by Sanjay Kumar & organised by Sakshi).

Illustrated Works

| 1988 | Situation III | 112 |

DAS, Sunil

Birth
4 Aug 1939. Calcutta.

Education
1954–9 Diploma in Painting, CGAC.
1961–3 (Murals) L'Ecole Nationale Superior des Beaux Arts, Paris. (On a French Government Scholarship).

Selected Exhibitions
1958 National Ex., RB.LKA. (LKNA: Three Horses)
1961 Salon de la Jeune Peinture, Paris.
1961–3 La Gallery Foyer des Art, Paris.
Prix de Dome, Paris.
Biennale de Prix, Paris.
Club de Quter Vents, Galery Dean la–Found, France.
Gallery Maison des Beaux Arts, Paris.
1964 Dhoomimal.*
1965 Kunika–CH.*
1966 Gy.CH*
Retrospective, Calcutta.*
1969 Retrospective, BAAC.*
1970 SOCA, JG.
1970–2 Indiche Kunst der Gegnwant, Gallery Coray, Zurich, Switzerland.
'Man and his World', Indian Pavilion, Montreal, Canada. (Organised by LKA).
1971 II International Triennale, RB.LKA.
Heidelburg, Germany.*
1973–5 Everson Museum, New York & Switzerland.
1975 Pioker Gallery, Hamilton, New York.*
Hilton Gallery, Frankfurt, W.Germany.
1976 Retrospective, Calcutta.*

1976–8	Ex.s in Basle, Zurich, Dusseldorf, Hamburg, New York.*
1978	National Ex., RB.LKA.(LKNA: **Rotation of Mankind**).
1979–81	Retrospective, Kuala Lumpur, Basle, New York.*
1981–3	'Four Indian Artists', Stockholm.
1984	Dhoomimal.*
1986	Tokyo Biennale, Japan.
	Zeitgenossissche Indiscme, Malerei, Germany.
1987	'Early Drawings (1956–62)', Chitrakoot.*
	'Indian Drawing Today', JG.
	'Contemporary Art, Centre for Culture and Molecular Biology, Hyderabad.
	XX Sao Paulo Biennale, Brazil.
	II Havana Biennale, Cuba.
	'Nehru and Environment', RB.LKA.
1988	Takaoka Municipal Museum of Art & Meguro Museum of Art, Tokyo, Festival of India, Japan.
1990–3	'Bengal Art Today', Gallerie 88, Calcutta.
	'Award Winners (1955–90), RB.LKA
	'Contemporary Art of India', Glenbarra Art Museum, Japan.
	'Image of Joy and Despair', National Museum of Singapore. (Organised by Joshua Art Gallery).
	'Contemporary Paintings from India, Veridan Gallery, New York.
	'Calcutta 300: Through the Eyes of Painters', BAAC.
	'East Meets West', Oxford Gallery, New York.
	Society of Contemporary Artists: Calcutta & Madras.
	'Contemporary Artists of India', Gallery Art and Data, Germany, Poland.
1992	Inaugural Ex.: Husain ki Sarai, Faridabad, U.P. Organised by Vadehra).
	Gallery Katayun, Calcutta.
	'Journeys Within Landscape', JG. (Organised by Sakshi)
	'Indian, European and Oriental Paintings and Works of Art', Sotheby's Auction, New Delhi. 8–9 Oct 1992.
1993	'Artists for HelpAge', Asprey's Auction, JG. Apr 1993.
	'Wounds', CIMA & NGMA.
	'Reflections & Images', Vadehra.
1994	CIMA.*
1995	Village Gallery, New Delhi.*
	'Indian Contemporary Paintings', Christie's Auction, London. 16 Oct 1995.
1996	'Modern and Contemporary Indian Paintings: One Hundred Years', Sotheby's Auction, London. 8 Oct 1996.

Illustrated Works

1962	Bull & Matador Series	153
1965	Untitled	75
1992	Untitled	214

DASGUPTA, Bimal

Birth
| 1917. | Bengal. |

Death
| 1995. | New Delhi. |

Education
| 1937–43 | Diploma (Painting), CGAC. |
| 1961–2 | Govt. Scholarship to travel around Europe. |

Teaching Experience
| 1963–77 | Delhi College of Art. |

Selected Exhibitions
1952	Contemporary Indian Art Travelling Ex.: China, Japan & Australia.
1955	AIFACS **(FS)**.*
1956	Delhi Silpi Chakra Art Gallery, New Delhi .*
	National Ex., RB.LKA. (LKNA: **The Blue Infinity**).
1957	Artistry House, Calcutta.*
1958	Travel Indian Art Ex.: Moscow, Germany & Poland.
1961	Marshal Kowaska Gallery, Poland.*
	Pargaman Museum, Berlin.*
1964	Dhoomimal (Also, 1970, 72, 77, 83).*
1965	Sao Paulo Biennale, Brazil
1966	Chicago*
1968	I, III & IV International Triennale, RB.LKA. (1975 & '78)
1970	Expo '70, Museum of Modern Art, Tokyo, Japan.
1972	18 Artists at Palo Alto, San Francisco.
1979	Contemporary Indian Art, Frankfurt, W.Germany.
	Travelling Ex. of Poland, Czechoslovakia, Hungary & Bulgaria.
	Asian Artists Ex., Fukuova Art Museum, Tokyo, 1979.
1980	Sarala Art Gallery, Madras.
	'Calcutta Painters' Group Show, Calcutta.
1982	'Calcutta Painters' Group Show, Calcutta.
1985–6	Festival of India, Paris.
1986	Festival of India, Moscow, USSR.

Illustrated Works
| 1964 | Reminiscence | 157 |

DASGUPTA, Dharamnarayan

Birth
| 7 Aug 1939. | Tripura. |

Education
| 1957–61 | Student at Kala Bhavan. |

Selected Exhibitions
1963	Artistry House, Calcutta **(FS)***
1966	Six Painters, Artistry House, Calcutta.
1979–80	Kala Yatra Ex.: Madras, New Delhi, Calcutta & Kuala Lumpur.
1981	'Indian Painting Today', JG.
1982	Kala Yatra Ex.: Bombay, Bangalore, London, Paris & Manchester.
1985	Dhoomimal.* (Also 1991)
1986	VI International Triennale, New Delhi.
	II Havana Biennale, Cuba.
	Contemporary Indian Paintings, Frankfurt, W.Germany.
1987	Eight Contemporary Artists, BAAC.
	XIX Sao Paulo Biennale, Brazil.
1988	Chitrakoot.*
1989	Bombay Art Society Cenetary Invitees Show, Bombay.
1992	BAAC Silver Jubilee, Calcutta.
1993	'Wounds', CIMA & NGMA.

Illustrated Works
| c.1989 | Untitled | 215 |

DAVE, Shanti

Birth
1931.

Education
1956 Post Graduate Diploma (Painting), M.S. University, Baroda.

Selected Exhibitions
1956 Baroda Group of Artists, Bombay.
1956 National Ex., RB.LKA. (LKNA: **Goats**).
1957 JG.*
 National Ex., RB.LKA. (LKNA: **Life**).
 South East Asian Art Ex., Manila.
1958 National Ex., RB.LKA. (LKNA: **The River Bank**).
1960 Kumar Gallery, New Delhi.*
 International Graphics Ex., Lugano, Switzerland.
1961 Grabowski Gallery, London.*
 Paris Biennale, Paris.
1962 Commonwealth Ex., London.
1963 Frankfurt Kunstkabinett, W. Germany.*
 Gallery Liguria, Rome.*
 Hadassah Klatchkin Gallery, Tel Aviv, Israel.*
 Asia Society, New York.
1964 Hungry Horse Art Gallery, Paddington, UK.
1965 Gallery 331, New Orleans.*
 Ahmedabad Museum, Ahmedabad.*
 Dhoomimal. (Also 1974, '78 & '84).*
 Sao Paulo Biennale, Brazil
 'Ten Contemporary Painters form India',
 University of South Florida, Tampa.
 Jacksonville Art Museum.
 Dalgado Museum of Art, New Orleans.
 Hunter Gallery of Art, Chattanooga, Colorado Springs.
 Long Beach Art Institute, San Francisco.
 East West Centre, Honolulu.
1966 Gy.CH (Also 1968).*
1972 Gallery Chanakya, New Delhi.*
1975 III & IV International Triennale, RB.LKA. (1978).
1978 Sarala Art Centre, Madras.*
1978-9 'Indian Contemporary Art Ex., Sofia, Prague,
 Tehran, Warsaw and Damascus.
1979 Pundole.*
 Arab Cultural Centre, Damascus.*
 Asian Artists' Ex., Fukuoka Art Museum, Japan.
1981 Urja Art Gallery, Baroda.*
1983 Koninujk Institute, Amsterdam.
1987 Chitrakoot Gallery, Calcutta.*
 Festival of India, Moscow, USSR
1988 Takaoka Municipal Museum of Art & Meguro Museum of Art,
 Tokyo, Festival of India, Japan.
1990 Gallery Crimson, Bangalore.*
1991 'National Exposition of Contemporary Art', NGMA.

Illustrated Works
1962 Untitled 158

DE, Biren

Birth
8 Oct 1926. Faridpur, Bengal.

Education
1944-9 Diploma (Fine Arts), CGAC.
1959-60 Fulbright Scholarship, USA.

Teaching Experience
1952-63 Lecturer, College of Art and Polytechnic, New Delhi.
1968 Visiting Faculty Member, School of Planning & Architecture,
 New Delhi.

Selected Exhibitions
1951 Salon de Mai, Paris, France.
1952 Freemasons Hall, New Delhi.
 (Organised by Delhi Silpi Chakra).
1953 AIFACS. (Also 1954, '56).*
1958 National Ex., RB.LKA. (LKNA: **Apparition**).
1959 Mainichi Biennale, Tokyo, Japan. (Also 1961).
1960 'Contemporary Art from India', Museum Folkwang, Essen,
 W.Germany.
1961 Sao Paulo Biennale, Brazil.
 Kunika-CH.*
1962 Venice Biennale, Italy.
1964 National Ex., RB.LKA. (LKNA: **Dying Ogre**).
1965 'Ten Contemporary Indian Painters', MIT, Cambridge, USA.
1967 Pittsburgh International Ex. of Contemporary
 Paintings and Sculpture, USA.
1968 I, II, III, IV & V International Triennale India, New Delhi (1971,
'75,' 78 & '82).
1971 'Contemporary Indian Painting' Ex.,
 Washington D.C, Pasadena, and Toronto.
 Gallery Chanakya, New Delhi.*
1973 Sydney Biennale, Australia
1977 'Two Painters from India' Ex.,
 Museum of Modern Art, Belgrade, Yugoslavia.
1979 'Modern Asian Art', Fukuoka Art Museum, Japan.
 (Also 1980).
1982 'Contemporary Indian Art', Festival of India,
 Royal Academy of Art, London.
 'Modern Indian Painting', Hirschorn Museum
 and Sculpture Garden, Washington D.C.
1983 'Neo-Tantra Art' Ex., Stuttgart, W.Germany.
1984 Tokyo Biennale, Japan.
1985-6 'Neo-Tantra: Contemporary Indian Painting Inspired by
 Tradition', Festival of India, Frederick S.Wight Art Gallery,
 University of California, Los Angeles, USA.
1988 Takaoka Municipal Museum of Art & Meguro Museum of Art,
 Tokyo, Festival of India, Japan.
1995 'Contemporary Indian Paintings: from the Chester & Davida
 Herwitz Collection' Part I, Sotheby's Auction, New York.
 12 Jne 1995.
 'Inaugural Ex.: River of Art', Art Today, New Delhi.
1996 'Contemporary Indian Paintings: from the Chester & Davida
 Herwitz Collection' Part II, Sotheby's Auction, New York.
 3 Apr 1996.
 'Modern and Contemporary Indian Paintings: One Hundred
 Years', Sotheby's Auction, London. 8 Oct 1996.

Illustrated Works
1954 Jain Monks 145
1957 Apparition 55

1964	Genesis' 64	185
1970	You, July' 70	159
1978	Genesis	245
1990	Aug '90	7
1991	Oct '91	92

DODIYA, Atul

Birth
20 Jan 1959. Bombay.

Education
1977–82 B.A. (Fine Arts), J.J. School.

Teaching Experience
1983 Teacher, J.J. School.

Selected Exhibitions
1981	'Monsoon Show', JG.
1985	Gallery 7, Bombay. (Group Show with Pushpamala & V.Akkitham).
1988	'Seventeen Indian Painters: Celebrating 25 Years of Gallery Chemould at the Jehangir', JG & Gy.CH.
1988–9	'The Richness of the Spirit – Selection of Contemporary Figurative Indian Art', National Museum, Kuwait, and Egyptian Academy, Rome.
1989	Gy.CH (FS) (Also in 1991, '95).*
	'Indian Eclectics', French Embassy and Sanskriti Pratisthan, New Delhi.
	'India – Contemporary Art', World Trade Centre, Amsterdam.
	'Artists Alert: Ex. for Safdar Hashmi Memorial Trust', New Delhi.
1991	'State of the Art', An Ex. of Electronically–aided canvases, JG.
1992	Inaugural Ex.: Husain ki Sarai', Faridabad, U.P. (Organised by Vadehra).
	Exposition Collective, Cite Internatonal des Arts, Paris.
1993	Gallery Apunto, Amsterdam.*
	'The Spirit of India', de Bijenkorf, Amsterdam. (Group Show with Bhupen Khakhar & Sudarshan Shetty).
	'Artists for HelpAge', Asprey's Auction, JG. Apr 1993.
	'Reflections & Images', Vadehra & JG. (Organised by Vadehra).
	'Inaugural Ex.: Trends and Images', CIMA.
1995	'Indian Contemporary Paintings', Christie's Auction, London. 16 Oct 1995.
1996	'Bombay', JG. (Organised by RPG Enterprises).

Illustrated Works
| 1989 | The Room | 216 |
| 1995 | Dr. Patel's Clinic – Lamington Road | 117 |

DOUGLAS, C.

Birth
1951. Kerala.

Education
1971–6	Diploma (Painting), MGAC.
1991–3	Government of India, Cultural Scholarship.
1994–6	Study in Ceramics at European Ceramics Centre. [Charles Wallace Trust Fellowship].

Selected Exhibitions
1981	Gallerie am Horwath House, Murnav, Germany.*
1982	Bayarishs Verins Bank, Garmish, Germany.*
1984–8	Munich Artists at Rathouse: Ex. of the Professional Artists, Grosse Kunst Ausstellung, Munich, W.Germany.
1986	European Patant Art Gallery, Munich.*
	International Art from Munich Studios.
1990	Bharat Bhavan Biennale, Bhopal.
	Three Indian Artists, European Art Gallery, Munich.
	'Touchstone', Sakshi Gallery– Bangalore & Madras.
1991	'9 Indian Contemporary Artists', Gemeinde Museum, Arnhem, Amsterdam.
	Rimbaud '91, Madras and Besancon, France. (Organised by Alliance Francaise de Madras.)
	'Artists for HelpAge', Asprey's Auction, JG. Apr 1993.
1995	'View from the Edge', JG. (Curated by S.Kumar & organised by Sakshi).
	'Watercolours: A Broader Spectrum– II', Gy.CH (Group Show with P.Barwe, G.Haloi, P.Kolte, M.Rai, V.Sundaram)

Illustrated Works
| 1993 | Untitled | 234 |
| 1995 | Untitled | 104 |

DUTTA RAY, Shyamal

Birth
8 May 1934. Ranchi, Bihar.

Education
1950–5 Diploma (Painting), CGAC.

Teaching Experience
1954–6 Teacher, Jagdbandhu Institution, Calcutta.

Selected Exhibitions
1958	Academy of Fine Arts, Calcutta.
1962	S.C.A. Gallery, Calcutta (FS).*
1964	Artistry House, Calcutta.*
1966	Calcutta.*
1967	Durgapur, W.Bengal.
1968	Bombay.*
1969	Asian Graphic Prints. Travelling Ex., USA.
	Group 8: First All–India Ex. of Graphic Arts, New Delhi.
1970	SOCA, JG.
1972	25 Years of Indian Art, RB.LKA.
	SOCA, BAAC & RB.LKA.
1973	SOCA, BAAC. (Also 1975).
1976	'Western Pacific Print Biennale', Australia.
	'Prints from India', Algeria.
1977	Max Mueller Bhavan, Calcutta.*
1978	'Inter–Grafik', East Germany. (Also in 1979, 80, 84).
1980	All India Graphic Ex., Chandigarh.
	'Third World Biennale of Graphics, London & Baghdad.
1981	'Indian Painting Today', JG.
	'Four Contemporary Artists', Bombay.
1982	Kala Yatra Ex.: Bombay, Bangalore, London, Manchester, Paris.
	Inaugural Ex. Roopankar Museum of Fine Arts, Bharat Bhavan, Bhopal.
	7 Contemporary Artists, Calcutta.
	Calcutta Art Gallery.*
	National Ex., RB.LKA. (LKNA: **Overthrown**).
1983	Asian Art Biennale, Dacca, Bangladesh.
1984	Chitrakoot. (Also 1986, 88, 91)*

Kala Yatra & Sistas, Madras.*
1985	Espace.* (Also in 1991, 93)
1986	VI International Triennale, RB.LKA.
	II Havana Biennale, Cuba.
1987	'Indian Drawing Today' , JG.
1989	Gy.CH.*
1990	'Bengal Art Today', Gallerie 88, Calcutta.
	'Calcutta through the eyes of Painters', BAAC.
1991	Espace & Chitrakoot.*
1993	'Artists for HelpAge', Asprey's Auction, JG. Apr 1993.
1995	'Modern and Contemporary Indian Paintings: One Hundred Years',
	Sotheby's Auction, London. 8 Oct 1996.

Illustrated Works

| 1971 | Chair | 183 |
| 1981 | Overthrown | 79 |

GADE, H.A.

Birth
15 Aug 1917. Talegaon Dashasar, Amravati District, Vidarbha, Maharashtra.

Education

1933–8	B.Sc., Nagpur University.
1939	Nagpur School of Art (Part Time).
1949	Diploma (Fine Arts).
1950	M.A. (Art).

Teaching Experience

1933–8	Teacher, Mathematics and Science.
1944–8	Spencer Training College, Jabalpur.
1958–	Central Institute of Education, New Delhi.

Selected Exhibitions

1948	Inaugural Ex.: PAG,
	Bombay Art Society's Salon, Bombay.
	Bombay (FS).*
1949	Salon de Mai, Paris.
	Stanford University, USA.
1949–55	Group Ex.s with PAG, Bombay, Ahmedbad, Baroda.
1950	Calcutta Group–PAG Joint Ex., Calcutta.
1951	Basle. (Also 1956).
1954	Venice Biennale, Italy. (Also 1957).
1955–6	'Contemporary Indian Art', Travelling Ex. to USSR, Romania,
	Czechoslovakia, Hungary & Bulgaria.
1956–63	Group Ex.s of the 'Bombay Group'.
	B.A.S.Annual Ex.
1957	Dhoomimal. (Also 1994).*
	Venice.
1958	'Twenty Artists', New Delhi.

Illustrated Works

| 1955 | Yellow & Green | 141 |

GAITONDE, V.S.

Birth
1924. Nagpur, Maharashtra.

Education

| 1943–8 | Diploma (Painting), J.J. School. |
| 1964–5 | J.D.R. IIIrd Fund Fellowship, New York. |

Selected Exhibitions

1957	'5000 Years of Indian Art', Essen, W.Germany.
	'Young Asian Artists', Tokyo.
1959	New Delhi
	Graham Gallery, New York.*
	Gallery'59: Inaugural Ex., Bombay.
1960	Group Show with S.Gujral, M.F.Husain, K.Khanna, K.S.Kulkarni,
	M.Samant & Ramkumar.
1963	Gallery' 63, New York*
1966	Bombay (Also in 1967, '70, '73, '74, '77, '80).*
1969	'Art Today I' Kunika–CH.
1970	'Art Today II' Asoka Gallery, Calcutta & Shridharani.
1971	'Art Today III: Graphics & Drawings' Asoka Gallery.
1973	Gallery Chanakya, New Delhi.*
1982	'Contemporary Indian Art' Festival of India, Royal Academy of
	Art, London.
1987	Festival of India: USSR.
	'Indian Drawing Today', JG.
1988	Takaoka Municipal Museum of Art & Meguro Museum of Art,
	Tokyo, Festival of India, Japan.
1991	'Remembering Kali Pundole, on its 28th Anniversary', Pundole.
1995	'Indian Contemporary Paintings', Christie's Auction, London.
	16 Oct 1995.
1996	'Modern and Contemporary Indian Paintings: One Hundred Years',
	Sotheby's Auction, London. 8 Oct 1996.

Illustrated Works

1952	Untitled	147
1969	Untitled	160
1972	Untitled	8
c.1980	Untitled	207
1985	Untitled	93

GOUD, K. Laxma

Birth
1940. Nizampur, Andhra Pradesh.

Education

1957–62	Diploma (Drawing & Painting), Government College of
	Fine Arts and Architecture, Hyderabad.
1963–5	Post–Diploma: Murals Painting & Drawing.M.S.University, Baroda.
	(Student of Prof.K.G.Subramanyan).

Teaching Experience
Sarojini Naidu School of Performing Art, Fine Art & Communication, University of Hyderabad.

Selected Exhibitions

1965–7	Kala Bhavan, Hyderabad (FS)*
1971	Kunika–CH*
1972	Gy.CH*
1973	Ansdell Gallery, London*

1974	'Figurative Indian Artists', Warsaw, Budapest, Belgrade.	

1974 'Figurative Indian Artists', Warsaw, Budapest, Belgrade.
 Goethe Institute, Munich. (Also 1975).
 Surya Gallerie, Freinsheim, W.Germany.*
1975 Griffei Kunst, Hamburg (Also 1976).
1976 Black Partridge Gallery, New Delhi*
 Tokyo Print Biennale, Japan.
1977 Sao Paulo Biennale, Brazil.
1978 AH*
1982 'Contemporary Indian Painting', Festival of India, Royal Academy
 of Art, London.
1983 'India in Print', Koninklijk Institute Vorde, Amsterdam, the
 Netherlands.
1985-6 Festival of India, USA. Includes: 'Contemporary IndianArt', Grey
 Art Gallery & Study Center, New York University 1985.
 'Indian Art Today: 4 Artists' (M.F.Husain, Laxma Goud,
 K.Ramanujam & S.H.Raza), The Phillips Collection, Washington
 D.C. 1986.
 'Contemporary Art of India: The Herwitz Collection', Worcester
 Art Museum, Worcester, Massachusetts.
1987 'Contemporary Indian Art', Festival of India, Geneva, Switzerland.
1991 The Gallery, Madras.*
1992 'Journeys Within Landscape', JG. (Organised by Sakshi)
1995 'Contemporary Indian Paintings: from the Chester & Davida
 Herwitz Collection' Part I, Sotheby's Auction, NewYork.
 12 Jne 1995.
1996 'Contemporary Indian Paintings: from the Chester & Davida
 Herwitz Collection' Part II, Sotheby's Auction, New York.
 3 Apr 1996.
 'Modern and Contemporary Indian Paintings: One Hundred Years',
 Sotheby's Auction, London. 8 Oct 1996.

Illustrated Works

1972	Untitled	175
1986	Women in Interiors	9
c.1989	Four Women	Back cover
1991	Untitled	217
c.1991	Untitled	99

GUJRAL, Satish

Birth
Dec 1925. Jhelum, Pre-partition Punjab.

Education

1939-44	Mayo School of Arts, Lahore.
1944-7	Diploma (Fine Arts), J.J. School.
1952-4	Palacio Nationale de Belles Artes, Mexico.
	(Student of D.A. Sequeiros [Mural Techniques]).

Selected Exhibitions

1952	Dhoomimal.* (Organised by Delhi Silpi Chakra).
1953	Mexico City.*
1955	New York.*
1956	National Ex., RB.LKA. (LKNA: **Despair**)
	London.*
	Bombay.*
	New Delhi.*
1957	National Ex., RB.LKA. (LKNA: **The Condemned**).
1959	Calcutta.*
1960	Group Show with six other Artists: M.F. Husain, Mohan Samant,
	V.S. Gaitonde, Ram Kumar, K.S. Kulkarni, Krishen Khanna.
	Bombay.*

1961 New York.*
 Asoka Gallery, Calcutta.*
 Travelled with Ex.s to Cairo, Mexico, Rome,
 Frankfurt, Paris, London, Montreal, Hawaii and Tokyo.
1963 Triveni Kala Sangam, New Delhi*
 Bombay*
1964 New Delhi*
 Foram Gallery, New York.*
1966 'Paper Collages', New Delhi.*
1967 'Paper Collages', Bombay.*
1968 'Paper Collages', Travelling Ex. to New York, Finland, Sweden,
 Madrid, USSR, Mexico, Peru, Argentina & Brazil.
1969-70 'Metal Sculptures', New Delhi.*
 Murals at New Delhi, Ahmedabad, Madras and Calcutta.*
1971 'Metal Sculptures', Vesline University, USA.*
 Chicago.*
1972 Bombay.*
1973 National Ex., RB.LKA. (LKNA: **Construction I**).
1974 Gallery Chanakya, New Delhi.*
1978 'Brunt Woods', New Delhi.*
1980 'Brunt Woods', New Delhi.*
1986 Retrospective, RB.LKA.*
 Roopankar Museum, Bharat Bhavan, Bhopal.*
1990 'Brunt Woods', Bombay.*
1991 'National Exposition of Contemporary Art', NGMA.
1992 'Indian, European and Oriental Paintings and Works of Art',
 Sotheby's Auction, New Delhi. 8-9 Oct 1992.
1994 'Paintings', JG*
1995 'Paintings, Drawings & Sculptures', Art Today, New Delhi.*
 'Indian Contemporary Paintings', Christie's Auction, London.
 16 Oct 1995.

Illustrated Works

1956	Condemned	52
1967	Playmates (1)	63
1968	Untitled	178
1994	Composition	246

HALDAR, Asit Kumar

Birth
1890. Calcutta, W.Bengal.
Death
1964.

Education

1906-10	CGAC, Student of Abanindranath Tagore.
1923	Study tour through England, France and Italy.

Teaching Experience

1911-23	Principal, Kala Bhavan.
1924	Principal, Maharaja's School of Arts and Crafts, Jaipur.
1925-45	Principal, Maharaja's School of Arts and Crafts, Lucknow.
1934	Fellow of Royal Society of Art, London.

Selected Exhibitions

1908	Inaugural Ex.: ISOA, Calcutta. (Also 1910, '12)
1909	ISOA Ex., Simla.
1911	ISOA's United Provinces Ex., Allahabad.
	Festival of Empire, Crystal Palace, England. (Organised by ISOA
	for George V's Coronation).

1914	22nd Ex. of Societe des peintres orientalistes francais, Grand Palais, Paris. Travelling to Belgium and Holland and Imperial Institute, England.
1924	Travelling Ex., USA. (Organised by American Federation of Art & ISOA).
1928	Athenee Gallery, Geneva, Switzerland. (Organised by James Cousins).
1938	Inaugural Ex.: Haldar Hall, Allahabad Museum.

Illustrated Works
| 1929 | Jagai – Madhai & Nityananda | 130 |

HALOI, Ganesh

Birth
1 Jly 1936. Jamalpur, Mymensingh District, East Bengal. (now in Bangladesh)

Education
| 1952–6 | CGAC. |

Teaching Experience
| 1957–63 | Senior Artist, Archaelogy Dept., Government of India, Ajanta Caves, Aurangabad. |
| 1963–93 | Reader at CGAC. |

Selected Exhibitions
1962	Artistry House, Calcutta.*
1967	Academy of Fine Arts, Calcutta (Also in 1979, '87).*
1967–95	BAAC, Calcutta.
	AIFACS, New Delhi.
1971–95	SOCA Annual Ex.s.
1980	4 Contemporary Artists of West Bengal, Calcutta.
1987	'Metascape', Chitrakoot.*
1989	Chitrakoot.*
1991	'Indian Contemporary Artists, Multiculturalism & Internationalism through Art_, Melbourne.
1992	'Conflict', Chitrakoot.*
1993	JG.*
	'Wounds', CIMA & NGMA.
1994	'Inaugural Ex.: Trends and Images', CIMA.
	Indian Contemporary Art, Gallery Maya, Hongkong.
1995	Bose Pacia Modern, New York.
1995	'Watercolours: A Broader Spectrum– II', Gy.CH (Group Show with P.Barwe, C.Douglas, P.Kolte, M.Rai, V.Sundaram)
1996	CIMA.*

Illustrated Works
| 1992 | Untitled | 247 |
| 1995 | Untitled | 106 |

HEBBAR, Krishna K.

Birth
| 15 Jun 1911. | Kattingeri Village, Karnataka. |
Death
| 26 Mar 1996. | Mumbai. |

Education
| 1934–8 | Diploma (Painting), J.J. School. |
| 1949–50 | Academy Julian (Paintings) & Ecole Estinne (Graphics), Paris. |

Teaching Experience
| 1939–46 | J.J.School |

Selected Exhibitions
1941	Academy of Fine Arts, Calcutta
1945	Bombay (FS).*
1947	B.A.S. Annual Ex.
1949	Paris.*
1950	London.*
1951	Salon de Mai, Paris
1953	All India Ex. of Paintings & Sculptures, travelling to USSR, Poland & W.Germany.
1955	Venice Biennale, Italy.
1956	National Ex., RB.LKA. (LKNA: **Rhythm**).
1957	National Ex., RB.LKA. (LKNA: **Song of the Field**).
1958	National Ex., RB.LKA. (LKNA: **Mahim Darga**).
1959	Sao Paulo Biennale, Brazil.
1964	New York.*
1969	Bonython Art Gallery, Sydney, Australia.
1971	Retrospective, RB.LKA.
1987	'Indian Drawing Today', JG.
1993	Asprey's HelpAge Auction, JG.
1994	Vadehra.*
1996	'Contemporary Indian Paintings: from the Chester & Davida Herwitz Collection' Part I, Sotheby's Auction, New York. 12 Jne 1995. 'Modern and Contemporary Indian Paintings: One Hundred Years', Sotheby's Auction, London. 8 Oct 1996.

Illustrated Works
1947	To Maidenhood	248
1948	Pandits	46
1983–6	Holocaust	249
1989	Rituals	96

HORE, Somnath

Birth
| 1920. | Chittagong (now present–day Bangladesh). |

Education
| 1945 | CGAC. |
| | Self–Taught. |

Teaching Experience
1954–8	Lecturer, Indian College of Art and Draughtsmanship, Calcutta.
1958–67	Senior Lecturer & Head of Graphic Arts Faculty, Delhi Polytechnic of Art.
1966	Visiting Professor in Graphic Arts Faculty, M.S. University, Baroda.
1968–9	Visiting Professor in Kala Bhavan.
1969–84	Professor, Graphic Arts Dept., Kala Bhavan.
1984–	Prof. Emeritus, Santiniketan.

Selected Exhibitions
1956	Calcutta (FS). (Also 1957, '58, '61, '62, '68).*
	'Contemporary Indian Art', USSR, Romania, Hungary, Czechoslovakia & Bulgaria.
1960	Lugano International Graphics Biennale, Switzerland.
	New Delhi. (Also 1963, '65, '67)*
	National Ex., RB.LKA. (LKNA: **Companions**).
1962	Venice Biennale, Italy
	Tokyo Print Biennale, Japan.
	National Ex., RB.LKA.

(LKNA: **Birth of a White Rose**).
1963	Sao Paulo Biennale, Brazil.
	National Ex., RB.LKA. (LKNA: **Dream**).
1966	International Association of Plastic Artists Ex., Tokyo.
1968	Calcutta.*
	I International Triennale, RB.LKA.
	Warsaw Biennale of Graphic Arts, Poland.
	Lublijana Prints Biennale, Yugoslavia.
1969	Group 8: First All India Graphic Arts Ex., New Delhi.
1973	Kunika–CH.*
1974	1st International Graphics Ex., AIFACS
1986	'Visions', BAAC. (Organised by Ladies Calcutta Group).
1991	Calcutta.*
	'National Exposition of Contemporary Art', NGMA.
1993	'Wounds', CIMA & NGMA.
1996	'Contemporary Indian Paintings: from the Chester & Davida Herwitz Collection' Part II, Sotheby's Auction, New York. 3 Apr 1996.

Illustrated Works
1960	Companions	152
1977	Famine Series	187
1985	Untitled (Sculpture)	250

HUSAIN, Maqbool Fida

Birth
17 Sep 1915. Pandharpur, Maharashtra.

Education
Self–Taught. (Began career as a painter of cinema hoardings and designer of toys and furniture in Bombay, 1937–41).

Selected Exhibitions
1947	Bombay.
1948–56	Group Ex.s with PAG.
1950	Bombay Art Society's Salon, Bombay. **(FS)***
	Calcutta Group–PAG Joint Show, Calcutta.
1951	Salon de Mai, Paris.
1953	Venice Biennale, Italy. (Also 1955).
1955	National Ex., RB.LKA. (LKNA: **Zameen**)
1956	Zurich & Prague.*
1958 (Organised	'Eight Painters', International Culture Centre, New Delhi. by Tom Keehn).
1959	Sao Paulo Biennale, Brazil. (Also 1971 with special invitation).
	Tokyo Biennale, Japan.
1960	Rome.*
	Frankfurt.* (Organised by Henna Bekkar von Rath & Kumar Gallery).
	Asoka Gallery, Calcutta.*
1961	Gy.CH, Princess Street, Bombay.*
	Tokyo.*
1962	Asoka Gallery, Calcutta.*
1964	Dhoomimal.* (Also 1965, '67 & '69)
	'Indian Paintings Now', London. (Organised by Arts Council of Great Britain).
1965	Baghdad.*
	Kabul.*
	'Drawings: The Arab image', Gy.CH, Bombay & Calcutta, and Kunika–CH.*
	Dhoomimal.*
1966	'Commonwealth Art Ex.', London.

	'Art Now in India', Newcastle, England & Ghent, Belgium.
	New Delhi.*
	Brussels & London. (Organised by Gy.CH).
	Oberoi Intercontinental Hotel, New Delhi.*
	Rourkela. (Organised by Gy.CH).
1967	New York.*
	Poland.*
	Czechoslovakia.*
	Dhoomimal & Gita Gallery.*
	'25 Years of Paintings Seen in Bombay.', Gy.CH.
1968	'Images of Kerala', Pundole.*
	Ahmedabad. (Organised by Gy.CH).
1969	'21 Years of Painting', JG.* (Organised by Gy.CH).
	Dhoomimal & Gita Gallery.*
	'Art Today I', Kunika–CH.
1970	'Art Today II', Asoka Gallery, Calcutta & Shridharani.
1971	Sao Paulo Biennale, Brazil. (Special Invitee with Pablo Picasso)
1973	Gallery Chanakya, New Delhi.
	Retrospective, BAAC.*
1978	Retrospective, RB.LKA. (Organised by Art Heritage).*
1982	'Six Indian Painters', Tate Gallery, London.
	'Contemporary Indian Art', Festival of India, Royal Academy of Art, London.
	'India: Myth & Reality– Aspects of Modern Indian Art', Museum of Modern Art, Oxford, England.
	'Modern Indian Paintings', Hirschorn Museum & Sculpture Garden, Washington D.C., USA.
1985–6	Festival of India, USA. Includes: 'Contemporary Indian Art', Grey Art Gallery & Study Center, New York University 1985.
	'Indian Art Today: 4 Artists' (M.F.Husain, Laxma Goud, K.Ramanujam & S.H.Raza), The Phillips Collection, Washington D.C. 1986.
	'Contemporary Art of India: The Herwitz Collection', Worcester Art Museum, Worcester, Massachusetts.
	Bharat Bhavan Biennale, Bhopal.
1987	'Indian Drawing Today', JG.
	Festival of India, Moscow, USSR.
1988	Takaoka Municipal Museum of Art & Meguro Museum of Art, Tokyo, Festival of India, Japan.
1991	'National Exposition of Contemporary Art', NGMA.
	'Husain, Husain and Husain', Cairo, Egypt.
	'Remembering Kali Pundole, on its 28th Anniversary', Pundole
	'State of the Art', An Ex. of Electronically–aided canvases, JG.
	'Nine Indian Contemporaries', CCA.
1993	'Reflections & Images', Vadehra & JG. (Organised by Vadehra).
1994	Pundole.*
1995	'Inaugural Ex.: River of Art', Art Today, New Delhi.
	'Contemporary Indian Paintings: from the Chester & Davida Herwitz Collection' Part I, Sotheby's Auction, New York. 12 Jne 1995.
	'Indian Contemporary Paintings', Christie's Auction, London. 16 Oct 1995.
	'Maqbool 'Fida' Husain', Art Today, New Delhi.*
1996	'Contemporary Indian Paintings: from the Chester & Davida Herwitz Collection' Part II, Sotheby's Auction, New York. 3 Apr 1996.
	'Modern and Contemporary Indian Paintings: One Hundred Years', Sotheby's Auction, London. 8 Oct 1996.

Illustrated Works
1950	Man Series	49
1955	Zameen (detail)	251
1956	Between the Spider and the Lamp	142
1972	Bhim: Mahabharata Series	186

1973	Ganga	10
1982	Mother Teresa Series	252
1990	Karbala: Civilisation Series	95

HUSAIN, Shamshad

Birth
20 Dec 1945. Bombay.

Education
1964–8	Diploma (Fine Arts),
	M.S. University, Baroda.
1979–80	Post-Graduation at
	Royal College of Art, London.
1983–5	Government of India Fellowship.

Selected Exhibitions
1964	Geneva, Switzerland.
	Gujarat State Ex.. (Also 1965).
1965	AIFACS Annual Ex.. (Also 1970, '74, '76, '80, '82).
1968	Hyderabad & New Delhi. (FS).*
1969	Pundole (Also 1970, '71, '93).*
	'Art Today I', Kunika–CH. (Also 1971).
1970	New Delhi (Also 1984).*
1972	Bombay (Also 1974, '76, '78, '83, '86, '91).*
1973	Copenhagen, Denmark.*
	Hoffheim, Werl, W. Germany (Also 1980 & '84).*
	'Two Painters', London.
	Gallery Denberg, Geneva, Switzerland. (Also 1975 & '77).*
1974	Hyderabad.*
1975	III, IV, V & VI International Triennale, RB.LKA. (1978, '82 & '86)
1977	Perth Festival, Australia.
1978	AH.*
1978–9	Kala Yatra Travelling Ex.– Delhi, Calcutta, Nagpur, Hyderabad, Bangalore, Goa, Madras, Cochin, Kuala Lumpur.
1980	Royal College of Art, Annual Ex., London.
	Asian Youth Festival, London.
1982	Inaugural Ex.: Bharat Bhavan, Bhopal.
1983	Baroda.*
	Hyderabad.*
	National Ex., RB.LKA. (LKNA: **Painting VI**).
1984	Tokyo Biennale, Japan.
1984–5	'Five Artists' Travelling Ex.– Hyderabad, Bombay, New Delhi, Calcutta, Bangalore, Madras.
1985	'Asian Art', Fukuoka Art Museum, Japan.
1985–6	Travelling Print Ex., USA.
1986	Bharat Bhavan Biennale, Bhopal.
	Madras.*
	Asian Biennale, Dacca.
	Ankara Biennale, Turkey.
	Festival of India, Moscow, U.S.S.R.
1986	I & II Bharat Bhavan Biennale, Bhopal (1988).
1987	Bangalore.*
1991	'Husain, Husain and Husain', Cairo, Egypt.
	'National Exposition of Contemporary Art', NGMA.
	Pundole.*
1993	'Artists for HelpAge', Asprey's Auction, JG. Apr 1993.
	'Reflections & Images', Vadehra & JG. (Organised by Vadehra).
1995	'Contemporary Indian Paintings: from the Chester & Davida Herwitz Collection' Part I, Sotheby's Auction, New York. 12 Jne 1995.

'Indian Contemporary Paintings', Christie's Auction, London. 16 Oct 1995.

| 1996 | 'Modern and Contemporary Indian Paintings: One Hundred Years', Sotheby's Auction, London. 8 Oct 1996. |

Illustrated Works
| 1980 | Untitled | 218 |

KALEKA, Ranbir Singh

Birth
1953. Patiala, Punjab.

Education
1970–5	Diploma (Painting),
	College of Art, Punjab University, Chandigarh.
1985–7	M.A. (Painting), Royal College of Art, London.
	(On a Charles Wallace Trust Fellowship).

Teaching Experience
1976–7	Fine Arts Dept., College for Women,
	Punjabi University, Patiala.
1980–5	Delhi College of Art, New Delhi.

Selected Exhibitions
1977	First All India Ex. of Surrealism, AIFACS
	Pictorial Space, LKA
1979	National Ex., RB.LKA. (LKNA: **Painting III**).
1980	Drawings' 80: All India Ex. of Drawings, Chandigarh
1982	India: Myth & Reality– Aspects of Modern Indian Art, MOMA, Oxford, England
	Contemporary Indian Art, as part of the Festival of India, Royal Academy of Art, London
1985	Contemporary Indian Art, as part of the Festival of India, Grey Art Gallery, New York University, New York, USA
1986	Contemporary Indian Art, Bucknell University, Lewisburg, Pennsylvania, USA
1987	Contemporary Indian Art, Robert Hull Fleming Museum, University of Vermont, Burlington, USA
	'Coup de Couer', Halles de L'Ile, Festival of India, Geneva, Switzerland
1988	Seventeen Indian Painters 'Celebrating 25 years at the Jehangir', JG & Gy.CH.
1994	Summer Ex.: Invited Artist– Royal Academy of Art, London
1995	'Indian Winter Mixed Show: An Ex. of Oriental antiques and Modern Indian Art', Smith Jariwala Gallery, London.
	Pitshanger Manor Gallery, London.
	'Contemporary Indian Paintings: from the Chester & Davida Herwitz Collection' Part I, Sotheby's Auction, New York. 12 Jne 1995.
1996	'Contemporary Indian Paintings: from the Chester & Davida Herwitz Collection' Part II, Sotheby's Auction, New York. 3 Apr 1996.
	Art Today, New Delhi*
	'Watercolours: A Broader Spectrum– III', Gy.CH (Group Show includes: T.Hyman, R.Kaleka, B.Khakhar, N.Malani, G.m.Sheikh, N.Sheikh).

Illustrated Works
1974	Nuptial Bubbles	88
1984	Family – I	219
1993	Family – II	11
1995	Scroll with Sculpture	233

KAR, Sanat

Birth
1935. W.Bengal.

Education
1950–5 Diploma (Painting), CGAC.

Teaching Experience
1953–9 Founder, Artists Circle, Calcutta.
1974–6 Teacher, Kala Bhavan.
1976–89 Head of Graphic Arts Faculty,
 Kala Bhavan.
1989–91 Principal, Kala Bhavan.

Selected Exhibitions
1961–95 SOCA Annual Ex.s.
1962 Calcutta **(FS)**.*
1967 Gy.CH, Calcutta.*
1969 New Delhi. (Also 1972).*
 Group 8: First All India Graphic Arts Ex., New Delhi.
1975 Nandan Gallery, Kala Bhavan, Santiniketan. (Also 1980).*
1976 Tokyo Print Biennale, Japan.
1979 Bangalore.*
1981 Goa.*
1983 'India in Print', Koninklijk Institute Vorde, Amsterdam.
1984 AH.*
 British Biennale of Prints, London.
1985 Cymroza.*
 Camlin Gallery, Bombay.*
 Sarala Art Gallery, Madras.*
 IV International Ex. of Small Graphic Forms, Poland.
 'Indian Printmaking Today', JG.
1987 'Eight Contemporary Artists', BAAC.
1988 Takaoka Municipal Museum of Art & Meguro Museum of Art,
 Tokyo, Festival of India, Japan.
 Kala Yatra.*
1989 Pundole. (Also 1991).*
1990 Calcutta. (Also 1992, '95).*

Illustrated Works

1984	Dreamer Series	253
c.1989	Ikebana Series	254

KEYT, George

Birth
1901. Kandy, Ceylon.
Death
1992.

Education
Self–taught.

Selected Exhibitions
1919 Ceylon Society of Arts, Colombo, Ceylon.
1928 W.W.Beling Memorial Group Ex., Colombo.
1929 Art Club, Colombo.
1930 Ex. with J.C.Beling and C.F.Winzer, Ferguson Memorial Hall,
 Colombo.
 Art Club, Colombo. (Also 1931 & '32).
1932 Joint Ex. with J.C.Beling, Motor Showrooms, Colombo.

1936 Joint Ex. with J.Daraniyagala, Colombo Art Gallery. (Organised by
 Ceylon Society of Arts).
1943 ''43 Group' Ex., Photographic Society, Colombo. (Organised by
 Lionel Wendt).
1946 Bombay.* (Organised by Mulk Raj Anand & Anil de Silva).
1995 'Contemporary Indian Paintings: from the Chester & Davida
 Herwitz Collection' Part I, Sotheby's Auction, New York. 12 Jne 1995.
1996 'Modern and Contemporary Indian Paintings: One Hundred Years',
 Sotheby's Auction, London. 8 Oct 1996.

Illustrated Works

1938	Yama & Savitri	129
1947	Reflections	44

KHAKHAR, Bhupen

Birth
1934. Gujarat.

Education
1952–4 B.A.
1954–6 B. Com.
1957–60 Chartered Accountancy.
1962–4 M.A. in Art Criticism,
 M.S. University, Baroda.

Teaching Experience
1976–9 Bath Academy, Corsham, England.

Selected Exhibitions
1965 JG.*
1967 Kunika–CH.*
1968 Sao Paulo Biennale, Brazil.
 I International Triennale, RB.LKA.
1972 Gy.CH.*
 Black Partridge Gallery, New Delhi.*
1977 'Pictorial Space', RB.LKA. (Curated by G.Kapur).
 Menton Biennale, France.
1978 'Six Who Declined to Participate', New Delhi.
1979 'Focus: 4 Painters Directions', Gy.CH. (Artists Include: B.Khakhar,
 T.Mehta, A.Padamsee & G.Patel; curated by G.Kapur).
1981 'Place for People', JG & RB.LKA.
1982 'Six Indian Artists', Tate Gallery, London.
 'Contemporary Indian Art', Festival of India,
 Royal Academy of Art, London.
1983 Gy.CH.*
 Knoedler Gallery, London.*
1986 Galeries Contemporaines, Centre Georges
 Pompidou, Paris.*
 Gallery Watari, Tokyo.*
 'Contemporary Indian Art', Festival of India,
 Centre Georges Pompidou, Paris.
1989 'The Times of India Auction of TIMELESS ART', Sotheby's Auction,
 Bombay. 26 Mar 1989.
1992 'Documente IX 1992, Kassel.
 'Journeys Within Landscape', JG. (Organised by Sakshi)
1993 'Wounds', CIMA & NGMA.
 'The Spirit of India', de Bijenkorf, Amsterdam (Group Ex. with
 Atul Dodiya & Sudarshan Shetty).
 'A Critical Difference: Contemporary Art from India' An
 Aberystwyth Arts Centre touring Ex. in collaboration with The
 Showroom, London).

Nouvellie Image Dan Hague, The Hague.
'Reflections & Images', Vadehra & JG. (Organised by Vadehra).
'Inaugural Ex.: Trends & Images', CIMA.

1995 'Contemporary Indian Paintings: from the Chester & Davida
Herwitz Collection' Part I, Sotheby's Auction, New York.
12 Jne 1995.
'Indian Contemporary Paintings', Christie's Auction, London.
16 Oct 1995.

1995-6 'The Other Self', NGMA & The Stedelijk Museum Bureau,
Amsterdam, the Netherlands.

1996 'Contemporary Indian Paintings: from the Chester & Davida
Herwitz Collection' Part II, Sotheby's Auction, New York.
3 Apr 1996.
'Modern and Contemporary Indian Paintings: One Hundred
Years', Sotheby's Auction, London. 8 Oct 1996.
'Watercolours: A Broader Spectrum- III', Gy.CH (Group Show
includes: T.Hyman, R.Kaleka, B.Khakhar, N.Malani, G.m.Sheikh,
N.Sheikh).

Illustrated Works

1969	Residency Bungalow	179
1972	Factory Strike	65
1977	Man Eating Jellabi	196
1981	You Can't Please All	255
1985	Fishermen in Goa	256
1987	Yayati	12
1996	Night	220

KHANNA, Krishen

Birth
1925. Lyallapur, in pre-partition Punjab

Education
 Imperial Service College, Windsor, England
 Punjab University, Lahore
 Basically self-taught in art.
1962-3 Fellowship – Rockefellar Council, New York.

Selected Exhibitions
1950 PAG Group Show, Bombay.
1954 Two-man Ex. with M.F.Husain, AIFACS.
1956 U.S.I.S, Madras (FS).*
1957 Tokyo Biennale, Japan (Also 1961).
1959 'Artists of Fame and Promise', Leicester Galleries, London.
1960 Leicester Galleries, London (Also 1962).*
 Graham Gallery, New York.
 Contemporary Art from India– Essen, Dortmund, Zurich.
 Sao Paulo Biennale, Brazil.
1961 JG.*
 Tokyo Biennale, Japan.
1962 Venice Biennale, Italy.
 Gallery Ted Lowry, New Jersey, USA.*
1963 Watkins Gallery, American University, Washington D.C.*
 'Ten Contemporary Painters from India', Travelling Ex.: University
of South Florida, Tampa;
Jacksonville Art Museum, Jacksonville;
Delgado Museum of Art, New Orleans;
Hunter Gallery of Art, Chattanooga;
Colorado Fine Arts Center, Colorado Springs;
Long Beach Art Center, Long Beach Institute of San Francisco;
East West Centre, Honolulu.

1964 Egan Gallery, New York.*
1965 National Ex., RB.LKA.
 (LKNA: **Window into Winter**).
1966 Paintings from India, Lincoln Center, New York.
1968 New Art Centre, London.*
1968 I, III, V International Triennale, New Delhi (1975 & '82).
1969 Contemporary Art: Dialogue between East & West, National
Museum of Modern Art, Tokyo.
1970 'Art Now I', Kunika–CH.
1972 'Art Now II', Asoka Gallery, Calcutta & Shridharani.
 One World Through Art, St.Paul, Minnesota.
1977-8 'Pictorial Space', RB.LKA. (Curated by G.Kapur).
1981 'Inaugural Exhibiton: Roopankar Museum of Fine Arts, Bharat
Bhavan, Bhopal.
1982 'India: Myth & Reality, Museum of Modern Art, Oxford.
 'Contemporary Indian Art', Festival of India, Royal Academy of
Art, London.
 Modern Indian paintings', Hirschorn Museum & Sculpture
Garden, Washington D.C.
1985 Two-man Ex. with Ramkumar, Gallery 7, Bombay.
1986 Festival of Art, Baghdad, Iraq.
1987 'Indian Drawing Today', JG.
 First Art Biennale of Pakistan, Lahore.
 Coups de Coeur, Festival of India, Geneva.
1988 Takaoka Municipal Museum of Art & Meguro Museum of Art,
Tokyo, Festival of India, Japan.
1989 CCA, New Delhi.*
 'Artists Alert: for Safdar Hashmi Memorial Trust', New Delhi.
1991 'Remembering Kali Pundole, on its 28th Anniversary', Pundole.
1993 'Reflections & Images', Vadehra & JG. (Organised by Vadehra).
1995 'Indian Contemporary Paintings', Christie's Auction, London.
16 Oct 1995.
1996 'Modern and Contemporary Indian Paintings: One Hundred
Years', Sotheby's Auction, London. 8 Oct 1996.

Illustrated Works

1971	Game I	69
1973	Lovers	13
c.1980	Truck series	192
1989	Four Bandwallas in Procession	103
1993	Zamama : Canon Series	257

KOLTE, Prabhakar M.

Birth
27 Jun 1946. Nerur Par, Maharashtra.

Education
1964-8 Diploma (Painting), J.J. School.

Teaching Experience
1972-93 Teacher at J.J. School.

Selected Exhibitions
1973 'Five Artists', JG. (Also 1974).
1975 'Contemporary Art in Maharasthra', New Delhi.
 (Also 1987 in Bombay).
1978 Indo–German Cultural Society, Bombay (FS).*
1983 Gy.CH. (Also 1987, '90, '93).*
1984 J.J.School.*
1985 'Six Indian Painters' in Titograd, Yugoslavia; Ankara & Istanbul,
Turkey. (Organised by ICCR).

1986	VI International Triennale, RB.LKA.
	I National Bharat Bhavan Biennale, Bhopal.
1987	'Seventeen Indian Painters: CelebratingGallery Chemould's 25
	Years at the Jehangir', JG & Gy.CH.
1989	'Centenary Ex. of B.A.S.', Bombay.
1990	'Six Bombay Artists, CMC Gallery, New Delhi.
1991	'Paintings of Miniature Format', JG. (LKA Organised).
	'Homage to Rimbaud– 91', Alliance Francaise, Madras.
1992	AH.*
	'Contemporary Artists from SAARC Countries', NGMA.
	'Pioneers of the New Generation', Calcutta (Organised by Arts
	Acre).
	'Selected Works from Sadrudin Daya's Collection', JG.
1993	'Wounds', CIMA & NGMA.
	'Inaugural Ex.: Trends and Images', CIMA.
	'Parallel Perceptions', Sakshi.
1994	'Hinged by Light', Pundole.
1995	'Watercolours: A Broader Spectrum– II', Gy.CH (Group Show with
	P.Barwe, C.Douglas, G.Haloi, M.Rai, V.Sundaram).

Illustrated Works

| 1973 | Space X–Rayed | 161 |
| 1995 | Untitled | 258 |

KRISHNA, Devyani

Birth
8 July 1918.

Education

	Indore School of Art.
1936–40	Diploma (Painting), J.J. School.
1940–1	M.A. (Mural Painting), J.J. School.
1968	Govt. Scholarship to travel in Eastern Europe and Scandanavia.

Teaching Experience
1953–80s Teacher, Modern School, New Delhi.

Selected Exhibitions

1942	Joint Show with Kanwal Krishna, Benaras Hindu University.
1946	UNESCO International Ex., Paris.
1951	Rome*
1952	Gallery Caplin, Oslo. Also at Dramini & Supsberg, Norway.*
	Gallery Aesthetica, Stockholm, Sweden.*
1957	Joint Show with Kanwal Krishna, Artists Club, Romania.
1967	International Ex. of Graphic Art, Yugoslavia.
1968	International Ex. of Graphic Art, Lugano, Switzerland.
	I & III International Triennale, RB.LKA (1975).
1970	Dusseldorf Gallery de Art, W.Germany.*
	Gallery Fulchery, The Hague, Netherlands.*
	International Triennale, Sweden.
1972	International Triennale, Norway & W.Germany.
1974	International Triennale, Italy & Norway.
1986	'Indian Women Artists', NGMA.

Illustrated Works

| 1974 | Allah Series | 189 |

KRISHNA, Kanwal

Birth
10 Jan 1910. Montgomery (undivided Punjab).
Death
1993.

Education

	Benaras Engineering College, Benaras.
1933–9	Diploma (Fine Arts), CGAC.
1951	Study Tour on invitation by Italian Government.
1952–3	Study Tour on invitation of the Norwegian Government.
1952	Prof.S.W.Hayter's Atelier 17, Paris.
1957	Study Tour on invitation of Romanian Government.
1964	New York University Study Grant.
1970	Study Tour on invitation of West German Government.

Teaching Experience

| 1953– | Head of Art Department, Modern School, New Delhi. |
| 1957 | Halybury College, London. |

Selected Exhibitions

1939	All India Exhibition of Fine Arts, Lahore.
1942	Joint Show with Devyani Krishna, Benaras Hindu University.
1946	UNESCO International Ex., Paris.
1947	International Ex., London.
1948	Jammu & Kashmir War Paintings Ex., New Delhi.
1950	Academy of Fine Arts, Calcutta. (Also 1961).
1951	Rome.*
1952	Gallery Caplin, Oslo. Also in Dramini & Supsberg, Norway.
	Gallery Aesthetica, Stockholm, Sweden.
1955	Watercolours Ex., Japan.
1957	Artists Club of Romania.*
1959	International Ex. of Graphic Art, Lugano, Switzerland.
1961	International Graphic Art Ex., Japan. (Also 1962).
1962	International Graphic Art Ex., Sao Paulo, Brazil. (Also 1963).
1964	Biennale, Poland.
1965	Graphics Biennale, Yugoslavia.
1970	Dusseldorf Gallery of Art, W.Germany.*
	Gallery Fulcherry, The Hague.
1973	International Ex. of Graphic Art, Miami.
1974	International Ex. of Graphic Art, New Delhi.
1991	National Exposition of Contemporary Art, NGMA.

Illustrated Works

| 1962 | Homage to Light Series | 51 |

KUDALLUR, Achuthan

Birth
15 Feb 1945. Kerala.

Education
Self-taught.

Selected Exhibitions

1974	Academy of Fine Arts, Calcutta. (1976 & '77)
1977	Max Mueller Bhavan, Madras. (FS).*
1980	Chandigarh Museum, Chandigarh.
	LKA Regional Centre, Madras.*
1981	JG. (Also 1986 & '88).*
	'Linear Trends in Madras Art Movements', Alliance Francaise,
	Madras.

1986	I, II, III National Bharat Bhavan Biennale, Bhopal. (1988, '90)
1987	Sakshi Gallery, Madras. (Also 1990 & '91).*
	Kala Yatra.
1988	National Ex., RB.LKA. (LKNA: **Blue I**).
	'Three Artists', Cymroza.
	'Ten Artists', Sarala Art Centre, Madras.
1990	Pundole. (Also 1996).*
	Sakshi Gallery, Madras. (Also 1991).*
	'Touchstone', Sakshi Gallery, Madras & Bangalore.
1992	'Homage to Arthur Rimbaud' Ex., India & Besancon, France.
	'Parallel Perceptions', Sakshi Gallery, Madras, and Shridharani.
	Arts Acre Invitees Ex., Calcutta.
	Silver Jubilee Ex., BAAC.
1993	JG.*
1996	'Madras and Emotion', Values Art Foundation, Madras.

Illustrated Works

| 1981 | Untitled | 259 |
| 1989 | Untitled | 260 |

MAJUMDAR, Kshitindranath

Birth
| 1891. | Nimtita, Murshidabad District, Bengal. |
Death
1975.

Education
| 1907–12 | ISOA (Student of Abanindranath Tagore). |

Teaching Experience
| 1912–30 | Teacher and Principal at ISOA. |
| 1942–64 | Principal, Art Dept., Allahabad University. |

Selected Exhibitions
1908	Inaugural Ex.: ISOA, Calcutta. (Also 1910, '12).
1909	ISOA Ex., Simla.
1911	ISOA's United Provinces Ex., Allahabad.
	Festival of Empire, Crystal Palace, England. (Organised by ISOA for George V's Coronation).
1914	22nd Ex. of Societe des peintres orientalistes francais, Grand Palais, Paris. Travelling to Belgium, Holland and Imperial Institute, England.
1915–6	ISOA Ex., Calcutta & Young Men's Indian Association, Madras.
1924	Travelling Ex., USA. (Organised by American Federation of Art).
1928	Athenee Gallery, Geneva, Switzerland. (Organised by J.Cousins).
1949	Retrospective, Benaras. (Also 1964).*
1955	National Ex., RB.LKA. (LKNA: **Kaikai & Dasharatha**).
1963	Retrospective, Calcutta.*

Illustrated Works
| 1926 | Ras–Lila | 34 |

MALANI, Nalini

Birth
| 19 Feb 1946. | Karachi, (now in Pakistan). |

Education
| 1964–9 | Diploma (Fine Arts), J.J. School. |
| 1970–2 | French Government Scholarship, Paris. |

Selected Exhibitions
1966	Pundole. **(FS)**. (Also 1973, '75, '77, '82, '84 & '86).
1976	Festival of Perth, Australia.
1977	'Pictorial Space', RB.LKA. (Curated by G.Kapur).
	The International Festival of Arts, Cagnes–sur–Mer, France.
1980	AH.*
1980–1	'Place for People', JG & RB.LKA.
1982	'India: Myth and Reality– Aspects of Modern Indian Art', Museum of Modern Art, Oxford.
	'Contemporary Indian Art', Festival of India, Royal Academy of Art, London.
	'7 Indian Artists', Travelling Ex.: Galerie Bolhagen–Worpswede, Kubur–Hanover & Amerika House–Hamburg, W.Germany.
1983	Contemporary Art Gallery, Ahmedabad.*
1985	'Les Artistes Etrangeres en France', Festival of India, Centre National des Arts Plastiques, Paris.
1986	Pundole.*
	'Indian Women Artists', NGMA.
1987	Havana Biennale, Cuba.
	'Coups de Coeur', Geneva, Switzerland.
	Smith Galleries, London. (Organised by Gallery 7).
1987–9	'Through the Looking Glass', Travelling Ex. at Bharat Bhavan, Bhopal, Kala Yatra, Shridharani, & CCA. (Artists include: A.Singh, Madhvi Parekh & Nilima Sheikh).
1988	Smith's of Convent Garden, London (Organised by Arun Sachdev & Gallery 7, Bombay).
1989	'The Times of India Auction of TIMELESS ART' by Sotheby's, Bombay. 26 Mar 1989.
1990	'Under the Skin', Gallery 7.*
	'Splash, Images on Glass', Gy.CH.
1991	'Heiroglyphs and other Works', Gy.CH and JG.*
1992	Heiroglyphs and other Works', Sakshi Gallery, Madras, Bangalore.*
	'City of Desires' (site–specific wall paintings), Gy.CH.*
	LTG Gallery, New Delhi.*
	'Journeys Within Landscape', JG. (Organised by Sakshi)
1993	'India Songs', Travelling Ex. for Art Gallery of New South Wales, Sydney.
	'A Critical Difference, Contemporary Art from India', An Aberystwyth Arts Centre & The Showroom, London, Travelling Ex., UK.
1994	'Parallel Perceptions', Sakshi Gallery, Bombay.
1995	'Contemporary Indian Paintings: from the Chester & Davida Herwitz Collection' Part I, Sotheby's Auction, New York. 12 Jne 1995.
1996	'Watercolours: A Broader Spectrum– III', Gy.CH (Group Show includes: T.Hyman, R.Kaleka, B.Khakhar, N.Malani, G.m.Sheikh, N.Sheikh).
	'Modern and Contemporary Indian Paintings: One Hundred Years', Sotheby's Auction, London. 8 Oct 1996.

Illustrated Works
1974	Women Series	82
1980	His Life Series	202
1993	Habits of Thinking	261

MAZUMDAR, Chittrovanu

Birth
13 Oct 1956. W.Bengal.

Education
1977–81 Diploma (Painting), CGAC.

Selected Exhibitions
1985 Academy of Fine Arts, Calcutta.* (Organised by Seagull).
1987 'Recent Works', BAAC.* (Jointly organised: Seagull & BAAC).
1989 'Recent Works', JG.* (Organised by Seagull).
1991 Victoria Memorial Durbar Hall and Sukh Sagar, Calcutta.*
 (Jointly organised by Seagull & Victoria Memorial Board of
 Trustees).
1993 'Wounds', CIMA & NGMA.
 Inaugural Ex.: 'Trends and Images', CIMA.
1994 'Recent Works', Travelling Ex. at JG, Vadehra & Sakshi, Madras.*
 (Organised by Seagull).

Illustrated Works
1994 Untitled 114

MAZUMDAR, Nirode

Birth
11 May 1916. Calcutta.
Death
26 Sep 1982. Calcutta.

Education
1929–31 ISOA (Student of Abanindranath Tagore).
1946–8 Academie A.Lhote & Ecole des Louvre, Paris. [On a French
 Government Scholarship].

Selected Exhibitions
1944–6 Group Ex.s with Calcutta Group, Calcutta.
1949 Gallery Barbizon, Paris.*
1957–8 Paris & Calcutta.*
1968 Retrospective, Alliance Francaise, New Delhi.
 'The Quest', Alliance Francaise, New Delhi.
1969 'Shodasi Kala', Academy of Fine Arts, Calcutta.*
1970 'The Final Spring', Academy of Fine Arts, Calcutta.*
1972 'Nitya Kala Symbolism' Academy of Fine Arts, Calcutta.*
1974 'Biotorini– River of Life', Academy of Fine Arts, Calcutta.*
1977 Gallery Transpositione, Paris.*
1978 Lyon.*

Illustrated Works
c.1964 Chandani Holding Gurudas' Feathers 72

MEHTA, Tyeb

Birth
26th Jly 1925. Kapadvanj, Kheda District, Gujarat.

Education
1947–52 Diploma (Painting), J.J. School.
1968 J.D.R. IIIrd Fund, New York Fellowship.

Selected Exhibitions
1959 Gallery 59, Bombay. (FS).*
1960 'Art Alive', Northampton Museum.
1961 Joint Ex. with Paritosh Sen, Gallery One, London.
1962 Gallery One, London.*
 Bear Lane Gallery, Oxford.*
1965 Gy.CH. (Also 1968, '71, '76, '84, '86, '90).*
 'Ten Contemporary Indian Painters' MIT & New Jersey State
 Museum, Trenton, USA, 1965.
 National Ex., RB.LKA. (LKNA: **Figure of a Woman**).
1966 Kumar Gallery, New Delhi. (Also 1967).*
 Taj Art Gallery, Bombay.*
1968 Commonwealth Institute Art Gallery, London.*
 I, III, V International Triennale, RB.LKA. (1975 & 82).
1969 Kunika–CH (Also 1971).*
1974 II Menton Biennale, France.
 International Festival of Painting, Cagnes–Sur–Mer, France.
1976 Black Partridge Gallery, New Delhi.*
1979 'Focus: 4 Painters Directions', Gy.CH. (Artists Include: B.Khakhar,
 T.Mehta, A.Padamsee & G.Patel; curated by G.Kapur).
1981 Inaugural Ex.: Roopankar Museum of Fine Arts, Bharat Bhavan,
 Bhopal.
1982 'India: Myth & Reality– Aspects of Modern Indian Art', Museum
 of Modern Art, Oxford, England.
 'Contemporary Indian Art', Festival of India, Royal Academy of
 Art, London.
 'Modern Indian Paintings', Hirschorn Museum & Sculpture
 Garden, Washington D.C., USA. (Organised by NGMA)
1985–6 Festival of India, USA. Includes: 'Contemporary IndianArt', Grey
 Art Gallery & Study Center, New York University.
 'Contemporary Art of India: The Herwitz Collection', Worcester
 Art Museum, Worcester, Massachusetts.
1986 Nandan Gallery, Kala Bhavan, Visva Bharati University,
 Santiniketan.*
 'Coups de Coeurs: Ex. of Indian Paintings', Festival of India,
 Geneva, Switzerland.
1987 Christie's Auction for HelpAge, Bombay.
1988 Takaoka Municipal Museum of Art & Meguro Museum of Art,
 Tokyo, Festival of India, Japan.
 II National Biennale Bharat Bhavan, Bhopal.
 'Seventeen Indian Painters: To Celebrate 25 Years of Gallery
 Chemould at the Jehangir.', JG.
1989 'The Times of India Auction of TIMELESS ART' by Sotheby's,
 Bombay. 26 Mar 1989.
1990 AH.*
 BAAC.*
1993 'Wounds', CIMA & NGMA.
 Vadehra.*
 'Reflections & Images', Vadehra & JG. (Organised by Vadehra).
1994 'Seven Indian Painters', Gallery Le Monde de l'Art, Paris.
1995 'Contemporary Indian Paintings: from the Chester & Davida
 Herwitz Collection' Part I, Sotheby's Auction, New York.
 12 Jne 1995.
 'Indian Contemporary Paintings', Christie's Auction, London.
 16 Oct 1995.

1996	'Contemporary Indian Paintings: from the Chester & Davida Herwitz Collection' Part II, Sotheby's Auction, New York. 3 Apr 1996.	

Illustrated Works

1962	Rickshawala	262
1966	Untitled	149
1972	Diagonal Series	67
1984	Rickshawala Series	263
1985	Studies of Trussed Bull on Rickshaw (Triptych)	14
1986	Santiniketan (Triptych)	221

MENON, Anjolie Ela

Birth
17 Jly 1940. Burnpur, West Bengal.

Education

	Unfinished Studies, J.J. School.
	B.A.(Literature), Delhi University, New Delhi.
1959–61	Atelier Fresque, Ecole Nationale des Beaux–Arts, Paris. (tutee of Prof.Aujame) [On a French Government Scholarship].
1980–1	Study Tour of France, U.K. & USA on invitation of respective governments.

Selected Exhibitions

1959	Gallery 59, Bhulabhai Institute, Bombay **(FS)**.*
1963	Alliance Francaise, Bombay. *
1968	I, II, III International Triennale, RB.LKA (1972 & '75).
1976	Gy.CH.*
1978	New Delhi.*
1980	New York & Washington D.C.*
	Paris Biennale, France.
1986	'Indian Women Artists', NGMA.
1988	Retrospective, 1950s–88, JG.*
1989	New York.*
	'The Times of India Auction of TIMELESS ART' by Sotheby's, Bombay. 26 Mar 1989.
1993	'Reflections & Images', Vadehra & JG. (Organised by Vadehra).
1995	'Indian Contemporary Paintings', Christie's Auction, London. 16 Oct 1995.
1996	Hong Kong.* (Organised by Vadehra).
	'Modern and Contemporary Indian Paintings: One Hundred Years', Sotheby's Auction, London. 8 Oct 1996.
	Vadehra.*
	New York.* (Organised by The Gallery, Madras).

Illustrated Works

1981	Nude with Pears	83
1983	Mataji	222
1987	Midday	264
1994	Stories of the Sea II	cover

MOHAMMEDI, Nasreen

Birth
5 Sep 1937. Karachi.
Death
1990.

Education

1954–7	Diploma in Design (Painting), St. Martin's School of Art, London.
1961–3	Study of Graphics, Paris. [On a French Government Scholarship].

Teaching Experience

1972–88	Fine Arts Faculty, M.S. University, Baroda.

Selected Exhibitions

1961	Gallery '59, Bhulabhai Institute, Bombay. **(FS)**.*
1963	Gy.CH.*
1966	British Council, Bahrain. (Also 1969).*
1968	Taj Art Gallery, Bombay.*
1969	British Council, Kuwait.*
	'Art Today I', Kunika–CH.
1971	Kunika–CH. (Also 1972).*
1974	JG. (Also 1977).*
1975	III & IV International Triennale, RB.LKA. (1978)
1976	National Ex., RB.LKA. (LKNA: **Drawing 1**).
	Black Partridge Gallery, New Delhi.*
1977	'Pictorial Space', RB.LKA (Curated by G.Kapur).
1981	Shridharani.*
1982	'Contemporary Indian Painting', Festival of India, Royal Academy of Art, London.
	Prithvi Gallery, Bombay.*
	Urja Art Gallery, Baroda.*
1985–6	'Artistes Indiens en France', Festival of India, Foundation Nationale des Arts Graphiques et Plastiques, Paris.
1986	'Indian Women Artists', NGMA.
1987	AH.*
	'Indian Drawing Today', JG.
1991	'Nasreen in Retrospect: Drawings, Paintings & Photographs', JG & Gy.CH.*
1995	Triveni Gallery, AH.*
1996	'Contemporary Indian Paintings: from the Chester & Davida Herwitz Collection' Part I, Sotheby's Auction, New York. 12 Jne 1995.

Illustrated Works

c.1965	Untitled	162
1978	Untitled	198

MOOKHERJEA, Sailoz

Birth
2 Nov 1907. Calcutta.
Death
5 Oct 1960. New Delhi.

Education

1928–32	Diploma (Fine Arts), CGAC.

Teaching Experience

1945–7	Sarada Ukil School, New Delhi.
1948–60	Delhi Polytechnic.

Selected Exhibitions

1937	Calcutta. **(FS)**.*
1939	Boy Scout Headquarters, Calcutta.*
1941	1, Chowringee Terrace, Calcutta. (Also 1943).*
1945	Town Hall, New Delhi.*
1950	Retrospective, New Delhi.*
1951	Salon de Mai, Paris.
1960	Fine Arts Department, Delhi Polytechnic.*
1961	Academy of Fine Arts, Calcutta.*
1962	Kunika–CH, New Delhi.*

Illustrated Works

1957	Shehnaiwalas	137
1959	Vision	45

MUKHERJEE, B.B.

Birth
1904. Behala, Bengal.
Death
1980.

Education

1917–9	Visva Bharati University, Santiniketan.
1919–24	Kala Bhavan, Visva Bharati University, Santiniketan. (student of Nandalal Bose).

Teaching Experience

1925–49	Teacher at Kala Bhavan (Librarian and Curator).
1952	Started Art Training and Children's School, Musoorie, U.P.
1954	Appointed as Educational Advisor to Art School, Patna.
1958–70	U.G.C. Professor, Art Theory Faculty, Kala Bhavan.

Selected Exhibitions

1921	ISOA, Calcutta.
1969	Retrospective, New Delhi.
1995	'Man and Nature: Reflections of Six Artists', NGMA. (Curated by Keshav Malik).

Illustrated Works

1932	Tree Lover	41
1947	Hindi Bhavan Fresco: Medieval Saints (Detail)	134

NAIDU, Reddeppa M.

Birth
10 Oct 1932. Kapulapalem, East Godavari District, Andhra Pradesh.

Education

1955–60	Diploma (Fine Arts), MGAC. Cultural Scholarship, Government of India.

Selected Exhibitions

1958	Ootacamund **(FS)**.*
1962	National Ex., RB.LKA. (LKNA: **Snake with Animals**).
1964	Hyderabad.*
1965	IV Paris Biennale, France.
1966	Hyderabad.*
1969	Oxford House, Madras.*

	X Sao Paulo Biennale, Brazil. (Also 1971).
	'Indian Painters '69', Calcutta.
1972	'Deity Series' , Aparna Art Gallery, Bangalore*.
1974	'Mahabharata Paintings', New Delhi.*
1977	Mayur Art Gallery, Madras.*
1978	IV, VII International Triennale, RB.LKA. (1991). Kala Yatra.*
1980	C.P. Art Centre, Madras.*
1982	Alliance Francaise Art Gallery, Madras. (Organised by Air–India).
1983	'Mahabharata Paintings', Aparna Art Gallery, Madras.*
1988	Kala Yatra.*
1989	Retrospective, The Grindlays Art Gallery, Madras & The Gallery, Madras.
	'Nehru Centenary Ex. on Nature & Environment', LK.RBA.

Illustrated Works

1971	Diety Series	61
1992	Ramayana Series	265

PADAMSEE, Akbar

Birth
12 Apr 1928. Bombay.

Education

1945–9	Diploma (Fine Arts), J.J. School.
1965	J.D.R. IIIrd Fund Scholarship.
1969–70	Jawaharlal Nehru Fellowship.

Selected Exhibitions

1952	Galerie Saint Placide, Paris. **(FS)**.*
1953	Galerie Raymond Creuse, Paris.*
	Venice Biennale, Italy. (Also 1955).
1956	Galerie Ventadour, Paris.
1957	Galerie Ventadour.*
1958	'Seven Indian Painters', Gallery One, London.
1959	Sao Paulo Biennale, Brazil.
	Tokyo Biennale, Japan.
1960	'Paintings in Grey', Gallery'59, Bhulabhai Institute, Bombay.*
1962	National Ex., RB.LKA. (LKNA: **Juhu**).
	Kunika–CH.*
1963	Gallery '63, New York.
1964	Gy.CH.*
1965	Galerie 9.*
1967	Museum of Contemporary Art, Montreal*.
1968	I, II, IV International Triennale, RB.LKA. (1971 & '82)
1972	Pundole. (Also 1974, '75, '86 & '93, '96).*
1980	Retrospective Ex.s, Art Heritage, Bombay and New Delhi*.
1981	'India: Myth & Reality– Aspects of Modern Indian Art', Museum of Modern Art, Oxford. UK.
	'Indian Painting Today', JG.
1982	'Contemporary Indian Art', Festival of India, Royal Academy of Art, London.
1984	'Contemporary Painters', Raj Bhavan, Bombay. (Organised by Pundole.)
1985–6	'Artistes Indiens en France', Foundation Nationale des Arts Graphiques et Plastiques, Paris.
1987	'Artists for HelpAge' Christie's Auction, Bombay.
	'Indian Drawing Today', JG.
	Festival of India, Moscow, USSR.
	'Remembering Kali Pundole, on its 28th Anniversary', Pundole
1988	AH (Also 1992).*
	Cymroza (Also 1990).*

1989	'The Times of India Auction of TIMELESS ART', Sotheby's, Bombay. 26 Mar 1989.
	'State of the Art', An Ex. of Electronically–aided canvases, JG.
1991	'National Exposition of Contemporary Art', NGMA.
1992	Sanskriti Art Gallery, Calcutta.*
	Group Ex. with L.Shreshtha and J.Chowdhury, Pundole.
1993	Sakshi Gallery, Bombay, Bangalore and Madras.*
	'Reflections & Images', JG. (Organised by Vadehra).
1994	'Mirror–Image Series', Pundole.*
1995	'Indian Contemporary Paintings', Christie's Auction, London. 16 Oct 1995.
1996	'Modern and Contemporary Indian Paintings: One Hundred Years', Sotheby's Auction, London. 8 Oct 1996.

Illustrated Works

1957	Still Life with Tea Pot	54
1960	Juhu	150
1975	Metascape	87
1987	Couple	266
1992	Head	Title
1994	Mirror Image Series	15

PAI, Laxman

Birth
21 Jan 1926. Margao, Goa.

Education
1943–7	Diploma (Art), J.J. School.
1977–	Principal, Goa College of Art.

Teaching Experience
1947–51	Teacher, J.J. School.

Selected Exhibitions
1950	Bombay (FS).*
1952	Rue de Seine, Paris.*
1953	Rue St.Placide, Paris.*
	Munich & New Delhi.*
1955–7	'Gita–Govinda Series', Retrospective (1945–55), Paris.*
1956	Rue Monsieur Le Prince, Paris.*
	'Rosenthal Porcelain Designs', Munich & Stuttgart, W.Germany.*
	New York, Bombay & Place Dauphine, Paris.*
1958	Bombay & New Delhi.*
1959–61	'Life of Buddha Series', St.George's Gallery, London; Paris, & Bremen.*
1960	Rue de Colisee, Paris.*
1961	National Ex., RB.LKA. (LKNA: Four Signs).
	Boulevard Malesherbes, Paris.
	Paris Biennale.
1962	Retrospective (1948–62), Bombay.*
1963	National Ex., RB.LKA. (LKNA: Eclipse).
	Sao Paulo Biennale, Brazil.
	Tokyo Biennale, Japan.
	'Ritusamhara', Bombay.*
1964	Bombay, Kasauli & New Delhi.*
1965	'Musical Moods', New Delhi & Bombay.*
1966	'Purusha & Prakriti', New Delhi & Bombay.
1967	'Dance Forms', New Delhi.*
1968	Bombay, Calcutta & New Delhi.*
1970	Silpakorn University, Bangkok.*
	National Art Gallery, Kuala Lumpur & Singapore.*
1971	Panaji, Goa, New Delhi & Bombay.*
1972	National Ex., RB.LKA. (LKNA: Trilogy).
1974	New York & Colgate, USA.*
1977	Bombay & Panaji. (Also 1984).*
1978	Margoa, Goa.*
1987	Retrospective (1947–87), Panaji, Goa.
1989	Retrospective, RB.LKA.*
1995	Dhoomimal.*

Illustrated Works
1954	Geet Govinda Series	58
1961	Four Signs	154
1991	Veer Navrasa Series	97

PAL, Gogi Saroj

Birth
3 Oct 1945. Neoli, Uttar Pradesh.

Education
1961–2	College of Art, Vanasthali (Rajasthan).
1962–7	Diploma (Fine Arts), Government College of Arts & Crafts, Lucknow.
1968–9	College of Art, New Delhi (Vocational Student). [Student of Rajesh Mehra].
1986–8	Fellowship, Culture Department, Government of India.

Teaching Experience
1970–2	Part –time Lecturer, Women's Polythechnic, New Delhi.
1975–6	Part–time Lecturer, Delhi College of Art.
1976–7	Part–time Lecturer, Maharani Bagh Women's Polythechnic.
1976–83	Lecturer, Women's Polytechnic, Delhi &College of Art, Jamia Millia.

Selected Exhibitions
1968	Joint Ex. with Jai Zharotia (Organised by Delhi Silpi Chakra).
1969	New Delhi.* (Organised by Delhi Silpi Chakra).
1972	Triveni Gallery, New Delhi.*
1975	Black Partridge Gallery, New Delhi.*
1979	Karnataka Academy of Arts, Bangalore.
1981	AH.*
1986	AH.*
	Gy.CH.*
	'Indian Women Artists', NGMA.
1988	Gallery 'Rohtas', Rawalpindi, Pakistan.*
1989	Kala Yatra.*
	Contemporary Paintings from India,
	'Art Wave USA', New York.
1990	National Ex., RB.LKA. (LKNA: Swayambaram).
1991	Lotus Gallery, Amsterdam.
1993	'Wounds', CIMA & NGMA.
	'A Critical Difference, Contemporary Art from India', An Aberystwyth Arts Centre & The Showroom, London, Travelling Ex., UK.
	'Contemporary Indian Art', Yokohama, Japan.
1995–6	'Inside Out', Ex. of Indian Women Artists, Middlesborough, UK.
1995	Art Today, New Delhi.*
1996	'Icons of Womanhood', A.R.K.S Gallery, London.*

Illustrated Works
1996	Yogini Shakti	223

PALSIKAR, S.B.

Birth
17 May 1917. Sakoli, Dist. Bhandara, Maharashtra.
Death
4 Mar 1984. Bombay.

Education
1940–2 Student of Prof. Bendre in Dadar Evening Classes.
1942–7 Diploma (Painting), J.J. School.
1950 Recipient of the 1st Cultural Scholarship in Fine Art by
 Government of India.

Teaching Experience
1947–68 Fellow and Teacher at J.J. School.
1968–75 Dean, J.J. School.

Selected Exhibitions
1950 B.A.S.Annual Exhibitions.
1984 Retrospective, JG.*

Illustrated Works
1952 Dancers with Snake 143
1972 Colour & Sound 163

PANIKER, K.C.S.

Birth
30 May 1911. Coimbatore, Madras State.
Death
1977. Madras.

Education
1936–40 MGAC.

Teaching Experience
1941–55 Lecturer. MGAC.
1944 Established Progressive Painters Association, Madras.
1955–7 Vice Principal, MGAC.
1957–77 Principal, MGAC.
1964 Established Cholamandal Artists' Village, near Mahabalipuram.

Selected Exhibitions
1928–30 Madras Fine Arts Society, Madras.
1941– Madras.*
 New Delhi.*
1954 Indian High Commission, Aldwych, London.*
 Lille, N.France.*
 Galerie Raymond Duncan, Paris.*
1964 Tokyo Biennale, Japan.
1967 Venice Biennale, Italy.
 National Ex., RB.LKA. (LKNA: **Words & Symbols**).
1968 I, II, III International Triennale, New Delhi. (1971 & '75)
1972 Kunika–CH.*
1974 Gy.CH.*
1978 Retrospective– RB.LKA & LKA, Madras.
1979 'Modern Asian Art', Fukuoka Art Museum, Japan.
1982 'Modern Indian Painting', Hirschorn Museum and Sculpture
 Garden, Washington D.C.
 'Contemporary Indian Art', Festival of India, Royal Academy of
 Art, London.
1983 'Tantra', Stuttgart, W.Germany.

1985–6 'Neo-Tantra: Contemporary Indian Painting Inspired by
 Tradition', Festival of India, Frederick S.Wight Art Gallery,
 University of California, Los Angeles, USA.

Illustrated Works
1958 Garden Series 57
1961 Moon on a Cross – A 151
1965 Words & Symbols Series 60

PAREKH, Madhvi

Birth
22 Apr 1942. Sanjaya, Near Ahmedabad, Gujarat.

Education
Self –taught.

Selected Exhibitions
1968 BAAC. (Also 1971).
1969 Joint Ex. with Manu Parekh, Chetana Art Gallery, Bombay.
1972 Gy.CH, Calcutta **(FS)***.
1975 Dhoomimal. (Also 1978, & '86).*
 III International Triennale, RB.LKA.
1977 'Head Series' with Manu Parekh, Dhoomimal.
1978 Dhoomimal.*
 'New Contemporaries', JG. (Organised by Marg Publication).
1979 National Ex., RB.LKA. (LKNA: **Journey to the Jungle**).
1982 Pundole.*
1983 'Three Women Artists', Bharat Bhavan, Bhopal.
1984 Urja Art Gallery, Baroda.*
 BAAC.*
 Group Show of Artists working at Garhi, New Delhi.
1985 Al–Khalleja, Kuwait.*
 'Play', Istanbul & Ankara, Turkey. (Organised by ICCR).
1986 Dhoomimal, New Delhi.*
1987 'Water colours by Four Women Artists', Bangalore.
 'Art for CRY', Bombay, New Delhi, Calcutta.
1988 Water Colours by Four Women Artists, JG & Bangalore.
1989 'Through the Looking Glass', CCA.
1990 Contemprorary Art, 'SAHMAT', LKA.
 'Tribute to Nelson Mandela', LTG Gallery, New Delhi.
1992 Sakshi Gallery, Madras*.
1993 'Reflections & Images', Vadehra & JG.
 (Organised by Vadehra).
1994 Vadehra.*

Illustrated Works
1992 Blue Goddess 224

PAREKH, Manu

Birth
5 Nov 1939. Ahmedabad, Gujarat.

Education
1951 Student to Mukund Shroff, Ahmedabad.
1958–62 Diploma (Drawing & Painting), J.J. School.

Selected Exhibitions
1967 Everest Gallery, Calcutta. **(FS)**.*
1968 Ahmedabad.*
1970 Taj Gallery, Bombay (Also 1978).*
1974 BAAC.*
 Dhoomimal (Also in 1975, '76, '81, '85, '88).*
1975 III, IV International Triennale, RB.LKA. (1978).
1982 'Modern Indian Paintings', Hirschorn Museum & Sculpture
 Garden, Washington D.C.
 '7 Indian Artists', Travelling Ex.: Galerie Bolhagen–Worpswede,
 Kubur–Hanover & Amerika House–Hamburg; Also Braunsweig &
 Bayreuth, W.Germany.
 'Contemporary Indian Art', Festival of India, Royal Academy of
 Art, London.
1984 Urja Art Gallery, Baroda.
 '10 Years of Work', BAAC.*
1988 Chitrakoot.*
1989 JG.*
 'The Times of India Auction of TIMELESS ART', Sotheby's Auction,
 Bombay. 26 Mar 1989.
1990 'Bhagalpur Blinding', Cymroza.* (Organised with Times of India).
 'Benares Landscape', Singapore.*
 Village Gallery, New Delhi.*
1991 Sophia Dychesne Art Gallery, Bombay.*
1992 '25 Years of Work by Seagull', New Delhi, Calcutta and Bombay.*
1993 'Reflections & Images', Vadehra & JG. (Organised by Vadehra).
 'Artists for HelpAge', Asprey's Auction, JG. Apr 1993.
1994 Vadehra.*
1995 'Indian Contemporary Paintings', Christie's Auction, London.
 16 Oct 1995.
1996 'Modern and Contemporary Indian Paintings: One Hundred
 Years', Sotheby's Auction, London. 8 Oct 1996.

Illustrated Works

1972	He	267
1979	Tree & Bird in Landscape	200
1987	Flower in the Ganga	108
1994	Untitled	268

PATEL, Gieve

Birth
18 Aug 1940. Bombay.

Education
Self–Taught. Doctor, Poet & Playwright.

Selected Exhibitions
1966 Bombay **(FS)**.*
1972 Pundole.*
1975 Gy.CH.*
1979 'Focus: 4 Painters Directions', Gy.CH. (Artists Include: B.Khakhar,
 T.Mehta, A.Padamsee & G.Patel; curated by G.Kapur).

1979–80 AH.*
1982 'India: Myth & Reality– Aspects of Modern Indian Art', Museum
 of Modern Art, Oxford.
 'Contemporary Indian Art', Festival of India, Royal Academy of
 Art, London.
1985–6 'Artistes Indiens en France', Festival of India, Foundation
 Nationale des Arts Graphiques et Plastiques, Paris.
 Festival of India, USA. Includes: 'Contemporary IndianArt', Grey
 Art Gallery & Study Center, New York University.
 'Contemporary Art of India: The Herwitz Collection',
 Worcester Art Museum, Worcester, Massachusetts.
1995 'Contemporary Indian Paintings: from the Chester & Davida
 Herwitz Collection' Part I, Sotheby's Auction, New York.
 12 Jne 1995.
 'Indian Contemporary Paintings', Christie's Auction, London.
 16 Oct 1995.
1996 'Looking into a Well', Gy.CH.*
 'Contemporary Indian Paintings: from the Chester & Davida
 Herwitz Collection' Part II, Sotheby's Auction, New York.
 3 Apr 1996.

Illustrated Works

1972	Politician on Floral Rostrum	68
1976	Figure in Landscape	191
1982	Gateway	270
1983–6	Off – Lamington Road	16
1983	Drowned Woman	269
1993	Looking into a Well II	107

PATEL, Jeram

Birth
20 Jne 1930. Sojitra, Kaira District, Gujarat.

Education
1950–5 J.J. School.
1957–9 Central School of Art and Craft, London,
 (Typography and Publicity Design).

Teaching Experience
 School of Architecture, Ahmedabad.
1976–81 Professor, Faculty of Fine Arts, M.S.University, Baroda.
1981–85 Dean, Faculty of Fine Arts, M.S.University,

Selected Exhibitions
1957 National Ex., RB.LKA. (LKNA: **Rasikpriya**).
1959 London **(FS)**.*
1962 Kunika–CH.*
 Shridharani.*
1963 Inaugural Ex.: 'Group 1890', New Delhi.
 National Ex., RB.LKA. (LKNA: **Study in Silence III**).
 Kunika–CH.*
1964 Tokyo Biennale, Japan.
1965 Sao Paulo Biennale, Brazil.
1967 Venice Biennale, Italy.
 British International Print Biennale, London.
 Third World Biennale of Graphic Art
1968 'Recent Drawings', Shridharani.*
 I, II, III International Triennale, RB.LKA. (1972, '75)
1973 National Ex., RB.LKA. (LKNA: **Black 3**).
1982 'Contemporary Indian Art', Festival of India, Royal Academy of
 Art, London.

'Modern Indian Painting', Hirschorn Museum & Sculpture
Garden, Washington D.C.

1984	National Ex., RB.LKA. (LKNA: **Organic Black**).	
1985	'East–West Visual Encounter', Max Mueller Bhavan, Bombay.	
	'All India Graphic Art Ex.', RB.LKA.	
1986	Dhoomimal.*	
1987	'Indian Drawing Today', JG.	
1990–1	'Nine Indian Contemporaries', CCA. (Artists include: A.Singh, Bal Chabbda, Himmat Shah, J.Swaminathan, M.F.Husain, M.Bawa, P.Singh & Ramkumar)	

Illustrated Works

1967	Jeram 2	64
1971	Untitled	164
1973	Black 3	17

PATWARDHAN, Sudhir

Birth
13 Jan 1949. Pune, Maharashtra.

Education
Self–Taught.
1967–72 Studied Medicine (Specialised in Radiology), Armed Forces
Medical College, Pune.

Selected Exhibitions

1974	B.A.S. Annual Ex.s. (Also 1975).
1979	AH & JG. (FS)*
	Madhya Pradesh Kala Parishad, Bhopal.
1981	'Place for People', JG & RB.LKA.
1982	Inaugural Ex., Bharat Bhavan, Bhopal.
	'India: Myth & Reality– Aspects of Modern Indian Art', Museum of Modern Art, Oxford.
	'Contemporary Indian Art', Festival of India, Royal Academy of Art, London.
	'7 Indian Artists', Travelling Ex.: Galerie Bolhagen–Worpswede, Kubur–Hanover & Amerika House–Hamburg; Also Braunsweig & Bayreuth, W.Germany.
1984	JG.*
	'Ten Artists', Gallery 7, Bombay.
1985	'Thirty Indian Artists in the Collection of Richardson Hindustan', JG.
1985–6	'Artistes Indiens en France', Festival of India, Foundation Nationale des Arts Graphiques et Plastiques, Paris.
	Festival of India, USA. Includes: 'Contemporary IndianArt', Grey Art Gallery & Study Center, New York University.
	'Contemporary Art of India: The Herwitz Collection', Worcester Art Museum, Worcester, Massachusetts.
1986	Georges Pompidou Centre, Festival of India, Paris.*
1987	'Coups de Coeur, Festival of India, Geneva, Switzerland.
1988	Pokharan, Thane, Bombay.*
	'Art for CRY', Bombay, Bangalore, Calcutta & New Delhi.
1989	JG.*
	'The Times of India Auction of TIMELESS ART' by Sotheby's, Bombay.
	'Artists Alert: In Memory of Safdar Hashmi', New Delhi.
1990	AH.*
	'Gadyaparva' Ex., Gy.CH.
1992	JG.*
	'Journeys Within Landscape', JG. (Organised by Sakshi)
	Silver Jubilee Ex., BAAC.

1993	Inaugural Ex.: 'Trends and Images', CIMA.
	'Parallel Perceptions', Sakshi.
1994	'Drawings' JG & Gy.CH.*
1995	'Contemporary Indian Paintings: from the Chester & Davida Herwitz Collection' Part I, Sotheby's Auction, New York. 12 Jne 1995.
	'Indian Contemporary Paintings', Christie's Auction, London. 16 Oct 1995.
1996	'Contemporary Indian Paintings: from the Chester & Davida Herwitz Collection' Part II, Sotheby's Auction, New York. 3 Apr 1996.

Illustrated Works

1977	Irani Restaurant	190
1983	Ceremony	18
1984	Town	203
1985	Nullah	271
1990	Pokaran I	225
1992	Pokaran	113

PYNE, Ganesh

Birth
11 Jne 1937. Calcutta.

Education
1955–9 Diploma (Drawing & Painting), CGAC.

Selected Exhibitions

1956	World Youth Festival Art Ex., Prague.
1957	Centenary of the First Struggle for Freedom in India, Calcutta.
1961	Birth Centenary of Rabindranath Tagore, Calcutta.
1968	I, II, III International Triennale, RB.LKA. (1971, '75).
	World Youth Festival Art Ex., Prague.
1969	Paris Biennale.
	'Indian Painters '69', Calcutta.
	(Organised by Max Mueller Bhavan)
1970	SOCA, JG.
	'Contemporary Indian Painting', W. Germany.
	Auction in Aid of Menuhin School of Music, Royal Academy of Art, London.
1972	'Twenty Five Years of Indian Art', New Delhi.
1975	'International Festival of Arts', Cagnes–sur–Mer, France.
	'Contemporary Indian Painting', W. Germany.
1978	'Modern Asian Art', Fukuoka Art Museum, Japan.
1980	'Contemporary Art of Asia', Japan.
	'Indian Painting Today', JG.
1982	'Contemporary Indian Art', Festival of India, Royal Academy of Art, London.
	'Modern Indian Paintings', Hirschorn Museum & Sculpture Garden, Washington D.C.
	'Indische Kunst Heute', Darmstadt, Germany.
1986	'Visions', BAAC. (Organised by Calcutta Ladies Group).
1987	'Indian Drawing Today', JG.
1989	'Times of India Auction of Timeless Art' by Sotheby's, Bombay.
	'Self Portraits', The Village Gallery, New Delhi.
1990	'Jottings (Preliminary Drawings for Paintings)', The Village Gallery, New Delhi.*
1993	'Wounds', CIMA & NGMA.
	Inaugural Ex.: 'Trends and Images', CIMA.
	'Reflections & Images', Vadehra & JG. (Organised by Vadehra).
1994	'Water Colours', The Village Art Gallery, New Delhi.*

1995 'Contemporary Indian Paintings: from the Chester & Davida Herwitz Collection' Part I, Sotheby's Auction, New York. 12 Jne. 'Indian Contemporary Paintings', Christie's Auction, London. 16 Oct 1995.

1996 'Contemporary Indian Paintings: from the Chester & Davida Herwitz Collection' Part II, Sotheby's Auction, New York. 3 Apr. 'Modern and Contemporary Indian Paintings: One Hundred Years', Sotheby's Auction, London. 8 Oct 1996.

Illustrated Works

1960–5	Untitled	273
1971	Mother and Child	184
1973	Ganga	78
1985	Night of the Merchant	226
1991	Before the Fountain	272
1993	The Ancient Salesman	19

RAMACHANDRAN, A.

Birth
29 Aug 1935. Attingal, Kerala.

Education
1954–7	M.A. (Malayam Literature), Kerala University.
1957–61	Fine Arts, Kala Bhavan, Visva–Bharati University, Santiniketan.
1962–5	Ph.D. 'Mural Painting of Kerala', Visva Bharati.
1975	Study Tour of Japan on Japan Foundation Grant.

Teaching Experience
1965– 92 Lecturer, History of Art, Jamia Millia University, New Delhi.

Selected Exhibitions
1965	Kumar Gallery, New Delhi.
1966	Kumar Gallery (FS). (Also 1967, '70, '75, '77).*
1967	Tokyo Biennale, Japan.
1968	I, II, III, V International Triennale, RB.LKA. (1971, 75, 82)
1969	'Contemporary Indian Painters', Australia.
	'Indian Painters '69', Max Mueller Bhavan, Calcutta.
	National Ex., RB.LKA. (LKNA: **Iconography**).
1970	Tokyo Biennale, Tokyo.
	'Indian Paintings '69', Gy.CH.
	'Contemporary Indian Painting', Museum of Modern Art, Tokyo.
1971	Sao Paulo Biennale, Brazil.
1973	'Indian Contemporary Painting', Travelling Ex.: WashingtonD.C., Pasadena in USA & Toronto, Canada.
	National Ex., RB.LKA. (LKNA: **Kali Puja**).
1974	Menton Biennale, France.
	'Contemporary Indian Painting', Travelling Ex.: Sofia, Bulgaria; Skopje & Titograd, Yugoslavia; Warsaw, Poland & Brussels, Belgium.
1977	'Pictorial Space',RB.LKA. (Curated by Geeta Kapur).
1978	Retrospective 1965–77, Kumar Gallery.*
1981	'Indian Painting Today', JG.
1982	'India: Myth and Reality', Museum of Modern Art, Oxford, England.
	'Contemporary Indian Art', Festival of India, Royal Academy of Art, London.
	'Modern Indian Painting', Hirschorn Museum, Washington D.C.
1984	Inaugural Ex. of Bharat Bhavan, Bhopal.
1987	'Coups de Coeur', Halle de l'Ile, Festival of India, Geneva.
1993	'Wounds', CIMA & NGMA.
1994–5	'Reality in Search of Myth', Calcutta, Madras, Bangalore,

Bombay, New Delhi.*

1995 'Indian Contemporary Paintings', Christie's Auction, London. 16 Oct 1995.

1996 ARKS Gallery, London.*
'Modern and Contemporary Indian Paintings: One Hundred Years', Sotheby's Auction, London. 8 Oct 1996.

Illustrated Works

1969	Iconography	66
1973	Kali Puja	182
1979	Gandhari	194
1984–6	Yayati Series: Madhyana (detail)	274–275
1988	Lotus Pond (Night) (Diptych)	20
1994	Hannah and Her Goats	98

RAMKUMAR

Birth
23 Sep 1924. Simla, Himachal Pradesh.

Education
1945–6	M.A.(Economics), St. Stephen's College, Delhi University.
1949–50	Academie of Andre Lhote, Paris.
1950–1	Atelier Fernand Leger, Paris.
1970–1	J.D.R. IIIrd Fund Fellowship.

Selected Exhibitions
1949	YMCA Hall, Simla **(FS)**.*
1950	Gallery Barbizon, Paris.*
1952	Delhi Silpi Chakra Ex., New Delhi.
1953	Alliance Francaise, Bombay.*
1956	Colombo.*
1957	Tokyo Biennale, Japan.
	National Ex., RB.LKA. (LKNA: **Sad Town**).
1958	Graphics Ex., Bombay. (Group Show with V.S.Gaitonde, M.F.Husain, T.Mehta & A.Padasmee).
	Kracow & Warsaw.*
	Venice Biennale, Italy.
	'Eight Indian Artists', Graham Gallery, New York.
	'Seven Indian Painters in Europe', Gallery One, London. (Curated by G.Butcher).
	National Ex., RB.LKA. (LKNA: **Woman**).
1959	Tokyo Biennale, Japan.
	Kumar Gallery, New Delhi. (Also 1960, '73)*
1961	Sao Paulo Biennale, Brazil. (Also 1965)
	Commonwealth Artists Ex., London.
	Kunika–CH.* (Also 1963, '65, '66).*
1963	Gallery 1963, New York.
1964	Gy.CH. (Also 1966, 74).*
1965	'Ten Indian artists', Gallery Rawel, New York. Travelling Ex. (Curated by Roy Craven).
	Gy.CH, Calcutta.
1965–6	'Art Now in India', Travelling Ex.– Galerie Contour, Ghent, Belgium; Towner Art Gallery, Eastbourne, England & Upper Grosvenor Gallery, London.
1967	Geeta Gallery, New Delhi & Prague, Czechoslovakia. (Joint shows with M.F.Husain).
1968	Dhoomimal.*
1971	Pundole.*
1973	'Indian Contemporary Painting', Travelling Ex.: WashingtonD.C., Pasadena in USA & Toronto, Canada.
1977	Gallery Chanakya, New Delhi. (Also 1979).*

1980	Sao Paulo Biennale, Brazil
	Asian Artists, Fukuova Art Museum, Japan.
	Retrospective 1953–80, BAAC.*
	AH.*
1983	Sarala Art Centre, Madras.*
	Indo–Greek Cultural Festival, Delphi, Greece.
1985	'Indian Artists in France', Festival of India, Paris.
	Retrospective 1953–85, AH.*
1986	Retrospective, Roopankar Museum, Bharat Bhavan, Bhopal.
	Retrospective, Pundole.*
1987	Coups de Coeur, Halle de l'Ile, Festival of India, Geneva.
	'Indian Drawing Today', JG.
1988	Takaoka Municipal Museum of Art & Meguro Museum of Art, Tokyo, Festival of India, Japan.
	Baghdad Biennale, Iraq.
	'Three Indian Artists', Karachi, Pakistan.
1990	CCA.
	Pundole.*
1991	'National Exposition of Contemporary Art', NGMA.
	Chitrakoot.*
	'Remembering Kali Pundole, on its 28th Anniversary', Pundole
1992	'The Subjective Eye', Sakshi (Curated by Abhishek Poddar).
	Vadehra.* (Also 1993)
1993	Retrospective 1949–93, NGMA. (Organised by Vadehra).
	'Reflections & Images', Vadehra & JG. (Organised by Vadehra).

Illustrated Works

1951	Prisoner's Dream	144
1964	Ruins Series	276
1969	Untitled	165
1987	Untitled	110
c.1989	Untitled	22
1993	Benaras Series	277

RAMANUJAM, K.

Birth
1941.
Death
1973.

Education
| 1961–6 | Diploma (Fine Arts), MGAC. [Student of K.C.S.Paniker]. |

Selected Exhibitions
1972	'Cholamandal Artists Village Ex., New Delhi. (Organised by UNICEF).
	'Contemporary Miniatures', PPA, Madras and Bombay.
1973	'Cholamandal Artists Works', Goethe Institute, Pune.
	Gy.CH.*
1986	'Contemporary Indian Art', Chester & Davida Herwitz Family Collection, Festival of India, Grey Art Gallery, New York.
	'Indian Art Today: 4 Artists' (M.F.Husain, Laxma Goud, K.Ramanujam & S.H.Raza), The Phillip's Collection, Washington D.C.
1995	'Contemporary Indian Paintings: from the Chester & Davida Herwitz Collection' Part I, Sotheby's Auction, New York.
	12 Jne 1995.
1996	'Contemporary Indian Paintings: from the Chester & Davida Herwitz Collection' Part II, Sotheby's Auction, New York.
	3 Apr 1996.
	Sakshi.*

Illustrated Works

| 1972 | Untitled | 21 |
| 1972 | Untitled | 62 |

RAZA, Syed Haider

Birth
| 1922. | Babaria, Madhya Pradesh, India. |

Education
1939–43	Nagpur School of Art.
1943–7	J.J School.
1950–3	Ecole Nationale des Beaux-Arts, Paris. [On a French Government Scholarship].

Teaching Experience
| 1962 | Visiting Lecturer, Art Department of Berkeley, California. |

Selected Exhibitions
1947–8	B.A.S., Bombay.*
1949	P.A.G.Ex., Bombay.
1950	Institute of Foreign Languages, Bombay.*
1951	Salon de Mai, Paris.
1952	Galerie Saint-Placide.
1953	Galerie R.Creuze.
1956	Venice Biennale, Italy.
1957	Les Arts en France et dans le Monde, Musee d'Art Moderne, Paris.
	'Transferences', Zwemmer Gallery, London.
1958	Gallerie Lara Vincy, Paris. (Also 1961, '62, '64, '67, '69).*
	'Trends in Contemporary Painting from India', Graham Gallery, New York.
	John Moores' Ex., Walker Art Gallery, Liverpool.
1959	JG.*
	AIFACS.*
1959–60	Galerie Dresdnere, Montreal, Canada.*
1960	Galerie Charpentier, Paris.
	Ecole de Paris (Also 1961, '62).
	'Modern Indian Art', Santiago, Trinidad and Mexico.
1962–8	Galerie Dresdnere, Toronto, Canada.*
1962	Lanyon Gallery, Palo Alto, California.*
	Worth Ryder Art Gallery, Berkeley, University of California.*
	Dom Galerie, Cologne.
1963–8	Dom Galerie, Cologne, Germany.*
	Salon Comparaisons, Paris.
	Rabat Biennale, Morocco.
1964	Menton Biennale, France.
1965	Realities Nouvelles, Paris.
	Promesses tenues, Musee Galliera, Paris.
1965–6	'Art Now in India', Newcastle, UK & Ghent Belgium.
1966	Menton Biennale.
1968	Tecta Galerie, Dusseldorf, W.Germany.*
	I International Triennale, RB.LKA.
	Menton Biennale.
	Terres des Hommes, Festival International, Montreal, Canada.
	Gy.CH. (Also 1976, '84,'88, '90).*
1971	Recherche et Expression, Montfermeil, Art et Fer Blanc,Paris.
1972	Menton Biennale.
	Gallerie d'Arte Pietra, Milan, Italy.
	Wolfgang-Gurlitt Museum, Linz, Austria.
1973	Estampes Contemporaines, Musee de Menton .
	Galleria Matuzia, San Remo.

Bibliotheque Nationale, Paris.
'Indian Contemporary Painters', Renwich, Washington.
Pacific Cultural Museum, Pasadena, California,USA.
1974 La Palette, Trouville, France.*
Premier Salon International d'Art Contemporain, Paris.
Salon Grands et Jeunes d'Aujourd'hui, Paris.
1975 Galleria Matuzia, San Remo, Italy.*
Sahel Palais de l'Europe, Menton.
1976 JG.*
Menton Biennale.
Stavanger Kunstforening Galerie, Norway.*
1977 La Tete de l'Art, Grenoble. (Also 1987).*
Peintures Indiennes, Musee de Vire, Gallerie Koloritten, Stavanger, Norway.
'Pictorial Space', RB.LKA. (Curated by Geeta Kapur).
1978 Salon de Dessin, Paris.
Vieux Presbitaire, Gorbio, France.
L'Estampe Aujourd'hui, Bibliotheque Nationale, Paris.
Foire Internationale d'Art Contemporain, Grand Palais, Paris.
1979 Jehangir Nicholson Museum, NCPA, Bombay.*
1981 Charlottenborg, Copenhagen, Denmark.
1982 Galerie Loeb, Berne, Switzerland.*
'Contemporary Indian Painting', Royal Academy of Art, London.
'India: Myth & Reality– Aspects of Modern Indian Painting', Museum of Modern Art, Oxford.
1983 Salon de Mai, Paris.
Bibliotheque Nationale, Luxembourg.
1984 J.Y.Noblet, Paris.
1985 Galerie Pierre Parat, Paris.*
'Artistes Indiens en France', Foundation Nationale des Arts Graphiques et Plastiques, Paris.
1986 'Contemporary Indian Art', Chester & Davida Herwitz Family Collection, Festival of India, Grey Art Gallery, New York.
'Indian Art Today: 4 Artists' (M.F.Husain, Laxma Goud, K.Ramanujam & S.H.Raza), ThePhillip's Collection, Washington D.C.
Bharat Bhavan Biennale, Bhopal.
1987 Galerie La Tete de l'Art, Grenoble.
Havana Biennale, Cuba.
'Coups de Coeur', Halles de L'Ile, Festival of India, Geneva, Switzerland.
'Contemporary Indian Art', Christie's Auction for HelpAge, Bombay.
1988 Maison de la Culture, Space Andre Malraux, Reims, France.
The National Museum of Contemporary Art, Olympiad, Seoul, South Korea.
'Art for CRY', Bombay, Bangalore, Calcutta & New Delhi.
1989 Salon de Mai, Grand Palais, Paris.
'Artistes Indiens a Paris, Galerie Cygne, Paris.
1990 L'Arthotheque d'Enterprise, Group Michel Ferrier, Echirolle, Grenoble.
'Realite Seconde', Galerie Ariane, Paris.
1991 Galerie Eterso, Cannes.*
Retrospective 1952–91, Palais Carnoles, Musee de Menton, Paris.*
'National Exposition of Contemporary Art', NGMA.
'State of the Art', An Ex. of Electronically–aided canvases, JG.
1993 'Artists for HelpAge', Asprey's Auction, JG. Apr 1993.
1995 'Contemporary Indian Paintings: from the Chester & Davida Herwitz Collection' Part I, Sotheby's Auction, New York. 12 Jne 1995.
'Indian Contemporary Paintings', Christie's Auction, London. 16 Oct.
1996 'Contemporary Indian Paintings: from the Chester & Davida Herwitz Collection' Part II, Sotheby's Auction, New York. 3 Apr.
'Modern and Contemporary Indian Paintings: One Hundred Years', Sotheby's Auction, London. 8 Oct 1996.

Illustrated Works

1951	Haut de Cagnes	140
1958	Untitled	146
1968	Grey Landscape	166
1983	Paysage	23
1986	Surya	94

REDDY, Krishna

Birth

15 Jly 1925. Chittoor, Andhra Pradesh.

Education

1942–7 Diploma (Fine Arts), Visva Bharati University, Santiniketan.
1951–2 Slade School of Fine Arts, London.
1952–5 Academie Grande Chaumiere, Paris. (Student of O. Zadkine in sculpture).
1953–5 (Specialised in Gravure), S.W.Hayter's Atelier 17, International Centre for Graphics, Paris.
1956–7 Academia di Belle Arti de Brera, Milan. (Student of Marino Masini in sculpture).

Teaching Experience

1952 – S.W. Hayter, Atelier 17.
Teacher, Arts Faculty, New York University.
Professor of Art & Director of Printmaking, New York University.

Selected Exhibitions

1954 Philadelphia Print Club, Philadelphia, USA.
1955 Salon de la Realities Nouvelles, Paris.
Salon de Mai, Paris.
1958 Kumar Gallery, New Delhi.*
Venice Biennale, Italy.
1960 Galerie von Hulsen, Leeuwarden, Holland.*
1960–3 International Biennale of Prints, Cincinnati Art Museum, Ohio.
1961 Galeria 22 Marzo, Venice.*
Galerie Horn, Luxembourg.*
Associated American Artists, New York. (Also 1974)*
Mala Galeria, Ljubliana, Yugoslavia.*
1962 Galerie 62, Klagenfurt, Austria.*
Kunika–CH*
'Hayter and Atelier 17: 1927–62', Institute of Contemporary Arts, London.
1963 Galerie Griechenbeisl, Vienna.*
Forum Stadt Gallery, Graz, Austria.*
Gallery Del Levante, Milano, Italy.
Paris Print Biennale, France.
Galerie Plaisir de France, Los Angeles, USA.*
1964 Galerie Agnes LeFort, Montreal, Canada.*
Jefferson Place Gallery, Washington D.C.*
International Triennale of Original Colour Graphics, Grenchen, Switzerland.
'La Gravure contemporaine', Bibliotheque Royale, Bruxelles, Belgium.
1966 Gy.CH. (Also 1974)*
Biennale Internationale de la Gravure, Cracovie, Poland.
Galerie of Art, Skokie, Illinois, USA.

1968	Norton Gallery, St.Louis, USA. (Also 1972)*
1969	2719 Gallery, Dallas, Texas, USA.*
1970	Comsky Gallery, Los Angeles.*
	Academy of Fine Arts, Calcutta. (Also 1973)*
1971	Contemporaries Gallery, Sacramento, USA.*
1972	Keller Gallery, Goslar, W.Germany.*
	Tokyo Print Biennale, Japan.
	3rd International Biennale of Engraving, Museo del Grabado, Buenos Aires, Argentina.
1973	State Academy of Fine Arts, Hyderabad.*
1976	Atelier Gallery, Hamburg, W.Germany.*
1977	Gallery Weintraub, New York.*
	Massachusetts College of Art, Boston, USA.
	Houghton Gallery, New York.
1977-8	'50 Years of Atelier 17', Retrospective, Brooklyn Museum, New York.
	'Contemporary Artists of India', ACIA Gallery, New York.
1978	Clark Gallery, Sapporo, Japan. (Also 1980)*
	Gallery Vivant, Tokyo, Japan.*
1979	'Prints by Sculptors', Roy G.Biv Gallery, New York.
1980-2	'Innovations in Intaglio: Atelier 17 & S.W.Hayter', a Travelling Ex., starting from Baltimore Museum, Baltimore.
1981	Art Ex. organised by the 3rd North American Telugu Conference, Chicago.
1981-2	Retrospective, Bronx Museum of Arts, New York.*
1982	Gy.CH.*
	V International Triennale, RB.LKA.
1984-5	Retrospective, BAAC (Presented by ICCR & BAAC).*
1988	Takaoka Municipal Museum of Art & Meguro Museum of Art, Tokyo, Festival of India, Japan.
1991	'National Exposition of Contemporary Art', NGMA.

Illustrated Works

1961	Water-Lilies	167
1962	Whirlpool	168

REDDY, P.T.

Birth
4 Jan 1915.Annaram village, Karimnagar District, Andhra Pradesh.

Education
1935-9	Diploma (Painting), J.J. School. (With P.J.Reddy Scholarship)
	1940-1 Lord Mayo Scholarship for Murals, J.J.School.
	1978-80 Govt. of India Culture Dept. Scholarship on Tantrik forms with a contemporary vision.

Selected Exhibitions
1936	B.A.S.Annual Ex.. (Also in many subsequent years)
1940	B.A.S. Salon (Artists' Centre) (FS).*
1941	'Young Turks' Group Show, J.J.School.
1941-3	Bombay.*
1943	B.A.S.*
1955	Hyderabad Art Society's Annual Ex..
1956	JG.*
1956-70	Hyderabad.*
1957	All India Industrial Ex. Grounds, Hyderabad.*
1958-63	Bombay*
1960	New Delhi.*
1962	New Delhi.*
1963	New Delhi.*
1966	New Delhi.*

1966-70	Bombay.*
1967	Calcutta.*
1968	I International Triennale, RB. LKA.
1968-71	New Delhi.*
1969	Lucknow*
1976	Retrospective, 1935-45, and 1955-75, All India Industrial Ex. Grounds, Kala Bhavan & Sudharma Modern Art Gallery, all in Hyderabad.
1979-80	Retrospective, 1935-79, in New Delhi, Lucknow, Bombay (1979), and Madras, Bangalore & Calcutta, (1980).
1983	Tantra Ex., Stuttgart, W.Germany.*
1985-6	'Neo-Tantra: Contemporary Indian Painting Inspired by Tradition', Frederick S.Wight Art Gallery, University of California, Los Angeles, USA. (Part of the Festival of India).

Illustrated Works
1942	Mrs. Krishna Huttee Singh	135

RODWITTIYA, Rekha

Birth
31 Oct 1958. Bangalore.

Education
1976-81	B.A.(Fine Arts), Faculty of Fine Arts, M.S. University, Baroda.
1982-4	M.A.(Painting), Royal College of Art, London. (Inlaks Scholarship).

Selected Exhibitions
1982	Urja Art Gallery, Baroda.*
	British Council Gallery, Bombay.
1983	Rebecca Smith Gallery, London.
	John Nevil Gallery, Cantebury.
1984	'Young Contemporaries', Sheffield, UK.
1985	AH (Also in 1987, 89, 93).*
	Cymroza (Also in 1986, 90, 93).*
	'Ex. of Contemporary Indian Art from The Davida & Chester Herwitz Collection', Grey Art Gallery, New York, Pennsylvania, Woraster & Vermont.
1986	'India in Switzerland: Six Young Contemporaries', Geneva, Switzerland.
	Sarala Art Centre, Madras.*
	VI International Triennale, RB.LKA.
1988	Gallery Sassi, Stockholm, Sweden.*
	Invited to exhibit in the celebration of the Declaration of Human Rights, U.N., Geneva.
1989	'Artists Alert: In Memory of Safdar Hashmi', New Delhi.
1991	Sakshi Gallery, Madras..*
1992	Sakshi Gallery, Bangalore (Also in 1994).*
	Seagull for Arts, Calcutta.*
	'Journeys Within Landscape', JG. (Organised by Sakshi).
1993	'Still-Life', Sakshi.
	'Images and Words' – A Travelling Ex. (Organised by SAHMAT for communal harmony).
1995	'Portraits', Sakshi.
	'Dialogues of Peace', Art Ex., on U.N.'s 50th Anniversary, Geneva.
	'Contemporary Indian Paintings: from the Chester & Davida Herwitz Collection' Part I, Sotheby's Auction, New York. 12 Jne 1995.
1995-6	'Inside Out – Women Artists of India', A Touring Ex. in England of Nine Women Artists.
1996	Invited to exhibit at Sakshi.*
	Invited to exhibit at AH.*

'Contemporary Indian Paintings: from the Chester & Davida Herwitz Collection' Part II, Sotheby's Auction, New York 3 Apr 1996.
'Modern and Contemporary Indian Paintings: One Hundred Years', Sotheby's Auction, London. 8 Oct 1996.

Illustrated Works

| 1989 | The Wilful Fashioning of Time | 240 |
| 1996 | Sharing Secrets | 115 & spine/cover |

ROERICH, Nicholas

Birth
10 Oct 1874. St. Petersburg, Russia.
Death
13 Dec 1947. Kulu, Himachal Pradesh.

Education
1893–7 Arts & Law Faculty, St. Petersburg University.
1897–8 Art Education, Paris.
1924 Expeditions to Sikkim and Bhutan.
1925–8 Central Asia Expedition. (Includes Russia, Siberia, Mongolia)

Teaching Experience
1906 Director of the School of Arts Encouragement Society.
1931–47 Established the Urusvati Institute, Kulu.

Selected Exhibitions
1902–4 St.Petersburg & Moscow.*
1920–23 Ex.s, USA.
1996 'Modern and Contemporary Indian Paintings: One Hundred Years', Sotheby's Auction, London. 8 Oct 1996.

Illustrated Works

| c.1920s | Himalayan Diety | 42 |

ROY, Jamini

Birth
Apr 1887. Beliatore, Bankura District,
Death
1972 Calcutta, W.Bengal.

Education
1903–8 Diploma (Fine Arts), CGAC.

Selected Exhibitions
1938 British Indian Street, Calcutta.*
1946 Burlington Gallery, London.
1953 New York.*
1987 'Centenary Ex.', NGMA.
1991 'National Exposition of Contemporary Art', NGMA.
 'Contemporary Indian Paintings: from the Chester & Davida Herwitz 1995 Collection' Part I, Sotheby's Auction, New York. 12 Jne 1995.
 'Indian Contemporary Paintings', Christie's Auction, London. 16 Oct 1995.
1996 'Contemporary Indian Paintings: from the Chester & Davida Herwitz Collection' Part II, Sotheby's Auction, New York. 3 Apr 1996.

'Modern and Contemporary Indian Paintings: One Hundred Years', Sotheby's Auction, London. 8 Oct 1996.

Illustrated Works

| c.1927 | Santhal Dance | 127 |
| c.1945 | Last Supper: Christ Series | 36 |

ROY, Suhas

Birth
1926. Bengal.

Education
1953–8 Diploma (Painting), Indian College of Arts and Draughtsmanship, Calcutta.
1965–6 Student of Prof.S.W. Hayter at Atelier 17 and Ecole Superior Des Beaux Arts, Paris. (On a Govt. of France Cultural Exchange Scholarship).

Teaching Experience
1959–73 Head of Graphic Department, Indian College of Art and Draughtsmanship.
1974–82 Lecturer in Painting, Kala Bhavan, Visva Bharati University, Santiniketan.
1982– Reader, Kala Bhavan.

Selected Exhibitions
1956 International Youth Art Ex., Prague.
1961 SOCA Ex., Calcutta.
1964 Calcutta.*
1965 Exposition a la Cite International des Arts, Paris.
 Group 8 Ex., Calcutta.
 BAAC.
1966 Exposition des Arts Etrangere, Boursiers du Government Francais, Paris.
1969 Asian Graphic Prints Travelling Ex., USA.
1970 Smithsonian Printmaking Workshop, New Delhi.
 Karnataka Chitrakala Parishad, Bangalore. (Also 1986).
 Safdar Hashmi Memorial Ex., New Delhi. (Also 1986).
 Tokyo Print Biennale, Japan.
 SOCA Ex., JG.
1971 'Contemporary Indian Art', travelling Ex. in Yugoslavia, Romania, Czechoslovakia & Hungary.
1975 III International Triennale, RB.LKA.
1986 Dhoomimal.
1987 'Indian Drawing Today', JG.
1993 'Wounds', CIMA & NGMA.
1996 'Modern and Contemporary Indian Paintings: One Hundred Years', Sotheby's Auction, London. 8 Oct 1996.

Illustrated Works

| 1992 | Radha Series | 227 |

SABAVALA, Jehangir A.

Birth
23 Aug 1922. Bombay.

Education
1939–41 Elphinstone College, University of Bombay.
1942–4 J.J. School.
1945–7 The Heatherley School of Art, London.
1948–51 The Academie Julian & Academie Andre Lhote, Paris.
1953–4 The Academie Julian.
1957 The Academie de la Grande Chaumiere, Paris.

Selected Exhibitions
1949 Grand Prix de la Peinture de Monaco.
1950 Salon National Independent, Paris.
1951 Bombay (Also 1953, '55, '58, '61, '64, '66, '76, '80, '83, '88, '93).*
1954 Venice Biennale, Italy.
1956 New Delhi (Also 1962, '66, '76, '79, '93).*
1963 Calcutta (Also 1983).*
1964 Contenporary Indian Art Ex., Sydney.
1965 Commonwealth Arts Festival, London.
1965–6 'Art Now in India' Liang Art Gallery, Newcastle-on-Tyne &
 Ghent, Belgium.
1968 'Art Scene Today', Ahmedabad.
1969 Gy.CH.*
 Commonwealth Institute, Edinburgh & London, UK.*
1970 'Indian Painters', Tehran.
1972 25 Years of Indian Art , New Delhi and Bombay.
1972–3 Travelling Ex., Kunika–CH., Gy.CH & JG*
1975 'Contemporary Artists from Maharashtra', New Delhi.
 Gallery Nasrudin, Boston.
 'Contemporary Art from India', Washington.
1976 'Art Ex., the 25th Pugwash Conference', Madras.
1978 '18th Annual State Art Ex., Maharashtra', Bombay.
1979 Asian Artists Ex., Fukuoka Art Museum, Tokyo.
 Kala Yatra's 'Contemporary Indian Painting and Sculpture',
 Kuala Lumpur.
1980 Kala Yatra's 'Contemporary Indian Painting and Sculpture',
 Calcutta.
1981 Indian Painting Today, JG.
 Kala Yatra's 'Contemporary Indian Painting and Sculpture',
 Cochin.
1982 Modern Indian Paintings, Smithsonian Institute, Washington.
1988 Madras.*
 'Art for CRY', Bombay, Calcutta, New Delhi, Bangalore.
 AH.*
1989 'Artists Alert' Ex. and Auction, for Safdar Hashmi Memorial Trust,
 New Delhi.
1990 'Tradition and Change', Bal Gandharva Art Gallery, Pune.
1992 'Indian, European and Oriental Paintings and Works of Art',
 Sotheby's Auction, New Delhi. 8–9 Oct 1992.
1993 'Artists for HelpAge', Asprey's Auction, JG. Apr 1993.
1995 'Indian Contemporary Paintings', Christie's Auction, London.
 16 Oct 1995.
1996 'Modern and Contemporary Indian Paintings: One Hundred
 Years', Sotheby's Auction, London. 8 Oct 1996.

Illustrated Works
1958 Crucifixion 53
1977 Of Cliff and Fall Series – V 86
1989 The Black Dune 236
1990 The Stranger – I 278

SAMANT, Mohan

Birth
1926. Bombay.

Education
1948–51 J.J. School.
1957–8 Italian Government Cultural Exchange Scholarship, Rome.
1959 Study Tour of USA, on an Asia Society Scholarship.

Selected Exhibitions
1952–6 B.A.S. Annual Exhibitions.
1956 National Ex., RB.LKA. (LKNA: **Lovers in the Palanquin**).
1956 Venice Biennale, Italy. (Also 1958).
1957 Tokyo Biennale, Japan. (Also 1959).
1958 Gallery One, London.
 Institute for Oriental Studies, Rome.
1959 Sao Paulo Biennale, Brazil. (Also 1961).
1960 Museum of Modern Art, New York.
 Paris Biennale, France.
1961 World House Galleries, New York. (Also 1962, '64, '65).*
 Carnegie International, Pittsburgh, USA.
1962 Mary Washington College, Yale Art Gallery, USA.*
1963 B.A.S.Annual Exhibition.
 Dunn International, Fredricktown, Canada & The Tate Gallery,
 London.
1964 Menton Biennale, France.
1965 Gy.CH, Calcutta.
1966 Gy.CH.*
1982 'India: Myth and Reality– Aspects of Modern Indian Art',
 Museum of Modern Art, Oxford.

.

Illustrated Works
1965 Untitled 59

SANTOSH, G.R.

Birth
19 June 1929. Srinagar, Kashmir.

Education
Self–Taught Craftsman, Painter, Weaver.
1947–53 Painting, Weaving, Papier–Mache.
1954–6 Government of India, Cultural Scholarship,
 M.S. University, Baroda. (Student of N.S.Bendre)

Selected Exhibitions
1957 National Ex., RB.LKA. (LKNA: **Peace**).
1961 II Paris Biennale, France.
1962 Kumar Gallery, New Delhi. (Also 1971).*
 Los Angeles, USA.*
1963 Sao Paulo Biennale, Brazil.
1964 National Ex., RB.LKA. (LKNA: **Nearer to Thee my Lord**).
1965 Mainichi Biennale, Tokyo.
1968 I, IV & V International Triennale, RB.LKA (1978 & '82)
 Gy.CH.*
1969 Sao Paulo Biennale, Brazil.
1973 National Ex., RB.LKA. (LKNA: **Untitled**).
1979–80 'Contemporary Indian Art' Ex., Japan. (Organised by NGMA).
1982 'Contemporary Indian Art', Festival of India, Royal Academy of
 Art, London.
 ' Modern Indian Paintings' , Hirschorn Museum and Sculpture
 Garden, Washington D.C., USA.

1983 Tantra Ex., Stuttgart, W.Germany.
 South Korea.*
1985-6 'Neo-Tantra: Contemporary Indian Painting Inspired by
 Tradition', Festival of India, Frederick S.Wight Art Gallery,
 University of California, Los Angeles, USA.
1988 Takaoka Municipal Museum of Art & Meguro Museum of Art,
 Tokyo, Festival of India, Japan.
 II National Biennale Bharat Bhavan, Bhopal.
1995 'Contemporary Indian Paintings: from the Chester & Davida
 Herwitz Collection' Part I, Sotheby's Auction, New York. 12 Jne.
1996 'Contemporary Indian Paintings: from the Chester & Davida
 Herwitz Collection' Part II, Sotheby's Auction, New York. 3 Apr.
 'Modern and Contemporary Indian Paintings: One Hundred
 Years', Sotheby's Auction, London. 8 Oct 1996.

Illustrated Works

1968	White & Red No. 1	169
1971	Untitled	24
1971	Untitled	71
1982	Untitled	199
1985	Untitled	279

SANYAL, Bhabesh C.

Birth
22 Apr 1904. Dibrugarh, Assam.

Education
1920-3 Serampore College, Bengal.
1923-8 Diploma (Fine Arts), CGAC.

Teaching Experience
1929-36 Teacher, Mayo Government School of Arts, Lahore.
1936-47 Freelance Teacher at Studio-cum-Workshop [Lahore School of
 Fine Arts].
1948-53 Founder Delhi Silpi Chakra.
1953-60 Head, Art Dept., Delhi Polytechnic.
1955 Advisor to Government of Nepal on Art Education.
1960-8 Secretary, Lalit Kala Akademi.

Selected Exhibitions
1936 Studio Inaugural Ex., Lahore.
1942 Inaugural Ex., Students of Studio, Lahore.
1948 Inaugural Ex., Delhi Silpi Chakra, Delhi.
1949 Inaugural Ex., Delhi Silpi Chakra Art Gallery at Dhoomimal.
 Salon de Mai, Paris.
1953 Venice Biennale, Italy.
1955-6 Travelling Ex.: Czechoslovakia, Hungary, Romania, Bulgaria,
 USSR & Poland.
1961 Sao Paulo Biennale. (Also 1965).
 Tokyo International Art Ex.
1968 I International Triennale, RB.LKA.
1971 New Delhi.*
1973 New Delhi.*
1976 'A Selection of 22 Paintings of the Decade-1965-75', JG.*
1993 'Wounds', CIMA & NGMA.

Illustrated Works

| 1941 | Three Girls | 280 |
| 1962 | In Brooding Mood | 50 |

SEN, Paritosh

Birth
18 Oct 1918. Dacca (In present day Bangladesh).

Education
1936-40 Diploma Fine Arts, MGAC.
1942 Founder Member: Calcutta Group.
1950-3 Academie Andre Lhote, Paris.
 Academie la Grande Chaumiere (Painting).
 Ecole des Beaux-Arts (Murals).
 Ecole des Louvre (History of Painting).
1969-70 French Fellowship for Designing and Typeface.
1970-1 J.D.R. IIIrd Fund Fellowship.

Teaching Experience
1954-6 Teacher, Daly College, Indore & Neterhat Vidyalaya, Bihar.
1956-79 Teacher, Design & Layout, Regional Institute of Printing
 Technology, Jadavpur.
1981-2 Visiting Professor, Maryland Institute of Art, Baltimore (On
 invitation of Indo-US subcommission on Culture and Education)

Selected Exhibitions
1944 First Calcutta Group Ex., Services Club, Calcutta.
1950 Brussels. (FS)*
1951 Calcutta Group-PAG Joint Ex., Calcutta.
1961 Joint Ex. with Tyeb Mehta, Gallery One, London.
1962 London.*
1965 The Commonwealth Arts Festival, London. (Also in 1986).
 Sao Paulo Biennale, Brazil.
 Asahi Shimbun Ex. of Art, Tokyo.
1968 Calcutta.*
 I International Triennale, RB.LKA. (Also 1971, '75)
1972 Four Indian Painters, Pittsburgh, USA.
1973 Bombay & Calcutta.*
1984 Four Indian Painters, Stockholm, Sweden.
1986 II Havana Biennale, Cuba.
1989 'Self-Portraits', The Village Gallery, New Delhi.
1992 The Village Gallery, New Delhi.*
 'Confluence'92', Calcutta.
1993 'Wounds', CIMA & NGMA.

Illustrated Works

1967	Bade Ghulam Ali Khan	73
1983	Boy Chopping Chicken in market	228
1990	Homage to van Gogh - I	281

SHEIKH, Ghulam. m.

Birth
16 February 1937. Surendranagar, Saurashtra.

Education
1955-61 Post Graduation, Faculty of Fine Arts, M.S. University, Baroda.
1963-6 Royal College of Art, London. [Commonwealth Scholarship.].

Teaching Experience
1966-82 Reader, M.S. University, Baroda.
1982-93 Dean, Faculty of Fine Arts, M.S. University, Baroda.

Selected Exhibitions
1959 'Baroda Group Show', JG.

1960	JG (FS).*
	Kunika Art Gallery, New Delhi.*
1962	National Ex., RB.LKA. (LKNA: **Chase**).
1963	Inaugural Ex.: 'Group 1890', Rabindra Bhavan, New Delhi.
	Taj Art Gallery, Bombay.
1967	V Paris Biennale, France.
1969	JG.*
	'Art Today', Black Partridge Art Gallery, New Delhi.
1970	Kunika–Chemould (Also 1971).*
	'Contemporary Indian Prints', Smithsonian Printmaking
	Workshop, New Delhi.
1971	'Art Today', Black Partridge Art Gallery, New Delhi.
	'Loans from Private Collections', NGMA.
1972	25 Years of Indian Art, LKA, New Delhi.
	'Group Show (4 Contemporaries)', JG.
1973	Graphic Workshops, Travelling Show.
1974	'Contemporary Painting of India', Belgrade, Warsaw, Sofia,
	Brussels.
	'Group Show (10 Contemporaries)', RB, LKA.
1975	Graphic Workshops, Travelling Show.
	Black Partridge Art Gallery, New Delhi.
	III Triennale, RB.LKA. International.
1976	Black Partridge Art Gallery, New Delhi.
1977	Black Partridge Art Gallery, New Delhi.
	('Pictorial Space', RB.LKA.)
1978	'Six Who Declined the Triennale', Kumar Gallery, New Delhi.
1979	'Contemporary Indian Painting', Iraq and otherWest Asian
	Countries.
1981	'Place for People', JG and RB, LKA.
1982	Inaugural Ex.: Roopankar Museum of Fine Arts, Bharat Bhavan,
	Bhopal.
	'Contemporary Indian Art', Festival of India, Royal Academy of
	Art, London.
	'Modern Indian Paintings', Hirschorn Museum, & Sculpture
	Garden, Washington D.C.
1984	15th International Art Ex., Tokyo.
1985	'East–West Visual Encounter', Max Mueller Bhavan and JG.
	'Returning Home', Centre Georges Pompidou, Paris.*
1992	'Journeys Within Landscape', JG. (Organised by Sakshi)
1993	'Reflections & Images', Vadehra & JG. (Organised by Vadehra).
1995	'Indian Contemporary Paintings', Christie's Auction, London.
	16 Oct 1995.
1996	'Watercolours: A Broader Spectrum– III', Gy.CH (Group Ex. also
	includes: T.Hyman, R.Kaleka, B.Khakhar, N.Malani, & N.Sheikh).

Illustrated Works

1975	Speechless City	193
1981	Speaking Street	89
1985–7	Passing Angel	25
1988	Meghdoot	282
1994	Passages (Diptych)	231

SHER–GIL, Amrita

Birth

| 30 Jan 1913. | Budapest, Hungary. |

Death

| 3 Dec 1941. | Lahore, Pre-partition India. |

Education

1924	School of Santa Annunciata, Florence.
1929	The Academie de la Grande Chaumiere, Paris. [Tutee of
	P.Vaillant].
	Ecole Nationale des Beaux–Arts [Tutee of Lucian Simon].

Selected Exhibitions

1933	Salon de Tuilleries, Paris.
1935	Simla Fine Arts Society Annual Ex..
	Allahabad & New Delhi.
1937	B.A.S.Annual Ex.
1986	'Indian Women Artists', NGMA.
1991	National Exposition of Art, NGMA.
1995	'Indian, European and Oriental Paintings and Works of Art',
	Sotheby's Auction, New Delhi. 8–9 Oct 1992.

Illustrated Works

| 1937 | Bride's Toilet | 39 |
| 1939 | Resting | 131 |

SHRESHTHA, Laxman

Birth

| 18 Oct 1939. | Siraha, a village in Nepal. |

Education

	Patna University, Bihar.
1957–62	Diploma (Painting), J.J. School.
1964–7	Ecole National Superieure des Beaux Arts, Paris. [French
	Government Scholarship].
	The Academie de la Grande Chaumiere, Paris.
	Atelier 17 of Prof.S.W. Hayter, Paris.
1970	Central School of Art and Craft, London. [BritishCouncil Grant].
1971	Study Tour to Baltimore & San Francisco. [I.V.P.Grant of US
	Government].

Selected Exhibitions

1963	Taj Art Gallery, Bombay **(FS)***
	Inaugural Ex., Gy.CH.
1964	NAFA Gallery, Kathmandu (Also in 1967, '69).*
1966	Maisons des Beaux Arts, Paris.
	New York. (Organised by International Art Exchange).
	Salle de la Presse, French Foreign Ministry, Paris.
1968	Gy.CH (Also 1970, '71, '73, '76).*
	I International Triennale, RB.LKA.
1969	Sixth Anniversary Ex. of Pundole Art Gallery.
1972	'Twenty–Five Years of Indian Art', RB.LKA.
1979	North Carolina Museum of Art, Raleigh, USA.*
1980	Gallery Surya Rettberg, Freinsheim, W.Germany.*
	Gallery F. Friendrich, Cologne.
1981	JG.*
	'Indian Painting Today', JG.
1984	Inaugural Ex.: 'Ten Artists', Gallery 7, Bombay.
	'Contemporary Painters', Raj Bhavan, Bombay. (Organised by
	Pundole).

1987	Gallery Maison Francaise, Nairobi, Kenya.*
	First Christie's Auction for HelpAge India, Bombay.
	'Indian Drawing Today', JG.
1988	JG.*
	'Seventeen Indian Painters: Celebrating 25 Years of Gallery Chemould at the Jehangir', JG & Gy.CH.
1991	'State of the Art', An Ex. of Electronically–aided canvases, JG.
1992	Inaugural Ex.: 'Husain ki Sarai', Faridabad, U.P.
	'Pioneers to the New Generation', Arts Acre, Calcutta.
	Joint Ex. with A.Padamsee & J.Chowdhury, Pundole.
1993	'Wounds', CIMA & NGMA.
	'Parallel Perceptions', Sakshi, Bombay, Bangalore and Madras.
	Inaugural Ex.: 'Trends & Images', CIMA.
	'Artists for HelpAge', Asprey's Auction, JG.
1993	'Reflections & Images', Vadehra & JG. (Organised by Vadehra).
1994	JG.*
1995	Prithvi Gallery, Bombay.*

Illustrated Works

| 1975 | Untitled | 170 |
| 1993 | Untitled | 283 |

SINGH, Arpita

Birth
22 June 1937. Bara Nagar, West Bengal.

Education
1954–9 Diploma (Fine Arts), Delhi Polytechnic.

Selected Exhibitions

1960	The Unknown, New Delhi (Also in 1961, '62).
1963	'In Memory of Sailoz Mookherjea', Kunika–CH.
1969	'Art Today', Kunika–CH (Also 1971, '72).
1972	Kunika–CH.*
	'Two Painters', Gy. CH.
	'25 Years of Indian Art', LKA, and other major cities.
1974	'Group Ex.', RB, LKA.
1975	III V Indian Triennale, RB. LKA. (1982)
	Dhoomimal.*
1976	Pundole.*
1977	Werl, W.Germany.*
	'Pictorial Space' , RB.LKA. (Curated by G. Kapur).
1978	AH (Also 1982, '85, '91).*
1981	'All India Drawing Ex.', Chaindigarh (Also 1982).
1982	'Contemporary Indian Art', Festival of India, Royal Academy of Art, London.
1984	Inaugural Ex., Bharat Bhavan, Bhopal.
	'Indo–Greek Cultural Ex.', Athens, Delphi, Greece.
	'Three Painters', Cymroza.
1985	'Five Indian Painters' , Istanbul, Ankara, & Belgrade.
	'Year of Handloom Celebration', New Delhi, Calcutta, Madras and Bombay.
1986	Festival of India, Georges Pompidou Centre, Paris.
	Bharat Bhavan Biennale, Bhopal.
	'Indian Women Artists', NGMA.
1987	Gallery 7, Bombay (Also 1990).*
	'Coups de Coeur', Halle de L'Ile, Festival of India, Geneva.
	II Biennale, Havana, Cuba.
	Algeria Biennale, Algeria.
	Helpage India, Taj Hotel, Bombay.

1988	'Four Painters', Bhopal, New Delhi, Bangalore.
	'Contemporary Figurative Indian Art', Kuwait.
	'Water Colour by Four Painters', JG.
	Smith's of Convent Garden, London (Organised by Arun Sachdev & Gallery 7, Bombay).
1989	'The Times of India Auction of, TIMELESS ART', Sotheby's, Bombay. 26 Mar 1989.
	'Artist Alert', Safdar Hashmi Memorial Trust, New Delhi.
	'Through the Looking Glass', CCA, New Delhi.
1990	'Nine Indian Contemporaries' , CCA, New Delhi.
	Habiart Gallery, Habitat Centre, New Delhi.
1991	Helpage India, Bombay.
1992	CCA.*
	Husain Ki Sarai, Faridabad, U.P. (Organised by Vadehra).
	Sotheby's Auction and Ex., New Delhi.
	'The Subjective Eye', Sakshi. (Curated by Abhishek Poddar).
1993	Schoo's Gallery, Amsterdam.*
	India Songs, Art Gallery of New South Wales, Sydney.
	'Wounds', CIMA, and NGMA.
	Inaugural Ex.: 'Trends and Images', CIMA.
	'Two Artists', Washington D.C. (Arpita & Paramjit Singh).
	'Indian Encounters', London.
1994	'Art for Children's Sake', Mobile Creches at Habiart Centre, New Delhi.
	'Drawing' 94', Espace. (Curated by Prayag Shukla).
	'Paintings 1992-94'. Vadehra.*
1995	'Watercolours: A Broader Spectrum–I', Gy.CH. (Group Ex. also includes: A.Ambalal, .Chowdhury, J.Chakravarty, & Madhvi Parekh).
1995	'Contemporary Indian Paintings: from the Chester & Davida Herwitz Collection' Part I, Sotheby's Auction, New York. 12 Jne 1995.
	'Indian Contemporary Paintings', Christie's Auction, London. 16 Oct 1995.
1996	'Contemporary Indian Paintings: from the Chester & Davida Herwitz Collection' Part II, Sotheby's Auction, New York.3Apr.
	'Modern and Contemporary Indian Paintings: One Hundred Years', Sotheby's Auction, London. 8 Oct 1996.

Illustrated Works

1972	Figures and Flowers Series	197
1987	Two Figures Lying on a Bed	26
1988	Andhretta Lily	284
1992	Couple Having Tea	111

SINGH, Paramjit

Birth
23 February 1935. Amritsar, Punjab.

Education
1953–8 Diploma (Fine Arts), Delhi Polytechnic.
1973 Atelier Nord, Norway (Print-making).

Teaching Experience
 Professor, Painting (Fine Arts Department), Jamia Millia Islamia, New Delhi.

Selected Exhibitions

1957	'Young Asian Artists', Tokyo.
1958	'Seven Painters', New Delhi.
1959	'Nine Painters', New Delhi.

1960	'The Unknown', New Delhi (Also 1961, '62).
1963	'In Memory of Sailoz Mookherjea', Kunika–CH.
1967	Triveni Gallery, New Delhi.*
1968	'Trends in Romanticism', JG.
1969	Gallery Chanakya, New Delhi (Also 1970).*
	'Art Today', Kunika–CH (Also 1971, '72).
1970	Art Expo 70, Indian Pavilion, Osaka, Japan.
	National Ex., RB.LKA. (LKNA: **The stone on the wall**).
1971	II, III, IV, V International Triennale, RB. LKA. (1975. '78 '82)
1972	Kunika–CH.*
	'Two Artists', Gy.CH.
1973	Kunstner Forbundent, Oslo, New Delhi.*
	Gallery Babylon, Brussels.*
	Art Gallery Achenbach – Lohrl, Dusseldorf, Germany.*
	Ex. of Prints, Atelier Nord and Gallery 71, Tromso, Norway.
1974	Gy.CH (Also 1978, '81, '85, '90).*
1975	Dhoomimal (Also 1979, '84, '87).*
1977	'Pictorial Space', RB. LKA. (Curated by G.Kapur).
1980	Silver Jubilee Ex. in Miniature Format, LKA.
1981	Mainz, W. Germany.*
	Gallery Alana, Oslo, Norway.*
1982	'Indian Art Today', Darmstadt, W. Germany.
	Inaugural Ex., Bharat Bhavan, Bhopal.
1983	Gallery Caprano, Braunschewig, W.Germany.*
1984	XV Tokyo Biennale, Japan.
1986	Bharat Bhavan Biennale, Bhopal.
	Ankara Art Biennale, Turkey.
1987	Cultural Centre, Bomlitz, W. Germany.*
	Festival of India, USSR.
1988	'25 Years of Gallery Chemould at the Jehangir', JG & Gy.CH.
	International Festival of Art, Baghdad, Iraq.
1989	Gallery Kilian, Celle, W. Germany.*
	'Artists Alert', Safdar Hashmi Memorial Trust, New Delhi.
	'Nature and Environment', LKA.
1990	CCA.*
	Habiart Gallery, Habitat Centre, New Delhi.
1991	'Nine Indian Contemporaries', CCA.
1992	Collection of Works, Husain ki Sarai, Vadehra.
	BAAC Silver Jubilee Show, Calcutta.
1993	Emirates Bank International, organised by ZPM and Gallery Espace, Sharjah.
	'Indian Encounters', Ex.s by The Gallery in London, New York, Dubai.
	'Masters of India', Arts Trust, Bombay.
	'Two Artists', Washington D.C. (Arpita & Paramjit Singh)
	Inaugural Ex.: 'Trends and Images', CIMA.
1994	CIMA.*
	The Gallery, Madras.*
	'Drawing' 94', AIFACS. (Curated by P.Shulka & organised by Espace).
	Cairo Biennale, Egypt.
	Art Festival, Israel.
	'Art for Children's Sake', Mobile Creches at Habiart Centre, New Delhi.
1995	'Indian Contemporary Paintings', Christie's Auction, London. 16 Oct 1995.
1996	'Modern and Contemporary Indian Paintings: One Hundred Years', Sotheby's Auction, London. 8 Oct 1996.

Illustrated Works

| 1970 | Stone on the Wall | 74 |
| 1995 | Water–Mirror (Diptych) | 109 |

SOUZA, Francis Newton

Birth
| 12 Apr 1924. | Saligao, Goa. |

Education
1937–9	St.Xavier's School, Bombay.
1940–5	Diploma (Painting), J.J. School.
1948	Founder Member–Spokesman of Progressive Artists Group (PAG).
1960	Study tour of Italy on an Italian Government Scholarship.

Selected Exhibitions
1948	Burlington House Gallery, London.
1949	PAG Group Ex., Bombay Art Society Salon, Bombay.
1951	Indian Embassy, London.*
1954	Institute of Contemporary Arts, London.
	Venice Biennale, Italy.
1955	Gallery One, Litchfield Road, London.*
1956	Gallery One, D'Arblay Street, London. (Also in 1957, '59, '60)*
1957	John Moore's Ex., Walker Art Gallery, Liverpool.
1960	Paris.*
1961	Gallery One, North Audley Street, London. (Also 1962).*
1962	Kumar Gallery, New Delhi.*
1963	Taj Gallery, Bombay.*
1966	Dhoomimal.*
1967	Guggenheim Foundation, USA.
1968	London Arts Gallery, Detroit, USA.*
1975	Arts 38, London.*
1976	Arts 38, London.*
	Dhoomimal.*
1977	'Commonwealth Artists of Fame', London.
1982	'India: Myth & Reality – Aspects of Modern Indian Art', Museum of Modern Art, Oxford.
	'Contemporary Indian Art', Festival of India, Royal Academy of Art, London.
	'Modern Indian Painting', Hirschorn Museum & Sculpture Garden, Washington D.C.
1983	'Souza in the Forties', Dhoomimal.*
1986	Retrospective, AH.*
	Dhoomimal.*
1993	'Souza, 1940s–1990s, Dhoomimal.*
	LTG Gallery, New Delhi.*
1995	'Indian Contemporary Paintings', Christie's Auction, London. 16 Oct 1995.
1996	'Contemporary Indian Paintings: from the Chester & Davida Herwitz Collection' Part II, Sotheby's Auction, New York. 3 Apr 1996.
	'Modern and Contemporary Indian Paintings: One Hundred Years', Sotheby's Auction, London. 8 Oct 1996.
	'Souza from the Alkazi Collection', Academy of Fine Arts & Literature, New Delhi.*
	LTG Gallery.*

Illustrated Works
1953	Mystic Repast	139
1955	Six Gentlemen of Our times	285
1961	Landscape in Red	47
1964	Couple	27
1984	Eros Killing Thanatos	102

SUBRAMANYAN, K.G.

Birth
15 Feb 1924. Kuthuparamba, North Malabar, Kerala State.

Education
1941–2	Presidency College, Madras.
1944–8	Kala Bhavan.
1955–6	Slade College of Art, London. [British Council Research Scholarship].
1966–7	J.D.R. IIIrd Fund Fellowship.
1976	Member Delegate, General Assembly World Craft Council, Oaxtepec, Mexico.

Teaching Experience
1951–9	Lecturer, M.S. University, Baroda.
1961–6	Reader (Painting Department), M.S. University, Baroda.
1966–80	Professor (Painting Dept., Faculty of Fine Arts), M.S. University, Baroda.
1968–73	Dean, M.S. University, Baroda.
1977–8	Visiting Fellow, Kala Bhavan, Visva–Bharati, Santiniketan.
1980–9	Professor of Paintings and Design, Kala Bhavan.
1987–8	Christensen Fellow, St. Catherine s College, Oxford.
1989–	Professor Emeritus, Kala Bhavan.

Selected Exhibitions
1953	'Indian Art', USA.
1955	Silpi Chakra, New Delhi (Also 1958).*
1956	JG (Also 1959, '61).*
	'Three Artists', Hitchin, UK.
1961	Sao Paulo Biennale, Brazil.
1963	New Delhi.*
1964	Tokyo Biennale, Japan.
	'Ten Indian Artists', USA.
1965	Ex. of Textile Paintings, Murals, Woven Hangings, New York World Fair.
	National Ex., RB.LKA. (LKNA: **Studio**).
1966	Gy.CH (Also 1967, '69).*
1967	Gallery Navina, New York.*
1968	I, III International Triennale, RB.LKA (1975).
1969	Kunika–CH.*
1971	Ex. of Polyptichs, Kunika–CH.*
	Indian Art, Tehran, Iran.
1972	Ex. of Terracota Reliefs, Kunika–CH.*
1976	Menton Biennale, France.
1978	Ex. of Terracota Reliefs, AH.*
	Nandan Gallery, Santinikentan (Also 1982).*
1979	Ex. of Prints, AH.*
	Sao Paulo Biennale, Brazil.
1979–80	Asian Artists Ex. – Part I & II Japan.
1980	AH.*
	Indian Art, Washington D.C.
1981	Retrospective, Bharat Bhavan, Bhopal.*
1982	Ex. of Glass and Acrylic Sheet Paintings, AH.*
	'Six Indian Artists', Tate Gallery, London.
	'India: Myth & Reality', Museum of Modern Art, Oxford, UK.
	'Contemporary Indian Art', Festival of India, Royal Academy of Art, London.
1983	Retrospective, BAAC.*
1984	Retrospective, AH.*
1985	AH. (Also 1988, '92).*
1985–6	Festival of India, USA. Includes: 'Contemporary IndianArt', Grey Art Gallery & Study Center, New York University 1985.
	'Contemporary Art of India: The Herwitz Collection', Worcester Art Museum, Worcester, Massachusetts.
1986	Ex. of Glass and Acrylic Sheet Paintings, AH.*
1987	Kala Yatra.*
	Festival of India, Moscow, USSR.
	'Coup de Coeur', Halle de l'Ile, Festival of India, Geneva.
1988	Museum of Modern Art, Oxford, UK.*
	Takaoka Municipal Museum of Art & Meguro Museum of Art, Tokyo, Festival of India, Japan.
	II National Biennale Bharat Bhavan, Bhopal.
1989–90	BAAC.*
	Cymroza.*
1994	Sakshi.*
	'Recent Works', CIMA.*
1995	'Contemporary Indian Paintings: from the Chester & Davida Herwitz Collection' Part I, Sotheby's Auction, New York. 12 Jne 1995.
1996	'Contemporary Indian Paintings: from the Chester & Davida Herwitz Collection' Part II, Sotheby's Auction, New York. 3 Apr 1996.
1989	Cymroza (Also 1990).*
	BAAC.*
1992	Sakshi Gallery, Madras.*
	Sakshi Gallery, Bangalore.*
	'Journeys Within Landscape', JG. (Organised by Sakshi)
1994	Sakshi.*
1995	'The Paris Paintings', AH.*

Illustrated Works
1970	Hunter and Trophy Series	176
1979	Girl and Cat Series	204
1980	Pink Woman, Blue Man	91
1980	Bowl of Fruit with Blind Mother	91
1986	Fairy Tales from Purvapalli Series	229
1988	Inayat Khan Series: Houses with Flying Horses	28
1990	Scene from Ramayana	101

SUD, Anupam

Birth
15 Jan 1944. Hoshiarpur, Punjab.

Education
1963–67	Diploma (Fine Arts), College of Art, New Delhi.
1968	Founder Member, 'Group 8'
1971–2	Print Making at Slade School, London. [British Council Scholarship]
1990	Study Tour of USA [CICA Fellowship].

Selected Exhibitions
1967,69	Solo Ex.s, New Delhi.*
1973	National Ex., RB.LKA. (LKNA: **Composition**).
	Ljubljana Biennale, Yugoslavia.
1974	Florence Biennale.
1975	III, IV International Triennale, RB. LKA (1978).
1977	'Pictorial Space', RB. LKA.
1985	'Indian Printmaking Today', JG.
1986	Inter–Asian Biennale, Ankara, Turkey.
1988	Vithi Gallery, Baroda.*
1989	AH.*
	Cymroza.*
1991	World Bank Art Society, Washington DC.*
1992	Chitrakoot.*

1993	'Reflections & Images', Vadehra & JG. (Organised by Vadehra).
1994	AH.* LTG Gallery New Delhi.
1996	'Contemporary Indian Paintings: from the Chester & Davida Herwitz Collection' Part II, Sotheby's Auction, New York. 3 Apr 1996.
1995	Cymroza.* 'Four Artists', Espace.
1996	AH.*

Illustrated Works

| 1984 | Dialogue I | 237 |

SULTAN ALI, J.

Birth
12 Sep 1920. Bombay.

Death
1990. Bombay.

Education

1939–45	MGAC (Student of D.P. Roy Chowdhury).
1946	Textile Designing, Madras.
1947	Lingham's Institute of Photography, Diploma from British Institute of Photography, London.

Teaching Experience

1947–8	Senior Instructor in Painting Department, MGAC.
1948–54	Teacher at Rishi Valley School, Madanapalli.
1954–69	Exhibition Officer, LKA.

Selected Exhibitions

1946	Madras (FS)*.
1956	'Contemporary Indian Art', Romania, USSR, Czechoslavakia, Hungary, Bulgaria.
1957	Sout East Asia Ex., Manila, Philippines.
1959	'Indian Contemporary Art', Villa Hugel, Essen, W. Germany.
1960	'Contemporary Indian Painting', U.A.E.
1961	Indian Art Ex., Latin America.
1962	'Commonwealth Art Today', Commonwealth Institute, London. 'Indian Art Today', Bulgaria.
1965	'Art Now from India', Commonwealth Arts Festival,London. 'Indian Contemporary Art', Nairobi, Kenya. 'Ten Contemporary Indian Painters', Massachusetts Institute of Technology, Massachusetts, and New Jersey State Museum, Trenton, New Jersey, USA. 'Art Now from India', Laing Art Gallery, Newcastle–upon–Tyne, UK.
1966	'Indian Art Ex.', Gallery Contour, Belgium. National Ex., RB.LKA. (LKNA: **Kondapalli**).
1967	IX Sao Paulo Biennale, Brazil.
1968	'Indian Contemporary Art', Brussels, Amsterdam, Copenhagen, Vienna and Oslo. 'Man and his World', Pavilion de L'Inde, Montreal. 'Modern Indian Painters', Bonython Gallery, Australia. Inaugural Group Ex, Gallery Chanakya, New Delhi. Ghalib Centenary Celebration Ex., Ghalib Academy, New Delhi.
1971	'Art Today III', Kunika–CH. II, III International Triennale, RB. LKA. (1975)
1972	Cholamandal Artists Village Ex., The UNICEF, New Delhi. Contemporary Miniatures by PPA, JG and Cholamandal Art Gallery, Madras.
1973	'25 Years of Indian Art', LKA. 'Ex. of Contemporary Paintings', Max Mueller Bhavan, Pune.

	'Indian Contemporary Art', Yugoslavia, Brussels, and Poland. 'Contemporary Indian Art', Taj Coromandel Hotel, Madras.
1979	Bindu-3 , Gallerie Surya, W. Germany.
1978	'Modern Indian Art from 1920s', NGMA Collection shown at Tehran, Damascus, Warsaw, Prague, Budapest, Sofia. '40 Artists form Madras', British Council, Madras. 'Retrospective of 4th Triennale – India 1978'. (Organised by Art Society, Neustadt, Gallerie Surya, W. Germany. Inaugural Show at Kala Yatra, Madras and Taj Art Gallery, Bombay. National Ex., RB.LKA. (LKNA: **Nirantar**).
1979	'24 Artists of Cholamandal', Venkatappa Art Gallery, Bangalore. Kala Yatra, Madras.* 'Ex. of paintings and Sculptures from India', Loke House Gallery, Kuala Lumpur. 'Asian Artists Ex.', Fukuoka Art Museum, Japan.
1980	'Contemporary Paintings in Miniature Format', RB.LKA & JG. 'Contemporary Indian Art', World Trade Fair, New Delhi.
1981	'Neue Kunst aus Indien', Universitat Beyreuth, W. Germany.
1982	'Indische Kunst Heute', Kunsthalle Darmstadt, W. Germany.
1983	Tantra Ex., Stuttgart, W. Germany.
1985	Ex. of Paintings by the Artists of Cholamandal Artists Village in Morocco, Algiers and Egypt.
1986	Bharat Bhavan Biennale, Bhopal.
1987	'Two Decades of Cholamandal', JG. 'Indian Drawing Today', JG.
1988	Ex. by Top Madras Artists, Max Mueller Bhavan and Sarala Art Gallery, Madras.
1989	'Contemporary Indian Art', Ramakrishna Mission Institute of Culture, Calcutta.
1990	Ex. of Drawings, Galarie 88, Calcutta.*
1995	'Contemporary Indian Paintings: from the Chester & Davida Herwitz Collection' Part I, Sotheby's Auction, New York. 12 Jne 1995.
1996	'Modern and Contemporary Indian Paintings: One Hundred Years', Sotheby's Auction, London. 8 Oct 1996.

Illustrated Works

1957	Village Life	56
1965	Kondapalli	29
1975	Untitled	172
1981	Bhumi Mata	205

SUNDARAM, Vivan

Birth
1943. Simla, Himachal Pradesh.

Education

| 1961–5 | BA (Fine Arts), M.S. University, Baroda. |
| 1966–8 | Post Diploma Slade School, London. [Commonwealth Scholarship]. |

Selected Exhibitions

1965	Taj Art Gallery, Bombay.
1966	Dhoomimal.* & Taj Art Gallery, Bombay.(FS)*
1968	'Young Contemporaries', Royal Academy of Arts, London. Arts Laboratory, London.*
1972	'The Heights of Macchu Picchu', Kunika–CH, Gy. CH, Calcutta and JG.*
1974	Gy. CH, Calcutta and JG.*

'Group Ex.', RB. LKA.
Indian Paintings and Graphics, Poland.

1976 'The Discreet Charm of the Bourgeoisie', RB, LKA,
 Academy of Fine Arts, Calcutta, JG, and Fine Arts Faculty,
 Baroda.*
 'The Indian Emergency–I', Triveni Kala Sangam, New Delhi.*

1977 'The Indian Emergency–II', Black Partridge Gallery,
 New Delhi, JG, and Fine Arts Faculty, Baroda.*
 'Pictorial Space', RB. LKA.

1978 'Six who Declined to Show in the Triennale', Kumar Gallery, New
 Delhi.

1981 'Place for People', JG, and RB. LKA.
 Urja Art Gallery, Baroda.*

1982 'Seven Indian Artists', Galerie Bolhagen, Worpswede, Kubur,
 Hanover; Amerika–House, Hamburg, W. Germany.
 'Contemporary Indian Art', Festival of India, Royal Academy of
 Art, London.

1984 Tokyo Biennale, Japan.

1984–5 'Signs of Fire', Dhoomimal, Gy.CH and Fine Arts Faculty, Baroda.*

1985 II Asian Art Show, Fukuoka Art Museum, Japan.

1985–6 Shridharani and JG.*

1986 Contemporary Asian Art Ex. Seoul, South Korea.

1987 II Biennale, Havana, Cuba.
 'Coups de Coeur', Halle de L'Ile, Festival of India, Geneva.
 Helpage Auction, Hotel Taj, Bombay.

1987–8 'Journeys', Aurobindo Gallery, New Delhi and Kala Yatra,
 Bangalore.*

1988 'Long Night: Drawings in Charcoal', RB. LKA & Gy.CH, Calcutta.*
 '25 Years of Gallery Chemould' at the Jehangir Gy. CH. & JG.
 'International Festival of Art', Baghdad, Iraq.
 'Art for CRY', Bombay, New Delhi, Calcutta, Bangalore.

1989 The Times of India Auction of TIMELESS ART', Sotheby's Auction,
 Bombay. 26 Mar 1989.
 'Artists Alert', Safdar Hashmi Memorial Trust, New Delhi.
 Glass Mural with Bhupen Khakhar and Nalini Malani, Bombay.

1990 'Splashes: Images on Glass', Gy.CH.
 Shridharani and Gy. CH.*
 'Long Night: Drawings in Charcoal', Max Mueller Bhavan, Hyderabad.
 'Homage to Nelson Mandela', LTG Art Gallery, New Delhi.
 'Art Mosaic', Calcutta.
 'Ambassador's Choice', NGMA. (Curated by E.M. Schoo).

1991 IV Biennale, Havana, Cuba.
 'Artists Against Communalism: Words and Images',
 SAHMAT, New Delhi and 15 other cities.

1991–2 'Engine Oils and Charcoal: Works on Paper', LTG Art Gallery, New
 Delhi, Sakshi Gallery, Bangalore,
 and Fine Arts Faculty, Baroda.*

1992 'Collaboration/Combines', Shridharani, JG and Gy. CH.*
 'Indian Painting in Dacca', Dacca, Bangladesh.
 'Journeys within Landscapes', Sakshi and JG.
 'Pioneers to a New Generation', Arts Acre, Calcutta.

1993 'Memorial', AIFACS, New Delhi.*
 'Critical Difference', An Aberstwyth Arts Centre
 Touring Ex., UK.
 'Riverscape', Cleveland Gallery and Middlesborough
 Art Gallery, Cleveland, UK.
 'Still–Life', Sakshi.

1994 'Map, Monument, Fallen Mortal', South London Gallery,
 London.*
 'Works with Paper', Contemporary Art Gallery, Ahmedabad.*
 'House/Boat', OBORO, Montreal.*
 'Hundred Years: From the NGMA Collection', NGMA, New Delhi.
 (curated by Geeta Kapur).
 'Drawings '94', Espace. (curated by P.Shulka)

'Art for Children's Sake', Mobile Creche Art Show, Habiart Gallery,
New Delhi.
Shraddha Rehabilitation Foundation Fund Raising Show, JG.

1994–5 'Riverscape', BAAC, & Sakshi.*

1995 'Watercolours: A Broader Spectrum– II', Gy.CH (Group Show with
 P.Barwe, C.Douglas, G.Haloi, P.Kolte, M.Rai)

1995–6 'The Sher-Gil Archive', Mucsarnok. Dorottya Gallery,
 Budapest, Hungarian Information and Cultural Centre,New Delhi,
 and Gy.CH.*

1996 'HOUSE/BOAT', Winnipeg Art Gallery, Winnipeg,
 and Vancouver Art Gallery, Vancouver.*

Illustrated Works

1975	Fire Next Time	201
1980	Portrait of Father	90
1985	Two Boys Sitting on an Outer Wall:	
	Kalidas and Pandu	286
1988	Allegorical Landscape	287
1989	Arabesque	30
1991	Approaching 100,000 Sorties	232

SWAMINATHAN, Jagdish

Birth
21 Jun 1928. Sanjauli, Simla, Himachal Pradesh.
Death
25 Apr 1994. New Delhi.

Education
1956 Delhi Polytechnic (Part Time).
1958 Academy of Fine Arts, Warsaw.
1968–70 Jawaharlal Nehru Fellowship.

Teaching Experience
 Cambridge School, New Delhi.
 Visiting Professor, Jamia Milia University, New Delhi.
1981–90 Founder Director, Bharat Bhavan, Bhopal.

Selected Exhibitions
1963 Inaugural Ex.: 'Group 1890', New Delhi.
1965 Gy.CH. (Also 1971).*
 Tokyo Biennale, Japan.
 UNESCO International Ex. of Indian Graphics, Poland.
1965–6 'Art From India Now'
1968 I International Triennale, RB.LKA.
1972 'Perceptions', Gallery Chanakya, New Delhi.*
1986 I National Bharat Bhavan Biennale, Bhopal.
1987 Festival of India, Moscow, USSR.
1988 Dhoomimal.*
 Takaoka Municipal Museum of Art & Meguro Museum of Art,
 Tokyo, Festival of India, Japan.
 II National Biennale Bharat Bhavan, Bhopal.
 'Seventeen Indian Painters: To Celebrate 25 Years of Gallery
 Chemould at the Jehangir.', JG.
1991 Gy.CH.*
 'Nine Indian Contemporaries', CCA.
1992 CCA.*
1993 Vadehra.*
 'Reflections & Images', Vadehra & JG. (Organised by Vadehra)
1995 'Indian Contemporary Paintings', Christie's Auction, London. 16
 Oct 1995.
1996 'Modern and Contemporary Indian Paintings: One Hundred Years',
 Sotheby's Auction, London. 8 Oct 1996.

Illustrated Works

TAGORE, Abanindranath

Birth
7 Aug 1871. Calcutta.
Death
1951.

Education
CGAC.
Private Tutors: Gilhardi & Palmer.

Teaching Experience
1907 Established ISOA.
Founder of Bengal School.

Selected Exhibitions
1908 Inaugural Ex.: ISOA, Calcutta. (Also 1910, '12)
1909 ISOA Ex., Simla.
1911 ISOA's United Provinces Ex., Allahabad.
Festival of Empire, Crystal Palace, England. (Organised by ISOA for George V's Coronation).
1914 22nd Ex. of Societe des peintres orientalistes francais, Grand Palais, Paris. Travelling to Belgium, Holland and Imperial Institute, England.
1915–6 ISOA Ex., Calcutta & Young Men's Indian Association, Madras.
1924 Travelling Ex., USA. (Organised by American Federation of Art & ISOA).
1928 Athenee Gallery, Geneva, Switzerland. (Organised by James Cousins).

Illustrated Works

TAGORE, Gaganendranath

Birth
1867. Calcutta.
Death
1938. Calcutta.

Education
Self–Taught.

Selected Exhibitions
1908 Inaugural Ex.: ISOA, Calcutta. (Also 1910, '12)
1909 ISOA Ex., Simla.
1911 ISOA's United Provinces Ex., Allahabad.
Festival of Empire, Crystal Palace, England. (Organised by ISOA for George V's Coronation).
1914 22nd Ex. of Societe des peintres orientalistes francais, Grand Palais, Paris. Travelling to Belgium, Holland and Imperial Institute, England.
1915–6 ISOA Ex., Calcutta & Young Men's Indian Association, Madras.

1924 Travelling Ex., USA. (Organised by American Federation of Art & ISOA).
1928 Athenee Gallery, Geneva, Switzerland. (Organised by James Cousins).

Illustrated Works

TAGORE, Rabindranath

Birth
7 May 1861.
Death
7 Aug 1941.

Education
Self–Taught.

Teaching Experience
1921 (23 Dec) Visva Bharati University Inaugurated.

Selected Exhibitions
1930 May–Dec, First Travelling Ex.– Galerie Pigalle, Paris; City Art Gallery, Birmingham, & India Society, London, UK; Moeller's Gallery, Berlin, Art Club of Saxony, Dresden & Gallery Caspari, Munich, Germany; Charlottenburg Picture Gallery, Copenhagen, Denmark; Geneva; State Moscow Museum of New Western Art, Moscow; Doll & Richards Gallery & Museum of Fine Arts, Boston and 56th Street Galleries, New York, USA.*
1931 The Newman Galleries, Philadelphia, USA.*
1932 CGAC.*
1934 Congress House, Madras.*
1938 Calmann Gallery, London.*
1939 Bangiya Sahitya Parishad, Calcutta.*
1943 Tagore Society, Prince of Wales Museum, Bombay.*
Kala Bhavan, Santiniketan. (Also 1945, '47, '49, '51, '52, '69)
1946 International Exhibition of Modern Art, Paris.
1947 National Gallery of Australia, Melbourne.
1950 Allahabad University, Allahabad.*
1953 National Library, Calcutta.*
JG.*
1955 Academy of Fine Arts, Calcutta. (Also 1957).*
1959 Rome–New York Art Foundation, Rome.
1961 Tagore Centenary Ex., Calcutta.*
Indian High Commission, Karachi.*
Swiss National Library, Switzerland.*
Colombo Art Gallery, Sri Lanka.*
(Also Ex.s in Ghana, W.Africa; Baghdad, Iraq; Dusseldorf & Stuttgart, W.Germany).
1965 NGMA.*
1967 BAAC.*
1972 BAAC.
1973 Rabindra Bhavan Gallery, Visva–Bharati University, Santiniketan. (Also 1975, '76, '77, '79).
1981–5 Travelling Ex. in Tokyo, Djakarta & Eastern Europe.
1982 'Six Indian Painters', Tate Gallery, London. (Artists include: Jamini Roy, Amrita Sher-Gil, M.F.Husain, K.G.Subramanyan & Bhupen Khakhar).
1986–7 Travelling Ex.– Barbican Gallery, London; Corner House, Manchester; The Third Eye, Glasgow & Cartwright Hall, Bedford; and Museum of Mordern Art, Oxford.*

1987–8 Festival of India, USSR & Japan.

Illustrated Works
1928	Composition	1
1929	Fantastic Bird	
	(with inscribed poem in Bengali)	128
1934	Two Figures	37

TEWARI, Vasundhara

Birth
1 Sep 1955. Calcutta.

Education
1973 Triveni Kala Sangam, New Delhi. (Student of R. Broota).
1973–76 B.A.(English Literature), Delhi University.
1982–4 Cultural Scholarship, Government of India.

Teaching Experience
 Art Department, Triveni Kala Sangam.

Selected Exhibitions
1980 Shridharani. (Also 1981, '91, '94).*
1984 University of Illinois, Chicago, USA.*
 Ex. of Contemporary Indian Art, Tokyo.
1986 Calcutta Art Gallery.*
 I National Bharat Bhavan Biennale, Bhopal.
 'Indian Women Artists', NGMA.
 II Havana Biennale, Cuba.
 VI International Triennale, RB.LKA.
1987 I International Biennale of Plastic Arts, Algiers.
 'Art for CRY', Bombay, Calcutta, New Delhi, Bangalore.
 Festival of India, Moscow, USSR.
1988 'Women Artists of India', NGMA Collection, Bulgaria and Poland.
1989 'Indian Eclectics: Some New Sensibilities in Contemporary Art',
 RB.LKA. (Organised by Sanskriti Pratisthan in collaboration with
 the Festival of France in India).
 'Artists Alert: Ex. for Safdar Hashmi Memorial Trust, New Delhi.
1990 'Tribute to van Gogh', Vadehra.
1991 Pundole.*
 'Artists of the Decade', Haibart Gallery, New Delhi.
 'The Girl Child', Maurya Sheraton, New Delhi.
 'Artists for HelpAge' Asprey's Auction at JG. (Also 1993).
 'Masters', JG. (Organised by Vadehra).
1992 'Looking for Tree of Life: A Journey to Asian Contemporary Art',
 The Museum of Modern Art, Saitama, Japan.
 'Man and Woman', JG. (Organised by The Arts Trust).
 T.A.I.S., Tokyo. (Also 1993).
1993 'More than a Decade Ago', The Artists' Choice – Display Gallery,
 New Delhi.
1994 Shridharani.*
1995 'Contemporary Indian Paintings: from the Chester & Davida
 Herwitz Collection' Part I, Sotheby's Auction, New York. 12 Jne 1995.

Illustrated Works
| 1991 | Reaching Out | 239 |
| 1991 | Subterranean | 116 |

VAIJ, Ramkinkar

Birth
1910. Bankura, West Bengal.
Death
1980.

Education
1925–9 Diploma (Fine Arts), Kala Bhavan, Visva–Bharati University.

Teaching Experience
 Head of Sculpture Dept., Kala Bhavan, Santiniketan.

Selected Exhibitions
1930s ISOA group Ex.s
1942 New Delhi (FS).*
1950 Realities Nouvelle, Paris. (Also 1951).
1950s Calcutta Group Ex.s, Calcutta.
1979 Asian Art Ex., Tokyo.
1960–1 Visvabharati Union, Santiniketan.*
 'Paintings, Sketches & Sulptures', Calcutta Arts Council,
 Calcutta.*
1972 BAAC*
 New Delhi.*
1990 Retrospective, NGMA.*
1995 'Man and Nature: Reflections on Six Artists'. (Curated by
 Keshav Malik).

Illustrated Works
1937–8	Santhal Family	132
c.1940	Landscape Series	40
c.1956	Threshing	133

VAIKUNTUM, T.

Birth
1942. Boorugupally, Karimnagar District, Andhra Pradesh.

Education
1965–70 Diploma (Drawing & Painting), College of Fine Arts and
 Architecture, Hyderabad.
1971–2 Painting & Printmaking, M.S. University, Baroda. (Student of
 Prof.K.G.Subramanyan). (On a Lalitha Kala Academy Fellowship).

Teaching Experience
1973–5 Bal Bhavan, Hyderabad.
1985 – Bal Bhavan.

Selected Exhibitions
1972 Kala Bhavan, Hyderabad.*
1982 'Charcoal Drawings', Kala Bhavan, Hyderabad.*
1983 Hyderabad Arts Society.*
1989 Max Mueller Bhavan, Hyderabad.*
 Grindlays Gallery, Madras.*
 Salarjung Museum, Hyderabad.
1990 Cymroza.
1991 Espace.*
 VII International Triennale, RB.LKA.
1992 The Gallery, Madras.*
 Buddhist Artist Camp, Calcutta.*
 Sanskrita Art Gallery, Calcutta.
 Art Encounter, Kassel, Germany.

1993 Cymroza.*
 'Artists for HelpAge' Asprey's Auction, JG.

Illustrated Works
1977 Untitled cover

VARMA, Raja Ravi

Birth
29 Apr 1848. Kerala.
Death
2 Oct 1906.

Education
Self–Taught.

Selected Exhibitions
1873 Madras.*
1893 World's Columbian Ex., Chicago.
1899 'Baroda Puranic Commission's' Trivandrum, Baroda & Bombay.*
1993 Ex. of Paintings, Drawings & oleographs from the Sri Chitra Art
 Gallery, Trivandrum; NGMA & Private Collections. National
 Museum, New Delhi.*

Illustrated Works
c.1890s Rukmini, Radha and Krishna 121
1904 Lady Holding Hookah in One Hand
 and Broom in Another 32

VASUDEV, S.G.

Birth
3 Mar 1941. Bangalore, Karnataka.

Education
1964–8 Diploma (Fine Arts), MGAC.
1964–6 Government of India, Cultural Scholarship.

Selected Exhibitions
1964 State LKA, Bangalore (Also 1965 & '79).
1965 National Ex. of Art, LKA (Also 1966–8, '72, 1974–9).
 Academy of Fine Arts, Calcutta (Also 1972).
 LKA, Madras (Also 1966–7, '77, '79, '80).
1966 Bangalore (Also 1967, '68, '74, '76, '89, '91, '92).*
1967 Madras (Also 1968, '69, '75, '91).*
 Bombay (Also 1969, '71, '74, '90, '92).*
 'Recent Indian Art' (Yugoslavia, Czechoslovakia, & Belgium).
 (Organised by LKA).
 National Ex., RB.LKA. (LKNA: **Procession**).
1968 New Delhi (Also 1969, '72, '76, '78).*
 Dharwar.*
 Paris Biennale, Paris.
1969 '18 Indian Painters', Max Mueller Bhavan,Calcutta.
1971 II, III, IV & V International Triennale, RB.LKA. (1975, '78, '82).
1972 '25 Years of Indian Art', RB.LKA.
 'Cholamandal Artists Village Ex., New Delhi. (Organised by
 UNICEF).
 'Contemporary Miniatures', PPA, Madras and Bombay.
1973 'Cholamandal Artists Works', Goethe Institute, Pune.
1977 Ottawa & Toronto, Canada.*

New York, Los Angeles, & Chicago, USA.*
 USA organised by NGMA.
1978 '40 Artists of Madras', British Council, Madras.
1983 Germany.*
1987 HelpAge Ex. and Auction, Bombay (Also in 1991).
1988 '10 Madras Artists', Max Mueller Bhavan, Madras.
1988 Takaoka Municipal Museum of Art & Meguro Museum of Art,
 Tokyo, Festival of India, Japan.
 II National Biennale Bharat Bhavan, Bhopal.
1989 'Spirit of Madras', Contemporary Indian Art Ex., Hyderabad
1993 Sakshi, Bombay & Madras.*

Illustrated Works
1972 Maithuna Series 173
1992–3 He & She Series 230

VENKATAPPA, K.

Birth
1887. Mysore City.

Education
1902–8 Fine Arts, Government Industrial School, Mysore.
1909–16 Fine Arts, Advanced Study, CGAC.

Selected Exhibitions
1908 Inaugural Exhibition: ISOA, Calcutta. (Also 1910, '12)
1909 ISOA Exhibition, Simla.
1911 ISOA's United Provinces Exhibition, Allahabad.
 Festival of Empire, Crystal Palace, England. (Organised by ISOA
 for George V's Coronation).
1914 22nd Exhibition of Societe des peintres orientalistes francais,
 Grand Palais, Paris. Travelling to Belgium and Holland and
 ImperialInstitute, England.
1924 Travelling Exhibition, USA. (Organised by American Federation of
 Art & ISOA).
1928 Athenee Gallery, Geneva, Switzerland.
 (Organised by James Cousins).

Illustrated Works
1913 Ramayana Series: Ravana & Jatayu 124

Bibliography

<div style="display:flex">

<div>

Notes to Bibliography:

1 Dates which follow ExC. are that of the exhibition for which the catalogue has been written.

2 The titles under the relevant **category** are ordered chronologically, from earliest to latest.

3 If no gallery name is specified then the publishers of the ExC. are assumed to be the main exhibiting gallery.

4 Certain substantial ExC. are represented as books (italicised).

5 A [*Refer...*] list for cross-reference purposes is provided for most artists and writers.

6 Certain bulletins consisted of just a few pages, and each article consisting of barely a page, and so no pagination is provided, though they be categorised as Journals. Eg: *Artrends*.

7 In many cases the reference is placed under the Publisher–cum–gallery rather than the author. This is considered more fair and convenient. Appropriate cross–References are provided.

8 Journal entry format used: *Journal title* vol.no (date*)*: page numbers.
 eg: *Artrends* 1.2 (Oct.1966).
 eg: *JAI* 27–28 (Jly 1994): 45–56.

9 ExC. (when including a titled text by author) under category of the exhibiting gallery is written as follows:
Category
Author 'Title of Text'. Exhibition Title ExC. Dates of exhibition.

Eg: **Pundole**
Roshan Shahani 'Continuities Animated...' Padamsee–Chowdhury–Shreshtha ExC. 7–26 Dec 1992.

10 Essays in books, under category of author, are presented as:
Author Title of Article. In *Title of Book*. Pagination of article. Editor(s). Place of publication: Publisher date of publication.

Eg: **Ananth, Deepak** An Engagement with Reality. In *India Myth and Reality– Aspects of Modern Indian Art* ExC. 55–62. D.Elliot, V.Musgrave & E.Alkazi, eds. Oxford: Museum of Modern Art 1982

11 The + sign after pagination signifies that illustrations follow the text so adding to the size of the article.

12 Regarding certain proper nouns/names. Various differences occur, and so I have stuck to one format. Eg: Amba Das is written as Ambadas, Ram Kumar as Ramkumar, Badri Narayan as Badrinarayan, Das Gupta as Dasgupta, Dhoomi Mal as Dhoomimal, etc. However, where other writers spell the name differently and are quoted, I make no change.

</div>

<div>

Abbreviations

AHJ	*Art Heritage Journal,* New Delhi: Art Heritage.
AIFACS	All India Fine Arts & Crafts Society, New Delhi.
Artrends	Artrends Bulletin, Madras: Progressive Painters Association
AT 1900–90	*Art in Theory 1900–1990: An Anthology of Changing Ideas.*
BAAC	Birla Academy of Art & Culture, Calcutta.
CIMA	Centre for International Modern Art, Calcutta.
CCA	Centre for Contemporary Art, New Delhi.
Chitrakoot	Chitrakoot Art Gallery, Calcutta.
Cymroza	Cymroza Art Gallery, Bombay.
Dhoomimal	Dhoomi Mal Art Centre, New Delhi.
Espace	Gallery Espace, New Delhi.
Gallery 7	Gallery 7, Bombay.
Gy.CH	Gallery Chemould, Bombay. (If ExC. refers to Calcutta branch, it will be specified)
IIAS	Indian Institute of Advanced Study, Simla.
IIC	India International Centre, New Delhi.
ISOA	Indian Society of Oriental Art, Calcutta.
IWI	*The Illustrated Weekly of India,* Bombay.
JAI	*Journal of Arts & Ideas*, New Delhi.
JG	Jehangir Art Gallery, Bombay.
J.J.School	Sir J.J.School of Art, Bombay.
Kunika–CH	Kunika–Chemould Gallery, New Delhi.
LKA	Lalit Kala Akademi, New Delhi.
LKC	*Lalit Kala Contemporary Journal,* New Delhi: LKA.
LTG	Little Theatre Gallery, New Delhi.
NCPA	National Centre for Performing Arts, Bombay.
NGMA	National Gallery of Modern Art, New Delhi.
Pundole	Pundole Art Gallery, Bombay.
RB.LKA	Rabindra Bhavan Gallery, Lalit Kala Akademi.
Rupam	Rupam Journal, Calcutta: ISOA.
Sakshi	Sakshi Art Gallery, Bombay. (If ExC. refers to Madras or Bangalore branch, it will be specified)
Seagull	Seagull Foundation for the Arts and/or Seagull Publications, Calcutta.
T & H	Thames & Hudson, London.
The Gallery	The Gallery, Madras.
Vadehra	Vadehra Art Gallery, New Delhi.

Miscellaneous

ed	Editor
ExC.	Exhibition Catalogue
n.d	no date
n.p.	no pagination
Q	Quarterly Journal
Rpt.	Reprinted
Trans.	Translator/Translated
Jan	January
Feb	February
Mar	March
Apr	April
May	May
Jne	June
Jly	July
Aug	August
Sep	September
Oct	October
Nov	November
Dec	December

</div>

</div>

LALIT KALA CONTEMPORARY JOURNAL

#	Date of Issue	
1	Jne 1962	
2	Dec 1964	
3	Jne 1965	
4	Apr 1966	
5	Sep 1966	
6	Apr 1967	
7–8	Sep 1967–Apr 1968	
9	Sep 1968	
10	Sep 1969	
11	Apr 1970	
12–13	Apr –Sep 1971	
14	Apr 1972	
15	Apr 1973	
16	Sep 1973	
17	Apr 1974	
18	Sep 1974	
19–20	Apr –Sep 1975	
21	Apr 1976	
22	Sep 1976	
23	Apr 1977	
24–25	Sep 1977–Apr 1978	
26	Sep 1978	
27	Apr 1979	
28	Sep 1979	
29	Apr 1980	
30	Sep 1980	
31	Apr 1981	
32	Apr 1985	
33	Dec 1985	
34	Jan 1987	
35	Sep 1987	
36	Sep 1990	
37	Mar 1991	
38	Mar 1993	
39	Mar 1994	
40	Mar 1995	Special Issue: J.Swaminathan
41	Sep 1995	Issue on Installation Art
42	Mar 1996	Special Issue: Art & Nature

ART HERITAGE JOURNAL

#	Date of Issue
	1978–9
	1979–80
	1980–1
1	1981–2
2	1982–3
3	1983–4
4	1984–5
5	1985–6
6	1986–7
7	1987–8
8	1988–9
9	1989–90
10	1990–1
11	1991–2
12	1992–3
13	1993–4
14	1994–5
15	1995–6

A

Aberystwyth Arts Centre. A Critical Difference: Contemporary Art from India, London ExC. Jan 1993. [Artists include: Bhupen Khakhar, Nalini Malani, Madhvi Parekh, Ravinder Reddy, NN Rimzon, Gogi Saroj Pal, Vivan Sundaram, VK Wankhede. Exhibition organised in collaboration with Showroom, London].

Abraham, Sara. 'The Art Scene in India: As a Promoter looks at it' *LKC* 37 (Mar 1991): 43–4. [*Refer* R.Chawla, M.Jakimowicz–Karle].

Acton, J. 'Two Decades of American Painting' *LKC* 6 (Apr 1967).

Ades, Dawn Dada & Surrealism. In *Concepts of Modern Art*. N.Stangos, ed. 110–37. T & H 1991.

Adimoolam, K.M. [*Refer* J.Appasamy, Art Heritage, J.James].

Adorno, Theodor Letter to Benjamin. In *AT 1900–90*. Harrison, C. & P.Wood, eds. 520–3. Oxford: Blackwells 1993.

AIFACS Publishers of Roop Lekha Journal.
2nd International Contemporary Art ExC. New Delhi, 1953.
5th International Contemporary Art ExC. 1965.
Shobita Punja. Jatin Das: Women of Clay ExC. 1–22 Oct 1992.
Ganga: Yusuf Arakkal ExC. 21 Mar– 27 Apr 1994.
Postcards from God: Imitiaz Dharker ExC. 23–30 Nov 1994.
Yogendra Bali. P.Khemraj ExC. 5–15 Dec 1994.
The Artist's word: Pain, Woman, & Clown Series: Dhiraj Chowdhury ExC. 12–20 Apr 1995.
All-India Graphics ExC. 22–30 Apr 1995.
Veer Munshi ExC. May 1995.
AIFACS Regional Centre (Haryana), Inaugural Art ExC. 25 Nov–17 Dec 1995 [Text includes essays by K.B.Goel, Rakshat Puri & Prayag Shukla].
Indo Exhibtion of Korean Women Artists Association ExC. 15–21 Jan 1996.

Air India Air India Art Collection: Magic Carpet Special Issue, 3 Oct 1968.

Albright Art Gallery Andrew C.Ritchie, Introduction. *British Contemporary Painters.* New York: *Albright Art Gallery, The Buffalo Fine Arts* Academy, 1946.

Alkazi, Ebrahim Publisher & Editor of Art Heritage Publications (Eg: *AHJ*, Monographs).
M.F.Husain: The Modern Artist and Tradition. New Delhi: Art Heritage Publication 1978.
'Shamsad Husain' *AHJ* (1978–9): 85–6.
'Preface' *AHJ* (1979–80).
'Editorial: Life celebrated and desecrated'. *AHJ* 4 (1984–5).
'Gujral Speaks' *AHJ* 6 (1986–7): 50–61 [Excerpts from interviews with S.Gujral conducted in Apr/May 1986]'.
Souza's Seasons In Hell' *AHJ* 6 (1986–7): 74–93.
'Nasreen Mohammedi' *AHJ* 6 (1986–7): 106–9.
'Editorial: Art and its Counterfeit'. *AHJ* 10 (1990–1).
'Fluidity of Being: Arpita Singh' *AHJ* 10 (1990–1): 38+
'Kumar Mangalsinhji: A Tranquil View of the World' *AHJ* 13 (1993–4): 5–8+
'Notes on Masterworks from Alkazi Collection' AIFACS ExC. 16–30 Nov 1995.
'Sudip Roy: The Pliant Brush' *AHJ* 15 (1995–6): 13+
'Tara Sabharwal: The Dream of Waking Consciousness' *AHJ* 15 (1995–6): 119–30+ [*Refer* Haku Shah].

Alkazi, Ebrahim, David Elliot & Victor Musgrave, eds. India: *Myth and Reality – Aspects of Modern Indian Art ExC.* Oxford: Museum of Modern Art

1982 [Text includes essays by K.G.Subramanyan, D.Ananth, K.Chaitanya, G.Kapur, Poems by G.Patel & M.F.Husain, F.N.Souza].

Altaf, ed. *Nasreen in Retrospect*. Bombay: Ashraf Mohammedi Trust 1995 [Text includes essays by Y.Dalmia, R.Dossal, & G.Kapur].

Ambadas [*Refer* Art Heritage, M.V.Devan, K.Malik, R.Mehra, Pundole, J.Swaminathan, Vadehra.].

Amberkar, V.R. 'Bendre'. *Design* 1.10 (Oct 1957).
'Krishna Reddy'. *Design* 3.1 (Jan 1959)*:* 29–31.
Hebbar: An Artist's Quest. New Delhi: Abhinav Publications 1974.

Anand, Mulk Raj Editor of *Marg*.
Editor of Sadanga Series, Bombay: Vakil & Sons.
'The Art of George Keyt'. *IWI* (Jly 1951).
'The Birth of Lalit Kala', ed. *LKC* 1 (Jne 19*62)*.
'Modern Movements of Art in India' *LKC* 1 (Jne 1962).
Amarnath Sehgal. Bombay: Mulk Raj Anand for *Marg* Publications 1964.
'Editorial: The Four Initiators of the contemporary Experimentalism' *LKC* 2 (Dec.1964)*:* 1–5.
'The artist as hero' LKC 7–8 (Sep 1977–Apr 1978): 1–6.
25 Years of Modern Indian Art. New Delhi: LKA, 1972.
'Thoughts on Poetic Parallelism' *LKC* 28 (Sep 1979): 5–11.
Poet : Painter: Paintings of Rabindranath Tagore. New Delhi: Abhinav Publications 1985. [*Refer* ISOA, LKA, NGMA].

Anantanarayanan, M Paniker. *Artrends* 1.1 (Oct 1961).
Dhanapal. *Artrends* 1.2 (Jan 1962).

Ananth, Deepak An Engagement with Reality. In *India Myth and Reality- Aspects of Modern Indian Art ExC*. D.Elliot, V.Musgrave & E.Alkazi, eds. 55–62. Oxford: Museum of Modern Art 1982.
'Storm over Asia: The art of Vivan Sundaram' *Art and Asia Pacific Q*2.1 (Jan 1995): 52–61.

Appasamy, Jaya 'On Influences' *LKC* 4 (Apr 1966).
'Nandalal Bose: A Tribute' *LKC* 5 (Sep 1966): 30–1.
Nandalal Bose: Portfolio on Haripura Posters. LKA, n.d.
'Biren De: A Profile' *LKC* 6 (Apr 1967): 28–30.
'Editorial' *LKC* 6 (Apr 1967).
'Contemporary Indian art– 1950s' *Marg* Supplement 21.1 (Dec 1967): 6–12.
'Indian art since Independence: Figurative to Abstract' *LKC* 7–8 (Sep 1967–Apr 1968): 15–8.
'Editorial: On Drawing' *LKC* 9 (Sep 1968): 1–5.
'Folk Paintings on Glass' *LKC* 9 (Sep 1968): 39–41.
Abanindranath Tagore and the Art of his times. New Delhi: LKA 1968.
'Contemporary Indian Sculpture' *LKC* 10 (Sep 1969): 1–6.
'Three Retrospective Exhibitions: M.F.Husain' *LKC* 10 (Sep 1969): 29–30.
'Contemporary Graphics in India' *LKC* 11 *(*Apr 1970): 14–6.
'The Graphic Art of Somnath Hore' *LKC* 11 (Apr 1970): 29–31.
An Introduction to Modern Indian Sculpture. New Delhi: ICCR & Vikas Publications 1970.
'Twenty Five Years of Indian Art: Painting, Sculpture and Graphics in the Post Independence Era' *LKC* 15 (Feb 1973): 27–30.
Twenty five years of Indian art. LKA, 1973.
'Indian Murals Old and New' *LKC* 14 (Apr 1972): 14–6.
'Two artists discuss their work: A.Ramachandran & Himmat Shah' *LKC* 14 (Apr 1972): 29–31.
'National Exhibition of 1972' *LKC* 14 (Apr 1972): 47–9.
'New Images in Indian Art – Fantasy' *LKC* 15 (Apr 1973): 3–9.
'New Images in Indian Art – Man' *LKC* 17 (Apr 1974): 3–6.
'A.Ramachandran: Conversations with artists' *LKC* 17 (Apr 1974): 17–9.
'Conversations with Printmakers: Introduction.' *LKC* 18 (Sep 1974): 23–4.

'The Paths of Absrtraction' *LKC* 19–20 (Apr –Sep 1975): 4–8.
'Eric Bowen' LKC 21 (Apr 1976): 17–8.
'Variations: Satish Gujral' *LKC* 21 (Apr 1976): 30–1.
'The linear Mode' *LKC* 22 (Sep 1976): 1–3.
'Ramkinkar's contribution to Contemporary Art' *LKC* 22 (Sep 1976): 25–7.
'Portfolio of a Young Artist: K.M.Adimoolam' *LKC* 22 (Sep 1976): 12–3.
'Gopal Ghose: Approach to Landscape' *LKC* 23 (Apr 1977): 14–5.
'Two Artists of distinction: Bikash Bhattacharjee & Sarbari Roy Chowdhury' *AHJ* (1978–79): 20–5.
Benode Behari Mukherjee *AHJ* (1978–9): 76–7.
'B.C.Sanyal' *LKC* 28 (Sep 1979): 12–5.
'Ramkinkar: Painter and Sculptor' *LKC* 30 (Sep 1980): 38–42.
Early Calcutta Lithographs *LKC* 31 Apr 1981
Indian Sculpture Today. In *Indian Sculpture Today 1983*. 9–12. Bombay: JG Publication 1983.
'Early Oil Painting in Bengal' *LKC* 32 (Apr 1985): 5–9.
'The Folk Inspiration in Modern Indian Painting' *LKC* 34 (Jan 1987): 19–23.
'Art's Indigenous Sources' *LKC* 34 (Mar 1987): 23–5.
'Ram Kinkar' *LKC* 34 (Jan 1987): 28. Rpt. from *Ramkinkar*. LKA 1961.
'The Painters of the Transition' *LKC* 34 (Jan 1987): 26–8. Rpt. from *Twenty five years of Indian art*. LKA 1973.
'Criticism and Contemporary Indian Painting' *LKC* 34 (Jan 1987): 36–9. Rpt. from Thought, 15 Jne 1957.
'Satish Gujral' *LKC* 34 (Jan 1*987*): 39–41. Rpt. from *Design* (Apr 1958).
'Modern Indian Painting' *LKC* 34 (Jan 1987): 41–5. Rpt. from Thought, 12 Aug 1967.
'On Modern Indian Painting' *LKC* 34 (Jan 1987): 45–8. Rpt. from Thought, 18 Aug 1956.
'Contemporary Indian Painting' *LKC* 34 (Jan 1987): 48–50. [*Refer* ISOA, D.Kowshik, LKA].

Ara, K.H. [*Refer* N.Ezekiel, A.S.Raman, The Asian Age, R. von Leyden].

Araeen, Rasheed Hou Hanru. 'An interview with Rasheed Araeen: Politics, art and publishing' *Art & Asia Pacific Q*2.1 (Jan 1995): 102–7.

Arakkal, Yusuf 'Of Human Concern' 15-2-93. Rpt. in Hommage (sic) to Kathe Kollwitz, Bangalore: Max Mueller Bhavan ExC. Mar 1993.
'Personal Language' New Delhi: College Art ExC. 8–20 May 1995. [*Refer* AIFACS, K.Malik, The Gallery].

Archer, W.G. *Bazaar Painting of Calcutta*. London: Victoria and Albert Museum 1953.
India and Modern Art. London: George Allen & Unwin 1959.

A.R.K.S. Gallery, London Ved Nayyar. The World of Gogi in her paintings: Icons of Womanhood ExC. 15 May–11 Jne 1996.
Rupika Chawla. A.Ramachandran: The Mythical Traveller Journeys into the Unknown ExC. 18 Jne–13 Jly 1996.
Claire Henry. Swirling Blades: New Paintings by Sunil Gawde ExC. 19 Jly–9 August 1996.

Art Heritage D.Nadkarni. *A.M.Davierwala* New Delhi: Art Heritage Monograph 1978.
Balkrishna Patel *AHJ* (1979–80): 18–9.
M.F.Husain *AHJ* (1978–9): 62–3.
Vinod Dave. *AHJ* (1979–80): 25–6.
Suryaprakash. *AHJ* (1979–80): 35.
Eunice de Souza. *Akbar Padamsee*. New Delhi: Art Heritage Monograph 1981.
Laxma Goud. *AHJ* 1 (1981–82): n.p.
Inder. 'P.S. Chandersheker'. *AHJ* 1 (1981–2): n.p.
Bhaskaran & Adimoolam ExC. 1982.
Himmat Shah ExC. 1–14 Feb 1983.

Navjot. *AHJ* 3 (1983–4): 41–3.
Ira Roy. *AHJ* 3 (1983–4): 44–6.
Dilip Tamuly. *AHJ* 3 (1983–4): 67–9.
Sanat Kar. *AHJ* 4 (1984–5): 14–7.
'Ajay Desai: Taking the plunge– the artist's notes on his work' *AHJ* 7 (1987–8): 5–6+
Keshav Malik 'Jai Zharotia: The Humus of Creative Memory' *AHJ* 7 (1987–8): 37+
'G.m.Sheikh: Paintings' *AHJ* 7 (1987–8): 74–7 (no text).
Ghulam m.Sheikh Shridharani ExC. 12–24 Feb 1988 [Text includes excerpt from G.m.Sheikh's 'Among Several Cultures and Times', a presentation at the Smithsonian Institution Symposium: 'Canvas of Culture', 1985].
'M.F.Husain's Mahabharata Series' *AHJ* 9 (1989–90): 86–7.
Udayan Vajpayi. 'Ambadas and the Unnamable Other' *AHJ* 11(1991–2):45–6+
V.S.Sarma. 'P.S.Chandersekhar: Return to the Rural Scene' *AHJ* 11 (1991–2): 49–50+
P.Chatterjee 'B.C.Sanyal: Bird Song' *AHJ* 11 (1991–92): 127–9+
P.N.Mago. 'Jai Zharotia: Innocence of Vision' *AHJ* 11 (1991–2): 63–4+
'Kishori Kaul: The Present Through the Past' *AHJ* 13 (1993–4): 101–4+
Arnawaz (Vasudev) *AHJ* 14 (1994–5): 53–80 [Text by Uma Mahadevan 'And Death Shall Have no Dominion', 53– 5; Geeta Doctor 'The Lotus and the Flame', 55–67; & S.Guhan 'Arnawaz as Friend', 68–71].
R.Shahani 'Shakuntala Kulkarni: A Form Rearing Over Its Shadow' *AHJ* 14 (1994–5): 93–6+
J.James. 'RM Palaniappan: The State of Free, Peripatetic Being'. *AHJ* 14 (1994–5): 97–8+
'M.H.Barbhuiya: Art & Social Reality' *AHJ* 15 (1995–6): 17–8+ [Bengali text of artist translated by Dr.Runki Basu].
Krishna Sikund 'Ashok Tewaree: Through the Looking Glass' *AHJ* 15 (1995–6): 33–6+
Gayatri Sinha 'The Devices and Desires of Anupam Sud' *AHJ* 15 (1995–6): 91–9+

Artrends A.Santhanaraj. 2.2 (Jan 1963).
J.Sultan Ali. 3.1 & 2 (Oct 1963–Jan 1964).
K.S.Kulkarni. 3.3 (April 1964)
[*Refer* M.Anantanarayan, M.V. Devan, J.James, K.C.S.Paniker, K.N.Ramachandran, Sunanda, S.V.Vasudev]

Art Today Gallery, New Delhi Aman Nath et al. River of Art: The Inaugural Delhi Show ExC. Jan 1995.
[Text: Aman Nath, with Notes by Geeti Sen, Rupika Chawla, Dnynaneshwar Nadkarni & Pranabranjan Ray].
Keshav Malik. Satish Gujral ExC. 19 Feb–3 Mar 1995.
Ved Nayyar. Gogi Saroj Pal: Recent Paintings & Installations ExC. 5–17 Mar 1995.
Keshav Malik. K.Khosa ExC. 19–31 Mar 1995.
Rupika Chawla. Rini Dhumal: The Image in Print ExC. 24 Apr – 5 May 1995.
Sir J.J.School of Art: Student Abstractions ExC. 22 May– 2 Jne 1995.
Anish Vohra. Young Baroda: Prints, Sculptures & Paintings ExC. 24 Jly– 4 Aug 1995.
D.Nadkarni. Madhav Satwelkar: Recent Paintings ExC. 2–21 Apr 1995.
Jai Zharotia ExC. 28 Aug–14 Sep 1995.
Shuvaprassana. People & Faces: Mixed Media & Oils ExC. 18 Sep– 6 Oct. 1995.
Maqbool 'Fida' Husain's Rare Paintings signed 'Fida' ExC. 13 Nov – 9 Dec.1995.
Madan Gopal Singh, 'Libido and the Elemental Sign'. Ranbir Singh Kaleka ExC. 12–25 Jan 1996.
AmanNath. Stephen Cox: An Indian Decade ExC. 29 Jan–9 Feb 1996.
O–Show: Osho School of Creative Arts ExC. 12–23 Feb 1996.
Sanjay Bhattacharyya ExC. 27 Feb– 22 Mar 1996.
MF Husain, Curator. Young Indore ExC. 29 Apr–17 May 1996 [Note by R.Trivedi].

Pranabranjan Ray, Curator & Text. Art Trends: West Bengal in the '90s ExC. 9–26 Apr 1996.

Arts Council of Great Britain Douglas Cooper. *Fernand Leger*, (Paintings, drawings, lithographs and book illustration), *Tate Gallery*. ExC. 17 Feb– 19 Mar 1950. [Arranged by the Arts Council of GB and the Association Francaise d'Action Artistique].
Dunn International, Tate Gallery ExC. 15 Nov–22 Dec 1963.
The Peggy Guggenheim Collection, Tate Gallery ExC. 31 Dec 1964–7 Mar 1965.
Tantra. Hayward Gallery ExC. 1971. (Includes essays by Plutip Rawson, Ajit Mookherjee.)

Ash, Gobardhan 'Before Nature with Humility' *AHJ* 15 (1995–6): 45+ [*Refer* S.Som]

B

BAAC M.F.Husain: A Retrospective ExC. 1973.
Veena Bhargava BAAC–The Black Partridge Art Gallery–JG ExC. Jan–Feb 1977.
Jatin Das: Paintings & Drawings ExC. 16 Oct–2 Nov 1986.
K.S.Kulkarni ExC. 18–30 Nov 1986.
Pranabranjan Ray. Eight Contemporary Artists ExC. Jan 1987.
Piloo Pochchanawala–The Sculpted Image ExC. 15–30 Nov 1987.
Paritosh Sen. Veena Bhargava ExC. 22 Nov– 4 Dec 1988.
Prodosh Das Gupta. The Art of D.P.Roy Chowdhury ExC. 21 Dec– 5 Jan 1989.
Bikash Bhattacharjee's **Durga** ExC. 2–13 May 1990 & A set of Six Post cards.
Calcutta 300: Calcutta Through the Eyes of Painters ExC.–cum–Calender, 7–26 August 1990.
S.Gujral: Iconic Painting & Architecture ExC. 9–28 Dec 1990. [Text includes testament by artist & Santo Datta's article, Rpt. from Indian Express, New Delhi 29.11.88].
Maneklal Banerjee ExC. 24 Sep – 6 Oct 1991.
Silver Jubilee Publications: for North, South, East and West Zones 1967–1992 ExC. 1992. [Eastern edition: 9–31 Jan 1992; text by Asok Mitra & Pranabendu Dasgupta. North edition: 9–30 Apr 1992; text by K.S.Kulkarni. Western edition: 9–30 Aug 1992; text by Sarayu Doshi. South Edition: 3–29 Nov 1992; text by Asok Mitra].
Shyamal Dutta Ray ExC. Mar 1993.
Maitreyi Chatterjee. Sculptures–Paintings–Sketches by Meera Mukherjee ExC. 11–28 Mar 1993.
Amithabh Banerjee: A Retrospective ExC. 11–26 Sep 1993.
J.Swaminathan 'Dogs Too Keep the Night Watch'. Manjit Bawa: Paintings & Sketches ExC. 16–31 Dec 1993.
Ganesh Haloi. Watercolour Trends ExC. 18–30 Jly 1995
Shyamal Dutta Ray. Gopal Ghose– A Retrospective ExC. 29 Aug–10 Sep 1995
Laila Mehreen Rahman ExC. 15–29 Dec 1995.

Badrinarayan 'Ramkumar: Landscape in austere metaphors' Times of India, 26 Oct 1956.
'Artists of the Third Epoch' *LKC* 3 (Jne 1965): 21–3.
'Art Chronicle' *LKC* 6 (Apr 1967).
'The Significance of Tantric Imagery today' *LKC* 12–13 (Apr–Sep 1971): 35–6.
Bombay Arts Society's Art Journal 1.4 (Jly 1972): 16–7.
'Murals in Bombay' *LKC* 14 (Apr 1972): 31–2.
'Contemporary art and the image of man as the inspiration' *LKC* 17 (Apr 1974): 13–6.
'Ceramic and glass in Indian architecture' *LKC* 21 (Apr 1976): 5–7 [*Refer* R.Chatterjee, Pundole, Sakshi].

Bajaj, Sujata Contemporaines, Paris: Grand Palais ExC. 1993 [Text: Jean Claude Carriere, Christine Marquet de Vasselot & Kamala Kapoor (translations from French by Latika & Dileep Padgaonkar)].

Banerjee, Arany Conversation with Bikash Bhattacharjee. *LKC* 15 (Feb 1973): 17–8
Conversation with Ganesh Pyne. *LKC* 15 (Feb 1973): 19–20
Sanat Kar. *LKC* 18 (Sep 1974): 28–30

Barnett, Cyril 'Souza/Geoffrey/Rao' *Studio International* (May 1966): 212–14
Kinetic Art. In *Concepts of Modern Art*. N.Stangos, ed. 212–24. T & H 1991.

Barthes, Roland From Work to Text. In *AT 1900–90*. Harrison, C & P.Woods, eds. 940–6. Oxford: Blackwells 1993. Rpt. from *Image, Music, Text*, London 1977. Trans: Stephen Heath from original: 'De l'oeuvre au texte'. In *Revue d'esthetique*, no.3, Paris 1971. [*Refer* M.B.Wiseman]

Bartholomew, Richard 'Biren De' Times of India, 11 Dec 1953.
'Ramkumar: The Early Years' *AHJ* 4 (1984–5): 84–9. Rpt. from The Hindustan Times Weekly, Sunday 23 Oct 1955.
'The Noble savage and the Ascetic– Biren De' 1958. Rpt. in *Biren De– a journey...as seen by 5 contemporaries*. New Delhi: Caxton Press 1972 [5 Contemporaries are: R.L.Bartolomew, J.Appasamy, K.Malik, S.A.Krishnan and N.Joshi].
'Satish Gujral – Contemporary Indian Artists 10' *Design* 2.4 (Apr 1958): 14–6+
'Impressions of Varnanasi: Wax and ink paintings by Ram Kumar' *AHJ* 4 (1984–5): 90–3. Rpt. from Thought 7 May 1960.
'Unreal City: Ramkumar's Benaras. *AHJ* 4 (1984–5): 94–6. Rpt. from *Arts & Events* 2.11 (21 May 1961).
Modern Art of Asia. Tokyo: Toto Shuppan Co.Ltd. 1961.
Jeram Patel Kunika–CH ExC. 1962.
'A.Ramachandran: Kinetic, Not Psychic'. In *A.Ramachandran– Kumar Gallery ExC*. 1978. Rpt. from Thought 24 Dec 1966.
Devyani Krishna ExC. 1974.
'Some Regional Graphic Centres: Delhi' *LKC* 18 (Sep 1974): 38–41.
'Ram Kumar' *LKC* 19–20 (Apr –Sep 1975): 9–14.
'Images of Contemporary Indian Art'. *Times of India Annual* (1975): 19–30.
'Ved Nayar: Variations' *LKC* 21 (Apr 1976): 31.
'Nature and Abstraction: An enquiry into their interaction. *LKC* 23 (Apr 1977): 24–30.
Jeram Patel. *LKC* 34 (Jan 1987): 53–5. Rpt. from Sao Paulo Biennale ExC. 1977.
'Attitudes to the Social Condition: Notes on Ram Kumar, Satish Gujral, Krishen Khanna and Ramachandran' *LKC* 24–25 (Sep 1977–Apr 1978): 31–9.
'Gogi Saroj Pal' *AHJ* (1979–80): 1–4.
Ram Kumar Retrospective BAAC ExC. Nov 1980.
'Ram Kumar: Landscape as Vision' *AHJ* 4 (1984–5): 97–109. Rpt. from Ramkumar–Recent Paintings 1978–80 AH ExC. 1–16 Dec 1980.
'The Three Worlds of Satish Gural' *AHJ* 6 (1986–87): 62–4+
'Criticism and Contemporary Indian Painting– 1' *LKC* 34 (Jan 1987): 36–9. Rpt. from Thought, 15 Jne 1957.
'Modern Indian Painting' *LKC* 34 (Jan 1987): 41–5.
'Two Poems' *LKC* 34 (Jan 1987): 56. [*Refer* S.Datta, LKA, P.T.Reddy]

Bartolomew, R.L. & Shiv S.Kapur. *M.F.Husain*. New York: H.N.Abrams 1971.

Barwe, Prabhakar Gy.CH ExC. 25 Feb–14 Mar 1992 [Notes by P.Barwe, translated from Marathi by artist]
Shraddajali. Bombay: Private Publication, Dec. 1995 [Text by M.F.Husain, R.Hoskote & C.Sambrani] [*Refer* Gy.CH, R.Hoskote, D.Nadkarni, C.Sambrani]

Bataille, Georges from 'Critical Dictionary' 1929–30. In *AT 1900–1990*. Harrison, C. & P.Wood, eds. 474–6. Oxford: Blackwells 1993
The Lugubrious Game. In *AT 1900–1990*. Harrison, C. & P.Wood, eds. 476–8. Oxford: Blackwells 1993.

Baudrillard, Jean Ethic of Labour, Aesthetic of Play. In *AT 1900–1990*. Harrison, C. & P.Wood, eds. 957–60. Oxford: Blackwells 1993.

Basu, Sukanta 'Feringhee Painting' *LKC* 10 (Sep 1969): 11–2. [*Refer* NGMA (Man & Nature)].

Bawa, Manjit [*Refer* BAAC, CCA, Rupika Chawla, CIMA ('Fantasy'), Espace, K.B.Goel, K.Khanna, Marg, M.G.Singh, J.Swaminathan].

Beier, Ulli *Aspect Journal: India Issue*. Ulli Beier, ed. Jan 1982.
'Contemporary art in India' *Aspect Journal:* India Issue (Jan 1982): 4–16.
'Conversation with Sultan Ali: I Paint Energy'. *Ibid*, 69–75. [*Refer* LKA].

Beier, Georgina & Ulli Beier 'J.Sultan Ali' In *Art in the Third World Series*. Port Moresby: Papua New Guinea Studies 1976.
'Tyeb Mehta' In *Art in the Third World Series*. Port Moresby: Papua New Guinea Studies 1977.
'Falling Figures– The Art of Tyeb Mehta' *Aspect Journal:* India Issue. Ulli Beier, ed. (Jan 1982): 79–86.

Bell, Clive 'The Aesthetic Hypothesis' London 1914. In *AT 1900–90*. Harrison, C. & P.Wood, eds. 113–5. Oxford: Blackwells 1993.

Bendre, N.S. [*Refer* V.R.Amberkar, R.Chatterji, Marg, R.Parimoo, A.S.Raman, Vadehra, G.Venkatachalam]

Benjamin, Andrew *Art, Mimesis and the Avant–Garde*. London & New York: Routledge, 1991.

Benjamin, Walter Letter to Gershom Scholem, 1931. In *AT 1900–90*. Harrison, C. & P.Wood, eds. 481–3. Oxford: Blackwells 1993.
The Author as Producer', 1934. In *AT 1900–90*. Harrison, C. & P.Wood, eds. 483–9. Oxford: Blackwells 1993.
The Work of Art in the Age of Mechanical Reproduction. In *AT 1900–90*. Harrison, C. & P.Wood, eds. 512–20. Oxford: Blackwells 1993.

Berger, John 'The moment of Cubism' *LKC* 9 (Sep 1968): 6–18.

Bergson, Henri from *Creative Evolution*, 1907. In *AT 1900–90*. Harrison, C. & P.Wood, eds. 140–3. Oxford: Blackwells 1993.

Beuys, Joseph 'Not Just a Few Are Called, But Everyone' 1972. In *AT 1900–90*. Harrison, C. & P.Wood, eds. 889–92. Oxford: Blackwells 1993.

Bhabha, Jamshed *Homi Bhabha* . Bombay: Private Publication 1968.

Bhagat, Dhanraj Note, India section. Third Triennale ExC. LKA, 1975: p54 [*Refer* K.Chaitanya, LKA, K.Malik].

Bhagat, Vajubhai [*Refer* K.Khandalavala, G.Venkatachalam]

Bharadwaj, Vinod 'Indian Contemporary Art Today' In *Contemporary Indian Art: Glenbarra Art Museum Collection*. Masanori Fukuoka, ed. Hemeji: Glenbarra Japan Co. 1993

Bhargava, Veena [*Refer*: BAAC, K.Chaitanya (1977–8), E.Datta, Gy.CH, P.Sen].

Bhaskaran, Nandini "Rich Colours, Gairing currency" Sunday Times of India, New Delhi, 11 Jne 1995.
Bhaskaran, R.B. [*Refer* Art Heritage, A.Contractor, J.James, D.Nadkarni, S.Ramakrishnan, J.Sultan Ali].

Bhatia, Rajiv 'Mansaram's Art: A Celebration of Life' Indian Perspectives [A Ministry of External Affairs Publication] 8.1 (Jly 1995).

Bhatia, Usha Drawings in Indian Art. In *Indian Drawing Today 1987*. 8–19. Bombay: JG Publications 1987.

Bhatt, Jyoti *Artrends* 3.1 & 2 (Oct 1963– Jan 1964).
LKA Gujarat ExC. Jan 1967.
'Conversation with K.G.Subramanyan' *LKC* 18 (Sep 1974): 25-8.
'Bindi Sheth: Mirror of the Mind' *AHJ* 13 (1993–4): 81–8. [*Refer* V.Purohit, K.G.Subramanyan].

Bhatt, J & Raghav Kaneria 'The documentation of Folk and Tribal Art' *AHJ* 9 (1989–90): 28–32.

Bhatt, S 'Paintings– Reddeppa Naidu' The Heritage, Dec 1989.

Bhattacharjee, Baruna [*Refer* CIMA].

Bhattacharjee, Bikash [*Refer* J.Appasamy, BAAC, A.Banerjee, CIMA, E.Datta, Gallerie 88, R.P.Gupta, P.Ray, SOCA].

Bhattacharyya, Chandria 'A Kaleidoscope of Images' *AHJ* 14 (1994–5): 121–132.

Bhattacharyya, Sanjay [*Refer* Art Today].

Birla Academy of Art & Culture, Calcutta. See **BAAC.**

Biswas, Nikhil [*Refer* E.Datta].

Black Partridge Gallery, New Delhi. Laxma Goud ExC. 1976.

Blake, William Martin Butlin, Ted Gott & Irena Zdanowicz. *Collection of the National Gallery of Victoria (NGV)* , Australia: NGV Publication 1989.

Bloch, Ernst Discussing Expressionism. In *AT 1900–90*. Harrison, C. & P.Wood, eds. 523–6. Oxford: Blackwells 1993.

Blok, Alexander 'The Decline of Humanism' 1918. [Extract from *The Spirit of Music*, London, 1946]. In *AT 1900–90*. Harrison, C. & P.Wood, eds. 260–2. Oxford: Blackwells 1993.

Boccioni, Umberto Futurist Painting: Technical Manifesto' 1910 [From Sackville ExC. 1912] In AT 1900–90. Harrison, C. & P.Wood, eds. 149–152. Oxford: Blackwells 1993.

Bohm, David *Wholeness and the Implicate Order.* London & New York: Ark Paperbacks [Imprint of Routledge] 1983.

Bombay Arts Society (BAS) 1952 Annual ExC.
1888–1988: Centenary Issue ExC. 1988.
103rd All India Annual Art Exhibition JG ExC. 3–9 Mar 1995.
104th JG ExC. 29 Feb –6 Mar 1996.

Bosch, Hieronymus Michael M.Stanic *Hieronymus Bosch.* London: Tiger Books International 1988.

Bose, Nandalal 'Stone Images of the Buddha in Sranath Museum' *Rupam* 24 (Oct 1925): 79–80.
On Art Calcutta: Kala Shetra Publications 1956 (Translated from Bengali by Kanai Samanta).
'Notes on Ornamental Art' *Visva–Bharati Q* 34.1–4 (May 1968–Apr 1969): 93–103.
'Art in education' *Visva–Bharati Q* 34.1–4 (May 1968–Apr 1969): 135–9.
'The Root–Principles of Art Creation' *Visva–Bharati Q*34.1–4 (May 1968–Apr 1969): 160–2.

'On the Subject of Art' *Visva–Bharati Q* 34. 1–4 (May 1968–Apr 1969): 163–6. [*Refer* J.Appasamy, R.Chakrabarty, Sankho Chaudhuri, Satyajit Chaudhury, K.Kripalani, LKA, K.Malik, Asok Mitra, B.B.Mukherjee (Jne 1962), A.Mukhopadhyay, NGMA, R.Parimoo, A.S.Raman, L.P.Sihare, S.Som, K.G.Subramanyan, G.Venkatachalam (1950)].

Borev, Yuri *Aesthetics: A textbook* Moscow: Progress Publishers 1985.

Bowen, Donald Art Chronicle. LKC 3 (Jne 1965): 31-3.

Breton, Andre from the First Manifesto of Surrealism, 1924. In *AT 1900–90*. Harrison, C & P.Wood, eds. 432–9. Oxford: Blackwells 1993.
Surrealism and Painting. In *AT 1900–90*. Harrison, C & P.Wood, eds. 440–6. Oxford: Blackwells 1993.
from the Second Manifesto of Surrealism. In *AT 1900–90*. Harrison, C & P.Wood, eds. 446–50. Oxford: Blackwells 1993.

Brion, Marcel *Modern Painting: from Impressionism to Abstract Art.* T & H 1958.

Bronner, Stephen Eric Philosophical Anticipations: A Commentary on the "Reification" (Georg Lukacs). In *Of Critical Theory & its Theorists.* Oxford, UK & Cambridge, USA: Blackwells 1993.
Dialectics at a Standstill: A Methodological Inquiry into the Philosophy of Theodor W.Adorno. In *Of Critical Theory & its Theorists.* Oxford, UK & Cambridge, USA: Blackwells 1993.
Fromm in America. In *Of Critical Theory & its Theorists.* Oxford, UK & Cambridge, USA: Blackwells 1993.
J.Habermas and the Language of Politics. In *Of Critical Theory & its Theorists.* Oxford, UK & Cambridge, USA: Blackwells 1993.

Broota, Rameshwar Drawings by Delhi Artists' CMC ExC. 5–16 Jan 1989 [Comp: R.Broota. Text by Keshav Malik 'In Search of the Quintessential Outline'].
A full monologue with Broota. *IWI* 8–11 Jne 1991. [*Refer* J.Appasamy (Apr 1974), The Asian Age, R.Joshi, K.Malik, A.Sachdev].

Broota, Shoba 'My Origins' New Delhi: Private Publication, November 1990
Gallery Leela, Bombay ExC. Mar 1995 [*Refer* CIMA, K.Malik, E.M.Schoo].

Burman, Sakti [*Refer* Pundole].

Business Standard (Newspaper)
'Why Art is Mc(Bull)' [On M.F.Husain's Madhuri Series] Style Section, 2 Dec 1995.
Rahul Gul 'N.N.Rimzon: A Moving Target'. 25 May 1996.
Meera Warrier 'G.R.Santosh: Inner Space' Style Section, 13 Jly 1996.

Butcher, G.M. Avinash Chandra, Molton Gallery London ExC. Sep 1960.
Avinash Chandra, Molton Gallery London ExC. 7 Sep–1 Oct 1964.
Tyeb Mehta, Gallery One London ExC. Jly 1962. Rpt. in Gy.CH ExC. Mar 1970.

C

Cage, John On Rauchenberg, Artist and his Work, 1961. In *AT 1900–90*. Harrison, C & P.Wood, eds. 717–21. Oxford: Blackwells 1993.

Capers, R.M. & J.Maddox *Images & Imagination: an introduction to art.* New York: The Ronald Press Company 1965.

Capra, Fritjof *The Tao of Physics.* London: Flamingo (Harpers Collins Publications) 1983.

Caur, Arpana Conversation with Aanal Chandaria, New Delhi. Unpublished Manuscript. 16.9.93.
Body is Just a Garment: New Works 1988–93, RB.LKA ExC. 5–13 Oct 1993. [*Refer* S.Chopra, Cymroza, K.Malik, R.Sengupta, The Observer, The Pioneer]

CCA Aman Nath in conversation with Paramjit Singh. *Annual* (1990-1): n.p.
M.G.Singh 'Syncope Gaze Realism' Manjit Bawa Drawings ExC. 27 Feb–9 Mar 1990.
Rupika Chawla. J.Swaminathan ExC. 24 Jan–24 Feb 1992.
Srimati Lal. Arpita Singh ExC. 24 Mar–24 Apr 1992.
J.Swaminathan 'Dogs Too Keep the Night watch' (23.12.92). Manjit Bawa ExC. 4 Jan–3 Feb 1993. Rpt. in BAAC ExC. Dec 1993.

Chaitanya, Krishna (Pseud. for K.K.Nair)
'Sarangan' *LKC* 21 (Apr 1976): 23–6.
'Art and the Predicament of Man' *LKC* 24–25 (Sep 1977–Apr 1978): 16–21.
'Art & Redemption: Ramachandran's quest' In *A.Ramachandran's Kumar Gallery ExC*. 1978. Rpt. in *India: Myth & Reality*. E.Alkazi et al, eds. 63–6. Oxford: MOMA 1982.
'Dhanraj Bhagat: Sculptor' *AHJ* (1978-9): 5–11.
A History of Indian Painting: Pahari Traditions. New Delhi: Abhinava Publications 1984.
'Arpita Singh' *LKC 33* (Dec 1985): 38–41.
'A.K.Mukherjee: Discovering the World & the Self' *AHJ 11 (1991-2)*: 9–11+
Life's demands on art. Paper presented at the IIC Symposium, New Delhi 4 Sep 1993.
Ravi Varma: His Moment in Our Art History. In *New Perspectives: Raja Ravi Varma*. Sharma, R.C., ed. & R.Chawla, assoc. ed. 27–33. New Delhi: National Museum 1993.
A History of Indian Painting: The Modern Period New Delhi: Abhinav Publications 1995. [*Refer* LKA]

Chakrabarty, Ramendranath. An Album of Nandalal Bose Santiniketan: Asramik Sangha 1956.

Chakraberti, Kanchan 'Murals in Santiniketan' *LKC* 14 (Apr 1972): 9–13.

Chakravarti, Ajit Sculptures of Jamini Roy. In *Jamini Roy: In the context of Indian Fork Sensibility and his impact on Modern Art*. 13–8. LKA 1992

Chakravarti, Jayanta et al. *The Santiniketan Murals*. Calcutta: Seagull Books in association with Visva–Bharati, 1995. [Text by J.Chakravarti, R.SivaKumar & Arun K.Nag; Foreword by K.G.Subramanyan].

Chand, Suruchi 'Painting Sounds' *Aspect Journal* : India Issue. Ulli Beier, ed. (Jan 1982): 54–61.

Chandersekhar, P.S. [*Refer AHJ*].

Chandra, Avinash [*Refer* G.M.Butcher, B.James]

Chandra, Moti *Studies in Early Indian Painting* . Bombay: Asia Publishing House 1970.

Chatterjee, Maitreyi 'A Purity of Vision'. In Sculptures–Paintings–Sketches by Meera Mukherjee BAAC ExC. 11–28 March 1993

Chatterjee, Ram Raithin Moitra. *Marg* 3.2 (1949)
J.A.Sabavala JG–Gy.CH ExC. Mar 1976
'BadriNarayan' *LKC* 29 (Apr 1980).
'Is Tantrik art a misnomer?' *LKC* 30 (Sep 1980): 28–30.
The Preamble. In *Indian Sculpture Today* 1983. 5–8. Bombay: JG Publications 1983.
Preface. In *Indian Printmaking Today 1985*. Bombay: JG Publications 1985.

The Changing Trends of Indian Drawing. In *Indian Drawing Today 1987*. 5–7. Bombay: JG Publications 1987
Bendre: The Painter and the Person. Bombay: The Bendre Foundation For Art & Culture & Indus Corporation 1990.

Chattopadhyay, Ratnabali 'Nationalism and Form in Indian Painting: A Study of the Bengal School.' *JAI* 14–15 (Jly-Dec.1987): 5–46.

Chaudhuri, Nirad C. The Art of Gaganendranath Tagore (18 Sep 1867–14 Feb 1938). In *Gaganendranath Tagore: His Paintings and Studies*. (A Souvenir Exhibition of Paintings, Drawings, Books, Manuscripts.) Calcutta: Rabindra Bharati Society Feb 1958.

Chaudhuri, Sankho 'The artist and Society' *LKC* 6 (Apr 1967).
Haripura Posters. In *Nandalal Bose: Centenary Exhibition*. 31–2. NGMA, 1983
Nandalal Bose and Santiniketan. In *Nandalal Bose: A Collection of Essays*. 45–9. LKA 1983.
Ramkinker Vaij – A Retrospective NGMA ExC. 1990. [*Refer* R.Hoskote, LKA, K.Malik, NGMA].

Chaudhury, Satyajit Nandalal Bose and Indian Modernity. In *Nandalal Bose: A Collection of Essays*. 31-43. LKA 1983.

Chavda, Shiavax Retrospective JG ExC. 2–8 Feb 1995 [*Refer* LKA, V.Purohit]

Chawla, Rupika Viswanandhan Joint ExC. 1991–2 [The Gallery: 5–13 Sep 1991; Espace: 24 Sep– 10 Oct 1991; Chitrakoot: 20 Nov–5 Dec 1991; Gy.CH: 5–20 Jan 1992].
Swaminathan Gy.CH ExC. Dec 1991.
Ramachandran: Art of the Muralist Bangalore: Kala Yatra & Sistas Publications 1994.
Surface and Depth. New Delhi: Viking–Penguin 1995. [*Refer* A.R.K.S Gallery, Art Today, CCA, Gy.CH, R.C.Sharma].

Chhabda, Bal Fist Solo: JG ExC. 1985.

Chitra (pseud.) 'Studies in the Development of Sabavala' *Marg* 6.2 (1951).

Chitrakoot Pranabranjan Ray. Ganesh Haloi: Metascape ExC. Nov 1987.
Shyamal Dutta Ray ExC. 16–31 Oct 1989. [Joint show with Gy.CH]
Arun Ghose. Ganesh Haloi ExC. 2–15 Dec 1989.
Ramkumar ExC. 20 Feb – 5 Mar 1991.
Kajal Sengupta. Shyamal Dutta Ray ExC. 12–25 Nov 1991.
Arun Ghose. Ganesh Haloi: Gouache ExC. 23 Feb–5 Mar 1992.
Ranjit Hoskote, and S.Gawde's diary entries: Dec 1990 to Jan 1994. Sunil Gawde ExC. 14–28 Feb 1994. [Joint show with Cymroza] [*Refer* Espace].

Chittoprasad [*Refer* LKA].

Chopra, Suneet 'Art and Policy Today.' Paper presented at IIC Symposium, New Delhi 4 Sep 1993.
Characteristics of Contemporary Indian Art Today. In *Contemporary Indian Art: Glenbarra Art Museum Collection*. Masanori Fukuova, ed. Hemeji: Glenbarra Japan Co. 1993
Dhiraj Chowdhury 1995. New Delhi: Art Arcade Publication 1995.
Arpana Caur 1975–95. New Delhi: Academy of Fine Arts & Literature Publications 1995.

Chowdhury, Dhiraj *South of France, Through a Painter's Eye* New Delhi: Art Konsult Publication 1996. [*Refer*: AIFACS, S.Chopra, K.Malik].

Chowdhury, D & S.Sarkar Calcutta Printmakers ExC. 1978–79.

Chowdhury, D.P.Roy. [*Refer* BAAC, LKA, P.R.R.Rao, G.Venkatachalam].

Chowdhury, Jogen 'Chandana Hore: Agony & Despair' *AHJ* 13 (1993–4): 29-36. [*Refer* CIMA, S.Datta, R.P.Gupta, Indian Express, G.Kapur, K.Malik, Pundole, Seagull].

Choy, Lee Weng 'Alternative Spaces & Radical Pleasures' *Art Asia Pacific* Q3.2 (1996): 45-9.

Churchland, Paul M. *Matter and Consciousness: A Contemporary Introduction to the Philosophy of the Mind* (Rev. Ed) London & Cambridge, Mass. USA: A Bradford Book, The MIT Press 1992.

Christie's Indian Contemporary Painting London Auction ExC. 16 Oct 1995

CIMA 'Wounds' ExC. Bombay, Calcutta & New Delhi, 1993.
*Trends & Images Inaugural ExC.*1993 [Essays by: K.Khandalavala, S.Tagore, R.Siva Kumar, Keshav Malik, Ratan Parimoo and Arun Ghosh].
Bikash Bhattacharjee: Recent Works JG ExC. 18-24 Jan 1994.[Text: 'In Search of Life' by artist].
Sunil Das: Recent Drawings ExC. 19-27 Feb 1994. [Text: 'This, Too, Is Art' as told by Sunil Das to Sohini Sen].
Shuvaprassana: Metropolis ExC. 14-26 Mar 1994.
Contemporary Miniatures ExC. 17 Sep-8 Oct 1994. [Essays by: Saryu V.Doshi & Arun Ghosh].
Paramjit Singh ExC. Calcutta 1994. [Includes artist's conversation with Baruna Bhattacharjee]
K.G.Subramanyan: Recent Works ExC. 8-18 Dec 1994. [Essays by K.G.Subramanyan: 'Bahurupee: A Polymorphic Vision' & R.Siva Kumar: ['Pilgrim's Progress'].
Lalu Prosad Shaw: Paintings, Drawings & Graphics 1970-95 ExC. 1995 [Text: Pranabranjan Ray].
Fantasy ExC. 25 Feb -12 Mar 1995. [Artists included: M.Bawa, B.Bhattacharjee, J.Chowdhury, B.Khakar, P.Kolte, and G.Pyne].
'Dreamers of Dream' *Sunday* 26 Feb-4 Mar 1995.
Abstract 95: Paintings of Badhan Das, Shoba Broota & Bhagwan Chavan ExC. 20-30 Apr 1995. [Text by Baruna Bhattacharjee]
Jogen: Oils & Drawings 1969-96 ExC. 20 Feb-10 Mar 1996. [Text includes 'Images of Experience: An Interview with Jogen Chowdhury by R.Siva Kumar; 'Jogen Chowdhury: A Search for Identity' by Baruna Bhattacharjee]
Highlights JG ExC. 13-20 Apr 1996.

Clarke, David 'Foreign Bodies: Chinese art at the 1995 Venice Biennale' *Art Asia Pacific* Q3.1 (1996): 32-4.

Clerk, S 'Hebbar's concerns with man' *LKC* 24-25 (Apr 1977-Sep 1978).
'Six Bombay Artists' *LKC* 28 (Sep 1979): 47-51.

Cohen, David 'Dhruva Mistry: A Well-Spring of Delight'. In Anthony Wilkinson Fine Art ExC. 4 Oct-1 Nov 1995 (in association with Royal Academy Friends Room) London 1995.

Contractor, Anahite Madhvi Parekh, Sakshi ExC. Madras 1992
'R.B.Bhaskaran's Individualistic Language'. R.B.Bhaskaran: A selection of Works 1965-1992 JG ExC. Feb 1992. [Travelling Exhibition- JG: Feb 1992, Dhoomimal Oct.1992, Madras: Sarala Art Centre Jan 1993, Pondicherry: Rajnivas, Mar 1993. Text also includes article by Mini Krishnan.].

Coomaraswamy, A.K. 'The Present State of Indian Art'. In *Raja Ravi Varma: New Perspectives.* New Delhi: National Museum, 1993. Rpt. from *Modern Review* (Aug 1907).
'The aim of Indian art'. *Modern Review* 3.1 (Jan 1908): 15-21.
'Art of the East and the West'. *Modern Review* 3.5 (May 1908): 397-9.
'Drawings of Rabindranath Tagore' *Rupam Journal* 42-44 (Apr -Oct 1930): 31-2.
Transformation of Nature in Art, 1934. Republished by Dover Publications, New York. 1st ed 1956.

Paroksha: Coomaraswamy Centenary Seminar Papers. G.m.Sheikh, K.G.Subramanyan & K.Vatysayan, eds. LKA 1984

Coomaraswamy, A.K. & Sister Nivedita *Myths of the Hindus and Buddhists.* Boston 1912

CRY Art for CRY Auction ExC. [JG: 30 Jan– 5 Feb 1995 & LKA: 17-23 Feb 1995).

Cymroza
Usha Vasudevan. Yusuf Arakkal ExC. 3-23 May 1989.
G.Padmanabhan 'Beguiling Women'. T.Vaikuntum ExC. 18 Jne-4 Jly 1990.
Ella Datta. Paritosh Sen ExC. 10-31 Oct 1990.
Ranvir Shah. Reddeppa Naidu: Tradition and Modernism. *Annual* (1991-2):
Paresh Maity ExC. 1991-2.
J.S.Rao 'Reflections'. Suryaprakash. *Annual* (1992-3): 17-20.
Dom Moraes & Jatin Das. Jatin Das ExC. 1993.
Pranabranjan Ray. 'Art in West Bengal since Sixties' *Annual* (1993-4): 21-2
Kajal Sengupta. 'Painting & Sculptures by Sixteen Contemporary Artists'. *Annual* (1993-4): 24-5.
Subba Ghosh. 'Anupam Sud: A Powerful Statement of Human Life'. *Annual* (1993-4): 95-8.
Prema Viswanathan. Arpana Caur: Body as Metaphor ExC. 5 Jan-22 Feb 1994.
Anupam Sud ExC. 13-30 Apr 1994.
Vidya Dehejia 'Woman's Body: Site of Contestation' Jan 1995. Meera Devidayal ExC.14 Feb-23 Mar 1995.

D

Dalmia, Yashodhara 'Tyeb Mehta- Beyond Narrative Painting' *AHJ* 9 (1989-90): 76-85.
'That brief thing called modern' *Art & Asia PacificQ* 2.1 (Jan 1995): 88-91
'Nasreen's Diaries: An Introduction' In *Nasreen in Retrospect.* Altaf Mohammedi, ed. 83-4. Bombay 1995.
'The Play of Life & Death' (on Tyeb Mehta's art) New Delhi: Sunday Review, 21 Jan 1996.

Das, Amithava 'So Close to Life' *IWI* 26 Oct-1 Nov 1991
'Self-Portrait- Amithava Das: Texture is my Language' as told to Sarita Chouhan 1994 (?) [*Refer* Dhoomimal, R.Hoskote, Sakshi, P.Shukla, M.G.Singh, G.Sinha].

Das, Jatin 'A Point of View' *LKC* 12-13 (Apr -Sep 1971): 45-7.
'Personally Speaking' *LKC* 37 (Mar 1991): 87-90. [*Refer*: AIFACS, BAAC, Cymroza, The Pioneer]

Das, Sunil [*Refer* CIMA, Gallerie Ganesha, SOCA, The Statesman, Village Gallery]

Dasgupta, Ananda Printmaking In India. In Indian Printmaking Today 1985. 8-32. Bombay: JG Publications 1985. [*Refer* Dhoomimal]

Dasgupta, Bimal Arts and Prints Gallery ExC. Nov 1964.
Untitled Booklet. New Delhi: Private Publication, 1987. [Text by Bimal Dasgupta, Krishna Chaitanya, S.A.Krishnan & Jaya Appasamy].
'Bimal Dasgupta- A Painter's sea of Dreams' *the India Magazine* (12 Sep 1992). [*Refer*: Gallerie 88, Gallerie Ganesha].

Dasgupta, Dharamnarayan [*Refer* BAAC (Jan 1987), SOCA].

Dasgupta, Pranbendu [*Refer* R.C.Gupta].

Dasgupta, Prodosh 'Ramkinkar: Individualist Approach' *LKC* 30 (Sep 1980):
 42-5.
'The Calcutta group: Its Aims and Achievements' *LKC* 31 (Apr 1981).
'The thin line between art and craft' *LKC* 33 (Dec 1985): 8-11.
Retrospective 1912–91 NGMA ExC. 1991.

Datta, Ella 'Akbar Padamsee– The spirit of Order' *AHJ* 8 (1988–9): 33–56
'Nikhil Biswas: Clowns & Martyrs' *AHJ* 8 (1988–9): 105–11.
'Veena Bhargava: Angst of the Carnival' *AHJ* 13 (1993–94): 121-2+.
Bikash Bhattacharjee: Recent Works JG ExC. 18–24 Jan 1995 [Presented by
 CIMA Gallery].
Veena Bhargava JG ExC. Dec 1995.
'Manu Parekh: Animal Passions' Calcutta: Business Standard 25 Nov 1995.
'The Second Benchmark' Calcutta: Business Standard 23 Mar 1996. [*Refer*
 Cymroza, Gallerie 88].

Datta, Santo 'K.C.S.Paniker: Three Retrospectives' *LKC* 27 (Apr 1979): 15–6
'Visitations: obsessive imagery in the works of some modern Indian painters'
 AHJ 2 (1982–3): 82–8.
[Artists included: J.Chowdhury, K.Khanna, and KCS Paniker].
'Biographical notes on Richard Bartholomew'.
'Shamshad and the Little Man' (?) 20 Feb 1983.
'Urbanisation of Indian Art' *JAI* 9 (Oct –Dec 1984): 5–22.
'Richard Bartholomew: The Critic Who Was a Movement' *LKC* 34 (Jan 1987):
 32–5.
'Drawing and the shifting Focus' In *Drawing'94* New Delhi: Gallery Espace
 Publication 1994.
'A Forgotten Pilgrim'. *Mukul Dey: Birth Centenary Exhibition of Intaglio and
 Drawings NGMA ExC.* 1995. [*Refer* BAAC, Espace, Pundole].

Dave, Shanti [*Refer* BadriNarayan (1966), Gy.CH].

Dave, Vinod [*Refer* AHJ, Gy.CH].

Davierwala, A.M. 'The Sculptor's Vocation', *AHJ* (1978–9): 37–43. [*Refer*
 Art Heritage, LKA].

Daya, Sadrudin *The S.H. Daya Collection of Contemporary Indian Art'
 Catalogue.* Bombay 1994.

de Bijenkorf b.v. The Spirit of India ExC. Apr–Jne 1993. [Artists included:
 Atul Dodiya, Bhupen Khakhar & Sudarshan Shetty. A series of exhibitions
 arranged in collaboration with Inventure India].

de Chirico, Giorgio 'The Return to the Craft' 1920. In *AT 1900–90.*
 Harrison, C & P.Wood, eds. 234–7. Oxford: Blackwells 1993.

de Francia, Peter Ranbir Singh Kaleka. In Profiles– *Seventeen Painters
 Gy.CH ExC.* 1985.
Rekha Rodwittiya. *AHJ* 4 (1984–5): 70–4.

De, Biren 'Evolution of my Art' *LKC* 32 (Apr 1985): 34-9.
Pictorial Space– A Journey Within. In Concepts of Space Ancient and
 Modern. Kapila Vatysayan, ed.567–82. New Delhi: Indira Gandhi National
 Centre for the Arts & Abhinav Publications 1991. [*Refer* J.Appasamy,
 R.L.Bartolomew, C.Fabri, N.Joshi, S.A.Krishnan, LKA, K.Malik, A.Mookherjee,
 R.Puri, A.S.Raman, K.Vatysayan].

De Stijl 'Manifesto 1', 1918. In *AT 1900–90.* Harrison, C & P.Wood, eds.
 278–9. Oxford: Blackwells 1993.

Delaunay, Robert 'On the Construction of Reality in Pure Painting' 1912. In
 AT 1900–90. Harrison, C & P.Wood, eds. 152–4. Oxford: Blackwells 1993.

Derrida, J *Derrida: A Critical Reader* . David Wood, ed. Oxford: Blackwells
 1993.
'Passions: 'An Oblique Offering', 1993. Trans: David Wood. In *Derrida: A
 Critical Reader* . David Wood, ed. 5– 35. Oxford: Blackwells 1993.

Desai, Niranjan 'Festival of India: A Cultural Construction Abroad' *Indian
 Horizons* 44. 3 (1995): 199–214.

Deutsche Bank, Bombay *Contemporary Art.* Deutsche Bank AG 1995.

Devan, M.V. (pseud. MVD) Jyoti Bhatt. *Artrends* 3.1 & 2 (Oct 1963–Jan
 1964).
Ambadas *Artrends* 4.1 (Oct 1964).
J.Swaminathan. *Artrends* 4.4 & 5.1 (Jly–Oct 1965).
'Art Chronicle' LKC 4 (Apr 1966).
A.Alphonso. *Artrends* 5.4 & 6.1 (Jly–Oct 1966).

Devi, Pria 'BiCultural Aspects' *LKC* 30 (Sep 1980): 12-8. [*Refer* LKA].

Dey, Bishnu 'The Pioneers of art in Modern India' *LKC* 1 (Jne 1962): 20-1.

Dey, Bishnu & Irwin, John *Jamini Roy.* Calcutta: ISOA 1944. Rpt. in *Jamini
 Roy.* NGMA ExC. 1987.

Dey, Mukul [*Refer* Santo Datta].

Dharker, Imitiaz [*Refer* AIFACS, S.Gangopadhyay, The Independent]

Dhoomimal J.Swaminthan. Piraji Sagara ExC. Oct 1973.
Pranabranjan Ray. 'Weird Portraits of Bikash Bhattacharjee'. Bikash
 Bhattacharjee ExC. 23 Oct–4 Nov 1979.
S.Gujral's Brunt (sic) Black Woods ExC. 1–18 Dec.1980.
Dhoomimal Art Bullet in Mar 1982.
Manohar Kaul. Bimal Dasgupta ExC. 1983.
Jagmohan 'Souza in the Forties'. Souza in the Forties ExC. 1983.
Vivan Sundaram, Signs of Fire: Works on paper & in mixed media ExC. 1984–
 5 [Joint Show Gy.CH: 15–31 Dec 1984 & Dhoomimal: 27 Feb–14 Mar
 1985].
Prayag Shukla. Madhvi Parekh ExC. 10–21 Jan 1986.
Jeram Patel. Dec 1986.
Prayag Shukla. Amithava Das ExC. 1987.
Prafulla Mohanti: Paintings ExC. 20 Feb–2 Mar 1987.
Prints ExC. 20–27 Aug 1987.
Ananda Dasgupta. Manu Parekh ExC. 23 Feb –4 Mar 1988.
J.Swaminathan & K.B.Goel. J.Swaminathan ExC. 1988.
J.Sultan Ali ExC. Nov 1991.
Souza 1940's–1990's ExC. 1993. [Text includes: 'My Credo in Art' (Rpt. from
 Contemporary Indian Art: Glenbarra Art Museum Collection M.Fukuova,
 ed.) & 'From Time to Time' (from Times of India, 12 Sep 1993) by
 F.N.Souza, and 'Rebel Without A Pause' by Srimati Lal (Rpt. from Times of
 India, 10 Oct 1993)].
G.R.Santosh '"Self" & the Elements' ExC. 21 Mar–5 Apr 1994.
Sushma Jain. Shail Choyal ExC. Mar 1996.

Doctor, Geeta 'The Figure of Space: The Graphics of Palaniappan' *LKC* 35
 (Sep 1987): 25-6.
'The Art Scene in India: The Role of the Media' *LKC* 37 (Mar 1991): 45-8.
'A Meeting with Laxma Goud' *Cymroza Annual* (1991–2): 23–6
'Arnawaz Vasudev: The Lotus and the Flame' *Cymroza Annual* (1991–2): 31–42.
'Criticism a Southern Perspective'. Paper presented at the IIC Symposium,
 New Delhi 4 Sep 1993.

Dodiya, Atul [*Refer* de Bijenkorf, Gy.CH, R.Hoskote, K.Kapoor, Sunday Times
 of India].

Doshi, Saryu V. Editorial: The IdentityCrisis: In the Visual and Performing Arts *Marg* 36.2 (n.d.): 2–4.
'Influence of Miniature Painting on Contemporary Art' In *Contemporary Miniatures CIMA ExC.* 1994. [*Refer* BAAC]

Dossal, Rukaya Watching Your Passing– Like Petals From a Flower. In *Nasreen in Retrospect.* Altaf Mohammedi, ed. 107–8. Bombay: Ashraf Mohammedi Trust 1995.

Douglas, C [*Refer* D.Nadkarni, Sakshi, H.Schavoir, E.M.Schoo, R.Shahani].

Dube, Anita 'The Season's Artists and Their Work' *AHJ* 3 (1983–4): 6–13.
'Graphic Art and Somnath Hore' *AHJ* 3 (1983–4): 80–6.
'Raja Ravi Varma: Painter of myth with high surface gloss' Economic Times, Jne 1993. [*Refer* Eicher Gallery].

Duchamp, Marcel 'The Richard Mutt Case' 1917. In *AT 1900–90.* Harrison, C. & P.Wood, eds. 248. Oxford: Blackwells 1993.

Dufour, Gary 'Out of Place' Paper presented at the NCPA Mohile–Parekh Centre Conference, Jan 1994.

Dutta, Ajit Kumar 'Jamini Roy as I saw and understood him' In *Jamini Roy* . 73-6. LKA, 1992. [*Refer* Gallerie Ganesha]

Dutta Ray, Shyamal [*Refer* BAAC, Chitrakoot, Espace, P.Ray (1977, 85, 87), SOCA].

EF

Economic Times (Newspaper) On M.F.Husain. 5 Nov 1992.

Eicher Gallery Of Women: Icons/Stars/Feasts. ExC. 16 Mar– 14 Apr 1996 [Text: Pooja Sood, Gayatri Sinha, Patricia Uberoi, & Kajri Jain. Artists included: Anita Dube, Manisha Parekh, Bharti Kher, Rekha Rodwittiya, Vasudha Tozhur].

Elliot, David Inayat Khan Peregrinations. AHJ 8 (1988–9): 98–9+ [*Refer* E.Alkazi]

Elwin, Verrier *The Art of the North–east frontier of India.* Shillong: The North–east frontier Agency 1959.
Folk Paintings of India. New Delhi: International Cultural Centre 1967.

Escholier, Raymond *Matisse From the Life.* Trans: Geraldine and H.M.Colvile; Introduction by R.H.Wilenski. London: Faber & Faber 1960.

Espace Kajal Sengupta. Shyamal Dutta Ray 12–25 Nov 1991. [Joint Show with Chitrakoot]
Srimati Lal. Mona Rai ExC. Nov 1992.
Prayag Shukla. An Exhibition of Paintings by M.F.Husain and Contemporary Indian Artists ExC. [Sharjah, UAE: 17–18 Apr 1993].
Nilima Sheikh: Song, Water, Air ExC. Sep 1993.
Shyamal Dutta Ray ExC. 27 Oct–10 Nov 1993.
Drawing '94 AIFACS ExC. 1994. Prayag Shukla, ed. [Text includes: A dialogue on Drawing between Gulam Mohammed Sheikh & Bhupen Khakhar; 'Line Drawings of Ganga Devi' by Jyotindra Jain; 'Between Drawing and Painting' by Nilima Sheikh].
Santo Datta 'A Journey Beyond Tools and Techniques'. Krishna Reddy ExC. 10 Dec 1994.
Sculpture'95 RB.LKA ExC 6–17 Dec 1995. [Text includes articles by Prayag Shukla, Josef James, Madan Lal, Balbir Singh Katt]
Gayatri Sinha. Gouache on paper: Amit Ambalal, Madhvi Parekh, Arpana

Caur, Sidharth, Yuriko Lochan ExC. 24 Nov –20 Dec 1995.
Manjit Bawa ExC. 18 Mar– 2 Apr 1996.

Ewington, Julie 'Five Elements: An abbreviated account of installation art in Sout–East Asia' *Art & Asia Pacific* Q2.1 (Jan 1995): 108–15.

Ezekiel, Nissim 'Ara a Painter of Nudes' *Design* 4.3 (Mar 1960): 28.
'Gieve Patel: Artist and Environment' *AHJ* 2 (1982–3): 77-81. [*Refer* Marg].

Fabri, Charles 'Biren De'. The Statesman. Dec. 1952.
'Art Criticism in India' in *Design* 4.7 (Jly 1960): 95–6.
'Satish Gujral' *Marg* 15.2 (Mar 1962: Supplement).
'Modern Arts and National Tradition.' *Design* 8.8. (Jly 1964): 99–101.
'Notes Towards a Biography of Amrita Sher–Gil' *LKC* 2 (Dec.1964): 27–30.
'Art Chronicle: Delhi' *LKC* 2 (Dec 1964): 48–9.
' Art appreciation for India' *LKC* 6 (Apr 1967): 17–8. [*Refer* LKA].

Farooqi, Anis 'The Role of the Script in Contemporary Indian Painting' *LKC* 32 (Apr 1985): 10–23.
Significant Directions in Contemporary Indian Art after 1947. In *Contemporary Indian Art: Glenbarra Art Museum Collection* Masanori Fukuoka, ed. Hemeji: Glenbarra Japan Co. 1993. [*Refer* NGMA].

Finch, Christopher. *Patrick Caulfield* . London: Penguin 1971.

Findlay, Ian 'Tales From A Solitary Life'. *Asian Art News* 6.1 (Jan–Feb 1996).
'Flying on Dreams' *Asian Art News* 6.1 (Jan–Feb 1996).
'The Long–Term View' *Asian Art News* 6.1 (Jan–Feb 1996).

Frampton, Kenneth 'De Stijl– The Evolution and Dissolution of Neoplasticism: 1917–31. In *Concepts of Modern Art.* N.Stangos, ed. 141–59. T & H 1991.

Fry, Roger 'An Essay in Aesthetics' 1909. In *AT 1900–90.* Harrison, C & P.Wood, eds. 78–86. Oxford: Blackwells 1993.

Fukuoka, Masanori, ed. *Contemporary Indian Art: Glenbarra Art Museum Collection.* Hemeji: Glenbarra Japan Co. 1993.

G

Gabo, Naum & Anton Pevsner The Realistic Manifesto, 1920. In *AT 1900–90.* Harrison, C & P.Wood, eds. 297–9. Oxford: Blackwells 1993.

Gade, H.A. [*Refer* S.A.Krishnan].

Gaitonde, V.S. [*Refer* P.Karunakar, LKA, D.Nadkarni, F.Nissen].

Gajendragadkar, P.B. *The Ten Classical Upanisads, Vol 1: ISA & KENA,* ed. Bombay: Bharatiya Vidya Bhavan 1981 [Includes Sankara Bhasya by S.N.Gajendragadkar & Bhasya according to Sri Ramanujacarya by N.S.Anatha Rangachar].

Gallerie 88, Calcutta Arup K.Datta. Bimal Dasgupta ExC. 28 Jan–12 Feb 1989.
Ella Datta 'A mood, a moment, a feeling'. Bikash Bhattacharjee ExC. 14–17 May 1993.
Ella Datta. Veena Bhargava ExC. 12–22 Jan 1994.

Gallerie Ganesha, New Delhi 'Old masters' ExC. Dec.1992.
K.Malik. Paresh Maity ExC. 18 Feb– 10 Mar 1993 [Jt. Show with AIFACS: 12–24 Feb 1993].
Ajit Kumar Dutta. Bimal Dasgupta ExC. 8–17 Dec. 1993.

'Old masters' ExC. Mar–Apr 1994.
Group Show ExC. 27 Jan–18 Feb 1995 [Artists included: BadriNarayan, Lalu
 Prasad Shaw, T.Vaikuntum & Jai Zharotia].
'Old masters' ExC. Mar 1995.
Neeraj Goswami ExC. Nov 1995.
Paromita Dasgupta & Mansaji Majumdar. Many Faces of Sunil Das ExC.
 18 Dec–12 Jan 1996.

Gallery 7 Ramkumar & Krishen Khanna ExC. Feb.1985.
Arun Sachdev. Festival of Indian Contemporary Art– I ExC. [Smith's of Covent
 Garden: 14–19 March 1988. Artists included: Arpita Singh, Nalini Malani,
 Rameshwar Broota, Vijay Shinde, Gurcharan Singh, Navjot].
Nalini Malani ExC. 19 Jan–3 Feb 1990.
Arun Sachdev. Arpita Singh ExC. 19 Feb–1 Mar 1990.
Sumitra K.Srinivasan. Anjana Mehra Oils ExC. 9–14 Nov 1992 [JG, Oil Pastel
 on paper & Oils: 16–22 Nov 1992]
Rini Dhumal ExC. 24 Mar– 10 Apr 1995 [Text includes: Sumitra K.Srinivasan
 'Journeys into the Psyche' & 'Art is One's Right', an interview with
 S.K.Srinivasan].
Vijay Shinde: Homage to my father ExC. 18 Apr– 5 May 1996.

Gallery Chanakya, New Delhi Michael Peppiatt 'Viswanadhan, Painter &
 Friend' Viswanadhan ExC. 19 Dec 1974– 4 Jan 1975.
Ramkumar ExC. Mar 1979.

Gallery Chemould. See Gy. CH

Gangopadhyay, Sumati. Imitiaz Dharker CCA ExC. 17 Sep– 8 Oct 1990.

Gaunt, William The Observer's Book of Modern Art. UK: Frederick Warne &
 Co. 1964.

Gawde, Sunil [Refer Chitrakoot, A.R.K.S.Gallery].

Gerrard, Charles R. 'The Young Turks of the Bombay Group of
 Contemporary Artists' J.J.School ExC. 1941.

German News 'Bhupen Khakhar' German News 35 (Jly–Aug 1993).

Ghose, D.C. 'Some aspects of Bengal Folk Art' LKC 29 (Apr 1980).
Bibliography of Modern Indian Art K.L.Kaul, ed. New Delhi: LKA 1980.

Ghose, Gopal [Refer J.Appasamy (Apr 1977), BAAC, LKA, G.Venkatachalam].

Ghosh, Arun Trends & Images: An Overview. In Trends & Images CIMA
 Inaugural ExC. 1993.
'Miniature Art From Traditional to Contemporary'. In Contemporary
 Miniatures CIMA ExC. 1994.

Gilot, Francoise & Carlton Lake Life with Picasso. London: Penguin 1965.

Gobhai, Mehli [Refer Gy.CH, R.Hoskote].

Goel, K.B. J.Swaminathan: Revolt, Nov. 1975. Rpt. in JAI 27–28 (Mar 1995).
'Expressionism: The World of Husain & Souza' Patriot 14 Jly 1982.
'In and Out of Jeram's Colour Maze' Patriot Review 14 Dec 1986.
'Mago's version of a Massacre' Patriot 19 April 1987.
J.Swaminathan: Africa of the Rational Mind. Swaminathan 88 Dhoomimal
 ExC. 1988. Rpt. in JAI 27–28 (Mar 1995).
'J.Swaminathan– From the Whole; Whole is said' CCA Annual 1989–90 (n.p.).
'Devraj Dakoji: A Secret Dialogue' AHJ 10 (1990–1): 50-1.
'Manjit Bawa' CCA Annual (1990–91): n.p.
'Paramjit Singh' CCA Annual (1990–91): n.p.
'Nine Indian Contemporaries' CCA Annual (1990–91): n.p.

'J.Swaminathan: The painter in his Labrinyth' Economic Times, 6 Dec 1991.
 Rpt. in JAI 27–28 (Mar 1995): 135–40.
'Minaskshi Quazi: A Formalist at Heart' AHJ 11 (1991–2): 21-3+
'Spontaneous drawings of Manjit (Bawa)' Cymroza Annual (1991–2):
 27–30.
'Vivan Sundaram' Riverscape ExC. 1992–93 [Later exhibitions at BAAC:
 3–18 Dec 1994, Sakshi: Jan–Feb 1995 & British Council: 28 Mar–18 Apr
 1995].
'Krishen Khanna– Of Accidental Innovations' Economic Times 26 Oct 1993.
'Swaminathan: The Self'. Rpt. in Vadehra ExC. Oct.–Nov 1993.
'Swaminathan: The Other'. Rpt. in Vadehra ExC. Oct.–Nov 1993.
'Ravi Varma– Of figures and mirrors on the wall' Economic Times 15 Jne
 1993.
'The Institutional Theory of Art'. In AIFACS Regional Centre (Haryana),
 Inaugural Art ExC. 1995.

Goetz, Dr.Hermann 'Whither Indian Art' Marg 1.2 (Jan 1947): 57–66+
'Rebel Artist: Francis Newton' Marg 3.3 (1949): 34–9.
'In Praise of Buddhist Art– Preliminary, A Brief Historical Survey of Buddhist
 Art in Indonesia'. Marg 9.4 (Sep 1956).
'The great crisis from Traditional to Modern Art' LKC 1 (Jne 1962): 8–14.
 [Refer LKA]

Golding, John The Masters 62: Braque. England: Knowledge Publications,
 1966.
Cubism. In Concepts of Modern Art. N.Stangos, ed. 50–78. T & H 1991.

Golding, Martin The Achievement of William Coldstream. Modern Painters
 3.4 (Winter 1990–1).

Goodwin, A 'The mirror, the window and the wall' LKC 14 (Apr 1972):
 19–21.

Goswamy, B.N. Sohan Qadri Gy.CH (Ed: Klingmann) ExC. Apr–May 1977.

Gottlieb, Adolph and Mark Rothko with Barnett Newman Statement. In
 AT 1900–90. Harrison, C & P.Wood, eds. 561–3. Oxford: Blackwells 1993.

Goud, Laxma AHJ (1978–9): 59–61. [Refer AHJ, Black Partridge, G.Doctor,
 Pundole, G.m.Sheikh, H.Winterberg].

Gowda, Sheela [Refer Gy. CH].

Green, Christopher Purism. In Concepts of Modern Art. N.Stangos, ed.
 79–84. T & H 1991.

Greenberg, Clement Avant–Garde and Kitsch. In AT 1900–90. Harrison,
 C & P.Wood, eds. 529–41. Oxford: Blackwells 1993.
The Decline of Cubism. In AT 1900–90. Harrison, C & P.Wood, eds. 569–72.
 Oxford: Blackwells 1993.

Greene, Lynne 'Pleasing the Heart: Dhruva Mistry in Birmingham'
 Contemporary Art 1.4 (Summer 1993): 36–40.

Greene, T.M. The Arts and the Art of Criticism. Princeton: Princeton
 University Press 1947.

Grohmann, Will Paul Klee. London: Beaverbrook Publications 1958.
 Kandinsky London: Beaverbrook Newspaper Ltd. 1960.

Gropius, Walter The Theory and Organisation of the Bauhaus. In AT 1900–
 90. Harrison, C & P.Wood, eds. 338– 43. Oxford: Blackwells 1993. Extract
 Rpt. from Bauhaus 1919–28. Bayer, W.H., Ise Gropius, W.Gropius, eds. NY:
 MOMA 1938.

Guha–Thakurta, Tapati 'Visualising the Nation: The Iconography of a
 'National Art' in Modern India' JAI 27–28 (Jne 1995): 7–39.
The Making of a New Indian Art: Artists, Aesthetics and Nationalism in Bengal
 1850–1920. Cambridge: C.U.P, 1992. [*Refer* R.C.Sharma].

Gujral, Satish Brunt (sic) Woods & Architecture: Icons' ExC [RB.LKA: 23
 Nov– 1 Dec 1990 & JG: 17–24 Jan 1990].
 Painting and Sculpture 1990–93 JG ExC. 20–27 Nov 1993.
The World of Satish Gujral: In his own words New Delhi: UBS Publishers
 Distributors 1993. [*Refer* E.Alkazi, J.Appasamy, Art Today, BAAC,
 R.L.Bartolomew, Dhoomimal, LKA, U.Vasudev, S.V.Vasudev].

Gupta, R.P, ed. *Visions: Paintings and Sculptures by Somnath Hore, Ganesh
 Pyne, Bikash Bhattacharjee and Jogen Chowdhury.* Calcutta: Ladies Study
 Group 1990 [Text includes R.P.Gupta 'Modern Bengali Painting and Graphic
 Arts: a Note on their Origins' 7–10; Asok Mitra 'Bengali Painting: its
 Political and Cultural Moorings' 91–5; Paritosh Sen 'Three Contemporary
 Painters' 96–101; K.G.Subramanyan 'The Vision of Somnath Hore' 102; and
 notes on the artists by Pranabendu Dasgupta].

Gupta, Samarendranath 'European Influence on Indian Painting' *Rupam* 5
 (Jan 1921): 20–3.

Gupta, Satish 'A Concept of Nature' *LKC* 29 (Apr 1980).

Gy.CH S.K.Bakre ExC. 1965.
J.Swaminathan 26 Nov–4 Dec 1965. [Including 'Poem to my friend,
 Swaminathan, the painter' by Octavio Paz].
Mohan Samant ExC. Feb 1966.
Shanti Dave ExC. 1966.
Shamlal. Ramkumar ExC. Oct 1966 [Joint show with Upper Grosvenor
 Gallery, London].
S.H.Raza ExC. 15–27 Apr 1968.
Ramkumar ExC. 10–25 Feb 1969.
Narayana Menon & M.F.Husain. 21 Years of Painting– M.F.Husain ExC. 19–31
 Mar 1969.
Laxman Shreshtha ExC. 16–30 Sep 1971.
Arpita & Paramjit Singh Joint ExC. 7–19 Feb 1972.
Santi P.Chowdhury. Veena Bhargava's **Pavement Serie**s ExC. 1973.
D.Nadkarni. Laxman Shreshtha ExC. 14 Nov–5 Dec 1973.
Ramkumar ExC. 31 Oct–19 Nov 1974.
Gieve Patel (**Railway Station Series**) ExC. 20 Nov–3 Dec 1975.
S.H.Raza ExC. 1976.
Piraji Sagara: Wood Reliefs ExC. 6–24 Oct 1978.
Meera Devidayal ExC. 17–31 Mar 1981.
Prabhakar Barwe ExC. 18 Feb–5 Mar 1983.
Amit Ambalal ExC. 10–31 Oct 1986.
Vijay Shankara Sharma. Prabhakar Barwe ExC. 7–30 Dec 1987.
Seventeen Indian Painters: Gy.CH's 25 years at the Jehangir, Bombay, 1988
 [JG 13–21 Sep 1988. Text includes Profiles, a conversation between Kekoo
 Gandhy & Bhupen Khakhar: 'Mirroring the Past' & 'Pictures & Posers' by
 Mala Marwah].
Vivan Sundaram, Long Night: Drawings in Charcoal Joint ExC. 14–26 Nov
 1988 [RB.LKA: 26 Aug–5 Sep 1988 & Gy.CH (Calcutta): 2–21 Dec
 1988][Text includes conversation with Anil Bhatti].
Dilip Ranade. Shakuntala Kulkarni ExC. 9–31 Dec 1988.
Gieve Patel, August 1989. Atul Dodiya ExC. 13–30 Sep 1989.
Vivan Sundaram ExC. 10–31 Mar 1990.
Paramjit Singh: Streams in the Woods ExC. 20 Apr–5 May 1990.
'Splash: Images on Glass' by Bhupen Khakhar, Nalini Malani & Vivan
 Sundaram. Portfolio of Postcards, 1990.
Vinod Dave & Kamala Kapoor. Vinod Dave ExC. 14 Jan–2 Feb 1991.
Rupika Chawla. J.Swaminathan ExC. 12–30 Dec 1991.
Mehli Gobhai ExC. 8–31 Dec 1992.

Vinod Dave ExC. 27 Jan–13 Feb 1993.
K.N.Srinivasa 'Anatomy of Sacrilege'. Sheela Gowda ExC. 2–30 Apr 1993
 [Exhibition earlier previewed at Venkatappa Gallery, Bangalore 6–12 Mar
 1993].
'Note by P.Kolte' [Trans. by R.Hoskote] Prabhakar Kolte ExC. Sep 1993.
Amit Ambalal ExC. 30 Sep–30 Oct 1993.
Nalani Malani: Bloodlines ExC. 15 Feb–18 Mar 1995.
Kamala Kapoor. Watercolours: A Broad Spectrum I– The raw and ragged edge
 ExC. 5–22 Apr 1995. [Artists included: A.Ambalal, J.Chowdhury,
 J.Chakravarty, Madhvi Parekh, Arpita Singh].
Roshan Shahani 'Muted Fires of Yearning'. In Song Space: scroll paintings of
 Nilima Sheikh ExC. 26 Sep–7 Oct 1995 [Exhibition held at Max Mueller
 Bhavan, Bombay].
Chaitanya Sambrani. Watercolours: A Broad Spectrum– II– Acts of painting:
 acts of play ExC.20 Nov–12 Dec 1995. [Artists included: P.Kolte, Mona Rai,
 G.Haloi, V.Sundaram, C.Douglas & P.Barwe].
Gieve Patel: Looking into a Well ExC.15 Dec–15 Jan 1996.
Chaitanya Sambrani. Watercolours: A Broad Spectrum III– Of places and of
 departures ExC. 20 Feb–12 Mar 1996. [Artists included: Bhupen Khakhar,
 Gulammohammed Sheikh, Nalini Malani, Nilima Sheikh, Ranbir Kaleka,
 Timothy Hyman].
Rummana Hussain – An Installation ExC. 1996 8–26 Apr 1996.
Ranjit Hoskote. Watercolours: A Broad Spectrum IV– Distance in Statute
 Miles ExC. 9–30 Sep 1996 [V.Akkitham, Navjot Altaf, B.V.Suresh &
 Indrapramit Roy].

H

Habermas, Jurgen Modernity– An Incomplete Project. In *AT 1900–90.*
 Harrison, C & P.Wood, eds. 1000–8. Oxford: Blackwells 1993.
The Philosophical Discourse of Modernity: 12 Lectures. Translated by
 Frederick Lawrence. Cambridge: Polity Press in association with Blackwells
 1987. Reprint. Cambridge: Polity Press 1990.

Haldar, Asit Kumar 'Stray Thoughts on Art.' *Rupam* 18 (Apr 1924): 79–83.
'The Subject Matter of Art' *Rupam* 5 (Jan 1921): 24–6. [*Refer* LKA,
 G.Venkatachalam].

Haloi, Ganesh [*Refer* BAAC, Chitrakoot, R.Hoskote, S.Mukherjee, SOCA].

Hanfi, Shamim *A Study based on the Yayati Series of A.Ramachandran.*
 New Delhi: Shaoor Publications Nov 1986.

Hanru, Hou 'Beyond the Cynical: China avant–garde in the 1990s' *Art Asia
 Pacific* Q3.1 (Jan 1996): 42–51. [*Refer* R.Araeen].

Haridasan, K.V. 'Bija Yantra' Kumar Gallery ExC. Apr 1971.
'Tantra, Art and Modernity' *LKC* 37 (Mar 1991): 65–6.
Intimations on Art: Indian, Western, Modernity, Tradition & Tantra.
 Trivandrum: Private Publication 1995. [*Refer* S.A.Krishnan].

Harrison, Charles Abstract Expressionism. In *Concepts of Modern Art.*
 N.Stangos, ed. 169–211. T & H 1991.

Harrison, Charles & Paul Wood, eds. *Art in Theory 1900–1990: An
 Anthology of Changing Ideas.* Oxford: Blackwells 1993.

Havell, E.B ' The new Indian school of paintings' *The Studio* 44.184 (15 Jly
 1908).
The Basis for Artistic & Industrial Revival in India. Aydar, Madras: Theosophist
 Office 1912.
'Indian art at Wembley' *Rupam* 21 (Jan 1925): 11–3.
'Fundamentals of Indian art: A Review' *Rupam* 27–28 (Jly–Oct 1926): 74–7.

'The Mathematical Basis of Indian iconography' *Rupam* 29 (Jan 1927): 6–12.

Hayter, S.W. 'On Prints' *LKC* 11 (Apr 1970).
Introduction. *Krishna Reddy: A Retrospective Bronx Museum ExC.* 5 Nov 1981– 28 Feb 1982.
'Krishna Reddy Works on another Plane' ICCR–BAAC ExC. 24 Dec 1984– 15 Jan 1985.

Heath, Lionel 'Modern Indian art at Wembley: Punjab' *Rupam* 21 (Jan 1925): 13–4.

Hebbar, Archana 'From Image to Icon: A study of the development of K.G.Subramanyan' *AHJ* 4 (1984–5): 37–49.

Hebbar, Krishna K. *Singing Line.* Peacock Publications, 1962. Reprint. *Singing Line.* New Delhi: Abhinav Publications 1982. [*Refer* S.I.Clerk, Jagmohan, JG Publications, S.A.Krishnan, LKA, V.Purohit, Vadehra, G.Venkatachalam].

Heilman, Philip 'Three Master Printmakers' 1996 National Print Biennale ExC. NY: Silvermine Guild Arts Center 1996.

Heisenberg, Werner *Physics & Philosophy.* London: Penguin 1990.

Help Age India JG–Asprey's Auction ExC. April 1993.

Herwitz, Daniel Indian Art from a Contemporary Perspective. In *Indian Art Today.* 17–27. New York: Grey Art Gallery & Festival of India 1986.

Hess, Lynda Panoramic Teraoka. *Art Asia Pacific* Q3.1 (Jan 1996): 78–83.

Hoet, Jan 'Authenticity is the Only Criterium'. International Contemporary Art Exhibition of the Inventure Collection, Amsterdam ExC. Nov 1989.

Hore, Somnath Somnath Hore: Statement *AHJ* 6 (1986–7): 110.
Tebhaga: An Artist's Diary and Sketchbook. Trans. from Bengali: Somnath Zutshi. Intro. by Samik Bandyopadhyay. Calcutta: Seagull 1990. [*Refer* J.Appasamy, A.Dube, R.P.Gupta, D.Kowshik, Kunika–CH, LKA, R.Parimoo, P.Ray (1977–8)].

Hoskote, Ranjit 'Atul Dodiya– A sense of force held in check' Bombay: Times of India, 27 Sep 1989.
'Prabhakar Kolte– Adventures in Interiority' *AHJ* 11 (1991–92): 101–6+
'The Art Scene in India: The Introductory Essay' *LKC* 37 (Mar 1991): 15–23.
'A.Padamsee– Between the hierartic and the Human' *AHJ* 11 (1991–92): 131–41+
'J.A.Sabavala: Pilgrim, Exile, Sorcerer' The gallery ExC. [JG: 17–24 Feb 1993 & AIFACS: 11–17 Mar 1993].
'G.Haloi– Devastated Landscape' Bombay: Times of India, May 1993.
'Amithava Das: Figures of a melancholy heroism' Spring 1993. Amithava Das: Exhibition of Paintings 1992–93 Sakshi ExC. 1993.
'Atul Dodiya– Of Threshold and Entry' Bombay: Interiors Magazine 1993.
'Atul Dodiya: Interim Reports' Gy.CH ExC. 19 Jan–11 Feb 1995.
Cymroza Gallery ExC. 8–25 Mar 1995.
'Vivan Sundaram: When art becomes archival' Bombay: Economic Times, Sunday 2 Apr 1995.
'Special Report: The Indian art mart has reached its watershed' Sunday Times of India, 11 Jne 1995.
'Tokens of Divination: Recent Works' Mehli Gobhai 'Works on paper' Gy.CH ExC. 16 Oct.–11 Nov 1995.
'The secret heart of the clock: A Tribute to Prabhakar Barwe'. Bombay: Times of India, 10 Dec 1995. Rpt. in *Shraddhanjali*, Bombay: Private Publication 1996. [*Refer* Chitrakoot, Pundole].

Hrahsel, Zothanpari 'Mizos venture into the Mainstream' New Delhi: *the India Magazine* 13.8 (Jly 1993): 64–9.

Hsing–Yueh, Lin 'Shooting Straight At The Hip'. Trans. Chen Chih–Ping. *Free China Review* 43.3 (Mar 1993) 38–47.

Husain, Maqbool Fida 'Poems' *Aspect Journal: India Issue.* Ulli Beier, ed. (Jan 1982): 18
Husain's 'Gufa' *Indian Architect & Builder* 8.4 (Dec 1994): 15–47.
'The Importrance of Being HUSAIN' *Sunday* 24–30 Mar 1996. [*Refer* E.Alkazi, J.Appasamy, Art Heritage, BAAC, R.L.Bartolomew, U.Beier, Business Standard, Economic Times, K.B.Goel, Gy.CH, G.Kapur, S.S.Kapur, K.Khanna, S.A.Krishnan, LKA, D.Nadkarni, V.Purohit, A.S.Raman, R.Shahni, C.Singh, Sunday Times, Vadehra].

Husain, Shamsad [*Refer* E.Alkazi, S.Datta, Pundole, G.Sinha].

IJ

IIAS Studies in Modern Indian Aesthetics. Simla: IIAS.
Aestheticians . Publications Division 1983.
Rabindranath Tagore & the challenges of Today: Selected Essays. Bhudeb Chaudhuri & K.G.Subramanyan, eds. 1988.
Rekha Jhanji. *The Sensuous in Art: Reflections on Indian Aesthetics.* IIAS in association with New Delhi: Motilal Banarsidass 1989.

Indian Council for Cultural Relations, New Delhi (ICCR) [*Refer* J.Appasamy (1970), BAAC (1985)].

Indian Express (Newspaper) Krishen Khanna. 15 Jan 1972.
K.Ramanujam: 'in fear and fantasy' 9 Jne 1973.
'Jogen Chowdhury: Beneath mind's half–lit layer' 2 Dec 1973.

Indian Museum, Calcutta B.N.Mukherjee *Album of Art Treasures: Kalighat Patas III.* 1987.

Irwin, John 'Symbolism in Early Indian Art' *AHJ* 2 (1982–3): 31-7. [*Refer* B.Dey]

ISOA *Abanindranath Tagore.* Pulinbihari Sen, ed. Golden Jubilee Number, Nov 1961. [Essays included by: Abanindranath Tagore– Likeness, 1–11; Shadanga: Six Limbs of Painting, 12–28; Some Notes on Artistic Anatomy, 29–39; Reminiscences, 40–8; Konarka: To and From, 49–53. S.K.Chaterjee, B.B.Mukhopadhyaya, P.Bisi, Rabindranath Tagore & others].
Gaganendranath Tagore. Pulinbihari Sen, ed. Mar 1972. [Essays included by: The Marquess of Zetland, Dineschandra Sen, Rathindranath Tagore, O.C.Ganguly, Nirad C.Chaudhuri, Rabindranath Tagore, B.Mukhopadhyaya, Asok Mitra, M.R.Anand, Amina Kar, Stella Kramrisch, Kshitis Roy, S.Tagore, Jaya Appasamy, Pulinbihari Sen].

JG *Indian Painting Today*, 1982.
Indian Sculpture Today, 1983.
Indian Printmaking Today, 1985.
Indian Drawing Today, 1987.
Creative Crafts of India, 1989.
K.K.Hebbar. *Voyage in Images*, 1991.

Jagmohan 'Art Chronicle' *LKC* 1 (Jne 1962).
Hebbar. *Artrends* 2.1 (Oct 1962).
'Art Chronicle' *LKC* 2 (Dec 1964): 49-50.
'Twenty five years of Independence in Indian Art' *Bombay Art Society's Art Journal*, 1972.
'The Bombay Art Scene in the Forties' *LKC* 28 (Sep 1979): 21-8.

Jain, Jyotindra *Folk Art & Culture of Gujarat* (Guide to the Collection of the Shreyas Folk Museum of Gujarat) Ahmedabad, 1980.
'Art and Artisans: Adivasi and folk art in India' *Art & Asia Pacific* Q2.1 (Jan 1995): 72–81. [*Refer* Espace].

Jakimowicz–Karle, Marta. *Bikash Bhattacharjee.* Bangalore: Kala Yatra & Sistas Publications 1991.

James, Bruce 'Some aspects of English painting during the past Decade' *LKC* 5 (Sep 1966).
'A Passage from India: Seven Painters in London' *LKC* 9 (Sep 1968): 19–29 [Artists included: Ashu Roy, Avinash Chandra, Balraj Khanna, Rama Rao, Sadanand Bakre, Viren Sahai, F.N.Souza].

James, Josef Artrends, Editor.
Paniker. *Artrends* 4.2 & 3 (Jan–Apr 1965).
S.G.Vasudev. *Artrends* 5.2 & 3 (Jan–Apr 1966).
V.Viswanathan (sic). *Artrends* 5.2 & 3 (Jan–Apr 1966).
K.Ramanujam. *Artrends* 5.4 & 6.1 (Jly–Oct 1966).
'The Madras School' *LKC* 6 (Apr 1967).
'Metaphysical content in Recent Contemporary Indian Painting' *LKC* 12–13 (Apr–Sep 1971).
'S.G.Vasudev' *LKC* 19–20 (Apr–Sep 1975): 38-9.
'K.C.S.Paniker' *LKC* 22 (Sep 1976): 10–1.
'Porfolio of Young Artists: Reddappa (sic) Naidu' LKC 22 (Sep 1976): 25.
'The New Figuratives' *LKC* 35 (Sep 1987): 13-9.
'An artists Village' *LKC* 35 (Sep 1987): 39-47.
'R.m.Palaniappan: Rare Algebra' *AHJ* 9 (1989–90): 36-43.
'The Contribution of South India to the Contemporary Art of the Country.' In *Contemporary Indian Art: Glenbarra Art Museum Collection.* Masanori Fukuoka, ed. Hemeji: Glenbarra Japan Co. 1993.
Contemporary Indian Sculpture: The Madras Metaphor. New Delhi: Oxford University Press (OUP) 1993. [*Refer* Art Heritage, Espace(1995), IIAS]

Jameson, Fredic from 'Reflections on the Brecht–Lukacs Debate'. In *AT 1900–90.* Harrison, C & P.Wood, eds. 976–9. Oxford: Blackwells 1993.

Janikiram, P.V. *Artrends*, Publisher & Editor. [*Refer* LKA].

Janin, L 'Art is One' LKC 7–8 (Sep 1977–Apr 1978): 19–23.

Januszczak, Waldemar 'Emil Nolde: Nazi artist, nasty art' London: Sunday Times, 31 Dec 1995.

Jehangir Art Gallery, Bombay See JG

Johnson, Ken 'Significant Others'. *Art in America* (Jne 1993).

Joshi, Nibha Tyeb Mehta Kunika–CH ExC. Dec–Jan 1971–2.
'Jeram Patel: Words parallel to his art' *LKC* 19–20 (Apr –Sep 1975): 28–30.
Art in Appreciation for Criticism is not art. In *Biren De– a journey... as seen by 5 contemporaries.* New Delhi: Caxton Press 1972.

Joshi, Rita. Rameshwar Broota: Faces, Genesis Art Gallery Calcutta ExC. 20–31 Mar 1990.

K

Kaleka, Ranbir Singh [*Refer* Art Today, P.de Francia, M.G.Singh].

Kandinsky, Wassily *Concerning the Spiritual in Art.* Trans. & Intro. M.T.H.Sadler. New York: Dover Publications 1977.
'The Cologne Lecture 1914' In *AT 1900–90.* Harrison, C. & P.Wood, eds. 94–

8. Oxford: Blackwells 1993.
'Plan for the Physico–psychological Department of the Russian Academy of Artistic Sciences' 1921. In *AT 1900–90* Harrison, C. & P.Wood, eds. 301–3. Oxford: Blackwells 1993.

Kanoria Centre for the Arts Brochure. Ahmedabad., n.d.

Kapoor, Kamala 'Excerpts from an Interview with Jehangir Sabavala' *AHJ* 7 (1987–8): 57–61+
'Anjana Mehra: New Explorations' *AHJ* 9 (1989–90): 44–8.
'Atul Dodiya: Contemplative Interiors' Sunday Observer, 24 Sep 1989.
'Of Epic Inner worlds' Bombay: Economic Times. 11 Nov 1991 [Artists included: Atul Dodiya, Shoba Ghare & Firdaus Dadabhoy].
'Akbar Padamsee: Experiment is the Key word' Bombay: Economic Times, 11 May 1993.
Laxman Shreshtha JG ExC. 1993–4.
An Overview of the Contemporary Indian Art Scene. In *Contemporary Art.* Bombay: Deutsche Bank AG 1995.
'Missives from the Streets: the art of Nalini Malani' *Art & Asia Pacific* Q2.1 (Jan 1995): 48–51.
'Remembering Nasreen' Bombay: Economic Times, Sunday 28 May 1995.
'Songspace: The Art of Nilima Sheikh' *Art Asia Pacific* Q3.2 (1996): 90–4. [*Refer* S.Bajaj, S.Patwardhan].

Kapoor, Wasim [*Refer* BAAC (1987)].

Kapur, Geeta 'Three Graphic Artists' *LKC* 5 (Sep 1966): 21–3.
Introduction and analytical notes. In *Husain.* Bombay: Sadanga Series, Vakil & Sons 1967.
'Implications of Internationalism in Contemporary Art' *Vrishchik* 2.3 (Jan 1971).
'Human Image in Indian Art' New Delhi: Times of India Dec 1972.
'The Evolution of Content in Amrita Sher–Gil's Paintings' In *Amrita Sher–Gil* V.Sundaram & G.Kapur, eds. Bombay: Marg Publications 1972.
'In Quest of Identity: Art & Indigenism in post–colonial culture with special *Reference* to Contemporary Indian painting– M.F.Husain. *Vrishchik* 4.1 (Mar 1973): n.p.
Pictorial Space LKA ExC. 14 Dec–3 Jan 1978.
Contemporary Indian Artists. New Delhi: Vikas Publishing House 1978 [Artists included: MF Husain, Bhupen Khakhar, Akbar Padamsee, F.N.Souza, Ram Kumar, J.Swaminathan].
Sudhir Patwardhan JG ExC. Mar 1979.
Four Painters Directions – Khakhar, Mehta, Padamsee and Patel Gy.CH ExC. [Part 1: 19 Feb–10 Mar 1979; Part 2: 13 Mar–7 Apr 1979].
Partisan Views About the Human Figure. In *Place for People ExC.* 1981 JG: 9–15 Nov 1981, RB.LKA: 21 Nov–3 Dec 1981 [Artists Included: Jogen Chowdhury, Bhupen Khakhar, Nalini Malani, Sudhir Patwardhan, Gulammohammed Sheikh, Vivan Sundaram].
'Nalini Malani' *AHJ* 2 (1982–3): 72–6.
'Modern Indian Painting: A Synoptic View' *JAI* (Oct–Dec 1982): 5–19.
'Ravi Varma: Representational Dilemmas of a Nineteenth Century Indian Painter' JAI 17–18 (Jne 1989): 59–80.
'Indian Modernism' In *Nine Contemporary Indian Artists.* E.M.Schoo, ed. Municipal Museum, Arnhem & Lotus Gallery, Amsterdam 1991.
'G.m.Sheikh: The Riddle of the Sphink' ExC. Mar 1991.
'Place of the Modern in Indian Cultural Practice' *Economic & Political Weekly* 26.49 (Dec 1991).
'Re–View 1930–1993: From the NGMA Collection– Exhibition Notes', New Delhi, 1993.
'Nalini Malani: Art of Dreamings and Defilings' Economic Times, 23 May 1993(?).
'Madhvi Parekh: Cocky amalgam of Pictorial Traditions' Economic Times, 30 May 1993.
A Stake in Modernity: Brief History of Contemporary Indian Art. In *Tradition*

& Change: Contemporary Art of Asia and the Pacific. Caroline Turner, ed. 27–44. Australia: University of Queensland Press 1993.
'Navigating the Void'. Paper presented at the NCPA Mohile–Parekh Centre Symposium, Bombay 5–8 Jan 1994.
'Hundred Years: The National Gallery of Modern Art exhibition: an excerpt. from the curator's working notes' *Art & Asia Pacific* Q2.1 (Jan 1995): 82–7.
Introduction & Elegy For An Unclaimed Beloved: Nasreen Mohammedi (1937–90). In *Nasreen in Retrospect*. Altaf Mohammedi, ed. 3–5 & 12–9. Bombay: Ashraf Mohammedi Trust 1995.
'When was Modernism in Indian Art?' *JAI* 27–28 (Mar 1995): 105–126.
'J.Swaminathan: the artist the ideologue the man his persona' *the India Magazine: J.Swaminathan Issue* 14.7 (Jne 1994): 16–7. Rpt. in *JAI* 27–28 (Mar 1995): 157–8. [*Refer* NGMA, Tate]

Kar, Amina 'Sunayani Devi – a Primitive of the Bengal School' *LKC* 4 (Apr 1966): 4–7.
'Gaganendranath Tagore a painter of his time' *LKC* 6 (Apr 1967): 1–6. [*Refer* ISOA].

Kar, Chintamoni *Indian Metal Sculpture*. London: Alec Tiranti Ltd. 1952.
Gaganendranath Tagore– Souvenir Volume. Calcutta: Academy of Fine Arts 1957.

Kar, Sanat [*Refer* Art Heritage, BAAC, A.Banerjee, Pundole, SOCA]

Karpeles, Andre 'The Calcutta School of Painting' Trans. from French by Gurudas Sirkar. *Rupam* 13-14 (Jan-Jne 1923): 2–7.

Karunakar, Pria 'Conversation with Paramjit Singh' *LKC* 15 (Apr 1973): 23–5.
'Conversation with Arpita Singh' *LKC* 15 (Apr 1973): 25–6.
'Tyeb Mehta: Abstraction and Images' *LKC* 17 (Apr 1974): 25–31.
'Gaitonde' *LKC* 19–20 (Apr–Sep 1975): 15–7.
'Nasreen Mohamedi' *LKC* 19–20 (Apr–Sep 1975): 34–6.
'Notes on Mixed media' *LKC* 21 (Apr 1976): 1–4.
'Variations – Mrinalini Mukherjee' *LKC* 21 (Apr 1976): 29–30.
'Akbar Padamsee: Nature as Landscape' *LKC* 23 (Apr 1977): 31-3.

Katt, Balbir Singh [*Refer* Espace (1995)].

Katyal, Anjum *Interfacing*. Calcutta: Seagull Books 1986 [With drawings by Chittrovanu Mazumdar].
Chittrovanu Mazumdar ExC. May–Aug 1994 [Delhi–Bombay–Madras Touring Exhibition. Presented by Seagull]. [*Refer* Seagull].

Kaul, Manohar 'Laxman Pai– Restless Quest for Inner Expression' *Kala Darshan* 3.2 (1990): 7–12. [*Refer* Dhoomimal].

Kaul, K.L. 'P.T.Reddy: Voyage and Vision' *LKC* 28 (Sep 1979): 16–20.

Kessar, Urmi 'A Conceptual Reappraisal of the Painting of Jamini Roy'. In *Jamini Roy*. 49–63. LKA 1992.

Keseru, Katali. The Sher–Gil Archive: An Installation, Vivan Sundaram ExC. (Trans. from Hungarian) [Joint Show with Mucsarnok's Dorottya Gallery, Budapest 14 Sep– 4 Oct 1995; Hungarian Information & Cultural Centre, New Delhi 4 Feb– 2 Mar 1996 & Gy.CH 14 Mar– 3 Apr 1996].

Keyt, George [*Refer* M.R.Anand, M.Russell].

Khakhar, Bhupen 'Notes on the visual Senses in my Painting' *LKC* 10 (Sep 1969): 24.
Booklet: Truth is Beauty, Beauty is God. Mar 1972.
'An Artist Must be vulnerable' *Aspect Journal: India Issue*. Ulli Beier, ed. (Jan. 1982): 27–36.

'The Love Story of Alka and Manilal' *Aspect Journal: India Issue*. Ulli Beier, ed. (Jan. 1982): 37–44.
Bhupen Khakhar in conversation with Rani Dharkar: 'Most people don't really understand my work'. The Sunday Review, 31 Mar 1996. [*Refer* Aberystwyth, CIMA (Mar 1995), de Bijenkorf, German News, Gy. CH (1988) J.Hoet, G.Kapur, NGMA (Dec 1996)].

Khandalavala, Karl J. Decorative artist– D.P.Roy Chowdhury. In *D.P.Roy Chowdhury*. P.R.Rao, ed. Bombay: New Book Co. 1943.
Amrita Sher–Gil. Bombay: New Book Co. 1944.
Vajubhai Bhagat JG ExC. 12–18 Mar 1981.
'Whither Modern art in India? '*LKC* 37 (Mar 1991): 9–12.

Khanna, Krishen 'Studies in the Development of M.F.Husain' *Marg* 6.2 (1951): 56–9.
Tyeb Mehta: Koodal Gy.CH ExC. 1970.
'A letter to a fellow artist' [Manjit Bawa] *LKC* 32 (Apr 1985): 40–1.
'Beyond the Bandwalla's Cacophany' *AHJ* 10 (1990–1): 44. [*Refer* R.L.Bartolomew, K.B.Goel, Indian Express, The Hindustan Times, the India Magazine, Times of India].

Khanna, Madhu 'The Digitized Cosmos: Symbol & Meaning of Ritual Mandalas' *AHJ* 9 (1989–90): 88–93. [*Refer* A.Mookherjee].

Kher, Bharti Subodh Gupta: Grey Zones ExC. 1996 [New Delhi: Academy of Fine Arts & Literature 25 Nov– 8 Dec 1995 & JG: 21–28 Mar 1996].

Khosa, K [*Refer* K.Malik].

Kirchner, Ernst Ludwig 'Programme of die Brucke 1906'. In *AT 1900–90*. Harrison, C & P.Wood, eds. 67–8. Oxford: Blackwells 1993.
ExC. Berne, 1954–5.

Kitaj, R.B Marlborough Fine Art (London & Zurich) ExC. Apr–Jne–Jly 1977 [Intro. by Robert Creeley].

Klee, Paul *Pedagogical Sketchbook*. Intro. & Trans. by Sibyl Moholy–Nagy. London: Faber & Faber 1953. [*Refer* W.Grohmann].

Koller, E 'Oskar Kokoschka-humanist first and last.' *LKC* 6 (Apr 1967): 9–14.

Kolte, Prabhakar *Homage to Palsikar* [Text: Letters & Poems shared by Prabhakar Kolte & S.B.Palsikar]. Bombay: Private Publication 1985. [*Refer* S.Clerk , Gy.CH, R.Hoskote, D.Nadkarni, Sakshi].

Kowshik, Dinkar 'Somnath Hore: Wounds in Bronze' *AHJ* 6 (1986–7):111–3+
'My student days in Santiniketan' *LKC* 10 (Sep 1969): 31–4.
'Suhas Roy' *LKC* 22 (Sep 1976): 16–7.
Nandalal Bose. New Delhi: National Book Trust 1985.
'Jaya Appasamy: A Profile' *LKC* 34 (Jan 1987): 12–8.
'The Need for Updating Art Education' *LKC* 37 (Mar 1991): 63–4. [*Refer* LKA].

Kramrisch, Stella 'Form Elements in the visual work of Rabindranath Tagore' *LKC* 2 (Dec.1964): 37–9+

Kramrisch, Stella, Late J.H.Cousins & Vasudeva Poduval *The arts and crafts of Kerala* Cochin: Paico Publishing House 1970.

Krauss, Rosalind A View of Modernism. In *AT 1900–90*. Harrison, C & P.Wood, eds. 953–6. Oxford: Blackwells 1993.
from 'The Originality of the Avant–Garde'. In *AT 1900–90*. Harrison, C & P.Wood, eds. 1060–5. Oxford: Blackwells 1993.

Kriplani, Krishna More than an Artist. In *Nandalal Bose: A Collection of Essays*. LKA 1983.

Krishna, Devyani [*Refer* R.L.Bartolomew].

Krishna, Kanwal 'From my Note Book' 1962–63.

Krishna, Devyani & Kanwal [*Refer* LKA].

Krishna, Nanditha 'The Art Scene in India: As a Traditionalist Looks at it' *LKC* 37 (Mar 1991): 49–52.

Krishnan, S.A. *Gade*: Sadanga Series. M.R.Anand, series ed. New Delhi: Vakils & Sons 1961.
'Santosh – a Painter of Kashmir' *LKC* 4 (Apr 1966): 19-21.
'Three Retrospectives: Hebbar' *LKC* 10 (Sep 1969): 27–9.
'Figurative and Abstract Art – a Symposium.' [Compiled & Presented] LKC 7–8 (Sep 1977–Apr 1978): 24–37.
'P.V.JanakiRam, a Sculptor of great promise' *LKC* 9 (Sep 1968): 30-1.
'Image and Inspiration: Studio interviews of Biren De, G.R. Santosh, Dhanraj Bhagat, K.V.Haridasan, and Om Prakash' *LKC* 12–13 (Apr–Sep 1971):15–29.
Santosh: Sublimation of Desire, Kumar Gallery ExC. 1971.
'Matter and Spirit in the work of Laxman Pai' *LKC* 15 (Apr 1973).
'Conversations with Printmakers – Anupam Sud' *LKC* 18 (Sep 1974): 33-5.
'Editorial' LKC 24–25 (Sep 1977–Apr 1978): 3–7.
'Manu Parekh: An interpretation of Biogenetic Imagery' *LKC* 27 (Apr 1979): 11-2.
Three Retrospectives: Husain LKC 27 (Apr 1979): 20-2.
'Interview with J.Sultan Ali' LKC 29 (Apr 1980): [*Refer* LKA, A.S.Raman, P.T.Reddy].

Kudallur, Achuthan JG ExC. 28 Oct–3 Nov 1986. [*Refer* Sakshi].

Kuhn, Thomas S. *The Structure of Scientific Revolutions*. London: The University of Chicago Press 1970. [2nd edition, enlarged].

Kulkarni, K.S. *Artrends* 3.3 (Apr 1964).
Kumar Gallery ExC. 1966.
'Musings on Modernity' *LKC* 37 (Mar 1991): 58–62.
'Triennales in India' *LKC* 36 (Sep 1990): 97-9. [*Refer* BAAC].

Kulkarni, Shakuntala 'Beyond Proscenium' JG ExC. 1994. [*Refer* Art Heritage, Gy.CH, The Gallery].

Kumar, Vinod 'The Andhra Scene' *LKC* 30 (Sep 1980): 25-8.
'Gogi Saroj Pal' *LKC* 33 (Dec 1985): 42+
F.N.Souza: 'The work of the forties' *LKC* 32 (Apr 1985): 42-3.

Kumar Gallery, New Delhi Ramkumar ExC. Sep 1959.
G.R.Santosh ExC. 1962.
Ramkumar ExC. Oct 1973. [*Refer* B.De, A.Ramachandran]

Kunika–CH Akbar Padamsee ExC. 1961.
J.Swaminathan ExC. Dec 1962.
Laxman Pai ExC. Mar 1965.
J.Swaminathan: Colour Geometry of Space ExC.1967.
S.Hore ExC. Mar–Apr 1973.

L

Labrador, Ana. P 'Beyond the fringe: making it as a filipina contemporary artist' *Art & Asia Pacific* Q2.2 (Jan 1995): 84–97.

Lal, Harkrishen 'Harkrishen Lal – Contemporary Indian Artists 11' *Design* (May 1958). [*Refer* Jagmohan].

Lal, Srimati [*Refer* CCA, Dhoomimal, Espace, Vadehra].

Lazzaro, S 'Two Letters' LKC 7-8 (Sep 1977–Apr 1978): 12-4.

Lee, James B. 'Yi Bul: the aesthetics of cultural complicity and subversion' *Art & Asia Pacific* Q2.2 (Jan 1995): 52–9.

Leger, Ferdinand [*Refer* Arts Council, Great Britain].

Levner, H 'Series 3 : The Interpretation of Visual Hallucinations' In *Psycholopathology and Pictorial Expression: An International Iconographical Collection*. n.p: Sandoz, 1963.

LKA (Lalit Kala Akademi Publications, New Delhi)
Publisher of the Lalit Kala Contemporary Journal (*LKC*) 1–42 (See abbreviations)
Third Triennale ExC. 1975.
Fourth Triennale ExC. 1978.
Fifth Triennale ExC. 1982.
Kala Mela'82, 16 Mar– 3 Apr 1982 [Text includes notes by J.Sultan Ali 'Evolution of Life and Art' & Josef James 'Festival Art'].
Nandalal Bose: A Collection of Essays– Centenary Volume. R.Bartolomew, hon. ed., 1983.
Paroksa: *Coomaraswamy Cenetary Seminar Papers*. Gulammohammed Sheikh, K.G.Subramanyan & Kapila Vatsyayan, eds. 1984.
Search for Roots, 1986.
Rabindranath Tagore. Portfolio of Drawings & Paintings 1–3, 1987.
Rabindranath Tagore: Collection of Essays. R.Parimoo, ed. 1989. [Includes essays by P.Neogy, R.Tagore, S.Kramrisch, K.G.Subramanyan, R.Parimoo, D.Kowshik, S.Sarkar & J.Shivpuri].
The Downtrodden and We ExC. 1991 [A tribute to Dr.B.R.Ambedkar, on his Birth Centenary Celebrations].
Petals of Offering ExC. 22 Apr 1992 [Felicitating Prof. B.C.Sanyal on his Ninetieth Birthday].
Award Winners: National Exhibition of Art 1955–90. New Delhi, 1991.
Jamini Roy: A collection of essays. 1992 [Text includes essays by B.C.Sanyal, U.Kessar, S.Som, and A.Nigam].
6th Asian Art Biennale, Bangladesh. New Delhi: LKA 1993.
Catalogue 1: Collections from the LKA 1958–66, New Delhi 1995.

LKA Individual Monographs

V.R.Amberkar *K.K.Hebbar* 1960.
Jaya Appasamy *Ramkinkar* 1961.
Mukti Mittra *A.K.Haldar* 1961.
Bishnu Dey *Prodosh Dasgupta* 1961.
M.Anantanarayan *Paniker* 1961.
Kshitis Roy *Gaganendranath Tagore* 1964.
Charles Fabri *Dhanraj Bhagat* 1964.
Rudi von Leyden *K.H.Ara* 1965.
Baldoon Dhingra *Sher–Gil* 1965.
Mulk Raj Anand *Chintamoni Kar* 1965.
Dwijendra Moitra *Gopal Ghose* 1966.
Jaya Appasamy *Sailoz Mookherjea* 1966.
S.A.Krishnan *K.Sreenivasulu* 1966.
Dinkar Kowshik *Sanyal* 1967.

Krishna Chaitanya *S.G.Thakur Singh* 1967.
Shamlal *Ramkumar* 1968.
V.Sitaramiah *Venkatappa* 1968.
Karl Khandalavala *Sankho Chaudhuri* 1970.
Gieve Patel *A.M.Davierwala* 1971.
S.A.Krishnan *Laxman Pai* 1971.
Kali Biswas *D.P.Roy Chowdhury* 1973.
Ajit Kumar Dutta *Jamini Roy* 1973.
S.A.Krishnan *P.V.Janakiram* 1974.
Richard Bartolomew *Krishna Reddy* 1974.
Santi P.Chowdhury *Paritosh Sen* 1975.
S.V.Vasudev *Pilloo Pochchanawala* 1981.
Hermann Goetz *Shiavax Chavda* 1983.
Ulli Beier *J.Sultan Ali* 1983.
Dnyaneshwar Nadkarni *Gaitonde* 1983.
Pranabranjan Ray *Somnath Hore* 1983.
Pria Devi *J.A.Sabavala* 1984.
Ajit Mookherjee *Biren De* 1985.
Anjali Sircar *L.Munuswamy* 1985.
Keshav Malik *Y.K.Shukla* 1987.
Manohar Prabhakar *Ramgopal Vijaiwargiya* 1988.
Asad Ali *Ranvir Singh Bisht* 1988.
Krishna Chaitanya *Bimal Dasgupta* 1989.
Ram Chatterji *V.P.Karmarkar* 1989.
Awadhesh Aman *Radhamohan* 1990.
Geeti Sen *Raza* 1990.
Dinanath Pathy *Sarat C.Debo* 1992.
A.S.Raman *K.Madhava Menon* 1992.
M.K.Sharma *Goverdhan Lal Joshi* 1992.
A.S.Raman *P.T.Reddy* 1992.
M.S.Nanjunda *Nicholas Roerich* 1992.
Somnath Hore *Chittaprosad* 1993.
P.N.Mago *Amarnath Sehgal* 1993.
Ajit Kumar Dutta *Devyani & Kanwal Krishna* 1994.
A.S.Raman *Reddeppa Naidu* 1994.
Subhash Shah *Piraji Sagara* 1995.
Krishen Khanna *J.Swaminathan* 1995.

LTG Gallery, New Delhi. Drawings of Amarnath Sehgal, A.Ramachandran, B.C.Sanyal, Gopi Gajwani, Jatin Das, Kanwal Krishna, K.Khosa, O.P.Sharma, Satish Gujral, ExC. 16 Feb–3 Mar 1990.
Vasundhra Tiwari, J.Zharotia, Shoba Broota, and other Group ExC. 14–28 Mar 1990.
P.T.Reddy ExC. 12–29 Nov 1990.
Paintings by Archana Shastri, Arpana Caur, Jaya Ganguly, Lalitha Lajmi ExC. 3–22 Dec 1990.
G.R.Santosh ExC. 15 Nov–4 Dec.1991.
Anupam Sud ExC. 12–28 Jan 1994.
Prafulla Mohanti ExC. 31 Jan–14 Feb 1994.
J.Zharotia ExC. Mar 16–31 1994.
Om Prakash ExC. 4–24 Oct 1994.
Samik Bandyopadhyay. Rabin Mondal ExC 5–21 Nov 1994.
A Homage: 125th Birth Anniversary of Mahatma Gandhi ExC. 26 Sep –21 Oct 1995.
[Text includes: 'Gandhi in conversation with G.Ramachandran 21–22 Oct 1924; 'Gandhi & Non–violence' by B.R.Nanda; 'Gandhi & Art: The Vision & the influence' by Ananda Das Gupta].

Lucie–Smith, Edward *Sexuality in Western Art*. London: T & H 1991.
Pop Art. In *Concepts of Modern Art*. N.Stangos, ed. 225–38. T & H 1991.

Ludwig, Anthony 'Essay on Souza's Aesthetics'. Dhoomimal ExC. 1986.

Lukacs, Georg ' "Tendency" or Partisanship?' 1932. In *AT 1900–90*.

Harrison, C & P.Wood. 395–400. Oxford: Blackwells 1993.

Lynn, Victoria India Songs. In *India Songs: Multiple Streams in Contemporary Indian Art.* 3-7. Australia: Art Gallery of New South Wales 1993.
'Thinking about Australian and Indian painting: A comparison of modernist painting from two post–colonial nations' *Art & Asia Pacific* Q2.1 (Jan 1995): 92–101.
'Between the Pot and the Sword: The art of N.N.Rimzon' *Art Asia Pacific* Q3.2 (Apr 1996).

Lynton, Norbet 'Modern Sculpture in Britain' *LKC* 6 (Apr 1967).
'Expressionism'. In *Concepts of Modern Art*. N.Stangos, ed. 30–49. T & H 1991.
'Futurism'. In *Concepts of Modern Art*. N.Stangos, ed. 97–105. T & H 1991.

Lyotard, Jean–Francois. What is Postmodernism? In *AT 1900–90*. Harrison, C & P.Wood, eds. 1008–15. Oxford: Blackwells 1993.

M

McCarthy, Thomas 'Introduction'. In *The Philosophical Discourse of Modernity: 12 Lectures*, by J.Habermas. Translated by Frederick Lawrence. vii-xvii Cambridge: Polity Press in association with Blackwells 1987. Reprint. Cambridge: Polity Press 1990.

McEvilley, Thomas *Art & Discontent: Theory at the Millennium*. USA: Documentext, McPherson & Co. 1991.

Mago, Pran Nath 'Search for Roots: Exploration of Folk Arts for Identity'. In *Search for Roots ExC*. Comp., P.N.Mago. 5–19. LKA 1986.
'G.R.Santosh– A Coalesce of Spiritual and Aesthetic Bliss' 1989. Rpt. in New Delhi: Private Publication, 1989 & Bombay, 1992.
Om Prakash Sharma– 35th Solo Exhibition Hyatt Regency ExC. Nov–Dec 1992.
'Delhi Art Scene I– III: Birth of Silpi Chakra' New Delhi: Sunday Patriot 10, 17 & 24 July 1994. [Refer Art Heritage, K.B.Goel, LKA, NGMA(1991)]

Maity, Paresh [*Refer* Cymroza, Gallerie Ganesh, The Asian Age].

Malani, Nalini *AHJ* (1979–80): 40-2 [Excerpts from a conversation with Y.Dalmia]
CCA ExC. 1989–90.
Hieroglyphs: Paintings & Monotypes, JG & Gy.CH Joint ExC. 19–28 Nov 1991 [Gy.CH: 19–28 Nov 1991 & 30 Nov– 7 Dec 1991]. [*Refer* Aberystwyth Arts Centre, Art Heritage, CCA, Gallery 7, Gy.CH, G.Kapur, A.Rajadhayaksha, Sakshi, The Current]

Malevich, Kasimir From Cubism and Futurism to Suprematism: The New Realism in Painting 1915–16. In *AT 1900–90*. Harrison, C & P.Wood, eds. Oxford: Blackwells 1993.
Non–Objective Art and Suprematism' 1919. In *AT 1900–90*. Harrison, C & P.Wood, eds. Oxford: Blackwells 1993.

Malik, Keshav Ambadas. Times of India, Nov 1964.
'Biren De– Within the Wheel' *Design* 14.8 (Aug 1970): 16–9. Rpt. in *Biren De...as seen by 5 Contemporaries ExC*. New Delhi: Caxton Press 1972.
'A Question of Symbols' *LKC* 12–13 (Apr–Sep 1971): 37–40.
'Monuments and Murals' *LKC* 14 (Apr 1972): 22–4.
'Sher–Gil Reconsidered' *LKC* 14 (Apr 1972): 50–2.
'Conversation with an artist – Rameshwar Broota' *LKC* 17 (Apr 1974): 19–20+
'Book Reviews' *LKC* 18 (Sep 1974): 49-50.

'Jogen Chowdhury: Portfolio of a Young Artist' *LKC* 22 (Sep 1976): 21-2.
'Conversation with Rameshwar Broota' *LKC* 24-25 (Apr 1977–Sep 1978):
'Thoughts on Six Painters (P.T.Reddy, P.S.Chandrashekhar, Dhiraj Chowdhury, K.Khosa, Rameshwar Broota & D.Doraiswamy)' LKC 24-25 (Sep 1977 –Apr 1978): 46–50.
Paramjit Singh. *LKC* 26 (Sep 1978):
'The obsession with Indianness' *LKC* 30 (Sep 1980): 22-5.
Kashmir Collection as acquired by the J & K Academy of Art Culture & Languages ExC. 1982.
'The technological Situation and the irrelevance of art' LKC 33 (Dec 1985): 33-5.
'Dhanraj Bhagat – Portrait of an artist' *LKC* 35 (Sep 1987): 9–11.
'Shoba Broota– Visions of an inner world' New Delhi: Times of India, Mar 1988.
'Four Women Artists' *AHJ* 8 (1988–9): 64–69+ [Includes: Kishori Kaul, Arpana Caur, Anupam Sud, Salvita Gomes Makhani]
'The Art Scene in India: As a Critic Looks at it' *LKC* 37 (Mar 1991): 36–42.
The tip of the iceberg. In *Nine Contemporary Indian Artists*. E.M.Schoo, ed. 12-5. Arnhem: Municipal Museum & Amsterdam: Lotus Gallery, 1991.
Dhiraj Chowdhury: Seventies\Eighties\Nineties– Drawings, Galerie Romain Rolland– Alliance Francaise de Delhi ExC. 27 Nov–11 Dec 1991.
'B.C.Sanyal: the middle course'. Seminar Papers: Sanyal and the art of his Times. LKA, Apr 1992.
'Conversation with a painter [K.Khosa]'. London: *Temenos* 13 (1992): 94–100.
Sankho Chaudhuri: The Art of Pure Forms LTG ExC. 8–23 Oct 1993.
Yusuf Arakkal– Thoughts in Retrospect JG. ExC. 14–20 Apr 1995. [*Refer* Art Heritage, Art Today, R.Broota, CIMA, LKA, NGMA, P.T.Reddy, Vadehra].

Mansaram, P 'The Art Scene in India: As an Expat Looks at it' *LKC* 37 (Mar 1991): 53–5.
'Speeding Towards Light' Dhoomimal Art Gallery ExC. 20–31 Jan 1995. [*Refer* R.Bhatia, S.V.Vasudev].

Maquet, Jaques *The Aesthetic Experience: An Anthropologist Looks at the Visual Arts.* New Haven & London: Yale University Press 1986.

Marg Publications *Artists Today: East–West Arts Visual Encounter.* Ezekiel, Nissim and U.Bickelmann, eds. Bombay, 1987.

Marwah, Mala 'F.N.Souza: Expression in Style' *LKC* 22 (Sep 1976): 4–6.
'A Conversation with Akbar Padamsee' *LKC* 23 (Apr 1977): 34–6.
'Notes on Four artists: B.Khakhar, N.Malani, G.Patel, V.Sundaram *LKC* 24–25 (Sep 1977–Apr 1978): 25–30.
'Drawing and linear expression – Six Contemporary Artists' *AHJ* (1978–9): 12-5.
'Arpita Singh' *AHJ* (1978–9): 45–7.
'Interview with Madhvi Parekh: A Hand can Turn into a Peacock, A Face into a flower, A Cloud into a Little Man...' *Aspect Journal: India Issue.* Ulli Beier, ed. (Jan 1982): 49–53. Rpt. in CCA Annual (1989–90): n.p.

Mazumdar, Chittrovanu [*Refer* A.Katyal].

Mazumdar, Kshitindranath [*Refer* LKA, Pannalal].

Mazumdar, Nirode Introduction. In *Drawings by Fourteen Contemporary Artists of Bengal.* Calcutta: P.Mukherjee & B.Mullick, 1970.
'On Tantra Art' *LKC* 12–13 (Apr–Sep 1971): 33–4. [*Refer* A.S.Raman, S.Sarkar].

Mehra, Anjana [*Refer* Gallery 7, K.Kapoor, The Gallery, R.Shahani].

Mehra, Rajesh [*Refer* Vadehra]:

Mehta, Tyeb [*Refer* U.Beier, D.Bowen, G.M.Butcher, Y.Dalmia, N.Joshi, G.Kapur, K.Khanna, P.Karunakar, K.Malik, Marg, R.Shahani].

Menon, Anjolie Ela [*Refer* I.Murti (pseud)].

MISCELLANEOUS Guide to Ajanta Frescoes. Hyderabad: The Archaeological Department, H.E.H.The Nizam's Government, 1927.
Pittsburgh International ExC. 30 Oct–10 Jan 1971. Pittsburgh: Museum of Art, Carnegie Institute, 1970.
Richardson Hindustan Collection of Thirty Artists ExC. 1985 [JG: 16–22 Dec 1985].
'Singapore Art Museum: A Perspective' *Art Asia Pacific* Q3.2 (1996: Supplement)

Mistry, Dhruv [*Refer* D.Cohen, L.Greene].

Mitra, Asok 'Rabindranath Tagore – the painter' in *Design* (Jan 1958).
'The Forces behind the modern movements' *LKC* 1 (Jne 1962): 15-9.
'Gagendranath Tagore' LKC 2 (Dec.1964): 7–11+
Nandalal Bose. In *Nandalal Bose: A Collection of Essays.* 17–24. LKA 1983. [*Refer* BAAC R.P.Gupta ISOA]

Mittal, Jagdish Art Chronicle: Hyderabad LKC 7–8 (Sep 1967–Apr 1968): 66–7.

Mitter, Partha *Much Maligned Monsters: History of European Reactions to Indian Art.* Oxford: O.U.P. 1977.
Indian Painting Today. In *Indian Painting Today: Four Artists from the Chester & Davida Herwitz Family Collection*– Laxma Goud, Maqbool F.Husain, K.M.Ramanujam & Syed Haider Raza. 6–16. Washington D.C.: Festival of India, 1986. [Exhibition: 22 Feb–6 Apr 1986].
Raja Ravi Varma: The Artist as a Professional. In *Raja Ravi Varma: New Perspectives.* R.C.Sharma, ed. 34–44. New Delhi: National Museum 1993.
Art & Nationalism in Colonial India 1850–1922: Occidental Orientations. Cambridge: C.U.P. 1994.

Mohammedi, Nasreen Diaries. In *Nasreen in Retrospect.* Altaf Mohammedi, ed. 85–100. Bombay: Ashraf Mohammedi Trust 1995. [*Refer* E.Alkazi, Altaf, Y.Dalmia, R.Dossal, K.Kapoor, P.Karunakar, R.Shahani].

Mondal, Rabin *Drawings* 1970–88. Calcutta: Tapas Hazra for Dialogue, Dec 1988.

Mondrian, Piet Alberto Busignani. *Mondrian.* T & H (Dolphin Art Book) 1968.
Dialogue on the New Plastic, 1919. In *AT 1900–90.* Harrison, C & P.Wood. 282–7. Oxford: Blackwells 1993.
Neo–Plasticism: the General Principle of Plastic Equivalence 1920–21. In *AT 1900–90.* Harrison, C & P.Wood. 287– 90. Oxford: Blackwells 1993.
Plastic Art and Pure Plastic Art, 1937. In *AT 1900–90.* Harrison, C & P.Wood. 368–74. Oxford: Blackwells 1993.

Monsur, Abul 'The World of Abanindranath Tagore: Enigma and Relevance' LKC 38 (Mar 1993): 38-44.

Mookherjea, Sailoz [*Refer* LKA, A.S.Raman, J.Swaminathan].

Mookherjee, Ajit *Modern Art in India.* New Delhi, 1956.
From Prehistoric to Modern Times: The Arts of India. Calcutta: Oxford & IBH Publishing Co. 1966.
Tantra Asana: a way to Self Realization. New Delhi: Ravi Kumar 1971.
'Arts of Bengal – Exhibition at the Whitechapel Gallery' *LKC* 29 (Apr 1980).
'Biren De– A Short Note' *LKC* 32 (Apr 1985): 32-3. [*Refer* LKA].

Mookherjee, Ajit & Madhu Khanna *The Tantric Way.* T & H 1977.
'The Art of Abanindranath Tagore' [Trans. from Bangali by Nirmal Chandra Chattopadhyaya] Visva Bharati Q (May 1943).

Mukherjee, Benode Behari 'My Experiments with murals' [Trans. from Bengali by Ajit Kumar Dutta] *LKC* 14 (Apr 1972): 3-8.
'A Quest for Art' [Trans. from Bengali ' Silpa Jaignasa' by Modhumita Mojumdar] *AHJ* (1978-9): 26-8. [*Refer* ISOA, LKA, NGMA, G.m.Sheikh, K.G.Subramanyan].

Mukherjee, Meera *Metalcraftsmen of India*. Calcutta: Anthropological Survey of India, August 1978.

Mukherjee, Sushil G.Haloi JG ExC. 6-12 May 1993.

Mukhopadhaya, Amit 'The art situation in Bengal before 1940-The Discovery of Jamini Roy' *LKC* 32 (Apr 1985): 24-9.
'Nandalal Bose: The Helmsman' *LKC* 38 (Mar 1993): 64-9.
'The Pioneer of Modern Indian Caricature in prints' LKC 39 (Mar 1994): 17-27.

Munuswamy, L 'The Art Scene in India- As a teacher looks at it' *LKC* 37 (Mar 1991): 33-5.
'R.M.Palaniappan: Concepts- Print Making- Mixed Media'. *Cymroza Annual* (1991-2): 13-8. [*Refer* LKA].

Muroi, Hisashi 'The post-colonial body in contemporary Japanese art' *Art Asia Pacific* Q3.1 (Jan 1996): 52-7.

Murti, Isana (pseud.) Retrospective JG ExC. 1988.
Anjolie Ela Menon. New Delhi: Ravi Dayal Publications 1995.

Muther, R *The History of Modern Painting: Vol 1-3*. London: Henry & Co. 1985.

N

Nadkarni, Dnyaneshwar 'Laxman Pai - Contemporary Indian Artist 15' *Design* 2.10 (Oct 1958): 27-9.
J.A.Sabavala Gy.CH ExC. Jne 1969.
Laxman Shreshtha Gy.CH ExC. Oct 1973.
'The Art of Davierwala' LKC 10 (Sep 1969): 21-3.
'Prabhakar Barwe' *LKC* 27 (Apr 1979): 8-10.
'The Eternal Trapezoid: The Paintings of Prabhakar Kolte' *LKC* 35 (Sep 1987): 27-9.
Abhay Khatau: The World is my Canvas ExC. Nov 1991 [Note by Ramu Pandit also].
'C.Douglas: A Personal Art' The Independent 22 Oct 1992.
Gopal S.Adivrekar: A Silver Lightning... JG ExC. 1995.
R.B.Bhaskaran: The Man and the Artist Cymroza ExC. 15 Nov- 2 Dec 1995.
M.F.Husain: Riding the Lightning. Translated from Marathi by Y.Deshpande Maitra. Bombay: Ramdas Baktal for Popular Prakashan Pvt. Ltd., 1996. [*Refer* Art Heritage, Gy.CH, LKA, S.Patwardhan, Pundole].

Nagoya, Saturo 'The art least likely to sell: Rental galleries in Tokyo' *Art Asia Pacific* Q3.2 (1996).

Naidu, Reddeppa *Artrends* 3.1 & 2 (Oct. 1963- Jan 1964). [*Refer* S.Bhatt, Dhoomimal, J.James, R.Shah, A.S.Raman, The Gallery].

Nandagopal, S 'Art and Development' *LKC* 35 (Sep 1987): 5-7.
K.Ramanujam. 'Destiny's Child' *IWI* 12-13 Jan 1991.
'The Art Scene in India: As a sculptor looks at it.' *LKC* 37 (Mar 1991): 26-32.

Nandi, S.K. [Refer IIAS]

Narlikar, Jayant V. *The Primeval Universe*. Oxford: An Opus Book, O.U.P. 1988.

Nath, Aman [*Refer Art Today*, CCA, Sanskriti Pratishthan]

National Gallery, London *Spanish Still Life, from Velazquez to Goya ExC.* 22 Feb -21 May 1995.

Navjot 'Navjot: Notes' 1990. [*Refer* AH, The Gallery, Sakshi].

Nayar, Ved 'The world of Gogi' *Cymroza Annual* (1991-92): 67-8+
Indian Contemporary Art and the Emerging Face of Global Contemporary Art. In *Contemporary Indian Art: Glenbarra Art Museum Collection*. Masanori Fukuoka, ed. Hemeji: Glenbarra Japan Co. 1993.
Note on 'Mankind 2192- Despair & Hope of Kalpavriksha' proposal for an 'Installation' in the forthcoming 8th Triennale- India, 1993. [*Refer* A.R.K.S. Gallery, R.L.Bartolomew].

Neogy, Pritwish *The Art & Aesthetics of Rabindranath Tagore: A Selection of Lectures, Essays and Letters*, ed. Calcutta: Orient Longmans 1961. [*Refer* LKA].

Newman, Barnett. The First Man Was an Artist. In *AT 1900-90*. Harrison, C & P.Wood, eds. 566-9. Oxford: Blackwells 1993.
The Sublime is Now. In *AT 1900-90*. Harrison, C & P.Wood, eds. 572-4. Oxford: Blackwells 1993.

Newton, Eric 'Abstract Art' *Artrends* 2.1 (Oct.1962), supplement.

NGMA L.P.Sihare. *Selections from the Collection of the National Gallery of Modern Art,*. n.d. (c.1972).
L.P.Sihare. A Handbook of Paintings and Graphics, 1974.
L.P.Sihare. A Handbook of Bengal School, 1975.
A.Farooqi. Modern Masterpieces From The Philadelphia Museum of Art ExC. 9 Oct-30 Nov 1980.
Sankho Chaudhuri. *Ramkinkar Vaij Retrospective ExC.* 1980.
Rabindranath Tagore: Selected Works of Art ExC. Dec 1981-Jan 1982.
L.P.Sihare. German Expressionist Paintings ExC. 11 Feb-14 Mar 1982.
Nandalal Bose: Centenary ExC., 1983 [Text includes: 'The Discipline of Art' by Nandalal Bose; 'Nandalal- Master Draughtsman' by Jaya Appasamy; 'Haripura Posters' by Sankho Chaudhuri; 'Nandalal Bose: His Aesthetic Percepts and Styles, A Few Problems' by Laxmi P.Sihare].
Laxmi P.Sihare 'Contemporary Neo-Tantra Art: A Perspective'. In *Neo-Tantra: Contemporary Indian Painting inspired by Tradition*. Edith A.Tonelli & Lee Mullican, eds. 16-22. Los Angeles: Frederick S.Wight Art Gallery, University of California, 1986 [Exhibition dates: 17 Dec.1985- 2 Feb 1986; publication as part of the Festival of India in USA].
A.Farooqi. *Indian Women Artists ExC.* 1986.
Jamini Roy: Centenary Exhibition. New Delhi 1987 [Exhibition dates: 15 Apr- 17 May 1987. Text includes articles by John Irwin & Bishnu Dey, (rpt. from ISOA, 1944.) Mulk Raj Anand, Jamini Roy & D.Chattapadhyaya].
Rabindranath Tagore, 1988. [Text includes: 'Tagore's Emergence as an Artist' by Kshitis Roy, 47-54].
Indian Contemporary Art. Meguro Museum of Art, ed. Tokyo: The Yomiuri Shimbun, The Japan Association of Art Museums 1988. [Text includes essays by J.Swaminathan 'Redemption from the Labyrinth' 10-11. & Masayoshi Homma 'Contemporary Indian Art' 15-7. Publication as part of the Festival of India in Japan].
Abanindranath Tagore, 1988. [Text: BenodeBehari Mukherjee; translated from Bengali by Kshitis Roy].
A.Farooqi. *L'Art Contemporain Indien: oeuvres du Musee de New Delhi*. Paris: Ministere De L'Information Et de la culture, Palais de la Culture, 1989.
Birth and Life of Modernity. Festival of France in India ExC. 6 Feb -5 Mar 1989.
National Exposition of Contemporary Art-1991 [Text: P.N.Mago 'The Changing Art Scene' 2-5; Geeta Kapur 'Modern Painting Since 1935' 40-3. (Rpt. from *The Arts of India*. Basil Gray, ed. Oxford: Phaidon, 1981);

K.G.Subramanyan 'Modern Indian Art in the Last Three Decades' 144–5].

Festival of China: Chinese painting & Calligraphy ExC. [NGMA: Dec 4–20 1992, & YB Chavan Centre, Bombay: Jan 3–12 1993].

Indian Contemporary Art ExC. Kuala Lumpur: Galeri Petronas, Menara Dayabumi, Aug 1995.

Mukul Dey: Birth Centenary Exhibition of Intaglio and Drawings ExC. 1995 [Text: Santo Datta 'A Forgotten Pilgrim'].

Man and Nature: Reflections of Six Artists ExC. 1995 [Collaboration with INTACH (Indian National Trust for Art and Cultural Heritage). Main Text: Keshav Malik 'Man and Nature: reflections on six artists: Rabindranath Tagore, Gaganendranath Tagore, Abanindranath Tagore, Nandalal Bose, Benode Behari Mukherjee, Ramkinker Vaij'].

The Other Self ExC. [NGMA: 9 Dec.1995– 9 Jan 1996 & The Stedelijk Museum Bureau, Amsterdam, Netherlands: 18 May– 23 Jne 1996. Artists included: Rob Birza, Bhupen Khakhar, Bastienne Kramer, Mrinalini Mukherjee, N.N.Rimzon, Berend Strik. Text includes articles by Els Reynders, Ashis Nandy and various interviews.].

Nicholson, Ben Notes on Abstract Art, 1941. In *AT 1900–90.* Harrison, C & P.Wood, ed. 380–2. Oxford: Blackwells 1993.

Nigam, Akhilesh Jamini Roy: perspective of Indian folk consciousness and his influence on Modern Art. 81–5. In *Jamini Roy.* 81–5. LKA 1992.

Nigam, R.C. 'Indian Art in Retrospect: Jamini Roy' *Bombay Art Society's Art Journal* 1.4 (Jly 1972): 13–4.

Nikam, N.A. *Ten Principal Upanisads: Some Fundamental Ideas, A Dialectical & Analytical Study.* Bombay: Somaiya Publications Pvt.Ltd. 1974.

Nissen, Foy 'V.S.Gaitonde: Contemporary Indian Artists–8' *Design* 2.2 (Feb 1958): 16–27+

OP

Orpen, Sir William *The Outline of Art,* ed. George Newnes, London, n.d.

Overy, Paul Vorticism. In *Concepts of Modern Art.* N.Stangos, ed. 106–9. T & H 1991.

Owens, Craig from 'The Allegorical Impulse: Towards a Theory of Postmodernism'. In *AT 1900–90.* Harrison, C & P.Wood, eds. 1051–60. Oxford: Blackwells 1993.

Padamsee, Akbar *SYZYGY:* Jawaharlal Nehru Fellowship Project, 1969–70. Bombay: Limited edition, n.d.
AHJ 4 (1984–85): 75–8.
'My Art: Padamsee' IWI 11–17 Sep 1993. [*Refer* E.Datta, R.Hoskote, K.Kapoor, G.Kapur, M.Marwah, P.Karunakar, Kunika–CH, Pundole, Shamlal].

Pai, Laxman 'Musical Moods' *Marg* 8.1 (Dec 1954): 32–3.
St.George's Gallery ExC. London, Jne 1959.
Retrospective: 1947–87 ExC. Kala Academy For Goa Daman and Diu, 1987.
Retrospective LKA ExC. 3–10 Jan 1989.
'The Art Scene in India: As a painter looks at it' *LKC* 37 (Mar 1991): 24–5. [*Refer* Dhoomimal, Jagmohan, S.A.Krishnan, D.Nadkarni, M.Sardessai].

Pal, Gogi Saroj [*Refer* Aberystwyth Arts Centre, R.L.Bartolomew, A.R.K.S.Gallery, ART Today, V.Kumar, V.Nayar, P.Shukla].

Palaniappan, R.M. *AHJ* 4 (1984–5): 33–6. [*Refer* G.Doctor, J.James, L.Munuswamy].

Palsikar, S.B. *Marg* 7.2 (Mar 1954): 37–40.
'Thoughts on Tantra' *LKC* 12–13 (Apr–Sep 1971):
Vasant Avaresekar. Memorial Exhibition JG ExC 20–26 Dec 1984. [*Refer* P.Kolte].

Pande, Purnima 'A Reassessment of The Bengal School in the Contemporary Context' *LKC* 38 (Mar 1993): 27–37.

Panikkar, Shivaji K. 'Rekha Rodwittiya: Insurected and the Resurrected Female Icons' *the India Magazine* 12.11 (Oct 1992): 6–13.
'Printmaking in Western India' *LKC* 39 (Mar 1994): 29–39.
'The Political meanings and the Linguistic Options in Modern India Art: A Synoptic View' Paper presented at the NCPA Mohile–Parekh Centre Conference, 5–8 Jan 1994.

Paniker, K.C.S Cholamandal. *Artrends* 5.4 & 6.1 (Jly–Oct.1966).
'Artrends' Vol.IV, No. 2 & 3 Jan–Apr 1965.
'Editorial' *LKC* 5 (Sep 1966).
'The artist on art, some thoughts' *LKC* 5 (Sep 1966).
'Contemporary Painters and Metaphysical Elements in the Art of the past' *LKC* 12–13 (Apr–Sep 1971): 11–2. [*Refer* M.Anantanarayanan, S.Dutta, A.Farooqi, J.James, LKA].

Pannalal 'Majumdar's "Ras-Lila"' *Rupam* 5 (Jan 1921): 23–4.

Parekh, Madhvi [*Refer* Aberystwyth Arts Centre, A.Contractor, Dhoomimal, G.Kapur, M. Marwah, Sakshi, Seagull].

Parekh, Manu ABC Academy, Varanasi ExC. 7–18 Apr 1993 [Note by Satish Gujral & artist]
'A Picture of Success: Manu Parekh' Habitat– Financial Express, 30 Jan 1996. [*Refer* E.Datta, Dhoomimal, S.A.Krishnan, Seagull, SOCA, Vadehra]

Parekh, Jayantilal 'Cochin Murals' *LKC* 32 (Apr 1985): 30–1.

Parikh, Shaila 'Indian Artists At Menton Biennale' *IWI* 17 Oct 1976.

Parimoo, Ratan 'Words and Paint: an essay on 20th century Indian art' *Design* 8.1 (Dec 1964).
'Baroda painters and sculptors – a school and a movement' *LKC* 4 (Apr 1966): 13–8.
'Review of Husain: Introduction and analytical notes by Geeta Kapoor (sic). Sadanga Series, Vakil & Sons (P) Ltd.' *LKC* 10 (Sep 1969): 41.
'Picasso's Guernica' *LKC* 14 (Apr 1972): 33.
'Cubist Influence on modern Indian painting' The Times of India, 23 Jly 1972.
'Modern Mexican Painters as Muralists' *LKC* 14 (Apr 1972): 34–6.
The paintings of the three Tagores– Abanindranath, Gaganendranath, and Rabindranath: Chronology and Comparative Study. Baroda: M.S.University Baroda 1973.
Studies in modern Indian art: a collection of essays. (SIMA) New Delhi: Kanak Publications 1975. [Includes: 'Sociological and Formal Problems of modern Indian art' 1–13; 'Tantric trend in contemporary Indian painting' 76–81; 'The struggle for image in contemporary art' 82–6; 'New trends in figurative painting' 87–104].
'New Sculpture from Baroda' *LKC* 28 (Sep 1979): 29–33.
'Paintings & Sketches of Nandalal Bose' *Marg* 36.2 (n.d., c.1983): 5–20.
J.Shivpuri 'A world without horizons– paintings of R. Parimoo' *LKC* 29 (Apr 1980):
'Profile of a Pioneer – N.S. Bendre' *LKC* 37 (Mar 1991): 72–86.
'Revivalism, Indigenous factors, or Modern Indian Art– Reconsidered in the context of Post Modernism' *LKC* 38 (Mar 1993): 7–18.
'Somnath Hore & His Times' A Paper presented at the NCPA Mohile–Parekh Centre, Jan 1994. [*Refer* J.Appasamy, LKA].

R.Parimoo, ed. *Rabindranath Tagore: Collection of Essays.* LKA 1989. [Includes essays by P.Neogy, R.Tagore, S.Kramrisch, K.G.Subramanyan, R.Parimoo, D.Kowshik, S.Sarkar & J.Shivpuri].

Parmar, Magan Soma [*Refer* K.G.Subramanyan].

Parthan, Baiju Om Prakash. Baiju Parthan: Measurement-Value-Meaning, Chaze Art Gallery, Margao, Goa ExC. 29–12 Apr 1996 [Text also includes a conversation with the artist. Exhibition curated by The Goan Art Forum] 'The Eureka Experience' The Sunday Review 26 May 1996.

Patankar, R.B. 'Aesthetics: Some Important Problems' *JAI* 6 (Jan–Mar 1984): 43–66.

Patel, Gieve *AHJ* (1979–80): 15–7.
'Indian Contemporary Painting' *Daedalus Journal of the American Academy of Arts & Sciences* (Fall 1989): 171–205.
'Poems' *Aspect Journal:* India Issue. Ulli Beier, ed. (Jan 1982): 20–5.
'S.Patwardhan'. Bombay: Sunday Observer 30 Dec 1984.
Contemporary Indian Painting. In *Contemporary Indian Painting.* New York: Grey Art Gallery 1988.
Looking into a Well Gy.CH ExC. 15 Dec–15 Jan 1996. [*Refer* Gy.CH, M.Marwah, G.Kapur, R.Parimoo (*SIMA*, 1975), Pundole, G.m.Sheikh].

Patel, Jeram [*Refer*: R.L.Bartolomew, Dhoomimal, K.B.Goel, N.Joshi, Marg, G.m.Sheikh, P.Shukla, J.Swaminathan].

Patwardhan, Sudhir *AHJ* (1978–9): 73–5 [Includes Note by artist and D.Nadkarni].
'Near & Far', Nov 1985. Centre Georges Pompidou Centre Paris ExC. 5 Mar–11 May 1986.
Kamala Kapoor. JG ExC. 19–25 Nov 1992. [*Refer* Gy.CH, JG, G.Kapur, G.Patel, A.Rajadhayaksha].

Pearman, Hugh 'Flights of Fancy: John Outram' London: Sunday Times 7 Jan 1996.

Peeradina, S 'Laxman Shreshtha' *Bombay Art Society Art Journal* 1982.

Picasso, Pablo Tate Gallery ExC. 6 Jly–18 Sep 1960 London: The Arts Council of Great Britain. [Introduction by Roland Penrose].
Picasso Speaks, 1923. In AT 1900–90. Harrison, C & Paul Wood, eds. Oxford: Blackwells 1993. [*Refer*: Indo F.Walhter].

Pochkhanawalla, Pilloo Pilloo Pochkhanwalla: sculptures, JG ExC. 20–26 Jan 1973.
Nikky Ty-Tomkins Seth. Pilloo 84: Pochkhanawala– a retrospective 1952–1984 Gy.CH ExC.1984.
The Sculpted Image BAAC ExC. 15–30 Nov 1987. [*Refer*: LKA].

Poshyananda, Apinan 'Yellow Face, White Gaze: The Asia Society Asia/America Show *Art & Asia Pacific* Q2.1 (Jan 1995): 30–1.
'Smile-a-while campaigns for cultural correctness' *Art & Asia Pacific* Q2.3 (Jly 1995): 34–41.

Prasad, Usha *Indian Painting: A Romance* New Delhi: Agam Prakashan, 1977.
'Indian Tradition Continues' *LKC* 28 (Sep 1979): 58–60.

Prasher, H.L. 'Views on the 4th Annual Art exhibition of Lalit Kala Akademi' *Design* 2.3 (Mar 1958).

Prithvi Gallery, Bombay Sumitra K.Srinivasan. Laxman Shreshtha ExC. 4–27 Nov 1994.

Pundole (Pundole Art Gallery, Bombay) (Miscellaneous).
Akbar Padamsee ExC. Nov 1972.
K.G.Subramanyn. Sanat Kar Apr 1988.
M.Vignoht. Sakti Burman ExC. 1990.
Shamsad Husain: Works on Canvas ExC. 21 Nov– 7 Dec 1991.
Ambadas. Pundole ExC. 19 Dec 1991–4 Jan 1992.
Ranjit Hoskote 'Notations for a Landscape' Ramkumar ExC. 11–30 May 1992.
Roshan Shahani 'Continuities Animated...' Padamsee-Chowdhury-Shreshtha ExC. 7–26 Dec 1992.
Gieve Patel, 1993. Akbar Padamsee: Watercolours 1992 ExC. 7–23 Feb 1993.
Badrinarayan: Watercolours ExC. 1993.
D.Nadkarni. Sakti Burman: Oils & Watercolours Pundole ExC. 15–31 Dec. 1994.
Akbar Padamsee: Mirror Images ExC. 21 Nov–9 Dec 1994. [Text: artist as told to Meher Pestonji].
Mithuna, London ExC. 20–28 Oct.1995 [Exhibition in collaboration with M.Desai & F.Rossi].

Puri, Rakshat Biren De. Thought 14 Dec 1952.
Identifying the Abstract in Abstract Art'. In *AIFACS Regional Centre (Haryana), Inaugural Art ExC.* New Delhi 1995.

Purohit, Vinayak 'Shiavix Chavda' *Design* 2.1 (Jan 1958).
'M.F. Hussain – Contemporary Indian Artists 9' *Design* 2.3 (Mar 1958): 18–20.
'K.K.Hebbar – Contemporary Indian Artists 12' *Design* 2.6 (Jne 1958): 13–5.
'S.B.Palsikar' *Design* 2.8 (Aug 1958).
'Baroda School of Art' *Design* 2.11 (Nov 1958): 24–6.
'Jehangir A. Sabavala – Contemporary Indian Artists 17' *Design* 2.11 (Nov 1958): 32–3.
'Ram Kinkar– Contemporary Indian Artists' *Design* 3.5 (May 1959): 26–8.
'S.H.Raza–Contemporary Indian Artists' *Design* 3.6 (Jne 1959): 22–3.
'Jyoti Bhatt' *Design* 7.4 (Apr 1963): 29–30.
'F.N.Souza' *Design* 7.5 (May 1963): 30–2.

Pyne, Ganesh 'Interview' Bombay: Economic Times Oct 1993. [*Refer* A.Banerjee, R.P.Gupta, The Village Gallery].

QR

Qadri, Sohan [*Refer* B.N.Goswamy].

RPG Enterprises Publications Bombay JG ExC. 1996.

Rai, Mona [*Refer* Espace, Sakshi, G.Sinha].

Rajadhayaksha, Ashish 'Sudhir Patwardhan: The Redemption of the Physical' *AHJ* 9 (1989–90): 4–9+.
'On Mueller's Medea' Heiner Mueller's Medea, Bombay: Max Mueller Bhavan ExC. [Performance by Alaknanda Samarth and installation by Nalini Malani].
Memorial : an installation with photographs and sculpture, Vivan Sundaram ExC. [AIFACS: 2–20 Dec 1993 & Sakshi, Melange Art & Design Centre: 11 Feb–3 Mar 1996] [*Refer* Sakshi, Venkatappa Art Gallery].

Ramachandran, A 'Notes from the Underground' *AHJ* 6 (1986–87): 23–5+
'Raja Ravi Varma Exhibition: A Prologue. In *Raja Ravi Varma: New Perspectives.* R.C.Sharma, ed. 13–23. New Delhi: National Museum 1993. [*Refer*: E.Alkazi, ed. J.Appasamy, A.R.K.S Gallery, R.L.Bartolomew, K.Chaitanya, R.Chawla, C.Fabri, S.Hanfi, Kumar Gallery, The Statesman, The Village Gallery].

Ramachandran, K.N. Srinivasulu. *Artrends* 1.3 (Apr 1962).
L.Munuswamy. *Artrends* 5.4 & 6.1 (Jly–Oct 1966).

Ramakrishna *The Gospel of Sri Ramakrishna.* Trans: Swami Nikhilananda.
 Mylapore, Madras: Sri Ramakrishna Math 1969.

Ramakrishnan, S 'R.B.Bhaskaran: A Thrust into Media Opportunities'. LKC
 27 (Apr 1979): 27–8.

Raman, A.S. *Sailoz Mookherjea.* New Delhi: Dhoomi Mal Dharam Das 1952.
Biren De– Younger Contemporaries IX' Times of India 29 Mar 1953.
'The Art of Husain'. IWI 1955. Rpt. in *The Critical Vision.* 8-9. LKA 1993.
'Some Younger Indian Painters' London: *Studio* (Mar 1956): 66–73.
'The Art of Bendre' IWI 1 Dec 1957.
'Sailoz Mookherjea: A Memory' IWI 1964. Rpt. in *The Critical Vision.* 28-31.
 LKA 1993.
'How Modern is Indian Art?' Contemporary Review 1971.
'Interview with N.S. Bendre' Sunday Standard, 1980. Rpt. in *The Critical
 Vision.* 59-63. LKA 1993.
'Interview with K.K. Hebbar' Sunday Standard, 1980. Rpt. in *ibid* 64-6.
'Interview with N. Mazumdar' Sunday Standard, 1980. Rpt. in *ibid* 67-72.
'Land beyond the canvas' Times of India, 1980. Rpt. in *ibid* 146-9.
'The life and death of an artist' Times of India 1981.
'K.H.Ara– The true story of an aesthetic innocent' Bombay: Times of India,
 1985. Rpt. in *The Critical Vision.* 104-7. LKA 1993.
Reddeppa Naidu. Dhoomimal ExC. 1990.
S.A.Krishnan LKC 34 (Jan 1987): 60-4. [*Refer* LKA, P.T.Reddy].

Ramanujam, K [*Refer* Indian Express, J.James, K.Johnson, J.Sultan Ali].

Ramkumar [*Refer* R.L.Bartolomew, Chitrakoot, Gallery Chanakya, Gy.CH,
 Kumar Gallery, LKA, Pundole, The Times of India, N.Verma, Vadehra].

Ramsden, E.H. *Introduction to Modern Art.* London: OUP 1940.

Randhawa, M.S. 'The Art of Nicholas Roerich' *LKC* 18 (Sep 1974): 3–5.

Rao, P.R.Ramachandra [D.P.Roy] *Chowdhury and his Art*, ed. Bombay: New
 Book Co, 1943. [Includes articles by: S.Radhakrishnan, Bireshwar Sen,
 Roop Krishna, M.C.Dey, A.K. Haldar, N.Bose, K. Khandalavala].
Modern Indian Painting Madras: Rachana 1953.

Rawson, Philip 'Art Now in India: Contemporary Indian Art Exhibition in
 Newcastle' *LKC* 5 (Sep 1966): 28-9.
'Interview' text: S.A.Krishnan *LKC* 26 (Sep 1978): 7-13.
'A Continuous Conversation' *LKC* 33 (Dec 1985): 19-21.

Raval, R.D. 'R.D.Raval – Contemporary Indian Artists 14' *Design* Sep 1958.

Ray, Anandjit [*Refer* Sakshi].

Ray, Pranabranjan 'Art Chronicle: Calcutta' LKC 2 (Dec 1964): 50-1.
'Early Graphic Arts in Bengal' *LKC* 18 (Sep 1974): 16–22.
'Letter to Editor' *LKC* 21 (Apr 1976): 41-2.
'Shyamal Dutta Ray– Exhibition Review' *LKC* 23 (Apr 1977): 39.
'To carry the roots in the veins' *LKC* 24–25 (Sep 1977–Apr 1978): 8-15.
'Husain on Motherland' *LKC* 31 (Apr 1981).
'Art Criticism–Why?' Paper Presented at IIC Symposium, New Delhi. 4 Sep 1993.
'Introductory Notes for a General Theory of Cultural Traffic'. Paper Presented
 at NCPA Mohile–Parekh Centre Conference on 'Local/Global: International
 Trends in Contemporary Arts of Asia', Bombay 5–8 Jan 1994. [*Refer* Art
 Today, BAAC, CIMA, Cymroza, Dhoomimal].

Raza, Syed Haider [Refer Gy.CH, LKA, Marg, V.Purohit, G.Sen,
 G.Venkatachalam, R. von Leyden, G.Waldemar].

Read, Herbet *Contemporary British Art* London: Penguin Books, 1951.

'Development in the Arts' LKC 7–8 (Sep 1977–Apr 1978).

Reddy, N. Krishna 'Artist on Art: Media versus Expression' *LKC* 11 (Apr
 1970): 22–5.
'This fascinating Universe Within Us' *LKC* 37 (Mar 1991): 67–71. [*Refer*
 V.Amberakar, R.L.Bartolomew, Espace, Gy.CH, S.W.Hayter, P.Heilman, LKA
 The Asian Age].

Reddy, P.T. *40 Years of P.T. Reddy.* Hyderabad: Andhra Pradesh Council of
 Artists 1982. [Essays included by A.S.Raman, P.T.Reddy, R.L.Bartholomew,
 Keshav Malik & S.A.Krishnan] [*Refer* C.R.Gerard, K.L.Kaul, LKA, K.Malik].

Reichardt, Jasia Op Art. In *Concepts of modern art.* N.Stangos, ed. 239–43.
 T & H 1991.

Reynolds, Juliet 'Problems of Identity: The Colonial Context' *LKC* 30 (Sep
 1980): 7-12.
'Anil Karanjia: A Journey Towards a Synthesis' *AHJ* 11 (1991–2): 17-20.

Richter, Gerhard from 'Interview with Benjamin Buchloh'. In *AT 1900–90.*
 Harrison, C & P.Wood, eds. 1036–47. Oxford: Blackwells 1993.

Rilke, Rainer Maria *Letters on Cezanne.* Clara Rilke, ed. Trans. from German
 by Joel Agee. London: Jonathan Cape 1988. Reprint Vintage 1991.

Rimzon, N.N. 'The Artist as Exile' *AHJ* 10 (1990–1): 21–23. [*Refer* Business
 Standard, V.Lynn].

Rodwittiya, Rekha 'Metaphorical Bridges' *AHJ* 9 (1989–90): 17-23.
'In Conversation with my Audience' Cymroza ExC.17 Mar–3 Apr 1993.
'One Full Circle'. Rekha Rodwittiya: Recent Works– Shades of Red Sakshi
 ExC. 1996. [*Refer* P.de Francia, Eicher Gallery, S.K.Pannikar].

Roerich, Nicholas B.C.Sanyal Roerich's The Concept of Art. In ...
Mulk Raj Anand Roerich: the man. In ...
Suniti Kumar Chatterji Roerich as I knew him. In ...
B.N.Goswamy Roerich's Mountains. In ... [*Refer* LKA M.S.Randhawa]

Roland, Benjamin *The Art & Architecture of India: Buddhist, Hindu, Jain.*
 Melbourne: Penguin 1953.

Rothko, Mark 'The Romantics were Prompted...' In *AT 1900–90.* Harrison,
 C & P.Wood, eds. 563–4. Oxford: Blackwells 1993.

Rouault Pierre Courthion. Edinburgh International Festival: T & H 1966.

Roy, Ira [*Refer* Art Heritage].

Roy, Kshitis [*Refer* NGMA].

Roy, Jamini [*Refer* B.Dey & J.Irwin, LKA, A.Mukhopadhyay, NGMA,
 S.Suhrawardy].

Roy, Pabitra Kumar *Beauty Art & Man: Studies in Recent Indian Theories of
 Art.* Simla: IIAS in association with Mushiram Manoharlal Publishers Pvt.
 Ltd., New Delhi 1990.

Roy, Suhas [*Refer* JG (1987) D.Kowshik].

Rughani, Pratap 'Taking Positions: Hindutva versus art' *the India Magazine*
 16 (Jan 1996).

Russell, Martin 'Work of George Keyt' *Marg* 1.3 (1947): 44-5+
George Keyt. Bombay: Marg Publications 1950.

S

Sabavala, Jehangir A. *Sabavala.* Introduction and analytical notes by S.V.Vasudev. Bombay: Sadanga Series, Vakil & Sons 1966.
'Contemporary artists of Repute' *Bombay Art Society Art Journal* 1971. *AHJ* (1979–80): 12–4.
The Reasoning Vision: J. Sabavala's Painterly Universe Bombay: Tata McGraw Hill 1980.
'The influence of the environment on the artist' *LKC* 33 (Dec 1985): 12–8. [*Refer* R.Chatterjee, Chitra, K.Kapoor, R.Hoskote, LKA, D.Nadkarni, V.Purohit].

Sachdev, Arun [*Refer* Gallery 7].

Sadanga Series [*Refer* H.A.Gade, M.F.Husain, A.Padamsee, S.H.Raza, J.A.Sabavala].

Sakshi Gallery, Bombay
Vasuda Thozdhur: Paintings and Drawings ExC. 1989–90.
Belinder Bhanoa. Vasuda Thozdhur ExC. 1990.
Badrinarayan ExC. 23 Feb–9 Feb 1991.
Mona Rai ExC. 18 Feb–3 Mar 1991.
Anahite Contractor. Madhvi Parekh ExC. 1991.
Rini Dhumal ExC. 1991.
Achuthan Kudallur ExC. 1991.
Ashish Rajadhyaksha. 'The City of Desires'. Nalini Malani: Hieroglyphs & Other Works, Painted Books.
Vivan Sundaram: Installations with Engine Oil and Charcoal, ExC. 1991–2.
Journeys within Landscapes ExC. [JG: 21–28 Jan 1992].
R.Sivakumar. K.G.Subramanyan ExC.1992.
C.Douglas: Mixed Media Works 1991–2 ExC. 1992.
Navjot & Altaf ExC. 1992–3.
Anandjit Ray: Works on Paper ExC. 1993.
Uma Vasudevan. Achuthan Kudallur: Paintings ExC. 1993.
Amithava Das: Works on Paper from 1972–1994 ExC. 1994 [Joint Show with Eicher Gallery: 10 Dec–7 Jan 1994].
Altaf ExC. 1992–1994. [Touring Exhibition at Madras & Bangalore: Sakshi Gallery & JG].
Roshan Shahni 'Wind from the Mosquito's Wings'. Vasudevan Akkitham ExC. 1993–4.
K.G.S. ExC.5–22 Jan 1994.
Vilas Shinde ExC. 5–25 Oct 1995.
Rani Bains. Binod Sharma ExC 1995–6.

Samant, Mohan 'Artist of the Year' *Bombay Art Society Art Journal* 1964. [*Refer* Gy.CH, *Time* magazine].

Sambrani, Chaitanya [*Refer* P.Barwe, Gy.CH, The Asian Age].

Sangari, K. K. 'Journeys' Vivan Sundaram: Soft Pastels on paper, Kala Yatra Sista Gallery ExC.16–31 Jan 1988.

Sankaracarya *Brahma Sutra Bhasya of Sankaracarya.* Trans. Swami Gambhirananda. Mayavati: Advaita Ashrama, Swami Ananyananda Apr 1983.

Sangari, KumKum 'The Changing Text' *JAI* 8 (Jly–Sep 1984): 61–76.

Sanskriti Pratishthan Aman Nath. Indian Eclectics: Some New Sensibilities in Contemporary Art ExC. New Delhi: Sanskriti Pratishthan, in collaboration with the Festival of France in India, 1989 [RB.LKA: 5–13 Oct 1989]. Sanat Kar ExC. 17–26 Jan 1992.

Santhanaraj, A *Artrends* 2.2 (Jan 1963). [*Refer* J.James].

Santosh, G. R. 'Tanmum Trayate iti Tantrah', New Delhi: Private Publication 1978.
'Art Is Sublimation' *Aspect Journal: India Issue.* Ulli Beier, ed. (Jan 1982): 45–8. [*Refer* Business Standard, Dhoomimal, Kumar Gallery, P.N.Mago, S.A.Krishnan].

Sanyal, B.C. A Selection of 22 Paintings of the decade 1965–75, JG ExC. 26 Dec 1975–1 Jan 1976.
'The fourth Documenta' *LKC* 9 (Sep 1968): 42–4.
'Art Education in India, its Relevance to Contemporary Art and some Discernable Trends' *Bombay Art Society Art Journal* 1982.
'Triennale' *LKC* 36 (Sep 1990): 96.
Jharokha Gallery ExC. 4–25 Jan 1994. [*Refer* J.Appasamy, Art Heritage, LKA].

Sardessai, Manoharrai 'The Genius of Laxman Pai' *Goa Today* (May 1987): 46–9.

Sarkar, Benoy Kumar 'Tendencies of Indian art: A Review' *Rupam Journal* 26 (Jan 1927): 55–8.

Sarkar, S & Chowdhury, D 'Calcutta Printmakers' ExC. 1978–9.

Sarkar, Sandip 'Nirode Mazumdar: A Solitude for Painting' *LKC* 22 (Sep 1976): 7–9.
'The art born of crisis' *LKC* 29 (Apr 1980): 22–5.
'The art lesson of Crisis' *LKC* 29 (Apr 1980).
'Problems of Identity: Historical Perspective' *LKC* 30 (Sep 1980): 3–7.
'The Tribal World of Rabin Mondal' *AHJ* 7 (1987–8): 11–19.
'Two Young Women Artists: Jaya Ganguly & Jayashree Chakravarty' *AHJ* 7 (1987–8): 44–56.

Scharf, Aaron Suprematism. In *Concepts of modern art.* N.Stangos, ed. 138–40. T & H 1991.
Constructivism. In *Concepts of modern art.* N.Stangos, ed. 160–8. T & H 1991.

Schavoir, H 'Feeling and Seeing: The Painting of C.Douglas'. LKC 35 (Sep 1987): 31.

Schier, Flint Painting after Art?: Comments on Wollheim. In *AT 1900–90.* Harrison, C & P.Wood, eds. 1111–6. Oxford: Blackwells 1993.

Schneede, Uwe M. *Surrealism.* Trans: Maria Pelikan. NewYork: H.N.Abrahms 1973.

Schoo, E.M. The Amabassador's Choice: Contemporary Indian Art From the Collection of H.E.Mrs.E.M.Schoo, NGMA ExC. 1–14 Dec.1990.
Nine Contemporary Indian Artists ExC. E.M.Schoo, ed. Arnhem: Municipal Museum & Amsterdam: Lotus Gallery 1991.

Seagull Publications & Seagull Foundation for the Arts
Anjum Katyal. Manu Parekh: Without Within ExC. [Touring Exhibition. Vadehra: 11–30 Sep 1992; RB.LKA: 17–30 Sep 1992. (This half presented in collaboration with Vadehra. Sukh Sagar, Calcutta: 16–25 Oct 1992 & JG: 11–18 Nov 1992].
Jogen Chowdhury 'On Drawings'. In *Drawings 1959–94 ExC.* [The Exhibitions were jointly presented by Seagull with Vadehra & Sakshi. Text includes Jogen Chowdhury's diary entries: 11 Apr 1969–21 Nov 1993. (trans from Bengali: Samik Bandyopadhyay)].
Madhvi Parekh: Fables of Everyday Life ExC. Bombay, Calcutta & Delhi, Nov 1993–Jan 1994. [Exhibition presented in Bombay & Calcutta by Seagull, and by Vadehra & Seagull in New Delhi].
Manu Parekh ExC. 1995. [Exhibition presented in Delhi by LKA & Seagull at RB.LKA: 1–8 Nov 1995 & in Bombay by Seagull, at JG: 15–22 Nov 1995] [*Refer* S.Hore, R.Sivakumar, K.G.Subramanyan].

Sen, Geeti 'The relation of tradition to contemporary Sculpture' LKC 23 (Apr 1977).
Raza Anthology 1980–90. Bombay: Chemould Publications, 1990.
'Is the critic obsolete? A strategy for survival.' A paper presented at the IIC Symposium 4 Sep 1993.
Image and Imagination: Five Contemporary Artists in India. Ahmedabad: Mapin Publishers Pvt.Ltd. 1996.
[Artists included: Meera Mukherjee, Arpita Singh, Jogen Chowdhury, Manjit Bawa & Ganesh Pyne] [*Refer* LKA, S.H.Raza].

Sen, Paritosh 'Reflections' *LKC* 9 (Sep 1968): 32–3.
'The figure in Indian Art' *LKC* 17 (Apr 1974): 7–12.
Veena Bhargava. *AHJ* 1 (1981–2): n.p.
'Triennale' *LKC* 36 (Sep 1990): 99. [*Refer* Cymroza, R.P.Gupta, JG, LKA, The Village Gallery].

Sen, Sunil Madhav 'Sunil Madhev Sen' *LKC* 5 (Sep 1966).
The Art of Sunil Madhav Sen Calcutta & New Delhi: Oxford Book and Stationary Co. 1971.

Sengupta, Kajal [*Refer* Art Heritage, Cymroza, Espace].

Sengupta, Ratnottama 'Caught between the easel and the bank' Sunday Times of India 11 Jne 1995.
'Arpana Caur: Stream of Duality'. Sunday Times of India Oct 1993.

Shah, Haku 'Folk Myth & Tribal Magic: Some aspects of folk and tribal art of Gujarat' Comp: E.Alkazi. *AHJ* (1978–9): 29–36.

Shah, Himmat [*Refer* J.Appasamy, Art Heritage, P.Shukla, S.Sinha].

Shahani, Kumar 'The Present Sky' Vivan Sundaram ExC. 1985–6. [Shridharani Gallery: 17–30 Dec 1985 & JG: 20–26 Jan 1986].

Shahani, Roshan 'Anjana Mehra, Navjot and Shakuntala Kulkarni' Shridharani Gallery ExC. Nov 1990.
Nasreen Mohammedi Photographs Gy.CH ExC. [JG: 9–15 May 1991 & Gy.CH: 9–22 May 1991].
'C.Douglas: Teasing Ambiguities' Times of India, 29 Oct 1992.
'Anjana Mehra: Observation as Ritual' Sunday Times of India 15 Nov 1992.
'Art Criticism: A Mode of Writing' Paper presented at the IIC Symposium, New Delhi 4 Sep 1993.
'Invoking a Sense of Touch: on the recent works of Rekha Rodwittiya & S.G.Vasudev' Times of India 2 Apr 1993.
Fire in the Wind. In *Tyeb Mehta's Celebration Times Bank–Vadehra ExC*. 14 Feb–2 Mar 1996.
'Postmodernism under the microscope' Sunday Times of India, Bombay 3 Mar 1996. [*Refer* Art Heritage, Pundole, Sakshi, Vadehra].

Shamlal Contemporary Indian Art. *Times of India Annual*, 1961. 29–40.
Padamsee. Bombay: Sadanga Series. Vakil & Sons 1964. [*Refer* Gy.CH, LKA].

Sharma, Om Prakash Art in Art New Delhi: Abhinav Publication 1994.

Sharma, R.C., ed. *Raja Ravi Varma: New Perspectives ExC*. R.Chawla, Associate ed. New Delhi: National Museum 1993. [Exhibition of Paintings, Drawings, watercolours & Oleographs from Sri Chitra Art Gallery, Thirvuananthapuram, Kerala, NGMA (New Delhi) & Private Collections. Text includes essays by: K.Chaitanya, R.Chawla, T.Guha–Thakurta, P.Mitter, A.Ramachandran & others.].

Sharma, Vijay Shankara [*Refer* Gy.CH].

Shastri, Archana 'Moments of Isolation: The artist reflects on her works'

AHJ 11 (1991–2): 53–4+
'As a Panoramic Landscape' *AHJ* 14 (1994–5): 169–70+

Shaw, Lalu Prasad *AHJ* 3 (1983–4): 77–9. [*Refer* CIMA, P.Ray].

Sheikh, Gulam mohammed
Jeram Patel's Recent Drawings, New Delhi: Shridharani Gallery ExC. Oct 1968.
Publisher & Joint Editor with Bhupen Khakhar *Vrishchik* [Estb.: Mar 1970].
'Some Regional Graphic Centres– Baroda' *LKC* 18 (Sep 1974): 45–8.
B.B.Mukherjee. LKC 23 (Apr 1977): 45–8.
K.G.Subramanyan *AHJ* (1978–9): 64–6.
G.m.Sheikh *Laxma Goud*. Andhra Pradesh: Lalit Kala Akademi 1979.
'Returning Home' *Aspect: India Issue*. U.Beier, ed. (Jan 1982): 62–8.
Returning Home: Exhibition of Paintings 1968–85, Centre Georges Pompidou, Musee national d'art moderne, Paris. ExC. 10 Sep –11 November 1985. [Text includes conversation with Gieve Patel 'Through Art to Life'; article by Timothy Hyman 'Sheikh's One Picture' and an excerpt from 'Returning Home', a series of essays in Gujarati, translated by Mala Marwah & G.m.Sheikh].
G.m.Sheikh 'Letter to a friend: (J.Swaminathan) May 1994' The Economic Times 28 Jne 1994. Rpt. in JAI 27–28 (Mar 1995): 141–6. [*Refer* Art Heritage, U.Beier, G.Kapur, P.Shukla, V.Sundaram].

Sheikh, Nilima 'The Exotic and the Ambiguous: Some Recurrent Tendencies in Modern Indian Painting' *Vrishchik* 4.1 (Mar 1973). [*Refer* Espace, Vadehra].

Sher–Gil, Amrita 'The Evolution of my Art' 1935. Rpt. *Amrita Sher–Gil*. Bombay: Marg Publications 1972.
'Indian Art Today'. Rpt. *ibid*.
'Trends of Art in India' Rpt. *ibid*.
'Art and Appreciation' Rpt. *ibid*.
'Letters of Amrita Sher Gil'. Rpt. *ibid*. [*Refer* K.B.Goel, G.Kapur, K.Khandalavala, K.Malik, NGMA, V.Sundaram et al].

Shih, J.J. 'From anguish to irony: The Chinese identity complex in Taiwanese art' Art & Asia Pacific Q2.3 (Jan 1995): 88–95.

Shimizu, Toshio. 'Japan–Asian Modernism: A Major historical survey exhibition in Tokyo' Art Asia Pacific Q3.2 (1996): 30–1.

Shinde, Deepak JG ExC.20–28 Jan 1992.

Shivpuri, J 'A world without horizons: The paintings of Ratan Parimoo' LKC 29 (Apr 1980). [*Refer* NGMA].

Sholapurkar, V.M. 'Sir J.J.School of Art: The neglect of a precious gift' Free Press Journal, 21 Aug 1980.

Shreshtha, Laxman [*Refer* Gy.CH, K.Kapoor, S.Peeradina, Prithvi Gallery].

Shukla, Prayag 'The Question of Social Content: Four Artists' Trans from Hindi: Mala Marwah. [Artists include: Jeram Patel, G.m.Sheikh, Tyeb Mehta & Himmat Shah] LKC 24–25 (Sep 1977–Apr 1978): 42–5.
'Gogi Saroj Pal' AHJ (1981–2): n.p.
'Himmat Shah: The Sculptor as Poet' *AHJ* 9 (1989–90): 33–5.
Drawing'94, ed. & text essay. New Delhi: Gallery Espace Publication 1994.
'The Act of sculpting Has to be Fulfilled: A Dialogue with Sankho Chaudhuri' In *Sculpture'95*. New Delhi: Gallery Espace Publication 1995.
'Few Glimpses of the Vast Repository of Drawing' . In *AIFACS Regional Centre (Haryana), Inaugural Art ExC*. New Delhi 1995. [*Refer* AIFACS, Art Heritage, Dhoomimal, Espace].

Shuvaprasana 'Vision of a Creative Community' Calcutta: Arts Acre
 Publication (n.d.).
Aves ExC. W.Germany, 1988. [Refer CIMA, Vadehra].

Sihare, Laxmi P. [Refer LKA, NGMA].

Singh, Arpita [Refer E.Alkazi, CCA, K.Chaitanya, Gallery 7, Gy.CH,
 P.Karunakar, M.Marwah, Vadehra].

Singh, Chandramani 'Notes on Some Early works of M.F.Husain' LKC 15
 (Apr 1973): 41–2.

Singh, Madan Gopal 'Syncope Gaze Realism' Manjit Bawa CCA ExC. 27
 Feb–8 Mar 1990.
'Amithava Das: A Differing Political Sign' AHJ (1990–1): 29–30+
'The Orientalist: A Note on Vivan Sundaram's Work'. JAI 17–18 (Jne 1989)
 141–3.
'Swami: Of His Times' the India Magazine 14.7(Jne 1994): 7–15. Rpt. JAI 27–
 28 (Mar 1995). [Refer Art Today, CCA].

Singh, Paramjit [Refer CCA, CIMA, K.B.Goel, Gy.CH, P.Karunakar, K.Malik,
 Vadehra].

Sinha, Gayatri 'Shamsad Husain: Studies in Loneliness' AHJ 9 (1989–90):
 49-52.
'Changing Criteria of Art Criticism' . Paper presented at the IIC Symposium,
 New Delhi 4 Sep 1993.
'India Songs: Indian women artists' Art and Asia Pacific Q2.2 (Apr 1995):
 98–107.
'Installation Art' LKC 41 (Sep 1995): 28-31.
'A Tree in My Life' Art Asia Pacific Q3.2 (Apr 1996). [Refer Espace].

Sinha, Sacchidanand 'Himmat Shah: The Innocent Eye' LKC 28 (Sep 1979):
55-7. Chaos and Creation. LKA 1981.

Siqueiros, D.A. Towards a Transformation of the Plastic Arts, 1934. In AT
 1900–90. Harrison, C & P.Wood, eds. 412–4. Oxford: Blackwells 1993.

Siqueiros, D.A., et al. A Declaration of Social, Political and Aesthetic
 Principles, 1922. In AT 1900–90. Harrison, C & P.Wood, eds. 387–8.
 Oxford: Blackwells 1993.

Sircar, Anjali 'The problems of indigenous sources of inspiration' LKC 32
 (Apr 1985): 15-23. [Refer LKA]

SivaKumar, R. et al The Santiniketan Murals. Calcutta: Seagull Books in
 association with Visva–Bharati 1995. [Text by J.Chakravarti, R.SivaKumar
 & Arun K.Nag; Foreword by K.G.Subramanyan] [Refer CIMA, Sakshi,
 K.G.Subramanyan].

Society of Contemporary Artists (SOCA), Calcutta
JG ExC. 23–29 Jan 1970.
SOCA Album 1960–91. Calcutta: SOCA Dec 1991.

Society of Contemporary PrintMakers: Assam Rabindra Bhavan, LKA ExC
 7–13 Aug 1995.

Sokolowski, T.W. Contemporary Indian art from Chester–Davida Herwitz
 Collection. New York: Grey Art Gallery & Study Center 1985–6.

Solomon, W.E.G. 'Review of, The Bombay Revival of Indian Art' Rupam 21
 (Jan 1925): 34-5.

Som, Sovom 'Gobardhan Ash: An Early Modern' AHJ 3 (1983-4): 24-5+

'The art of Jamini Roy and the Bengal Folk Paradigm' In Jamini Roy, 25-43.
 LKA 1992.
'Abanindranath Tagore and Gaganendranath Tagore– A Reappraisal' LKC 38
 (Mar 1993): 19-26.

Sotheby's Auction House 'The Times of India Auction of TIMELESS ART'
 ExC. 26 Mar 1989.
'Indian, European and Oriental Paintings and Works of Art', New Delhi 8-9
 Oct 1992.
'Contemporary Indian Paintings: The Chester & Davida Herwitz Charitable
 Trust', New York 12 Jne 1995.
'Contemporary Indian Paintings: From the Chester & Davida Herwitz
 Charitable Trust, Part II', New York 3 Apr 1996.
'Modern and Contemporary Indian Paintings: One Hundred Years' London, 8
 Oct 1996.

Souza, Francis Newton 'Nirvana of a maggot'. London: Encounter (Feb
 1955). Rpt. in Words & Lines. London: Villiers 1959.
Words and Lines. London: Villiers, Jly 1959 [Limited edition of 1000].
Souza. London: Anthony Blond Publications 1962.
'Notes from my Diary.' Aspect Journal: India Issue. U.Beier, ed. (Jan 1982):
 87–91.
'Interview with S.Balakrishnan' IWI 21 May 1989. Rpt. in CCA Annual
 (1990–1): n.p.
My Credo In Art. In Contemporary Indian Art from the Glenbarra Museum
 Collection. Masanori Fukuoka, ed. Hemeji: Glenbarra Japan Co. 1993.
 [Refer E.Alkazi, Dhoomimal, K.B.Goel, H.Goetz, G.Kapur, V.Kumar,
 A.Ludwig, Marg, M.Marwah, J.Swaminathan]

Spate, Virginia Orphism. In Concepts of modern art. N.Stangos, ed. T & H
 1991.

Spivak, Gayatri Chakravorti. Who Claims Alterity? In AT 1900–90.
 Harrison, C & P.Wood, eds. 1119–24. Oxford: Blackwells 1993.

Srinivasan, G. The Self and its Ideals in East–West Philosophy. Trivandrum:
 College Book House 1974.

Srinivasan, Sumitra K. [Refer Gallery 7, Prithvi].

Steinberg, Leo excerpt from Other Criteria. London: OUP, 1972. In AT:
 1900–90. Harrison, C & P.Woods, eds. 948-53. Oxford: Blackwells 1993.

Subramanyan, K.G. 'The artist on art' LKC 3 (Jne 1965): 13-5.
'Folk art and Modern artists in India' LKC 10 (Sep 1969): 15–20.
'B.B.Mukherjee: Retrospective ExC.' LKC 10 (Sep 1969): 25–7.
'Thoughts on Murals' LKC 14 (Apr 1972): 17–9.
'The Uses of art criticism' LKC 16 (Sep 1973): 1–9.
Moving Focus: Essays on Indian Art New Delhi: LKA 1978.
'Ram Kinkar – the man and his work' LKC 30 (Sep 1980): 33-8.
'The Drawings of Nandalal Bose' AHJ 2 (1982–3): 55–71.
'Retrospective Exhibition' BAAC ExC. 6–18 Dec 1983. [Text includes
 interview with R.Sivakumar]
The Significance of Ananda Coomaraswamy's Ideals in Our times. 15–9 In
 Paroksa: Coomaraswamy Centenary Seminar Papers. G.m.Sheikh,
 K.G.Subramanyan & K.Vatsyayan, eds. New Delhi: LKA 1984.
'Apothesis of the Ordinary' AHJ 4 (1984–5): 50–5.
'State of the Arts in Contemporary India' AHJ 4 (1984–5): 56–9+
The Living Tradition: Perspectives on modern Indian art. Calcutta: Seagull
 1987.
'Of Myth and fairytale' BAAC ExC. 1–10 Dec 1989. [Text includes
 conversation with R.Sivakumar. Published by Seagull in association with
 BAAC]
'Remembering Ramkinkar' AHJ 9 (1989–90): 66-70.

'Uncoded Myths: Conversing with a Japanese friend' *AHJ* 10 (1990–91): 48-9.

'Excerpts from a Notebook' *AHJ* 11 (1991–2): 155–6+

Magan Soma Parmar: A Tribute. *AHJ* 4 (1984–5): 79–83. Rpt. in *Cymroza Annual* (1991–2): 59–62.

The Creative Circuit. Calcutta: Seagull 1993.

Paper Presented at NCPA Mohile–Parekh Conference on 'Internationalism/ Perspectives/Realities', Jan 1994.

'What is in a line?' In *Drawing'94* Prayag Shukla, ed. New Delhi: Gallery Espace Publication 1994.

'Jyoti Bhatt: Photographer, Conserving a Precious Heritage' *AHJ* 14 (1994–5): 105–6+

Bahurupee: A Polymorphic Vision. In CIMA ExC. 8–18 Dec 1994.

'K.G.Subramanayan: Recent Works' 8 –18 Dec.1994 CIMA ExC. [Includes text 'Pilgrim's Progress by R.Siva Kumar].

'Pages from a Notebook.' K.G.Subramanyan: The Paris Paintings *AHJ* 15 (1994–5): 65–80. [*Refer* BAAC, J.Bhatt, CIMA, D.Elliot, JG (1989), G.Kapur, Sakshi].

Sud, Anupam [*Refer* Cymroza, S.A.Krishnan].

Suhrawardy, Shahid 'A short note on the work of Jamini Roy', University of Calcutta Paper, 1937.

'The art of Jamini Roy' *Marg* 2.1. (1949): 66–75+

Sultan Ali, J *Artrends* 3.1 & 2 (Oct 63–Jan 1964).

'A personal vision of tribal art and folk art' *LKC* 29 (Apr 1980):.

'The Dancing Ganesha' In *Aspect Journal: India Issue* (Jan 1982): 76–8.

'R.B.Bhaskaran: Agile Creativeness on Canvas.' In Untitled booklet on R.B.Bhaskaran. Madras: Private Publication, 1986. [Text also includes a Review by Josef James] [*Refer* U.Beier, Dhoomimal, S.A.Krishnan. LKA].

Summerson, John. Ben Nicholson. London: Penguin 1948.

Sunanda (Pseud.) *Artrends*.

Dhanraj Bhagat. *Artrends* 1.1 (Oct 1961).

Jamini Roy. *Artrends* 1.2 (Jan 1962).

Prodosh Das Gupta. *Artrends* 1.4 (Jly 1962).

Husain. *Artrends* 1.3 (Apr 1962).

Gujral. *Artrends* 2.2 (Jan 1963).

Laxman Pai. *Artrends* 2.4 (Jly 1963).

Redeppa Naidu *Artrends* 3.1 & 2 (Oct 1963–Jan 1964).

PV Janakiram. *Artrends* 4.4 & 5.1 (Jly–Oct 1965).

F.N.Souza. *Artrends* 5.2 & 3 (Jan–Apr 1966).

K.G.Subramanyan. *Artrends* 5.2 & 3 (Jan–Apr 1966).

A.M.Davierwalla. *Artrends* 5.4 & 6.1 (Jly–Oct 1966).

Sundaram, Vivan 'Swaminathan and the moment of Group 1890' *JAI* 27–28 (Jne 1995): 147–50. [*Refer* Dhoomimal, K.B.Goel, Gy.CH, R.Hoskote, K.Keseru, M.Marwah, A.Rajadhyaksha, Sakshi, KK.Sangari, K.Shahni, M.G.Singh].

Sundaram, V & G.Kapur, ed. *Amrita Sher-Gil* . Bombay: Marg Publication 1972. [Includes text by G.m.Sheikh & K.G.Subramanyan].

Surya Prakash

AHJ (1979–80).

'Reflections' Cymroza Gallery ExC. 1992–93.

'Andhrapradesh' (LKA).

Swaminathan, J Souza's Exhibition, 21 Oct 1962. Rpt. LKC 40 (Mar 1995): 31.

Jeram Patel, 1962. Rpt. LKC 40 (Mar 1995): 28-9.

'Homage to Sailoz' 28 Oct 1962. Rpt. in *LKC* 40 (Mar 1995): 32.

'Group 1890' Manifesto 1963.

'Values in Indian Art'. art now in India, Gy.CH–Commonwealth Institute ExC. London 1965. [Exhibition sponsored by LKA & the Ministry of Education, Govt. of India for the Commonwealth Arts Festival, London 1965].

'The significance of the traditional numen to Contemporary Art' *LKC* 29 (Apr 1980).

'Ambadas: A Lisping Revelation' (5.2.87). Gy.CH ExC. 4–14 Mar 1987.

A True Catalyst. In *Contemporary Indian Art: Catalogue of the Glenbarra Art Museum*. Masanori Fukuova, ed. Hemeji, Japan: Glenbarra Art Museum 1993.

'The Cygan: An Auto-bio note', 18.9.1993. Vadehra ExC. 15 Oct–14 Nov 1993 [Text also includes K.B.Goel's 'The Other'].

Special Issue on J.Swaminathan: *LKC* 40 (Mar 1995).

Swaminathan Issue: *the India Magazine* 14.7 (Jne 1994). [*Refer* BAAC, CCA, Dhoomimal, K.B.Goel, Gy.CH, G.Kapur, Kunika–CH, NGMA, V.Sundaram, A.Vajpayi].

T

Tagore, Abanindranath

Some Notes on Indian Artistic Anatomy. Calcutta: ISOA 1914 [Introduction by Dr. O.C.Ganguly] [*Refer* J.Appasamy, E.B.Havell, ISOA, A.Monsur, NGMA, B.K.Sarkar, S.Som].

Tagore, Gaganendranath [*Refer* M.R.Anand, N.C.Chaudhuri, K.Dasgupta, ISOA, A.Kar, C.Kar, LKA, A.Mitra, B.B.Mukherjee, A.Mukhopadhya, S.Som].

Tagore, Rabindranath [*Refer* M.R.Anand, A.K.Coomaraswamy, ISOA, S.Kramrisch, LKA, NGMA, P.Neogy, P.Ray, Tate Gallery, The Calcutta Municipal Gazette].

Tagore, Sundaram Historical Overview of Indian Artists' response to Modernism: Formative Phase, 1940-60s. In *Trends & Images CIMA Inaugural ExC*.1993.

'New Horizons: A Struggle for Modernism' *Asian Art News* 6.1 (Jan–Feb 1996): 28–34.

Tate Gallery, London Hundred Years of German Painting 1956.

Six Indian Painters: Rabindranath Tagore, Jamini Roy, Amrita Sher-Gil, M.F.Husain, K.G.Subramanyan, & Bhupen Khakhar, ExC. 1982. [Text by Geeta Kapur & note by Howard Hodgkin].

Teil, D 'Indian Painters in Paris' *LKC* 4 (Apr 1966).

Thacker, Manu & G.Venkatachalam, eds. *Present Day Painters of India*. Bombay: Sudhangshu Publication 1950.

The Asian Age (Newspaper)

'The Last Word: Profile of Rameshwar Broota 9 Oct 1994.

Veena Kotian. 'Salaam Bombay' The Age on Sunday, 23 Jly 1995.

Veena Kotian. 'Art in Bombay' 29 Sep 1995.

A Profile: Shireen Gandhy. 29 Sep 1995.

A.T.Jayanti. 'Past Masters: K.H.Ara' Bombay: 28 Nov 1995.

Uma Nair. 'Paresh Maity: This poet writes with a brush' New Delhi, 10 Dec 1995.

Uma Nair. 'Art in Delhi' 29 Dec 1995.

Chaitanya Sambrani. 'Final 'leaves & letters' from an artist's brush', Bombay, 29 Dec 1995.

Rajen Bali 'Krishna Reddy: Geometry is the Clay with which I build my pot' Calcutta 29 Dec 1995.

The Calcutta Municipal Gazette. *Special Supplement: Tagore Memorial*. Calcutta: The Calcutta Municipal Corporation May 1986.

The Current (Newspaper) 2 Feb 1974.

The Gallery, Madras Anjana–Navjot–Shakuntala, The Gallery–JG–
 Shridharani ExC. Dec 90–Jan 91.
Yusuf Arakkal ExC. 1995.

The Hindustan Times, New Delhi (Newspaper) Ramkumar. 23 Oct 1955.
Krishen Khanna. 11 Jan 1972.

The Independent (Newspaper) Meher Pestonji. 'Imitiaz Dharker: The Past is
 Searching for a Toehold' 18 Jan 1992.
The India Magazine Krishen Khanna: Looking beyond his canvas [Based on
 interviews with Chanda Singh] 4.10 (Sep 1984): 16–25.
Krishen Khanna: Artist's Sketchbook 11.5 (Apr 1991): 8–15.
The Art Market Issue. 15 (Jly–Aug 1995).

The Observer (Newspaper) Madhulika Sinh 'Arpana Caur: Art Couture' 10
 Oct 1993.

The Pioneer (Newspaper) S.Kalidas 'Foul Play? Anarchy in the art world'
 14 July 1996.
Jatin Das in conversation with Akshaya Mukul: 'I am not a Popular Artist' 26
 May 1996.

The Statesman, New Delhi (Newspaper) A.Ramachandran. 9 May 1967.
'Symbolic Art of Sunil Das' Oct 1972.
'A.Ramachandran: The Nuclear Age and Raginis' 27 Nov 1975.

The Sunday Times & Times of India (Newspaper) 'Ramkumar's paintings
 show unity of style' 13 Feb 1969.
Krishen Khanna. Bombay: 24 Nov 1970.
'Biren De: Splendours of Radiating Colours & Forms' 11 Nov 1971.
Krishen Khanna. New Delhi 9 Jan 1972.
Krishen Khanna. Bombay 11 Dec 1973.
'Ramkinkar Vaij.' Sunday Times 24 Aug 1980.
Atul Dodiya. Sunday Times of India 29 Sep 1991.

The Village Gallery, New Delhi A.Ramachandran & Paritosh Sen. Paritosh
 Sen: Instant Images & Acrylics as watercolours ExC. 6 Dec–27 Dec 1991 &
 28 Dec–18 Jan 1992.
Sunil Das: Drawings & Mixed Media Works ExC. Oct 1995.

Thozhur, V [*Refer* Cymroza].

Time Magazine, USA Mohan Samant. 6 Mar 1964.
'Art & Money' by Robert Hughes 134.22 (27 Nov 1989).

Tewari, Vasundhara 'Artists Sketch Book'. *The India Magazine* (Jan 1992):
Polarities. Dream/Reality, Shridharani Gallery ExC. 1994. [*Refer* S.Datta].

Tonelli, Edith A. [*Refer* NGMA].

Tuli, Neville 'Indian Contemporary Painting: The Fuller–Full Aesthetic'.
 Indian Horizons– Indian Realities Special Issue 43.3 (1994): 122–36 New
 Delhi: ICCR. Rpt. in *The Divine Peacock: Understanding Contemporary India*.
 K Satchidananda Murthy, ed. New Delhi: ICCR–Wiley Eastern Publications,
 1995.

Turner, Caroline, ed. *Tradition & Change: Contemporary Art of Asia and the
 Pacific.*
Australia: University of Queensland Press 1993.

UV

Ushiroshoji, M Fatal Movement Transcending Asian Modern Art. In
 Contemporary Indian Art : Catalogue of the Glenbarra Art Museum.
 M.Fukuoka, ed. Hemeji, Japan: Glenbarra Art Museum 1993.

Vadehra K.Malik. Nandalal Bose ExC. 5–15 Feb 1991.
Statement by N.S.Bendre. [Rpt. from *Artists Today*, Marg 1987]. Drawings &
 Paintings of N.S.Bendre ExC. 21 Feb–15 Mar 1992.
Manu Parekh ExC. 27 Mar–18 Apr 1992.
Roshan Shahni 'Let history cut across Me, Without Me' M.F.Husain ExC.
 1993.
Srimati Lal 'Symphony of Survival' Ramkumar ExC. 8–27 Feb 1993.
K.K.Hebbar ExC. 6 Mar–9 Apr 1993. [Text rpt. from *Voyage in Images*, JG
 Publication 1993].
Keshav Malik. Reflections & Images ExC. 6–21 Aug 1993. [JG: 30 Aug–5 Sep
 1993].
J.Swaminathan: Text De–Text ExC. 15 Oct–14 Nov 1993.
Sunita Paul. Mickey Patel ExC. 7–28 Sep 1994.
Nilima Sheikh 'Materialising Dream: Body and Fabric' Arpita Singh ExC. 29
 Sep–31 Oct 1994.
Rajesh Mehra. Ambadas ExC. Nov–Dec 1994.
Keshav Malik. Manu Parekh: Paintings 1993 –95 ExC. 20 Jan–16 Feb 1995.
Mansaji Majumdar. Shuvaprassana ExC. 17 Feb–8 Mar 1995.
M.Ramachandran 'Alternating Visions: Diptych' Paramjit Singh ExC. 26 Dec
 1995– 16 Jan 1996. [See NGMA, Seagull].

Vaij, Ramkinkar [*Refer* J.Appasamy, S.Chaudhuri, P.Dasgupta, LKA, NGMA,
 V.Purohit, B.C.Sanyal, K.G.Subramanyan, The Times of India].

Vaikuntum, T [*Refer* Cymroza].

Vajpayi, Ashok 'J.Swaminathan: A Furious Purity' *The India Magazine* 14
 (Jne 1994): 38–49. Rpt. in abridged form in *Art & Asia Pacific* Q2.1 (Jan
 1995): 62–71.
'Sep peintres indiens contemporains', au Monde de l'Art, Paris ExC. 18 Jan–
 31 Mar 1995. [Also Note by Raphael Doueb. Artists Exhibited: Manjit
 Bawa, Bal Chhabda, Jogen Chowdhury, Tyeb Mehta, S.H.Raza, Arpita Singh
 & K.G.Subramanyan].

Varma, Raja Ravi [*Refer* K.Chaitanya, K.B.Goel, T.Guha–Thakurta, LKA,
 P.Mitter, R.C.Sharma].

Vasudev, Arnawaz [*Refer* Art Heritage, Cymroza].

Vasudev, S.G. [*Refer* J.James, S.A.Krishnan, Sakshi].

Vasudev, S.V. (S.V.V. pseud) 'Seven Contemporaries: Amrita Sher–Gil,
 Svetoslav Roerich, Satish Gujral, Dhanraj Bhagat, R.D.Raval, Akbar
 Padamsee, Amarnath Sehgal.' *Marg* 6.1 (1952): 40–1.
Gujral. *Marg* 8.1 (Dec 1954).
V.S.Gaitonde. *Artrends* 5.4 & 6.1 (Jly–Oct.1966).
Mohan Samant. *Artrends* 5.4 & 6.1(Jly–Oct.1966).
'P.Mansaram: A Collage of Impressions' LKC 28 (Sep 1979): [*Refer* LKA,
 J.A.Sabavala].

Vasudev, Uma 'Why Murals – an interview with Satish Gujaral' *LKC* 14 (Apr
 1972): 25–8. [*Refer* LKA].

Vatsyayan, Kapila 'Problems of Identity: Tradition and Modernity' *LKC* 30
 (Sep 1980): 1-3.
The Indian Arts, their Ideational Background and Principles of Form. In
 Paroksha: Coomaraswamy Centenary Seminar Papers. K.Vatsyayan,
 G.m.Sheikh & K.G.Subramanyan, eds. LKA, 1984.

Vatysayan, Kapila, ed. *Concepts of Space– Ancient and Modern.* New Delhi:
 Indira Gandhi National Centre for the Performing Arts 1991.

Vatsyayan, Kapila, G.m.Sheikh & K.G.Subramanyan, eds. *Paroksha:
 Coomaraswamy Centenary Seminar Papers.* LKA 1984.

Venkatachalam, G *Hebbar*. Bombay: Nalanda Publications May 1948.
'Some Reminisences about the Bengal School' *LKC* 1 (Jne 1962). [*Refer*
 M.Thacker].

Venkatappa, K [*Refer* LKA)

Venkatappa Art Gallery, Bangalore A.Rajadhyaksha 'Encodings'. Alex
 Matthew & Pushpamala, Sculpture, Drawings, Prints, & Glass Paintings
 ExC. 16–23 May 1990.

Verma, Nirmal Ramkumar Retrospective NGMA–Vadehra ExC. 20 Nov–12
 Dec 1993

Viswanadhan [*Refer* R.Chawla, Gallery Chanakya].

Vogt, Paul *Expressionism: German Painting between 1905–20.* Trans:
 Anthony Vivis. Cologne: DuMont Buchverlag 1979.

von Leyden, Rudolf 'Studies in the Development of Ara' *Marg* 6.2 (1951):
 52–5.
Dr.Homi Bhabha & the World of Art. In *Homi Bhabha*. J.Bhabha, ed. Bombay:
 Private Publication 1968.
'Raza: Metamorphoses' Gy.CH ExC. Sep–Dec 1978. [Text includes note by
 J.Lassaigne].
Raza Gy.CH ExC. Oct. 1979.
Raza. Bombay: Chemould Publications 1985. [*Refer* LKA].

WXYZ

Welling, D
'Autonomy Achieved' in LKC 7–8 (Sep 1977–Apr 1978).

Waldemar, G
'Raza and the spirit of the Orient' LKC 16 (Sep 1973): 29–36.

Walther, Ingo F.
Picasso: Genius of The Century. Cologne: Benedikt Taschen Verlag GmbH &
 Co. 1986.

Whitfield, Sarah Fauvism. In *Concepts of modern art*. N.Stangos, ed. 11–29.
 T & H 1991.

Wilenski, R.H. *French Painting*. London: The Medici Society 1931.

Williams, Raymond. When was Modernism?. In *AT 1900–90*. Harrison, C &
 P.Wood, eds. 1116–9. Oxford: Blackwells 1993.

Winterberg, H 'Interview with Laxma Goud' *LKC* 15 (Apr 1973).

Wiseman, Mary Bittner *The Ecstasies of Roland Barthes*. London & New
 York: Routledge 1989.

Yee, Jung Hun 'Harvest Moon: The Ssack Exhibition at the Sonje Museum'
 *Art Asia Pacific Q*3.2 (1996).

Zharotia, Jai [*Refer* Art Heritage, Art Today, Cymroza].

Photographic Acknowledgements

I

My thanks to the following individuals and/or institutions for providing slides/transparencies for reproduction. The plate number(s) of the relevant illustration(s) is provided.

Ebrahim Alkazi	28, 80, 187, 202, 266, 274, 275
Prabhakar & Sonali Barwe	105, 235, 242, 243
R.B.Bhaskaran	57
Rameshwar Broota	5, 84, 181, 195, 212
Arpana Caur	238
Jogen Chowdhury	77
Sadrudin Daya & Bharti Kapadia	36, 78, 82, 87, 160, 210
Biren De	7, 55, 92, 145, 159, 185, 245
Atul Dodiya	117, 216
Shyamal Dutta Ray	183
Gallery Chemould & Shireen, Kekoo and Khorshed Gandhy	12, 65, Archival Photos, 179, 196
Gallery Espace & Renu Modi	100
Satish Gujral	246
Ganesh Haloi	247
K.K. Hebbar	249
Ranbir Singh Kaleka	11, 219, 233
Sanat Kar	253, 254
Bhupen Khakhar	220
Krishen Khanna	69
Prabhakar Kolte	161, 163
Tyeb Mehta	14, 221, 263
Anjolie Ela Menon	cover, 264
Altaf Mohammedi	162, 198
Reddeppa Naidu	265
National Gallery of Modern Art (NGMA) & Anjali Sen	6, 30, 32, 33, 34, 37, 39, 41, 90, 93, 101, 102, 120, 125, 127, 131, 133, 184, 191, 194, 229, 267
Ved Nayar & Gogi Saroj Pal	223
Akbar Padamsee	150
Laxman Pai	97, 154
Manu Parekh	200, 268
Gieve Patel	16, 107, 269, 270
Sudhir Patwardhan	18, 113, 203, 225, 271
Pundole Gallery & Dadibha Pundole	15, 27, 48
Ganesh Pyne	19, 272
A.Ramachandran	20, 98
Rekha Rodwittiya	115, 240
Jehangir Sabavala	236, 278
G.R.Santosh	279
Paritosh Sen	228
Ghulam m. Sheikh	89, 193
Laxman Shreshtha	283
Arpita & Paramjit Singh	111
Sotheby's and Patrick Bowring	9, 10, 23, 26, 88, 99, 146, 186, 206, 211, 213, 273, 284
Vivan Sundaram	287
Vasundhara Tewari	116, 239
Vadehra Gallery & Arun Vadehra	31
S.G.Vasudev	173, 230

II

My thanks to the following individuals and/or institutions for allowing me and Prakash Rao to photograph works in their collection or possession, and the subsequent permission to reproduce such works.

Rajan & Viren Bhagat and Family
Gallery Chemould & Shireen Gandhy
Dinesh & Amrita Jhaveri
Fine Art Resource Foundation and Usha & Ranjana Mirchandani
Jehangir Nicholson Museum at the NCPA and Jehangir Nicholson & Jamshed Bhabha
Shirin & Priya Paul
Pundole Gallery & Dadibha Pundole
Sakshi Gallery & Geeta Mehra

III

My thanks to the following individuals and/or institutions for allowing me permission to reproduce works in their collection.

Ebrahim Alkazi
Shoba Bhatia
H.Chaganlal
Chandigarh Government Museum and Art Gallery
Sadrudin Daya
Chester & Davida Herwitz
Masanori Fukuoka
Gallery Chemould
Harsh Goenka
Indian Museum, Calcutta
Jehangir Nicholson Museum at the NCPA
Dinesh Jhaveri
Geeta Khandelwal
Sunita Khandelwal
Lalit Kala Akademi, New Delhi
Maharaja Fatehsingh Museum, Baroda
National Gallery of Modern Art, New Delhi
Shirin Paul
Rabindra Bharati Society, Calcutta
Rabindra Bhavan, Visva–Bharati University, Santiniketan
Times of India Group
TISCO
Francis Wacziarg
Lionel Wendt Memorial Trust, Sri Lanka

IV

Lastly to Prabjit Singh and Prakash Rao for their photography and kind support.

Index